ART IN THE SAN FRANCISCO BAY AREA

1945 :: 1980

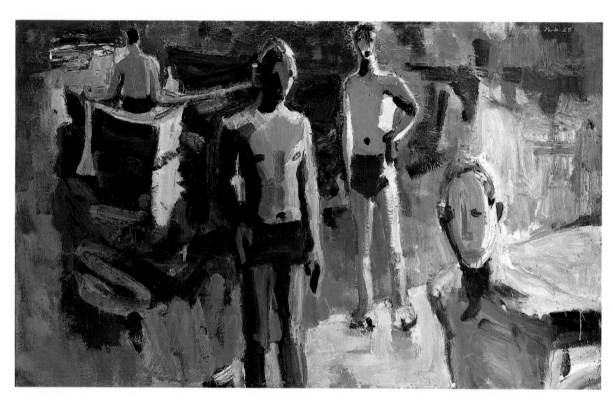

Frontispiece. David Park, *Four
Men,* 1958. Oil on canvas, 57″ ×
92″.

ART IN THE SAN FRANCISCO BAY AREA

1945 :: 1980 *An Illustrated History*

THOMAS ALBRIGHT

University of California Press

University of California Press
Berkeley and Los Angeles, California
University of California Press, Ltd.
London, England
© 1985 by
The Regents of the University of California

Printed in Japan

1 2 3 4 5 6 7 8 9

Library of Congress Cataloging in Publication Data

Albright, Thomas.
 Art in the San Francisco Bay area, 1945-1980.

Bibliography: p.
Includes index.
1. Art, American—California—San Francisco Bay
Area. 2. Art, Modern—20th century—California—San
Francisco Bay Area. I. Title.
N6535.S3A43 1985 709'.794'6 84-24112
ISBN 0-520-05193-9
ISBN 0-520-05518-7 (pbk.)

To my mother, Ruth Albright;
to the memory of my father, James Albright;
to my daughter, Sylvia Albright;
and to my dearest friend, Beverly Lohwasser.

Contents

Contents

Dr. Gladstone's Wonders of the World, and art as personal mythology. Fred Martin, Jeremy Anderson, and the mythical map. William T. Wiley. Robert Arneson. Joan Brown. Roy De Forest. Third World and feminist myths. The frog world of David Gilhooly. "Dude Ranch Dada" and the Super-Object school of ceramic making. Pluralism in art.

Acknowledgments

We would like to acknowledge the following individuals, foundations, and corporation whose generous contributions and support have made this publication possible.

Thomas and Verbia Albright
Mr. and Mrs. Harry Anderson
Gerson Bakar
James R. Bronkema
Herb Caen
David B. Devine
Mr. and Mrs. Richard S. Dinner
The Mortimer Fleishhacker Foundation
Dorothy Gelhaus
Rhoda and Richard Goldman
Evelyn and Walter Haas, Jr.
The Miriam and Peter Haas Fund
Walter and Elise Haas Fund
Frank Hamilton
Ann M. Hatch
Mr. and Mrs. Stanley Herzstein
Hoffman Cafe and Grill
Hospice of San Francisco
The Koret Foundation
Susan and Hunter Land
Modesto Lanzone

Maryon Davies Lewis
Susan Lohwasser
Byron Meyer
Ed and Mary Etta Moose
Dr. Phillip Polakoff
Toni and Arthur Rock
Mrs. Madeleine H. Russell
Alice and William Russell-Shapiro
The San Francisco Chronicle
The San Francisco Foundation
Mr. and Mrs. Charles Schwab
Mr. and Mrs. Donald Scutchfield
Roselyne and Richard Swig
Ray Towbis
Sanford M. Treguboff
Mr. and Mrs. Brooks Walker, Sr.
Brooks Walker, Jr.
Sandy Walker
Mrs. Paul L. Wattis
Mr. and Mrs. Thomas Weisel
Mason Wells

This publication also served as the basis for an exhibition in the Great Hall of the Oakland Museum, June 15–August 18, 1985.

Preface

One of the occupational hazards of being a journalist is that sooner or later someone is bound to suggest that you take some of the things you've written and expand them into a book. This is a sort of flattery that most of us quickly learn to ignore. What, after all, is wrong with a good story, where one learns only as much as has to be learned about a given subject, writes only as much as needs to be written about it, and then moves on to another investigation? Leave the making of books—like the elaboration of murals, or the carving of faces on Mount Rushmore—to those who are better equipped with time and temperament to deal with such ponderous things; leave it to the scholars and specialists who, to paraphrase H. L. Mencken, content themselves with learning more and more about less and less.

The occasion of my own undoing in this regard was a series of lectures on the history of postwar art in the San Francisco Bay Area—the first lectures of their kind—that I presented at the San Francisco Museum of Modern Art in the fall of 1974. When it was suggested that I turn the lectures into a book, the idea seemed attractive for several reasons. There was the unaccountable fact that although the San Francisco Bay Area has been an important art center for half a century or more—at least until the middle of the 1960s, it was second only to New York—no comprehensive study of its unique contributions to the nation's artistic and cultural heritage had ever been

made. There was the additional consideration that, after covering the art scene for more than a decade for the *San Francisco Chronicle,* I had become a kind of specialist on the subject almost in spite of myself. What finally made the temptation irresistible, though, was the misguided notion that writing the book would be relatively easy. After all, several people had warned me earlier that it would be "impossible" to put together the lecture series on short notice, but I had done it. And with so much material already gathered and organized, I thought, little more work seemed necessary than to provide a few new transitions, substantiate generalizations with some hard facts, and add footnotes and some other trappings of scholarship. Had I ever suspected that this was just the beginning of a ten-year effort that would involve countless hours of research, and innumerable rewrites and revisions, there might still be no book.

One of the most gratifying things about this project is the way so many people have been so helpful. In a class by herself has been my friend and agent, Beverly Lohwasser, who has been a constant source of inspiration and encouragement. More tangibly, she designed and coordinated the fundraising and marketing campaigns that have been crucial to the book's publication. In fact, she has been active in virtually every phase of the project, from conducting research and providing valuable advice in editorial decisions to assisting in

the selection of reproductions and overseeing layout. It is no exaggeration to say that without her commitment and dedication, this book could not have been produced.

With Gene Tanke, whom the University of California Press secured in the often thankless capacity of copy editor, I found an immediate rapport that occasionally verged on the uncanny. No editor and writer are ever going to see eye to eye on every point, but much more often than not he was able to make suggestions that managed to preserve my particular "voice" while greatly clarifying and sharpening what it was saying.

Robert Emory Johnson, who gathered many of the pictures, is an old friend and collaborator who confirmed his reputation for making the same kinds of choices that I would have made in his place. I was heartened to find, early on, that Chet Grycz, the Production Manager of the U.C. Press, shared the general vision of the book that the rest of us had, and clearly possessed the expertise to make that vision a reality. Other members of the U.C. Press staff to whom I am especially indebted are Charlene Woodcock, whose belief in the overall concept was such that she was willing to move an early draft through the preliminary round of reader reports at a time when many of its pages looked more like a paste-up collage than a manuscript; and Director Jim Clark, who eventually took charge as sponsoring editor, cajoled me into making a few more final revisions, and gained formal approval from the faculty publications committee.

Margo Cowan was also of great assistance in the fundraising campaign, and a special category must be devised for Jeannette Redensek, whose skills as a research assistant proved as invaluable as her all-around clerical and secretarial help. I am also deeply grateful to Terry St. John, John C. W. Carroll, and Michael Hennessey—Michael for letting us use his home as an office for the past three years.

My acknowledgments could obviously go on indefinitely, so I would like to end with a blanket "thank you" to all the librarians and other museum people, the dealers, the collectors, and other members of the art community, who helped with research, pictures, permissions, and other essentials. And, finally, my deepest gratitude to the artists, whose book this really is.

May 1, 1984

Introduction

Many forces have combined to give San Francisco its unique identity as a cultural center. For one, it has a certain "genius of place": a temperate climate (sunny in January, foggy in July); hills, woods, and seascapes of breathtaking beauty; and a cosmopolitan and polyglot population, distributed among at least a dozen dramatically distinct urban neighborhoods crowded into a small city that is nevertheless one of the great glamor capitals of the world. Its historic ties with Mexico and Central and South America, and its geographical position as a gateway to Asia, give it a cultural orientation quite different from that of the more European-looking cities of the Eastern seaboard. Coexisting with its urbanity is a deep-seated local reverence for nature, which has preserved a subtle but strong rapport with the heritage of the area's early Native American inhabitants and has made the Bay Area a stronghold of conservationists. For an artist, especially, the area is distinguished by such basic features as its characteristic light. "There's a cultivation of white here, the violent white of those plaster structures," Claes Oldenburg, who lived briefly in Oakland in the early 1950s, once observed.

Above all, the Bay Area's cultural life has always remained rooted in the kind of congenital split personality that characterized San Francisco's historic origins. Its early settlers were primarily adventurers, outcasts, and ne'er-do-wells, lured by gold and the prospect of instant wealth. But they also aspired to all the fine things that money could buy—including culture. As money poured in from the gold and silver mines in the Sierra Nevada, and later from construction of the transcontinental railroad, Nob Hill sprouted ornate mansions whose owners filled them with opulent European furnishings and grandiose paintings—primarily landscapes by Albert Bierstadt, William Keith, Thomas Hill, and scores of lesser artists who came from Europe or the East Coast. There were bookstores, photography studios, theaters of every kind, an academy of music, and a vigorous circle of bohemian writers, which in the middle 1860s briefly included both Mark Twain and Bret Harte. In 1873, a two-year-old San Francisco Art Association established the California School of Design, the first art school west of Chicago. Meanwhile, along the waterfront the saloons and bordellos of the Barbary Coast became an international mecca for devotees of pleasure, plain or fancy.

Hence the split personality: on the one hand, the parvenu's pretentions to urbanity and high culture (which San Francisco shares with every other provincial American city, though with somewhat more justification than most of them); on the other, the frontiersman's readiness to take risks, and to holler "bullshit" at the first sign of pomposity. On the surface, "the City"—as San Francisco likes to regard itself—cultivates a genteel, aristocratic image; underground, it breeds the volatile rebelliousness that has given birth to the

most revolutionary social and cultural movements of the past two generations—the Beats, the hippies, the student protest movement, the push for gay rights.

In keeping with the singularity of its character and history, the San Francisco Bay Area has developed a distinctive and vigorous artistic tradition. This is not to say that Bay Area art forms an isolated or coherent regional "school." San Francisco, though often grudgingly, is part of the United States, and the art of the Bay Area has always been very much an art of its time and its place; and in any case, art is always, first and foremost, the work of individual artists. However, drawing on the general currency of contemporary culture at certain points, and ignoring or obstinately resisting it at others, Bay Area artists have created a major body of American painting and sculpture (and photography as well) that reflects certain recurring attitudes. Independence, bluntness of speech, a stern austerity or elemental rawness, and a dedication to the vernacular are some of them. Others are an affinity for the mystical expressions of non-Western religions; a predilection for the eccentricities and broad humor of the "naive" folk artist; and a persistent dedication to simple (and not-so-simple) "realism"—an abiding interest in the verities of light and landscape, the irreducibles of the figure and of portraiture. In the dialectical tug-of-wars that are always straining the seams of contemporary art, Bay Area artists have generally favored homegrown elements over imported ones, personal experience over the supposed imperatives of art history, and a conception of art as vision, process, and act of communication rather than as a matter of pure form.

Although locally the term "Bay Area" has a technically precise meaning—it refers to the nine counties that touch the waters of San Francisco Bay—it will be applied in this survey in its more general sense, to the broad geographical area, extending over much of Northern and Central California, of which San Francisco has traditionally been the cultural center. Parts of this larger area—the Sacramento-Davis locale, for example—have recently attained distinct identities as centers of artistic activity (and as museum programs and professional galleries continue to grow in such cities as Sacramento and San Jose, they are likely to become more important cultural centers as well). Nonetheless, during the time span covered in this book, although more and more artists have moved further away to outposts in Big Sur and Mendocino, in Chico and Eureka, San Francisco has remained the place where their work has been most widely exposed, and the city with which their names are most commonly associated.

I decided to focus on the period between 1945 and 1980 for personal reasons. I first became directly involved with Bay Area art as a reviewer for the *San Francisco Chronicle* in 1957, and the vitality and power that attracted me at that time emanated largely from the shock waves still lingering from the explosion of Abstract Expressionism that had shaken the California School of Fine Arts shortly after the Second World War. Of course, much art of importance and quality was created in the Bay Area before this period, and it deserves fuller treatment. As it stands, my Chapter One, which covers events between 1915 and 1945, is designed only to set the stage.

I have excluded printmaking and photography, so as not to complicate further an already complicated account; Bay Area photography, in particular, has been another story, at least until the past few years, with its own proudly separatist traditions and attitudes. Within the sphere I have decided to cover I have further chosen to concentrate on the late forties, the fifties, and the very early sixties. This is partly because I find that period more intriguing, and partly because it seems more in need of recording than our present era, when the quantity of documentation and information on art has reached awesome, if not ludicrous, proportions.

From the beginning, two impulses have contended in the writing of this book: first, a desire to set forth a reasonably concise historical and critical account of the principal developments in Bay Area art since 1945; and second, an urge to acknowledge the seldom-recorded achievements of scores of individual Bay Area artists whose work has, in one way or another, been memorable and thereby enriched my life. I discovered in the early going that these two goals—the one necessarily selective, the other comprehensive and inclusive—were largely incompatible. My solution has been to compile an Appendix that serves two purposes: it summarizes the work of artists who are not mentioned in the text, and it also presents the kind of basic biographical data (birthdates, schools attended, and so on) that would tend to interrupt the flow of a narrative. This Appendix, although it contains almost seven hundred names, is in no sense exhaustive. The criteria for inclusion in it are similar to those I have used in writing the text; chief among them is whether, in going over thousands of old exhibition catalogues, newspaper clippings, and other materials, I found that an artist's name recalled work which has left a lasting visual impression. I should add that an artist's

inclusion only in the Appendix by no means necessarily indicates critical "exile." Fred Reichman and Art Holman, to name only two examples, have made more distinctive contributions to Bay Area art than many artists whose work is more historically "illustrative"; but they have made their contributions chiefly by swimming against the current rather than with it—and narratives, like streams, are supposed to flow.

The photographs used to illustrate this history represent the usual compromise between the ideal and the practical. The ideal, if one believes the printed word to be a wholly inadequate substitute for the image, would be to illustrate in full color every work of art mentioned in the text; the practical decision, considering the cost of color reproduction, would be to avoid it entirely. Thanks to the generosity of the organizations and individuals mentioned in the Acknowledgments, I have been able to present 114 color and 118 black and white photographs—a compromise much closer to the ideal than would otherwise have been possible. From the pool of pictures available for reproduction, I have tried to represent each artist who figures prominently in the text with at least one illustration of a characteristic work; and I have tried to use black and white photographs only when color is not an essential element of the work itself.

As a working newspaper critic who spends more time examining individual trees than trying to assign them to particular forests (or jungles, or perhaps deserts), I have developed a certain skepticism toward art history, and particularly toward the notion of a "contemporary history," which seems to me a contradiction in terms. I want, therefore, to affix a couple of caveats to the largely "contemporary art history" that follows.

First, histories, like Miss America contests, are made up of entries that have, by and large, already been screened and passed on to the finals by others—in the case of artists, the screening has been done primarily by the dealers, curators, and others responsible for giving exposure to art. (The critic, incidentally, plays a smaller role in this process than is commonly believed.) They take no account of those who, for one reason or another, never entered the competition, or of those who failed to meet the requirements for eligibility—the prevailing standards of contemporary taste.

Second, although in examining broad developments or "trends," one can sometimes pinpoint with a degree of accuracy the time and the circumstances that surround the origins of a particular art "movement," no really vital form of artistic expression ever fades away completely or "dies." New movements, because they are new, hold the spotlight for a time, but older expressions remain on stage and in the wings, exerting a subtle influence on the action.

Because I find almost anyone on the street more interesting than Miss America, and have a special fondness for subtle influences and subterranean currents, I have tried to provide at least a few correctives to the narrow view of events imposed by the conventions of writing a history. I have not hesitated to mention any artist whose work I consider worthy of recognition, regardless of whether his or her efforts have been acknowledged through more formal channels. I have stretched the time frame beyond 1980 in certain instances, generally where an artist's recent work has grown dramatically stronger than the work that would seem to represent the last word on his or her development if the cut-off date were inflexibly observed. I have tried to convey a sense of the multi-layered texture of events, and to balance the emphasis on a supposed evolution of *forms,* which dominates most art-historical thinking, with a sense of the inner movements of which forms are only the shadows. I have also tried to keep constantly in view the broader currents of cultural history, for which these forms are frequently the most sensitive barometer (a role in which they are often more interesting than as forms alone).

Nevertheless, I have found it necessary to adhere to certain conventions that seem essential if one is to impose any meaningful shape on what might otherwise be chaos (although chaos may be a more empirically accurate reflection of things). I have accepted the apparent need to deal in terms of broad trends or movements, and to proceed according to a rough chronology. I have made no effort to "rewrite" the story of Bay Area art in order to single out or emphasize in retrospect the accomplishments of members of various cultural or social minorities. There is a place for "revisionism," and a time; but what I have tried to do here is to set down a "standard history."

Ideally, a history of art would be a history of visions, convictions, and commitments, a story of individual lives progressively realized, made strong, and brought to completion; but that is the function of biography. We need more biographies of the artists who have contributed to the sequence of events that this study attempts to outline, as well as more close studies of particular phases or "periods" in the development of art in the Bay Area. And we should not forget that an artist's real biography is to be found in his or her own work, and that any history is at best a fragmentary approximation.

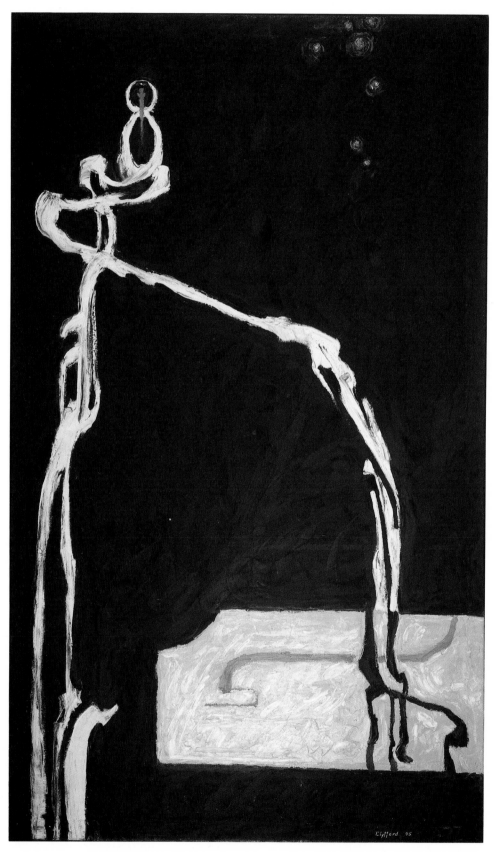

FIG. I. Clyfford Still, *Untitled*
(formerly *Self Portrait*), 1945. Oil
on canvas, 70⅞″ × 42″.

For some years, the birth of Abstract Expressionism in New York and in San Francisco had its own creation myths. The cataclysm in New York, it was said, was set off by Jackson Pollock, a lone paint-slinger in cowboy boots from the wilds of Wyoming, who rode into town to turn the New York art world on its head and singlehandedly change the course of American painting. The explosion in San Francisco was said to be the work of Clyfford Still, a messianic Old Testament prophet (in another view, he was more akin to Captain Ahab) who wandered out of the Dakota prairies into the quiet courtyard of the California School of Fine Arts one day in 1946, and instantly laid waste all decadent traditions and ushered in the art of a new millennium. (See Fig. 1.)

By now, of course, the myth of Pollock as the Daniel Boone of America's postwar artistic frontier has been dutifully shot down and laid to rest by the heavy artillery of contemporary scholarship. In its place we have prosaic accounts of how the development of Abstract Expressionism was influenced by the European Surrealists who settled in New York on the eve of the Second World War, and by earlier émigré artists such as Arshile Gorky and John Graham. We also know more about Pollock's own extended apprenticeship on the New York scene. Clyfford Still himself, in his last years, discounted exaggerated claims about his influence in the Bay Area. His San Francisco students, he said, "knew about everything that

was happening in New York and Europe."[1] Yet the myths about Still have lasted longer than those about Pollock. In part, this is because Still's work—his painting and his teaching—affected San Francisco artists on the deepest levels of attitude and feeling, and its impact has persisted in much of the best Bay Area art to the present day. Irving Sandler has described Still as "the most anti-traditional of all of the Abstract Expressionists."[2] And certainly, as we shall see, no figure could have been better suited than Still to galvanize a violent fusion of two complementary forces: a rebellious striving for self-definition that was beginning to stir throughout the nation in the years just after World War II; and a stubborn strain of maverick individualism that was already deeply rooted in Bay Area tradition.

To be sure, in 1945 an explosion of any sort seemed remote from the cloistered atmosphere of the California School of Fine Arts, serene in its twenty-year-old Mission style building (sometimes mistaken for an old monastery) on the seaward slope of Russian Hill—at the edge of North Beach and about half a mile from the financial district. Nor was individualism conspicuous in Bay Area painting or sculpture at the time. There was, nevertheless, a respectable local history of modernist experimentation and adaptation, if little real innovation. In fact, San Francisco's first full-fledged introduction to modern art had occurred thirty years earlier, only two

years after the initial revelation in Manhattan, and had come from the same source: the European paintings displayed in the New York Armory Show of 1913. Many of these paintings—including Marcel Duchamp's notorious *Nude Descending a Staircase*—were exhibited when the Panama-Pacific International Exposition opened in San Francisco in 1915.

Within its extravaganza of pavilions modeled on classical and Art Nouveau styles, the 1915 Exposition included the immense Palace of Fine Arts, designed by Bernard Maybeck, which contained the nucleus of a collection of over 11,400 works of painting and sculpture. (Restoration of the Palace—which now houses the Exploratorium, a hands-on science exhibit—was completed in 1975.) As was true of the Armory Show, these works were mostly conservative products of the European and American academies, but much of the more adventurous work that had baffled and outraged viewers in New York was shown in the San Francisco exhibition as well. The Italian Futurists, omitted from the Armory Show, were represented in some depth in San Francisco. At a time when Henry Varnum Poor, who specialized in mildly simplified landscape painting, was considered quite avant-garde among artists in the Bay Area, the ways in which the Impressionists and Post-Impressionists used color struck local painters with the force of a child's first Fourth of July. Clay Spohn, then a seventeen-year-old student at the Mark Hopkins Institute of Art on Nob Hill, recalled: "The French abstractionists . . . were so dominating, large, colorful, and startling that they over-powered everything else. The American Impressionists . . . seemed dull, trite, insignificant."[3] (In 1976, Spohn recorded his impressions of the early years of modern art in the Bay Area in a series of letters to the author.)

The most conspicuous local result of the Panama-Pacific fair was a new art museum modeled after the French government's Exposition pavilion. There was one museum in the City already—the M. H. de Young Memorial Museum in Golden Gate Park, constructed by the owner and publisher of the *San Francisco Chronicle* to house art at the California Midwinter Exposition of 1894. Before the 1915 Exposition was dismantled, Adolph Spreckels and Alma de Bretteville Spreckels, the City's chief social rivals to the de Young family, sought and obtained permission from the French government to duplicate its Exposition pavilion in permanent form. In 1924—construction was delayed by the war—the California Palace of the Legion of Honor opened in Lincoln Park as San Francisco's second art museum.

The impact of the modern painting introduced by the Exposition was subtle but decisive. By 1919, Willard Huntington Wright (the brother of the avant-garde Los Angeles painter Stanton Macdonald-Wright), in his new weekly art column in the *San Francisco Bulletin,* summarized the local scene as follows: "One sees curious transformations. Sargent evolving into Matisse, Whistler fading out in Signac, Bougereau metamorphosing into Picasso."[4]

Among the earliest Bay Area painters to embrace this new spirit was an East Bay artist, Selden Gile. His plein-air vistas of the Oakland waterfront and hills had at first been closely related to the dark-hued, "tobacco-juice" landscape paintings of William Keith. Around 1915, Gile's palette exploded into bright, vibrant, Impressionistic colors. By the 1920s his paintings had taken on a Fauvist intensity and gestural immediacy that foreshadowed the abstract *Berkeley* paintings of Richard Diebenkorn some thirty-five years later. (See Fig. 2.) Gile, a hard-drinking bachelor who had come to California in 1903, had been a close friend of Jack London and by about 1917 had become the center of a group of East Bay painters that called itself The Society of Six. One of its members was William H. Clapp, a Canadian-born, Oakland-reared painter who had studied in Paris; later, in Montreal, he had exhibited pointillist-inspired paintings as a member of the vanguard Canadian Group of Seven. The other members of The Society of Six were August Gay, a French-born painter who lived with Gile; and Maurice Logan, Bernard von Eichman, and Louis Siegriest. The last two, former classmates from the College of Arts and Crafts (then in Berkeley), were still in their teens. In 1918 Clapp was appointed curator of an art gallery that the city of Oakland had established two years earlier in an unprepossessing corner of its Municipal Auditorium, on the southern tip of Lake Merritt. Under his direction, and with the assistance of Florence Lehre, who wrote for the *Oakland Tribune,* the Oakland Art Gallery became the Bay Area's most adventurous exhibition space until the middle 1930s. From 1923 to 1928, its schedule included annual exhibitions by The Society of Six.

Gile's rustic cabin in the Oakland hills served for almost a decade as a weekly meeting place for The Six, who would gather for meals laced with garlic and washed down with copious quantities of home brew, red wine, and prune whiskey; the

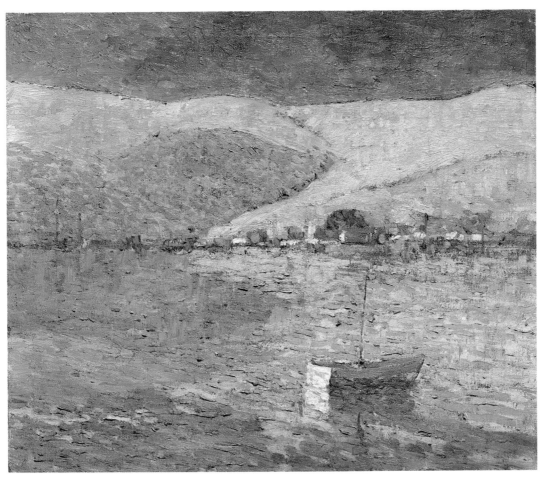

FIG. 2. Selden Connor Gile, *Boat and Yellow Hills,*
c. 1926. Oil on canvas, 30¼″ × 36″.

next day, they would take their small canvases and
paint-boxes out into the countryside and paint
away their hangovers together. Though they were
roisterous bohemians, even "Sunday painters" in
some respects, The Six were nonetheless keenly
curious, self-examining artists who kept abreast of
avant-garde developments in Europe and New
York through the 1920s (von Eichman, a mer-
chant seaman, would bring back armloads of art
magazines from his trips to the East Coast or
France). For the first of their six annual exhibi-
tions, Clapp even issued a manifesto for the
group. It said, in part: "We are not trying to
illustrate a thought or write a catalogue, but to
produce a joy through the use of the eyes. We
have much to express, but nothing to say."[5] They
painted with a lusty directness, shying away from
the pretty effect for its own sake. This tendency
reflected a trust in painterly instinct and a deep
suspicion of theory. Above all, The Six's attrac-
tion to developments in Europe and New York
was countered by a stubborn resistance. Eager as

they were to join in the release of energy that was
revolutionizing the international world of modern
art, they also clung to an ideal of incorporating the
new ideas into an art that had strong roots in
native tradition.

In contrast to the East Bay painters, the artists
who lived in San Francisco itself tended to be
more cosmopolitan. Their internationalist orienta-
tion was strengthened by the presence of such
foreign-born artists as the Swiss-Italian painter
Gottardo Piazzoni, the Italian sculptor Beniamino
Bufano, and the French painter Lucien Labaudt.
The San Francisco artists were more likely to have
closer ties—and often direct contact through travel
and study—with Europe or the East Coast. Most
of them were also associated, as teachers or
students, with the San Francisco Institute of Art, a
descendant of the school established by the San
Francisco Art Association in 1873. Its director, Lee
Randolph, appointed in 1917, was a young artist
freshly returned from Paris, but the moving force
for the next several years was Piazzoni. Piazzoni's

The Modernist Foundation

own painting leaned toward the spare distillations of shapes and the muted, chalky tonalism of Puvis de Chavannes. But he claimed a ground-floor association with Futurism, and he was philosophically committed to "any movement that makes for the advancement of art and the development of individuality."[6]

In 1917 the Institute of Art was renamed the California School of Fine Arts, and in 1926 the school moved into a new California Mission style building (designed by the famous architects Bakewell and Brown) on Russian Hill. The student body doubled. In the same year, across the bay, the College of Arts and Crafts, which Dr. Frederick H. Meyer had founded in Berkeley in 1907, moved to a large new campus in north Oakland. (Ten years later it was renamed the California College of Arts and Crafts.)

By this time, artistic factions had begun to form. Many of the more conservative San Francisco artists took refuge at the Bohemian Club. Though founded in the 1870s by a group of hard-drinking and hard-working artists and newspapermen, the club had gradually become an exclusive Nob Hill retreat for millionaires, having recruited more and more members from the business community to help pay its bills. The more innovative artists—Piazzoni, Ralph Stackpole, Rinaldo Cuneo, Sargent Johnson, Helen Forbes, Otis Oldfield, Charles Stafford Duncan, and Ray Boynton—clustered around the North Beach area between the flanks of Russian Hill and Telegraph Hill; many lived and had their studios nearby in the historic Montgomery Block building—on the edge of the financial district, a half-mile from the bohemian center of North Beach. (See Fig. 3.) In the fall of 1925, Beatrice Judd Ryan, with help from Maynard Dixon, opened a small downtown gallery, the Galerie Beaux Arts, for the exhibition and sale of work by these "progressives." It operated for eight years and was the City's first full-fledged private gallery devoted exclusively to contemporary art.

Throughout most of the 1920s, Bay Area artists were forced to grapple with two paramount issues. One of them—easy to state but terribly difficult to handle—was the old problem of how to deal with the philistines: how to gain the respect needed to be taken seriously as an artist, how to escape bourgeois censorship, and so on. (The display of two nude figure paintings in the Oakland Art Gallery's fifth annual exhibition in 1927 had excited great controversy.) The other question was much more complicated and one that each individual artist had to answer for

himself: how to reconcile the claims of modernism, as represented by developments in Europe and on the East Coast, with the demands of personal expression, with or without deliberate regionalist overtones.

Direct exposure to the current products of European artists continued to be offered on several fronts. The California Palace of the Legion of Honor opened in 1925 with an Inaugural Exposition of French Art, which included a small section for younger artists along with a large survey that ranged from Boudin to van Gogh. The same year, a German-born Impressionist painter named Galka Scheyer moved to San Francisco, and in 1926 she was appointed European representative for the Oakland Art Gallery. Visiting Switzerland during World War I, Scheyer had met Klee and Kandinsky, and she later brought them together with Jawlensky and Feininger as The Blue Four in an effort to generate a public for their work. The Blue Four were exhibited widely throughout the Bay Area in 1926 and 1927, and their paintings exerted a strong influence on such artists as August Gay. Scheyer's impact on the Oakland Art Gallery was reflected in its schedule for the late 1920s and early 1930s, which featured many group and solo shows of the German Expressionists.

Meanwhile, Bay Area artists who could afford the trip continued to travel to New York or Europe. Some, like Robert Howard, whose architect father John Galen Howard had designed the main buildings on the University of California campus in Berkeley, had been sent overseas during the war and stayed after the Armistice to continue his studies, primarily in Paris. Howard, who in his own words had "lived on a motorcycle" through much of his teens in Berkeley, had known young Alexander Calder, who also lived there while his father, Stirling Calder, was in charge of sculpture for the Panama-Pacific Exposition.[7] The two young sculptors renewed their acquaintance in Paris. The association with Calder during a decisive phase in his career contributed greatly to the articulated kinetic sculpture that Robert Howard developed after his return to the Bay Area in the 1930s.

But the attractions of Europe and New York had to contend with a strong undertow that kept many Bay Area artists at home and eventually brought back most of those who studied abroad or on the East Coast. For one of them, Clay Spohn, the dilemma was dramatized by two summer classes in which he enrolled: one was with Xavier Martinez, who was "quite inarticulate" but "created a great mystery about the art of painting

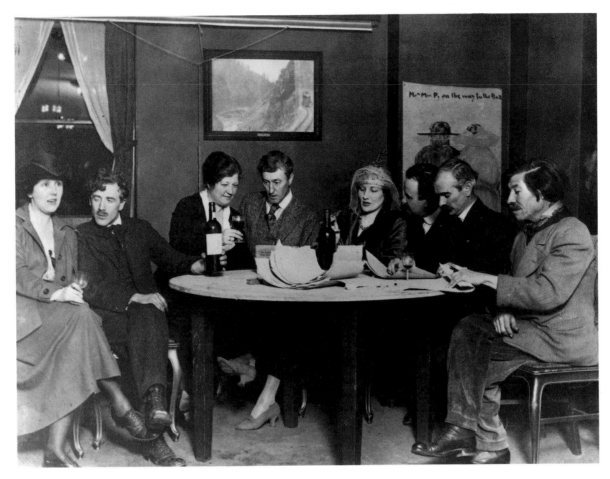

FIG. 3. At the Artists' Ball during Mardi Gras at the Hotel Oakland, March 4, 1919. Pictured left to right are Mrs. Harry Lafflier, Ralph Stackpole, Georgie Bordwell, George Sterling and friend, Harry Lafflier, Gottardo Piazzoni, and Xavier Martinez.

and of feeling things for oneself"; the other was with Armin Hansen, a sophisticated, European-trained seascape painter who suggested "the possibilities of method." It seemed a fact of life, Spohn wrote, that "in the 1920s, there was no place to look for the possibilities of the new, the exciting, the revolutionary, the bold, the awe-inspiring, the miraculously phenomenal, the shocking, the exuberant, and the exalted except toward Europe—unless, of course, one wanted to isolate oneself by becoming completely subjective, by looking within and discovering (or uncovering) the reality of oneself. And this seemed such a dangerous and lonesome thing to do, especially when one was still young and in some way had to try to make a living."[8]

Spohn made his trip to France in 1926. He spent a year studying at the Académie Moderne with Othon Friesz, and a good deal of time knocking about with Alexander Calder, whom he had met earlier in New York. (It was Spohn, Calder later

recalled, "who suggested I make things entirely of wire.")[9] After returning to San Francisco in 1927 Spohn experimented in a variety of styles, including Futurism and Orphism, before eventually gravitating to Surrealist fantasy and Dada-like assemblages, which seem to have been the earliest examples of their kind in West Coast art.

After the stock market crash of 1929, economic problems kept most artists at home, and the question of whether to go to Europe for study lost much of its urgency. The two poles around which Bay Area artists clustered during the 1930s were largely defined by the work and attitude of two foreign painters, both of whom were at work in the Bay Area as the decade began: Diego Rivera, the celebrated Mexican mural painter, and Hans Hofmann, the influential German painter and teacher.

Rivera was invited to San Francisco in 1930 to paint a mural for the social hall of the California School of Fine Arts, and during his stay, which

The Modernist Foundation

6

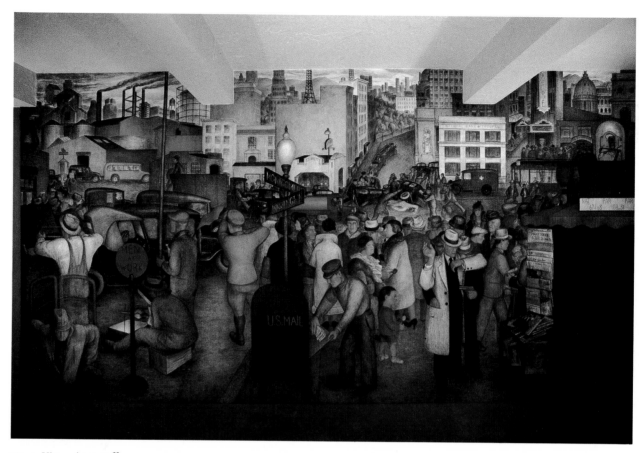

FIG. 5. Victor Arnautoff,
Metropolitan Life, left panel, 1934.
Fresco at Coit Tower, San
Francisco, 114″ × 207″.

FIG. 4. Diego
Rivera, at work on
the Treasure Island
murals, 1940.

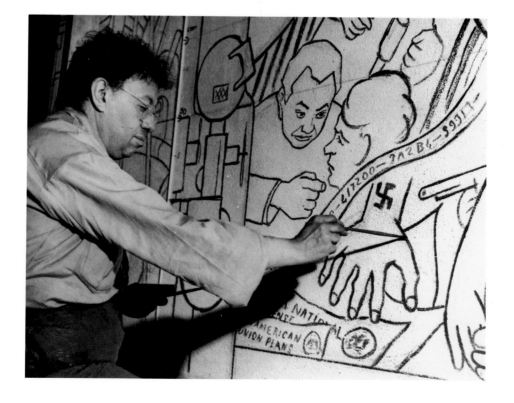

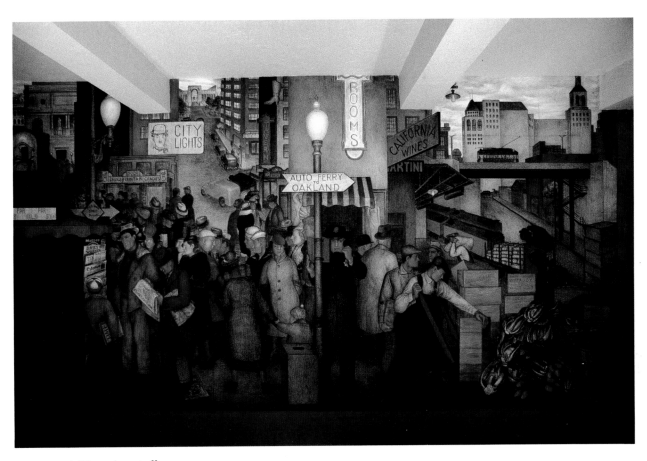

FIG. 6. Victor Arnautoff,
Metropolitan Life, right panel, 1934.
Fresco at Coit Tower, San
Francisco, 114″ × 207″.

stretched into the following year, he also painted an entire stairwell at a wildly incongruous location—the Luncheon Club of the Pacific Stock Exchange. (Both murals still exist at their original locations. A third mural, painted in 1930 on the dining room wall of the home of Mrs. Sigmund Stern in Atherton, was later transferred to Stern Hall at U.C. Berkeley.) In 1940 he returned to complete a large mural for an "art in action" display at the World's Fair on Treasure Island (this mural was later installed at San Francisco City College). (See Fig. 4.) The artistic impact of the Mexican mural movement and of its politically radical subject matter—already felt in San Francisco as elsewhere in the country during the 1920s—was intensified by Rivera's personal presence. Many artists—most notably, Emmy Lou Packard—worked directly with him on the 1940 project.

The arrival of Social Realism in art coincided with bitter labor disputes that erupted in the City—particularly along the waterfront—throughout the 1930s. As elsewhere, it was

especially conspicuous in the murals done under the Public Works of Art Project and the WPA. Most noteworthy of these were the frescoes for George Washington High School by Victor Arnautoff (1934) and the murals for Coit Tower (also 1934), done by twenty-five artists, including Arnautoff, Fred Pond, Lucien Labaudt, Ralph Stackpole, Ralph Chesse, John Langley Howard, Maxine Albro, Benjamin Cunningham, Bernard Zakheim, and Clifford Wight (who served as an assistant to Rivera for two years in Mexico, as well as during his first visit to San Francisco). (See Figs. 5, 6, and 7.)

The hallmarks of Social Realism—a mannered, heroicizing stylization derived in part from Cubism, in part from the renewed appreciation of Giotto and the Italian "primitives," and in part from a surge of interest in Egyptian and Mayan art—also appeared in the work of artists who were not moved by radical political ideals. In works where illustrative purposes were subordinated to formal ones, Social Realism (or its politically conservative version, American Scene

The Modernist Foundation

8

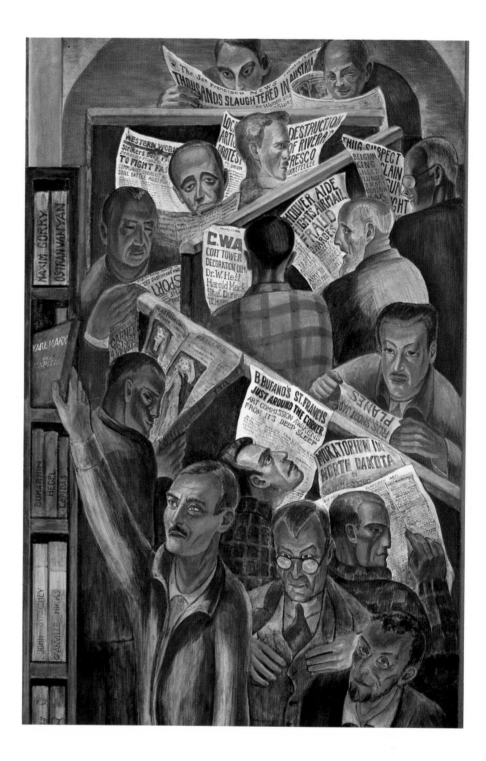

FIG. 7. Bernard Zakheim, *Library* (detail), 1934. Fresco at Coit Tower, San Francisco. Among the artists depicted in this mural are John Langley Howard, reaching for Karl Marx's *Das Kapital* on the shelf, Beniamino Bufano reading a newspaper headline about his *St. Francis* sculpture, and Ralph Stackpole reading a headline about the destruction of a Rivera mural in New York.

painting) shaded into Art Deco or Moderne. (See Fig. 8.) This tendency was exemplified in Ralph Stackpole's monumental figure sculptures outside the San Francisco Stock Exchange and in Robert Howard's dancing whales in front of the Steinhart Aquarium. Its most grandiose expression in the Bay Area was the giant stucco *Pacifica* figure, thirty feet high, that Stackpole created for the Panama-Pacific Court at the Treasure Island World's Fair. (Intended to be temporary, it was demolished in 1942.)

Perhaps because Bufano's sculpture so adroitly combined this Art Deco formality with broadly Social Realist subjects (*St. Francis, The Mother of Peace, Sun Yat-Sen*), he became, for many people, the personification of what a "modern artist" should be. In his more ambitious sculpture, Bufano often spelled out his gospel of social unity with embarrassing bluntness, particularly when (as in *The Mother of Peace*) he added little mosaic insets of wide-eyed children to the larger work. In his animals, however—bears, walruses, horses, or

The Modernist Foundation

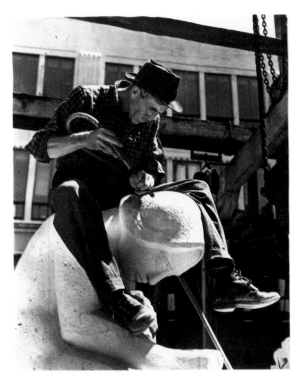

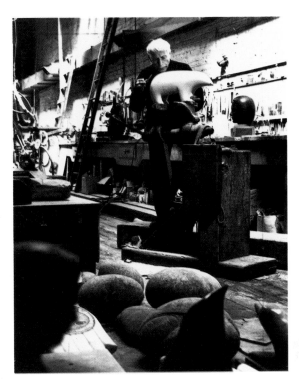

FIG. 8. Ralph
Stackpole, c. 1939.

FIG. 9. Sculptor
Beniamino Bufano
at work in his
studio, 1968.

snails, their forms stripped down to the barest essentials—he more often found the simplicity and self-containment appropriate to the sense of uncomplicated innocence and childlike wonder that he sought to express. It did not hurt Bufano's reputation with the public to be known as one of the City's more colorful bohemian "characters"— an elfin figure who said he had posed for the profile on the old buffalo nickel and had chopped off his trigger finger to send to President Wilson during World War I. (See Figs. 9 and 10.)

Hans Hofmann taught summer sessions at the University of California in Berkeley in 1930 and 1931. At the time he was known only as a painter who had been a teacher in Europe (an article in the *San Francisco Chronicle* introduced him as having studied with certain now-forgotten "European masters").[10] Hofmann was invited to Berkeley by two members of the art faculty who had studied with him in Munich, Worth Ryder and Glenn Wessels. Although his own non-objective paintings were still a decade or more in the future, Hofmann had already progressed far in his theoretical synthesis of the principles of modern painting developed since Cézanne.

Hofmann's impact on Bay Area art was not as direct or immediate as Rivera's. Wessels later recalled a dinner given in Hofmann's honor at which most of the invited painters had never heard of him and made fun of his German accent.[11] However, his ideas continued to be influential long after his departure, through the work and teaching of such followers as Wessels, Ryder, and John Haley. Under their impetus, while artists in San Francisco were turning increasingly toward regionalism and Social Realism, a self-conscious "Berkeley school" of painting—devotedly modern and internationalist, if rather tame—developed on the campus. In the work of Haley, its major exponent, it came out looking mostly like the painting of Dufy: the canvases were dominated by simple, open color areas upon which the drawing was superimposed, and relied for their effect on the tension between the two. Cézanne's influence was propagated by Erle Loran, who had spent a year (1927) living in Cézanne's studio in Aix-en-Provence and photographing the landscapes he had painted; Loran's diagrammed analyses entitled *Cézanne's Composition*, published in 1943, became a veritable bible in the Berkeley art department. Margaret Peterson, whose own painting resembled Picasso's, stimulated interest in El Greco and Russian icons. All this coexisted with a flourish-

10

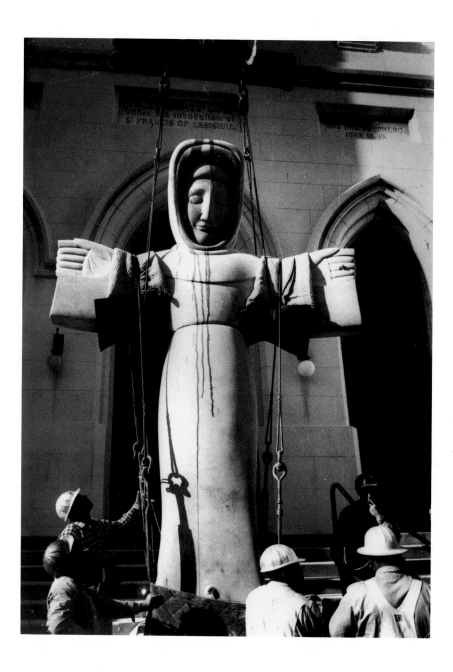

FIG. 10. Bufano's *St. Francis* being removed in 1961 from the St. Francis Church in North Beach.

ing Neo-Quattrocento trend. As Elmer Bischoff, a student between 1934 and 1939, described it, "The early Florentines and Sienese masters were the big thing. Giotto was number one."[12]

Many painters and sculptors, of course, took positions between the extremes of Social Realism and the apolitical avant-garde that had its stronghold in Berkeley. Lucien Labaudt, a self-taught painter and early disciple of Cubistic abstraction, alternated between, and sometimes combined, a neoclassical Surrealism and Social Realism. Labaudt also operated his own atelier, where he taught dress and costume design; and with his wife, Marcelle, he organized the annual Bohemian Ball, a costume extravaganza that filled the Civic

Auditorium with spectacular replicas of Angkor Wat and thousands of masquerading socialites and artists.

Sargent Johnson sought to combine the Brancusi-derived formal simplifications of his teachers, Stackpole and Bufano, with elements that reflected more directly his heritage as a black. The reliefs and murals he designed for the Maritime Museum in Aquatic Park were accomplished but conventional Art Deco, and his animals generally resembled Bufano's. In carved and brightly painted wood figures, however—and in copper masks modeled after African prototypes—Johnson came closer to his goal: to produce "strictly a Negro art," to show "the natural beauty and

The Modernist Foundation

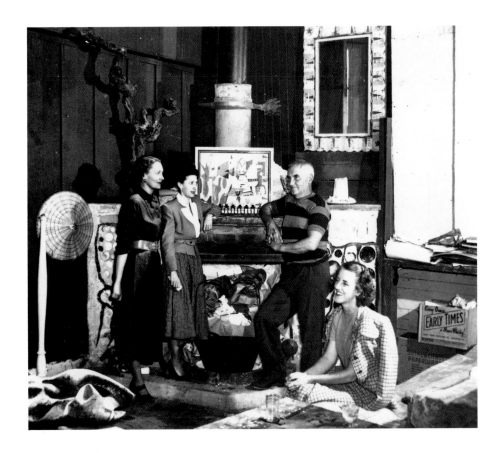

FIG. 11. Jean Varda,
in his studio with
friends, 1950.

dignity in that characteristic lip and that characteristic hair, bearing, and manner . . . not so much to the white man as to the Negro himself."[13]

Jean Varda, a lusty Greek who lived on a Sausalito houseboat, challenged Bufano for recognition as San Francisco's most colorful bohemian. (See Fig. 11.) His specialty was collage that combined Cubist shapes with heraldic figurative motifs and mixed colorful bits of paper with shiny gold leaf. He became an outspokenly critical odd-man-out as a member of the faculty at the California School of Fine Arts between 1945 and 1952—when Abstract Expressionism took the school by storm.

In the special classes offered by Maurice Sterne at the California School of Fine Arts in the late 1930s, some students found at least temporary escape from the need to choose between Social Realism and "Berkeley school" abstraction. As Hassel Smith, a student at that time, recalls: "Sterne was a figurative artist, not much of a painter but a hell of a draftsman, a sophisticated international personality who was already in his seventies. . . . One entered Sterne's class by special admission and it formed an enclave in the school, a nucleus of people on the West Coast who were prepared to make certain propositions other

than that Mexican crap. Nell Sinton was in that class and so was Jim Weeks. Finally, of course, we quit the school. The most creative of Sterne's students began to get past him. It was one of those things that frequently happens—we felt that we were doing what he instructed us to do, but what we actually did horrified him."[14]

Meanwhile, as the nation's economy stagnated and artists joined longshoremen and other workers in their demonstrations over the right to organize, the institutional side of the contemporary art world expanded and flourished. The San Francisco Museum of Art opened on the top floor of the Veterans Building, a Beaux Arts structure next to the Opera House, in January of 1935. Though initially conceived as an all-purpose art museum, within a year it had become the first museum outside New York to devote itself exclusively to modern art. (In 1975 its name was officially changed to the San Francisco Museum of Modern Art.) The museum's first director, Grace McCann Morley, remained as its head until 1960. (See Fig. 12.) The exhibition schedule listed shows of Picasso, Cézanne, and Miró, of Albers and Henry Moore, and even of Walt Disney. Regular shows of contemporary art from Mexico and Central and South America

The Modernist Foundation

reflected the interest in the Mexican mural movement and also the romantic attraction to Latin American culture generally that remained something of a regional fad through much of the 1930s. (Many local artists made a kind of economy-sized Grand Tour, spending a season or two studying or working in San Miguel Allende or Toluca.) The museum's schedule provided especially frequent offerings of Surrealism, and also gave strong emphasis to Oceanian, African, and other areas of "primitive" art.

The City had two other general-purpose art museums—the de Young and the Palace of the Legion of Honor—that were almost equally active in displaying modern and contemporary work. Ninfa Valvo, appointed curator of painting and sculpture at the de Young Museum in 1939, initiated a particularly vigorous program of adventurous exhibitions by local artists.

By 1940, as the nation eased out of the Great Depression and hovered uneasily on the brink of world war, the Bay Area boasted a small but reasonably vital and sophisticated community of modern artists. There was a certain gulf between the followers of Rivera and the disciples of Hofmann and others, who were more concerned with making formal innovations. But both groups were targets of a recently formed San Francisco branch of the Society for Sanity in Art, a Chicago-based organization that preached a return to old-fashioned and supposedly traditional values. And most of the artists who thought of themselves as progressive or radical—whether artistically or politically—shared a certain sense of solidarity. Artists as divergent in attitude as Hassel Smith and Erle Loran, as different in background as Sargent Johnson, Jean Varda, and Dong Kingman, often met to exchange views over rounds of drinks at such North Beach watering holes as The Iron Pot and The Black Cat.

As the new decade began, the biggest esthetic problem for many of these artists was posed, paradoxically enough, by the success of Picasso, the most visible symbol of twentieth-century modernism, of everything that stood for innovation and revolt. Hassel Smith put it this way: "The dilemma was either to go with all those Mexican chaps, or go on seemingly forever doing synthetic Cubism. . . . Picasso seemed to block the road ahead for younger artists. We felt he was like Michelangelo must have been at the end of the sixteenth century—this monstrous personality that dominated everything, and you could only do variations on his lines. That's why we were attracted to Magnasco, Caravaggio, and Salvator

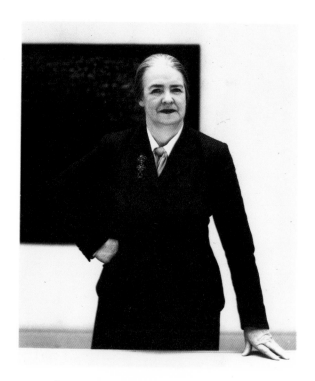

FIG. 12. Grace McCann Morley, Director of the San Francisco Museum of Art from 1935 to 1960, photographed in 1958.

Rosa; we felt they were in the same position that we were in—they were the earliest bohemian painters. They discovered a way to get by the Mannerist attitudes that Michelangelo represented, to bring form and content back to a one-to-one relationship, instead of emphasizing technical virtuosity entirely."[15]

At the same time, however, and in a way that attracted little notice, works that embodied new impulses were beginning to appear. One example was a work that Clay Spohn submitted to the San Francisco Art Association Annual in 1941. As he described it, it was "a combination painting and fly-swatter contraption that could be operated by the spectator. It was called *Wake Up and Live* and had a painting of a life-sized fly on a board set back in a deep shadow box" (Fig. 13). By manipulating the swatter, the viewer was supposed to realize "that if we didn't wake up to the real facts about the war in Europe . . . we might find ourselves in a bad way."[16]

The return to San Francisco of Robert Howard's younger brother Charles, after eighteen years in Europe and New York, added force to the impact of Surrealism. Charles Howard had exhibited his paintings with the Surrealists in England in 1936, and had developed a style that drew on both Miró and synthetic Cubism. His work was widely

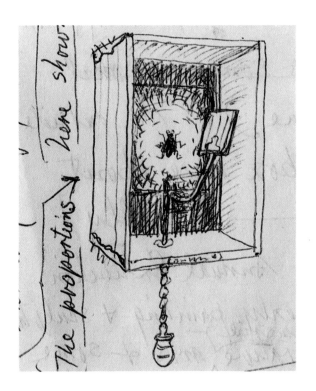

The proportions / zone show

FIG. 13. A sketch by Clay Spohn of *Wake Up and Live,* his controversial flyswatter contraption. Ballpoint pen on paper.

shown in the Bay Area between 1940 and 1946, when he was teaching at the California School of Fine Arts. (He returned to England after the war.)

An exhibition of abstract Surrealist paintings by Arshile Gorky at the Museum of Art in 1941 (his first museum show) stirred great interest among certain local painters. (Gorky had spent most of the summer of 1941 in San Francisco.)

One of the most important exhibitions in the Bay Area during the war years was hardly noticed at the time. It was a show at the San Francisco Museum of Art, in March of 1943, of the works of a painter who had drifted down from the state of Washington and had spent most of the preceding two years living in the East Bay and working in the shipyards. The block letters on the gallery wall misspelled his name as "Clifford Stills."

Clyfford Still's first one-man exhibition was a sort of retrospective show, presenting twenty-four paintings that dated back to 1929. They were a mixed lot: dour prairie landscapes that showed something of the American Scene style; a portrait of Walter Pritchard, a sculptor Still had known in Washington State; and several abstractions that pointed in different stylistic directions but shared a certain raw energy. "It was a crazy show," Still said many years later, "a scattergun display with no focus at all."[17] Few of the Bay Area artists who

were later so strongly affected by Still's work saw this exhibition; many of them were out of the country, serving in the armed forces. In a terse paragraph buried in the Sunday supplement to the *San Francisco Chronicle,* at the end of a review of the San Francisco Art Association's annual exhibition of prints and drawings, the critic Alfred Frankenstein wrote: "Vaguely like Picasso . . . perfect examples of modern experiment misunderstood and misapplied."[18] These lines, photographically much enlarged, would be displayed in the list of "Comments" that hung near the door to the gallery of another one-man show that Still had four years later at the California Palace of the Legion of Honor. This second show contained only slightly more than half the number of works displayed in the 1943 exhibition, but its impact on painting in the Bay Area would be felt for years to come.

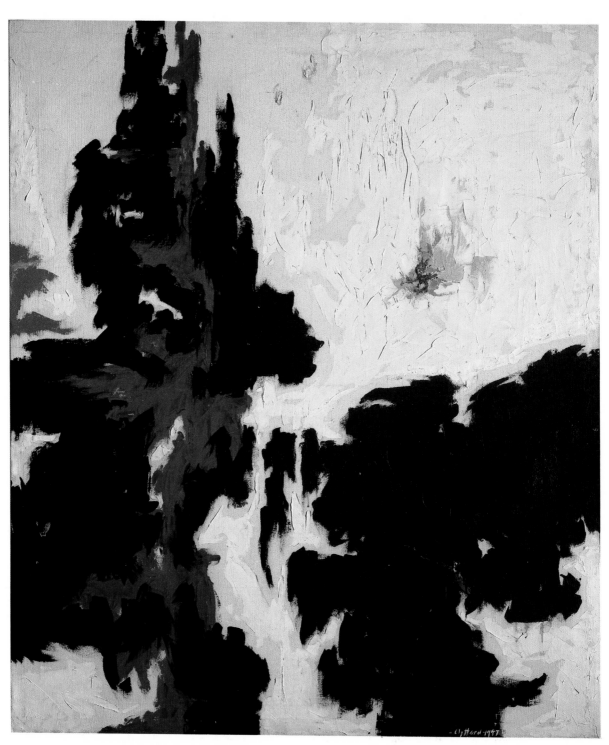

FIG. 14. Clyfford Still, *1947-Y*,
1947. Oil on canvas, 70⅛″ × 60″.

Clifford Still and the Explosion of Abstract Expressionism

VJ Day (Victory in Japan) was celebrated in San Francisco with an outburst of fireworks, broken bottles, dancing, and lovemaking in the streets. Then the City settled into the pleasant delusion of "returning to normal." The colony of artists that gathered in North Beach—which included Charles Surendorf, Luke Gibney, Sargent Johnson, and Dong Kingman—reconvened at the convivial bohemian bistros where they had gathered before the war. Henri Lenoir, the proprietor of The Iron Pot restaurant, gave Hassel Smith and other painters one-man shows and worked out agreements under which several of them—such as Otis Oldfield and Erle Loran—were able to hang their work in other local bars and restaurants, helping to offset the absence of galleries interested in non-traditional art. (See Fig. 15.) In the early 1940s, local record collectors had sparked a revival of New Orleans style jazz, which had gained impetus through a series of lectures and performances (most notably by Bunk Johnson, the pioneer New Orleans trumpeter) that was organized by Rudi Blesh in 1943 for the San Francisco Museum of Art. Once the war was over, the revival mushroomed—in places like the Dawn Club on Annie Street and Hambone Kelly's across the bay in El Cerrito—and San Francisco began to attract international attention as a center for traditional jazz.

A mood of mindless optimism swept most of the country. At the same time, an undercurrent of restless energy—partly a by-product of the expansive national mood, but partly a more subversive force—was stirring beneath the surface of American culture. It would soon find articulation in what Irving Sandler has called "the triumph of American painting." Triumph is an appropriate word. What took place amounted to a kind of vigorous cultural muscle-flexing, an aggressive affirmation of a new and distinctly American art, an art to fill the void left by the bankruptcy of the School of Paris, and to match the new pre-eminence of the United States as a world power. This triumph was not confined to painting. During the next two decades, it spread to sculpture, music, literature, and eventually, new hybrid forms that challenged the very definitions of "art" and "culture." The postwar mood was in striking contrast to the cultural climate that had followed World War I. With the ending of that "war to end all wars," American artists and writers resumed their traditional exodus to Europe; after World War II, most American artists stayed in the United States, as did most of the Europeans who had fled here from the Nazi incursions before the war began.

The European expatriates constituted one of two broad forces that had gradually given shape to a new artistic underground during the war years, primarily in New York. Refugee artists—most of them Surrealists like Max Ernst, André Masson, and Matta—formed a small circle from which

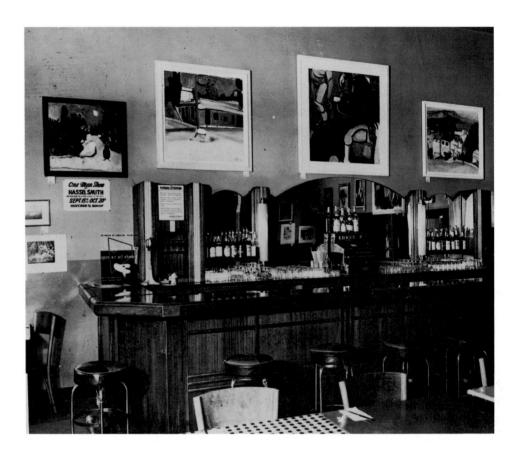

FIG. 15. Exhibition of paintings by Hassel Smith at the Iron Pot Cafe, 1945.

avant-garde ideas began to ripple out into the New York art world, principally through their exhibitions at Peggy Guggenheim's Art of This Century gallery.

The second force, more difficult to define, found expression in efforts to create urgent, defiant, revolutionary forms of art that had distinctly American roots. In painting, the beginnings of this attitude go back to the 1930s, when Social Realism (revolution, defiance) struggled for dominance with Regionalism (distinctly American), and both locked horns with Cubist abstraction and non-objective painting, with their "self-indulgent," art-for-art's-sake esthetic and internationalist ideals.

It would be a mistake to overemphasize the deliberateness of this "Americanist" impulse, or to interpret it in a narrowly specific sense. By the materialist standards that became more and more firmly entrenched as the conversion to a consumer society gained momentum, these artists were indeed "un-American," and their work was frequently called just that. Nevertheless, in their rebellion against tradition and convention they were seeking—both individually and collectively—a new sense of identity that could accommodate the facts of the postwar world: the collapse of traditional values, which the war had

both mirrored and furthered; the disintegration of European political and cultural power; and the shift of the world's center of gravity to the United States. Because this rebellion was social as well as cultural, the identity quest often led to cultural slumming. ("I want to descend in the social scale," Lawrence Ferlinghetti wrote a decade later in his "Junkman's Obligatto.") It embraced the vernacular, the vulgar, and the outcast. Norman Mailer and James Jones began their epic war novels, writing in the clipped, violent, and profane language of the barracks and the streets. Jackson Pollock's Western-style denims set a new style of bohemian dress, which found an urban counterpart in the welder's helmet and apron of David Smith, who projected a new image of the sculptor as down-to-earth foundry worker. Painters rebelled against the polish and refinement—the sense of *métier*—associated with School of Paris elegance; their canvases became rough expressions of unharnessed power and action.

The appointment of Douglas MacAgy as director of the California School of Fine Arts, early in 1945, was the first in a sequence of events that was to challenge traditional notions about painting in San Francisco as radically as they were being challenged in New York. (See Fig. 16.) The

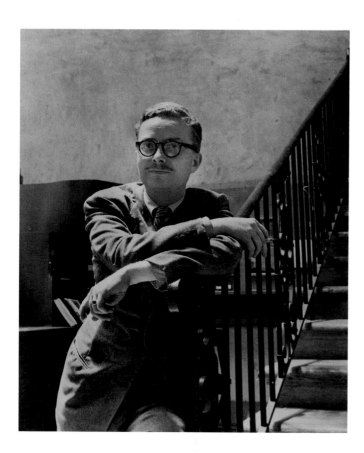

FIG. 16. Douglas MacAgy, Director of the California School of Fine Arts from 1945 to 1950, photographed c. 1947.

school, financially ailing since the Depression, and suffering from reduced attendance during the war, had reached such straits that in MacAgy's words the trustees "were rather desperate" and therefore "able to bring themselves to make concessions." The concessions that attracted him, MacAgy said, "were that I could go in there and propose and work out for a certain number of years my own curriculum, my own ideas of what an art school should be, and appoint my own faculty. Under those circumstances, I moved in."[1]

A native of Winnipeg, MacAgy had studied at the University of Toronto, the Courtauld Institute in London, the University of Pennsylvania, the Barnes Foundation, and Western Reserve University in Cleveland before taking a job as a curator at the Cleveland Museum, where he had attracted the attention of Grace Morley with his installation of a Picasso exhibition. Morley had invited MacAgy west in 1941 to work as her assistant at the San Francisco Museum of Art. With him came his new wife, Jermayne MacAgy, who had received a Ph.D. from Western Reserve and been active in art education in Cleveland. After a few months in San Francisco, Jermayne took a position as head of the education department at the California Palace of the Legion of Honor, and in 1942 she was appointed assistant to the museum's

director, Thomas Carr Howe. When Howe joined the Navy shortly afterward, Jermayne MacAgy became the museum's acting director, and she remained influential in planning its exhibitions after his return in 1946. Many of the Abstract Expressionist painters who became associated with the California School of Fine Arts were to have their most important exhibitions at the Legion.

Douglas MacAgy, as remembered years later by Clyfford Still, was "autocratic" and "the complete academic." "He liked his big cigars and Brooks Brothers suits. He was like a small army officer. He called one faculty meeting, and when a few of the instructors put forward some ideas, he never called another."[2] One of MacAgy's earliest symbolic acts was to hang a curtain over the Rivera mural in the school's exhibition hall. He devoted the spring and summer of 1945 to revamping the faculty. Among the handful of instructors who remained from the previous regime were William Gaw, Dorr Bothwell, and Paul Forster. The new faculty members included Robert Howard, Clay Spohn, and two younger painters, David Park and Hassel Smith.

David Park, a Bostonian, had come to Los Angeles in 1928 to live with an aunt, after his indifferent career as a student (he failed to graduate

Clyfford Still and Abstract Expressionism

from high school) had brought embarrassment to his Unitarian minister father and the family's circle of well-bred and literary friends. The aunt, Edith Truesdell, had studied painting, and she encouraged Park's interest in it. A year later, he moved to San Francisco to attend a summer session at the University of California, but he soon dropped out of school and spent the early 1930s as a stonecutter and assistant to Ralph Stackpole; he also worked under sponsorship of the Federal Art Project. Following his first one-man show at the San Francisco Museum of Art in 1935 (he had another there in 1940), Park returned to Boston to teach at a girls' school. He came back to California in 1941, and spent the war years working nights in an Emeryville cable factory. He began to teach part-time at the California School of Fine Arts in 1944.

Park's oil and tempera paintings of the mid-thirties often focused on musicians and dancers; their hard, dry, volumetric style showed influences of Derain, Rivera, and the neo-Roman paintings of Picasso, as well as the early Italian fresco painters. By the end of the decade, Park had moved into a vein of Cubist abstraction that emphasized boldly outlined forms modeled on the distortions of Picasso's abstract figures of the late thirties. By the time he began to teach at the California School of Fine Arts, he was doing smaller, more subdued paintings in which profiles were reduced to simple, pictographic shapes arranged like playful jigsaw puzzles of "positive" and "negative" spaces.

Hassel Smith had also been a teenager when he moved with his family from Michigan to California in the early 1930s, settling in San Mateo. He returned to the Midwest to complete his education at Northwestern University. He took a few studio courses, a heavy load of English literature classes, and "any other subject that interested me," and finally received his degree in art history. The large section of modern painting at the Chicago World's Fair in 1933 had stimulated Smith's fascination with modern art; an appearance by the Ballet Russe made him a confirmed balletomane and further established a conscious "commitment to the avant-garde position in the arts that I have never since questioned."[3]

Smith came back to San Francisco to study at the California School of Fine Arts from 1936 to 1938, and spent the next two years painting plein-air landscapes around the City while he served as a state relief worker with a caseload on skid row. In 1940, with the money from a Rosenberg Foundation grant, he went to Angels

Camp in the Sierra foothills, where he spent two years painting landscape and also did his first figurative painting. In 1943, when his Rosenberg money ran out, he worked for the Farm Security Administration in migrant worker camps around the San Joaquin Valley, and before he returned to San Francisco in 1945 he also worked as a timber scaler for the U.S. Forest Service in Oregon. (The diversity of experience typical of this generation of artists, even of those who had not been involved directly in the war, stands in sharp contrast to the more specialized backgrounds of most artists today, whose résumés consist largely of lists of academic degrees and teaching jobs.)

By 1945, Smith was painting in a broad, brushy figurative style strongly influenced, as he said, by Soutine and Munch (a large traveling exhibition of Munch's paintings had come to the de Young Museum shortly after the artist's death in 1944). Smith's paintings were often mordantly satirical in content and approach. Their themes—drunks in bars, Indians eating ice cream cones in front of huge water tanks—seem to anticipate the iconography of Pop art, but their rich, painterly, almost abstract approach suggests the Bay Area Figurative style that was to emerge in the early 1950s. An outgoing iconoclast with the disputatiousness of a born devil's advocate, Smith started teaching at the California School of Fine Arts in 1945 as a substitute instructor in a lithography class. When MacAgy took over, he asked Smith to stay.

MacAgy also moved to give the school a freer, more vital atmosphere. He made studio facilities available to students around the clock, and brought in musicians, poetry readings, and other events. In an effort to make the school less parochial, he began to hire teachers from elsewhere and to invite visitors for summer sessions. At the same time, Fine Arts remained a basic, no-nonsense art school, granting neither degrees nor academic credit.

Perhaps the most dramatic change in the school's character occurred as the G.I. Bill—which provided tuition-free education for ex-servicemen—gradually brought in a new breed of students. The G.I. Bill made it possible for veterans who had neither money nor previous formal training in painting or sculpture to undertake the study of art. Most of these new students were men in their middle or late twenties, and they had a maturity—sometimes hardened by wartime experiences—seldom found in previous generations of art students. Their reasons for enrolling at the California School of Fine Arts were as varied as their places of origin. Walter

FIG. 17. Elmer
Bischoff and Hassel
Smith in the
courtyard of the
California School of
Fine Arts, 1947.

Kuhlman had visited San Francisco one day during the war, and while riding a cable car had promised himself, "If I ever survive this thing, I'm coming back here to live."⁴ Jack Jefferson decided to stay on the West Coast after a four-year hitch in the Marines, and checked out different art schools until he settled on San Francisco. Jorge Goya-Lukich, a student of mathematics and physics at Western Reserve University before the war, had been stationed at Mills Field in Marin County, and was inspired to look further into painting after seeing a show of contemporary French art at the San Francisco Museum of Art. As he put it, "I went into CSFA not knowing one end of the brush from the other."⁵ Like other developments at the school, this influx of G.I. Bill students was not as sudden and swift as accounts often suggest. But by the 1947–1948 school year, a core of about a dozen ex-servicemen had gathered there. Hassel Smith recalls: "To a very large extent, when I was a student at the school [before the war] it was a debutante kind of place . . . just crawling with socialites. The G.I. Bill brought in . . . a very swinging bunch," but it was a bunch of "working artists."⁶

These students began responding early to the new energies that had been stirring among artists in New York. A few had had the chance to see Pollock's work in some depth in a one-man show of seventeen paintings and eight drawings at the San Francisco Museum of Art in August of 1945. Grace Morley purchased one of the show's most dramatic paintings, *Guardians of the Secret* (1943),

and it remained on display in the museum's permanent collection galleries. The following year, the San Francisco Museum gave Mark Rothko a one-man museum exhibition (August and September of 1946), and bought his majestic *Slow Swirl by the Edge of the Sea* (1944). Like *Guardians of the Secret* and Gorky's *Enigmatic Combat* (1936–1937), acquired before the war, it became a direct and continuing source of inspiration and study for many local artists. "A lot of names were current—Baziotes, Gottlieb, Pollock of course," Elmer Bischoff observed. "It was . . . an osmosis. These ideas were just there, they were in the air and they infiltrated and took hold."⁷

Bischoff was one of the six new instructors that MacAgy added to the school's faculty in the fall of 1946, in his second year as director. A ceramics and jewelry teacher at a high school in Sacramento following his graduation from the University of California in 1939, Bischoff had enlisted in the Army Air Force at the outbreak of the war and served three years with the intelligence branch in London. Determined not to go back to Sacramento, he was interviewed by MacAgy for a last-minute faculty opening and found himself teaching the next day. Strongly influenced by Margaret Peterson as a student, Bischoff had spent the previous ten years painting "homages to Picasso—the big still-lifes that Picasso painted in the 1920s."⁸ Introspective, thin-skinned, and highly articulate, he became close friends with David Park and, at least for a time, also with Hassel Smith. (See Fig. 17.)

Clyfford Still and Abstract Expressionism

Edward Corbett had attended high school in Richmond and studied at the California School of Fine Arts before the war, where he and Smith had been classmates under Maurice Sterne. When he began teaching there part-time late in 1946, Corbett was unique among Bay Area artists in practicing a form of geometric abstraction based on Mondrian. An intellectual with a broad range of literary and philosophical interests—he read Sartre, Camus, Kierkegaard, Heidegger, and Husserl—he became a close friend of Smith's. The house they shared in Point Richmond with Robert McChesney (whom MacAgy later hired to set up a silkscreen class at the school) became a center for parties and informal gatherings.

In addition to Bischoff and Corbett, MacAgy hired Jean Varda, the photographer Ansel Adams, and Ernest Mundt. (Mundt, a graduate of the Technische Hochschule in Berlin and a devoted disciple of the Bauhaus, was to replace MacAgy when he resigned from the school in 1950.)

The most notable addition to the faculty, however, came about that fall almost by accident, when a charismatic, patriarchal figure "in a long black overcoat" took over as a replacement for a newly hired teacher who had failed to show up. (See Figs. 18 and 19.) The background, as Clay Spohn remembered it, was as follows: "Douglas [MacAgy] came to my office and said, 'I want to show you something. A man phoned yesterday from Sacramento or Davis looking for a teaching job.' Douglas set up the two paintings against various pieces of furniture. They were exactly the same size, about 36 inches by 28 inches. Each was done as large, bold strokes of rather dull color, more or less monochromatic with slight changes in the hue and occurring well inside the borders of the white canvas background. No attempt had been made to represent anything other than the strokes of pigment and the way they were applied—thick, heavy strokes, one into the other, applied in a more or less vertical direction to be sympathetic to the longest dimension of the canvases, which were to be regarded as seen vertically. Frankly, I don't know what I thought. Yes, they did have spirit and zest, they were strong with a certain gusto and flair that gave them vitality. I wasn't able to say anything more than, 'Yes, they're interesting.' . . . So finally Douglas said, 'They do carry authority.' And he was right. . . . He then went on to describe the man and the impression he had made . . . and he said he might hire him as soon as he could see his way to make up a class for him. Well, of course, it turned out to be Clyfford Still."[9] As MacAgy

FIG. 18. Mark and Mell Rothko with Clyfford Still in San Francisco, 1946.

recalled the event later: "I hadn't known any of [Still's] work except from some ads in the art magazines for his exhibition at Peggy Guggenheim's Art of This Century gallery which had just occurred. He turned up one day from Sacramento where he was disgruntled about some high school job that he had either been applying for or had decided not to take. . . . He came in and he brought out some little dog-eared snapshots of his paintings. . . . You couldn't tell very much [about them] but he was an enormously impressive person . . . and on the spur of the moment I took him on."[10]

Born in Grandin, North Dakota, in November of 1904, Clyfford Still spent his youth on the prairie of southern Alberta, where his father, an accountant, had settled some newly opened home-

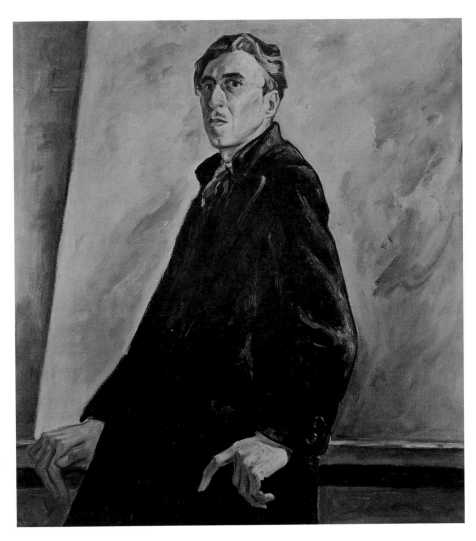

FIG. 19. Clyfford Still, *Self Portrait,*
1940. Oil on canvas, 41½″ × 38″.

stead territory. The family maintained a second home in Spokane, where Still and his mother sometimes spent the winters. Still's experiences on the plains nurtured an extraordinary self-reliance, as well as a strain of tough, frontiersman's practicality. Death was a constant presence—"when there were snowstorms, you either stood up and lived or laid down and died"—and Still came to prize "a certain rigor" that he later sought to express in his paintings.[11]

Still picked up what knowledge of art he could by hanging around "the preacher's library," where he perused books with titles like *Masters Everyone Should Know* that featured reproductions of such painters as Alma-Tadema and Burne-Jones; but he also encountered—and copied—Velázquez, Rembrandt, and other old masters. A special favorite was Turner. In his spare time, Still painted some portraits—of himself, his parents, and other relatives—but mostly landscapes ("Turner painted the sea, but the prairie to me was just as grand").[12]

In the fall of 1928 he made a brief journey to New York, staying long enough to visit the Metropolitan Museum and to enroll in a class at the Art Students League taught by Vaclav Vytlacil (once a student of Hans Hofmann's in Munich). Both experiences left a sour aftertaste. The museum, Still felt, reduced everything to examples of historical "schools," objects "to glorify popes and kings or decorate the walls of rich men." After being graduated from Spokane University in 1933, Still joined the faculty of Washington State College at Pullman. There he had little to do with

Clyfford Still and Abstract Expressionism

22

his fellow art instructors; he was closer to teachers in the music, English literature, mathematics, and philosophy departments. Anarchistic in his convictions, Still was uninterested in Marx, hostile to Freud, cool to avant-garde heroes like Eliot and Pound; in his philosophical interests he leaned toward Hume, Nietzsche, Hegel, Kant, and the early Greeks—Socrates, Plato, Aristotle, Longinus. His "heroes" were artists like Rembrandt, Blake, Turner, and Beethoven, men who had struggled and eventually attained a kind of exalted, transcendent freedom from the "imperatives" of their times. His own goal was to achieve in painting "the kind of vastness and depth of a Beethoven sonata or a Sophocles drama—the humanity, aspiration, joy, and tragedy that they represent." A friend remembered: "Still was, like Beethoven, supremely confident. He knew exactly where he was going."[13]

Given Still's "outsider" background—in some respects, a throwback to a way of life that had largely vanished with the disappearance of the frontier—it was natural that his art should be as estranged from what he called "the modernist academy" as from academic painting of the traditional kind. Modernism was pre-eminently an urban expression—a celebration, or a criticism, of the man-made. Still's early paintings run parallel to the reactionary, anti-modernist stance of Regionalism or American Scene painting, which reverted to the celebration of nature that had dominated American painting in the nineteenth century. They reflect his fascination with "the awful bigness, the drama of the land, the men, and the machines."[14] (See Fig. 20.) But they are also fascinating battlegrounds on which the old-shoe conventions of Regionalism grapple with strikingly unfamiliar, alien elements: heavily knifed, sludgy impastos; worm's-eye views that emphasize soaring verticals; shredded cloud shapes and jagged shadows.

In 1934 and 1935, Still spent two summers at Yaddo, a retreat for artists, musicians, and writers operated by the Trask Foundation in Saratoga Springs, New York. And at about the same time, he set out, "more or less deliberately, to begin again." The decisive break, he said much later, was not a move from naturalism to nonrepresentational painting as such, but "the turning away from landscape to the figure—to dealing with the figure imaginatively, and with a kind of austerity." He added, "I wasn't going to start throwing paint on canvas; for me it was necessary to dig in, to paint through until I reached another side."[15]

Still's paintings from the middle and late 1930s (most of which have never been exhibited) project a sense of urgency, adventure, risk, and courage. The earliest are dominated by gaunt male figures, elongated and rough-hewn, painted in thick ridges of dull earth colors; they loom over or stride relentlessly across dark, strangely flickering landscapes. Eventually, heads became massive, rough-hewn blocks, the features concentrated in deep-set, gaping eye-holes, like Easter Island statues (Fig. 21). The figures explode into convulsions of crackling contour lines, twisting limbs, writhing fingers. Ultimately, the compositions become engulfed by details of these already distorted and fragmentary forms—fingers and fists become vastly enlarged, intensified, transfigured. "It is like stripping down Rembrandt or Velázquez to see what an eye can do by itself, or an arm, or a head—and then going beyond to see what just the *idea* of an eye or an arm or a head might be," Still said. "In a sense, all the paintings are self-portraits. The figure stands behind it all until eventually you could say it explodes across the whole canvas. But by then, of course, it's become a whole new world. Simply by talking about it you have already begun to falsify, because you are giving *names* to these ideas, and the forms and colors and textures have become something else, for which there are no words."[16]

Still's years in the Bay Area, between 1941 and 1943, were a time of privation and struggle, for his family now included two daughters, one of them an infant. He took work under contract to the Navy as a steel checker and crane operator in an Oakland shipyard that made submarine tenders; later, he worked in San Francisco for the Hammond Aircraft Company, which made assemblies for Douglas A-20 airplanes. Nevertheless, painting in makeshift studios in the spare rooms of rented houses near the U.C. Berkeley campus and later in Oakland, Still completed at least two startlingly prophetic works. In *1941-2-C,* a relatively large work (41½ by 52 inches) now in the collection of the Albright-Knox Gallery, the image is reduced to a single dark, shaggy, monolithic shape that looms from the lower margin of the canvas and spreads across most of its surface, crowding an airless, deep blue field that bounds its three other sides. The other work, *1943-A,* which still belongs to the artist's estate, is a smaller one (35½ by 30 inches) painted on a sheet of blue denim—a frequent substitute for more expensive canvas in Still's painting of that period. It contains only a few crucially

Clyfford Still and Abstract Expressionism

FIG. 20. Clyfford Still, *Row of Elevators*, c. 1928–1929. Oil on canvas, 34¼″ × 44½″.

FIG. 21. Clyfford Still, *Brown Study*, c. 1935. Oil on canvas, 29¹⁵⁄₁₆″ × 20¼″.

placed patches of black and red, together with a pair of red and yellow lines that work to charge and energize the blue ground, combining with it to form ah organism of abstract shapes from which symmetry and other compositional conventions have been totally purged. Still seems to have suffered a lack of confidence in these paintings when it came time for his first San Francisco Museum of Art "retrospective," because that exhibit included just three works completed since his departure from Washington State—relatively safe abstractions in which one could detect parallels to Miró, Picasso, and the pictographs of Northwest Indian art. (Still recorded *1941-2-C* as one of two paintings "submitted but not hung."[17] Another work apparently not exhibited at this time, *1941-R,* is shown in Fig. 22.)

Smarting over the combination of criticism and neglect that greeted his exhibition at the San Francisco Museum of Art, Still left the area in the fall of 1943 to take a teaching job at the Richmond Professional Institute (then a division of the College of William and Mary) in Virginia. Living on campus and painting in a private studio nearby, he worked in isolation to clarify his vision and distill his expression. He took the resulting paintings with him when he moved to New York in 1945, where they made a profound impression on Mark Rothko, who urged Peggy Guggenheim to look at them; she chose four to install in a space she reserved for "trial balloons," and scheduled a one-man show for Still for February and March of 1946.

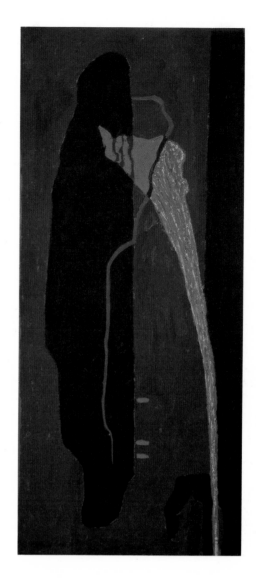

In contrast to the earlier show in San Francisco, all but two of the twelve canvases displayed at the Art of This Century gallery in 1946 dated from the previous two years. In general, the shaggy, central image of a painting such as *1941-2-C,* now frequently darkened to the blackness (and sometimes the consistency) of soot, had expanded to flood almost the entire canvas. Form had broken apart; space had become as palpable as a wall but at the same time suggested infinite depths. The *Untitled,* 1945 (formerly *Self Portrait,* and Ph-233 according to Still's later system of identification), which Peggy Guggenheim bought and eventually gave to the San Francisco Museum of Art, was one of Still's earliest "black paintings" (see Fig. 1, facing p. 1). In these works, inky, opaque fields were split by swift, twisting streaks of white or livid color—"life lines," as Still called them, "a means of giving life to the canvas."[18] Other paintings seemed to contain the shattered ruins of totemic figures; sometimes these ruins were shredded islands of color forged into tensely interlocking organisms of "positive" and "negative" shapes; sometimes they merely flickered along an extreme margin or corner of the canvas, energizing an otherwise inert ground and at the same time suggesting extension beyond the physical boundaries of the painting. These were works that seemed to have swallowed up their own sources in art history. Raw, "ugly," and grandiloquent, they fused the individualism and passion of Expressionism with the lofty objectivity of a Mondrian or Malevich. They also seemed to unite the two poles into which Abstract Expressionism was beginning to divide: the "action painting" exemplified by Willem de Kooning, with its emphasis on spontaneity, energy, and gestures; and the more austere, concentrated, and single-minded "idea painting,"

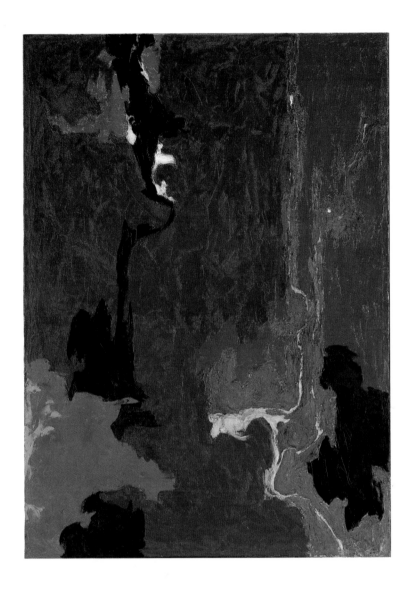

FIG. 22. Clyfford
Still, *1941-R,* 1941.
Oil on denim,
58⅛″ × 25⅜″.

FIG. 23. Clyfford
Still, *Untitled,* 1946.
Oil on canvas, 61¼″
× 44½″.

as Harold Rosenberg called it, that came to be exemplified most purely in the work of Mark Rothko and Barnett Newman. Above all, they implied an unprecedented individual freedom, and at the same time a radical commitment to the primacy of the individual, the specific, and the concrete. (See Figs. 14, 23, and 24.)

It all added up to a completely new vision, which one either accepted or rejected outright. Ernest Briggs, who first saw one of Still's paintings in the Third Annual Exhibition of Painting (December 1, 1948–January 16, 1949) at the California Palace of the Legion of Honor, vividly described this reaction: "I remember the annual as loaded with room after room of smallish sort of decorative take-offs, a lot of so-called Klee-type things and very sweet French surfaces . . . and then this Still painting, and it

was absolutely a contradiction of all the rest. . . . I mean, if you accepted it, you had to reject the other, and if you accepted the other stuff, you had to reject it. It had a very repelling effect, and yet somehow you felt the vitality and fresh air."[19]

In the highly charged atmosphere of romanticism and rebellion that hung in the dark cement corridors and claustrophobic studios of the California School of Fine Arts during the postwar years, the mood swung between an almost religious devotion to the idea of Art, and a volatile, anything-goes abandon. Students sometimes closeted themselves all night in their studios, and spent most of the day down the hill at Bruno's bar, drinking wine and discussing the prevalent topics of intellectual interest: existentialism, Zen, the poetry of Dylan Thomas. A small coterie of

Clyfford Still and Abstract Expressionism

teachers and students—notably Hassel Smith, Deborah Remington, and Ernest Briggs—were avid followers of contemporary jazz. Parties were frequent, often with dancing to the Studio 13 Jazz Band, a traditional jazz combo founded by Mac-Agy, in which MacAgy played drums and David Park piano.

"There was a conflict of feeling," Deborah Remington remembered: "a hard, serious, knuck-led-in feeling about painting—[but] also the feel-ing that you didn't care what you did today because tomorrow you might not be alive . . . that kind of hangover from the war."[20]

"There was an immense, all-pervasive vitality, akin to the vitality of a gymnasium," Bischoff recalled. "The impact of all manner of other possibilities and undreamt-of ways of coming alive on canvas was tremendous." At the same time, the school, he said, was like "a monastery with a brotherhood composed of members recently liber-ated from a world of semi-darkness. . . . It seemed as though everyone there had a hunger, and in a way, this hunger created a common bond. . . . As with a monastery, once within its walls, the individual felt himself beyond the reach of society in general. Beyond this, for the long haul, the artist himself was seen as needing to stand as a fortress against the dissuading and subversive forces of the outside."[21]

In this setting, Clyfford Still stood out as a compelling combination of relevance and anom-aly. Hubert Crehan, a student who later became managing editor of *Art News,* remembers Still as "wiry, quick in movements, [with a] shock of gray hair, ascetic looking. He came to a Hallow-een party in a monk's cowl, a costume which accentuated his character type." Clay Spohn affirmed: "There was a dignity about him, and a seriousness, or rather a sincerity of attitude. . . . His whole bearing and manner of speech was that of a person of greater inner control." Still drank little, had few close attachments and no intimate friends, and his aloofness was heightened by his use of a damp, concrete cubicle in the school's basement as his studio.[22]

On the other hand, some students found it shockingly out of character with this monastic image that Still enjoyed going to baseball games. He and MacAgy also frequently went together to wrestling matches—"a fascinating and somewhat comic form of theater," Still called it.[23] Spohn remembered that Still and MacAgy sometimes enjoyed playing pranks and performing "nonsen-sical games or rituals to express their private contempt for certain conventional attitudes." And

Crehan recalled: "[Still's] prize possession was a gray Jaguar sedan, and he seemed to get a lot of pleasure under its hood polishing its chrome-plated engine head and dusting its body."[24]

These very contradictions contributed to the larger-than-life image that Still enjoyed during most of the four years he taught at the California School of Fine Arts. Jon Schueler has recalled how Still made something of a hermetic initiation rite of ushering small groups of chosen students into the Gothic depths of his studio, "in the base of that tower," to view his new work. "He had a huge painting on each of the four walls. He had set this thing up as a show, in a way. . . . It was the goddamndest cell you'd ever want to see. You could look straight up and never find the ceiling. I got the feeling that he was down in this closed space . . . that he was at the bottom with some-thing going on endlessly above."[25] Impressionable students such as Crehan, noting Still's indifference to teaching (which he regarded as an economic expedient to be given as little time as possible), decided that it must be related to a Zen concept: "He decided to be the silent witness, keeping his own counsel." In an era when conformity, ano-nymity, and the entire question of self-identity had become critical problems, Still encouraged a kind of cult of personality. As Crehan recalled: "From time to time, [Still] would enter the classroom and begin to expound about the 'revo-lution' which was going on in painting, insinuat-ing that the center of it was precisely in the room where we all were at the moment, and that we were engaged in some conspiratorial movement together, subverting the values of Western art. We had [the] conviction that the making of abstract paintings was almost a secret weapon in the cause not only of beauty but of truth as well."[26]

It did not detract from Still's magnetism that he also represented a direct connection with the vanguard of new American painters. He periodi-cally made the long cross-country drive to the East Coast, where he retained his tangential association with the New York Abstract Expres-sionists, and he spent the summer of 1948 helping Mark Rothko, William Baziotes, and Robert Motherwell in the preliminary planning for the Subjects of the Artist school. He also had two more one-man shows at Betty Parsons's gallery in New York, one in April of 1947 and the other in April and May of 1950.

Few students or teachers actually saw Still's paintings until July of 1947, when Jermayne MacAgy organized a one-man show at the Cali-fornia Palace of the Legion of Honor. It contained

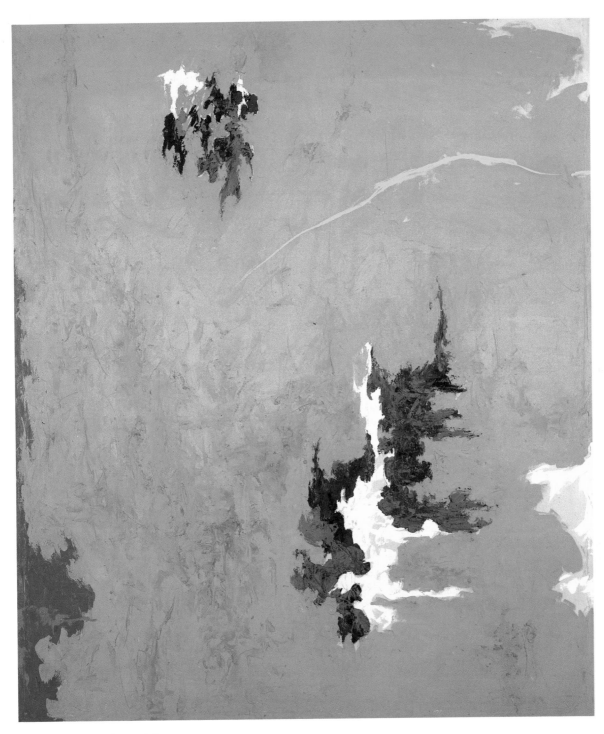

FIG. 24. Clyfford Still, *Untitled*,
1948. Oil on canvas, 80¾″ × 68¾″.

FIG. 25. Mark Rothko in a classroom at the California School of Fine Arts in the late forties.

thirteen works spanning the past four years—six of them completed since Still had begun teaching at the California School of Fine Arts the previous fall. The impact of the show was immediate and dramatic. "People came up to his vast pictures very quietly, and toppled over into them without a murmur, and came out with nothing to say," the poet Kenneth Rexroth later wrote.[27] "Our first response to these potent, utterly original oils was one of disbelief; then came shock, then admiration" wrote Kenneth Sawyer, a student at the time, who later published criticism in several national magazines. "Most of us, veterans of the Second World War, had stern convictions as to the nature of modern painting; it must be Mondrian, Miró, or Picasso. What we were confronted with on the walls of the Legion Museum was unrelated to these preconceptions—unrelated in the most upsetting fashion. . . . Still's works were marked by a violence, a rawness which few of us—though we naturally accepted the violence of the current Europeans—were prepared to recognize as art. It was unnerving to have one's preconceptions so efficiently shorn in a single exhibition. Here was painting that instructed even as it destroyed; the School of Paris had died quite suddenly for us; something new, something most of us could not yet define, had occurred."[28]

In general, the formal influence of Still's work was reflected in a tendency toward dark, earthen colors, and rough, ragged surfaces—"a kind of relentless thing that was sort of anti-beauty in a sense," as Jack Jefferson described it, "a willingness to use something really raw and brutal."[29] It was also seen in a dramatic increase in scale. Not vast by today's standards, but by the standards of the 1940s, it was immense in a way that viewers sometimes found outrageous.

Still's influence at the California School of Fine Arts was reinforced by the presence of Mark Rothko during two summer sessions there, in 1947 and 1949. (See Fig. 25.) Still and Rothko had developed an especially close friendship in the years since Still's first show at Peggy Guggenheim's, and it is probable that Still influenced the development of Rothko's work during this time: it moved quickly away from the ideographic shapes and automatist calligraphy of such paintings as *Slow Swirl* to concentrate on washes of radiant, transparent color in shaggy, irregular patches that seemed to float across his canvases (see Fig. 26). Rothko also exerted a distinct influence of his own at the California School of Fine Arts, independent of Still's and quite disproportionate to the short periods of time that he taught there (June 23 to August 1, 1947, and July 5 to August 12, 1949). Rothko's painting, Ernest Briggs remembers, "triggered an instantaneous release of pinks and blues and reds and soft edges."[30]

Clyfford Still and Abstract Expressionism

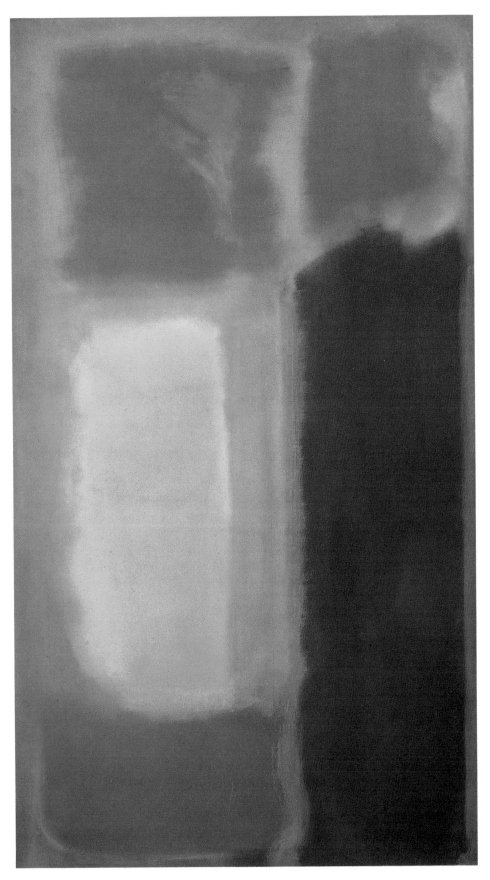

FIG. 26. Mark Rothko, *Number 15*,
1948. Oil on canvas, 52⅛″ × 29⅜″.

Beyond the style or expression of his painting, Rothko's personality and attitude offered an alternative for those who found Still's intellectual stance and personal manner too forbidding. Ernest Briggs recalled Rothko as a sophisticate, "a New Yorker . . . a member of the art world. He could talk endlessly and very brilliantly and poetically and metaphorically and mysteriously."[31] For Bischoff, Rothko "voiced the hope of breaking through solitude" as opposed to Still's emphasis on "the valiant and solitary stand the artist must take for the sake of his own integrity."[32]

"In a sense, they complemented each other," Spohn wrote. "Rothko was far more personable and outgoingly warm toward others, but at the same time there was a feeling of futility in his thinking. He used to speak of life as a tragic comedy. Still had a contempt for the general run of people, since he felt most of them were stupid fools. Rothko, on the other hand, loved people as a group . . . or as individuals. He suffered much emotionally . . . he desired respect and recognition of the fact that he was a lovable guy. Still only loved his ideals and his objective. He didn't give a damn about anything other than his vision of some kind of ultimate. But they both loved art and those principles of art they believed in."[33]

The New York painter Ad Reinhardt taught a summer session at the school in 1950, while his work was undergoing a transformation as dramatic as Rothko's. He proved bewildering to most of the students and teachers who came in contact with him. He was a disconcerting guest at drinking sessions at Edward Corbett's house in Point Richmond, where he seemed content to observe Corbett, Smith, McChesney, and others; he made runs to the liquor store to replenish their supply, but he never took a drink himself. And he frequently tossed out questions about the value and integrity of the work everyone else around him was doing. Thus it was not considered an accident when he once showed his class a slide of a Still or a Rothko painting (the accounts vary) upside down—no laughing matter in those earnest days.[34]

The "golden age" of Abstract Expressionism at the California School of Fine Arts was remarkably short—an extraordinarily concentrated and dynamic period of four or five years. Its explosive energy, furthrmore, sprang from a massive contradiction that most students and teachers seemed content to leave unexamined: the belief that they could give full expression to their yearning for absolute creative freedom only by painting in a way that reflected the influence of Clyfford Still or Mark Rothko. In fact, most of them believed it was imperative to combat the forces of reaction by spreading this gospel to others.

This contradiction between absolute freedom and absolute control was as strong a component of Still's personality as it was an implicit statement in his work. In theory, at least, Still's expression stood for the unqualified freedom of every artist to follow his own path, coupled with the responsibility to pursue that path to its end, to accept "the self-discipline necessary to the realization of his profoundest capacity."[35] Some students remembered Still as bending over backward to avoid imposing his own views. Spohn recalls that he resented students who "in attempting to flatter him imitated the superficial surface qualities and effects of his work, probably thinking he was teaching a system of rules and methods rather than a way of thinking, feeling and seeing."[36] And Jeremy Anderson observed that "the longer people studied with Still, the less their work looked like his."[37]

Nonetheless, he had what Jon Schueler described as a tremendous desire for control: his "need to dominate [the] surface was greater than Mondrian's, [and he also wanted] to control what people would think about it. . . . I'm sure he'd like to tell people who buy [one of] his paintings where to set it up in their house . . . and probably when they could look at it and when they couldn't." Inevitably, Still's outspoken attacks against Cubism, figurative painting, or any esthetic he felt inimical to his own began to be translated, rightly or wrongly, into certain "rules." Briggs said, "He was extreme in relation to eliminating the horizon line [or] any reference to the figure. . . . We felt that you couldn't have a hunk of sky." Diebenkorn remembered that for Still, geometry "equaled sterility" and was therefore also anathema. Bischoff noted that straight edges of any kind were tacitly forbidden.[38]

According to Spohn, Still's belief that the school should align itself solidly behind Abstract Expressionism brought him into occasional conflict with Douglas MacAgy, who held out for—or had to accept as a political reality—a more catholic balance of approaches among the teaching staff. Still himself said that during his years at the school he threatened to resign more or less regularly, "until I got what I wanted."[39] (There was also tension in the relations of Still and Rothko to other members of the faculty; David Park once led a campaign to secure greater rights and privileges for the local teachers.)

Perhaps no aspect of Still's thinking affected students and other artists more strongly or problematically than what Schueler called his "absolute social stance" (Corbett called it his "fuck-them-all attitude"). "He had a completely enclosed way of thinking about his art as it relates to society," said Schueler. "One of the things he was saying over and over again . . . was that the artist is nothing unless he accepts the total responsibility for everything that he does. Moving beyond the painting to the painting being shown, he . . . thought it shouldn't be in a group show . . . the message would be lost, the picture itself would become confused by the imposition of one painting against the other. Then he certainly took a stand against competitive, juried shows. . . . He felt that an artist should be in a position where he is either invited or not invited. . . . He felt that a dealer or a museum director or anybody else had no business choosing the paintings, setting up the show, fixing the lighting, anything."[40]

Still himself boycotted the big competitive annual shows. (He was not always able to keep out of them, however. Jermayne MacAgy was so insistent his work be included in the 1948 annual show that despite Still's objection, she sent to New York and borrowed a painting he had consigned to Betty Parsons.) He advised his students to do the same: "We're grown men, not like children who put their paintings on the wall and hope for a gold star. I told them to wait until the museum came to them."[41]

This attitude, of course, posed dilemmas that did not escape some of Still's students, especially when they began to feel it was time to seek some recognition in the world at large. Still himself wrestled with these problems during much of the time he was in San Francisco, most notably in his dealings with Betty Parsons. In November of 1947—after his first show at her New York gallery the previous April—he wrote to say that he was determined not to exhibit his work again in any public gallery, and requested that she return the pictures that had not been sold. By the following March, he had relented somewhat: he told Parsons she could keep the pictures until his return to New York that summer, on the condition that she show them only to persons who might have some insight into their values, and on no account to permit anyone to write about them. In further exchanges of correspondence, he continued to vacillate. He insisted that his work was not "just painting" and that it could have no value except when seen as what he called a created revelation. He reiterated his fear that his paintings

would be misinterpreted in the context of the gallery: their implicit critique of materialistic and conformist standards would be ignored or overlooked, and they would be incorporated into the traditional frameworks of property values or establishment esthetics, seen as marketable products or statements of academic formulas. Yet, for all these misgivings, Still allowed Parsons to continue to represent him until after he had moved back to New York in 1952, when he finally reclaimed his paintings—and refused to exhibit them anywhere for the next seven years.[42]

The hard reality was that if an artist wanted his work to be seen beyond a small circle of peers and friends, he had to exhibit it somehow, and to exhibit it more or less within the context where art was normally shown. Spohn recalled—with some disapproval—Still's and Rothko's frequent preoccupation with "the politics of art, or how to beat the game, or who was to get control . . . in the presentation and marketing of one's art."[43] But the fact was, an artist played the game to win, or else he lost it. Still "played the gallery game" more successfully than most, Schueler said. "He played it to the point that he actually was free of it." According to Briggs, "he often used the analogy of guerrilla warfare as the only position viable for an artist."[44] And Still himself has said: "Revolutions are futile, but subversion offers possibilities. . . . The myth of the artist in his studio 'waiting to be discovered' is a futile ideal. There has never been a time when I was not involved in the art world."[45]

Many of the inconsistencies and contradictions that this attitude involved seemed to come to a head in the evolution of Metart Galleries—San Francisco's earliest "alternative space" in the contemporary sense of the word. It was organized, with Still's advice, by twelve of his students. (Edith Dugmore remembers the original group as consisting of Edward Dugmore, Jeremy Anderson, Ernest Briggs, Jorge Goya, Jack Jefferson, Jack Cohantz, Hubert Crehan, William Huberich, Kiyo Koizumi, Zoe Longfield, Frances Spencer, and Horst Trave. The cooperative eventually grew to 24 members.)[46] Conceived as "a twelve-man partnership, the terms of which entitle each partner to full control of the galleries' facilities during the month that he is exhibiting his work," the galleries opened in April 1949, in a storefront next to a Chinese laundry at 527 Bush Street, near the downtown entrance to Chinatown.

Still's philosophy was evident in Metart's first press release: "Metart Galleries was formed in direct response to the problem of bringing the

work of the creative artist to public attention under conditions which leave the artist freest from outside control in exhibiting. . . . The necessity of one-man shows follows from the belief that only in a full statement of his work can the artist advance toward that form of 'communication' possible in the plastic arts, where a single work, even if a so-called masterpiece, will be only a partial revelation of the total meaning of his creative experience. Anything less than a one-man show is merely a concession to the unimportant decorative aspects of art, the dealers' interest in 'selling a painting,' or the museums' practice of collecting and exhibiting the isolated 'facts' without understanding their 'meaning.' This view undermines the kinds of judgments on art works which rashly declare a single work to be good or bad on the basis of 'good taste' or [being] 'well-painted.' Judgment can be arrived at only through a complete understanding of an artist's work, not merely through sensual reactions or appreciation of craftsmanship. From this standpoint, the value of an artist lies primarily in his integrity and intelligence as a human being engaged in a cultural activity. . . . Operation of a gallery on these premises leaves the artist an independent agent, both as a worker and as an exhibitor. He remains free from any school of painting and unincorporated by any commercial interest."[47]

The Metart Galleries opened with a show of Ernest Briggs (and as Alfred Frankenstein noted in an enthusiastic review in the Sunday *Chronicle,* "somewhat original" hours—2 P.M. to 8 P.M. Wednesday through Friday, and noon to five Sundays). Its high ideals soon descended a bit, with a plan for "patron membership." For a donation of ten dollars a year, a patron would get a 25 percent discount on the price of any purchase, and a yearly choice of "any one in a comprehensive selected group of original prints, watercolors, and drawings by the artists represented"; the First Annual Selection Show was held on November 20, 1949. Thirty years later, Clyfford Still said that the cooperative had compromised itself almost from the beginning. "I told my San Francisco students that they had a strong underground and they should try to keep it underground as long as they could. I encouraged them to start a gallery separate from the establishment, which they did, and of course the first thing they did then was to call the establishment in—the reviewers, museum people, and so on."[48]

During Metart's fifteen-month existence, each of the original artist members was able to mount a showing of his own work; most were reviewed in one or more of the daily newspapers. On the invitation of the Metart members, Still exhibited his own paintings at the galleries between June 17 and July 14, 1950. It was one of his memorable exhibitions, according to Hassel Smith: "There were lots of small paintings that were just delightful. They gave you the idea of a personality with a lot more facets."[49] For Hubert Crehan, this show was extensive enough to reveal the sources of some of Still's ideas: "For example, there were two large dark blue and black canvases [that] could easily be read as a night sky. . . . There was a large painting [that] appeared to be based on the image of a driven fog with mystic flashes of gold light emanating from a hidden sun. What this show did for me was to break the prohibitions I had made about inquiring into 'content,' the quality of the 'unknown.' "[50] (See Figs. 27 and 28.)

Still's show, however, was the last one ever to appear at Metart. Not enough money had been raised to keep it operating, and according to Alfred Frankenstein, it was also the victim of internal dissension: "In reviewing one of its shows, I observed that some of the students had picked up some of the clichés of Abstract Expressionism from their teachers. . . . This remark prompted a bitter tirade from . . . Jorge Goya, [who] had made the mistake of speaking in the name of the cooperative without consulting its other members—or so some of them insisted—and the ensuing row broke up the gallery, which was a great shame."[51] By the end of the year, Still had left San Francisco permanently to return to New York. In the years ahead, many of his former students—including Briggs, Schueler, and Dugmore—followed him.

In the end, Still's influence on students at the California School of Fine Arts, and on painting and sculpture in the Bay Area in general, was both profound and nebulous. A great many artists imitated or adapted various aspects of his painting, and reacted against others, for years to come; a few of them developed forceful, individual styles, as we shall see in the next chapter. And yet Still's vision of art as essentially a branch of morals may have affected more artists more deeply than any of the specific forms of his work. Perhaps his most important contribution was his continual emphasis on the freedom and integrity of the artist, and on the inseparability of "attitude" and "content" in art. The notion that the artist is fundamentally indivisible from his art—that his work and life, in the deepest sense, are the same thing, as distinguished from the workaday approach of the

FIG. 27. Clyfford Still, *Untitled*,
1949. Oil on canvas, 68″ × 58¼″.

34

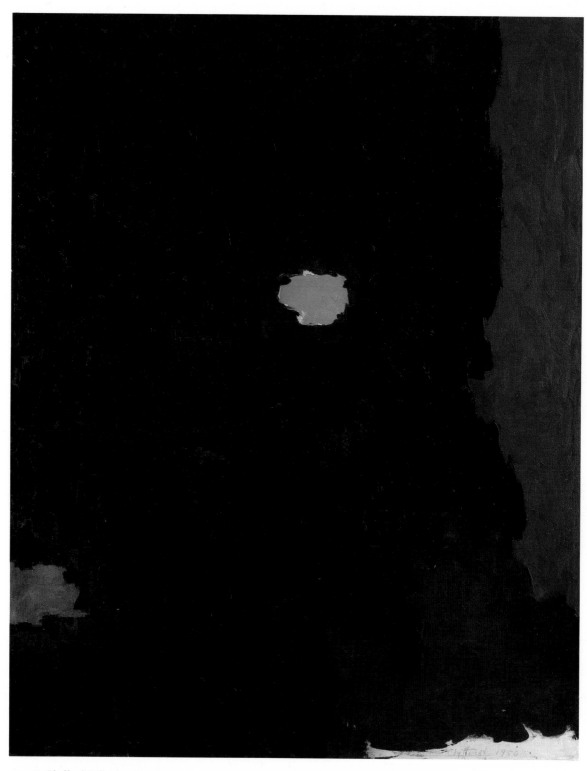

FIG. 28. Clyfford Still, *1950-B,*
1950. Oil on canvas, 83½″ × 67⅜″.

nine-to-five "professional"—has been central to the strongest tradition of Bay Area art.

Yet in the deepest sense, Still probably had no real followers. To "follow" Still would have meant resisting or rejecting his influence as violently as he himself had resisted and rejected the dominant influences of his own formative years, and it would have meant pursuing one's own course with the same monomaniacal determination and faith. To an artist of lesser talent, the solitary path that Still insisted upon seemed to lead inevitably to isolation and neglect. Also, as Irving Sandler has pointed out, the newcomers to Abstract Expressionism "regarded their elders as heroes to be emulated and not, as the first generation had regarded the leaders of the School of Paris, as masters to be gotten around or past."[52]

Most of the younger artists who sought to free themselves from Still's influence gravitated instead to the orbits of Hofmann and de Kooning, whose painting seemed more inclusive, more catholic in its sources, and thus more "open" to development. They thereby achieved a certain measure of flexibility. However, in equating freedom with "openness," younger artists embraced a framework of relative values. Within this framework, the absolute and the unqualified—the kind of despotic conviction with which Still had driven himself to achieve his uniquely powerful form of expression—was the one attribute which, by definition, was no longer available to them. Whether younger painters felt more compatible with Hofmann and de Kooning, or whether they were convinced, as Crehan wrote, that "Still was open to extension," the result was the same: a domestication and refinement of their ideas, a housebroken Abstract Expressionism.[53] They reverted to producing new forms of "good painting"—quite good, sometimes, but at a safe remove from the realm of revelation. As MacAgy later summarized: "Of all these people in the States at that time, including de Kooning . . . and Pollock . . . the top ones who have remained top and exalted are both Rothko and Still, but just those two in that era. I don't see any other painters or artists who have come along since anywhere in the world who are up to [their] particular exaltation. . . . But you can't follow men like that. They weren't presenting a style that could be developed. They were presenting a form that they had reached themselves and which was only good for them."[54]

In their dealings with the art world, too, few of Still's students would be willing or able to match his success at "guerrilla warfare." It was one thing for an artist of Still's originality and power, who was already attaining recognition in New York, to lecture his students about the advantages of remaining "underground." It was another matter for a young painter just out of school, with no public exhibitions to his credit and perhaps no great gift anyway, to resist showing his work whenever an opportunity arose. Still's students, holding fewer trump cards than he did, played their hands as best they could. Generally, they insisted on greater dignity and respect in their relations with dealers, museum people, and others than artists had customarily demanded or received in the past.

Still's triumph, such as it was, exacted an awesome price. After his return to New York in the 1950s, relationships among the Abstract Expressionist painters rapidly disintegrated into vindictive cabals, armed camps that grew smaller and smaller, until each consisted of a single embattled, and often paranoid, artist. Even the friendship between Still and Rothko, once so close, broke up in bitter recriminations. As Cocteau had once written, "The only outcome of an increasingly pronounced individualism is solitude."

Nonetheless, Still's body of work remains one of the monumental achievements of twentieth-century art. For artists in the Bay Area at the end of the 1940s, it also stood as a monumental obstacle, even more implacable than the work of Picasso had seemed a decade earlier. It could not be surmounted, circumvented, or effectively undermined. It was the kind of ultimate statement that other artists could approach only by picking up the pieces, or by coming at it from an entirely different direction and then developing a similarly unique and unqualified expression of their own. Efforts of this sort did not really become noticeable in Bay Area art until a slightly later period, when artists became less self-conscious about the whole idea of art and monumentality.

FIG. 29. Frank
Lobdell, *Black Edges
III,* 1962. Oil on
canvas, 83½″ × 70″.

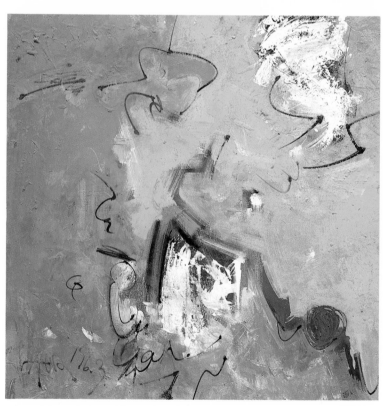

FIG. 30. Hassel
Smith, *Homage to
Bob Scobey,* 1963.
Oil on canvas, 48″
× 48″.

Abstract Expressionism swept through the ranks of Bay Area painters in the late 1940s with the intensity of a religious revival. (See Fig. 31.) Years later, even such a salty iconoclast as Hassel Smith could say that his "conversion" to it was "instantaneous," and had come about when he saw Clyfford Still's 1947 show at the Legion of Honor.[1] Although generally influenced by Still, and sometimes Rothko, many Bay Area painters developed distinctive styles of Abstract Expressionism in the years ahead.

Among teachers at the California School of Fine Arts, David Park, Elmer Bischoff, and Ed Corbett were quickly caught up in the momentum. Bischoff's earliest abstract paintings were inspired by Rothko's pictographic abstractions of the mid-1940s, but he soon moved into a meaty, gestural action painting. It was characterized by dynamic paths of movement, lush, thick surfaces, and dissonant, sometimes violent color. David Park destroyed most of his nonrepresentational paintings in 1949, but the few that survive show the strident, acrid palette and blistered, slab-like surfaces that distinguished Abstract Expressionism (School of Fine Arts style) incongruously coupled with bold, blockily geometric forms. In 1948, Park, Bischoff, and Hassel Smith were given a three-artist show at the San Francisco Museum of Art. Author Mark Schorer later described it as "city blocks of canvas . . . great areas covered with the same flat dun or gray, and then somewhere an outrageous splash and splatter. Freewheeling is hardly the word to describe these paintings, that were at least as bewildering as they were brilliant."[2] Ed Corbett abandoned his Mondrianesque geometries for a looser, more intuitive and painterly expression. His new works, spare and soft-spoken in comparison with the more robust gesturalism that generally prevailed among Bay Area Abstract Expressionists, contained ragged fields within narrow spectra of atmospheric grays that suggested a foundation in natural imagery (see Fig. 32).

The two artists who became the best-known representatives of Bay Area Abstract Expressionism, Richard Diebenkorn and Sam Francis, were both students in the postwar years. Diebenkorn, a shy painter in his early twenties when he enrolled in 1946 at the California School of Fine Arts (where he began teaching the following year) (see Fig. 33), had practiced a Hopperesque vein of tightly structured urban realism while attending Stanford University in the early 1940s. The son of a wealthy sales executive, Diebenkorn had displayed a precocious talent for drawing that had been encouraged by everyone from his grandmother, Florence Stephens—a lawyer, poet, short-story writer, and amateur painter—to the family cook, who provided him with art supplies. His early efforts showed facility and versatility,

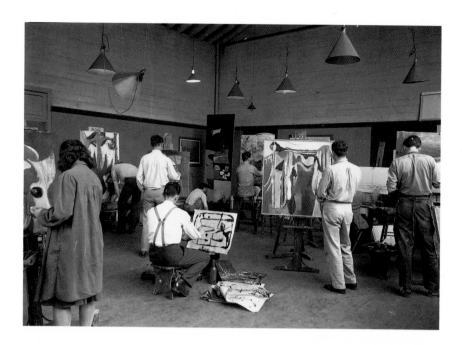

FIG. 31. Classroom at the California School of Fine Arts, 1947.

sometimes uneasily combined with the prevalent School of Fine Arts assumption that art should be as hardboiled as a Bogart movie. David Park had steered him toward an abstract style that blended elements of Picasso and Miró, and the paintings in his first one-man show at the Palace of the Legion of Honor in 1948 were rooted largely in Cubism, relying heavily on bold draftsmanship and dramatic contrasts of light and dark.

Between 1948 and 1950 Diebenkorn seems to have schooled himself in practically every variety of Abstract Expressionism. His paintings often coupled Still's ragged areas of raw, unmodulated ochres and ox-bloods with Miróesque symbols and spontaneous, whiplash calligraphy that seems to stand somewhere between Gorky's use of line and the gesturalism developed by Hassel Smith. (See Fig. 34.) They also showed traces of Rothko's thinly stained, soft-edged color patches, and of the fractured pictographic shapes that twist and interweave through de Kooning's all-over abstractions of the late 1940s. More than most of his fellow teachers and students, Diebenkorn seemed ready to allow relatively explicit allusions to images, as well as a clear sense of atmospheric light and space, in his eclectic abstractions. And he seems to have been hospitable to the kinds of spontaneous "accidents" on canvas that his more puritanical colleagues were inclined to reject in their own work as too "easy." By the last years of the 1940s he had found an authoritative style in which painting and drawing deftly interacted. It combined the raw, indecorous, parched-earth look that was becoming a hallmark of Bay Area

Abstract Expressionism with a certain sense of fluidity and grace, a reticent but distinct sensuality that reflected his abiding love of Matisse. Although it appeared to be highly improvisational, his painting was in fact carefully, even academically, balanced and structured. This mixture of "toughness," seductiveness, and structural integrity had a strong influence on a second wave of Abstract Expressionists in the Bay Area.

Sam Francis was a student at U.C. Berkeley between 1947 and 1950, although Clyfford Still remembered seeing him "hanging around the school [of Fine Arts] on weekends, talking with the students."[3] A native of San Mateo who had pursued a psychology and premedical major at Berkeley before the war, Francis had taken up painting while recovering from spinal tuberculosis, the result of an air crash injury he had suffered during his training as an Army Air Corps pilot. Following his discharge in 1947, he had returned to Berkeley, where he took his B.A. degree in 1949 and his M.A. in 1950.

Francis's early abstractions reflected Still's influence in their sense of unbounded space and use of cragged forms that crowd along an edge, and Rothko's influence in their thin areas of luminous, atmospheric colors. By 1949 he was doing more distinctive paintings, covered with irregularly shaped and spaced "cells" or "corpuscles" of rich, highly saturated colors; these generally mingled with drips, runs, or "bleeds" of paint that set up a counterstructure of "falling" verticals. Paintings such as *Opposites* (1950), which was 96 by 72 inches, rivaled those of Still and Rothko in size.

FIG. 32. Edward Corbett, *Untitled*, 1949. Oil on panel, 23″ × 17¼″.

FIG. 33. Richard Diebenkorn in David Park's studio, 1949. In the background is Hassel Smith.

Francis left for Paris in 1950, and lived alternately in Europe and Japan before settling in Santa Monica in 1962. His influence on the art of the Bay Area has been negligible, but for a time in the early 1950s, French critics, notably Michael Tapies, acclaimed him as one of the principal figures of an Ecole du Pacifique, whose "members" included not only Bay Area Abstract Expressionist painters but such Northwest painters as Mark Tobey and Morris Graves. In practice, this "school"—which the French saw as an alternative to the painting being done in New York—consisted principally of a small and changing coterie of West Coast visitors or expatriates who gathered around the salon and studio of the sculptor Claire Falkenstein, a student at the California School of Fine Arts during most of the 1940s and a teacher there in 1947–1948. At any rate, Francis's airy, colorful, light-saturated, and increasingly decorative paintings were among the first American Abstract Expressionist works to be widely seen in Europe, and they exerted a substantial influence on European painting.

Abstract Expressionism was no more homogeneous in the Bay Area than it was on the East Coast. Styles ranged widely, even among the students at the California School of Fine Arts, who saw themselves, and were perceived by others, as hard-core Abstract Expressionists: from Jorge Goya's thin, floating washes of pastel colors to the brick-like slabs of paint with which Edward Dugmore constructed his abstractions with a palette knife; from Ernest Briggs's pointillistic fields teeming with motes of color to the explosive

coverings of paint that John Grillo—probably the earliest and purest of the school's action painters—spread across canvases, discarded doors, and virtually any other available surface.

One characteristic that set Bay Area Abstract Expressionism apart was its acceptance of fairly explicit references to nature. Organic images were clear in Lawrence Calcagno's early abstractions, where sun discs and the shapes of trees were enclosed by heavy black lines that suggested stained glass (as well as Picasso) and gave them the character of icons. The gentle atmosphere and vast spaces of Jon Schueler's early abstract paintings suggested an inspiration in his wartime experiences as a flyer. John Hultberg, after painting nonrepresentationally for "a few months," found himself coming back to landscape painting "with a kind of deep perspective as if painted from . . . an airplane."[4] Jorge Goya said, summing up a common attitude, "I didn't really care whether the impetus came from exterior or interior. As a matter of fact, you could see around you that there were many people in the studio with Still, possibly myself included, who were really defining exterior experiences . . . landscapes or portraits or buildings. And on the other hand, [in] Hassel's class [Smith taught a popular class in landscape painting] one tree took on so many different forms . . . that you knew this was some kind of refining of an interior experience flowing through the tree."[5]

There were pockets of militant resistance to Abstract Expressionism, as well as independence or isolation from it. Conservative painting persisted, of course, virtually without change during

The Golden Years of Abstract Expressionism

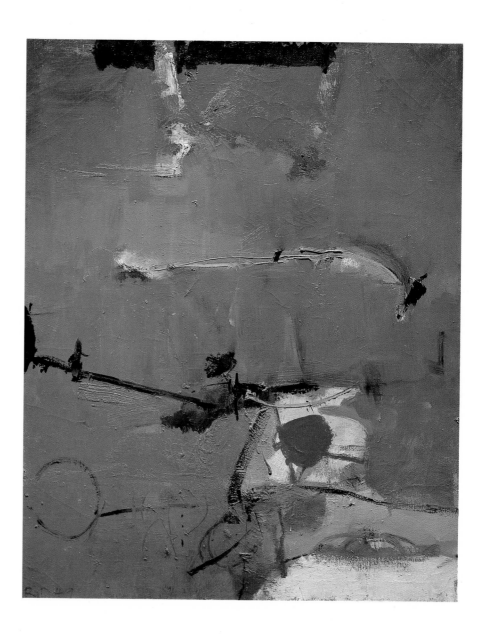

FIG. 34. Richard
Diebenkorn,
Untitled, 1949. Oil
on canvas, 45″ ×
36″.

the years when Abstract Expressionism reached its peak; it continued to dominate the annual exhibitions of the Society of Western Artists and the so-called Thirteen Watercolorists (who actually numbered about twenty), as well as the more conspicuous downtown galleries.

The art department at U.C. Berkeley—which before the war had considered itself the area's staunchest bastion of modernist ideals—generally rejected the kind of abstract painting that Still and Rothko represented. According to Erle Loran, "We called it the drip school, even the shit school. It was pretty repulsive looking stuff. . . . We saw in it a revolt against Hofmann's and our teaching—which was very concrete, and based on real knowledge—Giotto and so on."[6] The irony

was that Hofmann's own painting had changed dramatically since he had taught at Berkeley in 1930 and exhibited his works in a one-man show at the California Palace of the Legion of Honor in 1931. His new painting was quite unlike Still's or Rothko's, representing a more gestural, calligraphic form of Abstract Expressionism. Nonetheless, Loran recalled the consternation of Worth Ryder, a Hofmann disciple since the 1920s, when they went to see the first display of some of these recent Abstract Expressionist works at the San Francisco Museum of Art: "Ryder was absolutely baffled by their freedom."[7]

Among the most remarkable Bay Area artists who remained at a peculiar tangent to Abstract Expressionism were three painters who briefly

joined together in the late 1950s as a group called Dynaton. One of the three was Wolfgang Paalen, an Austrian-born Surrealist who had been a close friend of Matta in Paris during the late 1930s. He had already exerted an important influence on artists in Europe and the United States with his avant-garde magazine *Dyn,* which he began to publish in 1942 in Mexico City. *Dyn* promoted primitive art and broke with the illustrative branch of Surrealism represented by the dream imagery of Dali. *Dyn* wanted to uphold Surrealism's roots in automatism—the capacity of art to "prefigure . . . a new order of things" rather than to be "simply an academic copy of a previously terminated psychological experience."[8] In March of 1950, with his wife Luchita Hurtado, a fashion illustrator for *Vogue,* and their nine-year-old son, Paalen settled in Mill Valley, where an old acquaintance, Gordon Onslow-Ford, had come to live three years earlier.

Onslow-Ford, an Englishman who had studied briefly with Leger in Paris and had also become a close friend and collaborator of Matta in the late 1930s, had played a role similar to Paalen's in propagating Surrealist automatism, largely through a series of New York lectures (at the New School for Social Research) and a concurrent schedule of exhibitions of major Surrealist artists. He had also assembled an impressive collection of modernist and Surrealist painting. Paalen and Onslow-Ford teamed up with a younger painter, Lee Mullican, who shared their fascination with "primitive" cultures and had studied Indian art in the Southwest, and together they presented a show called Dynaton at the San Francisco Museum of Art in 1951.

The name Dynaton—taken from the Greek word for "the possible"—meant "a limitless continuum in which all forms of reality are potentially implicit," Paalen explained in an exhibition catalogue. "Our *aims* are not solutions of formal problems, but a new meaning. . . . Art, for us, has no business . . . but to complement the quantitative understanding of science by a cosmography in terms of quality. . . . Our pictures are objects for . . . active meditation."[9]

Jacqueline Johnson, Onslow-Ford's wife, elaborated in her catalogue essay: "The whole modern era is marked . . . by a shift of interest from sentiment, from the self as actor, to the self as theater of action; and the real message is a transformation of reality by a transformation of our awareness. . . . There is, for each of the three painters in the exhibition . . . a bold taking possession of a visual equivalent of a state of

FIG. 35. Wolfgang Paalen, *Planetary Face,* 1947. Oil on canvas, 59″ × 55¼″.

being, the making actual of an object of marvelous inner processes. It is an insight that [is] most clear, most touching, when it surprises with its revelation even the man who makes it."[10]

Although this description seems to anticipate Harold Rosenberg's article on action painting (which appeared in *Art News* late in 1952), the work of the three painters had little in common with de Kooning, Hofmann, and other so-called action painters. All three used motifs and themes inspired by the myths and forms of non-Western cultures, with a subcurrent of allusion to extraterrestrial beings and energies, and references to Zen. Paalen's paintings were based on short, gestural strokes of rich color that suggested the faceting of stained glass; they remained abstract, but suggested images of totems or guardian figures (see Fig. 35). Onslow-Ford, whose earlier Surrealist works had been filled with pointillist mosaics of color that coalesced in symbolic shapes, showed paintings in the Dynaton exhibition in which he began to simplify his formal vocabulary, reducing it to the line, the circle, and the dot, spread out in all-over, kinetic fields. Mullican displayed talismanic sculptures of painted wooden sticks, as well as paintings in which matchstick ridges of pigment, applied with a palette knife, formed strong rhythmic patterns,

The Golden Years of Abstract Expressionism

which alternated between abstraction and images suggesting suns and Indian figures. (The trio drifted apart shortly after the Dynaton exhibition. Paalen moved back to Mexico, where he committed suicide in 1959, and Mullican settled in Southern California. Onslow-Ford remained in the Bay Area, and his paintings continued to explore the line, the circle, and the dot.)

One of the most irrepressibly independent artists of the period was Clay Spohn. His mordant, prankish, wildly inventive streak of visual-verbal fancy, expressed in Dadaesque assemblages like the flyswatter contraption he had exhibited in the San Francisco Art Association Annual of 1941 (see Fig. 13, p. 13), culminated in a *Museum of Unknown and Little Known Objects,* which he organized at the California School of Fine Arts in 1949 (Figs. 36 and 37). In this work, other artists, including Richard Diebenkorn and Frank Lobdell, contributed to what might today be called an installation piece. Among Spohn's own creations were *Forking Events,* a collection of table forks twisted into various imaginative shapes; *Mole Samplers—Mouse Seeds,* a jar filled with moldy grains of uncooked rice; and an outlandish *Chastity Belt.* Spohn's lampooning humor and impatience with artistic pretentiousness—both outgrowths of an utterly serious view of art and the artist's role—set the tone for much of the funky art that was to appear in the 1950s.

The idealism with which the Abstract Expressionist painters championed unimpeded self-expression in art was all the more fervent because they believed the public was hostile or indifferent to their cause. Jon Schueler remembered one of Ernest Briggs's paintings being pulled down and stepped on during an open air show at the Palace of Fine Arts (probably one of the annual outdoor art festivals the San Francisco Art Commission inaugurated in 1948).[11] Robert McChesney recalled a spectator aiming a foot at one of his works in a rival outdoor show launched at about the same time in Oakland's Jack London Square.[12]

But the resistance encountered by the early Abstract Expressionists is frequently exaggerated. In fact, the new painting that emanated from the California School of Fine Arts received relatively broad exposure almost at once. In addition to exhibitions at the Legion of Honor and the San Francisco Museum of Art, and representation at outdoor art festivals, many painters from the school had one-artist or two-artist shows at the Labaudt Gallery, founded in 1946 by Marcelle Labaudt in her husband's former studio at 1407 Gough Street. Madame Labaudt pursued the unique policy of exhibiting only "emerging" artists whose work had never been shown before, and at least until the late 1950s her gallery exhibited many of the painters who later became most influential in the Bay Area. More often than not, exhibitions of Abstract Expressionist work received favorable or sympathetic reviews from Alfred Frankenstein and his assistant, R. H. Hagan, in the *San Francisco Chronicle.* Thus by 1950 Abstract Expressionism had become almost as widely accepted—among artists and cognoscenti, at least—in San Francisco as it was in New York. In 1949, only two years after the San Francisco Art Association's annual show in which Clyfford Still's paintings had provoked such awe and surprise, the 69th Annual Oil and Sculpture Exhibition at the San Francisco Museum of Modern Art was completely dominated by the new Abstract Expressionist style. Erle Loran reported in *Art News:* "Under the leadership of Clyfford Still and Mark Rothko it is absolutely true that a new trend in painting has been marked off. . . . It recalls the group feeling that we have read about among the French Impressionists."[13]

Before leaving the School of Fine Arts in 1950, the inveterate satirist Clay Spohn had put together a booklet of "instructions" for his students that came to be known as "the Abstract Expressionist kit." Between the early and late 1950s, a more or less academic form of Abstract Expressionism became an established idiom of Bay Area painting. In general, this style emphasized areas—broad, shaggy shapes, irregularly composed—as distinct from gestures. Sometimes these areas were transparent and radiant in the manner of Rothko, but more often they had Still's clotted and scabrous surfaces; their colors ran to dry, sour browns and ox-bloods or ashen blacks and grays. Gifford Phillips noted "a moving mass, not quite porous, not quite solid" and Maurice Tuchman observed "very thickly painted . . . surfaces, coruscating dashes of pigment crackling (or sometimes cracking) through the surface . . . and a lateral stretching of form and textured surface toward the picture edges, with effects produced by painting wet-on-wet."[14] These areas were sometimes combined with the free, looping calligraphy of Hassel Smith's painting, or with the more controlled heavy black line and shallow space—a kind of fractured Cubism—found in de Kooning's abstractions of the late 1940s (and in a somewhat different way, in the abstractions of Diebenkorn).

As Abstract Expressionism became an increasingly established *manner* of making abstract paintings, instead of an underground movement, it

FIG. 36. *The Museum of Unknown and Little Known Objects*, exhibited at the California School of Fine Arts in 1949.

FIG. 37. Explanatory sketch made by Clay Spohn for the *Museum of Unknown and Little Known Objects*.

seemed a dramatically appropriate time for some of the major players to leave the stage. In the Bay Area, the curtain on its heroic youth was symbolically rung down in the summer of 1950, when Douglas MacAgy tendered his resignation at the California School of Fine Arts and was replaced as director by Ernest Mundt. Among the rumors surrounding MacAgy's departure was a story that he had left in rage when the school's board of trustees refused to hire Marcel Duchamp as a teacher. In his own account, years later, MacAgy gave more interesting and more important reasons: "I'd wanted Marcel there, but it never got that far. I chose to leave simply because I didn't want to use up [the] years ahead under conditions that were bound to come. . . . I was concerned about an impending change in the quality of the student body." The "postwar pool of mature students was dwindling," he said, and would be replaced either by "throngs of girls who can't make college and want to mark time while they look for husbands" or by students "who would trade being artists for being teachers when the cards are down." "Socially and economically," he concluded, "what we'd been doing in the school's shelter was shortly to be put out of date by a different school situation."[15]

Lawrence Calcagno summarized the turnabout at Fine Arts in this way: "[MacAgy] could function and flourish because there was [a] vacuum in the community . . . no one was paying any attention and nobody cared. . . . But by 1949, the San Francisco Art Association Annual was abstract or non-objective, and this was when the reaction set in. Then it was very swift, because I think it went right up to the hierarchy of the patrons. . . . When it became widespread enough so that the community would take notice, then they cut it down."[16]

Still's departure from the school was practically coincidental with MacAgy's. Corbett and Spohn left in the same year for New Mexico. Smith, Park, and Bischoff remained on the faculty until 1952, when Smith was dismissed and the other two resigned in protest. Briggs, Dugmore, Schueler, Grillo, and Hultberg were among the former CSFA students who left for New York to further their careers, and they initiated an exodus among the area's more ambitious younger artists that continued through the 1960s. Only in the late 1970s, when the New York-centered avant-garde had lost its cohesion and vitality, did this movement slow and begin to show signs of reversing.

In preparing the manuscript for *A Period of Exploration,* published in conjunction with a large survey of painting and sculpture from the late 1940s and early 1950s organized in 1973 at the Oakland Museum, Mary Fuller McChesney asked thirty-three former CSFA students and teachers whether there had been a "San Francisco school" of art during that period.[17] Two-thirds of them said there had been pronounced differences between Abstract Expressionist painting on the East and West coasts, though many believed the distinctions had been short-lived. Most felt the West Coast version had been more elemental, organic, sensuous but anti-seductive, and specifically more *anti-French;* Briggs remembered his work being appreciatively called "brutal" by Rothko when the latter first saw it.[18] They also thought West Coast painting was freer from intellectual self-consciousness about its place in the history of art—a fact attributed to the area's greater psychological as well as geographical distance from Europe (and from the tastemakers and powerbrokers of the East Coast art world), as well as to the militantly anti-European biases of Still and Rothko. Perhaps as a corollary to this, some also felt that it was less programmatically rigorous, more open to wayward allusions to nature and stray shapes: "All kinds of strange childhood haunts and fantasies got into the painting," Jorge Goya remarked.[19]

A distinctive West Coast style is also suggested by the fact that the work of many Bay Area painters who moved to the East Coast—including, it can be argued, Still himself—did in fact tend to become more *formal,* sometimes with startling speed. Briggs's textures thinned, his colors flattened, and his jagged, Still-like rivulets and islands of form gradually took on a brittle, hard-edged sharpness. The severity of Corbett's earlier exercises in Mondrianesque geometry reasserted itself in spare, organic abstractions that revolved around the tensions of two or three simple shapes and solid colors, and their occasional allusions to landscape.

In general, Bay Area Abstract Expressionism in the 1950s separated into two distinct branches, the extremes of which were defined by the painting of Frank Lobdell and Hassel Smith.

Frank Lobdell had studied at the Saint Paul School of Fine Arts in Minnesota before the war, and attended the California School of Fine Arts from 1946 to 1950. In person shy and quietly intense, in his paintings Lobdell forged a personal style that was somber, dramatic, agonized, and grave. (See Fig. 38.) It seemed to carry on

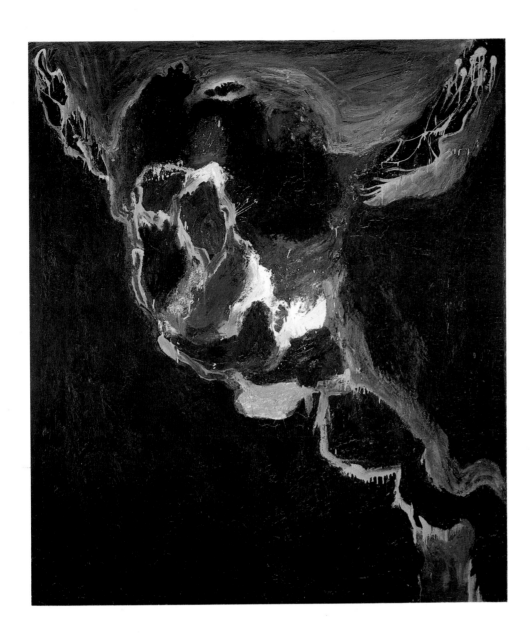

FIG. 39. Frank Lobdell, *April 1957*, 1957. Oil on canvas, 70″ × 60″.

FIG. 38. Frank Lobdell, 1974.

FIG. 40. Frank Lobdell, *Summer 1967*
(in memory of James Budd Dixon),
1967. Oil on canvas, 91″ × 180″.

Clyfford Still's solemnity and sense of deep moral purpose, but it had the greater openness associated with de Kooning. Alfred Frankenstein noted a Hofmann influence in Lobdell's paintings of the early 1940s, which were dominated by brilliant reds, greens, and yellows.[20] By about 1950, however, Lobdell had developed a distinctive style. It was akin to Still's in its emphasis on rugged paint handling and dark "unpleasant" color, but it was dominated by strongly rhythmic forms, gnarled and convoluted, and displayed a somewhat greater willingness to use shapes that evoked specific associations.

In the early 1950s, Lobdell developed a distinctive vocabulary of ambiguous, enigmatic, vaguely archeological images, some of them suggesting roots in Northwestern Indian art: boomerangs, rhombuses, sun discs surrounded by spinning rays, wing shapes, jawbones, ragged claws, and obscure pictographs. These were inscribed with heavy black lines in grounds of thick, heavily worked white paint. (Industrial white was the only material he could afford at the time, Lobdell once said.) The forms often seemed animated—thrusting, leaping, or swirling within a vast, unseen circle, precariously balancing centrifugal and centripetal energies. And they occupied an extraordinary space that seemed related to the kind of organic "tissue," or abstract color matrix, that Chagall frequently created with a sumptuously painted ground color or mixture of colors—

both void and substance, irradiated with light and yet solid enough to carve and mold the forms within it.

In the late 1950s Lobdell's paintings became more and more taciturn and brooding. Volcanic blacks in thick impastos enveloped writhing, upward-groping biomorphic shapes. (See Fig. 39.) Herschel Chipp, in *Art News,* described the paintings as "ominous voids which may be either deep black or misty white, charged with the chilling mystery of unfathomable space. . . . [The forms] are endowed with the agony of a human organism confronted with an environment that offers little that is certain—no horizon, no gravity, no substance."[21]

Like de Kooning's earlier works, Lobdell's paintings made the process of their creation—formation and change, working and reworking, decisions and revisions—a part of their content. But they conveyed little sense of spontaneous "action" or dynamic energy; on the contrary, they suggested heavy labor, difficult choices of great consequence. The images—neither abstract nor specifically figurative—seemed forced to the surface through persistent and painful effort like thoughts that must struggle for expression out of the unformed impulses of the mind. Lobdell has acknowledged that struggle, commitment, and choice have been among his principal metaphorical "themes."

Lobdell has been almost as stiff-backed and

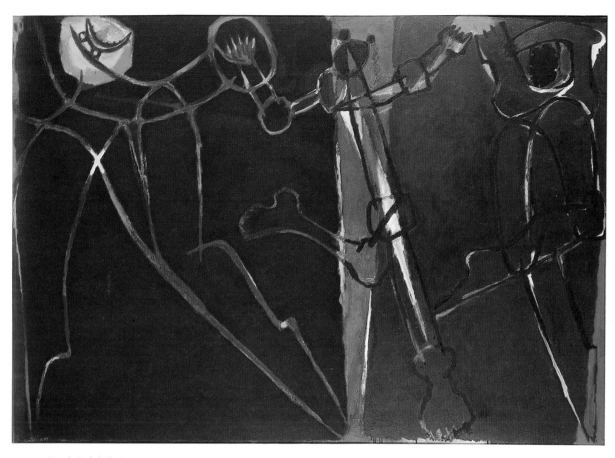

FIG. 41. Frank Lobdell, *Dance VIII,*
1971. Oil on canvas, 62″ × 88″.

withdrawn about exhibiting his work as Still: he has exhibited very rarely, and only on his own terms. As Hilton Kramer observed, Lobdell and his painting stand for "a feeling of struggle against impossible odds—a feeling that the artist was a man who assumed burdens so great that he could not be expected to carry them to any easy success. Indeed, it was the essence of this position that anything easy, flippant, or even spontaneous, was to be regarded with deep suspicion if not outright hostility. Art was . . . something that had to come hard."²² Lobdell was one of the most influential teachers at the California School of Fine Arts from 1957 to 1965, when he left to join the art department at Stanford University.

Color returned to Lobdell's painting in the late 1960s, but it was generally confined to areas that entered into jangling contrast with thick, chalky white grounds and boldly twisting black lines (Fig. 40). Eventually these lines began to suggest scrambled fragments of torsos, limbs, and schematic features, and in a 1969–1971 *Dance* series, definite images of broken,

Picasso-inspired "bone-figures"—dancers and acrobats—finally appeared (Fig. 41). They twist through a more open, less clotted picture space in a bone-rattling *danse macabre,* with unexpected flashes of grotesque comedy. Lobdell's painting changed significantly in the early 1970s. The few works that survive from those years suggest that he concentrated on exploring color and light in a sort of field painting akin to Robert Motherwell's *Open* series. By the last years of the decade, the heavy Stone Age pictography of Lobdell's personal symbolic language had returned to his painting, but the jagged forms and insinuating ghost images floated in a new sort of space, airy and saturated with light; they shifted almost playfully between pure abstraction and suggestions of imagery, made with a sharp-edged whimsicality reminiscent of Saul Steinberg.

Hassel Smith, by contrast, developed a style that carried forward the violently physical, improvisatory, jazz-related action painting that had been a strong subcurrent at the California School

The Golden Years of Abstract Expressionism

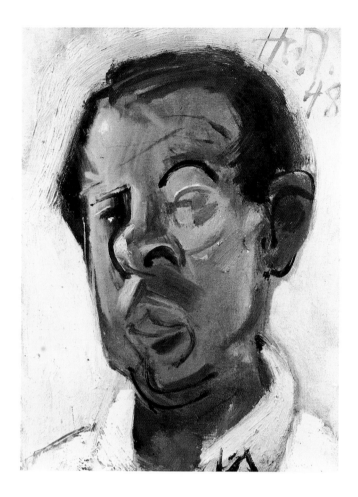

FIG. 42. Hassel Smith, *Self Portrait,* 1948. Oil on canvasboard, 16″ × 12″.

of Fine Arts since John Grillo's early efforts. (See Fig. 42.) It was also rooted in certain aspects of Clyfford Still's abstraction, but in Smith's paintings these aspects were recast as mercurial, exuberant, sometimes flamboyantly improvisational *events.*

Smith's earliest Abstract Expressionist works of the late 1940s tended (as Diebenkorn's did) to seek a resolution between the irregular color areas of Still and Rothko and the gestural draftsmanship of de Kooning and Gorky. Smith's surfaces were usually splashier, thinner, and more slapdash than Diebenkorn's. His dynamic, hooking calligraphy was more apt to have an openly comical quality, sometimes taking the form of barbed, cartoon-like pictographs, symbols, or anatomical shapes. Such allusions were reinforced by titles like *Alone with the Killer* (1948, Fig. 43). The spontaneity and immediacy of many of the paintings, such as *Homage to Bob Scobey,* reflected his interest in jazz (see Fig. 30, p. 36). (Scobey, a trumpet player, was a member of the Lu Watters Yerba Buena Jazz Band in the early years of the Bay Area Dixieland revival and later headed his own group.)

After leaving the California School of Fine Arts in 1952, Smith lived and painted in a house on San Francisco's Potrero Hill. His paintings from this time were filled with dapples of color applied in short, quick daubs. ("I mostly did them at night, and I couldn't see what I was doing. It was always a revelation to get them out and see them.")[23] In 1955 Smith moved to Sebastopol and devoted the next year to tending an apple orchard. When he resumed painting, his abstractions were lush, with strong suggestions of landscape in their space and color.

Smith's impulsive action painting had none of the weight and gravity of Lobdell's. There was little sense of indecision or struggle in it; whatever conflicts he may have suffered in his life or his thought never reached the canvas itself: there, everything seemed immediate and unequivocal. Nor was Smith's earthy temperament receptive to the Spartan rigor, the emphasis on undeviating commitment to implicit metaphysical ideas, that were bound up with the ethical Abstract Expressionism of Lobdell. His painting was widely exhibited, in Europe as well as in the United

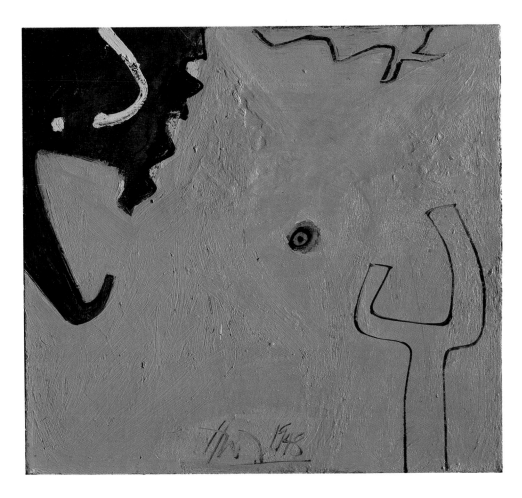

FIG. 43. Hassel Smith, *Alone with the Killer,* 1948. Oil on canvas, 20″ × 22″.

States. Between 1956 and 1962 he showed regularly at the Ferus Gallery in Los Angeles (where his work influenced the abstractions of John Altoon). When he moved to Hollywood to teach for a year at UCLA in the early 1960s, he returned for a time to a broad and satirical figurative style that resembled his eccentric paintings of twenty years before. In 1966 he left to teach at the West of England College of Art in Bristol, and it remained his home base through the 1970s, although he returned frequently to the Bay Area as a visiting instructor at U.C. Davis, U.C. Berkeley, and the San Francisco Art Institute (the former CSFA). During this period, he relinquished virtually every trace of his earlier painting to adopt a style of hard-edged, geometric abstraction. At the same time he changed his medium from oil to acrylic. The new paintings consisted most often of flat planes of solid color, sometimes combined with stenciled numbers to suggest gameboards. The change, Smith has said, was a conscious response to his teaching: he sensed a discrepancy between the painting he did and the principles he taught, and he decided to resolve it in favor of the

principles. It also reflected his insight into "the true nature of modernism." "The crucial decision," he said, "is to stop inventing shapes. . . . This is what Mondrian did, this is what Still and Rothko did . . . these are the only true modern artists." He also believed in making painting "fully accessible, with no mystification whatsoever." As he put it: "The old genius personality, of which Picasso was one, is an anachronism. What Mondrian did was to make a painting which was accessible to everyone—there was a sort of egalitarian ideal. If you look at this painting and say, 'Well, I could do that,' you've got the message."[24]

The work of "teacher-painters" such as Jack Jefferson and Alvin Light tended to gravitate toward the pole of Abstract Expressionism represented by Lobdell. Jefferson, like Still, was a native of the Dakotas who grew up on the great northern prairie. During his student years at the California School of Fine Arts, he was deeply impressed by certain aspects of Still's painting, and his own early works took on some of these attributes: the convulsive, organic forms; the

The Golden Years of Abstract Expressionism

50

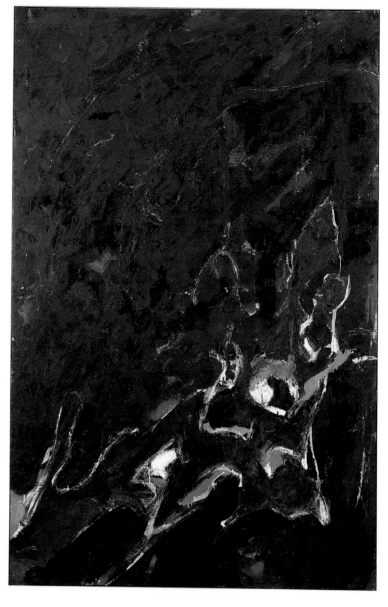

FIG. 44. Jack
Jefferson, *Mission
#20*, 1957. Oil on
canvas, 76″ × 50″.

stark, "sort of anti-color," the "grays and blacks and reds"; the intensity and "fervor" and "willingness to use something really raw and brutal."[25] But in contrast to the relatively few and simple color areas of Still's painting, Jefferson's early works contained dense thickets of dark and shadowy linear forms, overlapping and interlocking, which opened up to hints of deeper space, raked by the barest traces of light. Jefferson's painting in the late 1950s moved from an all-over complexity toward greater simplification, concentrating on what he called "a central image effect," but he did not settle into any specifically identifiable vocabulary of forms (Fig. 44).[26] In the later 1960s and the 1970s, Jefferson concentrated on a body of small, mixed media works-on-paper.

These relied on a more limited repertoire of larger and smaller irregular shapes. Some hinted at geometry (although their edges or corners opened into freer shapes or color areas), others at anatomy. The emphasis, however, was on movement and transformation, of an almost musical kind. Jefferson remained at the Art Institute (the former CSFA) as an instructor through the 1960s and 1970s. His works were exhibited even less frequently than Lobdell's; but his quietly forceful, uncompromising form of Abstract Expressionism, and his determined commitment to pursuing his own path, strongly influenced many younger San Francisco painters.

Alvin Light, after briefly attending the College of the Pacific in his home town of Stockton,

The Golden Years of Abstract Expressionism

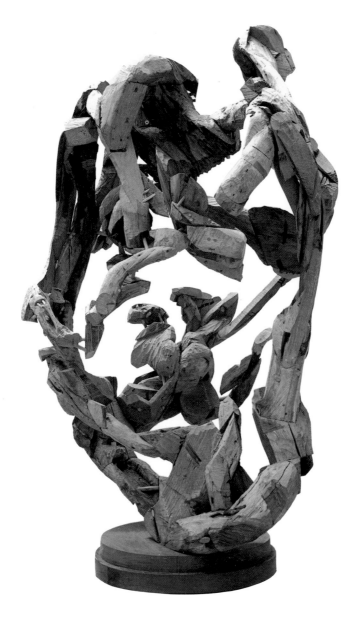

FIG. 45. Alvin Light, *November 1964,* 1964. Wood and pigmented epoxy, 98⅜″ × 59″ × 61⅛″.

enrolled at the California School of Fine Arts in 1951. He spent the rest of his life there, first as a student and then as a teacher (after 1962). As a beginning student, Light painted, primarily in a figurative style, and explored a variety of sculptural materials. These included some of the area's earlier experiments with plastic. By the mid-1950s, Light had settled on the medium of wood. Setting up a studio with Manuel Neri in a cramped basement beneath the Cafe Trieste in North Beach, he developed a kind of three-dimensional translation of Abstract Expressionism. Working with rich natural woods, he chiseled, chipped, notched, hollowed, mortised, and laminated to form massive, rugged chunks, which he then joined together into totemic and monumental sculptures, alive with athletic torsion, thrust, and expansion.

He often added daubs of pigment to the richly textured surfaces left by saw, chisel, and axe. His forms preserved the immediacy and movement of gesture painting, but the feeling conveyed by his heavy, organic shapes was closer to Lobdell's expressionism—solemn, somewhat dour, turned inward. Light was not prolific, and he rarely exhibited, but his work for twenty-five years maintained an extraordinary integrity. His sculpture of the late 1950s and early 1960s most often rose in choppy, angular, but insistently ascending rhythms to form vertical structures that suggested the human figure (see Fig. 45). In the 1970s, his sculpture made somewhat more conspicuous use of found objects (veneer, milled beams) and became more open, closer to the ground and yet less earthbound. All of Light's work was essentially additive, a form of assemblage; but it had the

The Golden Years of Abstract Expressionism

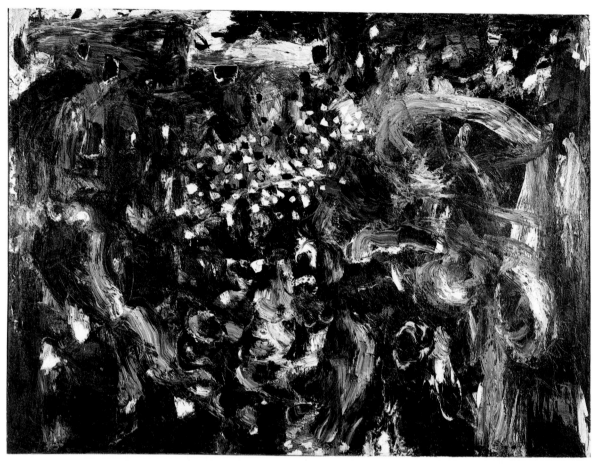

FIG. 46. James Kelly, *Last Days of Dylan Thomas,* 1953. Oil on canvas, 64½" × 87".

tough, intractable unity of objects produced by organic growth and natural forces—rocks, pinnacles, oddly shaped trees.

Other, generally younger painters, most of them students or former students at Fine Arts, inclined more to the action painting exemplified by Hassel Smith. Among the most noteworthy of the action painters were James Kelly, Sonia Gechtoff, Julius Wasserstein, and Deborah Remington. Kelly's specialty was a volcanic gesturalism in which boundless energy was suggested through the accumulation of dense swatches and slabs of color that drove in surging, rhythmic trajectories across his canvases. His better paintings, such as *The Last Days of Dylan Thomas* (Fig. 46), had an almost violent lyricism. Gechtoff's paintings were big, generally vertical canvases filled with cascades and short, quick flurries of thickly ridged brush strokes, most often in monochromes of blacks or browns and off-whites. They evoked a sense of the natural elements, although Gechtoff, like Kelly, frequently gave her

paintings titles that alluded to literary interests (such as *Camus* and *Rules of the Game*). Wasserstein's early paintings inclined toward floating, smoky swirls of dark, inky shapes with thick and juicy surfaces; they took on symbolic implications through titles like *Black Magic*. Remington's early abstractions were dark, shadowy, amorphous spaces in which cryptic shapes seemed to teeter on the verge of definition.

In contrast to such artists as Lobdell, Jefferson, and Light, who remained closely tied to the classroom and studio and thus developed in relative isolation, these action painters tended, like Hassel Smith, to be outgoing and gregarious. Most of them shared an interest in jazz and poetry, and they became part of the nucleus of an artistic underground that was beginning to center in North Beach. Kelly was a bartender at The Place, a tiny tavern at the foot of the hill on Upper Grant Avenue which was operated by two former students from Black Mountain College, Leo Krikorian, a painter and photographer, and Knute

Stiles, a painter who later wrote criticism for *Artforum*. By the mid-1950s The Place had become the central gathering point for the new, anti-establishment Beat poets of San Francisco. Wasserstein and Remington both had their first shows in 1953 at the King Ubu Gallery, which one of these poets, Robert Duncan, had just opened on Fillmore Street near Union, close to the area where many of the Beat artists eventually lived and had their studios.

Many of the Bay Area action painters also became associated with an underground that was beginning to develop in Los Angeles. Its focal point was the Syndell Studio, a freewheeling salon founded by Ben Bartosh, Michael Scoles, Walter Hopps, Jim Newman, Ed Moses, and Craig Kauffman in an old building made of pier pilings in Brentwood. In May of 1955 this group organized an exhibition called Action in the merry-go-round building at the Santa Monica pier, which introduced to the Los Angeles area such painters as Smith, Corbett, Dixon, Madeline Diamond, Wasserstein, Kelly, Gechtoff, Remington, Jay De Feo, Roy De Forest, Fred Martin, Paul Wonner, and William Theo Brown. These and other Bay Area painters later began to exhibit at the Ferus, an adventurous gallery housed in somewhat more conventional quarters on La Cienega Boulevard, which Hopps opened in 1957 in partnership with the sculptor Edward Kienholz.

The general course taken by such painters in the early 1950s formed one of the links between the Abstract Expressionism of the 1940s and the funky art that was to grow out of the Beat era in the last half of the 1950s. In general, the ethical grip loosened in their work, as it did in Smith's. They remained committed to abstraction, at least for the time being. But their work frequently partook of irony, fantasy, and other allusive, if non-figurative, elements that had been alien to the staunchly nonrepresentational and anti-literary stance with which Abstract Expressionism in San Francisco had begun. The "teacher-painters," on the other hand, tended to hold more firmly to the high seriousness (or as their critics saw it, academic caution) that had characterized Bay Area Abstract Expressionism in its youth. (Paradoxically, a great many of these painters—Bischoff, Diebenkorn, and Park among them—gradually moved away from abstraction toward the figure.)

In a category by itself was the painting of James Budd Dixon (Fig. 47). An anomaly in many ways among Abstract Expressionist painters associated with the California School of Fine Arts, Dixon came from a wealthy San Francisco family, and had been something of a playboy in his youth. As a student at the University of California in the 1920s, he had shown talent as an illustrator for various campus publications, working in a style touched by Art Nouveau and German Expressionism. He spent the 1930s working in a Social Realist style, and did not begin to develop a style of his own until after the war, when he enrolled at the California School of Fine Arts under the G.I. Bill. He was then forty-five, four years older than Clyfford Still. Unlike most of his classmates and teachers, Dixon showed little interest in the paintings of Still and Rothko. His inspiration came instead from the early work of Jackson Pollock, which he had seen at Pollock's one-man exhibition at the San Francisco Museum of Art in 1945.

Dixon's earliest mature paintings combined a vigorous calligraphy of pictographs and spirals with thinly applied daubs of intense color. Quite soon, however, his "drawing" dwindled to a few slashing incisions, which were almost submerged in thickly piled encrustations of overlapping skeins, tracks, and mottlings of unmixed paint. Dixon was perhaps the most daring—and most successful—colorist among the first wave of Bay Area Abstract Expressionists. His early abstractions were generally convulsive cacophonies of flaming reds and oranges, icy blues and shrill greens. Their harsh, blistered surfaces and dramatic impact (which was all out of proportion to their relatively small size), combined with their intensity of color and movement, made them an epitome of the raw, "brutal" look associated with West Coast Abstract Expressionism (see Fig. 48). He could also be lyrical and subtle, however, and occasionally one of his ink drawings or small paintings struck a note of exquisite, Oriental delicacy.

Dixon became an instructor at the California School of Fine Arts in 1950, and in the decade that followed, his work continued to evolve. Line, color, and form became increasingly indistinguishable, fusing into rich, all-over tapestries of surging rhythms and sweeping movement. Colors were interlaced with large "clouds" of white and jagged black silhouettes, which in combination seemed to hint at natural shapes refracted by water. The power of the earlier abstractions remained, but it was diffused so as to allow a more reflective feeling. An accelerating drinking problem made Dixon's work sporadic and uneven between the early 1960s and his death in 1967. He had had only two one-man shows during his lifetime, and the first, at the San Francisco

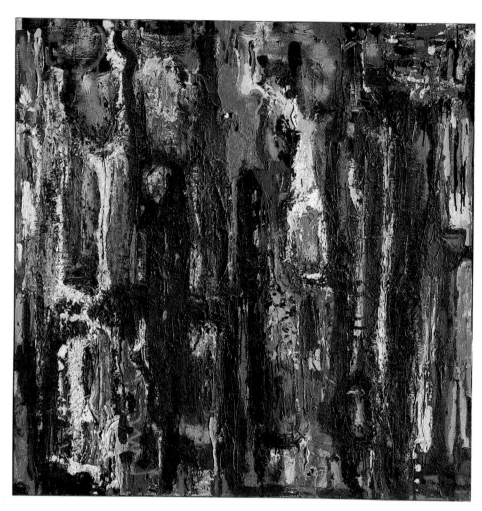

FIG. 48. James Budd
Dixon, *Study in Red and
Green #13,* 1958. Oil on
canvas, 48″ × 48″.

FIG. 47. James Budd
Dixon, 1948.

Museum of Art in 1939, came well before his
mature period. Most of his work passed into the
permanent collection of the Oakland Museum.

As the 1950s progressed, perhaps a majority of
Bay Area painters were influenced by Abstract
Expressionism in one way or another. It some-
times seemed as though every young painter who
had not followed Diebenkorn into figurative
painting was adapting Lobdell's awkward, lum-
bering shapes and thick-skinned surfaces. Even
older painters were affected. Louis Siegriest
adapted the Abstract Expressionist idea of texture-
as-content to his preoccupation with the landscape
of the Southwestern desert, using gypsum, as-
phalt, and other materials to create landscape
abstractions of extraordinary subtlety and richness
(see Fig. 49). And Matthew Barnes, in the
paintings completed during the three or four years
before his death in 1951, created dramatic abstrac-
tions of thick, choppy, swirling brush strokes that
seemed to have been inspired by Pollock.

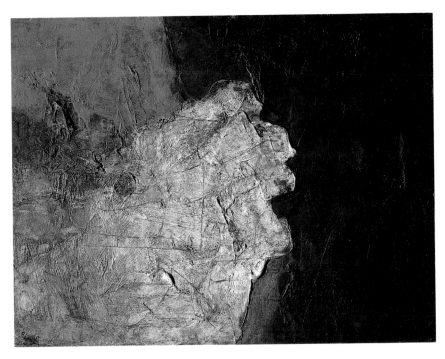

FIG. 49. Louis Siegriest, *Dark Canyon*, 1962. Oil on canvas, 36″ × 48″.

Abstract Expressionism also made inroads among the veteran faculty members at the University of California at Berkeley—at about the same time that many painters at the California School of Fine Arts were turning to more representational painting. "The influences with us," Erle Loran observed, "came principally from Hofmann, de Kooning, and Kline."[27] Loran's own abstraction of the middle and late 1950s was characterized by a heavy, calligraphic black line and a flight-like sense of movement that resembled the abstraction of Marca-Relli. Glenn Wessels's paintings in the 1950s took on a powerful painterly energy, although they remained anchored to landscape—most often, suggestions of tumultuous seas and stormy skies. John Haley moved to a kind of abstraction that emphasized central shapes composed of simple, gestural arabesques and swatches of color; their margins were worked into plain white or light-colored grounds, and the overall effect remotely resembled the early abstraction of Philip Guston.

As cultural phenomenon, Abstract Expressionism had reached its zenith in Bay Area art by the mid-1950s. In college art appreciation classes, Pollock and the New York action painters were presented as the heroic pioneers of the new art. Art history was redefined, so that Rembrandt's late paintings, Turner's seascapes, and even John Singer Sargent's splashily brushed fabrics were reinterpreted as harbingers of the new era, and the work of Raphael, Ingres, and Beardsley was proportionately downgraded. In the terminology of the classic pendulum theory, "painterly" was in and "tactile" (hard edges and distinct forms) was out. Abstract Expressionism was no longer an end to be reached through dedicated rebellion against the constraints of tradition. It had arrived. But having arrived, it quickly became a point of departure, and a new target for revolt. It became known disparagingly as "A.E.," and by the early 1960s the trend was toward more "classical" styles of "post-painterly" abstraction. The pendulum was about to swing again.

As an esthetic phenomenon, however, Abstract Expressionism has remained a significant force in the art of the Bay Area. Its approaches have been pursued with conviction and originality by Frank Lobdell, Jack Jefferson, and several younger painters. Its tough-minded attitude toward the integrity of art and artists and the crucial role of personal commitment has persisted, even among artists who otherwise reject it. And in the 1980s, artists of a new generation, seeking to bring to their painting a renewed sense of energy, vitality, and passionate dedication, are turning to it for inspiration.

The Golden Years of Abstract Expressionism

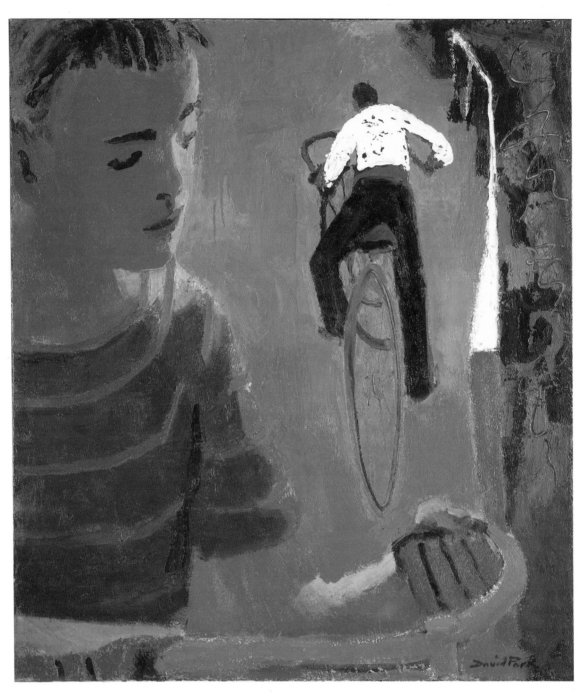

FIG. 50. David Park, *Kids on Bikes,*
1950. Oil on canvas, 48″ × 42″.

Shortly after his 1949 exhibition at the San Francisco Museum of Art (with Smith and Bischoff), David Park gathered up his paintings of the past four years—most of them Abstract Expressionist works—and disposed of them at the city dump. He then completed a painting that startled most of his painter friends. Entitled *Kids on Bikes* (1950), it retained the shrill colors and viscous surfaces that had distinguished his Abstract Expressionist style, but two of the shapes in it—the large one looming out of the left side of the canvas and the smaller one on a radically foreshortened path behind it—were unmistakably kids on bikes (Fig. 50). When Richard Diebenkorn, who was teaching in New Mexico, saw a newspaper reproduction of it, his reaction was, "My God! What's happened to David?" The initial consensus was that Park was retrogressing, that he had "chickened out."[1]

The distinguishing features of the style developed by painters who followed Park's lead—a style that came to dominate Bay Area painting during the 1950s—was described by Paul Mills, the curator of the Oakland Art Museum, in these words: "The bold methods of handling paint, which are a mark of Abstract Expressionism around here . . . are applied to shapes which come from either real or imagined scenes." Mills went on to describe his first encounter with the style: "Elmer Bischoff had a one-man show of figura-

tive paintings at the gallery at the California School of Fine Arts in January of 1956. This was the first time any of these painters had shown an entire gallery of figurative work and the impact was . . . unexpected. Some of the landscapes and seascapes at first looked simply like non-objective action paintings to me. The recognition of subject came as an odd shock. [It was] rather like getting to know a Mozart opera sung in Italian without caring about the meaning of the Italian, and then walking in on a performance of the opera and discovering after a moment that it is in English."[2]

Mills recorded these impressions in his introduction to a catalogue prepared for an exhibition he organized at the Oakland Art Museum a year and a half later, in September of 1957. He also expressed misgivings about whether the work of the twelve artists he had brought together under one rubric—Contemporary Bay Area Figurative Painting—ought to be construed as a "movement." (The twelve were: Park, Bischoff, Richard Diebenkorn, James Weeks, Paul Wonner, William Theo Brown, Walter Snelgrove, Bruce McGaw, Joseph Brooks, Robert Downs, Robert Qualters, and Henry Villierme.) But his hesitation was not shared. For three or four years in the late 1950s, local followers of the arts swelled with the provincial pride of discovering that the Bay Area had finally given birth to its own home-grown—and nationally recognized—regional "school."

To many Abstract Expressionists, particularly the action painters, this "return to nature" represented a conservative retreat, and in a sense it was. Whereas European painting in general, and French painting in particular, had been looked down upon in the iconoclastic atmosphere that prevailed at the California School of Fine Arts during the late 1940s, in the 1950s painters like Richard Diebenkorn and Elmer Bischoff openly expressed their admiration for Degas, Toulouse-Lautrec, and Edvard Munch—all of whom were given important local exhibitions in the early years of the decade. There was intense interest in Matisse, Bonnard and Vuillard were looked at afresh, and Old Masters like Velázquez, Rembrandt, and Titian were being re-examined. Painters were also rediscovering such then obscure or forgotten artists as Giorgio Morandi, Balthus, Joaquin Sarolla, and Fattori and other Italian Impressionists of the Macchiaioli School. The paintings of Alberto Giacometti and Francis Bacon were a more contemporary influence, as were the *Woman* paintings that de Kooning had begun about the same time Park painted *Kids on Bikes*. Life drawing once again became a central discipline for certain local artists, who met regularly once or twice a week to work from models. Absolute originality of expression was no longer an overriding goal among these painters. Unlike the artists who had rallied around Still just a few years earlier, these artists were not inclined to think of their work as a kind of time bomb about to detonate a worldwide cultural revolution. "Good painting" (although the standards had dramatically changed) became honorable again.

In further contrast to Abstract Expressionism, Bay Area Figurative painting—or new realism, as it was sometimes called—was quickly accepted by the art-conscious public, which was happy to welcome a new style that could be understood in terms of recognizable images. Although by 1950 Abstract Expressionism had been accepted by most painters, it was still greeted with a measure of hostility and ridicule from the public. By contrast, David Park's *Kids on Bikes* (Fig. 50, p. 56), generally considered the very first Bay Area Figurative painting, won first prize in the 1951 San Francisco Art Association's annual show, a year after it was painted.

Art always grows out of attitudes that are shaped not only by art history but by the more general cultural and political currents of the times, even as the finest works of art ultimately manage to transcend them. As the art of the 1930s reflected the Depression and American political isolationism, and early Abstract Expressionism had mir-

rored the restless energy of the immediate postwar years, the development of Bay Area Figurative painting in the early 1950s coincided with a new mood of conservatism generally. When Eisenhower was elected President in 1952, the "Give 'em hell" spirit of the Truman administration gave way to a genial, paternal style of leadership well-suited to a decade of success-oriented conformity, symbolized by the man in the gray flannel suit. As the nation increasingly aligned itself against all forces of political and social change, the moral leadership it had briefly enjoyed after World War II dissipated, and initiative in the Cold War passed to the Soviet Union. The idealistic fervor that characterized the restless postwar years gave way to a more cautious and passive humanism. Nietzschean nihilism and Sartre's edgy existentialism yielded to the more sentimental, moralizing philosophical perspective of Camus. Zen Buddhism, with its emphasis on acquiescence and openness, attained greater popularity, in large part through the translations and commentaries of Allan Watts, who shared a houseboat with Jean Varda in Sausalito. In jazz, the rebellious spirit of be-bop gave way, at least for a time, to the cerebrations of "cool" musicians like Dave Brubeck and Paul Desmond, who launched their professional careers in San Francisco. The young actor James Dean, portraying the sullen but sensitive existential man in pitched battle against inhumane establishment values, may have founded a dynasty of rebel images that captured the imagination of successive generations of American youth. But the heroes of mainstream America were show business personalities like Milton Berle and Arthur Godfrey, who conformed to the bland, fatherly pattern of the president, and reached vast audiences through the quickly growing television industry.

This conservative trend was reflected in developments at the Bay Area's two major art schools. The California School of Fine Arts in San Francisco, like the Art Students League in New York, had never before concerned itself with academic credits or degrees. But during Ernest Mundt's directorship, it was formally recognized by the Western College Association and authorized to grant a Bachelor of Fine Arts degree. In the spring of 1955, following a major financial crisis, Mundt was himself swept out of office and replaced by Gurdon Woods, a sculptor who had previously been director of the art department of the private Town School for Boys. Woods hired such artist-teachers as Elmer Bischoff (1956) and Frank Lobdell (1957), but he also increased the school's emphasis on teacher training and applied art courses, and in 1956 he

instituted a graduate program. In 1960 the name of the school was changed to San Francisco Art Institute (SFAI). Across the bay in Oakland, the California College of Arts and Crafts had always been geared more toward preparing students for professional careers, and had traditionally drawn a relatively conservative student body and faculty. In the late 1950s, abetted by the various crises that shook the California School of Fine Arts, it became the gravitational center for the "revival" of figurative painting, as the California School of Fine Arts had been the cradle of Abstract Expressionism a decade earlier.

Yet Bay Area Figurative painting was not simply a counterrevolution against Abstract Expressionism; it was a genuine extension of it. Like the "second-wave" New York gesture painters who gathered around de Kooning, painters in the Bay Area were restive under what they felt to be the limitations of Abstract Expressionism. Its emphasis on the personal freedom of the artist led them to be interested in the possibilities of what the critic Louis Finkelstein called "polyreferential-ness" (another term for what others condemned as eclecticism).[3] For them, Abstract Expressionism suggested ways of expanding the range of imagery and implication, rather than constricting it through the kind of pictorial reduction that Still, Rothko, Newman, and (to a lesser degree) Pollock had come to stand for. Furthermore, even at the peak of its popularity, abstraction as a style had always been forced to contend with the Bay Region's traditionally strong sense of place. Artists like James Weeks had persisted in painting convincingly in a figurative style all through the Still-Rothko years at the California School of Fine Arts—within its very walls, in fact. Weeks described the Bay Area Figurative "movement" as a "Hegelian third state." It was a "reaction against the reaction. Subject matter got so it dominated painting to such a degree that there was no painting left. Then everybody . . . went overboard on the abstract side."[4] "Figurative painting can incorporate so many ideas that it sort of includes abstract painting."[5]

Picasso became a model again—though in a different way—for young painters like Joan Brown, who felt that her work could have internal consistency without being confined to a particular style or medium. "I respond to Picasso," she said, "because he wasn't worried about 'style' as a definition of his ego. He didn't need to be an 'abstract painter' or a 'still-life painter' or a 'portrait painter'—he did whatever he pleased, setting his own rules and breaking them just as soon as he made them."[6]

For David Park (Fig. 51), the acceptance of external subject matter brought new freedom: "I could paint with more absorption, with a certain enthusiasm for the subject which would allow some of the esthetic qualities, such as color and composition, to evolve more naturally. With subjects . . . I feel a natural development of the painting rather than a formal one." Park also felt there was no sharp division between figurative painting and abstraction. "The line between non-objective painting and figurative painting is no different than the line between still life and portrait painting," he said. "And I don't think there is any idea of 'progress' involved, [even though] some painters talk as though progress was a kind of duty, and that non-objective or some other kind of painting is 'progressive.' I think concepts of progress in painting are rather foolish."[7]

Although these painters ransacked both art history and everyday life for sources, with a rapacity that scandalized more orthodox Abstract Expressionists, they retained the ethos of struggle and self-discovery. Painting remained an essentially moral enterprise—"hard-bought," in Park's words, and not "easily come by."[8] The sense of privation and difficulty was emphasized by the use of pigments that were often closer to house paint than to Winsor-Newton, and by the use of crude, home-made stretcher bars. There was a disdain for effects that sought to please. "The complexity of yourself being poured into the painting is the issue," Bischoff said.[9] "Art ought to be a troublesome thing," said Park, "and one of the reasons for painting representationally is that this makes for much more troublesome pictures."[10]

During his Abstract Expressionist period, Park had shocked Richard Diebenkorn and other colleagues with his "terribly excessive" use of paint—common house paint in cans.[11] This approach to the medium, and the practice of letting his forms grow out of his material, carried over into his first figurative paintings. So did the structural use of color that Abstract Expressionism had helped him to develop ("I think you can make a thing any shape and size and put it any place in the painting if you make it work in color," he once told Bischoff).[12] On the other hand, Park mounted a deliberate assault against the inviolability of the "picture plane"—most often by pulling part of a figure radically forward along the canvas edge, and opposing to it a diagonal line (a fence, a trombone, the oar of a boat) that careens back into the picture. (Paul Mills suggests a parodistic intent in Park's exaggerated use of "thin slivers" of figurative shapes along the edges of such early 1950s pictures as

FIG. 51. David Park, 1956.

FIG. 52. David Park, *Cellist,* 1959.
Oil on canvas, *56″ × 56″.*

Rehearsal. They were, he writes, "knowing, very witty, and very ruthless" imitations of Still's manner of using edges to create the "expanded or exploded" space that had become a hallmark of the school's Abstract Expressionist style.)[13] Park also eliminated horizon and ground lines. "The background of the painting is often simultaneously floor, wall, sky, and then suddenly just the flat paint surface," Mills pointed out. "This . . . so weakens the orthodox structural architecture of figurative space that most of his shapes become a vague, changeable substance which is thing, space, and surface all at once."[14]

High among Park's historical enthusiasms were the frescoes of Piero della Francesca. Their strong, nearly abstract shapes created by overlapping parts of one figure with those of another, together with his own earlier experiments with interlocking "positive" and "negative" shapes, contributed to the development of what Mills called "mosaic composition" and Diebenkorn saw as "a kind of fabric of persons." According to Mills, Park's compositions, "as eccentric as they are at times, are as tight as a typesetter's locked form of type. Because of this rigid control, these paintings were able to contain a far greater saturation of iconoclastic and contradictory elements than would otherwise have been possible."[15]

Park applied his new approach primarily to the themes he had treated most often in his figurative paintings of the 1930s—generally, groups of people engaged in unremarkable collective activity, such as walking along the street or playing music together. The figures in these groupings seem psychologically distant from one another, withdrawn into a realm of introspection; placed as they are within broad areas of freely brushed, heavily textured paint, they occupy an ambiguous world between abstraction and everyday reality that borders on the surreal.

Park's "iconoclasm" may have been the source of some of the problems that haunt his early figurative works, and a few of the later ones as well. Whether deliberately or because of a more fundamental contradiction in his effort to reconcile abstraction and figuration, he often became somewhat too explicit in articulating certain details—facial features, pinstripe shirt patterns, perhaps only an eyebrow or a hair style. This tendency was sometimes coupled with an irresolution in the treatment of space, so that a tapestry of otherwise flat and tensely interlocking color patches suddenly faltered into mushy areas sharply punctured by semi-volumetric forms.

These early paintings were completed during Park's last two years of teaching at the California



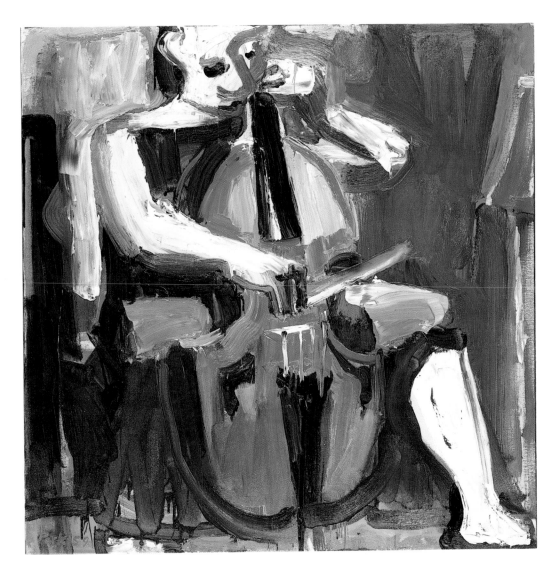

School of Fine Arts. After resigning, along with Elmer Bischoff, when Hassel Smith was dropped from the school's faculty, he tried his hand at various odd jobs and then settled into painting full time in the living room of the cramped Berkeley quarters that he shared with his wife Lydia. In 1955 he joined the art department at the University of California and the next year bought a house in the Berkeley hills, where a converted attic became his studio. Park remained active as a teacher until 1959, when he underwent disc surgery to alleviate a chronic back pain. A second operation in February of 1960 led to a diagnosis of terminal cancer, and he died that September.

By the mid-1950s Park was coming to grips seriously with the possibilities and problems raised in his earlier paintings. Color and light were freed from the claustrophobic spaces of his earlier "mosaic" compositions; they became shimmering, palpable atmospheres through which the figures moved and breathed. From his earlier suggestions of genre, Park moved to more generalized paintings with such self-descriptive titles as *Woman in Landscape, Standing Couple,* and *Four Men* (see frontispiece). References to narrative or action were eliminated, along with any sense of extra-visual relationships among the figures, or between the figures and their surroundings; they became forms organized in space. Finally, somewhat as de Kooning had a few years earlier, Park liberated gesture, using light, color, and heavy brushloads of paint to sculpt the massive, rough-hewn figures that dominated his last paintings (see Fig. 52). Park spent his final months, when he had become too weak to work in oil any longer, doing incisive little figure sketches on small sheets of paper with ink sticks and gouache. They formed poignant punctuation marks to a sadly abbreviated career.

Park's horror of fencing himself in gave his art a restless, unresolved character; often, a single

painting was a battleground of triumphs and reverses, of bold invention and hesitation. His attempt to forge a new figurative art from the slags of Abstract Expressionism opened up challenges enough to occupy artists in the Bay Area and elsewhere for years to come; Park, with only a decade left, could tackle but a few of them. His audacious "failures," however, were stronger than many of the less ambitious "successes" that were to follow.

Elmer Bischoff, who was strongly influenced by his friendship with Park, began his transition from abstraction to figurative painting at about the time he resigned his teaching post at the California School of Fine Arts in 1952. "The thing was playing itself dry," he has said of Abstract Expressionism. "I can only compare it to the end of a love affair. When I was in the real grips of Abstract Expressionism, the marks and gestures had a hyper-existence. But it was your own passion that inflamed these things, and there was just a gradual loss of this passion."[16]

Bischoff took part-time work driving a truck for Railway Express and devoted the next year and a half to building a new foundation for his art. Because he was relatively inexperienced with figure drawing ("the training at Cal was pretty formalist; there was a kind of fear of drawing the figure from observation"), he practiced sketching during lunch hours, parking his truck outside a cafeteria where he could view diners through the windows.

In the fall of 1953, he moved to Marysville to become an instructor at Yuba College, where he taught until 1956. Living in a duplex, he rigged up a studio in its two-car garage and began painting there each day at 4 A.M. ("I knew I'd never get out of Marysville if I didn't paint my way out.")[17]

Following his dramatic one-man show at the California School of Fine Arts early in 1956, Bischoff returned to CSFA that fall to set up a new graduate program; he became its chairman, and one of the school's most influential teachers. (See Fig. 53.) He lived and painted nearby in the historic Montgomery Block building until it was condemned and razed in 1959, to make way for the pyramidal Transamerica Building. A *Chronicle* reporter who interviewed Bischoff there early in 1959, on the occasion of his receiving a Ford Foundation grant of ten thousand dollars, found him living alone in a "tiny studio" furnished with only a cot, a small telephone table, and a dresser covered with small, half-pint cans of paint— because tubes were "too expensive."[18] Later that year, Bischoff moved to a spacious studio on

FIG. 53. Elmer Bischoff in the early sixties.

Shattuck Avenue in Berkeley (where he continued to work into the 1980s), and in 1963 he joined the faculty at the University of California at Berkeley.

Bischoff's paintings moved at a slower tempo than Park's. And in contrast to Park's paintings, Bischoff's early figurative works leaned more to an abstract *impressionism,* emphasizing an almost atmospheric sense of space. The richly orchestrated colors and lush impastos were shot through with a softening light, luminous, pearl-gray overcast evocative of the Bay Area landscape on a foggy day. Light and color were paramount "as expressive content and also as organizational elements," Bischoff has said. "I guess this could represent some kind of rebellion against my early schooling, where 'organization' of a painting was always seen as an organization of contours, a continuity and relatedness of edges. But to me it was always painters like Rembrandt and Titian who exerted a positive attraction. In their work it doesn't matter where you place things in the picture. Color and light are the primary organization forces."[19]

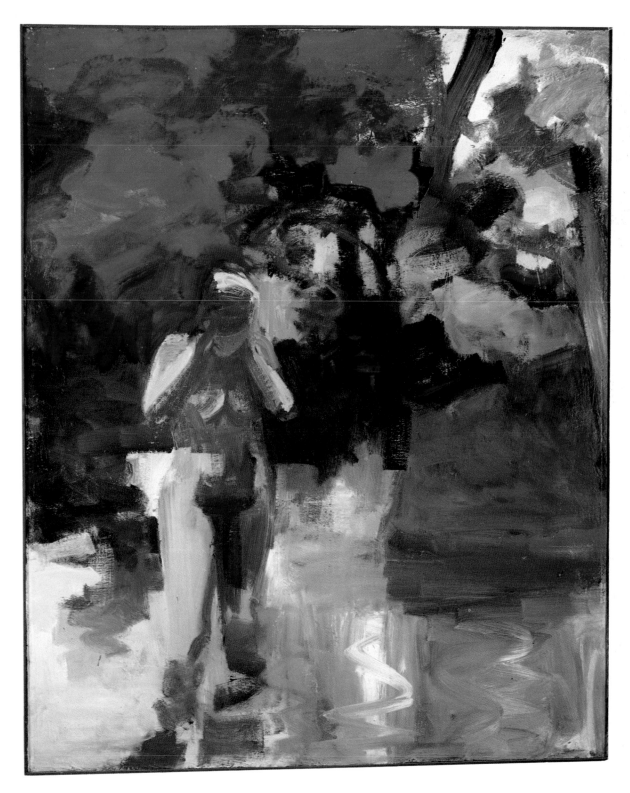

FIG. 54. Elmer Bischoff, *Girl
Wading*, 1959. Oil on canvas, 82⅝″
× 67¾″.

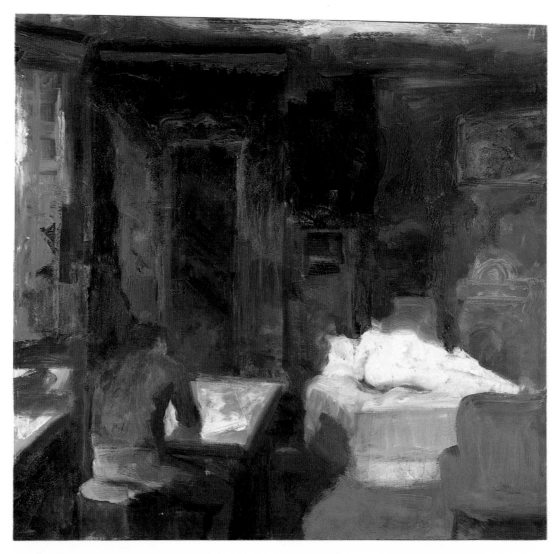

FIG. 55. Elmer Bischoff, *Red Fireplace,* 1970. Oil on canvas, 80″ × 84½″.

Figurative and natural imagery also seemed to assume somewhat greater importance for Bischoff than they did for Park—not in a narrative or anecdotal sense, but as part of a complex dialogue between formal and expressive qualities. Bischoff's earliest figurative paintings usually concentrated on commonplace images—persons in rooms, on streets, sitting motionless, reading in bed—and sometimes remotely suggested Edward Hopper in their somber poetry of place and mood. As in Park's paintings—indeed, as in the work of most of the new figurative painters—the figures seemed withdrawn, isolated, self-absorbed. But Bischoff's figures, more often than Park's, were solitary; they seemed to commune more closely with their surroundings. (See Fig. 54.)

In his paintings of the late 1950s, Bischoff turned away from relatively individualized figures and settings to more generalized themes, occasionally drawn from classical mythology (although in the late 1960s he frequently returned to Hopperesque figures in interiors). (See Fig. 55.) As the 1960s advanced, Bischoff's surfaces thinned out. Paint was applied in mottlings, forming dappled shadows that enveloped interiors occupied by impassive, expressionless figures. Although often immense in scale, these paintings conveyed an intimate feeling that sometimes recalled Vuillard. Bischoff pursued figurative painting into the 1970s, but Park's death in 1960, and the departure of Diebenkorn and James Weeks for teaching jobs elsewhere in the country, made his position an increasingly isolated one.

In 1973 Bischoff resumed abstract painting, in a manner quite different from both his earlier abstraction and his subsequent figurative work,

although it retained links with both. Moving from oil to acrylic, generally emphasizing grounds of veiled off-whites or light grays, he developed a vocabulary of idiosyncratic, energetically angular color shapes. Some were weighty and organic, recalling Frank Lobdell's early abstractions. Others were more gestural, almost playful, coupled with a slicing calligraphy that recalled Hassel Smith's earlier painting. Their movement was often built around a vestigial grid structure carried over from the mainstream abstraction of the 1960s. They seemed to represent an attempt to recapture the exuberance and exaltation of Abstract Expressionist painting in its youth, in terms that would be relevant three decades later. Perhaps for this very reason they often projected a sense of futility beneath the surface effects of calculated sound and fury.

Richard Diebenkorn (Fig. 56), the painter who became the best-known representative of the Bay Area Figurative "school," was a relative latecomer to it. Matisse (in addition to Hopper) had made a particularly strong impression on him during his undergraduate years at Stanford, where Daniel Mendelowitz, one of his teachers, took students to lunch at the Palo Alto home of Michael and Sarah Stein, where they could view a private collection of Matisses, Picassos, and Cézannes. Diebenkorn later devoted more time to studying the Matisses, Picassos, Braques, and Bonnards in the Phillips Collection when he was assigned to a base near Washington, D.C., after enlisting in the Marine Corps Officers Training Program in 1943. Maurice Tuchman has noted that Matisse's *The Studio, Quai St. Michel* of 1916 at the Phillips affected Diebenkorn "continuously during the next two decades" with its "candid way" of exposing the "painting process" and "the emphatic contrast between indoor space and outdoor space . . . which allows a painter to emphasize the tangibility of space and evanescence of light."[20]

These early interests in figurative painting—and in Cubism—never receded far from the surface during the last years of the 1940s, when Diebenkorn embarked on a course of abstraction related to Still and Rothko. They became even more prominent after he left the California School of Fine Arts in 1950 to spend two years as a graduate student at the University of New Mexico in Albuquerque. Fragmentary, elusive, sometimes humorous suggestions of images now appeared in his abstractions. There were allusions to pigs and other farm animals (Diebenkorn lived on a ranch during much of this time); erotic anatomical shapes; lettering; variations on the whimsical

FIG. 56. Richard Diebenkorn, *Self Portrait,* 1980. Dry point, 4¹⁵⁄₁₆″ × 4″.

backdrops of George Herriman's Krazy Kat comics (of which Diebenkorn had an anthology). Equally persistent in these improvisatory abstractions was a formal though flexible ordering of geometric planes in an ambiguous space. Diebenkorn banned blue from his palette during most of this period to avoid its connotations of representational space. But these tawny, luminously atmospheric paintings nonetheless suggest the desert, seen in aerial perspective. By the time he and his wife returned to the Bay Area at the end of 1953, Diebenkorn's painting was evolving, gradually but decidedly, toward distinctly representational images.

The transition accelerated in the *Berkeley* paintings, which Diebenkorn completed between the fall of 1953 and 1955 (a Rosenberg Fellowship enabled him to work full-time during these years). He worked at a home in the Berkeley hills, overlooking San Francisco Bay and the lowlands bordering the eastern shoreline. Returning to strong, vivid colors—emphasizing tart, acidulous greens, hot, dry salmons, and deep, full-bodied blues—Diebenkorn built up rich, juicy paint surfaces. They were arranged in loose but well-defined color planes that plunged diagonally into space, setting up an acute "bird's-eye" perspective. The strongest of these paintings achieved an extraordinary balance between abstraction and dizzying panoramas of natural landscape. (See Fig. 57.)

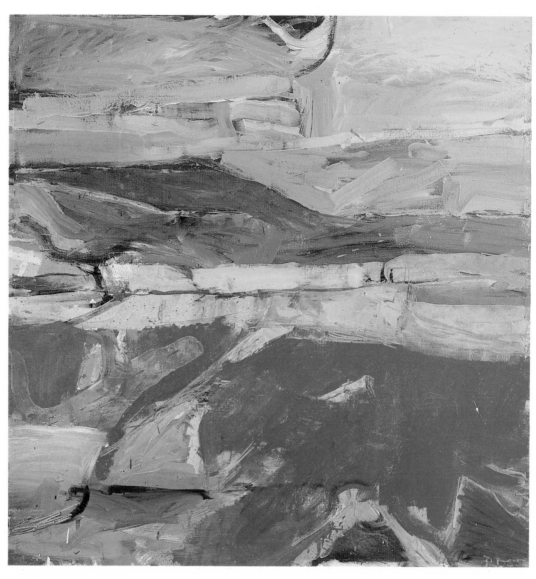

FIG. 57. Richard Diebenkorn,
Berkeley #32, 1955. Oil on canvas,
59" × 57".

The transformation was completed one day in the summer of 1955 when Diebenkorn chose a small canvas and began to paint "a messy still life" of some objects lying around his studio.[21] He continued for some time to exhibit abstract paintings, but in his studio he pushed forward to paintings in which the figure itself finally appeared—usually, it was locked into compact geometric structures that combined shallow, enclosed spaces (porches, terraces, interiors with windows) and suggestions of distant landscape. Diebenkorn explained his move away from abstraction in terms of a growing suspicion about its often flamboyant emotionalism: "I came to mistrust my desire to explode the picture and supercharge it in some way. I think what is more important is a feeling of strength in reserve—tension beneath calm. I don't want to be less violent or discordant or less shocking than before, but I think I can make my paintings more powerful this way."[22]

The solitary human forms that occupied most of Diebenkorn's figurative works were handled almost as architectural elements. (See Fig. 58.) Yet they also projected naggingly disturbing, expressive overtones—as did his paintings of empty interiors or landscapes. "There is this separation of environment and man," he said, "a separation I

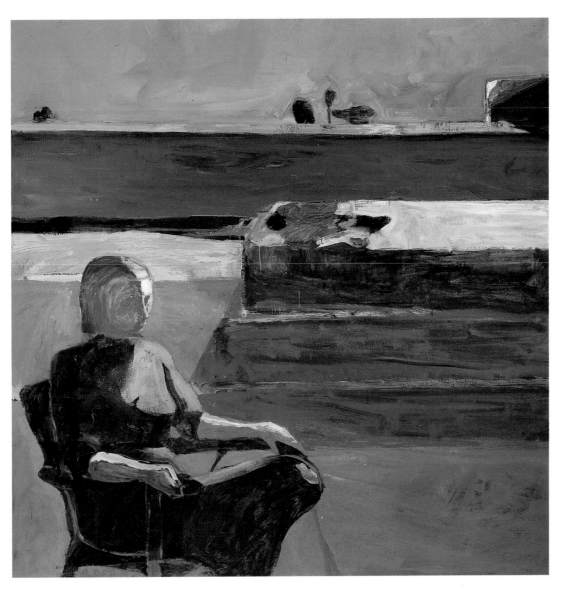

FIG. 58. Richard Diebenkorn,
Woman on Porch, 1958. Oil on
canvas, 72″ × 72″.

guess I want to deal with."[23] Like de Kooning's figurative paintings, Diebenkorn's were often the outgrowth of laborious trial and error, and a sort of record of the process remained visible in pentimenti—erasures and corrections—on the finished painting. However, in Diebenkorn's work these characteristics of action painting were coupled with a sober restraint—and frequently a sense of caution.

Many who had been shocked by what seemed to be Diebenkorn's sudden switch from abstraction to figurative painting were surprised all over again by the development of his painting in the late 1960s. In 1965 he traveled to the Soviet Union

as a guest of the Soviet Artists' Congress, and in the paintings he completed after his return to Berkeley—inspired primarily by his impressions of Matisse's paintings in The Hermitage—he adopted a severe, almost geometrically abstract schematization. In 1966, after leaving for Southern California to join the art department at UCLA and setting up a studio in a section of Santa Monica named after a nearby amusement park, Diebenkorn embarked on his *Ocean Park* series. On the surface, these new paintings appeared to represent a return to out-and-out abstraction. Actually, the line between abstraction and "realism" had been very thin in all of Diebenkorn's figurative paint-

The Bay Area Figurative School

FIG. 59. James Weeks, *Sheep Heads #1,* 1949. Oil on canvas, 34″ × 48″.

ings of the late 1950s and early 1960s, a fact that made them generally less persuasive than the figurative work of Park and Bischoff.

James Weeks, the fourth principal "first-generation" Bay Area Figurative painter, was the son of Anson Weeks, the leader of a fashionable ballroom orchestra at the Mark Hopkins hotel. He was a close friend of the members of Dave Brubeck's octet (which included his brother, Jack Weeks) when they were among the first men to study at Mills College under Darius Milhaud in the middle 1940s. Musicians became one of the persistent themes of Weeks's paintings.

Weeks studied at the California School of Fine Arts from 1940 to 1942 with William Gaw, and began to teach there part-time in 1948. Although the expressionist textures popular among abstract painters at the school appeared in his early paintings, he remained committed—without rejecting the value of abstraction—to figurative painting. Matisse—whose work he had seen close-at-hand at Michael and Sarah Stein's house in Palo Alto—remained a paramount inspiration. He admired Munch, Beckmann, and Gorky, as well as the figurative elements of Rothko's early paintings, and he was drawn to Japanese prints as "an alternative to Western drawing."[24] Through Gaw, he had also become well acquainted with the figure painting that had been practiced in the Bay Area in the 1930s—the dramatic compositions of Maynard Dixon, for example, which appeared to influence the formal organization of some of Weeks's paintings.

Paintings such as *Sheep Heads* (1949)—the subject was inspired by Weeks's part-time work in a slaughterhouse—focused on simple images concentrated into massive, interlocking shapes crowded into relatively small dimensions; they retained a Cubist approach, in which overlapping planes receded into shallow space. (See Fig. 59.) After spending the summer of 1951 studying mural painting at the Escuela de Pintura y Escultura in Mexico City (and then working as a sign painter for Foster and Kleiser), Weeks turned to big still-life arrangements in which bold, roughly painted color areas were knit together by heavy black outlines and free-floating arabesques—a blunt, clangorous homage to Matisse. In certain paintings, such as *Woman Seated in Park* (1953), he approached an almost gestural abstraction, but by the later 1950s he had pulled back from suggestions of cyclonic energy to a monumentalizing formal simplicity. Some of the paintings from these years expanded almost to billboard dimensions: a canvas nearly eight feet square (*Jazz Band*) was included in the Contemporary Bay Area Figurative Painting Show, and Paul Mills saw others as large as twelve and fourteen feet in Weeks's studio.[25] These paintings were built around dramatic, cacophonous juxtapositions of color, in which areas of very close gradations collided with areas of violent intensity. The figures were constructed of blunt, tightly interlocking slashes of these colors, and their advancing and receding properties created a semblance of three-dimensional space that dissolved at various junctures to fuse with the flat surface of the canvas. (See Fig. 60.)

Weeks was given an Abraham Rosenberg Fellowship in 1952; his first one-man show at the

FIG. 60. James Weeks, *Two Musicians,* 1960. Oil on canvas, 83½" × 66".

FIG. 61. Paul Wonner, *Imaginary Still Life with Slice of Cheese,* 1977. Acrylic on canvas, 70″ × 48″.

Labaudt Gallery in 1951 was followed by exhibitions at the Legion of Honor in 1953 and at the new Six Gallery in 1955. But the middle and late 1950s were a troubled time for him. He destroyed the paintings he had exhibited in the 1957 exhibition at the Oakland Museum, as well as some of his other more heroically scaled work.

In 1962 Weeks turned for the first time to landscape, in which he sought an abstract clarity of form. In general, his paintings of the 1960s seemed to revolve around the fundamental problem of trying to reconcile Matisse with Cézanne— to balance color with form, and broadly patterned

surfaces with more clearly articulated volume and space. The clarity and articulation in his paintings became increasingly refined as the 1960s progressed—a development that received added impetus in 1966, when he switched from oil to acrylic and began to emphasize transparency and a golden, glowing light. There was a corresponding loss of immediacy. Most of Weeks's paintings since the late 1960s have been worked on over several years.

Weeks moved to Los Angeles in 1967 to join Diebenkorn on the faculty at UCLA. In 1970 he moved to Massachusetts and spent the 1970s as an

associate professor at Boston University. His paintings of the past decade have alternated between landscape and figurative groups, the latter generally chamber musicians rehearsing in cloistered rooms; the mood has been serene, elegiac, classical, and soft-spoken, frequently to the point of blandness.

Among the other participants in the Oakland Museum's 1957 exhibition entitled Contemporary Bay Area Figurative Painting, the most widely known is Paul Wonner. A student at the California College of Arts and Crafts in the early 1940s, and later at U.C. Berkeley, Wonner had never been an Abstract Expressionist and was somewhat hostile to the movement. He worked in a spontaneous figurative style that owed much of its liveliness to the origin of his paintings in sketches, the animation of which they preserved. In theme as well as in style, his painting often projected a light, gently humorous fantasy. A use of emphatic whites (which seem to look ahead to the early paintings of Wayne Thiebaud) gave a cold brilliance to his color, a sense of detachment to his objects. Wonner's paintings of the late 1970s became more crisply literal, frequently to the point of trompe l'oeil. They focused with a brittle clarity on table tops littered with still-life objects, rendered with surreal and allegorical touches and allusions to art-historical sources: postcards and appointment books, for example, bearing reproductions of Old Master paintings, particularly still-life paintings (Fig. 61). Viewed individually, Wonner's better paintings were cooly provocative; seen together, they suggested formula.

The new figurative style spread rapidly among Bay Area painters, in part because of the teaching activities of its major practitioners. In addition to Park's and Bischoff's instruction at U.C. Berkeley and the California School of Fine Arts, Diebenkorn taught at the California College of Arts and Crafts in Oakland and Weeks taught for various periods at both the San Francisco and the Oakland schools. The movement was also strengthened by a dramatic flurry of national attention that focused on the more prominent Bay Area Figurative painters for five or six years after the Oakland Museum exhibition in 1957. Diebenkorn's first exhibition at the Poindexter Gallery in New York in 1958 received critical praise, and three color reproductions, in *Time*.[26] A year earlier, *Art News* had already called attention to his work in an illustrated article by Herschel Chipp, "Diebenkorn Paints a Picture."[27] In 1959, Diebenkorn and Nathan Oliveira were included in the New Images of Man exhibition organized by Peter Selz for the Museum of Modern Art in New York, where they joined such artists as Giacometti and Bacon, Pollock and de Kooning. By 1960, Park, Bischoff, Diebenkorn, and Weeks were all represented in major New York galleries. And by 1962, the national news magazines *Time* and *Life,* traditionally hostile to anything that smacked of innovation in art, were pointing with enthusiasm to the new "movement," in articles with titles like "The Human Figure Returns in Separate Ways and Places" (*Life,* June 8, 1962) and "Up from Goopiness" (*Time,* April 27, 1962).

The rapid rise and acceptance of the Figurative "school" opened the door for a resurgence of representational painting in general; figure, landscape, and still life became increasingly familiar sights in Bay Area painting during the late 1950s. Figurative painters whose styles and attitudes had little or no relationship to those of painters like Park, Bischoff, Diebenkorn, and Weeks were sometimes indiscriminately brought together under the Bay Area Figurative umbrella. (Ralph Borge, for example, a teacher at the California College of Arts and Crafts who specialized in meticulous Surrealist pictures of an Andrew Wyeth variety, was included in a national news magazine article on the Bay Area Figurative "school.")

Of the younger artists who gravitated into the orbit of the Bay Area figurative style, the most important in the years ahead was a sculptor, Manuel Neri. Born in 1930 in Sanger, an agricultural town near Fresno, Neri grew up in the San Joaquin and San Fernando valleys, where his parents worked as farm laborers. While making up requirements at San Francisco City College so he could enter the University of California, where he planned to study engineering, Neri enrolled in a class in ceramics. This soon brought him into contact with Peter Voulkos, who was doing graduate work at the California College of Arts and Crafts in 1951–1952, after his graduation from Montana State University at Bozeman. Neri followed Voulkos to Helena in the summer of 1953 to work with him in the ceramics workshop Voulkos had recently established for the Bray Foundation. The influence Voulkos exerted on him, Neri recalled, was principally one of attitude—the way "he forced himself onto the material, completely imposed himself on it, instead of taking that kind of sacred approach toward ceramics that most people did."[28]

After serving two years in the army, Neri returned to the California College of Arts and Crafts in 1955. While studying sculpture and

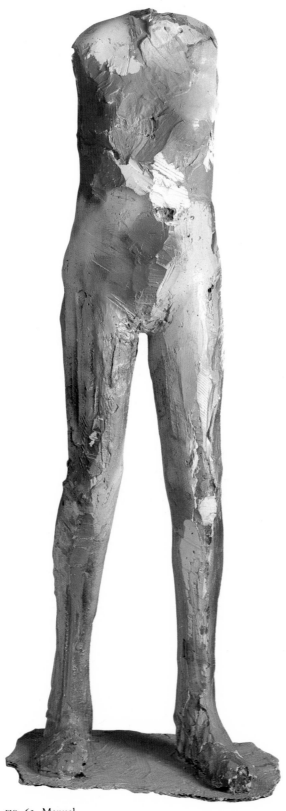

FIG. 62. Manuel
Neri, *Untitled*, 1959.
Plaster with enamel,
60″ × 22″ × 13½″.

painting at CCAC, he was inspired by a plaster sculpture with which Jay De Feo had been experimenting, and soon abandoned ceramics for plaster. He also explored a wild array of other materials, and generally painted their surfaces in patches of bright color—a conscious bow, he has said, to the painted sculpture of Marini and Picasso. These early sculptures, rugged pillars that sometimes towered six or seven feet high, often took abstract forms. But they also retained a strong foundation in the structure of the human figure, reduced to spare, bone-like trunks that supported simple, Cubistic planes and masses. By 1957 such experiments with unorthodox materials led to an invitation to leave the California College of Arts and Crafts, and so Neri transferred to the California School of Fine Arts, primarily in order to study with Elmer Bischoff.

In San Francisco Neri shared Alvin Light's basement studio in North Beach. There he found the freedom of the locale's new bohemian underground conducive to his enthusiasm for working with more than a single medium, and for exploring materials that had traditionally been off-limits to serious art. With the painter Joan Brown (to whom he was married between 1962 and 1966) Neri was active in The Six Gallery, where shows sometimes consisted of little more than the opening night party.

"The whole funk idea was to look into new ideas and new materials. Schools satisfied no one," Neri said. "We treated everything equally—painting, drawing, sculpture, everything was important. The same thing with junk. A lot of people used house paint. No one worried much if some of it fell off. . . . We were influenced by the figurative painters—they were our teachers. A lot of the funk thing also arose from a strange kind of misinterpretation of what was happening in New York. We'd look at those little black-and-white reproductions of de Kooning in the magazines, and we'd think that he was using really wild, crazy colors and sloshing them on in big, thick layers. So we started painting right out of the can and building up surfaces a half-inch thick. Finally, some original de Koonings were exhibited at one of the museums. Most of us were really disappointed—the paint was so thin, and the color was really dead. But the misinterpretation was a good thing."[29]

As Alvin Light had developed a form of Abstract Expressionist sculpture in wood, Neri began to create a sculptural counterpart to Bay Area Figurative painting in the medium of plaster.

By 1958 he was concentrating on life-sized plaster figures, which were generally featureless, sometimes headless, and usually lacking one or more limbs. In combining blunt, powerfully abstract form with a sense of flesh, blood, and interior structure, they sometimes seemed to parallel the treatment of the figure in David Park's painting (see Fig. 62). At the same time, Neri's surfaces were gashed, eroded, and deeply notched, suggesting ravagement or decay. Armatures of wood and chickenwire sometimes showed through. The chalky white surfaces were touched with swatches of metallic silver or vivid polychrome, alternately highlighting the sculptural volume and rendering it ambiguous. As Dean Wallace wrote in the *San Francisco Chronicle* of Neri's first major solo exhibition at the Dilexi Gallery in 1960: "Each piece is a quick but far-reaching solution to an immediate problem—how to capture and mold a white-hot idea before it cools."[30]

Like the work of the older figurative painters, Neri's sculpture began to reach a wider audience. He showed in New York and Los Angeles in 1962–1963, and a few of his pieces entered public and private collections. He began teaching at the School of Fine Arts in 1959, and five years later joined the art department at the University of California at Davis. Shortly afterward, he bought an old church building in Benicia, which served as his home and studio through the 1970s (see Fig. 63).

A trip to Europe in 1961 became a turning point in Neri's development. After returning home, he began to go over many of his earlier pieces. "All that junk I turned out . . . I carefully examined and reworked. . . . I wanted to get something more than just immediacy. Some pieces I've [continued to work] on for twelve years."[31] In his sculpture of the late 1960s and 1970s, the "white-hot idea" cooled to a more classical and yet a more subtly intense and paradoxical style of expression.

Neri's forms and materials now varied greatly. He continued to rework ragged, standing figures left over from the funk days, whacking off an arm or leg from a piece that he had once considered "finished," progressively distilling and intensifying. In the mid-1970s, he began to work directly from live models (previously, he had relied on life drawings, "keeping the model at one remove").[32] These figures became more attenuated and fragile but also more dynamic, caught in awkward postures tense with a feeling of interrupted movement. Color softened to an ashen monochrome or a spectral white, sparingly touched with soft pastels—though occasionally a blaring accent of

FIG. 63. Manuel Neri in his Benicia studio, 1980.

74

FIG. 64. Manuel Neri, *Blue Blond,* 1979. Plaster, dry pigment, and water over steel armature with styrofoam core; 34″ × 18″ × 25″.

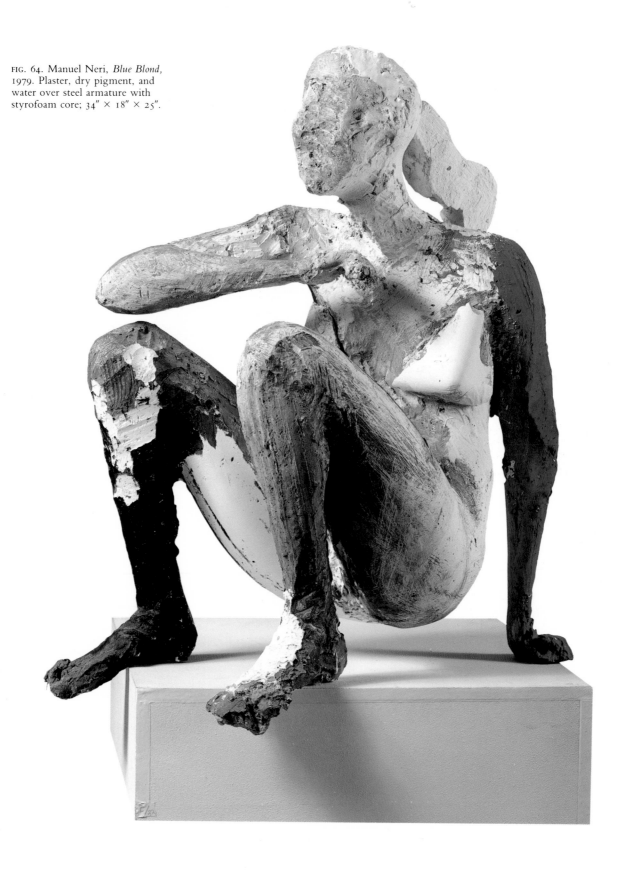

electric blue or red covered an arm or obliterated a face. (See Fig. 64.) Neri made several small bronze figures in a swiftly modeled style reminiscent of early de Kooning. From these he soon moved to life-sized bronze figures cast from earlier plaster sculptures, similarly gouged and hacked or ragged and gnarled and covered with dramatic overpainting. In the last years of the 1970s, Neri began to spend his summers in Italy, carving (and then painting) figures in Carrara marble. In keeping with their material, these figures assumed a massiveness and stoic monumentality reminiscent of ancient Egyptian sculpture.

For all its variety of forms and media, Neri's work seems to constitute a single, continuing process of exploration and redefinition, maintaining a delicate balance between impulsiveness and reflection, urgency and contemplation. His most powerful pieces are silent dialogues between a multitude of subtle contradictions. They are at once somnambulant and charged with latent motion, graceless and dignified, vulnerable and self-contained. They allude poignantly to the ideals of antique figure sculpture, yet represent unmistakably the sagging, slouching, and often fractured forms of contemporary mortals. They suggest the vitality of warm flesh and blood, yet also reveal themselves to be mere armatures covered with a skin of plaster, metal, or stone smeared with paint.

Joan Brown, like Neri, became an art student almost by accident. Newly graduated from high school, with virtually no training or interest in art, she was enrolled by her parents at Lone Mountain College, then a Catholic women's school. The night before her first day of classes, she panicked at the prospect of continuing her education in such cloistered circumstances, and responded to a newspaper ad by signing up for classes at the California School of Fine Arts the next morning. (See Fig. 65.)

By the time she became an art student in 1955, Brown recalls, the conventions of Bay Area Figurative painting had already become classroom techniques.[33] Only seventeen, she was overcome with embarrassment when she entered her first class and found that she was expected to draw from a nude model. Energy was at a low ebb at the school during her first year: "People had a good time . . . playing bongo drums in the patio and partying . . . but in terms of art, there really wasn't anything."[34]

Elmer Bischoff, who came to teach at the school in 1956, became the most important influence on her career: "He was the first serious, committed

FIG. 65. Joan Brown modeling for a class at the California School of Fine Arts, c. 1958.

person I ever met in my life," she said.[35] Her early work was strongly affected by the heavy impasto and thick-skinned paint surfaces of Bischoff and Frank Lobdell. But she was drawn to her own subject matter—dogs, shoes, and "certain kinds of things, over and over."[36] She was also interested in de Kooning, and perhaps more than any other San Francisco painter, she "misinterpreted" his work in her early paintings in the manner that Neri described. These paintings centered on simple forms—generalized busts or full figures in the manner of David Park, dogs and other animals, still-life objects that were frequently rendered with a whimsical or fantastic touch. The images were virtually sculpted in massive globs and skeins of high-keyed, direct-from-the-can colors, which were generally set against broader areas of shrill chocolate browns. (See Fig. 66.) The impastos sometimes reached thicknesses of four or five inches. "I loved the application as well as the look of the paint, right out of the gallon can," Brown remembered. "I loved what happened when I was using the trowel, the physical exuberance of just whipping through it with a big, giant brush."[37]

Brown exhibited her early paintings at the adventurous offbeat galleries that were springing

76

FIG. 66. Joan Brown, *Girl Sitting,*
1962. Oil on canvas, 47¾" × 60".

up in tandem with the Beat scene—The Six (1957), Spatsa (1959), and Batman (1959). The wave of enthusiasm for Bay Area Figurative painting on the East Coast swept her to her first solo show in New York, at the Staempfli Gallery, in 1960. Her youth (she was only twenty-two), her impressive talent, and the fact that she was a woman painter (considered unusual at that time) brought her a sudden stardom of sorts. In 1962 she was given *Mademoiselle* magazine's award for Outstanding Single Achievement in Art; she exhibited again at Staempfli in 1961 and 1964, and at the David Stuart Gallery in Los Angeles in 1961, 1962, and 1964.

Erratic at best, Brown's early work frequently managed to combine perverse humor with a sort of primitive intensity. By 1965, no longer satisfied with the felicities of these paintings and the recognition she had attained through them, Brown withdrew from exhibiting to redefine and redirect her energies. Abandoning the palette knives and trowels, reducing her colors to muted greens and grays, she spent a year painting a small, humble still-life composition as an exercise to sharpen her form and distill the basics of her handling of pigment. Brown's subsequent paintings developed from her roots in Bay Area Figurative painting into a form of idiosyncratic expressionism of the kind discussed more fully in Chapter Eleven.

Nathan Oliveira, who was younger than the "first-generation" figurative painters but somewhat older than Neri and Brown, developed a forcefully individual figurative style from early roots in Abstract Expressionism. He was a student at the California College of Arts and Crafts from 1947 to 1952, and a teacher there in the late 1950s. In his early paintings, he alternated between a tentative approach to the figure and a highly abstract style that centered on black, eroded shapes. The emphasis on black and white seemed to reflect his early training in lithography (in 1950 he had taken summer classes with Max Beckmann at Mills College). But his principal theme soon established itself: the solitary human form, isolated against—or engulfed by—grounds that implied environments of threatening gray vastness (see Fig. 67). Figures of women—constructed of thick, interwoven globs, trickles, and crusts of unmixed colors—gradually assumed a central role. Gaunt, spectral, and death-like, often shrouded in ashen monochrome, they seemed to be modeled after the wasteland figures of Giacometti rather than the violent termagants of de Kooning. Oliveira's work, more than that of

other Bay Area Figurative painters, belonged to a classical strain of agonized expressionism that seemed to reflect an existentialist view of man—battered, tragic, but enduring.

Oliveira was among the other Bay Area Figurative painters who were catapulted into national recognition in the last years of the 1950s. But in 1964, his painting fell into an inexplicable slump. In 1966, when he began to teach at Stanford (where he remained through the 1970s), he rented a studio in an old Palo Alto lodge hall; its stage—dramatically illuminated and furnished with enigmatic props—became the subject of a series of small paintings that he slowly developed over the next two years. Gradually, the solitary figure returned. Oliveira's paintings of the late 1960s and much of the 1970s seemed to reflect a determined effort to revive the obsessive quality of his earlier imagery, but to dress it in a more contemporary style, with brighter colors and a less emphatic contrast between figure and ground. A series of paintings from the early 1970s reduced isolated female forms to ghostly radiances hovering ambiguously on monochromatic fields, like the images in holograms. In the last years of the decade, Oliveira made a large series of monotypes in which eccentric images that suggested Indian fetish objects (or the paintings of William T. Wiley)—feathers, striped cords—were bathed in amorphous atmospheres. A series of large paintings focused on indistinct landscape forms, enveloped in atmospheric effects that resembled a cross between Turner's scenes of Venice and Diebenkorn's *Ocean Park* series. Oliveira rarely regained the expressive power of the monochromatic figurative painting he did in the late 1950s. He seemed, rather, to be straining for significant subject matter, and attempting to conceal its absence beneath ingratiating surface effects. On the other hand, in the early 1980s he turned for the first time to sculpture in bronze. The most distinctive of these pieces were mysterious "landscapes" resembling relief maps, strewn with enigmatic objects—modeled or cast debris—that suggested fetishes or ruins. They brought to mind relief maps of archeological digs from which the archeologists themselves had vanished as abruptly and inexplicably as the civilizations whose relics they were exploring.

By the last years of the 1950s, literally dozens of painters had been absorbed into the mainstream of Bay Area Figurative painting. Some, like Fred Reichman and Jim Rosen, developed modes of expression so individual that they left their sources in the Bay Area Figurative movement far behind.

The Bay Area Figurative School

78

FIG. 67. Nathan Oliveira, *Standing Man with Stick*, 1959. Oil on canvas, 68⅞″ × 60¼″.

Wayne Thiebaud moved from a style rooted in the Bay Area Figurative mold toward a highly personal form of Pop art (Chapter Six). In the work of such painters as Charles Gill, Robert Bechtle, and Richard McLean, who were associated with the California College of Arts and Crafts, Bay Area Figurative painting in the 1950s style evolved into the Photo Realism of the 1970s (Chapter Ten). Still other painters like Joe Oda and Jack Freeman carried on the style more or less as artists like Bischoff and Weeks had left it. Terry St. John and Lundy Siegriest became the nucleus of a small group of painters, schooled in the Bay Area Figurative conventions, who carried traditionalism so far as to revive The Society of Six's practice of plein-air landscape painting—although, in the late 1970s, it was necessary to go beyond the Oakland hills to find pastoral scenes of the sort Selden Gile and his friends had painted fifty years before; most often, they took their easels to sites in the foothills around Mount Diablo. In general, by the mid-1960s Bay Area Figurative painting was as commonplace, and as codified, as Abstract Expressionism had become before it. Most younger painters were moving on to newer clichés.

The role of representational imagery in Bay Area Figurative painting—at first so hotly debated by its champions and detractors—now seems more problematic. Almost from the beginning, many East Coast critics expressed reservations about the importance of the figure to this style. "[These painters] have restored the human figure nominally [but] they do not seem to believe in its singular efficacy," Dore Ashton wrote in 1960 in *The New York Times*. "The figure is there, all right, but an undefined 'atmosphere' . . . wears away at it, obscuring its features and blunting its profiles until it is virtually absorbed."[38] Hilton Kramer said that the Bay Area Figurative painters were painting the figure "in a serious way without any real decision about its meaning. . . . It lacks necessity."[39] Writing later about Diebenkorn's figurative paintings, Kramer called Diebenkorn "an abstract painter who now painted figures and landscapes. . . . If no longer abstract in the strictest sense, [his painting] remained Abstract Expressionist in taste, physical deportment, and esthetic loyalty."[40]

With the passage of time and the appearance of more truly alien challenges—such as Neo-Dada, Formalist abstraction, and Pop art—both the painters who remained committed to Abstract Expressionism and the Bay Area Figurative painters came to acknowledge the broad family resemblance in their work. Both insisted on the necessity of commitment and dedication, and on seeing art as an ethical act that ultimately had to be its own reward. And the ethical "statement" of Bay Area Figurative painting was essentially the same as that of Abstract Expressionism: that art is primarily a process by which not only the work of art but also the artist himself is continually being created.

Yet the Figurative painters differed from the Abstract Expressionists in their willingness to exploit the metaphorical possibilities inherent in the human form, and in representational imagery generally. The "record" of successive decisions, choices, and revisions that they left on the canvas itself tended to be more measured and contemplative than was typical of the high-energy action painters. And one of their favorite metaphors was the studio itself. To the Abstract Expressionists, the painting environment was relatively unimportant; it was primarily a functional space in which a purely internal "action" occurred. By contrast, the studios of most of the Bay Area Figurative painters, though simple and utilitarian, were often mirror images of the physical and psychological characteristics of their work. The almost palpable soft light and reverential hush of Bischoff's figurative paintings are the filtered light and quiet isolation of his Berkeley loft: a space of plain-spoken, Quakerish functionalism set aside for doing serious work that is its own fulfillment. The best Bay Area Figurative painting (and sculpture) shares this earthy, practical, and yet far from mundane character. It celebrates the peculiar mystique of the artist's studio—both the cloistered, monastic ambiance and the utilitarian ethic embodied in its easels, brushes, and other props, among which the human model could be counted. It echoes the quietly charged atmosphere of a place in which an act of creation has been carried out. It proclaims itself to be, above all, the work of an artist laboring with the unpredictable materials of his craft in the self-absorbed isolation that his calling imposes.

FIG. 68. Bruce Conner, *Señorita,*
1962. Assemblage on wood, 34″ ×
21″.

In the middle 1950s, a new social phenomenon arose in San Francisco—and New York—and it found expression in a new kind of art. Like the social phenomenon, the art had been developing slowly for several years before it finally attracted the attention of outsiders, who gave it a label that served more to distort than to define. The social movement was dubbed the Beat Generation and those who took part in it Beats or Beatniks. (After Soviet Russia's Sputnik was launched in 1957, *Chronicle* columnist Herb Caen began using *-nik* with maddeningly comic virtuosity, and with "Beatnik" the affix stuck.) The art did not find an accepted label so quickly, but when it did, in the 1960s, it was called Funk art.

The problem with both labels was their timing. Beatniks did not really exist until after the word was coined. Ever since the war, independent musicians, artists, poets, hipsters, and bohemians had been gathering in San Francisco's North Beach and New York's Greenwich Village; in the late 1950s, journalists developed a stereotyped image—the Beatnik—to describe them, and disaffected young people from Hoboken to Milpitas rushed to convert the stereotype into a self-parodying reality. On the other hand, by the time the term Funk art gained currency, the art that it described, at least in its purest forms, had already largely vanished from the scene. The big Funk Show organized by Peter Selz at the University Art Museum in Berkeley in 1967, which brought national recognition to the movement, presented a few remnants of the real thing mingled with sleek organic abstractions in silicone and lucite. Bruce Conner, one of the best-known and most powerful practitioners of the real thing, insisted on maintaining a distinction between "funky" and Funk: "funky," he said, should refer to the art that grew out of the authentic Beat movement in the middle and late 1950s, and Funk to the "school" that crystallized in the mid-1960s.[1] This distinction was affirmed by Harold Paris, whose own art was closer to the Funk style, when he described the "Sweet Land of Funk" in an article in 1967 in *Art in America:* "Almost imperceptibly," he wrote, "funk art has grown away from the funky art of the fifties."[2] We shall observe that distinction here, in a slightly altered form: Funk or Funk art for the 1960s variety, and funk (instead of funky) for work that principally reflected the Beat sensibility of the 1950s.

Whereas Abstract Expressionism and Bay Area Figurative painting largely originated inside the art schools, funk arose from the bohemian underground outside. It was not a coherent (or even incoherent) "style" forged by artists working in their studios, but a constellation of attitudes and ideas shared by various circles of friends who met in bars and coffee houses and displayed their work in informal, cooperative "galleries." These ideas and attitudes found expression in all the arts—painting, sculpture, poetry, music, theater, film—

and tended to break down the traditional barriers between them. There were various epicenters of activity—in Berkeley, Marin County, Big Sur, and a few isolated pockets in the City—but its center was along upper Grant Avenue in North Beach.

Abstract Expressionism and the Figurative painting that grew out of it had obliquely expressed a sense of gathering crisis in American life following the Second World War, a turning inward after the brief euphoria of a military victory that many people now saw as largely Pyrrhic. The year 1950 brought with it the war in Korea and a rising tide of paranoia about Communism; and as the decade advanced the rift widened between those who championed dogged pursuit of the American Dream and others for whom the dream seemed to be turning into a Madison Avenue nightmare. The H-bomb had joined the A-bomb in the arsenal of potentially earth-shattering weaponry, and the United States and the Soviet Union were beginning an all-out competition to see which nation could stockpile more of them; the image of a white mushroom cloud, symbolizing instant and total annihilation, hung over the consciousness of people everywhere. Technology began to run rampant, fueled not only by the arms race but by the mushrooming market for consumer goods, created in large part by the growth of television and other mass media. Norms of appearance and conduct became increasingly rigid; the House Committee on Un-American Activities and Joseph McCarthy's U.S. Senate committee moved eagerly to track down and punish deviations from the accepted political ideology.

Young people, especially, reacted to the situation with a growing restlessness. Though success through conformity remained the goal for a majority of American youths, among others a mood of futility—a sense of no longer being able to control one's own destiny—began to spread. It was coupled with a feeling of impatience, a desire to seize the day (for there might be no tomorrow), and above all with a heightened sense of the ironic and the absurd. In the 1960s this unrest became widespread and led to open revolt and organized political and social upheavals. In the late 1950s, however, it more often took the form of withdrawal. For the young, Marlon Brando and Elvis Presley joined James Dean as popular heroes, inarticulate rebels who lived for the moment in a world of fast bikes, "primitive" music, blatant sexuality, and the constant threat of violence. Disguised as stand-up comics, Mort Sahl and

FIG. 69. Jazz session at the Coffee Gallery, 1959.

(more threateningly) Lenny Bruce used their nightclub acts to stage guerrilla attacks on bigotry, hypocritical sexual mores, big business, and the military establishment. Novels like J. D. Salinger's *Catcher in the Rye* and Jack Kerouac's *On the Road,* though vastly different in style, popularized the notion of a pilgrimage in search of one's own destiny.

The somewhat older and hipper among the culturally disaffected rallied around the cult of the jazz musician (see Fig. 69), creating a type that Norman Mailer called the "white Negro," a hipster who imitated the lifestyle of jazz greats like Charlie Parker.[3] This style of life could flourish only in the bowels of the great American cities. Its practitioners, fueled by alcohol and drugs, lived by night and swung between a frenzied emotionalism and a lofty detachment known as "cool." Improvisation become the highest form of creativity, and whether a work of art survived became a matter of indifference. The traditional distinction between the creator of art and the performing artist was broken down; as in action painting, it was the process rather than the product that

The Beat Era

ultimately counted. Creation thus became intimately bound up with the artist's personal life.

Among intellectuals, an attraction to the anti-intellectual and the nonrational became widespread. The mood of despondency stimulated interest in the plays and novels of Samuel Beckett, where the existentialism of Sartre, shorn of its concept of "responsibility," entered the featureless world of the tragicomically absurd. Oriental philosophy became more influential. Translations of the novels of Hermann Hesse appeared—*Steppenwolf* was one of the underground bibles of the late 1950s. There was renewed interest in more esoteric forms of mysticism (astrology, the Tarot) and in the metaphysical writings of such authors as Gurdjieff and Ouspensky. Mexican culture had an especially deep attraction for the Beat artists of the 1950s. They admired its tenuous balance of violent extremes—the events of everyday life shading into the occult, the natural landscape intensifying into the peyote vision, with its insight that all existence is sacred but not necessarily solemn.

This atmosphere had much in common with the mood in Europe during and after the First World War, when Dada and Surrealism were born. The spirits of Ernst and Schwitters—and to a lesser degree, of Duchamp and Picabia—reappeared in some funk art, clothed in new, post-Abstract Expressionist forms. Events took place which a few years later, especially in the art world in New York, would be publicized as "happenings," but which in this more innocent place and time were seen simply as wild parties. A famous example was an evening of "collective expressionism" organized by Edward Silverstone Taylor in 1957 at The Six Gallery: Allen Ginsberg and Jack Kerouac read poetry, and participants then destroyed a piano and many of the art works on display. Artists working in various media exchanged ideas, collaborated, moved from one form to another, and drew diverse forms together. Searching for greater movement and impact—for greater *reality*—painters turned from the static flat canvas to the dimensionality of assemblage or sculpture. Jordan Belson abandoned a brief but successful career as an abstract painter to experiment with visionary abstract films—which he later raised to an unprecedented level of expression. The dancer Ann Halprin wove together extraordinary combinations of new music and impromptu theater. In a sense, everything ultimately became a form of theater. This trend achieved a Wagnerian dimension in Vortex, a series of concerts held at the Morrison Planetar-

ium in the late 1950s, which enveloped the spectator in wall-to-wall electronic sound and overhead light effects; these were the result of a collaboration between Jordan Belson, who was responsible for visuals, and Henry Jacobs, who circulated the sounds around a circle of thirty-six loudspeakers. The assault against the boundaries separating one art from another became an attack on the barriers between "art" and "life." Eventually, the theater spilled out onto the streets.

Yet compared with the "counterculture" that came to flourish in the 1960s, the underground that gave birth to the funk art of the 1950s was riddled with conflicts and contradictions—which were reflected in the tension and drama, the emphasis on blacks and whites, of much Beat art. The intense, bleak abstractions of Franz Kline epitomized the mood; for away from the jam sessions, the readings, and the gallery parties, a sense of desperate personal isolation prevailed. The ideal of immediacy through improvisation coexisted with a yearning for permanence and immortality. Although funk painting and Beat poetry were "liberated" from the museum and the printed page and taken to the street, the street was mostly Grant Avenue; art was frequently used as a weapon in the cultural warfare between hip and square. Satori—the wholeness and lack of ego proposed by Oriental philosophy—was often sought, but the dualism of Western philosophy and religion prevailed, if often through ironic inversions (evil was good, madness was sanity). Drugs that created an illusion of heightened reality—peyote, mescaline, and marijuana—alternated with drugs that washed everything into a Lethe of unconsciousness. On one hand, poets and painters sought a new concreteness, related to Zen, that would transcend mere imagery or metaphor ("I would like the moon in my poems to be a real moon, one which would suddenly be covered with a cloud that has nothing to do with the poem," Jack Spicer wrote).[4] On the other hand, they created works in which every detail seemed to be entirely symbolic, Jungian mirrors held up to the various facets of the observer's psyche. "Dumb" objects were selected as subjects of paintings and elements of assemblage partly because they reflected on "dumbness" and absurdity—and partly because a sudden shift of perspective could make the ridiculous sublime. A compulsion to communicate fought with an urge to conceal or obscure. The widespread feeling that real communication between people was impossible (a theme that linked Samuel Beckett to Jules Feiffer and Professor Irwin Corey) was aggravated

FIG. 70. Harry
Smith and his mural
at Jimbo's Bop
City, c. 1952.

by fear and loathing of the Bomb—anything one said could be annihilated forever in a Doomsday flash. Yet the sense of futility only seemed to intensify the urgency. The result was an equivocal kind of communication, related to the art of the verbal "put-on" developed by jazz musicians. Although the jazzmen used familiar melodic and harmonic materials, they did so in a way that kept their real "meaning" (or rejection of meaning) arcane and private, understandable only to a relatively small underground audience. The word "funky" itself was picked up by artists from jazz musicians. "We just adopted the word," said Manuel Neri. "I remember listening to a group at the Jazz Cellar one night and hearing a guy say to one of the musicians, 'Hey, that's really funky. I don't want to hear that.' I like the term because it was a put-down term—it meant something that was old-fashioned and corny. It fit with what we were doing—re-examining old ideas, throwing out new ideas, getting back to basics."[5]

Underground activity in the arts had begun to stir in the Bay Area as early as the first years of the 1940s, and much of it was associated with a small beachhead of bohemians that had established itself along the fringes of the University of California campus in Berkeley. One if its most important early manifestations was in film. Harry Smith experimented with abstractions painted directly on filmstrips in the early 1940s, and pioneered a form of animated collage that seemed to mix visual alchemy with be-bop. (See Fig. 70.) In 1946

James Broughton and Sidney Peterson produced their earliest Surrealist fantasy, *The Potted Psalms,* and in the same year experimental film was given public exposure through the Art in Cinema series that Frank Stauffacher initiated at the San Francisco Museum of Art.

North Beach, the Bay Area's traditional bohemian stronghold, with its low-rent flats and studio space, cheap Italian food, and informal bars, attracted students and faculty members from the California School of Fine Arts on nearby Russian Hill. City Lights Bookstore, together with City Lights Publications, established in 1952 by Peter Martin and Lawrence Ferlinghetti (then Ferlig), became a center and an outlet for the burst of literary activity that soon followed. As more people arrived—from New York, Los Angeles (which provided a particularly large influx of artists), and such isolated bastions of avant-garde education as Black Mountain College in North Carolina and Reed College in Portland—new gathering spots joined The Place along upper Grant Avenue: The Anxious Asp, Miss Smith's Tea Room, the Co-Existence Bagel Shop (Fig. 71). Besides becoming a regular hangout for the poets, The Place staged Dada festivals and a weekly series of "open mike" Blabbermouth Nights, as well as regular exhibitions of paintings or assemblage; occasionally, its walls and ceilings were flooded with impromptu light projections— primitive light shows—produced by Wally Hedrick or Charles Yerby with homemade projection

FIG. 71. Inside the Co-Existence Bagel Shop, North Beach, 1959.

contraptions. An old upright piano was used for sporadic jam sessions.

The Coffee Gallery, Vesuvio's, and the Jazz Cellar all mounted more or less regular displays of paintings. Herb Wasserman's Triangle Gallery at the corner of Broadway and Columbus provided a more specialized, informal showplace, as did the Dilexi Gallery, which James Newman and Robert Alexander founded in 1957 in Alexander's loft above the Jazz Workshop on Broadway. Meanwhile, other outposts formed, in the Tenderloin and on the other side of Russian Hill, near the corner of Fillmore and Union streets, where the more "establishment" East-West Gallery was located. Many poets and artists, particularly those of the homosexual contingent, lived in the Hotel Wentley at Polk and Sutter streets and gathered in a Foster's all-night cafete-

ria on the street floor beneath. The King Ubu Gallery, which Duncan, Jess (Collins), and Harry Jacobus had opened at 3119 Fillmore Street in 1953, reopened in 1955 (after a brief closure) as The Six. (The original six were Jack Spicer, Wally Hedrick, Hayward King, Deborah Remington, John Allen Ryan, and David Simpson.) Dimitri Grachis later founded the Spatsa Gallery in a one-car garage nearby.

The Six Gallery—at least until its demise in 1958—typified the free-wheeling, anything-goes atmosphere that surrounded funk art in its heyday. "Most of the shows would open with a big party, and afterward there was never anybody around to let people in," Manuel Neri recalled. "More than once, someone would paint a whole show the night before it opened. The immediacy was exciting, even if the work was raw and

The Beat Era

incoherent. We were all presenting ideas as fast as we could get them down."[6]

By 1957, when the celebrated obscenity trial revolving around Ginsberg's poem *Howl* drew the first wave of international publicity to North Beach, the four short blocks on Grant Avenue between Columbus Avenue and Filbert Street had become the most highly charged Main Street in America. Poet Michael McClure, who had come from Nebraska three years earlier, remembered his arrival in San Francisco as a disappointment. "It was boring as the world was boring. . . . But North Beach was an exception to that. It was as if North Beach had a kind of dome over it. There you could mix with the old bohemians and the old anarchists and the young kids wearing sandals and growing beards for the first time. There would be little bars where you could sip wine and see people writing poems and playing chess and talking mysteriously about peyote. A touch of the anarchist, of the philosopher, a kind of romance of narrow streets leading into Chinatown—all that was North Beach."[7]

One of the earliest and most influential funk artists was a reclusive former radiochemist known only as Jess (his surname was Collins). As a student at the California School of Fine Arts between 1949 and 1951 (Still, Corbett, Smith, Bischoff, and Park were among his teachers), Jess was steeped in the Abstract Expressionist esthetic. Almost from the beginning, however, his approach differed substantially from both the non-objectivists and the figurative painters. Robert Duncan, his companion since 1951, noted in Jess's work "the inspiration of long neglected and even despised sources in nineteenth-century phantasy." He added: "The painting of Vuillard and Bonnard, the Nabis, or of Edvard Munch and Gauguin or Sérusier, had a special import for young painters who were responding to the suggestions of patterns and auras of color, to happenings in the painting itself from which a picture began to come."[8] Leaning toward murky, muddy colors and thick, gummy paint surfaces, Jess's early paintings often resembled the clumsy copies of Victorian allegorical painting found in dusty corners of thrift shops—or, as Alfred Frankenstein put it, "paintings of mythological subjects as reproduced in forgotten family magazines."[9] "The work takes on a romantic, visionary, literary tone," Frankenstein wrote, "and with this the artist fights a long battle to forge a technique adequate to his new point of view."[10]

In fact, according to Duncan, Jess was not greatly interested in painting as such, but in art that was "diverse and derivative," an art that was not "a thing in itself," dedicated to incorporating the specific values of painting, but "a medium for the life of the spirit."[11] In the early 1950s, he began to assemble fragments of pictures and words found in old books and contemporary magazines into collages, and sometimes—with the addition of old light bulbs, feather dusters, discarded toasters, and other found objects—into more dimensional constructions which he called "assemblies." Although the collages, with their incongruous juxtapositions and frequent use of nineteenth-century engravings, resemble the early "collage novels" of Max Ernst, Jess's principal inspiration was his memories of scrapbooks filled with magazine ads and newspaper comics with which his great aunt had entertained him as a child in Southern California. There had also been a memorable visit with his father to the Mojave Desert diggings of an old prospector, whose home, assembled from scrap wood, junk, tin cans, and natural objects, was wallpapered with paste-up pictures from magazines. The "junk" constructions and scrambled, densely packed arrangements of images and words glued to old window shades that constituted Jess's first show at the King Ubu Gallery in 1953 were collectively called "Necrofacts, or dead art."[12] They suggested dusty, nineteenth-century Victorian reliquaries in which dried flowers, locks of hair, and other objects commonly associated with sentimentality, nostalgia, or mere everydayness were rearranged and somehow recharged with a disturbing energy from the demimonde of the subconscious. (See Fig. 72.) Part Dadaesque and part Visionary, they anticipated and profoundly affected the spirit of later Bay Area assemblage.

By the late 1950s, Jess's "struggle" to develop new means of expression had crystallized in two distinct forms which, though not unprecedented, he used in new and decidedly idiosyncratic ways. The first form, which he called "the paste-up," began with *Tricky Cad Case*, a remarkable small collage done in 1954 that consisted wholly of snippets of pictures and words taken from Dick Tracy comic strips, rearranged (like the title) to form a sequence that partook equally of comic absurdity and total gibberish. It was one of many works made by funk artists in the 1950s that some commentators were later to interpret as presaging Pop art, although the motivation and spirit behind

them were fundamentally different. In other "paste-ups," Jess began to incorporate pieces from jigsaw puzzles. He elaborated his paste-up technique during a two-year trip to Europe in 1955 and 1956. Later, while living in Stinson Beach, he enlarged the paste-ups to an environmental scale, often using old window shades, and sometimes also screens and old wood frames. These works, conceived as "ephemeral votive objects," were represented in the Art of Assemblage Exhibition at the Museum of Modern Art in New York in 1961.

The other form was what Jess called the "translation"—or, in cases where the repainting of one of his own old, abandoned works was concerned, the "salvage." These were paintings, in impastos as thick and buttery as cake frosting, generally based on pictures from old children's books or illustrations from old science journals, although Jess sometimes turned to other sources that were less obscure: magazine photographs of the Beatles and views of the earth from outer space. (See Fig. 73.) On the other hand, one of his earlier works, *Paranoiac Portrait of Robert Creeley* (1954), borrowed from the multiple images of the paste-up. The "translations" produced results that went beyond the simple transposition of images from one medium to another. With their thick,

The Beat Era

FIG. 73. Jess,
Trinity's Trine,
1964. Oil on canvas
over wood, 45⅞″ ×
48⅛″.

tapestry-like surfaces, bland colors, and wiry black outlines, Jess's paintings of old laboratory instruments took on overtones of fairy tales and alchemy; the *Paranoiac Portrait of Robert Creeley* creates a sort of comic-book mysticism that foreshadowed the Visionary art of the late 1960s.

In contrast to the art of Jess, which represented an inward-turning, mystical vein of funk, with roots in European Surrealism and Jungian symbolism, the art of Wally Hedrick seemed to have roots in the American tradition of the backyard

inventor, and in the satirical tradition of Clay Spohn. Hedrick's earliest paintings, done as a student at the California School of Fine Arts in the early 1950s, drew on the formal clichés of decorative or "Byzantine" Cubism, but these clichés were expressed in clashing colors or dull monochrome, with viscous and blistered surfaces. Fred Martin later described them as "hot, ornate, almost feverishly whimsical. . . . The paint often cracks or the stretchers warp from the very urgency of his methods. . . . The cracking, the

twisting, and the failing to dry all form part of the basic sensibility of his works."[13] Far from appearing "modern," these Neo-Cubist paintings had a clumsy directness that made them seem, like the neo-Symbolist paintings of Jess, weirdly old-fashioned.

For Hedrick (Fig. 74), painting was only one of several outlets for a brash, irreverent energy. As early as 1948 he had begun to experiment with modulated light, and by 1953 he had created a "light machine"—an electrical contraption with a keyboard, glass cake-plates, and other bric-à-brac—that he played as an instrument in jam sessions. The machine went through several permutations, but in general speakers were attached to lights that responded with different color mixtures and levels of intensity to changes in pitch, register, and volume. Hedrick also assembled junk sculpture, such as his 1953 Christmas tree made of tin cans and other debris, which included the functioning speaker of an old radio. His black pine coffin, with the words "Art is Dead" emblazoned on it, showed up at various Bay Area art events in the 1950s.

In his assemblages, as in his paintings, Hedrick worked to mine new meaning out of familiar things; he explored the ambiguous relationship between cliché and archetype. Perhaps his most influential contribution to the course of Bay Area art was his elaboration of the kind of punning that had frequently been found in the work of Clay Spohn. As Fred Martin recalled: "[He] would construct long chains of related words, by slow permutations of sound and sense moving from Botticelli to Bottom Jelly, from Schopenhauer to Shopping Hour. The direction of development was from the accepted, the respectable, the concepts of a high culture, to the unacceptable and disreputable facts of vulgar and common life." Hedrick himself said he had "a sense of kinship with the old lampooning cartoonists."[14] The puns not only became titles but frequently appeared, in mock decorative lettering, within the painting itself.

In the late 1950s, Hedrick turned away from the Neo-Cubist elements of his early style, and from stylistic consistency in general; he was "coming to regard style," in Martin's words, "simply as a function of idea." He dabbled in alchemy and the Hindu *Kama Sutra.* Many of his paintings displayed idiosyncratic icons and had high-flown or metaphysical titles—*Spirit Plus Idea,* and *Chalice or Cross (For Services Rendered)*—which were both emphasized and mocked by styles that inclined

Wally Hedrick 57 Jern Bywhr 75

FIG. 74. Wally Hedrick, 1957.

toward a quirky Byzantine or an eccentric Baroque. (See Fig. 75.) As the war in Vietnam escalated, Hedrick began to deal with political subjects in a broad, caricaturish style, in paintings with such titles as *Madame Nhu's Barbeque, Take a Vietnamese to Bed Tonight,* and *Napalm Sundae* (1963). Later, in his extended *Vietnam Series,* he abandoned his figurative style for rough-textured, all-black canvases, and gave his paintings only numbers as titles. In the early 1970s, after his dismissal from a teaching post at the San Francisco Art Institute, he devoted most of his time to operating a home repair business in the town of San Geronimo, in Marin County. His few paintings of the 1970s were most often crudely Photo Realistic versions of old mail-order catalogue advertisements painted in a black-and-white monochrome. As the 1980s began, Hedrick was again painting large canvases that presented highly personal (often sexual) images in a raw, aggressive style reminiscent of his work of the late 1950s. As Fred Martin observed of Hedrick's earlier work: "Because idea is the source of his art, each style or permutation thereof is executed with an almost staggering directness, and the frills of the professional stylist are torn everywhere by his almost elephantine stomp of authenticity, by his intent, in his own words, to paint out what doesn't count."[15]

The Beat Era

FIG. 75. Wally Hedrick, *Hermetic Image,* 1961. Oil on canvas, 84″ × 60″.

FIG. 76. Jay De Feo, c. 1959.

The most powerful artist to emerge from the early period of funk art in the Bay Area was Jay De Feo (Fig. 76). After receiving her M.A. degree from the University of California in 1951, she used a traveling fellowship to spend the next two years in Europe, principally in Florence. Her *Florence Series* (1952), a collection of ink and tempera sketches on torn and collaged paper, concentrated on the rich scale of monochromes (blacks, whites, and grays) that became characteristic of her later work. Her sketches resembled Kline's work in the sweep of their abstract forms, but they had stronger implications of mass and volume.

De Feo married Wally Hedrick after her return to California in 1953 and moved into a large building at 2322 Fillmore Street that became a kind of Grand Hotel for painters, poets, filmmakers, and musicians. (It eventually also housed the studios of Joan and William H. Brown, Sonia Gechtoff and James Kelly, Craig Kauffman, James Newman, and Michael and Joanna McClure.) Between 1956 and 1958, De Feo created several immense paintings with titles that suggested inspiration in religion, myth, or magic: *Origin* (1956), *The Veronica* (1957), *Death Wish* (1958), and *Daphne* (1958). They were essentially abstract, with skeins of black, white, and gray gathered into bold, wing-like shapes that

The Beat Era

FIG. 77. Jay De Feo,
Doctor Jazz, 1958.
Oil on paper, 132″
× 42½″.

FIG. 78. Jay De Feo,
The Eyes, 1958.
Graphite on paper,
48″ × 96″.

seemed to thrust upward with a soaring energy (see Fig. 77). In 1958 she also completed a huge pencil drawing (four by eight feet) called *The Eyes,* in which two eyes peered with hypnotic force from behind a thin scrim of vertical lines (Fig. 78). This work was inspired by a piece of poetry by Philip Lamantia: "Tell him I have eyes only for heaven."[16] At about this time, De Feo also began doing paintings like *Incision,* in which the paint was troweled on in thick slags and combined with stones, string, and other foreign materials to achieve an almost sculptural relief. This painting—with its bleak sludges of marbled black, white, and gray, which seemed to struggle against their own mass and weight, its machine-like gash cutting through the surface and its strings dangling helplessly from rock-like masses at the bottom—epitomized the funky sensibility of the late 1950s. De Feo and Hedrick were both among the Sixteen Americans selected by Dorothy Miller to exhibit at the Museum of Modern Art in New York in 1959; De Feo also showed at the Ferus Gallery in Los Angeles in 1960.

By 1958 De Feo had embarked on a project that became an obsession for the next six years. Retrieving a canvas she had abandoned during her earlier *Mountain Series,* she began to paint with the single notion, as she put it, that the work "would have a center."[17] After six months of work, she decided that the proportions of the canvas were wrong for the shape it was taking. A new and larger canvas was stretched, and the old one was simply attached to it with two coats of rabbit-skin glue. As the painting progressed, it began to incorporate wire, beads, and pearls—materials De Feo had used while making jewelry some years

before. Ideas that she had previously expressed in separate paintings began to be incorporated in a single, continually changing work entitled *The Rose.* By the end of 1960 it had assumed a geometric character; wooden supports were added, but they soon disappeared under continuing applications of paint. Somewhat later, the painting entered "a rococo phase." By simultaneously "carving down" and building up, De Feo "managed to save it from self-destructing" and "peeled it back to a somewhat 'classic' final version."[18] By then, in December of 1964, she, Hedrick, and the painting were being evicted from their Fillmore Street studio. A wall had to be removed from the building in order to remove the painting, which was crated and carried away by a full crew of Bekins movers, under the supervision of Walter Hopps, then director of the Pasadena Art Museum—an event recorded by Bruce Conner in his film *The White Rose.* It was then driven to the Pasadena Art Museum, where De Feo was still adding finishing touches to it when it went on exhibition for the first time. Ultimately, the painting weighed 2,300 pounds, measured 129 by 92 inches, and had a paint surface between two and eight inches thick. The paint alone—a cheap variety of local manufacture (Bay City) favored by impecunious artists of the period—had cost $4,375.51. More to the point, *The Rose* was a monumental creation: a vibrant wall of whorls and gnarls and boulders in De Feo's characteristic monochrome, cut through by the ridged relief of a mandala that centered in radiant light and reached out into enveloping shadows (Fig. 79).

The Rose was the sort of ultimate statement after which an artist can only begin again. De Feo and

FIG. 79. Jay De Feo, *The Rose*, 1958–1964. Oil on canvas, 129″ × 92″ × 8″.

Hedrick were divorced shortly after they left the Fillmore Street studio, and De Feo spent the 1970s living in a cottage in Larkspur, working toward a new sense of direction for her art. Several large works she completed early in this period seemed like battlegrounds on which the sensibilities of two eras were locked in combat: the awkwardly aggressive forms and rugged surfaces of fifties funk versus the hard, crisp shapes and flat, clean-cut grounds of the more formal sixties. Later in the 1970s, De Feo turned to realistic, if elusive, drawings of still-life objects, such as camera tripods and eyeglasses. By 1980 she had returned to more abstract forms, although they often suggested distinctly real things: a *One O'Clock Jump* series, for example, used fragmented disc shapes that resembled broken nuclear reactors. Later, she began to use strong color for the very first time in paintings dominated by angular forms with machine-cut edges and a massiveness and weight that called to mind mangled industrial objects—anvils, vises, twisted railroad ties. She seemed in many of these works to be concentrating on painting problems she had circumvented or overridden in her more direct paintings of the Beat era (which were also more austere, in spite of their sometimes obsessive excesses).

In the early 1970s, *The Rose*—for which a waiting list of purchasers had once included thirteen museums as well as many individual collectors—was retired to a conference room at the San Francisco Art Institute, where it languished until its deterioration stimulated a campaign to have it restored. De Feo's reputation had been in eclipse, however, since she had taken so much time out from exhibiting to complete the work, and by 1983 the restoration project, only partially completed, had been stalled for several years. The painting remained in the Art Institute's conference room, covered with a cocoon of plastic, suggesting a Christo wrapping or a religious statue shrouded for Lent.

In 1957, two artists arrived in San Francisco who were to have a decisive impact on funk art during the rest of the decade. They were Wallace Berman and Bruce Conner.

Berman, a slight, self-effacing, and yet strangely charismatic figure, lived in the Bay Area for only four years, but he remained a catalytic force among underground artists, poets, and writers in San Francisco and Los Angeles for a much longer period. (See Fig. 80.) After a brief stint of formal art training at the Chouinard and Jepson art schools in 1944, he associated himself for several years with

FIG. 80. Wallace Berman with peyote buttons, 1960.

the Los Angeles jazz scene (he collaborated in writing rhythm and blues tunes with Jimmy Witherspoon in 1946). His earliest drawings dealt with the underground worlds of jazz and dope addiction, and were sometimes laced with erotic fantasies. Already collage-like in concept, they combined naïve, academically realistic portraits of musicians with frightful Surrealist images of dinosaurs, serpents, and syringes.

From 1948 to 1950, while working in an establishment that specialized in "antiquing" the surfaces of imitation period furniture, Berman began putting together waste odds and ends to make his earliest assemblage sculptures. He added photographs, drawings, and word images, creating complex tableaux that sometimes suggested shrines or temples. In 1954, during a brief visit to San Francisco, he sought out Jess and Robert Duncan, and talked with them for an afternoon in their apartment on Baker Street. According to Duncan, the visit produced "an unfolding recognition that we were possibly fellows in our feeling of what art was. . . . In our conscious alliance with the critical breakthrough of Dada and Surrealism as in our alliance with the Romantic Movement at large, we began to see ourselves as fashioning unnamed contexts, contexts of a new life way in the making, a secret mission."[19]

Later that year, Berman produced the first issue of *Semina*—small, folio-like containers in which he assembled photographs, drawings, and poems, each printed on a separate card with a small hand-press; they were stuffed in random order

into an envelope pasted to the inside of the folio's cover. Berman gave away each edition, generally about two hundred copies, to his friends.

By the middle 1950s, Berman had become associated with the Los Angeles artists—Robert Alexander, John Altoon, George Herms, John Reed, Craig Kauffman, Billy Al Bengston—who gathered around Ed Kienholz's studio on Santa Monica Boulevard, and who later formed the nucleus of the Ferus Gallery when it opened in 1957. Berman had the fourth exhibition at Ferus, and it turned out to be the first and last time his assemblages were ever shown. The show was a kind of retrospective, ranging from an early *Homage to Hermann Hesse* to a group of recent works in which Hebraic letters were painted on parchment-like fragments. In *Cross,* a photograph hanging from one arm of an old wood-beam crucifix gave a close-up view of male and female organs in intercourse. This attracted the attention of the Los Angeles vice squad, and when Berman refused to withdraw the work, he was arrested, convicted, and fined for "inciting lewd and

lascivious behavior." Shortly afterward, Berman, his wife Shirley, and their young son Tosh moved to San Francisco, where they settled in an old Victorian house on Scott Street.

During his four years in the Bay Area, Berman produced no more assemblages, but concentrated his energies on putting together further editions of *Semina,* which became closer in format to a scrapbook and incorporated works by many of the artists and poets of North Beach—Larry and Patricia Jordan, Bob Kaufman, Michael McClure, Philip Lamantia. (See Fig. 81.) Berman became closely acquainted with Conner and other Beat artists, and his presence greatly strengthened the gravitational pull that drew Los Angeles artists and poets to the Bay Area in the late 1950s— among them Arthur Richer, Elias Romero, Robert Alexander, David Meltzer, and John Reed.

In 1960 Berman moved to Larkspur, making his home in one of three abandoned shacks in the swampland on the edge of a canal off San Francisco Bay. George Herms became a squatter in the second shack. The third—roofless and

FIG. 81. Wallace Berman, cover and pages from *Semina*, no. 4, 1959.

FIG. 82. Wallace Berman, *Untitled*, 1975. Verifax collage, negative; 33½″ × 30½″.

without windows—Berman made into the Semina Gallery, where he put on "exhibitions," each of which ran for two hours on a single Sunday afternoon. Herms, Arthur Richer, John Reed, Paul Beattie, and the photographer Edmund Teske were among the artists whose work was shown there in the months before the Semina Gallery literally sank into the mudflats.

The collages that Berman created while he was living in the Bay Area—many of them simply pasted on the backs of postcards and sent to friends—were generally intimate in scale and expression: family snapshots, pictures of birds and peyote buttons. Some were erotic, and many were accusatory—using images from the daily papers that were transformed into icons of violence or homages to victims of violence (Charlie Parker, Lenny Bruce, Wardell Gray). Their component images suggested random occurrences, but in combination they gained a peculiar intensity that made each collage more than the sum of its parts. This resonance reflected a fascination with the power of certain drugs to transform apparent commonplaces into objects of wonder and great significance, and also an interest in Zen, with its emphasis on the "is-ness" of things. Also increasingly prominent in Berman's work was a sense of connectedness. *Semina Seven,* which Berman published while living in Larkspur in 1961, contained a group of otherwise unrelated photographs inscribed with large "alephs"—in cabalistic literature, the aleph is the "first of the mother letters" from which derive all other letters, or language, and hence all things, or at least our sense of them.

After returning to Los Angeles with his family in 1961, Berman settled in Topanga Canyon, and in the middle 1960s he developed his monumental verifax prints. In both formal and expressive terms, these works—created on a copy machine, with components assembled into compositions as large as four feet square—raised collage to an unprecedented level of unity, subtlety, and power. Most of the collages contained a dozen or more identical images (some had over fifty): a hand holding a transistor radio, sometimes accompanied by Hebraic script. But the faces of

The Beat Era

the radios were transformed into a kind of screen of cosmic consciousness, as across each one a different image, positive or negative, appeared to flicker, pass, and dematerialize. There were images of football players and popes, Egyptian friezes and space ships, mushrooms and mushroom clouds, clock faces, nebulae, and Talmudic wheels. Individually intense, the images collectively became neutralized, ethereal apparitions. They became like the symbolic images in a pack of Tarot cards, assuming new configurations of meaning with each reshuffling. More potently than any other body of work created by the funk artists of the Beat era, Berman's verifax collages expressed the Jungian descent into a psychological underworld in search of the philosopher's stone: the illumination through which the "pilgrim" recomposes, or improvises, himself, rearranging reality into new contexts and patterns. (See Fig. 82.)

Bruce Conner—who was prompted to move to San Francisco after hearing reports on the local scene from Michael McClure, a fellow student from the University of Nebraska—had been a funk artist almost from the beginning. (See Fig. 83.) His student paintings (1952–1956) were principally thick encrustations of white oils on masonite, often cut into shapes that resembled rocks, fragments of wall, or scraps of wood; the paint was built up in a way that often suggested deterioration and decay. During a year in New York, while working his way through the Brooklyn Art School by producing designs for a greeting card company, Conner had become involved with mediums and Tibetan monks, as well as with the ritualized use of hashish and peyote. There he also began a series of ink drawings based on Dante and other visionary themes. They consisted principally of varying degrees of darkness, produced by hopelessly complex networks of obsessive squiggles and hatchings. When Conner and his new wife, Jean, moved to San Francisco in 1957, they set up their studio in the same big building on Fillmore Street that housed the McClures, the Browns, Hedrick and De Feo, and the other funk artists.

John Coplans, in his catalogue for the exhibition Assemblage in California, held in 1968 on the campus of the University of California at Irvine, asserted that Conner began to fashion his assemblages under the influence of his meeting with Wallace Berman.[20] But Conner discounts the force of this influence, and an artist of his temperament could as easily have developed them from a purely organic response to the environment in San

FIG. 83. Bruce Conner, c. 1958.

Francisco. One important source of inspiration, Conner has recalled, was the old Sutro Museum (which burned to the ground in the late 1960s), a Victorian relic from the late nineteenth century perched on a cliff above Playland-at-the-Beach.[21] It housed a surrealistic treasure house of mummies, mechanical dolls, and toothpick carnivals, as well as the wardrobe used by Tom Thumb. Another source of ideas, and also of materials, was an old junk store on McAllister Street run by an ancient black man, a storefront preacher known as Reverend Jackson, who had carved a tiny chapel into the ceiling-high debris that filled a back room. Finally, there were plenty of raw ingredients—architectural gingerbread, dowels, fixtures—to be had for the picking in the rubble of demolished buildings that spread through the Western Addition in the wake of the City's first major urban renewal project.

Conner's earliest assemblages began to take shape in 1958. Most were inspired by his collaboration with McClure in founding what they called The Rat Bastard Protective Society (other charter members were Hedrick, De Feo, Brown, and Neri). On its simplest level, the RBPS was just what its name implied: a barbed commentary on the defensive clannishness to which experimental artists were driven by a society that was hostile or indifferent to their work. As Conner said, speaking of the funk artists' indifference to technical finesse and the durability of their creations, "No one else cared what we were doing, so why should we?"[22] But there were also overtones of Artaud's

FIG. 84. Bruce Conner, *Child,* 1959–1960. Assemblage: wax figure with nylon, cloth, metal, and twine in a high chair; 34⅜″ × 17″ × 16½″.

"living theater" and "culture-in-action" concepts in their work. Their primitivistic fetish objects and bundles of mysterious things were the artifacts of a self-created "civilization." Such pieces as Conner's *Rat Secret Weapon, Rat U.S.O.,* and *Rat Doctor* anticipated the more elaborate and systematized mythological structures created later by the artists dealt with in Chapter Eleven.

Conner's assemblages soon took many directions and forms. Common to most of them was the use of nylon stockings, with their hint of sexual fetishism. They served simultaneously as screens (like spiderwebs, veiling objects and images in mystery) and as containers (stuffed with detritus and knotted shut, they suggested internal organs). Old window shades, furs, jewelry, fragments of photographs, mirrors, nutshells, cigarette butts—all entered into the conglomerates, frequently under a covering of candle wax or dust and dirt. This covering united the disparate objects visually and also enveloped them in a sinister atmosphere, in which an undercurrent of fetishism mingled with evocations of decay and death. The titles of these early pieces hint at many

of Conner's major themes: *Arachne, Spider Lady Nest, Night Lady, Le Bijou, For Marilyn, Altar Piece, Good Friday, Annunciation, Cosmic Death Song, Tick Tock Jelly Clock Cosmotron.* The objects of which these assemblages were made seemed, as Philip Leider observed, not so much "found" as irretrievably lost, festering with dry rot; but the relationships between them crackled with psychic energy.[23]

A few of Conner's assemblages became fully dimensional sculptures. Some were outspoken expressions of social protest. *Child,* a grotesquely gnarled, life-sized figure in black wax placed in a real highchair, was inspired by the gas-chamber execution of the convicted rapist Caryl Chessman, who for years had made appeals for clemency from San Quentin's Death Row. It scandalized viewers when it was exhibited in a San Francisco Art Association Annual at the M. H. de Young Memorial Museum. (See Fig. 84.)

Conner spent 1961 and 1962 traveling in Mexico, and his assemblages became more sparse. ("It's hard to find junk there," he explained. "They use everything.")[24] Objects and images

FIG. 85. Bruce
Conner, *Triptych*,
1964. Mixed media
on masonite; three
pieces: 44⅛″ ×
31¼″, 47¾″ × 49¼″,
44¼″ × 31″.

now reflected the influence of Mexican religious and popular art: altarpieces, crosses, pictures of Our Lady of Guadalupe (sometimes combined with tattered pin-up girls). (See Fig. 68, p. 80.) In 1963 Conner visited Wichita, Kansas. Many of the assemblages he completed there had grounds of faded and tattered chunks of old linoleum, which gave them a particularly corrosive as well as nostalgic quality; they were like Abstract Expressionist paintings without paint (see Fig. 85).

The assemblages and collages grew logically into the films which Conner began to make in 1958, and upon which he concentrated more exclusively after receiving a Ford Foundation grant in 1963. ("I stopped gluing it down," he said.)[25] His first film, entitled merely *A Movie,* was a twelve-minute collage of stock footage, juxtaposed to emphasize the relationship between sex and violence in American popular culture. Most of his later films combined smatterings of live footage with a preponderance of stock. Highly concentrated and usually very brief—one 1965 film lasted only ten seconds—Conner's films were brilliantly edited so that the collision and flow of images formed a current that moved

parallel to their thematic content. They were also "choreographed" to soundtracks. For *The White Rose* (1965) Conner used Miles Davis's "Sketches in Spain," and for *Vivian* (1965) he used Conway Twitty's "Mona Lisa." These works established Conner as one of the most important independent filmmakers of the 1960s.

Conner also turned increasingly to mystical drawings, constructed of countless whorls, abstract squiggles, and hieroglyphic lines rendered in felt-tip or ballpoint pen. They often suggested fields of magnetized iron filings, or vastly enlarged, highly energized fingerprints, as well as the ritualistic process that went into their formation. The shapes gathered into densely packed masses to form mandalas, or they separated and interacted with the white space of the paper to create swirling paths of movement. (See Fig. 86.)

Conner exhibited his work regularly from the time he first arrived in the Bay Area, and by the mid-1960s it was also being shown in London, Paris, and Rome. In 1966, feeling he had been victimized by "the art business," he withdrew from "public art"—the first of several such withdrawals. In the years that followed, he helped

produce light shows for rock dances (with Ben Van Meter's North American Ibis Alchemical Company), designed a cover for the first issue of the Haight-Ashbury *Oracle,* campaigned for election to the San Francisco Board of Supervisors in 1967 (he drew 5,228 votes), and produced a series of lithographs at the Tamarind Workshop in Los Angeles. He also created three volumes of Ernst-like photo-etchings that were published by Crown Point Press under the title *The Dennis Hopper One-Man Show,* and was the subject of a solemn, tongue-in-cheek photo-documentary by Tom Garver, "Bruce Conner Makes a Sandwich," published in a 1967 issue of *Artforum.*[26] In the middle 1970s, Conner completed a series of large acrylic paintings that translated the intricate shapes of his drawings into expansive, cell-like forms in black on unprimed canvas. He later collaborated with photographer Edmund Shea in *Angels,* a series of photograms of his body in various hieratic poses (photograms are photographs made without a camera, by directly exposing photographic paper to light). In the last years of the 1970s, he turned his attention to the punk rock scene, taking still photographs at local punk rock

clubs and completing a film (1981) in collaboration with David Byrne, leader of the New Wave group The Talking Heads. In 1982, Conner was immersing himself in the world of gospel music.

When George Herms arrived in San Francisco in 1959, he became the Bay Area's third major practitioner of assemblage. (See Fig. 87.) Like Berman, he was self-taught as an artist, and had developed a mature assemblage style by the time he became active in the Bay Area. In 1955 he met Berman and Robert Alexander, and after studying engineering for a semester at the University of California in Berkeley, made an extensive hitch-hiking trip through Mexico. He had begun to comb the beaches during his travels, and his first "exhibition" was a secret private ritual carried out in 1957, when he installed some objects he had made among the foundation blocks of a row of demolished buildings in Hermosa Beach, leaving them to rot. Shortly after his arrival in San Francisco, two years later, he moved into a decrepit shack next to Wallace Berman on a canal in Larkspur.

Herms created the most informal and the simplest of funk assemblages: they were gentle

FIG. 86. Bruce Conner, *Untitled Drawing 1966-D-9,* 1966. Felt-tip pen on paper, 25½" × 25½".

and genial, less sardonic than Conner's and less hermetic and more humorous than Berman's. The objects in his assemblages more often became metaphors without any diminution of their original identities and associations. *The Librarian* (Fig. 88) was a heap of old books, arranged in the shape of a simple, extended cross. *Poet* was a dais supporting an open book and a mushroom. Some of his pieces invited an almost literary interpretation in terms of their "controlling image," which was often provided by the title. *Saturn* (1960), for example, was dominated by objects that formed rings; an old girdle and a highway detour sign alluded to Saturn's astrological meaning of obstruction; rubber balls eaten away by decay reflected the planet's association with age. But the transformation from object to metaphor was never complete. The works derived their poetic power from the way their components could never be quite pinned down as object or symbol,

but seemed to exist in a twilight zone between. (See Fig. 89.)

The prolific year that Herms spent working in Larkspur culminated in a group of monumental tableaux that formed his first major one-man show, at the Batman Gallery on Fillmore Street in 1961. The show's centerpiece was a group of related assemblages collectively called *The Meat Market*—a conglomeration of old clothing dummies, dolls, cabinets, and other objects which, with the help of some price-tags for cuts of meat found at the Larkspur dump, became the metaphorical props and furnishings of an old-fashioned butcher shop.

Herms's Larkspur period ended when his battered shack was declared a public nuisance by city officials and he was ordered to vacate it. He sold his work at a public event he called the Tap City Circus ("tap city" was hipster argot for "broke") and moved back to Southern California.

The Beat Era

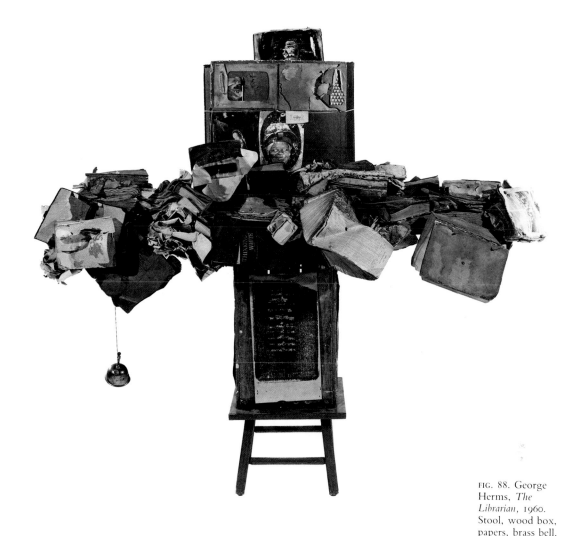

FIG. 88. George Herms, *The Librarian,* 1960. Stool, wood box, papers, brass bell, and books; 57" × 63" × 21".

More and more Beat artists arrived in the Bay Area in the last years of the 1950s, and so did more and more writers and photographers for *Life* and *Look* and the NBC-TV "Today Show," and more and more hangers-on and tourists. The artists tended to gather in loose, transient circles with common interests—which as often as not included the ritual use of drugs like peyote or methedrine; they sometimes shared living and working spaces. A mystically inclined circle that formed around Berman and Herms included Keith Sanzenbach, Dick Kiggens, Jack Carrigg, Paul Beattie, and Larry and Patricia Jordan, in addition to the Los Angeles expatriates Robert Alexander, Arthur Richer, and John Reed. Alexander was particularly important as a kind of all-around catalyst in this group. An outgoing, energetic street-person who had become involved with a mystical branch of Mohammedanism, Alexander—or Baza, as he was called—did incisive, evocative collages that sometimes included scraps of written poetry, along with handprints or footprints. He returned to Los Angeles in 1960, and in the 1970s was the

FIG. 87. George Herms, Larkspur, California, 1961.

The Beat Era

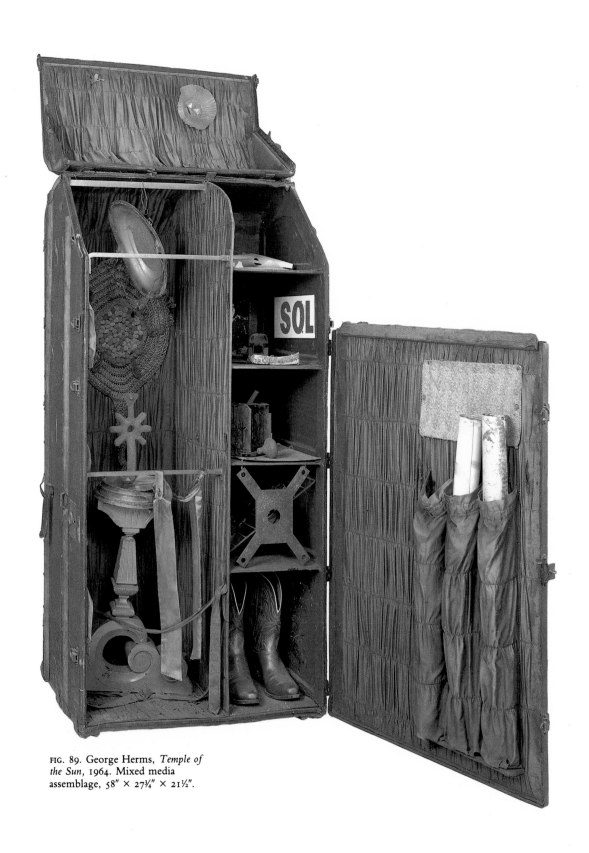

FIG. 89. George Herms, *Temple of the Sun*, 1964. Mixed media assemblage, 58″ × 27¾″ × 21½″.

leader of a Family of Life church in Venice, California, where he staged exhibitions and readings by Beat-era artists and poets from the Bay Area as well as Los Angeles.

Keith Sanzenbach, although his work was exhibited only in a few bookstores and bars, became something of an underground legend after his death in 1964. For a brief period, he made some of the era's most profound paintings. A prize-winning poet at Syracuse University, he completed a year of graduate work at the University of New Mexico in Albuquerque before coming to San Francisco in 1957.

Sanzenbach moved through a succession of cheap hotel rooms, communal living and studio spaces, and Sausalito houseboats. At one time he lived and painted in the attic of Wallace Berman's house on Scott Street. He mixed alcohol, barbiturates, and methedrine, and it was a combination of these that caused his death while he was living at Big Sur, on April 15, 1964.

A precocious and facile draftsman, Sanzenbach occasionally painted realistic landscapes and harbor scenes which he sold to friends and tourist galleries in Sausalito. His serious work reflected his psychological explorations, in which he was influenced by his reading of Jung and esoteric literature and by his experiments with hallucinogens and other drugs. A work that preoccupied him for several years was the *Chaos Notebook,* in which his reflections on suicide, death, and the supernatural were chronicled in writings and drawings that mingled surrealism and expressionism and anticipated the more nightmarish features of psychedelic art in the later 1960s. Sanzenbach's most monumental works originated with a series of small mandalas—circles in Sumi ink on paper—painted while he was living in isolation in the Santa Cruz mountains for a short period in 1958. These developed into a series of immense paintings that he completed over the next two or three years while living and working on the roof of an old firehouse on Waller Street, in the Haight-Ashbury district. Most were done on large burlap wrappers acquired from a nearby carpet dealer. Their gestural shapes—painted in sweeping swaths and trickles of thin pigment, mixed with gold leaf and scraps of torn paper—rested on a minimal underpinning of loose, circular forms and lines that seemed to radiate out from their centers into the surrounding chaos. (See Fig. 90.) Raw and funky, with crusty surfaces and dry, parched colors, these paintings represented a curious bridge between Abstract Expressionism and the Visionary art that would

later be refined by some of Sanzenbach's friends, notably the early light-show artists Elias Romero and Bill Hamm.

Another loose circle of Beat painters included Arthur Monroe, Michael McCracken, and Michael Bowen, who shared a large loft in the late 1950s at 72 Commercial Street. Monroe, the most original, had been among the black artists and poets—notably Harvey Cropper, Ahmed Basheer, and Ted Joans—who were close to Charlie Parker during his down-and-out last months in New York's West Village. Arriving in San Francisco in the mid-1950s, after traveling through Mexico, Monroe alternated between abstract works and figure paintings boldly brushed in oil on large sheets of paper. The abstract works were complex, rhythmic calligraphies in rich blacks or browns and gold, which suggested the exotic glyphs of the Mayans and other pre-Hispanic American cultures. The paintings, as well as some of the assemblages that Monroe fashioned in nails, paper, and wood, occasionally assumed circular, mandala formats. In the 1960s and 1970s, Monroe traveled in Central and South America, Japan, Korea, and Nigeria, and various influences from these sources entered into his subsequent painting—Sumi-like monochromes, calligraphic motifs, infinity symbols.

Many artists associated with the Beat scene had few interests in common beyond a preference for low-rent living space, drinking in North Beach bars, and being where the action was. The scene embraced almost a full range of stylistic attitudes—including those of older painters like Avrum Rubenstein, whose style was a pastiche of Ben Shahn and Raphael Soyer, and Alex Anderson, who had painted murals for The Black Cat in the 1940s and alternated between a steely, pre-Raphaelite realism and an extravagant, campy expressionism.

One of the most remarkable North Beach painters was a young black artist, Aaron Miller, who created a monumental series of wall frescoes depicting the Stations of the Cross in an African Methodist Episcopal church on Post Street in the Japan Town district. Except for a stint of painting insignias while serving in the army, Miller said, he had never painted before. In his frescoes (for which he received the scant proceeds of a church collection), the crucifixion story was presented with primitive power. From fantastic architectural and landscape backgrounds, expressively distorted figures seemed to step into the viewer's space, and villainous Roman soldiers leered and tormented with the heightened presence of comic-book

106

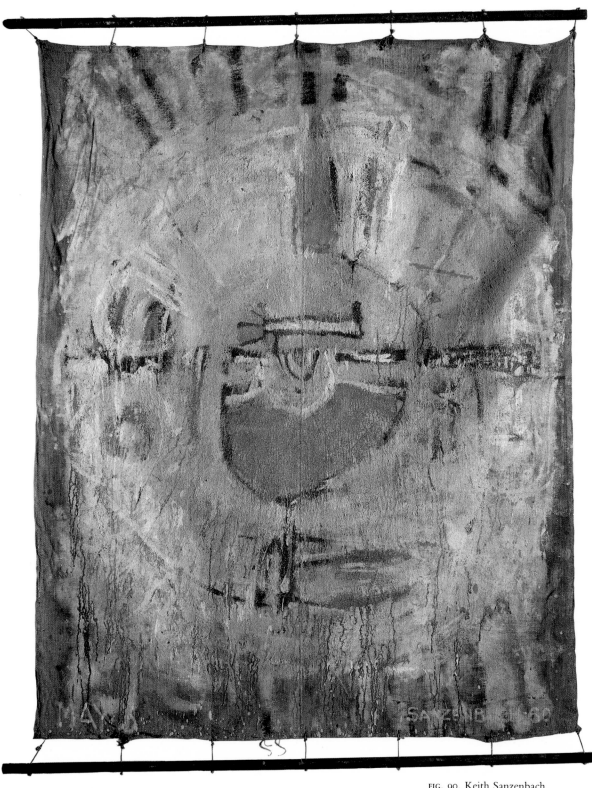

FIG. 90. Keith Sanzenbach, *Mandala,* 1960. Oil and lacquer on burlap, 86″ × 69″.

FIG. 91. Aaron Miller, *Jesus is Laid in the Tomb*, 1950. Housepaint on plasterboard, 168″ × 108″.

caricature. (See Fig. 91.) Incarcerated in mental hospitals during most of the 1960s, Miller died in the early 1970s, apparently of starvation, in a cheap San Francisco hotel room. The church and all but two of the frescoes were demolished in 1974 in an urban renewal project.

A few artists who came to the Bay Area in the late 1950s carried the spirit of vintage funk art into the next decade. The most extraordinary was Fredric Hobbs, who had lived and studied for several years in Madrid before coming to San Francisco. Inspired by Goya, Hobbs's paintings were populated with demons performing sacrifices and contemporary witches' sabbaths; they combined an old Masters' graphic style with violent, expressionistic colors and paint surfaces— or, on occasion, blood. His grotesque figures gradually became translated into sculpture. In the early 1960s—inspired by the folk idols used in pagan rituals and primitive religious processions— Hobbs began adding wheels to his mutilated Everymen and deformed Earth Mothers and rolling them about the streets. His most ambitious "parade sculpture" was *The Trojan Horse,* a horrendous tableau of mythological monsters that rose from Procrustean slags of plexiglass attached to a stripped-down auto chassis (Fig. 92). Wearing an orange jumpsuit, Hobbs drove the creation to Los Angeles, where he exhibited it at several locations.

In the Beat period, basically a mere five years between 1955 and 1960, an immense wave of anti-establishment energy crested and broke in a dozen different directions. It was a time of radical transition, in which the dawn of Neo-Dada (and Pop art) contended with the twilight of Abstract Expressionism—and in many ways with the final fading of nineteenth-century romanticism generally.

The cross-currents that gave the period its special character in the Bay Area had counterparts on the East Coast, in the milieu that gave rise to the work of Robert Rauschenberg, Andy Warhol, and Jasper Johns. Bruce Conner's films, for example, with their use of filmstrip lead-ins and other devices that called attention to the medium

The Beat Era

FIG. 92a. Fredric Hobbs, *The Trojan Horse*, 1966–1967. Fiberglass and acrylic on Chrysler sedan chassis.

FIG. 92b. Fredric Hobbs driving *The Trojan Horse*.

itself, were at least superficially allied to the structuralist esthetic that first crystallized in the East, in the 1960s, around Marshall McLuhan's fertile notion that "the medium is the message." And on the surface, Wallace Berman's work bore a certain resemblance to that of Andy Warhol: it showed the same predilection for serial formats and inexpensive mechanical reproduction, the same inclination to explore various modes of expression while refusing to present itself as High Art.

But the new day broke more quickly on the East Coast, and the balance of forces there was fundamentally different. Conner, Berman, and other funk artists on the West Coast developed their work organically from a core of personal and social experience which remained central to it. They leaned more toward absurd and savage comedy than the first-generation Abstract Expressionists, but in their own way they were just as impassioned, uncompromising, and morally concerned; and their irony, like Kierkegaard's, was not a form of cynicism but a "concealed enthusiasm in a negative age." For all their use of "despised sources" (Duncan) and the "vulgar" and "disreputable" (Martin), they expressed a fundamental reverence for the life of the spirit, and for the power of art to enshrine and communicate it.

East Coast artists like Rauschenberg and Johns also mined the "gap between . . . art and life" (as Rauschenberg called it).[27] But perhaps because they were working on the floodlit stage of the New York art world, they developed strategies for neutralizing the objects and images with which they dealt, ways of domesticating and converting them into harmless objets d'art. East Coast assemblagists, and stagers of "happenings" in particular, put a frame of art around pieces of reality, in the manner of Duchamp; and to keep the frame intact, they engaged in a loud dialogue with art history at every possible point. This rationale led logically to the conceptualist claim that a mound of dirt, if placed in the proper context, could be a work of art.

In contrast, the best West Coast funk artists created a form of visual poetry, as concrete as its materials and as metaphorical as the connections one could draw between them. They sought to intensify the meanings of their images, and multiply their connections with the real world. Theirs was basically an "outsider art," closer to nature than to culture, an organic expression of the artist's evolving life and experience. As Fred Martin remarked when Wally Hedrick was once called a precursor of Pop art because he had

painted a picture of a television set a decade before Pop art was born: "He was not a precursor because the works were not participants in some large and objective cultural involvement; they were only Hedrick making what he would make out of the stuff of his life."[28] At its outer extreme, this esthetic degenerated into the life-is-art stance of the cracked hobbyist or maker of environments whose work disappears into the landscape, just as the Duchamp-inspired museum art of the East Coast has gradually lost its capacity to shock and has disappeared into the history of taste. Thus one legacy of 1950s Beat art lies in the funky assemblages and sculptures that rose anonymously during the 1960s on the Emeryville mudflats, just across the Bay Bridge from the City. But in those few special years of precariously balanced contradictions and paradoxes, when most funk artists were unconcerned about whether their work survived or not—and in the mature achievements of such artists as Berman, Conner, Herms, De Feo, Jordan Belson, and Manuel Neri in the decades that followed—works of enduring spirit and vitality were created.

As the 1950s ended, the bohemian community that had nurtured the Beat movement and early funk art was rapidly disintegrating, for the familiar reasons: bohemian communities attract tourists, who attract shopkeepers, who drive up rents. Overrun by sightseers in Gray Line buses, and teenagers eager to be considered Beatniks but unable to gain admittance to the bars (they stood outside with their bongo drums and recorders, becoming the earliest "street people"), North Beach no longer had the privacy that had been so attractive to artists only a few years earlier. The artist and his audience in North Beach had once been virtually identical; as long as a center for activity remained, it had been possible for artists to communicate with each other and receive mutual recognition. But by the early years of the 1960s, more and more of them were moving away—to Haight Street or Potrero Hill in the City, to Mendocino, Big Sur, New York, or Mexico. One by one, most of the old gathering spots closed—The Place, the Co-Existence Bagel Shop, Cassandra's Coffee House, Mike's Pool Hall—or their clientele and atmosphere inexorably changed. The transformation of North Beach was completed when Broadway became a midway of night clubs featuring topless dancers. In an odd way, the kinetically flashing lights and honky-tonk neon signs of these clubs, with their bright, hard-edged colors, symbolized the era that was to follow in Bay Area art.

The Beat Era

FIG. 93. Robert Arneson, *Alice House Wall*, 1967. Polychromed earthenware, 60″ × 95″ × 13″.

It would be hard to find two artists more radically opposed to Clyfford Still, in personality and viewpoint, than William T. Wiley and Robert Arneson. Wiley, who lived in an old house on a wooded hillside in Marin County, worked in a barn across the brook, where he painted pictures of hatchets buried in old stumps and made peculiar objects of tree branches and animal hides. With his faded blue denims, black felt cowboy hat, and drooping mustache, he fit the image of an easy-going Zen frontiersman: homespun, wryly laconic, nonjudgmental. Arneson was a burly, rough-hewn, and expansive man of the type one might expect to find presiding over a keg of beer at a Future Farmers' Fourth of July picnic. Working in a studio on the campus of a former agricultural school in the Sacramento Valley (U.C. Davis), he used clay—a medium widely considered unfit for serious art—to make ceramic beer bottles, trophies, and toilets. Like Wiley, he took the down-home position that art was nothing very special—certainly nothing precious or "elitist"—and that the artist was basically just "one of the boys."

Wiley and Arneson became two of the most prominent Bay Area artists of the 1960s and 1970s. In their own ways, they took new directions which were representative of changes that shook the world of contemporary art quite as decisively as Abstract Expressionism had shaken it after the war; and their work partook of some of the self-conscious regionalism which, in Northern California, was one of the most characteristic forms these changes took. A few years earlier, Bay Area Figurative painting and funk were significant departures from the kinds of expression that artists like Still, Pollock, and Rothko had evolved during the 1940s, and from the conventions to which these individual styles had been reduced by their followers. But the Figurative and funk styles had both developed within the general philosophical framework of Abstract Expressionism, with its emphasis on art as a rigorously ethical, almost religious activity, and on the passionate, committed identification of the artist with his work. The styles and movements that began to proliferate in the early 1960s—and the growing number of working and exhibiting artists involved in them—marked a watershed, a fundamental change in sensibility. By the end of the 1970s, when this change had been completed, contemporary art no longer functioned primarily as a critique of culture that remained fundamentally estranged from it, as it had during the 1940s and 1950s. It had become a firmly established branch of contemporary culture, and one of the most sensitive barometers of the two broad currents that most clearly distinguished it: the conversion, which had been accelerating since the end of World War II, from a production-based economy to an economy geared primarily toward consumption; and the growing homogenization of cultural values brought about

by the revolution in mass communications. The latter, in the world of art, produced the succession of stylistic changes, known as the mainstream, that swept virtually every corner of the country in the 1960s, and against which regionalism arose in certain areas (Northern California, Chicago, Texas) as a militant and frequently self-parodying reaction.

As was the case with Abstract Expressionism fifteen years earlier, this watershed occurred at a time of profound changes in the political and social, as well as the economic, world. In his inaugural address in January 1961, President John F. Kennedy made a stirring appeal for new efforts and new commitments. Intellectuals and liberals who had withdrawn from public life during the Eisenhower administration found new hope, and many were given conspicuous roles in government. Young people accepted the challenge of engaging in active programs of social reform. And the lifestyle of the new first family, no less than the administration's official policy, gave new emphasis to the values of art and culture. The assassination of the president less than three years later left an aftermath of frustration and rage, but the apathy of the 1950s did not return. A positive feeling persisted, a conviction that changes could be achieved if people were willing to fight for them.

Along with a new wave of optimism, the early 1960s brought unprecedented peacetime prosperity to America. The exodus from the major cities continued to gain momentum, and in the burgeoning suburban areas middle-class consumers, surrounded with new, labor-saving home appliances, used their new leisure time to consume more of almost everything—including generous, if generally diluted, quantities of art and culture. The Book of the Month Club and similar programs offered everything from reproductions of famous paintings to stereophonic records (another new invention). Presiding over all of this, it often seemed, was the new household deity of television, the consumer product par excellence. No longer a novelty, as in the 1950s, it mixed advertising with mass entertainment in such a way that the ad man's pitches became an accepted element of popular culture.

Media of every kind proliferated, and among the specialized magazines that sprang up were several journals devoted to contemporary art. To meet the seemingly insatiable if often superficial curiosity of their new audience, editors and writers cast about increasingly for the offbeat, the

brand new, the sensational "discovery." The interval between the time a phenomenon developed "underground" and the time it was paraded before the public became shorter every year, and more and more developments were consciously fabricated with publicity uppermost in mind. Eventually, as Norman Mailer had prophesied in the late 1950s, news about events, or the critical reviews, began to become as important as the events themselves.

Artists seemed to have as many reasons as most others to share in the nation's more optimistic outlook. A lucrative market had gradually developed for Abstract Expressionism during the 1950s in New York. A new generation of college-educated business and professional people had acquired a receptivity to contemporary art, if not always a deep understanding of it, through the art history and art appreciation classes that had multiplied in American universities. Encouraged by tax concessions, private business found it attractive policy to tone up a "corporate image" by purchasing works of contemporary art to hang in lobbies and service areas, and even in employees' private offices. More direct support eventually came at the public level. San Francisco and many other cities passed ordinances that permitted a certain percentage (usually 2 percent) of the total cost of new public buildings to be spent for art works. By the end of the decade, the federal government had established the National Endowment for the Arts, and the country's mushrooming crop of artists was competing feverishly for its grants.

Even the art section of *Time* magazine, perhaps the most sensitive barometer of average American taste, made an about-face. Once predictably sarcastic and hostile toward modern art, it began to welcome the work of new artists, though its level of critical discrimination remained about the same. Avant-garde art, like everything else, was no longer underground, or did not stay there very long.

By the beginning of the 1960s, the United States had come to think of itself as the center of the contemporary art world. The United States, in this context, meant New York, which had, besides money, two main sources of power: a factory of ideas and theories that arose in response to the work of certain artists (known loosely as the New York School); and a fast-growing network of communications, primarily art magazines, that spread a new gospel to the hinterlands. At the core of this gospel was a militant reaction against Abstract Expressionism.

This reaction followed two principal lines. The first was primarily a revolt against abstraction. Some elements of it had appeared earlier, of course, in the work of the Bay Area Figurative painters and in the creations of the funk artists. But now, in the work of such New York artists as Robert Rauschenberg, Jasper Johns, and Larry Rivers, it took on a kind of aggressive self-consciousness. In 1953 Rauschenberg, until then a relatively conventional Abstract Expressionist painter, signaled his defection dramatically. After carefully erasing a de Kooning drawing, he asked de Kooning for permission to exhibit it. Outside the glare of media attention already being focused on the New York art world, a self-conscious gesture like this would have been virtually unthinkable. (Who would a West Coast artist in the mid-1960s have erased? Diebenkorn, perhaps, or Rico Lebrun, but who would have paid attention if he had?) Artists such as Rauschenberg and Johns, inspired by Duchamp, helped to stimulate a revival of interest in Duchamp's ideas, which culminated in a Duchamp retrospective organized by Walter Hopps at the Pasadena Art Museum in 1963.

The second main line of revolt was directed against the expressionist component of Abstract Expressionism, and it was closely associated with the ideas of the critic Clement Greenberg. Greenberg's approach combined Darwinism with the purist doctrines put forward by apologists for abstract art early in the century. He argued that the history of modernist art was an evolutionary sequence of stages, in which each stage became more progressive by purging itself of elements that were alien to its nature; thus painting should be flat, like the canvas itself, and should concern itself only with its unique properties, form and color. Greenberg had, with some discomfort, adjusted these ideas sufficiently to become one of the earliest promoters of Jackson Pollock, but his détente with the "action" branch of Abstract Expressionism was short-lived. By 1955 he had decided that the color-field abstraction developed by Still, Newman, and Rothko was more important, because these color painters had cast away "decipherable references to Cubism," which Greenberg now considered old-fashioned.[1] By the end of the decade, there arose a new school of abstract painting—"stain" painting—that conformed more closely to Greenberg's theories than any school that had existed when they were first formulated. The peculiarities of stain painting, developed by Helen Frankenthaler and Morris Louis, were intimately bound up with the charac-

teristics of a relatively new paint medium, acrylic. More fluid than oil, acrylic seemed more responsive to physical laws—the pull of gravity, the principle of flow. In the drip paintings of Pollock, the pigment remained more or less as it was when it first came in contact with the canvas; one could sense how it had been pushed or hurled about. The acrylic paintings of Frankenthaler and Louis, though influenced by Pollock, appeared almost to have painted themselves. Whereas the Neo-Dada works that took off from Rauschenberg and Johns tended to grow more and more three-dimensional, reaching physically into space, the new Formalist abstraction, its shapes and colors reduced to pure hues and "essential forms," expanded laterally to assume an almost wall-like presence. At its strongest—as in the paintings of Ellsworth Kelly—it drew the viewer into a realm of pure sensation.

Both Neo-Dada and the new Formalist abstraction shared a tendency to "objectify" and conceptualize. The Abstract Expressionists had struggled to make their paintings living organisms that would embody—rather than symbolize or illustrate—their emotions and ideas. Nonetheless, their work was also metaphorical, intended to convey much more than the sum of its physical material. But in the work of the new color-field painters (as Frank Stella later put it), what you saw—color, shape, scale—was what you got. Or almost everything you got, because such work, if it was to be perceived as anything more than spots of color, presupposed the viewer's ability to place it within an invisible framework of ideas, in this case to recognize its specific contribution to a continuing dialectic of self-purifying and self-renewing art-historical evolution. Similarly, the work of Rauschenberg, Johns, and other Neo-Dadaists, although more unruly than that of the Formalists, had an "objective" tone of psychological neutrality or distance. The heavy, "painterly" brush marks and other Abstract Expressionist devices no longer functioned as a symbolic shorthand to express the struggle of creation or imply metaphorical content. They were simply physical facts, like the canvas itself and the found objects that were frequently attached to it. They thereby became a kind of conceptual, or contextual, parody of Abstract Expressionism. Such parody achieved perhaps its most lucid expression in Roy Lichtenstein's 1965 *Little Big Painting,* which depicted a loaded, gestural Abstract Expressionist brushstroke with the cool, mechanical precision and Ben Day dots of mass-produced, full-color advertising art.

114 Lichtenstein's painting belonged, of course, to Pop art, which combined Neo-Dada's detached, ironic approach to the realism of everyday objects with the flat surfaces, intense colors, and bold formal simplifications of the new abstract painters. In Pop art, too, a strong conceptual bias lurked, so to speak, in the wings. As Duchamp said of Andy Warhol's early paintings: "If a man takes fifty Campbell's soup cans and puts them on canvas, it is not the retinal image that concerns us. What interests us is the concept that wants to put fifty Campbell's soup cans on a canvas."[2]

Pop art became the first "movement" in modern art to win immediate acceptance from the public at large. People were clearly happy to see painting return to images they found instantly recognizable. Beyond that, Pop painting had a distinctively stylish "contemporary" look, and one could like it without having to feel déclassé. Its hip, sassy stance was a "cool" put-down of Abstract Expressionism's uncompromisingly serious claims. Even more than Formalist abstraction and Neo-Dada, Pop art mirrored the mood of a country that was feeling good about itself. For so long indoctrinated with a sense of cultural inferiority to Europe, Americans became aware of the richness and vitality of their own vernacular, of the visual forms that had grown organically and often anonymously out of the nation's pragmatic, commercial culture. In helping stimulate a reexamination of neglected aspects of America's visual heritage, Pop art contributed to a nostalgia boom that continued unabated through the 1970s. This was the positive side of Pop. Its negative side was that it all too easily became a triumph of the very commercialism it seemed to parody. (Actually, the intention to parody was usually attributed to these works by apologists; the Pop artists themselves, perhaps cannily, maintained a cryptic silence on the subject.)

No art center in the United States was immune to the radical changes that swept through the art world as the 1960s began, although in most places these changes occurred more slowly and more erratically than in New York. In the Bay Area, the market for contemporary art remained for some time notoriously slim. Walter Keane, who specialized in waifs with Bambi eyes, was still the area's top seller. After early schooling or first exhibitions in San Francisco, such artists as Mark di Suvero, Ron Bladen, and Robert Morris joined in the exodus to New York that had been set in motion by Still's former students in the early 1950s. Other ambitious young artists, among them Ron Davis and Robert Graham, began to migrate to Los Angeles, where a plentiful supply of "new money" was gravitating toward the chic world of contemporary art.

Symptomatic of the vagaries of the Bay Area art world in the early 1960s was the short local history of the magazine *Artforum*. Founded in 1962 by John Irwin, the magazine hired Philip Leider, who had helped operate the John Bolles Gallery, as its managing editor; John Coplans and Arthur Secunda were contributing editors from San Francisco and Los Angeles. The first issues were dedicated principally to exploring the work of Bay Area artists; the tone was less analytic than promotional, or at least zealously committed to gaining greater recognition for West Coast artists. As the magazine sought a wider advertising base than San Francisco galleries were able or willing to provide, its coverage and its advertising came to focus increasingly on Southern California, and it moved its editorial offices there in the mid-1960s. Its editors then cast their eyes eastward, and by the time the magazine relocated to New York in the early 1970s, it had become the bible of avant-garde art fashions for much of the English-speaking world. Exhibitions in San Francisco (and increasingly in Los Angeles) were relegated to back-of-the-book monthly "reports."

Nonetheless, there soon developed a local "art scene," responsive to the new facts of life on the national stage but adapted to the more relaxed style that prevailed in the Bay Area. Galleries such as Dilexi and Bolles, originally conducted with a freewheeling, bohemian informality, became increasingly professional in operation and respectable in tone. New galleries were established. With the steady increase in the number and professionalism of dealers who welcomed the work of serious local artists, the artist-run or artist-oriented underground gallery—like the long-defunct Metart, Six, or King Ubu—tended to disappear. The bigger galleries had the additional advantage of being able to attract the attention of East Coast dealers and curators for possible exchange arrangements with New York galleries, or for inclusion in prestigious group shows, such as the Whitney Museum's annual exhibition.

In the late 1960s two of the finest new museum buildings in the country rose in the East Bay. The Oakland Museum, designed by Kevin Roche as a series of low-slung terraces surmounted by sculpture courts and lushly landscaped gardens, had separate floors for history, natural sciences, and art; working from the nucleus that the old Oakland Art Gallery had amassed in its cramped quarters in the nearby Municipal Auditorium,

FIG. 94. The
Oakland Museum,
opened in 1969 on a
7.7 acre site in
downtown
Oakland.

FIG. 95. Interior of
the University Art
Museum, Berkeley.
Opened in
November, 1970.

curator Paul Mills assembled a unique permanent collection devoted to historic and contemporary California art. (See Fig. 94.) The new University Art Museum in Berkeley, a dramatic concrete structure arranged in five ascending levels that fanned out like a hand of cards, and with an interior of ramps from which dramatic perspectives unfolded as in a Cubistic Piranesi drawing, was designed by Mario Ciampi, a San Francisco architect. (See Fig. 95.) Peter Selz, the new museum's first director, came to the Bay Area from the Museum of Modern Art in New York, where he had been the curator of the department of painting and sculpture exhibitions. His experi-

ence and his connections there were major factors in establishing, virtually from scratch and mostly by donations, a small but respectable collection of both historic and modern works. Its nucleus was a cross-section of forty-five paintings given to the museum in the early 1960s by Hans Hofmann (whose gift of $250,000 for the Memorial Galleries to Hans and Maria Hofmann on the museum's top floor was instrumental in getting construction of the new building underway).

The San Francisco Museum, under the directorship of Gerald Nordland (Grace Morley had resigned in 1960 to accept a post with UNESCO, with which she had been involved since 1945),

Funk, Pop, and Formalism

expanded to fill another floor of the Veterans Building. Local artists continued to find opportunities to exhibit at the San Francisco Art Institute (which changed its name from the California School of Fine Arts in 1960) and at the Richmond Art Center (founded in 1950). A Berkeley Art Center was established later in the 1960s, and it was joined by still another new municipal art center in Walnut Creek.

In general, as the 1960s progressed, everything multiplied: the number of artists, students, teachers, places to show, and opportunities for exposure in the media. Only ten or fifteen years earlier, painters of the stature of Frank Lobdell and Hassel Smith had exhibited in quiet, out-of-the-way places like the Labaudt Gallery, and other gifted artists had sometimes found the few existing avenues of exposure closed to them entirely. By the end of the 1960s dozens of mediocre artists, the ink on their M.F.A. certificates hardly dry, were being shown in highly professional galleries and reviewed in newspapers and even art journals.

Bay Area artists who resisted the lure of New York benefited from the new teaching jobs that became available: established art schools and university art departments were being enlarged to meet expanding enrollments—the children of the postwar "baby boom" were reaching college age—and new state colleges were springing up in outlying areas. Teaching as an occupation—at least on a regular, long-term basis—had once been regarded with skepticism by many artists. (Those associated with the California School of Fine Arts, in particular, had held a certain disdain toward what they felt was the academicism of faculty members at U.C. Berkeley—mixed, according to Berkeley's Erle Loran, with a degree of resentment because "we had regular salaries while the guys in San Francisco had to get by in a less orderly way.")[3] But teaching had begun to gain a kind of respectability in the 1950s, as painter-teachers like Diebenkorn seemed to demonstrate that the two roles could be carried on with no visibly harmful effects to the integrity of their art. By the mid-1960s the University of California's campus at Davis, near Sacramento, previously a center for agriculture and home economics students, boasted one of the most vigorous art departments in Northern California, with a faculty that included Manuel Neri, William T. Wiley, Wayne Thiebaud, Robert Arneson, and Roy De Forest. Art departments were strengthened at state colleges in Sacramento and San Jose. The expansion of job opportunities meant that artists could join others in the general rush to the suburbs. In this, they were greatly encouraged by urban renewal projects within San Francisco itself, particularly the leveling of the old produce district, where many artists had rented cheap lofts. The best-known "San Francisco" artists in the 1960s were likely to live in the East Bay, Sacramento, San Jose, or isolated little towns like Port Costa or Benicia or Woodacre. Bay Area artists—and one might argue, their art—became suburbanized.

The financial security afforded by university and college teaching jobs—which usually required only two days a week in the classroom and also provided access to sophisticated sculpture, ceramics, and print-making equipment—gave artist-teachers a great deal of independence with which to carry on their work. On the other hand, surrounded primarily by other artist-teachers and students, and relatively isolated from the more varied social life of San Francisco, they may have become more receptive than in the past to the barrage of specialized information that issued from the new art journals and related media. In contrast to the rich mixture of interests embraced by the publications that were widely read by artists in the 1950s—*Evergreen Review, The Nation, Commentary*—these journals maintained a narrow focus on issues of contemporary art.

In general, the influence of Johns, Rauschenberg, and other Neo-Dadaists encouraged a relaxation from the view of art as a life-and-death commitment, which had prevailed in the Bay Area since Clyfford Still. At the same time, the Formalist influence prompted a more general move toward greater "clarity," crispness, and detachment—which in the case of painters was often accompanied by a corresponding switch from oil pigments to acrylic. There was thus a simultaneous loosening and tightening: the content or *substance* of art became less urgent, even a matter of indifference or a subject for tongue-in-cheek parody, while the *look* of the work, its technique and style, became relatively more important. There was also a new emphasis on durability, if not on craft as such (for a deliberate awkwardness and rusticity was often a part of the new style). Unlike the perishable assemblages of the North Beach funk artists, Bay Area art in the 1960s was increasingly built to show, and to last.

Although most Bay Area artists were affected to some degree by the new ideas that swept westward from New York, the best among them gave these ideas a fresh, individual inflection derived from persistent regional characteristics. In the work of Wiley and Arneson, Pop and Neo-

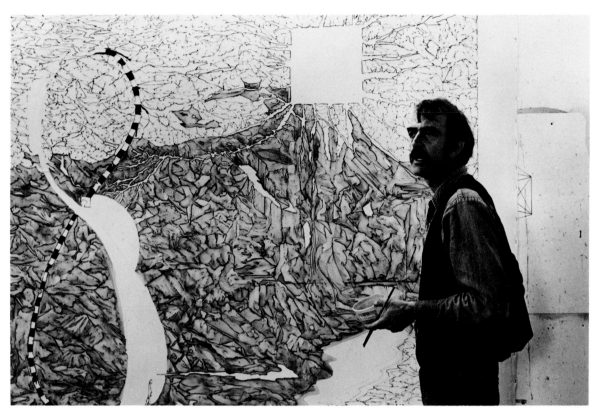

FIG. 96. William T. Wiley in his
Woodacre studio, 1975.

Dada—the two most common imports from the
East—mingled with indigenous expressionism as
well as with the native predilection for "childhood
haunts and fantasies." Wayne Thiebaud brought
about a curious reconciliation between Pop art and
Bay Area Figurative painting. And an expression-
ist approach or a foundation in landscape lingered
even in the work of Formalist painters like David
Simpson and Sam Tchakalian.

Wiley (Fig. 96) was one of three students
attending the San Francisco Art Institute in 1960
who had grown up together in Richland,
Washington (the others were Robert Hudson and
William Allan); each was to become a significant
figure in Bay Area art in the 1960s. Hudson
remembers Richland as a plutonium boom town
where most of a transient population lived in
fourteen square blocks of trailer courts. Both he
and Wiley had credited Richland high school
teacher Jim McGrath with giving focus to their
early interest in art.[4] McGrath, a painter himself,
had his high-school students doing Abstract Ex-
pressionist paintings; his own work, Wiley recalls,
frequently included written narrations. He also

developed their fascination with the life and rituals
of Indians on nearby reservations.

As students at the Art Institute, and later as
teachers, all three were involved in a peculiar
ferment that, in part, reflected the influence of
artist-teachers such as Frank Lobdell, and in part
signaled the beginnings of a reaction against it.
Their painting retained, at least at first, what John
Coplans described as the "thick skin . . . hard and
long worked paint" associated with Lobdell, with
its intimations of "a saturnine morality, an avoid-
ance of all that is considered modish or flashy or
that may come easily."[6] But there was something
more. As Philip Leider observed: "The concerns
of this group and those artists associated with
them—William Geis . . . Roger Jacobsen, Carlos
Villa, Bernice Bing, among others—have nothing
in common with Bay Area Figurative art. . . .
Both in sculpture and painting—and there is a
remarkable melding of mood and execution be-
tween the two, a fluidity of interchange of ideas
and techniques that is unique—the major preoccu-
pation is with parody and with the grotesque. The
subject of the parody is most often art problems—

Funk, Pop, and Formalism

118

FIG. 97. William T.
Wiley, *Whats it All
Mean*, 1967. Acrylic
on plywood and
mixed media.

FIG. 98. William T.
Wiley, *One Abstract
Expressionist Painting
Rolled and Taped*,
1966. Canvas, tape,
and wire; 34″ × 5″.

the conversion of the mythic shapes [of] the early work of Still and Rothko . . . into Joan Brown's *The Oven Blew Out.* . . . Robert Hudson will simply copy onto his sculpture some motif out of a painting of William Wiley's."[7] The work of these artists was thus more freewheeling than the academic conventions to which most Bay Area Figurative painting had been reduced by 1960, but it was also more self-consciously concerned with artistic "issues" (more a form of "art-school art") than the work growing out of the funk esthetic of North Beach in the 1950s.

Wiley in particular became recognized by teachers and fellow students as an outstanding talent. His earliest works were relatively straightforward, sometimes quite strong Abstract Expressionist paintings, reflecting Lobdell's preference for weighty, heavily outlined forms, gestural surfaces, and striking contrasts between blacks and whites and strong colors. Early on, however, Wiley displayed an interest in certain non-abstract ideas associated with culture, history, and myths. *Legend* (1959), *Folklore* (1961), and *Columbus Re-Routed* (consisting of three huge canvases completed in the early 1960s) foreshadowed the direction his later work was to pursue. In *Columbus,* the theme of voyaging into the unknown invoked the ethic of inner search that governed Lobdell's painting, and Lobdell's influence was further suggested by the presence of heroic pyramids and similarly archetypal shapes. But a tongue-in-cheek irony was apparent in Wiley's handling of these themes, and in his wryly spoofing title. The emphatic black contours resembled the drawing of cartoons, and the jagged shapes around a central field resembled Still's characteristic shredded forms translated into something that resembled wrapping paper, partially peeled away.

By 1962 Wiley was adding found objects to his paintings, which were beginning to take on the character of constructions. Influenced by his interest in Duchamp, they were something like the work of Jasper Johns with a Western drawl. In a construction entitled *Whats It All Mean* (Fig. 97), Wiley reduced Johns's oblique and paradoxical questioning to a statement as blunt as a miniature outhouse in a novelty store. As Lichtenstein had in *Little Big Painting,* Wiley proclaimed his own triumph over "A.E." in 1966 with a simple roll of canvas entitled *One Abstract Expressionist Painting Rolled and Taped* (Fig. 98). It may or may not have had anything painted inside.

Wiley's work moved in many directions, most of which soon reappeared in the work of other Bay Area artists. In the middle 1960s, following a Magritte retrospective exhibited at U.C. Berkeley, he painted large canvases in which enigmatic images—a chained pyramid, a coil of hose—were sometimes accompanied by words in carefully stenciled letters; they were done in drab, grayish colors, and in their style belonged to a relatively conventional mode of illustrative Surrealism. Together with Bruce Nauman, Wiley took part in activities that anticipated the development of conceptual art (and later collaborated with such conceptualists as Terry Fox when that movement was at its peak). By the late 1960s, Wiley was turning from combinations of painting and assemblage to free-standing sculptural objects, which often suggested some functional apparatus of which the function itself was impossible to identify: lattice-works and grids were common elements, and some pieces contained funky organic matter. Like his earlier paintings and constructions, most of Wiley's sculptural objects had narrative or "conceptual" underpinnings—meanings extrinsic to the form itself, which were suggested by titles or verbal inscriptions. A work consisting of a large ball of black electrician's tape, for example, was supposed to keep expanding—accumulating more and more strips of tape—until the Vietnam war came to an end.

Wiley's materials became increasingly rustic; they included stumps, roughly chiseled poles and branches, and an assortment of ready-made objects. His constructions grew more elaborate and complex. For example, *Thank You Hide* (1971) consisted of a large piece of animal hide into which the words "Thank You" had been cut, and to which was attached, among other things, the following: a rusted spike; a broken bottle; an arrowhead; an Iguana skin (from the collection of Wiley's eldest son); a piece of petrified wood surrounded by wavy drawn lines and the words "Nomad is an Island"; a shelf above the hide filled with bottles, forked branches, a jar labeled Fresh Bait, and a copy of Nietzsche's *Beyond Good and Evil;* a fishing stick with a line attached to a pickaxe; and a group of watercolors with written texts describing the objects and some of the history behind them. (See Fig. 99.) Wiley described the process of creation as follows: "I picked up the hide at a rummage sale—it was already there, so I felt absolved of any responsibility for killing [the animal]. Then Brenda [Richardson, a curator of the University Art Museum] gave me Nietzsche's *Beyond Good and Evil* to read. One day on the can, I just opened it to the middle and read a statement. I can't remember what it was, but it made me think, and I said 'thank you' to myself. Then I saw the words cut out on the hide. The hide seemed like a perfect net for a whole lot of things, in terms of the history of objects—Indian artifacts, for example; I used to sift the ground for them when I was growing up in Washington. The broken bottle, a friend brought by one day."[8]

Wiley was one of the pivotal figures in the transition between the funk art of the 1950s, with its lingering roots in Abstract Expressionism, and the more self-conscious Funk art that followed. His attitude and personal style provided a model for the laid-back, life-is-art rusticity that became prominent in much Bay Area art after the mid-1960s.

"Abstract Expressionism was revolutionary in its way, but it became a heavy moral trip," Wiley said of the early evolution of his work—and attitude—away from its Abstract Expressionist roots. "If you drew a line it had to be grounded to God's tongue or the core of the earth to justify putting it there. When I was doing the first *Columbus* painting, the absolute openness that was possible occurred to me. A door swung open, but only about half way and then closed again." Later, during a visit to New York in 1967, "the door" opened again. "I was struck," he said, "by what an incredible concept art was . . . nothing moral, no good or bad. All the restrictions and things I'd imposed on myself weren't necessary, but up for change, flexible. The door kind of swung all the way around in a circle and then went closed again, but now everything was inside it. I decided to simplify, to work within the idea of failure—so I wouldn't be battling success. Weakness is a greater strength."[9]

One consequence of Wiley's unhurried, unforced approach to art, life, and chance (*Refusing to Push It* was the title of one painting) was a wide-openness to influences and "imitation."

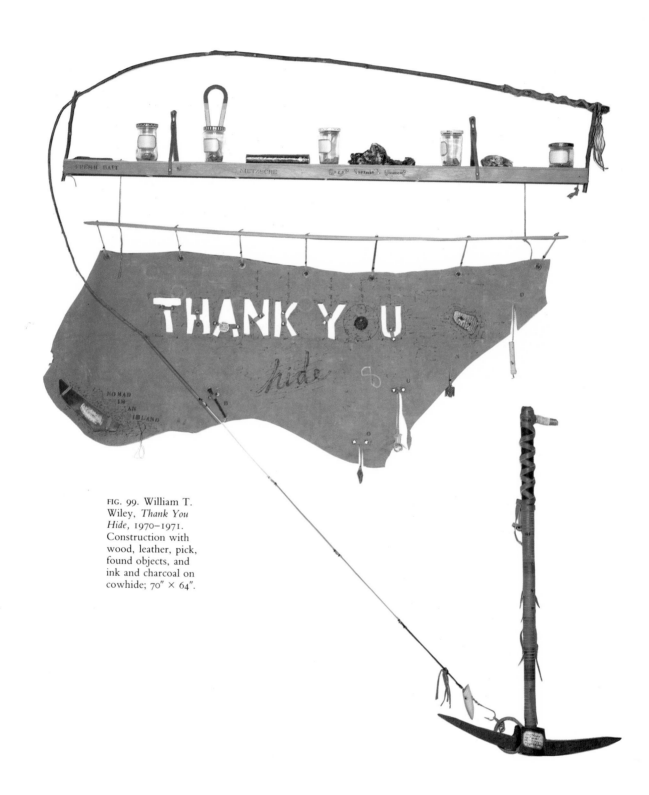

FIG. 99. William T. Wiley, *Thank You Hide*, 1970–1971. Construction with wood, leather, pick, found objects, and ink and charcoal on cowhide; 70″ × 64″.

"What you get from other people is a different language, a different phase of your own existence. . . . In my education you couldn't take from somebody else, [but] if you're thirsty, why pre-prejudice yourself about the taste of the water? Trust yourself enough to drink it and go on."[10] Accordingly, as Lieder noted, among Wiley and the circle of artists associated with him, there was often an interchange and overlapping of themes, motifs, and approaches—so much interchange, in fact, that it was sometimes difficult to tell where the work of one left off and the other began.

Wiley acknowledged an interest in "the Eastern thing—Zen," though claiming that he was not "much of a scholar."[11] Whatever the source of his attitudes, they proved as intoxicating to students, at U.C. Davis and elsewhere, as Clyfford Still's quite different ideas had been a generation earlier, and they were similarly embraced as a source of new freedom. Jock Reynolds, a student at Davis in the late 1960s, had this to say about Wiley: "He really is a person who can suspend judgment about a situation, work, etc., that might initially look empty. He leaves himself open about avenues of approach, materials, ideas. There's a story about one guy: Wiley had visited his studio, he was having trouble with his work, it wasn't coming through the way he wanted, and finally he showed Wiley a spiderweb—he'd left this spider alone for months and it had spun the whole corner of his studio. Wiley pointed out that that was the most interesting thing there, and it was significant that he'd been letting it happen."[12]

Whereas Wiley's work may be seen as a canny regionalist adaptation of the Neo-Dada of Johns and Rauschenberg—his style was dubbed "Dude Ranch Dada" by Hilton Kramer in reviewing a one-man show at the Hansen-Fuller Gallery in 1971—Robert Arneson originated the form that became California's most distinctive contribution to Pop art.[13] A graduate student working in ceramics at Mills College in the late 1950s, Arneson cast his earliest pieces in the orientalizing, decorative-utilitarian tradition of Anthony Prieto, a highly respected and influential craftsman who had taught for years at Mills and was head of its ceramics department. In 1958 or 1959 Arneson was stimulated by the "Abstract Expressionist ceramics" that were beginning to attract the attention of potters everywhere to Peter Voulkos, then working in Los Angeles. In 1961, more or less by accident, Arneson hit upon the blend of Funk and Pop art that was to become his trademark. While manning an art-in-action booth at the State Fair in Sacramento, to which Prieto

FIG. 100. Robert Arneson, *No Deposit, No Return,* 1961. Stoneware, 10¾" × 5".

brought his top graduate students each year, Arneson threw a pot that bore a vague resemblance to a beer bottle. He added a lid, the words "no deposit, no return," and the idea was born, although it was another year or so before he began to take up his joke in earnest. (See Fig. 100.)

Arneson produced several dozen more beer and pop bottles, this time of a vaguely anthropomorphic cast. He then went on to toilets (with penis flush-handles, clitoral drains, and turds in their bowls), scales, and other bathroom objects— "neglected images," as he wryly described them. Their surfaces were goopy and globby, their glazes shrill and screeching. (See Fig. 101.) He did a series of visually punning "trophies" ("I always wanted to be a sports hero but could never quite make it"), a typewriter with fingers for keys, and a toaster with human hands coming out of its apertures ("they seemed to say something about the human condition").[14] In terms of subject alone, these early ceramic pieces were 100 percent Pop, equaled only by the productions of Warhol or Oldenburg in the total banality of the everyday

Funk, Pop, and Formalism

FIG. 101. Robert
Arneson, *Funk John,*
1963. Stoneware,
36″ × 20″.

objects that inspired them. They were handled,
however, with a combination of expressionism
and irony that was closer to the Neo-Dada of
Rauschenberg and Johns. At the same time, they
embraced a wildly personal element—an idiosyn-
cracy and intensity—that reflected something
unique, "the creation of an increasingly personal
fantasy rather than a public or rhetorical gesture,"
as Stephen Prokopoff has described it; "the artist
[becomes] absorbed in the objects, places or
situations, that surround him—the perimeters of
his most intimate experience—so that they are
given an intimate, intensely autobiographic
existence."[15] This characteristic would emerge
more prominently and consistently in the work of
Arneson and other Bay Area artists later in the
1960s.

The outrageousness of Arneson's early ceramic
objects was, in part, a reaction to the outsider
status to which ceramists, like photographers,
were commonly relegated by the world of "fine
art"; their work was seen as a craft rather than a
legitimate art form, and art and craft were rigidly
segregated in group shows and art festivals.

Arneson's early work was most often exhibited
within a traditional crafts context, where its
iconoclasm of theme and style was doubly outra-
geous. (At this time Voulkos's abstract "mastadon
droppings," as they were called, were still on the
fringes of acceptability.) His entries in a show at
the M. H. de Young Memorial Museum in 1962
drew furious criticism. As Garth Clark has
pointed out, Arneson's "sloppy use of the material
[linked] the objects with the hobby-craft esthetic
of thick, oozing, and virulently colored glazes
over complacent whiteware. . . . Whereas Pop art
drew its esthetic from a commercial craft form of
poster-advertising art, the Funk art drew from
what might be termed *consumer craft.* When Alfred
Frankenstein said that Arneson had gone one
better than Dada, [that] he had produced the
'ready-made home-made,' he touched the essence
of the Funk esthetic."[16]

Most of these early pieces were made after
Arneson had joined the faculty at U.C. Davis in
1962. Such ceramic sculptures as *Model for a Float
Celebrating the Birth of William T. Wiley* illustrate
his involvement in the clannish group of painters,
sculptors, and others from which the Funk art of
the 1960s was developing, with its penchant for
in-jokes, put-ons, and puns. Later in the 1960s,
Arneson began to tone down the expressionistic
violence and rugged surface treatment of his
work, and his glazes became richer, purer, more
vibrant. A turning point was *Alice Street,* a series
of pieces begun in 1966 (Arneson's tract home in
Davis was at 1303 Alice Street). Two of these
pieces were made of modules assembled into huge
structures (*Big Alice Street* was eight feet square
and rose two feet from the floor) in which painted
and sculpted images combined to create a cross
between a *House and Garden* architect's rendering
and an Alice-in-Wonderland cartoon fantasy. (See
Fig. 93, p. 110.)

Throughout the 1960s, the influence of Arne-
son's ceramic art was immense, and it spread far
beyond the Bay Area. At a time when the
integration of painting and sculpture was a major
preoccupation among artists, Arneson showed a
way to make *objects* that achieved an original and
ingratiating fusion of the two. "Hotter" than the
Pop art soft sculpture of Oldenburg and "cooler"
than the Abstract Expressionist ceramic sculpture
of Peter Voulkos, Arneson's work, and the
sensibility it reflected, corresponded to the combi-
nation of rebellious iconoclasm and hip humor
that characterized the contemporary mood. By
1966, when Arneson and seven of his undergradu-
ate students exhibited together at the American

FIG. 102. Wayne Thiebaud in his studio, c. 1980.

Craft Council's San Francisco gallery, it was apparent that a ceramics movement, of sorts, had developed. The participants included Margaret Dodd, David Gilhooly, Steven Kaltenbach, Richard Shaw, Peter Vandenberge, Chris Unterseher, and Gerald Walburg. Most of these students, in one area or another, later attained a degree of distinction of their own.

Wayne Thiebaud (Fig. 102), somewhat older than Wiley and Arneson, was a late-blooming Bay Area Figurative painter who achieved overnight acclaim in New York, almost by accident, as a peculiarly California Pop artist. He worked from 1938 until 1949 as a self-taught cartoonist, designer, and advertising artist, first in Hollywood and later in New York; he has described himself as "a kind of painting cartoonist."[17] After serving in the Army from 1942 to 1946, he entered San Jose State College on the G.I. Bill in 1949; in 1950—he was then thirty years old—he enrolled at Sacramento State, to study for his Master's degree, which he received in 1952. While working toward his degree at State, he began teaching at Sacramento City College. Except for a leave of absence in 1956–1957, he taught at Sacramento City College until 1960, when he joined the art faculty at U.C. Davis. He continued to teach there through the 1970s.

Thiebaud spent his leave of absence in New York, working as an advertising artist. He became personally acquainted with Kline and de Kooning, two idols of long standing. He became aware of the formative work of Rauschenberg and Johns. And he reached a dramatic turning point in his own painting.

Thiebaud had painted "pop" subjects—gumball dispensers and slot machines—as early as 1953. But in these works the images had been largely obscured by thick, heavily worked Abstract Expressionist paint surfaces, to which the addition of gold and silver metallic paint sometimes created a Byzantine-icon effect. "I was affected by people like Jackson Pollock . . . [and was] trying any desperate way to make my paintings look like art," Thiebaud said.[18]

While in New York, Thiebaud turned to a series of very small paintings based on images of foodstuffs piled up in display windows. He played down expressionist paint handling and concentrated on the autonomy of the images—or more exactly, on the basic geometry of their shapes; then, in groupings of nearly identical images, he used broadly painted details of design and surface to distinguish one more or less standardized pie slice or gumball from another. When he returned to California, Thiebaud continued to clarify his

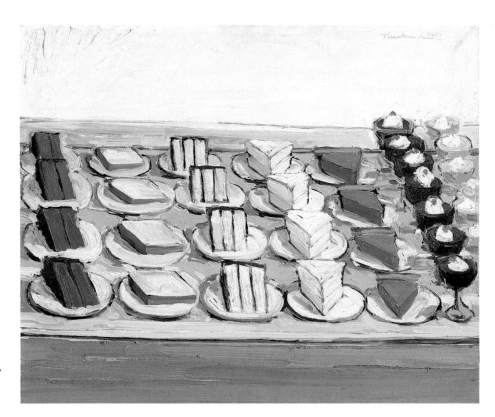

FIG. 103. Wayne Thiebaud, *Desserts,* 1961. Oil on canvas, 24″ × 30″.

vision. "I took certain old paintings and isolated the subjects, masked out the backgrounds. I got to these very simple shapes: triangles, circles, squares, crescents are all they really are, anybody can do them."[19] Horizon lines disappeared, and the images were set against pure blue or green grounds. Thiebaud's major sources during this time were the kinds of traditional painters to whom the Bay Area Figurative painters were looking—Morandi, Balthus, van Gogh, Chardin, Hopper, Sarolla. But he has acknowledged that observing the work of the "pre-Pop" artists in New York helped to confirm for him the direction that his work had started to take.

Thiebaud's first one-man shows in San Francisco (the Museum of Art) and New York (the Staempfli and Tanager galleries) took place in 1960—a year or so before Oldenburg began to show plaster edibles in his New York storefront, and some two years before Warhol first displayed his soup can paintings at the Ferus Gallery in Los Angeles. His paintings received little attention. "Apart from one critic's naming Thiebaud 'the hungriest artist in California' they were ignored," John Coplans later recalled.[20] (See Fig. 103.) In 1962, however—after his work was included in the big Sidney Janis display called The New Realism, which officially launched Pop art into the

New York art world—Thiebaud became widely recognized as one of the major new Pop painters.

By this time, except for a lingering emphasis on dark gray or bluish grounds that would shortly yield to brilliant whites, Thiebaud's paintings had arrived at many of the features that distinguished his style for several years: the isolated image, reduced to a simple, basic form, or the repetition and systematic variation of similar images in loose geometric groupings; the tense, carefully calibrated intervals between forms and the clean, largely uninterrupted backgrounds; and the luscious, full colors and thick impastos—a kind of "bas-relief modeling," as Thiebaud put it, rather than an illusionistic rendering of forms in depth.[21]

Thiebaud himself persistently (though never loudly) disclaimed his association with Pop art, insisting that he was basically a humble practitioner working in painting's three traditional categories: still life, portraiture, and landscape. Beginning in 1963, he turned increasingly to painting the figure. He most often painted likenesses of specific individuals, but his figures had none of the psychological attributes of portraits; they were wooden and rigidly posed, and each detail received equally sharp emphasis. These were followed by paintings that focused on landscape. (See Fig. 104.) The forms—trees,

Funk, Pop, and Formalism

FIG. 104. Wayne Thiebaud, *Reflected Landscape*, 1966–1968. Oil on canvas, 40″ × 40″.

ponds, clouds—were highly simplified, and the perspective was often bizarrely exaggerated. This change of subject and style was frequently accompanied by a change of medium, the juicy impastos of the earlier oils giving way to thinly stained acrylics or combinations of oil, pastel, and charcoal. In the late 1970s, Thiebaud concentrated on views of San Francisco: steep hillsides seen from careening, worm's-eye perspectives, with streets that sometimes seemed to shoot bolt upright and fuse with the verticals of nearby skyscrapers. The creamy textures of the earlier paintings often reappeared.

Thiebaud's best paintings were complex deceptions in which the sophisticated eye and technique of a professional were seemingly coupled with the disarming bluntness of the advertising artist (or self-taught "primitive") and the amateur hobbyist's love of pushing paint around. The three traditional categories of painting that he professed to practice were constantly merging and overlapping. An arrangement of lipsticks and compacts took on the character of a landscape with trees and ponds; pie slices assumed the presence of portraiture; and figures, isolated against empty backgrounds, were treated as still-life objects. Most of Thiebaud's pictures were painted from memory. Their somewhat dream-like, hallucinatory quality was intensified by what Thiebaud described as the "quality of glare" produced by dazzling white grounds, which was frequently emphasized by vibrant blue "shadows."[22] In Thiebaud's weaker paintings, the contradictions of his art yielded to a resolution that was too concrete, producing works that suggested either a kind of commercial art illustration or, at the opposite extreme, a dilettante's Sunday painting.

Thiebaud's influence on Bay Area artists in the 1960s and 1970s was quite different from Wiley's and Arneson's in some respects, but complementary in others. His love for the tradition of painting in general, and for realism in particular, moved him to adopt a relatively conservative attitude toward discipline and craft; few budding conceptualists were attracted to his classes at Davis, as they were to Wiley's. Thiebaud held to a more old-fashioned work ethic, and gave his students exercises in painting from life and other traditional classroom projects. "In some ways, I'm of the dumb brute school of painting," he has said. "Most painters I know just work most of the time. In fact, I tell my students I don't want them to have ideas. I think ideas are dangerous for painters."[23]

Yet Thiebaud's insistence on the commonplace and the personal, and his simultaneously accepting and ironic attitude toward his banal subjects, were a quietly corroborating echo to Wiley's less equivocal expression. Like Wiley, Thiebaud was convincing as a shrewd but homespun Westerner—in Thiebaud's case, a Westerner of the Will Rogers type, given to cracker-barrel observations and droll asides. And like Wiley, Thiebaud was doggedly asserting his independence from the New York art scene even while he was quietly becoming known on the East Coast as one of California's most prominent painters and was gaining an international reputation.

Arneson and Wiley became the hub of a close-knit circle of Davis-based artists that included such students as Steven Kaltenbach, Bruce Nauman, and John C. Fernie, as well as a fellow teacher, Roy De Forest. It intersected with such artists as William Allan and Robert Hudson in San Francisco, and to a lesser extent with such Berkeley artists as Peter Voulkos, James Melchert, and Harold Paris. Their work formed the nucleus of Funk art, the most widely publicized Bay Area "movement" in the middle and late years of the 1960s.

Insofar as the Funk art of the 1960s had any authentic existence as a category—it was, in many ways, invented by critics and curators—it differed fundamentally from the Beat funk art of the previous decade, and had no particularly strong roots in it. What the two styles had in common was a shared sense of social isolation—at least at the beginning of "sixties Funk," before anything had begun to sell; the practitioners of Funk art, like the funk artists, were resigned to the fact that they were their own principal audience, and their camaraderie and clannishness were heightened by the greater physical isolation of the 1960s. But whereas the funk art of the 1950s had been a product of the city, the Funk art of the 1960s was a joint product of the country, or the suburbs, and the art school. The earlier funk had fed from a rich ferment of literature and music, poetry and philosophy, art and experience; the later Funk art drew relatively more of its intellectual sources from the narrower preoccupations of the contemporary art world. Parody—scholasticism's form of comic relief—was Funk art's most frequent impulse. Formalist ideals and the detachment of mainstream art, as well as the work of other Funk artists, were its most common targets. The prosaic imagery and corny objects characteristic of the little country places where the artists found

FIG. 105. *The Slant Step,* date unknown. Wood, linoleum, rubber, nails; 18¹³⁄₁₆″ × 15″ × 12¼″.

FIG. 106. William T. Wiley, *Slant Step Becomes Rhino/Rhino Becomes Slant Step,* 1966. Plaster, acrylic, paint, and chain; 22″ × 12″ × 12″.

FIG. 107. Ron Peetz and Phil Weidman, *Hairy Slant Step,* 1968. Wood, human hair; size unknown.

themselves—cowboys-and-Indians kitsch, old-fashioned novelties from the fleamarkets and second-hand stores—became the principal elements in the vocabulary of the new Funk artists. Whereas the funk artists of the 1950s had shunned an appearance of newness, cultivating a sense of use, character, and age to the point of decay, the new Funk artists frequently embraced the bright colors and slick, shiny surfaces (if not the impersonality) of the new consumer culture.

Perhaps the most memorable manifestation of Funk art in its virginal form (as it developed around the core group at U.C. Davis) was the Slant Step Show, which took place in San Francisco in 1966 at the Berkeley Gallery. It had its origins in a strange object that Wiley spotted in a salvage shop. Constructed of wood, it had a plain vertical back; a "riser" attached midway from top to bottom, that descended at a steep, 45-degree angle to a base that dropped a few more inches to the floor; and sides that were notched with uncharacteristically graceful curves. (See Fig. 105.) It was covered with tacky green linoleum. The combination of ugliness and uselessness—the form suggested function, but no one could ever figure out a purpose for it—seemed to be its principal attraction to artists, then and later: there appeared to be no reason, esthetic or utilitarian, for the object to exist. According to Bruce Nauman, Wiley spent a lot of time simply looking at the thing by himself, and eventually brought Nauman to see it. Wiley finally bought it for fifty cents and gave it to Nauman for Christmas.

Nauman planned to take the step to a carpenter's shop and have an edition of copies made, but he never did; he cast a mold of it, but most of the time it served as a foot-stool in his studio. Wiley, however, made several pieces based on the idea, and eventually an in-group mystique developed around the thing (Figs. 106, 107). Nauman and William Allan started to shoot a movie about how a slant step is made, but they never finished it. The idea of the exhibition then developed. It was to include slant steps by Wiley and various friends and followers, linked up with the work of William Witherup, a poet who wrote a piece called *The Slant Chant* for the occasion. (Excerpt: "Night of the slant step swollen with old shoes. . . . Day of the slant step acrid with the butts of old ladies. . . . Phosphorescent linoleum peeling away from the scalp. . . . St. Slant Step rocking in his cave among the bones of old slant steps.")

After the exhibition was set up in the gallery, someone sneaked in late at night, took all the work down, and piled it into a corner. When the show officially opened, people merely pawed through the pile. The original slant step disappeared—according to Nauman, Richard Serra slipped it from the gallery while no one was looking and later took it with him when he moved to New York.²⁴ The Slant Step Show became a sort of legendary landmark in the underground history of Bay Area art during the 1960s. Wiley was still making slant steps of various kinds a year or so later.

Funk, Pop, and Formalism

This kind of uninhibited informality gradually withdrew from Funk art—or at least retreated into the privacy of artists' get-togethers. The work itself took on more of a public air. When the Berkeley Gallery organized a sequel to the Slant Step Show called The Repair Show, it turned out to be a relatively sedate group exhibition—a selection of well-made, Dada-inspired objects that did not alter their appearance for the duration of the show and could be viewed every day during regular gallery hours.

Bay Area Funk, as a "movement," reached its climax (or anticlimax) with the big Funk Art exhibition that Peter Selz organized in 1967 for the University Art Museum in Berkeley (which was still occupying a former boiler house behind Sproul Hall, the campus administration building). The juxtaposition of works by Bruce Conner, Manuel Neri, and other artists of the 1950s with the Wileys and Arnesons and others of their circle demonstrated dramatically the profound gulf between sixties Funk and fifties funk—and how strongly each belonged to its decade. Funk art, for all its expressionistic facade, was fundamentally a curious mutation of the detached, disengaged attitude reflected by the same mainstream art—Formalism and Pop—that it so frequently appeared to lampoon; funk, on the other hand, had been a strange, unexpected permutation of Abstract Expressionism. The irony in funk coexisted with a deep undercurrent of mordant seriousness, of poetry and mysticism; its mask of absurdity often wore the crooked grimace of real terror. The hip, flippant parody in Funk art, the ingratiating outrageousness of its adolescent iconoclasm and sophomoric humor, appealed to an audience that was increasingly won over by the growing "youth culture" of the 1960s.

A minority of Bay Area painters in the 1960s explored what they considered the new issues of abstract painting. There was no concentration of hard-edgers or color-field painters on any one school faculty, and their work was not brought together in group exhibitions. The Formalist painter resigned himself to an isolated and frequently overlooked position.

Two of the earliest and most original Formalists were David Simpson and Sam Tchakalian. Around 1960, both began to develop Formalist approaches more or less independently, from roots in Abstract Expressionism. Simpson, a student at the California School of Fine Arts between 1949 and 1951 (and again in 1955–1956) developed a form of horizontal stripe painting in the last years of the 1950s, while he was living near Sacramento and teaching at American River Junior College. It was clearly grounded in his impressions of the flat horizons, open vistas, and stratified space of the Sacramento Delta landscape, to which he also alluded in such titles as Storm, Stars and Stripes (1960) (see Fig. 108) and Variable Bands. These early abstractions were done in thin films of oil, their stripes freely brushed and left with soft, bleeding edges. They emphasized grayed and darkened colors that suggested atmospheric space, nocturnal light, and tule fogs.

By 1963 Simpson had moved further toward total nonrepresentation, using vivid, pure colors that had little or no resemblance to those found in nature. Paint thinned, surfaces flattened, and edges sharpened, bringing his forms into a closer relationship to the geometric than to the organic. Simpson turned from oil to copolymer paint, and then to acrylic. By the mid-1960s he had arrived at a form of pure color painting, although it still retained sources in nature. At about the same time, he began a series of Rainbows on which he worked for the rest of the decade. In the earlier paintings, bands of closely graded, usually nonspectral hues formed arcs that pulsated against rectangular grounds of flat, solid color. In the last years of the 1960s, the canvas supports themselves changed shape to conform to the large, gently curving forms.

Early in the 1970s, Simpson began a series of dynamic, elliptically shaped canvases, echoed by energized interior forms, which alluded to space-age events. But later in the decade he abandoned the various odd-shaped formats upon which he had been working since the early 1960s, and confined himself to large, rectangular surfaces. The thin color bands of the previous painting yielded to more expansive square and rectangular planes of color, of a subdued but radiant intensity. His compositions were most often dominated by large central "windows," framed by narrow bands of contrasting or complementary colors, varying in width and arranged in broken, staccato rhythms around the edges. In these paintings, Simpson—a teacher at U.C. Berkeley since the mid-1960s—continued to concentrate on the equation of light and energy, as he had more obviously in the earlier ellipses and rainbows. But his principal goal, as he said, was "to create space; to *find room*." Simpson considered the spirit of his art to be more closely akin to Rothko than to Stella. "Although I admire some of his paintings, I can't agree with Frank Stella's . . . dictum, 'what you see is what you get.' The implications of what you see are what you get, and are what make what

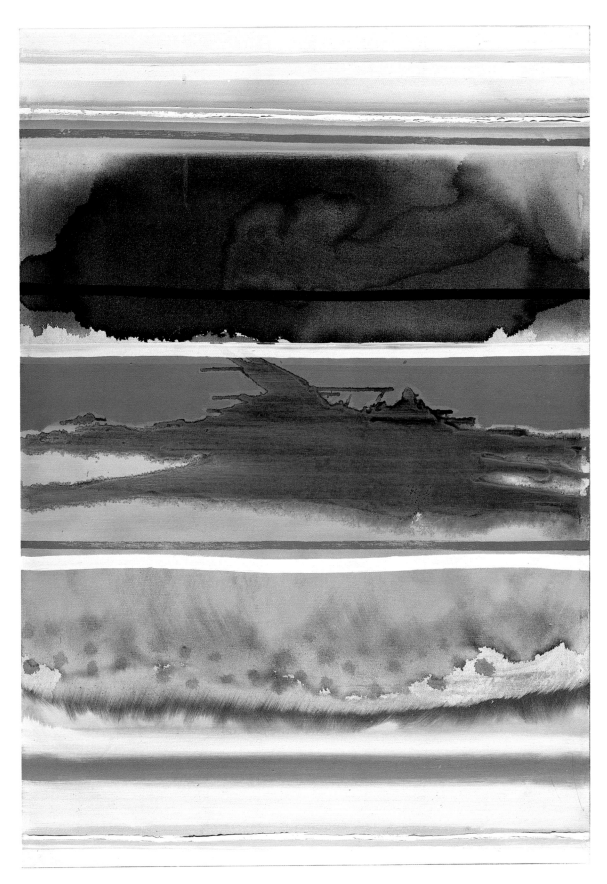

FIG. 108. David Simpson, *Storm, Stars, and Stripes,* 1960. Oil on canvas, 64″ × 45″.

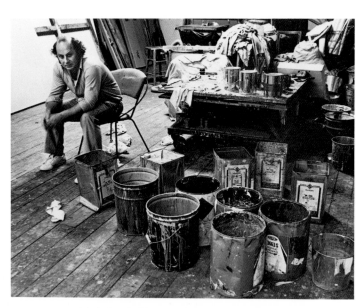

FIG. 109. Sam Tchakalian in his
Duboce Street studio, San
Francisco, 1975.

you see significant or not. Paintings are more than just objects. . . . It may be out of fashion to believe that art should be redemptive, but I believe it should be when it can."[25]

Sam Tchakalian's early work reflected the funky impulse of the late 1950s. He combined crumpled gnarls of Japanese mulberry paper with thick globs of oil paint to produce ruggedly textured collage-paintings, most often in dramatic contrasts of blacks, whites, and grays. Their titles generally lampooned the heroicizing bent of Abstract Expressionism—as in *Moral Taint*. In the first years of the 1960s, Tchakalian's surface crusts grew heavier and more sculptural, but around 1962 the collaged paper began to drop away. By the mid-1960s, Tchakalian's painting consisted entirely of lush, unbroken fields of solid color produced by pouring, rolling, and brushing layer upon layer of oil onto immensely scaled horizontal canvases. Color and paint itself literally became the content of these paintings, which were essentially elements of architecture. They depended for their effect on the sensitivity with which they were installed and lighted within the setting of a gallery (for a time, in the early 1970s, Tchakalian displayed his paintings at floor level). In the late 1970s, Tchakalian brought greater variety of color and incident back to his painting by mixing, modulating, and making long, horizontal scrapes across his canvases. These techniques produced essentially decorative stratifications of marbled color separated by irregular ridges.

Although closely related to mainstream color-field painting in appearance, Tchakalian's abstractions grew, as Simpson's did, from fundamentally different motives and assumptions. His approach and methods, like his style of life—he worked in a loft-studio perpetually littered with paint rags and five-gallon paint cans—remained allied to the esthetic of action painting. (See Fig. 109.) His color abstractions disclosed the artist's hand in their rhythmically ridged brush strokes; and as if to preclude any possibility of confusion with the more solemn East Coast product, he gave them self-spoofing titles that smacked of the puns developed in the 1950s by Wally Hedrick and carried on by the Funk artists—*Blew One* (1964), *Orange Juice* (1966) (see Fig. 110), *Pat Brown* (1966). At the same time, Tchakalian's *physical,* impersonal, almost mechanical way of working, separated him from such earlier Abstract Expressionists as Lobdell and Jefferson and connected his paintings to the process-and-materials abstraction that developed in the early 1970s.

Of the various trends that dominated American painting in the early 1960s, Pop art had the most problematic existence in the Bay Area, and in California generally, despite the state's notoriety as a place where Pop seemed to be everywhere: "weather, clothes, 'skinny-dipping,' hobby-craft, sun-drenched mentality, Doggie Diner, perfumed toilet tissue, do-it-yourself," was how Harold Paris litanized California in an *Art in America* article entitled "Sweet Land of Funk."[26] Three

FIG. 110. Sam Tchakalian, *Orange Juice,* 1966. Oil on canvas, 76¼″ × 97⅛″.

Bay Area artists—Mel Ramos, Peter Saul, and Gerald Gooch—made use of many of the ingredients of the Pop style for distinctly individual ends.

Ramos's paintings, although set somewhat apart by their sensuous, Thiebaud-inspired paint surfaces, came closest to the cool, deadpan stance that was the hallmark of the Pop style in New York. A student of Thiebaud's in Sacramento in the late 1950s, Ramos began to paint comic book characters—*Superman* (1961), *Flash Gordon* and *The Green Lantern* (1962)—isolated against simple, solid-color grounds. He progressed, by way of a long, leggy *Phantom Lady* (1963), to the cheesecake nudes surrounded by merchandise (*Chiquita* [see Fig. 111], *Miss Lemon Drop*) that brought him an early national reputation as a Pop parodist of advertising art and pin-up girls (Petty or Vargas style).

While living in Paris in the late 1950s, Peter Saul had drawn on images from advertising art, comic books, and other popular sources in his oil-crayon drawings and collages. These suggested vague parallels to the style that David Hockney was developing from sources in Rauschenberg and Larry Rivers (and which also looked forward, curiously enough, to the late figurative paintings of Philip Guston). Saul had a peripheral relationship to the Bay Area Funk artists while he lived in Mill Valley in the mid-1960s. He moved to New York in the late 1960s, and there, inspired by the Vietnam war and the accompanying polarities in American life, he turned to gross, apocalyptic visions of sex and violence, in a screeching, cartoon-like style dominated by grotesquely distended figures that resembled the contortions of Plastic Man. This comic exaggeration of the catastrophic had parallels in contemporary novels like *Catch 22* and *Slaughterhouse Five.*

Gerald Gooch approached the deadpan literalism of Pop art in the drawings and lithographs he

FIG. 111. Mel
Ramos, *Chiquita,*
1964. Oil on
canvas, 70″ × 60″.

began to exhibit in the late 1960s. They included sequential images of the topless dancer Carol Doda, caught, as on a filmstrip, in various phases of a go-go routine; and of a bedsheet as it changed shape in response to what the viewer was expected to assume were the movements of a lovemaking couple underneath. The images were rendered in a highly conventional, academic-realist drawing style (Gooch said his favorite artist was Norman Rockwell).[27]

Pop images were only one of Gooch's interests. His concern with motion was expressed in three-dimensional glass boxes in which lights changed to form outlines of moving figures. From increasingly "realistic" renderings, Gooch turned to mirrors, generally inscribed with lettered riddles such as "what is reality?" and "what is a fake?" A distinctive furnishing in Gooch's San Leandro home was a life-sized coffin, lined with mirrors, and with a mirror suspended above, into which guests were invited to enter and meditate on their images as they reflected into infinity. In the early

1970s, he gravitated to painting, sculpture, and actions that had parallels both in Conceptualist events and in the themes and attitudes current among Bay Area Visionary artists (discussed in Chapters Eight and Nine). The paintings centered on verbal conundrums that combined attributes of Zen aphorisms with Victorian sampler slogans. They were inscribed in thickly piled traceries of paint, applied by teams of friends working together with plastic squeeze tubes, in the manner of cake decorators; Gooch established the basic design, generally an emblematic mosaic of Byzantine richness and symmetry, and "orchestrated the energy."[28] (See Fig. 112.) He drew little distinction between his "public" work and more private projects, such as a cement walkway in his yard in which artist friends designed individual sections, with imprints of hands, feet, and more intimate details, in the manner of the sidewalk of Grauman's Chinese Theater in Hollywood. One of Gooch's last projects—perhaps his final one—began with a gigantic block of granite, which he

Funk, Pop, and Formalism

FIG. 112. Gerald Gooch, *The Son Created the Father Two*, 1974. Oil on canvas, 72″ × 72″.

progressively sandblasted until it was reduced to the shape of a miniscule egg. It is said that shortly afterward, while teaching a class at Laney College in Oakland, he excused himself to go to the bathroom and never returned. By the end of the decade, Gooch had abandoned art and was living in a religious commune in the Pacific Northwest.

Such were some of the main currents that moved through American and Bay Area art in the early years of the 1960s. Most of them were over-publicized, over-praised and over-promoted, both nationally and locally. Certainly, many of the ideas and attitudes that began to motivate artists as the 1960s progressed were of dubious value. Of course one can argue, with Thiebaud and de Kooning, that as much important art has been produced in spite of ideas as because of them. On the other hand, it seems particularly true of this period that the ideas were often more interesting than the art that supposedly issued from them.

As time passes, it may be easier to see beyond what was gaudy and superficial in Bay Area art of the 1960s. Certainly, there was much in it of more than temporary value. The new spirit of "openness" articulated by Wiley was probably salutary, at least until it became a matter of simply being laid-back; and there was a compelling undertone of poetry, as well as sardonic humor, in the best of Wiley's work, particularly quite late in the decade. Arneson's best ceramic pieces were fine, low comedy; and his strongest work, like Wiley's, was yet to come in the 1970s. Thiebaud, at his most forceful, demonstrated, like Morandi, that our perception of exterior reality is as deep a mystery as the interior visions that the Abstract Expressionists had sought to express, and can inspire a painting of like intensity. And Simpson was already beginning to show, like Rothko and John McLaughlin, that there can be an expressive art that achieves its power by excluding the conspicuous presence of the artist.

Funk, Pop, and Formalism

FIG. 113. Peter
Voulkos, *Mr. Ishi*,
1969. Bronze, 27′ ×
20′ × 20′.

When Peter Voulkos was asked to resign from the Otis Art Institute in Los Angeles in 1959, the stage had already been set for him to become one of the Bay Area's most influential artists. He was bringing bold innovations to sculpture, at a time when sculpture itself was emerging as the most prominent art form of the decade.

Like many artists who have left their imprint on the Bay Area (Still, Rothko, Diebenkorn, and indirectly, Kienholz), Voulkos came from the Northwest. A stocky, robust, relentlessly energetic man, he was born in Bozeman, Montana, in 1924 of Greek immigrant parents. After working his way through high school, he hitch-hiked to Portland, where he gained experience as an apprentice moldmaker in an iron foundry before being drafted into the U.S. Army Air Force. After the war he used the G.I. Bill to enroll at Montana State University, where he became a commercial art major—and, in his final year, took a required course in ceramics. The medium was never the same afterward. "I began to understand what art was all about through clay," Voulkos said. "Clay is an intimate thing . . . a blob of nothing . . . then the minute you touch it, it moves."[1]

Almost from the start, Voulkos was making significant technical departures. His pottery won important regional and national crafts awards. It created a small stir during the two years (1950–1952) he spent completing credits for a Master's degree at the California College of Arts and Crafts in Oakland. "Pete was doing traditional things compared to what he did later," Manuel Neri recalled, "things like Greek pots . . . except instead of being a foot high, they'd be four feet high."[2] The immense scale of these early ceramic vessels was an outgrowth of one of the peculiar advantages of "provincialism": never having seen the originals, Voulkos often misinterpreted the scale of works he saw in reproductions. Thus, instead of fabricating a variation, he produced something unique.

Voulkos returned to Montana in the summer of 1952, to help establish the Archie Bray Foundation for Ceramic Artists in Helena. Among the artists to visit there was the Japanese folk potter Shoji Hamada, whose Zen-inspired "courting of the accidental" prompted Voulkos to move further from symmetry in his wheel-thrown ceramics. The next year, Voulkos spent a week visiting New York, where he made his first acquaintance with Abstract Expressionism. He was invited to Los Angeles in 1954 to organize and become chairman of the Otis Art Institute's new ceramics department. In the five years that followed, he turned the relatively traditionalist school upside down. What he called his "pot shop" became the center for a group of young, anything-goes artists (students and non-students alike) who included Billy Al Bengston, Kenneth Price, Michael Frimkess, John Mason, Henry Takemoto, Paul Soldner, Jerry Rothman, and

FIG. 114. Peter
Voulkos, *Little Big
Horn,* 1959. Glazed
clay, 62″ × 40″ ×
40″.

Malcolm McLain. His own art, meanwhile, developed dramatically, as he drew upon ideas from the ceramics of Miró and Picasso, from the stacked and cantilevered sculpture of Fritz Wotruba, and from the free reign given to physical materials by the New York Abstract Expressionist painters. He embarked on a series of increasingly audacious experiments: cutting through the surfaces of his ceramics or adding slabs to them to create relief; and combining wheel-thrown and hand-manipulated forms—spheres, cylinders, slabs—to build big, stacked constructions that formed a ceramic counterpart to assemblage. These innovations culminated, in 1958–1959, in massive, full-fledged ceramic sculptures that weighed up to a ton—great swelling, thrusting convulsions of clay, glazed in unruly polychrome drips, spatters, and crackles, a ceramic equivalent to action painting. (See Fig. 114.)

Given Voulkos's volatile personality and radically original art, an explosive confrontation with Otis's conservative director, Millard Sheets, was inevitable. When it finally came, Voulkos already had an invitation, delivered by Erle Loran some time before, to help set up a ceramics department at the University of California. In the summer of 1959, he moved to Berkeley.

Voulkos arrived in the Bay Area at a time when more and more artists were moving away from painting toward some form of three-dimensional expression. The work of Bruce Nauman, a member of the circle of Funk artists at U.C. Davis

in the mid-1960s, went through a metamorphosis that was typical of many Bay Area artists. He began as a painter of landscapes that reflected many of the then-standard influences—Oliveira and Diebenkorn on the West Coast, Lester Johnson and Al Held in the East. In 1965 Nauman began to add three-dimensional components to his surfaces—first, these were of welded steel, which he bolted to the canvas and painted over, and later they were made of fiberglass, because it was lighter. These were "just shapes that came out of the paintings," Nauman said. "The shapes were there and then I started to make the shapes stick out of the paintings. Then I stopped making the painting altogether and just made the shapes."[3]

This development—like the dramatically protruding masses of paint in Jay De Feo's *The Rose* (see Fig. 79, p. 94), or the sticks and laths that William T. Wiley was attaching to his canvases—exemplified an evident push away from the flat surface toward more dimensional formats, which tended to erase traditional distinctions between painting and sculpture. But although Formalism, the more purist of the two broad currents that dominated American art in the 1960s—Neo-Dada was the other—was opposed in theory to this hybridization of forms, it brought about a similar result. For example, one of Sam Tchakalian's big painted canvas squares of uniformly textured, barely articulated color—"pure painting" in Clement Greenberg's terms—could as easily be interpreted as a kind of sculptural low relief: as no longer a representation or a symbol but as a real object on a real wall. Most people were content, with Greenberg, to continue regarding work like this as painting; but in the 1960s there was no lack of elaborate theoretical formulations to rationalize new developments that made "sculpture" of practically anything else. There was sculpture which, like the ceramic works of Voulkos and Arneson, injected new vitality into traditional materials. There were also the klunky painted metal constructions of Robert Hudson, William T. Wiley's spindly fabrications of tree branches and twigs, the sleek geometric abstractions of Fletcher Benton and Tony DeLap. There was sculpture that dazzlingly exploited new materials and technologies: cast lucite, vacuum-formed acrylics, sprayed enamel and lacquer. (Tom Akawie and other Bay Area artists learned the fine points of spray techniques from Art Himsl, a specialist in painting custom cars, who had a garage in Concord.) There was kinetic sculpture, and sculpture composed of fluorescent, neon, and other forms of light. By the end of the decade,

there would be Minimalism, which consisted of virtually nothing, and Conceptualism, wherein nothing was finally achieved.

Above and beyond all other distinctions was the paramount preoccupation with space itself, or more precisely, with *actuality*. Sculpture meant the action of concrete, physical objects in real space—and later, with performance art, in real time. The tendency for art to become theater and for theater to shade into real life, already apparent in the funk underground of the 1950s, now spread through the art schools and the professional art establishment. Painting turned into sculpture, sculpture into environments, and environments into happenings. Art was quite literally moving out into the "real world." When the Los Angeles County Museum of Art filled its new temporary exhibition building, and most of its courtyards, for the landmark exhibition entitled Sculpture of the Sixties, it was clear that the term could now signify anything from quasi-architectural objects (the floor plates of Carl Andre) to constructions not far removed from the carnival or amusement park (the chamber of horrors tableaux of Ed Kienholz and the halls of mirrors of Lucas Samaras).

There were several reasons why the physical nature of sculpture had a strong appeal to artists in the early 1960s. In an age when so many kinds of artistic expression were competing for attention, it was a sure-fire attention-grabber. The new connoisseur of contemporary art was young, impatient, and on the move, and one caught his attention with art that he might trip over or bump into, art that physically moved by itself or threatened to engulf him. Much contemporary sculpture was therefore a branch of show business. Beyond this, sculpture seemed to offer more new avenues for exploration than painting did, and seemed more responsive to the expansive mood of the times. Space-age technology produced an entire range of new materials and processes: titanium and fiberglass, vacuum forming, computer programming. Because sculpture must rely more heavily on the availability of tools and materials, large studios, and warehouse space—that is, on money—sculptors benefited even more than painters from the windfalls stirred by the new national prosperity. Sculptors like Voulkos at Berkeley and Tio Giambruni at Davis were invited to develop university sculpture departments with sophisticated technical facilities, which they would of course use for their own work. Sculptors also shared in the increased patronage of the arts by business firms and government bodies,

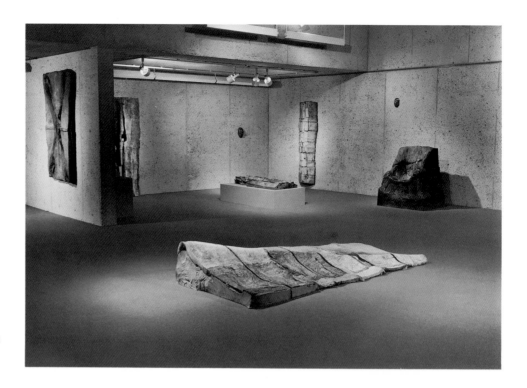

FIG. 115. Stephen De Staebler's retrospective at the Oakland Museum, 1974.

which purchased or commissioned monumental pieces for private and public buildings, parks, plazas, and shopping malls. And, of course, some artists turned to sculpture for the oldest and simplest reason of all: they had something profound and urgent to express, and it was something that could only be expressed in three dimensions.

Voulkos's reputation and influence were already widespread by the time he joined the faculty at U.C. Berkeley, and the "pot palace," a basement ceramics studio that he improvised on the site of the present University Art Museum, soon became as fertile a center of activity as his "pot shop" at the Otis Institute had been before. Among the earliest sculptors to gather there were Stephen De Staebler, Ron Nagle, and Harold Paris.

De Staebler became the most original and powerful clay sculptor of the group. Prompted by Voulkos's manner of literally throwing himself into the ceramic-making process, De Staebler began to roll around, jump on, and otherwise manhandle great slabs of clay. He soon decided that the forms achieved through collaborating with the natural forces of gravity and pressure were more dramatic than those arrived at through the studied manipulation of the hand. From this initial insight, his work developed with great consistency into a form of sculpture in which the raw clay seemed to have been arrested in various stages of metamorphosis, between landscape and

figure, or between figure and monument. (See Fig. 115.) De Staebler's forms ranged from small masks (wall-hangings) to towering columns suggesting pyramidal monuments fallen into ruin, in which anatomical fragments seemed to have been imbedded and petrified (see Fig. 116). He created massive "chairs" that were like lava flows congealed into Wagnerian thrones, and huge cauldrons that seemed designed for primitive, savage rites. One of De Staebler's most important innovations was to achieve a monumental scale by moving away from the integral monolithic form. He built his pieces from separately fired sections; after being cut sheer on three sides, the ceramic chunks could be placed, or stacked, so that the ridges, folds, vertebrae, and other shapes along their surfaces joined to evoke continuous forms in low or high relief. (See Fig. 117.) By mixing pigments directly into the clay or rubbing them on the surface before the initial firing, rather than glazing them, De Staebler achieved a remarkable range of subtle pastel colors without sacrificing the earthy richness of his raw material. In his most powerful sculpture, the laws and processes that govern the workings of clay seemed to become metaphors for the processes of nature itself.

After attending two of Voulkos's summer workshops in Montana, James Melchert left his job as an art instructor at Carthage College in Illinois to join Voulkos when he began to teach at

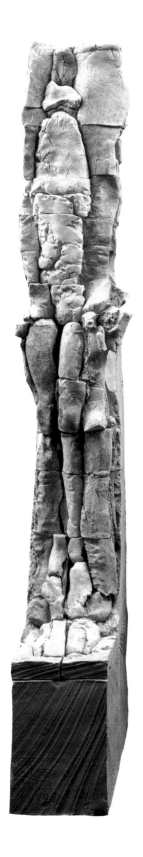

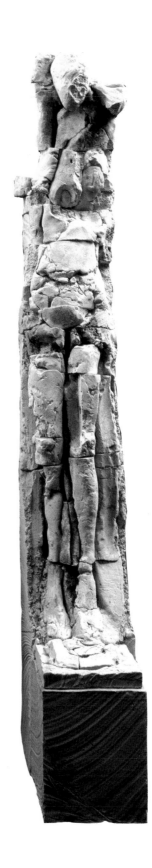

FIG. 116. Stephen
De Staebler, left:
*Standing Figure with
Bow Leg,* 1979.
Fired clay, 86½″ ×
11½″ × 26″. Right:
*Standing Woman with
Yellow Breast,* 1979.
Fired clay, 87½″ ×
14½″ × 26½″.

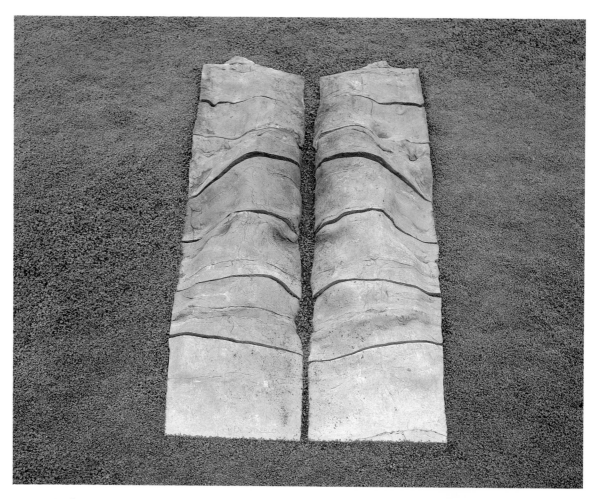

FIG. 117. Stephen
De Staebler, *Moab
II*, 1972. Fired clay,
18″ × 162″ × 90″.

FIG. 118. James
Melchert, *Door F*,
1962. Earthenware,
wood, and lead; 76″
× 36″ × 10½″.

U.C. Berkeley. Melchert's early ceramic sculptures were funky and usually small in scale; many suggested a cross between a traditional vessel and a long-necked clam (see Fig. 118). Teaching at the San Francisco Art Institute in the early 1960s, he came into the orbit of its circle of sculptors who were experimenting with heavily painted surfaces, and he began to work with low-fire, brightly colored glazes. Influenced largely by contemporary filmmakers and writers—Bergman, Resnais, Robbe-Grillet—Melchert's themes became more literary and structuralist. In 1964, inspired by Raymond Queneau's *Exercises in Style,* a book that retold the same story in a hundred different ways, Melchert fashioned a group of forty variations on the lower case letter *a*—*precious a* (glazed), *pre-a* (unfired clay), and so on. The natural drift of such work, with its emphasis on the idea, was toward Conceptualism, and in the 1970s Melchert moved away from object sculpture to concentrate on "location projects." These involved projecting slides upon the same environments that the slides depicted—for example, pictures of people opening and walking through doors were projected life-sized on the doors that had been photographed.

Ron Nagle developed a style that had roots in the ceramics of Ken Price and Michael Frimkess, two former Voulkos students in Los Angeles; he had seen their work reproduced in slides when he was attending the San Francisco Art Institute as a summer student in the late 1950s. Price, a frequent visitor to the Bay Area, was especially influential in Nagle's choice of the cup as the basic shape for his work, and in his adoption of what he called an "L.A. consciousness," an appreciation of "dimestore cheap preciousness." Nagle was also inspired by Giorgio Morandi ("the graphic profile . . . that loose kind of feel he has when he draws pottery") and by Japanese ceramics ("that tough and tender look").[4] Through the 1960s and 1970s, Nagle's cups became sleeker, glossier, more and more richly glazed; their shapes sometimes suggested miniaturized Art Deco architecture, and they were nested in handsomely crafted boxes or on customdesigned pedestals that emphasized their peculiar blend of elegance and vulgarity. (See Fig. 119.) Like Arneson's ceramics, they were more painterly than sculptural: they were primarily scaffoldings for layer upon layer of foamy glazes and sprayed or splattered china paints that were fired after each application to build up sheens of extraordinary translucence and depth. Nagle taught at the Art Institute in the early 1960s, and, along with Melchert, was instrumental in shifting

FIG. 119. Ron Nagle, *Untitled,* 1980. Earthenware, 2¼" × 2¼".

the emphasis of the school's ceramics department from stoneware, with its aura of handcraft and sobriety, to low-fire techniques, with their inclinations toward kitsch. His work strongly affected the style of Richard Shaw.

In contrast to these younger sculptors, Harold Paris (Fig. 120) was already a seasoned artist with a varied background when he arrived in the Bay Area in 1959. As a teenager in New York, he had been active with the Yiddish Theatre, where his father was an actor. He had studied with Stanley William Hayter in Paris in 1949; he had cast bronze at his own foundry while serving as a civilian arts and crafts instructor for the army in Nancy, France, in 1958; and he had created accomplished prints in a graphic style based on German Expressionism.

Paris's relationship with Voulkos was that of a collaborator rather than a follower, and his contributions to Bay Area sculpture became almost as influential as those of Voulkos. His earliest project

FIG. 120. Harold Paris working
on a ceramic wall, 1960.

was *Walls for Mem,* three massive ceramic pieces on which he worked between 1961 and 1963. They originated in detailed preliminary drawings incised into the surfaces of the clay, but Paris went to work on the walls with an Abstract Expressionist impetuosity and vigor, altering and frequently obliterating the original shapes. His first wall was done in a single twenty-four-hour period. Each was built around privately conceived mythic themes in which a Moloch or angel of death and a more beneficent angel of life were central figures. (See Fig. 121.) At the same time, Paris resumed working in cast bronze. Like his ceramic works, the bronze sculptures were somewhat melodramatic treatments of themes of ruin and decay: one, for example, was a group of "chairs," to which human remains seemed to cling, imbedded in ghastly, crumpled slags of metal. The theatricality implicit in much of Paris's work reached its fullest expression in a group of room-sized environments

he assembled in the mid-1960s. Paris turned increasingly to new processes and materials for the sleekly organic and clean-cut geometric forms with which these rooms were sparsely furnished—vacuum-formed plastics, rubber, wood, formica, stainless steel. (See Fig. 122.) They thereby provided a contrast of tactile sensations as well as visual ones. The rooms were usually enclosed in black, darkened except for punctuation points of light that dramatically illuminated the abstract and symbolic sculptural forms that the rooms contained. Spectators were sometimes permitted to enter only one at a time, in stockinged feet. (Peter Selz believes that Lucas Samaras was the only other American sculptor to begin making environmental works this early.)[5] The ritualistic atmosphere was occasionally reinforced by performances that Paris conducted inside the rooms, as well as by titles referring to metaphysical themes and to such apocalyptic horrors of contemporary

FIG. 121. Harold Paris, *Wall III*
(formerly *Wall for Mem*), 1962.
Fired ceramic, 90″ × 156″ × 48″.

life as the holocaust and the Vietnam war. Paris's big environments—which in retrospect seem to have been his most important pieces—were followed by several series of very small works, generally called *Souls* or *Letters,* composed of found objects that were imbedded in transparent blocks of silicon gel or in sheets of handmade paper. Paris's work often seemed to represent a dialectic, only occasionally resolved, between two eras: the dramatic expressionism of the immediate postwar years, with its supercharged emotionalism and ambitious, sometimes overreaching themes; and the detached preoccupation with materials and processes, the concern with craft, that dominated the "cooler" attitude of the esthetic mainstream in the 1960s and 1970s.

While Voulkos was inspiring interest among other artists in the sculptural possibilities of clay, he was himself becoming frustrated with the limitations it placed on scale and structure, and was beginning to explore the potential of cast bronze. Shortly after Voulkos arrived in Berkeley, another new faculty member, Don Haskin, an experienced bronze caster, proposed that they set up a factory, and soon Haskin, Voulkos, and Harold Paris were working together in what they called The Garbanzo Works, a small rented corner of a big commercial foundry on the Berkeley waterfront. By the fall of 1962, some ten thousand pounds of bronze had been cast at the makeshift foundry, and more than fifty artists and students had been involved in its operations. (As Stephen De Staebler remembers it, the earliest experiments in bronze casting on the Berkeley campus—including a few of Voulkos's own—had taken place slightly earlier in a seminar conducted by Jacques Schnier, which made use of a small foundry housed in the U.C. Engineering Building.)[6] The Garbanzo Works and a much larger foundry that Voulkos later set up on Third Street, hard by the Southern Pacific railroad

Sculpture of the Sixties

144

FIG. 122. Harold Paris, *Room I,*
1964–1966. Formica, plaster, cast
resin, polyethelene, and rubber; 50′
× 20′ × 12′.

FIG. 123. In the Garbanzo Works in
Berkeley, 1960. Left to right:
Michael Frimkess, Donald Haskin,
Peter Voulkos.

tracks on the frontier between Berkeley and
Albany, served as an important extension of his
classroom on the U.C. campus during the 1960s.
(See Fig. 123.) Many younger Bay Area sculptors
served for a time as assistants to Voulkos.

Voulkos's own earliest bronzes were similar in
approach to his ceramic sculpture; they were
assemblages of disparate elements that he cast
from "found objects" using the lost wax method.
Relatively small and with the ragged expression-
ism of decaying bird carcasses, the bronzes were
usually mounted on rolling platforms; some were
jokes, and bore spoofing titles. (See Fig. 124.)
After moving into his cavernous new foundry on
Third Street, Voulkos—with the help of cranes, a
forklift, and a battalion of assistants, but always
directly involved in the work himself—began to
build his more polished, large-scale "public sculp-
tures." A prominent element in the earliest of

these was a table-like structure—a carry-over
from the earlier rolling platforms—supported by
massive cylindrical legs. The objects placed on
these tabletops gradually developed into a charac-
teristic vocabulary of forms, which in many
variations reappeared in most of Voulkos's sub-
sequent large bronzes: the dome, the rectangular
cube, the T, the flat sheet, the doughnut, and
the elbow. The dome shape—often broken or
notched—was cast from a big cooking kettle that
Voulkos found; the doughnut originated with an
oversized inner tube. The doughnut, especially,
underwent numerous metamorphoses. Opened
out, it could be twisted into coiling forms that
vaguely suggested spaghetti. It could be bent into
the kind of racing zig-zags that moved among the
thirty-foot-high stacked tables of Voulkos's gi-
gantic commissioned piece for the San Francisco
Hall of Justice. Or it could unfold into the swift,

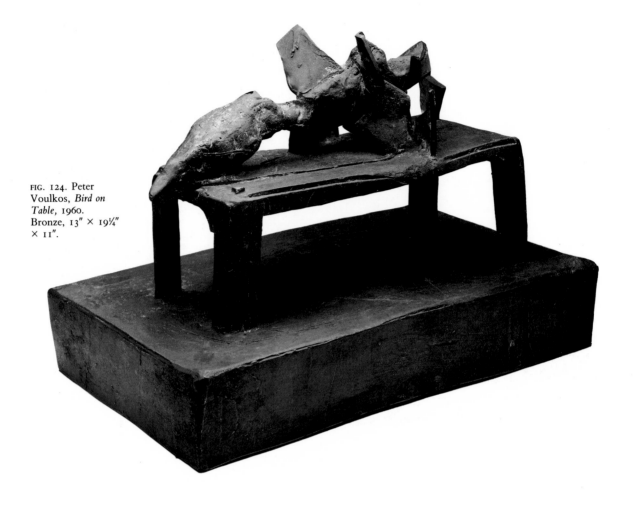

FIG. 124. Peter Voulkos, *Bird on Table,* 1960. Bronze, 13″ × 19¼″ × 11″.

seventy-foot-long extension of a 1972 untitled sculpture that was installed at Highland Park, Illinois. The large bronze pieces—with their industrial scale and Baroque exuberance—seemed to hint at a reconciliation, seldom fully achieved, between two opposites: the demands of public art for monumentality and an aloof "objectivity," and the evocativeness, immediacy, and risk of a more personal expression, touched by a delicate surrealism that sometimes suggested parallels to living organisms or outlandish landscapes.

The installations of Voulkos's big pieces were frequently major events: "Voulkos and Company"—a changing crew of assistants, students, and friends who sometimes doubled as a jazz ensemble (Voulkos is an accomplished jazz and flamenco guitarist)—was apt to arrive on the eve of a scheduled gallery opening, ready to work all night with welding torches and a 24,000-pound forklift. Frequently, a work's final form was improvised on the spot. Throughout the twenty-year period when Voulkos was concentrating on

bronze, most of his production in clay took place in public demonstrations, where he worked, much like a jazz performer, before audiences who gathered to watch him at schools and workshops throughout the country. His later pieces—plates and vessels of various sorts—became progressively simpler, more elegant, and in a craggy Oriental way, more refined—as if, having subjected ceramics to so many violent innovations, he was gradually converting it back into a traditional crafts medium.

Voulkos's personal style, even more than his work, had a lasting impact in the Bay Area. The rough, uninhibited way in which he approached materials, his "macho" physicality and booming profanity, encouraged sculptors to assume the unpretentious (or perhaps inversely pretentious) pose of belonging to the working-class world of mechanics, forgers, and welders. By and large, an intimate association between sculpture and personal workmanship continued to prevail in the Bay Area, throughout an era when sculptors

elsewhere often worked by remote control, giving engineers and other technicians responsibility for the physical production of their ideas. As Alfred Frankenstein wrote in reviewing an exhibition on the roof garden of Oakland's new Kaiser Center building in 1963—the earliest Bay Area show to call attention to the new developments in sculpture—the one unifying element in Bay Area sculpture was "the artist's direct, intense, not to say violent involvement with his own creation." He continued: "Everybody is casting like crazy. Every other shed in the back lanes of Berkeley is a sculpture foundry, but the foundry work is rather different from that of older times. For one thing, the artists themselves are doing it; making molds and pouring metal are no longer menial trades but artistic techniques; their fire, smoke, noise, and physical effort go into the sculpture itself and are no longer unpleasant incidentals on which the artist turns his cultivated back. . . . The grand gesture, with which the abstract painters lashed out twenty years ago, reaches unexpected conclusions here."[7]

If the attitude and tone that prevailed in much Bay Area sculpture of the 1960s was set by Voulkos, its thematic content—part hermetically mythic, part self-spoofing and punning—was shaped largely by a circle of painter-sculptors connected with the California School of Fine Arts (renamed the San Francisco Art Institute in 1960). The senior member of this group—and at least at the beginning its most influential figure—was a retiring former student at CSFA during the Clyfford Still era, Jeremy Anderson (Fig. 125). Anderson had studied sculpture with Robert Howard and drawing with Clay Spohn (as well as painting with Still and Rothko). His earliest sculptures were bony, bulbous pieces in colorless raw plaster, reflecting an inspiration in Picasso and Miró. He was also influenced by the early, cage-like constructions of Giacometti and by Sumerian and Near Eastern art. His fascination with a large collection of medieval weapons then on permanent display at the M. H. de Young Memorial Museum was reflected in forms that alluded to clubs, maces, battle-axes, and catapults.

While visiting France on an Abraham Rosenberg traveling fellowship in 1950, Anderson was especially impressed by the order, mystery, and ceremonial significance of the "one thousand stones of Carnac" in Brittany. More than any particular style or form, the power of myth itself became an overriding preoccupation for him. "Myth," he observed, "explains what the mountains and the seas are here for."[8]

FIG. 125. Jeremy Anderson and his sculpture, *Chessboard Table*, 1952.

Beginning in 1952, carved wood—generally redwood, but sometimes fruitwood or teak—became Anderson's principal material. His work through most of the 1950s alternated between thin vertical columns, which resembled hatracks, and large table-like "shelves" supported by legs, some with two levels. The columns became axes, and the shelves platforms, for bristling spines, swelling mounds, and irregular shapes that sometimes suggested sex organs or viscera, sometimes bizarre mechanical contraptions. The emphasis was on profile and silhouette. The sculptures had no titles, so that their "content" remained ambiguous and open-ended.

Pieces like these still fit comfortably into the tradition of Surrealist abstraction. An important change took place in Anderson's work around 1960, when he began adding cryptic or teasing titles, such as *R.I.P.* and *Horizontal Hospitality*. These were sometimes accompanied by words carved into the sculpture itself. These verbal allusions—which recalled the punning humor of Spohn and the bawdy puns that Wally Hedrick

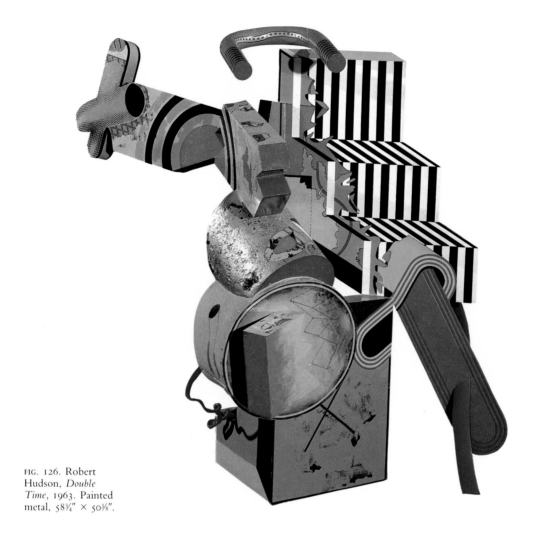

FIG. 126. Robert Hudson, *Double Time,* 1963. Painted metal, 58¾" × 50⅛".

developed later—expanded the implications of Anderson's forms, projecting them into a realm of comic-book absurdity without detracting from their formal and poetic power. Retaining roots in the fertile, abstract Surrealism of Miró, they also shared a kinship with the eccentric, folk-inspired wood sculpture that H. C. Westermann was developing concurrently in Chicago. (Peter Saul cites a Westermann show at the Dilexi Gallery in 1962 as a paramount influence on Bay Area Funk art as a whole.)[9] Anderson's sculpture forged a unique link between the more traditional biomorphic abstraction of Robert Howard and his wife Adaline Kent and the Dadaesque comedy of Clay Spohn. His work thereby helped set the stage for the Funk surrealism of the 1960s.

The Art Institute group associated with Anderson was soon dubbed the "polychrome move-

ment" (by *Artforum,* one of its most vocal champions). Most of the artists involved in it were painters, or former painters, who sought to carry over the use of painted surfaces to three-dimensional forms.

Robert Hudson was, in many respects, the prototypical "polychrome sculptor." Like William T. Wiley, he had grown up in Richland, Washington; his parents lived in a trailer court (he used the back seat of the family car as a bedroom), and he absorbed the cowboys-and-Indians subculture peculiar to the region, with its ubiquitous Country-Western music and nearby Indian reservations where traditional rites were still practiced. He enrolled at the California School of Fine Arts in 1957 and began his career as a painter, working in the style of late-blooming Abstract Expressionism then prevalent at the school, with its growing

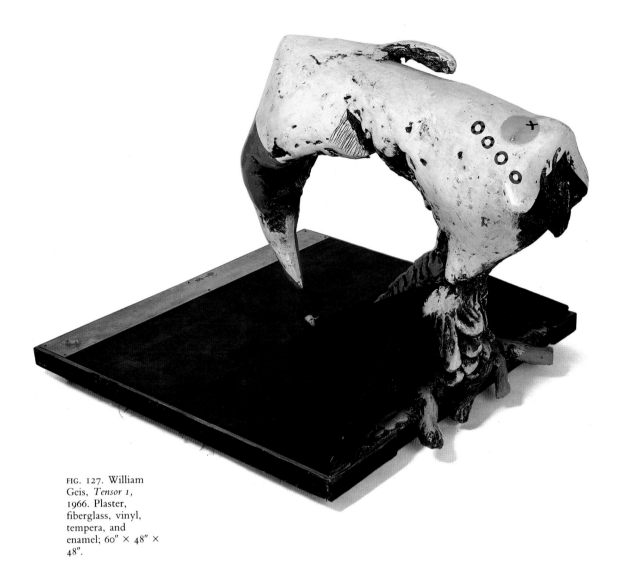

FIG. 127. William Geis, *Tensor 1,* 1966. Plaster, fiberglass, vinyl, tempera, and enamel; 60″ × 48″ × 48″.

emphasis on Surrealism and parody. He soon found painting on canvas too limiting, and turned to making exuberant assemblages of welded steel; with their surfaces brightly painted in a crazy-quilt of colors and in abstract, figurative, and symbolic motifs, they brought to mind an explosion in a comic-book factory. (See Fig. 126.)

Nevertheless, as Fidel Danieli wrote of Hudson's early work in *Artforum,* these were full-fledged, sometimes formally powerful sculptures that had "carried over all the painterly strategies." Danieli likened their Baroque, gawkily acrobatic, frequently anthropomorphic forms to the drawings in the Dr. Seuss books.[10] The sculptural components—themselves composites of fabricated and found ingredients—were contradicted by the painted ones: real painted steel stairsteps, for example, came to a dead end against a "wall"

upon which was painted an illusionistic sky. This "classic" (outrageously comical) phase of Hudson's sculpture lasted until the late 1960s, when an unexpected post-Minimalist austerity entered his work. His new sculptures used unadorned industrial materials—glass, metal, stacks of black neoprene sheets—held in place by straps or tautly guyed with wires and supported on rolling platforms. The restricted range of non-colors—blacks, grays, silvers—contributed to a somnambulent, Surrealist feeling, the sense of industrial equipment sleeping.

William Geis developed a style of sculpture that combined elements of Hudson's brightly painted surfaces and irrational construction with Wiley's cryptic painted images and the organic, frequently zoomorphic shapes of Frank Lobdell. (See Fig. 127.) His early sculptures were big constructions

Sculpture of the Sixties

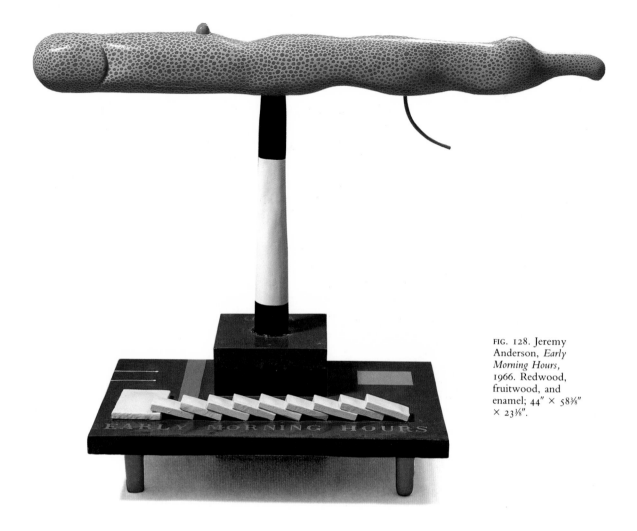

FIG. 128. Jeremy Anderson, *Early Morning Hours,* 1966. Redwood, fruitwood, and enamel; 44″ × 58⅜″ × 23⅜″.

of plaster; the forms were monstrous, resembling giant claws. The surfaces were touched with paint and with spidery drawings that alluded to Möbius strips, pyramids, and other symbolic images. Eventually, Geis began to mount these pieces on platforms vulgarly upholstered in plastic alligator hide or tiger striping, sometimes split with velvet-lined openings through which erotically charged organic forms rose up.

Anderson himself began to use color somewhat later than these other sculptors—tentatively in a 1963 piece called *Altar,* and aggressively in many of his larger works from 1965 onward. He used bright enamel paints and often completely covered his raw material. His *Early Morning Hours* (1966) (see Fig. 128)—the words carved into a pedestal supporting a long, irregular, spotted form that suggests a giant slug turning into a French tickler—established the archetypal look of Bay

Area Funk of the late 1960s: slick, bright, unabashedly eccentric and Freudian, with conspicuous, if ambiguous, connections between images and words.

Another sculptor associated with this group was Arlo Acton. After enrolling at the California School of Fine Arts in 1959, he developed a form of sculpture that coupled Alvin Light's approach to shaping and assembling wood with the cartoon humor of Robert Hudson. Like Light, Acton relied principally on the natural colors and textures of his materials, but his materials included everything from roughly chiseled chunks of raw eucalyptus to old toilet seats, shoe lasts, and sections of wine barrels. They were pieced and joined together in the manner of early funky assemblage. In structure, however, they were more closely related to traditional Cubist sculpture, with smaller pieces clustering around big

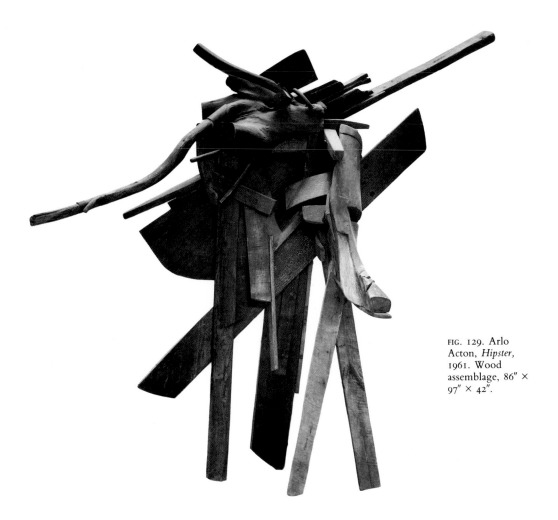

FIG. 129. Arlo
Acton, *Hipster,*
1961. Wood
assemblage, 86″ ×
97″ × 42″.

timbers in sequences of massive planes and stac-
cato extensions. (See Fig. 129.) Like Anderson,
Hudson, and Geis, Acton had done his most
innovative and influential work before the 1960s
had ended.

In general, as the 1960s advanced, sculpture
tended to lose its rough edges and to take on some
of the sleek, technological finish of Formalist
painting. This development was particularly no-
ticeable at San Jose State College. Don Potts, a
painting student there in the early 1960s, moved
gradually to sculpture in which he applied a
carpenter's woodcraft to utilitarian forms—a dea-
con's bench, a pencil-holder, a flamenco guitar—
that he called "Totems to My Existence" (the title
of his Master's show in 1965). He also did more
abstract pieces in unpainted wood and leather that
were generally organic in form and sometimes had
erotic overtones: shapes like pelvic girdles or

saddles, trimmed with fur-lined edges and
equipped with "arms" or rockers.

In 1966 Potts began to consolidate his ideas in
the concept of a car. At first, he planned a
relatively straightforward sculpture that would
combine the forms of vehicle and human figure.
But the project grew increasingly complex, and
finally resulted, almost four years later, in a sleek,
meticulously engineered skeleton called *The
Master Chassis* (see Fig. 130), complete with
four-cylinder engine (operated by radio control),
running gears, clutch, hydraulic steering, and
other functioning mechanisms. Although the car's
actual velocity was limited, its slender, biomor-
phic, strictly symmetrical form—like that of a
precision-engineered insect—was a veritable icon
of speed. Potts also completed a series of inter-
changeable auto "bodies"—almost equally skeletal
constructions of fabric and steel or stainless steel

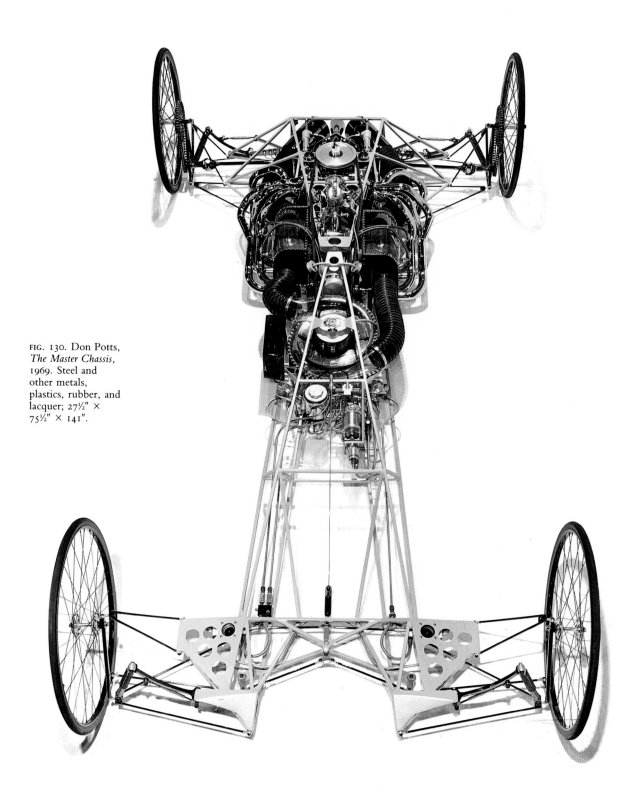

FIG. 130. Don Potts,
The Master Chassis,
1969. Steel and
other metals,
plastics, rubber, and
lacquer; 27½" ×
75½" × 141".

FIG. 131. Fletcher Benton, *Dynamic Rhythms Orange, Phase III, 1976.* Bronze, 84″ × 84″.

plates—that could be mounted on the chassis like a change of clothes. He became increasingly engrossed in his work, continually revising and refining as his technological sophistication grew. Thomas Garver has suggested that for Potts, the car came to represent a kind of alchemical labor of self-transformation (as the "large glass" may have been for Marcel Duchamp).[11]

Fletcher Benton's first sculptures were primitive experiments aimed at introducing movement into painting. Arriving in San Francisco shortly after leaving Miami University (Ohio) in 1956, Benton painted in an Abstract Expressionist style while working as a sign painter around North Beach. In 1960 he began a series of portrait studies of other Bay Area artists, in which their figures were translated into cold blue silhouettes against stark white backgrounds. In a few of these paintings he began to add figures cut out of balsa wood,

suspended in front of the canvas and driven by a motor that would cause them to pivot back and forth.

Finding these crude animated figures a dead end, Benton began "to play around with the motors without using the figures."[12] He then drew on his experience as a sign painter to develop a vocabulary of hard-edged geometric shapes and full, bright colors. Housed in boxes and powered by homemade internal mechanisms, Benton's early kinetic pieces consisted of two or three plastic planes cut in various geometric shapes, each a different solid color; they went through programmed sequences, changing from one simple combination of forms to another.

Benton explored changing surface patterns in a *Light Series* (1965–1968) in which rear illumination was filtered through revolving moiré screens. But his principal works of the late 1960s were pieces

FIG. 132. Bruce Beasley opening the autoclave, 1972. Inside, the sculpture has been processing for almost two weeks.

that exploited the movement of overlapping, transparent color planes. Enclosed in shiny, high-reflecting frames of copper, aluminum, or stainless steel, the moving panels—vertical rectangles, or sometimes discs, in solid primary colors—were sandwiched between "windows" of clear acrylic. As one panel passed in front of another, their colors combined to create a continuous spectacle of changing color modulations. Benton's largest piece of this kind—a mural-sized window—was commissioned by the Oakland Museum and installed in its third-floor art division gallery.

Benton's work in the mid-1970s became more fully sculptural. A series entitled *Folded Circles* ranged from table models to pieces of monumental size; primarily made of bronze, their constructivist combinations of creased, cut-out, and re-arranged geometric shapes were played against rich surface patinas and lacquers. (See Fig. 131.) By the late 1970s, Benton had turned to still more purely sculptural structures in unadorned plate steel. Most of them belonged to a series entitled *Folded Squares;* they were cut into the shapes of stylized letters and playfully rearranged in a way that invited the viewer to reassemble in his mind's eye the square from which the pieces had been cut. A number of younger constructivist sculptors—David Bottini among them—developed in the 1970s from among Benton's students and assistants at San Jose State University.

Plastic and related materials had attracted a handful of Bay Area sculptors from a relatively early date. Robert Howard and Alvin Light had experimented with plastics for a brief period in the early 1950s. Just after the Second World War and well before either of them, Freda Koblick, at first working in a commercial context as a plastics consultant and designer, had begun to cast objects in transparent polymethyl methacrylate—lucite. Gradually, she moved into large-scale architectural commissions, and in the 1960s to self-contained works of sculpture—sleek, transparent, rhythmic abstractions that took their principal impetus from natural forms.

Bruce Beasley contributed most dramatically to the medium itself in the 1960s: he developed his own processes for casting large-scale forms in transparent acrylic, something that even specialists in the plastics and chemical industries had been unable to achieve. This occurred in 1966, after Beasley, on the basis of a few relatively small experimental castings, had won a commission for a monumental outdoor sculpture for the state capitol grounds in Sacramento. He spent the next two years assembling equipment—including a 30,000-pound autoclave, a gigantic "oven" in which the liquid plastic is subjected to a combination of heat and pressure that transforms it into a transparent solid (see Fig. 132). By trial and error, Beasley developed the technology required to

FIG. 133. Bruce Beasley, *Apolymon,*
1970. Cast acrylic, 108″ × 192″.

produce the work, which he called *Apolymon.* (See
Fig. 133.) It was a rippling organic abstraction of
crystalline transparency, sanded and polished to
the perfection of a giant jewel and virtually
dissolving in the dazzle of its own reflected light.
It rose fifteen feet high and weighed 13,000
pounds. After its completion, Beasley continued
to work in lucite on a smaller scale and in
generally more geometric forms, hollowed by
spheres and hemispheres that refracted light and
distorted surrounding imagery with fascinating
"fish-eye" effects.

Among other sculptors working with plastic,
Jerrold Ballaine and Sam Richardson achieved
their most distinctive expressions within it. Bal-
laine's first experiments with three-dimensional
forms were paintings from which organic

shapes cut out of masonite projected into the
room. His desire for more convoluted forms
led him to search for more pliant materials.
First he tried sheet acrylic, heated and bent to
shape; soon afterward, he discovered a still
more elastic plastic—a cellulosic butyrate—and,
with it, the vacuum-forming process. Ballaine
soon built his own vacuum-forming machine
and other equipment.

Ballaine took part in the Slant Step exhibition as
well as the 1967 Funk Show, and in general his
sleek pieces in vacuum-formed plastic joined the
romance of high-tech finish to the organic surreal-
ism of Funk art. By the last years of the 1960s he
had developed the simple forms of his *Airtight
Series.* Here, swelling, convex volumes billowed
out from squares attached to the wall, with one or

Sculpture of the Sixties

FIG. 134. Jerrold
Ballaine, *Untitled,*
c. 1967. Vacuum-
formed plastic,
44″ × 44″.

two horizontal bars recessed into their central areas. High-keyed Murano paint, sometimes augmented by other pigments, was applied in surfaces that alternated between matte and shiny; they transmitted one color as light passed through, and reflected its opposite number on the color spectrum. The transparent colors and reflections took on the rich, Tangerine Flake iridescence of the painted surfaces of custom cars, with an effect that was at once erotic and cool. (See Fig. 134.)

Sam Richardson was a landscape painter who moved to landscape sculpture in the middle 1960s. Among his earliest three-dimensional pieces was a floor-to-ceiling plastic "tornado" that twisted above forms whose ridged and hollowed surfaces resembled cross sections of topographical maps. By 1968 he had miniaturized his scale and was concentrating on small, clean-cut cubes surmounted by bald, rolling "hills" and "valleys" formed of polyurethane foam. These were covered with fiberglass, sanded to a smooth matte surface, and sprayed with lacquers in soft tints that suggested the shadows and highlights projected by the slant of sunlight at different times of day. (See Fig. 135.)

Some were covered with "snow." The pieces were given folksy titles ("About a mile across that snow plain there's a deep crevasse"), which contributed a touch of ironic deliberation to their tendency to be cute. In the late 1970s, tiny "trees," poles with taut lines strung between them, and the shadows that these objects cast became the principal features of Richardson's miniature plastic cubes—and of similar pieces covered with surfaces of raw leather that resembled areas of desert. Richardson sometimes projected these ideas to environmental scale in indoor and outdoor installation pieces.

By the late 1960s sculpture had become an important activity on most of the college and university campuses in the Bay Area. Perhaps the greatest diversity flourished at U.C. Davis, where, in addition to the growing number of ceramists inspired by Robert Arneson, and a contingent of conceptualists influenced by Bruce Nauman and William T. Wiley, such sculptors as Tio Giambruni and Gerald Walburg continued to work in monumental styles. In the Berkeley industrial area in 1970, the California College of Arts and Crafts opened a spacious off-campus

FIG. 135. Sam Richardson, *Boulder in a Gulley*, 1972. Fiberglass, lacquer, and rock; 6½″ × 6½″ × 2″.

foundry, which accommodated a glass studio as well as casting equipment. After 1970 CCAC also became a significant center of ceramic activity, with Viola Frey and Art Nelson as its most influential teachers.

Bay Area galleries were filled with work by local sculptors of virtually every description. The most interesting were often artists who stood at a certain remove, esthetically or socially, from the main trends in Bay Area sculpture: the "polychrome" group in San Francisco, the Funk artists at Davis, and the sculptors who gathered around Voulkos in Berkeley.

James Prestini's work reflected his background as a Bauhaus-inspired craftsman, machinist, engineer, and researcher. His severely symmetrical constructions, made of steel and composed of standard structural elements—I-Beams, H-Beams, channels, angles, pipes, and tubes—maintained an extraordinary balance between the strict integrity of each of their parts and a gestalt in which each element assumed its place in a "higher order of structure."[13] Chrome and nickel-plated surfaces, polished to achieve the properties of mirrors, reflected not only the surrounding environment but also other parts of the sculpture itself, creating an illusion that its solid volumes were dematerializing or becoming transparent—a mirage of movement, space, and light. (See Fig. 136.)

Victor Royer also made sculpture that celebrated the materials and esthetic of contemporary technology, but it did so with a sensibility and method of working more like that of found-object assemblage, and with overt allusions to mysticism. His pieces were fashioned from brass and aluminum cylinders, fittings, and notched gears, which he sometimes nickel-plated and polished to the finely calibrated finish of precision-tooled machine parts. Their forms, generally spare and vertical, had a totemic, anthropomorphic character that seemed both primitive and futuristic. (See Fig. 137.) Usually small and often kinetic, with the movement of finely tuned watches, Royer's sculptures were frequently named for planets and signs of the zodiac. His most monumental piece was the seven-foot-high kinetic *Sun Machine V*, which was purchased in 1970 by the National Gallery of Victoria in Melbourne.

Sculpture of the Sixties

FIG. 136. James
Prestini, *Construction
No. 214*, 1970.
Nickel plated steel,
27⅞″ × 13⅞″ × 8″.

At an opposite pole to sculptors such as these, John Baxter made assemblages of weathered stones and driftwood gathered on the beach. His sculptures, generally consisting of two or three dramatically related elements, had some of the character of Oriental religious monuments. Their Zen-like purity and presence remain unique in Bay Area sculpture. (See Fig. 138.)

Peter Gutkin's handsomely crafted wood pedestals and reliquary-like containers supported or housed sleekly organic, iridescently painted plastic forms that often suggested exotic plants and had an aura of visionary beauty (Fig. 139). In the 1970s his sculpture took on a rough, raw look; generally, blocks of unfinished wood, sheet steel, and plates of frosted glass were gathered together in geometric floor pieces that projected a feeling of clenched, intensely compressed masses. Gutkin later moved back to a high-tech look, setting thin discs of anodized aluminum above squat, doughnut-shaped pedestals covered with gold paint—elementally simple and yet strangely mysterious artifacts with the compelling presence of meditation objects.

FIG. 137. Victor Royer, *Moon Machine III*, 1967–1976. Nickel plated brass and plexiglass, kinetic; 96″ high, including base.

FIG. 138. John Baxter, *Sebastian*, 1964. Wood with carnelians, 15¾″ × 7¼″ × 3½″.

FIG. 139. Peter Gutkin, *Fetal Fern*, 1967–1968. Wood, plastic, and lacquers; 83″ high.

FIG. 140. Barbara Spring, *Mr. and Mrs. Ernest Carving*, 1976. Wood, 72″ × 48″.

FIG. 143. Paul Harris, *Hannah Ascending the Stairs*, 1975–1982. Painted stuffed cloth and wood, 132″ × 96″.

Barbara Spring, John Battenberg, Robert Cremean, and Paul Harris were among a minority of Bay Area sculptors who continued to work in a figurative style. Spring specialized in life-sized replicas of ordinary people, made principally of wood. They straddled a fine line between photographic literalism and the stylization of folk sculpture, often to comic but disquieting effect. (See Fig. 140.) Battenberg's early sculpture revolved around cast bronze toy airplanes and soldiers imbedded in ravaged "warscapes." Later, he made life-sized castings of uniforms and boots, eerily standing up as though an invisible figure might be inside. In the 1970s, he turned to the figure itself, at first in attitudes that made more or less explicit reference to themes of sexual bondage games, and later to a more conventional eroticism in big, cast-bronze figures. (See Fig. 141.)

Cremean, who settled at Tomales Bay in the early 1960s, worked primarily in wood—laminated, elegantly carved, sanded, and polished. His forms were simplified, dissected, and reconstituted in a synthetic Cubist manner that sometimes recalled the stylizations of Art Deco, sometimes

the mannequin figures of the Italian metaphysical painters. They were frequently combined with props, to make rather heavy-handed reference to symbolic themes. (See Fig. 142.)

Harris, a teacher at U.C. Berkeley during the late 1960s, specialized in whimsical, life-sized figures of stuffed fabric, generally covered with florid, 1930s-style prints and resembling the folk-inspired figures of Elie Nadelman; they were often set in room-sized environments of cans or cloth, and tended to blend into their backgrounds as if camouflaged (see Fig. 143). Harris also made still-life sculpture of bronze that exploited subtle distortions of shape, perspective, and scale; they frequently alluded to motifs of historic modern paintings and sculpture, and straddled a fine line between observation and fantasy.

A core group of more traditional, generally older sculptors managed to survive the various innovations of the 1960s with their attitudes and styles more or less intact. Ruth Asawa alternated between abstractions of natural forms, in intricate open-work patterns of thin woven wire (Fig. 144), and conventional figure pieces such as her mer-

FIG. 142. Robert
Cremean, *Vatican
Corridor, A
Non-Specific
Autobiography*, 1976.
Laminated sugar
pine; twenty
columns: ten at 96″
× 24″ × 16″; ten at
96″ × 29″ × 16″.

FIG. 141. John
Battenberg, *Queen
Anne Is Dead I
Think*, 1975. Cast
bronze, 11″ × 21″ ×
60″.

FIG. 144. Ruth Asawa, *Untitled*, 1974.
Bronze wire and copper pipe,
12′ diameter.

maid fountain at Ghirardelli Square. A student at Black Mountain College (1946–1949) before settling in San Francisco, she was active in art programs with public school children, who sometimes collaborated with her in her public projects. Sid Gordin shifted between painted wood constructions that resembled miniature Mondrian-esque architectures, with quirky Art Deco touches, and small, organic abstractions in bronze that were like playfully acrobatic drawings in space (Fig. 145). Old-timers like Henri-Marie Rose and Richard O'Hanlon (who was one of the last of the veteran stonecarvers), and younger sculptors like Jacques Overhoff, whose specialty was cement worked in a variety of styles, carried little prestige in the official art world, but they were often the sculptors whose work was most widely seen—as architectural accessories commissioned or purchased for new buildings and outdoor spaces, both public and private. (See Fig. 146.)

Considering the near-explosion of sculptural activity that took place in the 1960s, the quantity of enduringly significant works it produced seems astonishingly small. With the striking exception of Manuel Neri (Chapter Four), and the somewhat more provisional ones of Robert Arneson and Stephen De Staebler, even the most important and influential Bay Area sculptors of the era did not produce coherent bodies of sculpture that continued to evolve, deepen, and mature. Instead, they moved abruptly from one medium to another (Voulkos, Hudson, Beasley, Benton); from room-sized environments to intimately scaled miniatures or vice versa (Harold Paris, Sam Richardson); and, indeed, back and forth between sculpture, painting, collage, and print-making (Hudson, Paris, Wiley, and others). Their best work—Voulkos's ceramic sculpture, Hudson's painted steel creations, or Geis's big plaster and fiberglass "claws"—comes out of one or two brief "periods," generally early ones. Or it fragments

Sculpture of the Sixties

FIG. 146. Jacques
Overhoff, *Torque,*
1979–1981. Steel
reinforced concrete
and ceramic tiles,
40′ high.

into isolated monuments—like Voulkos's big
bronze, *Mr. Ishi* (see Fig. 113, p. 134), at the
Oakland Museum—that achieve their impact not
so much as individual milestones along a continu-
ing journey of self-discovery as in terms of
architecture: they successfully solve a specific
problem of placing an appropriate form in a
particular environment.

FIG. 145. Sidney
Gordin, *November
1967 #3,* 1967.
Acrylic painted
wood, 72″ × 48″
× 8″.

If any collective development eventually
emerged from all this activity, it was the profes-
sionalization that had overtaken so much sculp-
ture—especially public sculpture—as the 1980s
began. By the time the Oakland Museum ar-
ranged a display of large outdoor pieces in the
summer of 1982 to greet delegates to the Twelfth
International Sculpture Conference (a convention
for sculptors was in itself a sign of the times), the
neo-constructivist abstraction of Corten steel slabs
had become a cliché almost as widespread and
meaningless as neoclassical figures carved in
marble had been one hundred and fifty years
before.

As the 1960s came to an end, the emphasis on
sheer physicality inherent in the sculpture, espe-
cially monumental sculpture, was contending
with a curious countercurrent that was moving
away from the material world. It was inspired by
the ideal of an art that would be more functionally
integrated with "life," and with what many
people were beginning to see as intimations of a
profoundly new spiritual order. This ideal became
the foundation of Visionary art, and also—at least
in the beginning—of Conceptualism.

FIG. 147. Gage Taylor, *Mescaline Woods,* 1969. Oil on canvas, 26¼" × 30½".

FIG. 148. Tad Bridenthal, *Limbic System,* 1969. Light, mirrors, and plastic, 72" × 72".

It is probably appropriate that two of the most widely visible developments in the visual arts of the late 1960s first came to public attention through the news and society columns of the daily press—and that their legacy may now be found chiefly in the inventories of commercial "head shops" and in fading wall murals in the Mission and Western Addition areas of San Francisco and off Telegraph Avenue in Berkeley.

The psychedelic art and the political art of the so-called counterculture, although different from each other in most respects, were both militantly populist or anti-elitist in form and content; unlike Pop, with its pretensions to "high art," they were genuine popular arts. Psychedelic art, in addition, was distinctly a San Francisco product, rather than a regional replaying of a style that had already received its seal of approval on the East Coast.

These and other factors—not least of them, the general artistic quality of most of the work itself—have tended to cast doubt on the relevance of these forms to a discussion of "serious" art. Certainly, the impact of the psychedelic and political art of the 1960s on the historic evolution of forms and ideas has been negligible—although the same could be said of other forms that the art world customarily accepts as art with fewer reservations. Be that as it may, its impact on a personal level was often enormous; individual lives were changed by it. It left a vivid imprint (if not a profound or lasting one, in the manner of the Bauhaus) on the everyday visual environment—on design, advertising, fashions—and it contributed to the shaping of a new, syncretically "post-modernist" sensibility. At a time when artists of many persuasions were seeking a fuller integration of art and life, the psychedelic and political artists of the 1960s, for better or worse, achieved this fusion to a greater degree than most others; one of the problems with their art, in fact, is the very success with which they realized this intention. Above all, these forms reflected one of the most fascinating chapters in the cultural history of the Bay Area.

On the surface, the times seemed hardly conducive to the growth of what was a fundamentally affirmative expression, a kind of rebirth of the utopian vision. To many people, American society had never seemed in worse shape. Anti-war protests disrupted university and college campuses across the country, and demonstrations for civil rights spread from the South to big cities in the North. Social life was torn by urban riots and a rise in violent crime, and political life was shaken by the assassinations of John Kennedy, Robert Kennedy, and Martin Luther King, and by many more assassination threats and attempts. Yet, particularly among young people, there arose a new wave of revolutionary optimism, which manifested itself in many areas: in political and social activism, in psychedelic posters, and, by the end of the decade, in a more overtly mystical form

that has been called Visionary art.[1] More generally, it found expression in all the activities of the radical counterculture.

The counterculture was, in some respects, a continuation of the Beat movement of the 1950s, but with important differences. In the Beat movement, perhaps for the first time in American history, significant numbers of young, primarily middle-class people "dropped out" of the "establishment" and self-consciously rejected its values. Their energy, however, had been primarily negative in a political or social sense. Partaking of the apathy that prevailed in the Eisenhower years, the Beats turned inward, to an art and a literature that were generally angry, and often pessimistic or despairing.

The idealism and activism engendered during the short-lived Kennedy administration helped to direct the rebellion of a younger generation outward into society. Cool jazz was supplanted by folk music. The withdrawal and nihilism of the Beats gave way to the Free Speech Movement in Berkeley (1964) and campus demonstrations in favor of civil rights and against the war in Vietnam. The attention lavished on their activities by the mass media gave American teenagers and young adults a new sense of group identity. One of the principal differences between the Beat and hippie eras was a dramatic increase in the number of people involved. The new youth culture was, on the average, much younger than the Beat Generation had been. It was composed principally of teenagers, college students, and (increasingly) high school drop-outs. Banned from bars and taverns because of their youth, they gathered in coffee houses, or simply on the street, and gravitated toward drugs other than alcohol, which they regarded as an opiate of the older generation.

The most powerful Beat art had usually maintained a tenuous balance between a current of angry or sorrowful social statement and a more purely existential, or visionary, exultation or despair. In the counterculture of the last half of the 1960s, these two currents took different directions, so that they coexisted quite independently and sometimes antagonistically. One current was a neo-Marxist movement that channeled its energies toward revolutionary political and social change; it responded directly to the increasing incidence of violence in American life. The other current was comprised of the hippies, who rallied to Timothy Leary's slogan, "Turn on, tune in, drop out."

The neo-Marxist component preserved the Beats' antipathy to establishment culture. But it also built on the new mood of confidence and solidarity—and the fact of increasing numbers—to form coherent organizations that directed personal alienation into acts of overt hostility, as well as into more constructive forms of protest. For example, political activists forged a tightly knit network to help support draft-resisters and get them to sanctuary in Canada—in contrast to the 1950s, when opponents of the draft had been thrown on their own resources.

The hippie element was uninterested in overthrowing society, but was convinced that it was capable of *converting* it—or, at least, of setting up an "alternative" of its own that would attract increasing numbers of disaffected drop-outs from society at large. Under this rationale, the hippies took part in entrepreneurial activities and cooperative efforts that most of the Beats would have disdained.

Insofar as a model existed for the subculture that the hippies evolved, it was the tribal pattern of living characteristic of "primitive" peoples in general, and of the American Indian in particular. Rousseau's ideal of a return to nature was coupled with an emphasis on "holistic" thought and styles of living. Whereas the Beats had emphasized their fragmentation and "alienation," the hippies were impelled by an intense urge toward synthesis. The prototypical manifestation was the mass "love-in" or "human be-in"—an immense celebratory gathering that took place in Golden Gate Park (Fig. 149). Collective and frequently anonymous expression was emphasized. Jazz, always chiefly a soloists' art, gave way to rock music, which was built on a more integrated concept, emphasizing textures that rose in vertical blocks of sound. The groups that performed it had collective names, played together over long periods of time, and sometimes also lived together. (See Fig. 150.)

Among visual artists, there was a new preoccupation with Jung's concept of the collective unconscious, as distinct from the individual unconscious emphasized in Freudian psychology. The model was the universal archetype rather than the individual neurotic dream. The emphasis on collective expression was accompanied by a resurgence of internationalist eclecticism—frowned on by artists in the "buy American" postwar years—on a scale that had seen few parallels since the synthesis of Oriental, Egyptian, and Mayan traditions in the Art Deco of the 1920s. There was an influx of elements of non-Western religion and philosophy that vastly extended and multiplied the earlier infusions of Zen. These developments, in turn, were bound up with an increasing use of drugs—marijuana, peyote, mescaline, and par-

The Utopian Vision

FIG. 149. Allen Ginsberg and Dr. Timothy Leary at the Human Be-In, Golden Gate Park, San Francisco, January 1967.

FIG. 150. Jerry Garcia and the Grateful Dead performing on Haight Street, spring 1968.

168

FIG. 151. Janis Joplin, 1967. Detail.
Original 19″ × 17″.

FIG. 152. Janis Joplin, backstage at Winterland, 1968.

ticularly the synthetic hallucinogen LSD, which became the most popular of the "mind-expanders." The psychedelic art that began to surface in the mid-1960s frequently gave expression to drug-induced visions. Its stylistic trademark was vivid color, vibrant energy, flowing organic patterns, and a tendency to compress time and space so that images from the most disparate cultures and time periods were brought together in elaborate montages.

According to Marshall McLuhan, who became one of the era's more influential commentators, all these phenomena were intimately related to the pervasive impact of television. He theorized that the "vertical" accumulation or montaging of images—one piling on top of another at breakneck speed—characteristic of television was superseding the "linear thinking" fostered by the tradition of reading. Thus linear thought would give way to a new vision governed by the principles of tapestry, mosaic, or collage. Because television could convey information instantly to virtually every corner of the earth, McLuhan argued, it could weld viewers into a kind of worldwide tribal unit or "global village." Those who were coming of age in the middle 1960s were the first generation to grow up watching a television set. It therefore seemed to follow that the "art" of this generation might incorporate,

almost indiscriminately, elements from Hinduism and Yoga, the Tantric Buddhism of Tibet, the Sufi poetry of the Near East, African religions, and the native cultures of the Americas, not to mention television commercials and Saturday morning cartoons, Victorian furniture, and package design—artifacts from the great plains of American popular culture that even most Pop artists had so far overlooked.

Hippie visual expression was frequently tribal in the strictest sense of the word. Much of it was lavished on personal adornment—costumes, jewelry, bells. An overlay of psychedelic decoration worked to transform mass-produced utilitarian objects—automobiles, vans, windows, walls—into artifacts that thereby became identified with the subculture. Unlike the urgent, tense, and highly personal art of the Beats, the visual expression of the counterculture was primarily functional. For the political activists, it took the form of straightforward propaganda posters that followed the Social Realist conventions of the 1930s and (somewhat later) murals that were strongly influenced by the Mexican mural painters. For the hippies, it consisted principally of accessories to the overriding preoccupation with lifestyle and with music—the focal points of their subculture, as poetry had been the focus for the Beats. (See Figs. 151, 152.)

The Utopian Vision

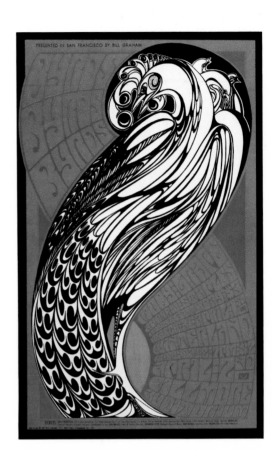

FIG. 153. Wes Wilson, poster for Fillmore Auditorium concert, 1967. Offset lithograph, 22¼″ × 13¾″.

FIG. 154. Victor Moscoso, poster for Avalon Ballroom concert, 1967. Offset lithograph, 20″ × 14″.

FIG. 155. Rick Griffin, poster for The Joint Show at Moore Gallery, San Francisco, 1967. Offset lithograph, 28″ × 22″.

Aspects of the psychedelic art that emerged in the middle 1960s had been anticipated in the work of some Beat artists, most notably in the mandala paintings of Keith Sanzenbach (see Fig. 90, p. 106). Two artists closely associated with Sanzenbach, Bill Hamm and Elias Romero, were the first to develop one of the two distinctive forms of the "psychedelic age," the light show. (Paul Beattie and Warner Jepson had already collaborated in independent experiments with light projections in 1960, working in dancer Ann Halprin's studio.) Hamm, a painter, and Romero, a painter and poet who had been associated with Wallace Berman in Los Angeles, began working together on primitive light projections in a former Mission district church. By floating colored emulsions on water, they projected globular, changing images onto a large screen, creating fluid, abstract color fields.

Initially, Hamm and Romero conceived of their experiments as a form of kinetic painting, a way of making Abstract Expressionist painting move. But they soon explored the possibilities of incorporating more explicit imagery and symbols, adding rotating color discs and slide projections to their battery of techniques. They unleashed their new form on the public on a grand scale early in 1966 at the historic San Francisco Trips Festival. This was the first of the big multimedia events that were to characterize the short-lived psyche-

delic age. Co-produced by author Ken Kesey (*One Flew Over the Cuckoo's Nest, Sometimes a Great Notion*) and Stewart Brand, who later achieved celebrity as founder of the *Whole Earth Catalog,* the Trips Festival filled Longshoreman's Hall with a succession of rock bands and a parade of stroboscopic and liquid light projections, all on a vast, environmental scale. A poster announcing the event, designed by Bruce Conner, took the form of one of the first psychedelic mandalas. The festival was recorded by a young filmmaker, Ben Van Meter, in his "experimental documentary" *Trips Festival.*[2]

Along with the first big rock programs came the second most characteristic visual form of the early rock age, the psychedelic poster. Its principal originator, Wes Wilson, received his first and most important impetus from an exhibition entitled Jugendstil and Expressionism in German Posters, organized by Herschel Chipp at the University Art Gallery in Berkeley in 1965. His early posters—most of them designed for rock concerts at Bill Graham's Fillmore Auditorium, a cavernous hall on Geary Boulevard near Fillmore Street—were distinguished by their borrowings from sources long scorned by the art-historical establishment—Mucha, Beardsley, and Klimt, among others. Sinuous, Art Nouveau-inspired figures and lettering that was stylized almost to

the point of illegibility flowed together in a single, integrated design that jumped with vivid color contrasts (see Fig. 153). Other poster-makers followed. Mouse Studios designed most of its work for Family Dog, a cooperative group loosely headed by Chet Helms, which operated the rival Avalon Ballroom. (This free-spirited enterprise, in contrast to the strictly business Fillmore Auditorium, often gave free admission to impecunious street people.) Mouse Studios was a collaboration between Stanley Mouse, previously a designer in Los Angeles of some of the earliest "monster" T-shirts, who specialized in a fantastic illustrational style, and an artist known only as Kelly, whose own work gravitated toward montages of photographic images in which Magrittean juxtapositions and distortions of scale were combined with the Victorian flavor of Maxfield Parrish. Victor Moscoso was unique among the poster-makers in having an extensive formal background in art; he had studied with Albers and Rico Lebrun at Yale and with Diebenkorn, Bischoff, and Oliveira at the San Francisco Art Institute. He developed a style that leaned toward the pulsating color contrasts of Op art, coupled with images and lettering inspired by Arabic and Sanskrit (see Fig. 154). By contrast, Rick Griffin illustrated hashish pipes and marijuana plants in a meticulous, emblematic graphic style that nostalgically

recalled traditions of nineteenth-century American advertising art and package design (see Fig. 155).

The poster-makers, who received relatively little money for their work (their fees were simply part of a production's advertising budget), were generally motivated by the same idealism that prevailed among the hippie community generally: a belief that their visual statements might alter people's consciousness, and thereby change society. (See Fig. 156.) Moscoso said he had moved to posters from painting because he realized that few people would ever see his paintings, whereas for a dollar or two anyone could buy one of his posters.[3]

The public—and particularly the news media—greeted these colorful graphic works, as they did most expressions of the new hippie subculture, with much more warmth than was ever extended to manifestations of the Beat subculture. Color spreads appeared in the national picture magazines. The influence of the eye-catching psychedelic style soon showed in department-store window displays, advertising layouts, and, of course, the designs of album covers for rock-music records.

The psychedelic or "acid-rock" phase of the counterculture built to a peak in 1967–1968. Hamm's light-show productions inspired com-

The Utopian Vision

FIG. 156. The poster artists, 1967.
Left to right: Kelly, Victor Moscoso,
Rick Griffin, Wes Wilson, Mouse.

petitors such as the North American Ibis Company, founded by Ben Van Meter in 1966. Hamm, meanwhile, joined forces with two jazz musicians, drummer Jerry Granelli and bassist Fred Marshall, a maker of bizarre string instruments, to develop his light projections into a concert form called The Light Sound Dimension—which combined abstract lights and sounds in a programmatic format that dramatically suggested a space voyage. A dozen more poster-makers—photographer Robert Seidemann, Robert Fried, Wilfried Sätty, and Joe and Irene McHugh were among the better known—soon entered the field, and the works of Wilson, Moscoso, Griffin, Kelly, and Mouse were beginning to be valued as collectors' items.

If light shows and posters reflected the more atavistic side of McLuhan's "global village," its futuristic spirit found expression in a more loosely defined development that devoted itself to the "consciousness-expanding" potential of technology. The exploration of space, the increasing sophistication of electronic computers, the new materials and processes that lent themselves to the fabrication of ethereally beautiful high-tech artifacts (which assumed some of the attributes of devotional objects)—all these served to endow the notion of technological progress with the magical

aura it had possessed for artists before the nuclear age, when the century was younger and more optimistic.

At the most modest technological level were the light boxes of Joseph Riccio: simply mechanized works that produced streaky, Turneresque effects and translated some of the fascination of light shows into portable objects. John Rosenbaum made small-scale boxes that emphasized the hypnotic properties of slowly revolving, overlapping wheels of solarized color.

James Reineking's sculptures of very simple shapes—obelisks, hollow cylinders—contained transmitters that emitted low, buzzing sounds, sometimes on the threshold of audibility, which seemed to extend the visual forms into a non-visual dimension. Tad Bridenthal made large polygonal boxes within which a viewer could place his head, or sometimes enclose himself entirely, to look into an illusional infinity of mirrors and colored lights (Fig. 148, p. 164). Matt Glavin teamed with engineer Don Campbell to create a complex laser sculpture in which needle-thin rays of directed light passed through and bounced off of transparent plastic obstructions—creating an effect like that of a pinball game translated into pure energy (Fig. 157).

The Utopian Vision

FIG. 157. Matt Glavin and Don
Campbell, *Laser Environment No. 1*,
1970. Four lasers, mirrors, motors,
and plastic; 48″ × 60″ × 36″.

Much of this work was less concerned with the traditional aims of art than with exploring the boundaries of human perception. Roger Ferragallo, for example, experimented with the visual phenomenon known as binocular disparity. His paintings presented side-by-side geometric images, each from the slightly different perspective of the left or the right eye. With practice and much concentration on the part of the viewer, the painted images could eventually be made to fuse into a third, "ghost" image that seemed to stand in front of the canvas with an extraordinary illusion of three-dimensionality, without the aid of glasses or other devices. Ferragallo saw his experiments as a potential means of revolutionizing perception at its source—in the brain.[4]

Such developments gained impetus from the opening of the Museum of Arts and Sciences—better known as The Exploratorium—in the reincarnated Palace of Fine Arts building designed by Bernard Maybeck for the 1915 exposition. The museum—developed by Dr. Frank Oppen-

The Utopian Vision

FIG. 158. R. Crumb, *Mr. Natural and Flakey Foont in A Gurl in Hotpants,* 1971.

FIG. 159. S. Clay Wilson, untitled comic, 1967.

heimer, a distinguished physicist—promoted collaborative ventures between artists and scientists or engineers, and installed long-term or permanent exhibitions of their work: holography, sound-programmed kinetic sculptures, computerized graphics, video displays, and more. For a brief period in 1969, a national organization called Experiments in Art and Technology maintained a Bay Area chapter. Its most visible public production was a series of three performances billed as *Inside/Outside,* which were presented at the San Francisco Museum of Art in August 1969, in conjunction with a large exhibition entitled Machine Art organized by the Museum of Modern Art in New York.

These and other efforts furthered interest among local artists in exploring certain new media, particularly video. But the art-and-technology movement failed to generate the enthusi-

asm in the Bay Area that it did in Los Angeles or on the East Coast. The expressionistic and individualistic traditions of Bay Area art worked against wholehearted acceptance of the detached, "objective" attitude that was integral to the art-and-technology esthetic, as well as against the concept of collaboration itself.

As the hippie counterculture lost its early sense of community and cohesiveness in the last years of the 1960s, it split into urban and rural components. The rural component moved out to the new communes that sprouted in more or less remote locales all over Northern California, as well as to areas in New Mexico and southern Oregon. The urban group remained based in San Francisco and Berkeley, and its members frequently became involved in "alternative" commercial enterprises. These ventures, like Bill Graham's multimillion-dollar concert-production business, often became

increasingly difficult to distinguish from the commercial enterprises they were supposed to have been "alternatives" to. Posters of real originality were submerged in a sea of gaudy imitations (many were designed to glow under ultraviolet light) produced for the tourist trade. By the middle of 1968, Wilson and Fried had abandoned poster-making for more "serious" painting. (Wilson worked in a style modeled after German Expressionism, frequently reviving the Expressionists' folk-inspired practice of painting on glass; Fried practiced a variety of hard-edged abstraction that sometimes suggested a psychedelic Nicholas Krushenick.)

A similar cleavage developed in the visual expression of the counterculture. The adolescent exuberance, earthiness, and iconoclasm—as well as a sharp commercial instinct—that had found expression in certain aspects of the poster movement reappeared in the underground comic books—or "comix," in the fashionable argot. Their originator and most influential figure was a Philadelphia-reared former designer of comic greeting cards, R. Crumb (his real name), who forged a vigorous style that was a veritable

anthology of traditional American cartoon illustration, embracing elements of Krazy Kat and Jules Feiffer, Popeye and Orphan Annie, Snuffy Smith and *Mad Magazine*. (See Fig. 158.) (Crumb disliked such strips as Gordo and Pogo because of their more self-consciously artistic styles.) Rick Griffin and Victor Moscoso worked in an anti-literary, abstract, and fantastic cartoon style that used science-fiction themes or Escher-like settings and mutant versions of such familiar comic-strip figures as Mickey Mouse and Donald Duck. Crumb, Griffin, Moscoso, and a fourth cartoonist, S. Clay Wilson, pooled their interests to publish *Zap Two,* the first of the underground "comix" to attract widespread attention. Wilson had come from Kansas with a series of cartoons that drew, as Crumb's did, on the "realistic" narrative tradition of American comics; but they were distinguished by a prolix, steely style and a predilection for unbridled raunch: orgiastic fantasies involving motorcycle gangs, pirates, urban hustlers, and the scum of the Old West. (See Fig. 159.) Crumb credited Wilson with starting "this big sex revolution in comics."[5]

The more exotic, mystical strain of expression

The Utopian Vision

FIG. 160. Robert
Comings playing
*The First Bolinas
Instrument*, 1968.

FIG. 161. Robert Comings, *Core
English Poem Machine (The
Ritual Kit)*, 1968. Mixed media
assemblage, 9" × 7½".

that had sometimes found its way into the rock posters—and into the anonymous folk art with which the hippies had decorated everything from rooms to cars—contributed to the development of the Visionary art that flowered in the last years of the 1960s. Its practitioners were generally artists with some formal training who held definite notions about what they wanted their art to accomplish, esthetically and also socially. Reacting against the increasing detachment, refinement, and abstraction of mainstream painting and sculpture, they were primarily concerned with restoring "content" to art, with making art an instrument of spiritual communication and renewal. In contrast to the large scale of most painting and sculpture of the 1960s, the Visionaries usually worked small. Although they cultivated fantasy, most of them also believed in subordinating the ego; they tended to avoid the morbid areas of irrationality courted by an earlier generation of Surrealists. Instead, they emphasized universally symbolic forms like the mandala, or dreamlike visions of landscapes that had an Edenesque innocence and splendor. In their microscopic

detail and jewel-like precisionism, these sometimes recalled the ideal of the Pre-Raphaelite Brotherhood a century before—to see nature "through eyes without lids." Donald Brewer, director of the University of Southern California Art Galleries in 1971, wrote: "Perhaps reversing the idea of the earlier Surrealists, these visionaries convey the sense that the conscious world is now that dark 'other side.' . . . Conversely, the unconscious world—their primary source—is the only possible channel to a new alternative reality."[6]

The work of the Visionaries began to appear in 1968 in small, out-of-the-way San Francisco art galleries with such fanciful names as The U.F.O., Sun, and Mandrake. Most notable was a short-lived gallery called The Unicorn, two second-floor rooms of an old Victorian flat on Fillmore near Sacramento Street, which had the atmosphere of an astrologer's parlor (it had been Jay De Feo's studio a few years earlier, when she was painting *The Rose*). One of its earliest shows was by an artist named Robert Comings (see Fig. 160). It included paintings, drawings, constructions, found objects, toys, scrapbooks, musical instru-

The Utopian Vision

FIG. 162. Norman Stiegelmeyer, *Return to the Infinite*, 1977–1978. Oil, acrylic, and metallic paint on canvas; 48″ × 60″.

ments, and a machine for making poetry and chants from accidental combinations of letters and numerals (Fig. 161). Intriguing as isolated objects, taken together they conveyed an impression that Comings had singlehandedly forged the artifacts, folklore, and ritual of a new culture, whose roots were in nature, primitive tribal rites, and Oriental philosophy, with a touch of Dada thrown in. In fact, Comings regarded his work primarily as a form of ritual rather than as art in any traditional sense. After three exhibitions in San Francisco galleries, he left the art world altogether in the early 1970s to settle in Sonoma County, where he devoted his time to making his surroundings into a total living environment in the manner of the organic habitats of certain "outsider" artists. Comings's work in many ways epitomized the spirit of Visionary art, as Wallace Berman's had captured the funkier visionary sensibility of the previous decade. It gave form to energies that seemed to flow from a "primitive" (or enlightened) state of consciousness, in which no basic distinctions are made between art-making and worship, or between work and play.

In contrast to Comings, Norman Stiegelmeyer was Visionary art's most prominent "academician" and influential painter. The strength of his abstract painting style and his impact as a teacher (at the San Francisco Art Institute from the mid-1960s to 1975) established the tone, and in many cases the formal vocabulary as well, for at least one major branch of Bay Area Visionary art. As an organizer of exhibitions he helped to define and promote the Bay Area Visionary "school."

Among the formative influences on Stiegelmeyer's art were the works of William Blake, a "hellfire and brimstone" religious background, and his involvement as a teenager in hot-rodding, with its esthetic of painted flaming dragons and sinuous monsters.[7] His early paintings, strongly influenced by the thick impasto and symbolic colors of Frank Lobdell, were populated with convulsive figures inspired by icons of medieval religious art, and engaged in hallucinatory scenes of violence. Gradually, his paint became thinner, his forms more abstract and flat, recalling Miró; they were set against deep black or blue spaces, or on "walls" that plunged into vast depths to suggest cosmic "rooms" (see Fig. 162). Stiegelmeyer had initiated a formal meditation program

The Utopian Vision

FIG. 163. Bill Martin, *The Rock,* 1971. Oil on canvas, 24″ × 24″.

at the San Francisco Zen Center in the mid-1960s, and Tantric Buddhism remained the strongest influence on his art. The reconciliation of dualities—good-evil, spirit-matter, man-woman—and the focus and release of energies were recurrent themes. In the late 1970s he constructed transparent plastic boxes occupied by mysterious objects, suggesting surreal rooms furnished in 1930s Moderne. They teetered uncertainly on a thin line between mysticism and vulgarity.

In contrast to the exotic and essentially abstract visions of Stiegelmeyer and Comings, Bill Martin and Gage Taylor concentrated on fantastic landscapes ("alternative realities," Taylor called them) that had deep roots in Western tradition—especially in the spiritualization of nature characteristic of the Hudson River School and in the Pre-Raphaelite Brotherhood. Often using small, circular canvases that suggested portholes, Martin applied a painstaking and time-consuming technique to producing landscapes filled with profusions of plants, trees, animals, cascades, and freshets. They were painted in bright, intense colors and with a gem-like precision reminiscent of medieval illumination or Persian miniature painting (see Fig. 163). Taylor's landscape fanta-

sies combined profuse detail with heavier, painterly surfaces and achieved a "naïve" and nostalgic flavor, like the work of a visionary Grandma Moses. His countrysides were populated with grotesque, anthropomorphic trees, tropical flowers, exotic animals, and treasure boxes half hidden in lush groundcover (see Fig. 147, p. 164). (Taylor once said he would sometimes put in images such as pots of gold and then paint them out again, so as to be "the only one who knows they're there.") For a time, his paintings focused on the life and habits of an invented creature that resembled a small flying plant and consisted of a spiritual aura, a membrane containing pure mind, and reproductive organs ("they have no arms, so they're incapable of inflicting damage").

In contrast to the introverted character of Comings's and Stiegelmeyer's more overtly spiritual work, Martin and Taylor saw their painting as an active tool of spiritual and social revolution. "I'm not outwardly political, but I consider my painting to be about the social revolution," Taylor said. And Martin: "I'd like to change the world. My paintings are a calculated plot, working on as many levels as I can."[8] To this end, both produced large numbers of inexpensive, full-color repro-

The Utopian Vision

FIG. 164. Sätty, from *The Cosmic Bicycle* (San Francisco: Straight Arrow Books, 1971), 1969. Collage, 7¾" × 5¼".

ductions of their work, which they rarely exhibited in the original.

The most extraordinary artist to emerge from the Visionary milieu was Wilfried Sätty. Drawing on an immense "image bank" built up from every conceivable source—including antique texts on alchemy and magic and old and contemporary news magazines—Sätty pieced together montages of extraordinary intricacy and depth. They created dreamlike scenes and otherworldly settings in the tradition of Max Ernst, but with more overtly mystical overtones (see Fig. 164). In his larger prints, Sätty experimented with applying colors directly on the litho-offset press; he made many runs with each print to achieve complex overlays, using the huge, lumbering machine as a fluid, flexible palette. Unlike such slow-working artists as Martin and Taylor, Sätty prized the speed that his use of ready-made images made possible: "My standard of drawing has been set by nineteenth-century engravings. If I were to try to draw everything myself, it would take months for each idea. I would have to let a hundred other ideas go."[9]

While the psychedelic music and poster scene

dissolved, and most Visionary artists turned to other things, Sätty continued to develop and refine his art. He worked in a small, window-less library room that resembled an alchemist's den. It was accessible only by ladder from the dirt-floored basement of a building dating from the Barbary Coast days. Using carpeting and furniture discarded from Pacific Heights mansions, Sätty transformed the basement into a Surrealist environment in which he sometimes threw lavish parties. In the middle 1970s he concentrated on literary subjects, designing montages to illustrate the Dracula tale and a volume of Edgar Allan Poe. Coming to grips with such pre-existing themes seemed to intensify and clarify his expression. His work culminated, in the last years of the 1970s, in a vast series of montages dealing with the early history and myths of San Francisco (Fig. 165). In these, fragments of old engravings were used to create imaginary scenes that often included images drawn from dozens of different sources, meticulously assembled to create an aura of documentary realism. But something had happened to the realism: the concrete images of the nineteenth century, as if sent through a time-warp, had taken

The Utopian Vision

FIG. 165. Sätty, from the *San Francisco* series, c. 1980. Collage, 12″ × 9¼″.

on the sort of mental, immaterial reality that characterizes the images of the electronic age.

Sharing the evangelistic zeal of other Visionary artists, Sätty saw his work as part of a continuing mission to develop an alternative "visual language." "I am using the language of the mass media to create an alternative to the media," he said. "Advertising and media artists are the most influential artists in our culture, which is based on information. . . . It can turn us into an entirely mindless society. In my work I am trying to restore imagination to the media—to raise questions that have no answers, except as they are formed in the imagination of each individual."[10]

By the last years of the 1960s, the evolution of the hippie community toward more stable forms and values was paralleled by a maturing—or mellowing—of the more militant, activist wing of the "revolution." From simple anti-establishment sloganeering, many members of cultural and ethnic minorities took up the difficult challenge of re-establishing the frazzled connections with their cultural heritages or "roots," affirming the validity and vitality of non-Western traditions and creating the framework for a new cultural pluralism.

In 1967, William O. Thomas, a painter and stonecarver, opened the Blackman's Art Gallery, on the street level of a refurbished Victorian on lower Haight Street. Operated on a semi-cooperative basis, it displayed work by a dozen or more black artists, primarily in their twenties and thirties, whose approaches and artistic backgrounds were as foreign to the "anything goes" esthetic of the more avant-garde galleries as they were to the art sold in traditional commercial galleries on Sutter Street. Among the more talented were Joseph Geran, Jr., Robert Henry, and John Britton. Most were inspired by traditional African forms and images, but their work ranged from hard-edge abstraction to academically traditional still-life and portrait styles.

The Galeria de la Raza, founded in a Mission district storefront in 1970 by a group of Chicano artists that included Rene Yanez, Rupert Garcia, and Ralph Maradiaga, pursued a highly diversified program, which alternated between educational exhibitions (Mexican movie posters, Huichol yarn painting) and group and solo shows by local Chicano and Latino artists. It showed the work of Gerald Concha (hard-edge color abstraction), Richard Serra (minimalist structures of raw wood), and postermakers who practiced a clichéd Social Realism. Besides showing the expressionist abstractions of Manuel Villamor and Peter Rodri-

guez, which incorporated fragmentary allusions to the imagery of pre-Hispanic cultures, it exhibited "tortilla" artists such as Yanez and Calvin Tondre, who gathered folk artifacts and commercial objects into thickly encrusted assemblages modeled after traditional Mexican crèches and home altars. Among the artists who confronted more specifically political themes, Garcia developed a unique and powerful graphic style; summarizing his images in flat, boldly reductive patterns whose abstract tensions served to underline the figurative content, he created a vehicle for protest that was as dignified as it was dramatic (see Fig. 166).

The Galeria also provided a staging ground for the mural painting that spread rapidly through San Francisco's Mission district in the 1970s. Its strange amalgam of sources—the exotic forms of pre-Hispanic cultures, militant Social Realism inspired by the Mexican mural painters of the 1930s, the lurid vulgarity of contemporary Pop art (and local "tortilla art"), and a heady jolt of the psychedelic—provided a neat summation of the ideals and enthusiasms, the contradictions and paradoxes, that characterized the "revolution" of the 1960s.

By the early years of the 1970s, Fortune magazine—traditionally the bulwark of buttoned-down capitalist conservatism—was advertising for new readers with full-page layouts in Rolling Stone, the rock journal that had begun in San Francisco as the bible of the counterculture. The counterculture, as Stewart Brand was to say in the late 1970s (by which time the former Merry Prankster had become a staff adviser to California's Governor Jerry Brown), "became the culture."[11]

There was a large kernel of truth in Brand's claim. Certainly the artistic expression of the counterculture was swiftly incorporated into the cultural mainstream, where it had a wide-ranging influence. In addition to its impact on advertising, packaging, and fashion design, the more revivalistic elements of rock art contributed to the resurrection of Art Nouveau and Victoriana—indeed, to a wave of interest in neglected cultural heirlooms that culminated in the "nostalgia boom" of the 1970s. It formed a bridge to the appreciation of such exotic objects as Tibetan tankas and Huichol Indian yarn paintings. But ultimately the counterculture remains more interesting for its sociological character than for most of the artistic expression it engendered. The very attributes that gave psychedelic art wide appeal—its sensuousness and rather monotonously celebratory spirit—worked to deprive it of real depth or cutting edge; it

182

appealed primarily to a taste for sensation (or sensationalism), not for deeper emotional or intellectual experience. The medium was most of the message.

The posters proved inseparable from the music, dependent upon it for their energy no less than for their function. The light shows never resolved, and seldom even addressed, the problem of developing a structure in time, and proved effective primarily as environmental backdrops. Their most important contribution was to bring a new vocabulary, and consciousness, of visual effects into theater, opera, and film. Rock art was, in the end, a kind of West Coast—or very San Francisco—Pop art: less "elitist," more egalitarian and youth-oriented, than the expensive paintings of a Warhol or Rosenquist, but no less a part of the chic new game of cultural slumming that was becoming the "in thing" at the hippest, if not always the highest, levels of jet set society.

The real revolution of the 1960s was the transformation of practically everything—including the notion of "revolution" itself—into a merchandisable commodity, in the service of an omnivorous consumerism. And the principal contribution of the counterculture—as Stewart Brand's *Whole Earth Catalog* so graphically made clear—was to add an array of goods and services to the commodities available to a new class of young, impressionable middle-class consumers with lots of spending money, and to generate a new, multimillion-dollar business: the rock music industry. Finally, everything, including art, could be absorbed into the machinery of consumerism's crowning achievement: the concept of lifestyle, whereby people are encouraged at once to create and to consume the ultimate consumer product, their own personalities. A shopper's paradise of "self-realization" and "self-fulfillment" programs offered not just a change of styles but a change of self. If one were the same person as he or she had been five years before—living in the same house, with the same people, having the same job and feeling basically the same emotions—he or she had become just a little obsolete, like last year's automobile, or last month's Top Forty hits on the record charts.

As Altamont—a barren pass between Oakland and Stockton where the Rolling Stones played their ill-fated "last" outdoor concert—gave its name to the antithesis of the sense of community and "good vibes" that had been symbolized by Woodstock only a year earlier, the Rainbow Show, organized in 1975 by the Fine Arts Museums of San Francisco and held in two parts

at the de Young Museum and the Legion of Honor, signaled the demise of the Visionary art movement. Conceived as a celebration of the visionary spirit in general and Bay Area art in particular, the show was announced by an immense barrage of advance publicity, but it ran aground on the weakness of its own premises: it assumed that the rainbow was a symbol of great interest for visionary artists, and perhaps even for Bay Area artists in general, and that an impressive exhibition could be assembled without exercising much critical discrimination. The result was a compendium of amateurish clichés and slick commercial products, a dramatic demonstration that the utopianism of the late 1960s was an idea whose time had come and gone.

Meanwhile, by the mid-1970s the end of the war in Vietnam and the resignation of Richard Nixon from the presidency deprived the protest movements of the 1960s of their principal sources of revolutionary fervor. The political radicalism of the past decade received its death blow when a group of fanatic terrorists calling itself the Symbionese Liberation Army—a bizarre and tragic caricature of the radical Left—kidnapped Patricia Hearst and forced radical activists to choose between denouncing or condoning its excesses. Something was lost, whichever choice was made.

By this time also, the modest successes achieved by ethnic minorities in their campaigns for equality and recognition had softened the sense of urgency behind their efforts. The MIX (Museum Intercommunity Exchange) program, initiated at the San Francisco Museum of Art in the early 1970s, brought the work of minority-group artists into the exhibition schedule and permanent collection so effectively that it phased itself out of existence; its activities became integrated with those of the rest of the museum. The Blackman's Gallery closed, and most of the artists associated with it simply disappeared from the scene. The Mexican Museum, founded in 1975 by Peter Rodriguez, and the Chinese Culture Center, established in the tower of the Holiday Inn across from Chinatown's Portsmouth Square, were strictly cultural institutions, without controversial social or political overtones, devoted to exhibitions of both local and foreign artists. The Mexican Museum acquired a significant permanent collection of historic and modern works: pre-Hispanic sculpture and Colonial Mexican religious art, paintings and drawings by the revolutionary Mexican artists of the 1920s and 1930s, and work by contemporary Mexican and Mexican-American artists.

The Utopian Vision

FIG. 166. Rupert Garcia, *Attica is Fascismo*, 1972. Silkscreen, 26″ × 20″.

FIG. 167b. BART station mural (detail).

FIG. 167a. Mural by Michael Rios, Anthony Machado, and Richard Montez at the BART (Bay Area Rapid Transit) station, Twenty-fourth and Mission streets in San Francisco, 1975.

The Mission district murals—an authentic "people's art" representing a large urban neighborhood whose dominant cultural tradition includes a distinctive heritage of mural art—continue to proliferate and to project a certain vitality. (See Fig. 167.) They have not stimulated any rebellions, but they have added color to the area, and rents there are beginning to increase.

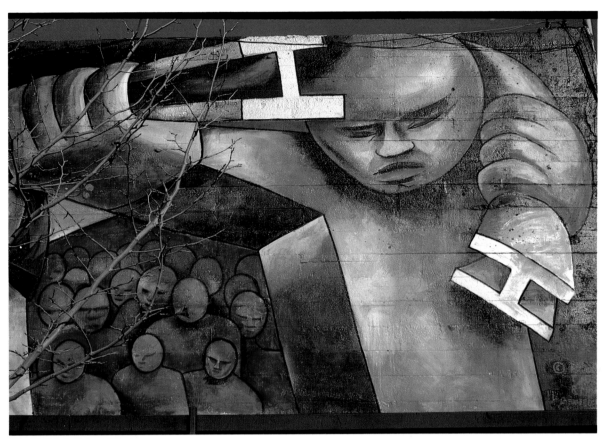

FIG. 167c. BART station mural (detail).

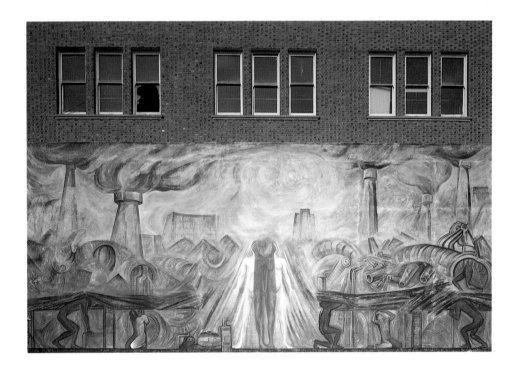

FIG. 167d. Mural by Michael Rios, Anthony Machado, and Gilberto Ramirez (a guest artist from Mexico) on Cogswell College, Folsom and Twenty-sixth streets, San Francisco, 1975. The building and mural were demolished in 1984 to make way for a new apartment building.

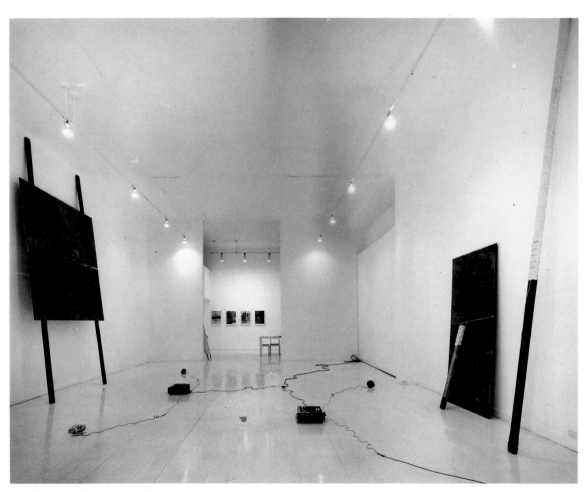

FIG. 168. Terry Fox, first hospital piece, *My sin consisted of a temptation visited upon me to pass the breath of my heart through a tube to both sides of the surface.* Installation at Gallery Reese Palley, San Francisco, 1971.

In October 1969, when the Richmond Art Center staged a large exhibition of sculpture that featured a 7,000-pound block of melting dry ice, it was clear that something new was appearing on the local art scene. The exhibition was called The Return of Abstract Expressionism. Most viewers could find little in it to justify such a title—or, for that matter, to justify any claim to representing "art." But their excursion to Richmond did allow them to witness the first extensive display of the developments that eventually came to be known under the umbrella term of Conceptualism or "conceptual art."

Conceptualism took a great many forms, some much more conceptual than others. It was in part the logical (or too logical) extension of several tendencies in the art of the 1950s and 1960s. There was a clear line of descent from Harold Rosenberg's theory of action painting, in which the finished work was seen primarily as a manifestation of the *processes* that went into its making. It was linked to the increasing projection of art into "real life" that prompted the progression from collage and assemblage to environments and happenings, and culminated in designs or scenarios that were practicable only as diagrams or stage directions (such as Oldenburg's drawings for unrealizable colossal monuments, and a Fluxus "work" that consisted simply of the written instruction, "Fill a Swimming Pool with Lime Jello"). A conceptualist attitude was implicit in most Pop art, and was a

crucial, if paradoxical, undercurrent in Minimalism: in theory Minimalism rejected the superstructure of ideas that had grown up around contemporary art in the early 1960s, but in practice it frequently depended on this superstructure for its very existence as art. One strong component of Conceptualism in its early stages was a mood of revolt against the collectible art object—the chic hard-edge abstraction or cosmetic gesture painting, with its consumerist aura of money and fashion. Nevertheless, Conceptualism soon gave rise to new categories of collectibles: "documentation," correspondence, memorabilia, even deeds to excavations in the Southwestern desert. Especially in the Bay Area, there was a relationship between Conceptualism and the movement of such Visionary artists as Gerald Gooch and Robert Comings toward progressively dematerialized forms of expression, which sometimes ended in a renunciation of all artistic effort, if not always of the idea of art itself.

Conceptual art partook of varying combinations of philosophy and metaphysics, spirituality and scholasticism, hermeticism and populism, pedagogy and put-on. The forms it took ran across a wide spectrum, from earthworks (large-scale rearrangements of the natural environment, or "displacements" to museums of natural materials such as leaves or piles of dirt) to "performance art" (rituals or happenings that ranged from the highly public to the totally private). (See Fig. 169.)

FIG. 169. Paul Cotton, *Bird in Flight,* August 19, 1978. The earth, body, black paint, ink, and paper.

In contrast to the self-purification that Clement Greenberg held up as central to contemporary art, these conceptualist manifestations usually exemplified the adulteration of forms that Greenberg's critical rival, Harold Rosenberg, saw as the principal hallmark of vanguard art. And, like Duchamp's ready-mades of half a century before, their claim to status as art depended on a giant leap of theory (or as some saw it, a semantic somersault); it depended on a change not so much in form as in *context*. In fact, it would probably be more accurate to call all these things "contextual" rather than "conceptual" art.

Whereas Visionary art was basically a regional phenomenon, Conceptualism was perhaps the most international of art movements since Abstract Expressionism. The fact that in Conceptualism the idea often *is* the work made it possible to circulate such art directly through the worldwide network of communications; thus "correspondence art" could be exchanged among various national and international constellations of art pen-pals. Performance artists like Terry Fox and Tom Marioni traveled widely, for they could carry with them in a suitcase everything they might need to do a given work.

Nonetheless, conceptualist activities in the Bay Area shared certain family resemblances. One of these, alluded to in the title of the 1969 Richmond Art Center exhibition, was a lingering attachment to the regional tradition of Abstract Expressionism—a concentration on process and performance, rather than on the making of monumental earthworks (the scarcity of vacant land and the area's militant conservationism were probably additional factors). The emphasis on improvisation—on action and ritual—and a general atmosphere of raw, functionalist austerity brought Bay Area Conceptualism closer to the informal, visually impoverished, and often politically underground conceptualist activities of East German and Eastern European artists than to the more

FIG. 170. Bruce
Nauman, *Device for
a Left Armpit*, 1967.
Copper painted
plaster, 14″ × 7″ ×
10″.

"new music" tradition in the Bay Area reaches back to Henry Cowell in the 1920s and early 1930s.) The experimentation in electronic music was carried on by such multifaceted artists as Warner Jepson and Paul Beattie, and was continued and extended in the mid-1960s by such composers as Terry Riley. It was institutionalized when the fledgling San Francisco Tape Center merged with the Mills College Performing Group in 1968 and moved to the college's Oakland campus. Both groups were absorbed the following year into the Mills College Center for Contemporary Music, which became a focal point for avant-garde presentations through the early 1970s.

There were other direct antecedents. The Collective Expressionism show that brought the historic Six Gallery to its dramatic end in 1957 was a Neo-Dada event which teetered on the edge of being a conceptualist happening; the same was true of the Slant Step Show that Bruce Nauman and William Wiley organized nine years later. Nauman, before he left the Bay Area in the late 1960s, had done a variety of pieces that anticipated the conceptualist works for which he became widely recognized in the 1970s. They often had self-explanatory titles: *Cast of the Space Under My Chair* (1966–1968); *Collection of Various Flexible Materials Separated by Layers of Grease with Holes the Size of My Waist and Wrists* (1966); *Device for a Left Armpit* (1967) (Fig. 170). Dennis Oppenheim, who had been caught up in the Funk movement as a student at the California College of Arts and Crafts in the early 1960s, experimented with "displacement" pieces before he left the Bay Area (at around the same time Nauman did) to make his mark as a conceptualist on the East Coast. One of his first shows of such work took place at the tiny Green Gallery on Fillmore Street. It consisted of samples of earth collected from sites in the Oakland hills and displayed in specimen containers, together with maps and related documents. Meanwhile, a little-known enclave of conceptualist happeners— gathered around Paul Cotton, Stephen Laub, and Michael Haimovitz—was quietly active in Berkeley. Haimovitz created elaborate events in and around the communal house in which he lived; they were primarily "This is Your Life" fantasies that focused on one or two generally unsuspecting protagonists, and sometimes involved as many as a hundred participants.

The earliest conceptualist occurrences to make themselves widely noticed in the Bay Area were extensions of the Visionary ideology of the counterculture, and of its informal alliance with the art-and-technology movement. One of the

systematic and less intuitive approaches of such New York artists as Sol LeWitt. And frequently, as in Europe, conceptualists were inspired by events in their own past, which they enlarged to symbolic dimensions that touched on areas of social and political commentary.

The roots of Bay Area Conceptualism reach into an avant-garde consciousness that had solidified in the late 1950s around activities associated primarily with dance, theater, and music. Ann Halprin and Welland Lathrop, inspired by the ideas of Artaud, elaborated forms of dance theater which became increasingly dominated by improvisation and elements of ritual, and which embraced audience involvement in actual space and real time. While Henry Jacobs and Jordan Belson were making pioneering experiments in electronic music, Harry Partch was active in Sausalito, experimenting with novel acoustic instruments which he made himself. (Indeed, the

FIG. 171. Step 2 from the Dilexi Score, September 1970.

SUN. MON. TUES. WED. THURS. FRI. SAT.

CITY-CALENDAR MATRIX

Events take place in areas of the grid that correspond to the day of the event.

The matrix recognizes that the city is made up of weekdays as well as weekends, and of typical places as well as special places.

Equal emphasis is given to all places and times leaving the individual and the artist to determine a focus. An event on Friday, September 18th, would occur in the area of Potrero Hill. The artist could focus on a particular area and time within that framework (Jackson Park at 5 pm) or develop a series of events that would occur throughout the 24 hour period and involve everyone within the square mile area of September 18.

SCORE DEVELOPMENT **STEP 2**

© Dilexi Foundation and Lawrence Halprin & Associates, 1969

first, and most widely publicized, was the Flux-Fest staged on March 31, 1967, at the Longshoreman's Hall, a kind of sequel to the Trips Festival of the previous year. Its principal impresario was a young local poet, lecturer, and self-styled "astronaut of inner space," Jeff Berner; he brought together "work" by various "members" of Fluxus, a diverse aggregation of international conceptualists given to such Dada whimsy as the public destruction of pianos, and then combined it with elements of a psychedelic party (music by Quicksilver Messenger Service and Wildflower). In May, Berner introduced local audiences to the more "serious" side of Fluxus with a large exhibition called Aktual Art International at the San Francisco Museum of Art. It contained posters, manifestos, books, "happenings kits," and other memorabilia of avant-garde activities that Berner had collected in a dozen different countries.

This moved another self-professed Fluxist, Ken Friedman, to call a press conference at a Haight-Ashbury ice-cream parlor to proclaim his sharp disagreement with Berner's philosophy and announce the convocation of the First Surrealist Congress of America (a largely conceptual affair, since its more celebrated "participants"—Christo, Ben Vautier, Milos Knizak—were represented strictly by proxy). In contrast to Berner with his

big public functions, Friedman quietly discharged his duties as "director of Fluxus West" in a secluded, unfurnished room on Divisadero Street, surrounded by the materials of his peculiar station: Fluxpost "stamps" and envelopes, plastic specimen boxes for the making of Fluxkits, and obsessively compiled mailing lists—which in some respects were the only authentic proof of existence that the primarily conceptual network of Fluxists could claim.

A watershed, of sorts, occurred in December 1968, when James Newman called a press conference to announce that the Dilexi Gallery—which now occupied posh quarters on Clay Street, on the edge of the financial district—was observing its tenth anniversary by ending its exhibition program and becoming a nonprofit foundation with an open-ended program aimed at "removing the obstacles between art and life." "There is an art elite who are on the mailing lists, go to openings, and subscribe to the art magazines," Newman said. "The art world has become small and irrelevant against the general conditions of things in the world. Art, all kinds of artistic expression, should be in the way, not hidden."[1]

Television, naturally enough, figured prominently in the foundation's schemes for bringing art to a mass audience. Its earliest project was a series of programs created by artists in various media, in

conjunction with KQED public television. The first, a collaboration between sculptor Arlo Acton and composer Terry Riley called "Music with Balls," was televised in April 1969. It was a highly effective synthesis of abstract visuals—chiefly Acton's spherical sculptures of glittering titanium—and a sound track on which Riley played hypnotically repetitive music on a soprano saxophone together with the feedback from two tape machines. Subsequent films were made by Philip Makanna, Frank Zappa and the Mothers of Invention, Ann Halprin's Watts Project and Dancers' Workshop, Andy Warhol, and others.

The foundation's most ambitious project was planned for September of 1970, and was to consist of a series of thirty-five events—happenings, environmental works—to be staged on thirty-five consecutive days in thirty-five different mile-square areas of San Francisco (with a few sites out on the bay). The schedule was designed by the simple expedient of superimposing a September calendar page over a map of the City. The various happenings were to be devised principally by recognized artists, but community participation was a major goal. Designed in large part by Lawrence Halprin, the landscape architect and systems analyst, the project got as far as an elaborately diagrammed "score" and a "pilot day," intended to stimulate financial support for the event, that took place a year before it was scheduled to occur, on September 12, 1969, in the Bernal Heights district. (See Fig. 171.) The avant-garde turned out in some force for a day of low-keyed festivity that ranged from construction of a geodesic dome to a nocturnal "mountain ceremony" on the windswept hilltop. But community participation was minimal—a few lower-grade classes from Le Conte Elementary School and a scattering of bemused spectators. Neighborhood residents who arrived at the hilltop that night looking for "the dance" were somewhat bewildered to find weirdly costumed performers rolling around the hillside and speaking in tongues. The enthusiasm—and financial backing—the foundation had hoped to generate for the full-scale event failed to materialize.

The Dilexi Foundation soon lapsed into inactivity, but the philosophical stance it reflected set the tone for other early conceptualist events of a primarily public, socially engaged, and sometimes festive nature. One of the more spectacular, on the night of June 3, 1969, was an unannounced light show that "painted" a low-lying fog cover over downtown San Francisco. It was the work of Mel Henderson, a maker of Dadaesque sculptural contraptions and instructor at San Francisco State College, who set up fifteen klieg lights along Market Street from the Ferry Building to Twin Peaks and had collaborators direct professional attendants in controlling the patterns they made. Henderson followed up a week later with a stunt that involved dropping paper bags filled with yellow dye oil into the ocean twelve miles off the Golden Gate, thus defining a four-mile length of the imaginary line that limits U.S. territorial fishing waters. A subsequent, unofficial event (the previous projects had received all the proper clearances) occurred when Henderson called a battalion of Yellow Cabs to arrive simultaneously at a location near Castro and Market Streets, and photographed from the air the vivid patterns that resulted as they converged.

In 1970 the local art establishment gave its imprimatur to such conceptualist manifestations when the San Francisco Museum of Art's Society for the Encouragement of Contemporary Art presented a $1,000 award to Bonnie Sherk for the construction of three "portable parks." (See Fig. 172.) The "parks"—potted palm trees, turf, real livestock—were set up for four successive days in June in three unlikely urban locales: along an elevated freeway extension near the Opera House, beneath a freeway exit, and along a block of Maiden Lane. They had the startling impact of real-life Magrittean mirages. Sherk provided a sequel in the autumn by bringing a two-ton dry-ice "snowdrift," in four big piles, to the front of the museum building.

Just as it seemed that such amiable public performance pieces were being cozily assimilated as a new form of popular entertainment, three East Bay residents administered the Bay Area's most spectacular conceptualist coup. Known collectively as Sam's Cafe, the three—Marc and Terri Keyser and David Shire—inaugurated a gallery of sorts in a former hash house on University Avenue in Berkeley, where they staged such prankish "shows" as a group of "abstract paintings" made of rotting food. Eventually, printed announcements and other mailings of a sophomorically farcical nature began to subsume most of their other activities. This provided a preamble to Sam's climactic stunt in 1971, which consisted of mailing phony collection notices to twenty thousand San Francisco households. Recipients were told that they must immediately pay $76.40 to a Sam's Collection Agency, and were given telephone numbers of newspapers, television stations, and the Bank of America, all of which received thousands of irate calls demanding an

FIG. 172. Bonnie
Sherk, *Portable Park,
No. 2,* San
Francisco, 1970.

explanation. Shrewdly calculated to involve the media, the event made conceptual art front-page and prime-time news. The three perpetrators showed up two days later for a press conference on the front steps of the First Unitarian Church on Franklin Street, where conceptualists turned out in force to photograph the news photographers who were photographing them. When it was over, the three were arrested by postal officials on the only charge the authorities felt could stick: sending "a filthy and vile substance" through the mails. (Three plastic vials purporting to contain human feces had been included in a "press kit.") At a brief non-jury trial in October, the three were acquitted. But their "process piece" and its attendant publicity had made certain telling points to a large audience. It had demonstrated the vulnerability of the mass media to manipulation by a handful of people (a point later demonstrated much more dramatically by the Symbionese Liberation Army's kidnapping of newspaper heiress Patty Hearst); and it had exposed the fragility of the

sophisticated network of contemporary communications (and credit) in general. But it was the last appearance of Sam's Cafe and its three constituents, all of whom vanished from the scene as abruptly as they had appeared. This was consistent with the logic of a statement attributed to one member of the group (unidentified) in an article from an unknown publication reproduced in the November 1971 issue of *Especially Galleries:* "[Warhol] takes something out of life, like a Campbell's Soup can, but then he puts it into the art gallery world where it loses its relationship to people's lives. We're trying to keep life in life."[2]

Conceptual art on a mass, public scale continued to surface sporadically in the Bay Area—most grandly and magnificently in the fall of 1976 in Christo's *Running Fence.* (See Fig. 173.) The "fence" was a white curtain that snaked across twenty-four and one-half miles of Marin and Sonoma counties, through the little town of Valley Ford, and ended in the Pacific Ocean near Bodega Bay. The project involved scores of

FIG. 173. Christo, with three
hundred assistants, *Running Fence,*
September 1976. Approximately
two million square yards of white
nylon made into panels 18′ high
and 62′ long.

property owners and regulatory agencies in the
two counties, hundreds of helpers, and uncounted
hours and column inches of news coverage. But in
general the impetus to large-scale events waned in
the early 1970s. The impulse to bridge "the gap
between art and life" tended to assimilate itself
into the undifferentiated current of daily living,
and to become virtually indistinguishable from it.
Henderson's later "events" were mild-mannered
classroom projects. Sherk concentrated on devel-
oping a "crossroads community" better known as
The Farm—a complex of former warehouse
buildings located almost directly under the convo-
luted freeway exit from Highway 101 to Army
Street. The buildings were made over to provide
space for transplanted pine trees, hay, straw,
chickens, and rabbits, as well as for children to
improvise plays and for dancers and musicians to
perform—an updated version of an old-fashioned
neighborhood center.

The forms of Conceptualism that proved most
durable in the Bay Area, as elsewhere, assumed the
attributes of a gallery and museum art. One of the
earliest conceptualist strongholds was established
at the Richmond Art Center in the last months of
1968, shortly after Tom Marioni's appointment to
the post of curator, under the center's director,
Hayward King. Marioni was forced to resign in
February of 1971, when a more conservative and
community-minded administration took over the
parks and recreation department under which the
center operates. But before he left he had intro-
duced most of the more important local conceptu-
alists. After his departure from Richmond, Mari-
oni devoted full time to directing a Museum of
Conceptual Art that he had already established in
San Francisco—a largely conceptual museum first
housed in a virtually empty loft on the fourth floor
of a decrepit building at 86 Third Street. In January
1973, aided by a $5,000 grant from the National
Endowment for the Arts, it moved to even funkier
quarters across the street above Breen's, an old-
fashioned saloon that Marioni made an "adjunct"
to the museum.

Conceptualism

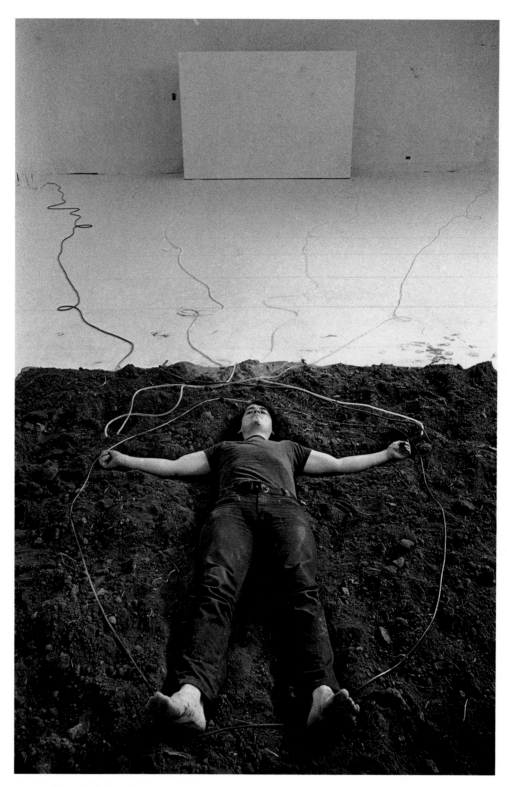

FIG. 174. Terry Fox, *Levitation*.
Installation at the Richmond Art
Center, Richmond, Calif., 1970.

Brenda Richardson, an associate curator of the University Art Museum in Berkeley, introduced conceptualist work to its exhibition schedule at an early date, and Conceptualism also established an unexpected San Francisco beachhead in a chic gallery opened by an East Coast dealer, Reese Palley, in the Frank Lloyd Wright building on Maiden Lane. The gallery's mainstay was the sale of kitsch porcelain birds by Boehm, which were featured prominently in a street-floor showroom. But a more informal exhibition space was installed in the basement, and under the direction of Carol Lindsley it became the site for an active schedule of conceptualist shows and performances.

This more private form of conceptual art emerged most dramatically at the Richmond Art Center in 1970, in a work by Terry Fox entitled *Levitation* (Fig. 174). It took place in the center's larger gallery (thirty by sixty feet), the floors and walls of which were covered over with blinding white paper. Fox had a ton and a half of dirt (removed from beneath a San Francisco freeway) arranged in an eleven and one-half foot square on the gallery floor. He fasted for a day, then drew a circle with his own blood in the center of the dirt mound and lay on his back in the middle of it, holding four fifty-foot-long polyethylene tubes: one filled with blood, another with urine, the third with milk, and the fourth with water. They represented the expulsion of elemental fluids from his body, as part of a metaphoric effort to release the spirit from the physical form. Fox remained there, in total seclusion, for six hours, trying to levitate.

The "residue" of this action—together with Marioni's two-page description of Fox's attempt—remained behind as the finished "work," or at least that portion of it made visible to the public. It did not remain long: within a day, city bureaucrats forced Marioni to remove the piece, on the grounds that it constituted a health hazard. Fox wrote later: "[It was] my strongest piece of sculpture because the whole room was energized. . . . Everyone who saw it felt something. . . . You read the notice before you entered, so you knew that a person had lain there for six hours trying to levitate. Then you walked into this brilliant, surreal space, which emphasized the physicality of the earth, the blood, the urine. Most of the audience didn't even go in; they walked around and stood on the outskirts. It was terrifying and depressing."[3]

Fox had visited Europe in 1967, where he had discovered Artaud—an important early influence—and taken an active part in the student uprisings in Paris. This "theater of the streets" had reinforced for him a developing sense of art as confrontation between an audience and a situation of an extreme kind. He was also strongly affected by the mythic rituals that Joseph Beuys had elaborated out of the intimate materials of his own experiences. (Later, in 1970, he collaborated with Beuys in Dusseldorf.) Fox had been diagnosed as a victim of Hodgkin's disease when he was a senior in high school, and the harrowing medical treatments he underwent (he was pronounced cured in 1972) left a profound imprint on his art. Following extensive surgery in the fall of 1971, he installed his first hospital piece (several more followed) as a one-man show in the elegant new quarters on Sutter Street to which the Reese Palley gallery had just moved. (See Fig. 168, p. 186.) The piece was a starkly dramatic environment that included blackboards (partially erased) chalked with figures relating to the costs of medical care; a white enamel bowl and a cloth; a bare hanging light bulb; and wires snaking across the empty white floor to two tape recorders. These reproduced the sounds of Fox breathing and chanting.

Fox's subsequent Bay Area shows—sporadic and infrequent—continued to develop the themes, or obsessions, of these early works: an emphasis on ritual activity, increasingly carried out in private, with only the "residue" available for public viewing: a strict concentration on "real time"; visual austerity; the primal subject matter of myth (life, death, ceremony); and a consistent symbolism that emphasized a visceral physicality: dust, smoke, flour, yeast, cots and stretchers, bowls and sterile white surfaces. Fox's "passive observation of the extreme and repetitive hospital routines related to isolation precautions . . . heightened his own awareness of both time and ritual," Brenda Richardson observed. "With an almost subconscious compulsion he has repeatedly employed curtains and veils (perhaps symbolic of the membrane which covers his chest) and materials like bread and sponges with holes or craters (perhaps symbolic of his wound). With a frequency that precludes coincidence, Fox has selected objects with a core covered with or surrounded by rings or layers of material or 'skin.' "[4]

Fox's most prominent Bay Area exhibition took place in Berkeley in September 1973 at the University Art Museum. The installation was located behind a semitransparent curtain which concealed all but vague shadows from viewers inside the museum proper, but it was possible to walk onto a balcony outside and clearly see the "backstage" area through wall-sized windows.

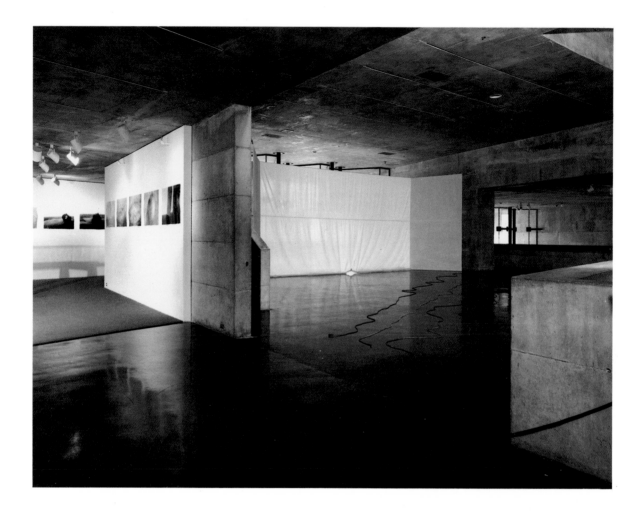

The space itself—white, blanched, sterile—contained basins, candles, vials, mirrors, and other paraphernalia suggestive of arcane rituals. (See Fig. 175.) Fox came and went at irregular and unscheduled intervals, performing slow, rhythmically measured actions. Most notably, he made a large "drawing" by carefully pouring flour upon the floor, shaping it into rib-like arcs, carving a "canal" in the center of each ridge, and then, after sipping water from a basin, letting it fall from his mouth, drop by drop, until each canal was filled. It was a process that seemed to involve physical and psychological concentration to an extraordinary degree; yet at the same time Fox's personality, or ego, seemed strangely removed, so that his activity conveyed an impression of the indifferent workings of nature, combining the methodical regularity of a pulse beat with the inching relentlessness of a geological process.

Marioni himself became prominent as a conceptualist performer after leaving his curatorial job in Richmond. His first show at the Richmond Art Center in 1968 had comprised conventional minimalist sculpture fashioned mostly of colored lucite, but shortly after he became the center's curator an alter-ego conceptualist named "Allan Fish" began to take part in many of the group shows that Marioni organized. (See Fig. 176.) *Birds in Flight,* included in the Return of Abstract Expressionism exhibit, consisted of a packet of multicolored construction paper, with instructions for the viewer to crumple the papers one by one and throw them at the wall. In addition to flight, a favorite theme of Fish's was drinking beer. In 1970, after drinking beer all afternoon, he stood on a stepladder and urinated into a galvanized tub (which changed in pitch as the water level rose); the *Piss Piece* was part of an exhibition of Sound Sculpture at his Museum of Conceptual Art. A performance by Fish at the Oakland Museum consisted of a beer party with various friends; the debris was exhibited as a "record."

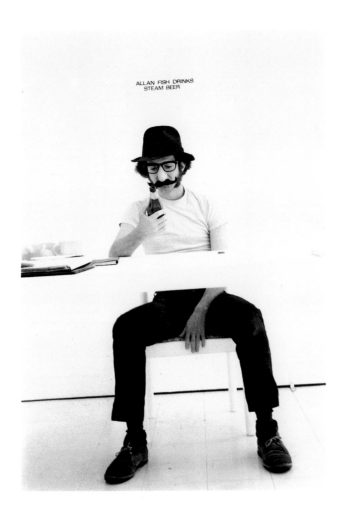

ALLAN FISH DRINKS
STEAM BEER

FIG. 175. Terry Fox, untitled orientation gallery for an installation at the University Art Museum, University of California, Berkeley, 1973.

FIG. 176. Tom Marioni as Allan Fish, in a performance at Gallery Reese Palley, San Francisco, 1971.

After leaving the Richmond Art Center, Fish-Marioni performed an "identity transfer" at the Berkeley Gallery in which Marioni finally unmasked himself.

Marioni's subsequent performances included a residue of such hi-jinks. One of his most memorable performances was taking the $500 budget reserved for him to exhibit at the de Saisset Art Museum at the Jesuit University of Santa Clara in 1972 and spending $350 to buy a used Fiat. The rest of the money was used to print formal invitations to the show, which he entitled My First Car as "a spoof on Don Potts." On the night of the opening, Marioni drove the car up the steps of the ornate Mission style gallery, eased it through the double doors, and parked it. "I believe," he explained, "during the Renaissance the church supported the artist. . . . I thought the church should support an artist now, and I needed a car."[5] The show was closed the following day at the behest of the university's president. Marioni continued to drive the car until it blew up six months later.

Under Fox's influence, however, Marioni's emphasis gradually shifted in the mid-1970s to ritualistic, trance-like, generally private and sometimes quite magical actions. Flight, sound, and improvisation allied to jazz were recurring themes; "drawing," in an extended sense, was a principal medium. A work called *Bird* (part of a seven-day performance called *The Creation* in 1972) consisted of "running and jumping with a pencil, marking the paper while trying to fly."[6] In *The Sound of Flight* (see Fig. 177), at the de Young Museum in 1977, Marioni displayed "drawings" produced from the ritualistic motion across sheets of paper of drum brushes dipped in gold dust, an action which he solemnly performed throughout the exhibition in a gallery next door. He compared his art with "modern prayer," and said: "I am trying to communicate in a primitive way through the drum, which is my drawing board. These are

Conceptualism

FIG. 177. Tom Marioni, *The Sound of Flight,* 1977.

the sounds and rhythms of my pulse and breathing. I want to make a picture with these sounds, a psychic picture. As I rub on this paper with the drum brushes, an image slowly appears: a landscape."[7] Marioni later turned to making room-sized environments in which art and the making of art were central subjects, enveloped in hushed atmospheres that were at once romantically moody and touched with a tongue-in-cheek irony. (See Fig. 178.)

Among the conceptualists whom Marioni was most active in promoting was Paul Kos. His early work focused on the forms and processes of the natural landscape. He recreated sixty-four square feet of Yellowstone National Park, complete with sulphur smells and bubbling mud and water, for the Richmond Art Center's Return of Abstract Expressionism show. For the Sound Sculpture show, he used $10,000 worth of sound equipment to record the melting of two twenty-five-pound blocks of ice. In April 1971, he installed two tons of sand over a tiny hole bored in the floor of the

Reese Palley gallery on Maiden Lane and let it drift, as through an hour glass, to form a conical pile on the basement floor below.

Kos eventually turned from the natural landscape to the social one, frequently with more or less oblique political overtones. In a show of Bay Area conceptualists organized by Marioni for the Newport Harbor Art Museum in 1972, he installed a pool table that was set up in a corner perilously close to a dozen steel traps. His contribution to a San Francisco–Fort Worth exchange show in 1976 was a large wire-mesh cage inside which a video monitor played a tape of his wife portraying Tokyo Rose, seductively inviting viewers inside (Fig. 179). *rEVOLUTION, NOTES for the INVASION, MAR MAR MARCH* (Fig. 180) consisted of a narrow room bathed in a hot red Martian light, its floor crossed by two-by-four planks at regular intervals. On a video monitor at its far end could be seen the movement of a tiny image, accompanied by regular, rhythmic sounds that resembled beats on

FIG. 178. Tom Marioni, *Paris,* 1980.
Mixed media installation.

FIG. 179 (*right*).
Paul and Marlene
Kos, *Tokyo Rose*,
1975–1976.
Aluminum screen
and framing,
television monitor
and video tape, 10′
× 10⅓′ × 25⅓′.

FIG. 180 (*above*).
Paul Kos,
*rEVOLUTION,
NOTES FOR THE
INVASION, MAR
MAR MARCH*,
1973. Mixed media.

FIGS. 181a, 181b.
Howard Fried,
Seaquick, 1972.
Unannounced
performance with
nine panels and
teeter-totter.

a snare drum. As a viewer stepped carefully across the two-by-fours for a closer look, the image defined itself as that of a figure marching back and forth above the keys of a typewriter that struck *mar mar march* on a sheet of paper, over and over, with rigidly mechanical or military regularity.

Howard Fried was another of the more frequently exhibited Bay Area conceptualists. He explored the relationship of art and life within the framework of systems that resembled the rules of games, or that carried absurd premises to frighteningly logical extremes. His first show documented the moving of his studio to San Francisco from Davis (where he received his degree) through a

maze of photographs, words, and even mathematical notations that served to comment upon and amplify each other—and, eventually, to cancel each other out in the manner of the nonsensical logic of Samuel Beckett.

Fried's performances often set up systems in the form of an athletic contest. Ambivalent forces were pitted in aggressive conflicts that went on until one or both contestants fell victim to the logic that the self-imposed system demanded. One night on the roof above his Rose Street studio, Fried organized a baseball game played with rotten tomatoes. Home plate was located at the lowest point on a pitched roof, and a skylight

Conceptualism

FIG. 182. Lynn Hershman,
Dante Hotel, November 30, 1973–
August 31, 1974.

had to be circumvented to reach it from third base. Fried himself was the first to fall through the skylight, badly cutting both arms; he was taken to the hospital and an hour later, stitched and bandaged, returned to resume playing. Fried's second show at the Reese Palley gallery, in 1972, contained a vicious-looking teeter-totter without handles; heavily greased beforehand, it was used for an event in which two persons of equal weight, clad only in rain slickers, were matched on either end, sliding, slipping, and eventually falling as the movements grew in violence. (See Fig. 181.)

In the 1970s, Fried turned to static installations, which often centered on representations of cups. In one of them, cup images were placed on opposite walls covered with highly patterned abstract drawings; one "cup" was photographic and tiny in size, the other sculptural and immense, creating an Alice-in-Wonderland sense of dislocation.

Many of the artists who left a faint mark on Conceptualism with one or two shows in the early 1970s had moved, with Fried, to making more conventional objects by the time the decade ended

(Steven Kaltenbach) or had simply faded quietly from the gallery and museum scene (Robert Kinmont, John Fernie). One of the most distinctive and durable was Lynn Hershman. Her early work consisted of wax masks—often self-portraits cast from life—together with busts and full figures arranged in expressionistic, theatrical settings. Hershman's sculpture progressively acquired "voices"—tape-recorded monologues and dialogues that recreated soap-opera situations—and then real-life surroundings. One of her most sensational pieces consisted of two female figures, surrounded by characteristic props, arranged as corpses on a bed in a cheap room at the Dante Hotel in North Beach. The verisimilitude was so complete that one unsuspecting visitor called the police. (See Fig. 182.)

Beginning in 1975, Hershman began the step-by-step creation of a fictitious personage, "Roberta Breitmore," complete with identification papers, case history, and curriculum vitae. Disguised with a blonde wig and tacky miniskirt and boots, Roberta performed real-life activities in the real world, recording them in photographs, on

Conceptualism

FIG. 183. Lew Thomas, *Summa Bibliographica,* 1978. Installation at San Francisco's Camerawork Gallery.

tape, and in diaries. Among Breitmore's activities were opening a checking account, attending Weight Watchers, and advertising and interviewing for a roommate. In contrast to Marioni's "Allan Fish," Hershman's "Roberta Breitmore" was intended as "a sociological study of alienation and loneliness. Her performance takes the form of a real-life drama based on real life in real time. As she gathers a history and identity, the people and situations she encounters become archetypes and fictional. . . . She is, in effect, a mirror magnet for a sector of San Francisco's community. . . . After Roberta's suicide the accumulated articles of her research will be made public."[8] The documents and props associated with this problematic piece— which seemed to exploit both the pathetic type that Breitmore was supposed to represent and the real people who, by responding to her in good faith, unwittingly played a part—were displayed in a solo show in 1978 at the M. H. de Young Memorial Museum.

Marioni and Fox, and most of the conceptualists associated with them, had seen their art primarily as an extension of the traditional concerns of sculpture—working with and altering space, however temporarily. Photography, initially a means of "documenting" performances and other impermanent conceptualist events, eventually became, along with video, an autonomous conceptualist form. Two of the earliest and most influential Bay Area conceptualist photographers were Lew Thomas and Sam Samore.

Thomas inclined toward a high degree of Formalism, engaging in reflexive investigations of the medium of photography itself. Among his more rigorous explorations was a work built around highly enlarged prints, of uniform size and format, processed so that half of the prints were all white and the other half all black. In a series of shows at different locations, these were arranged in various "sculptural," or architectural, configurations, which Thomas in turn photographed, eventually compiling the "documentation" as a work of its own. Thomas was also active as an organizer of photography shows at various locations in which conceptualist and linguistic components were uppermost. (See Fig. 183.) Samore became known for work

Conceptualism

of a more Dadaistic bent, often laced with social commentary in which art-world practices were a conspicuous target. One project involved the founding of a "photographic museum" whose activities, including exhibitions, consisted solely of mailed announcements.

Correspondence art and related forms of conceptualist ephemera flourished for a time in the mid-1970s, stimulated by occasional visits from such itinerant apostles of the form as Dana Atchley, the head and sole functionary of the Ace Space Company. Its specialty was mailing requests for "art works" to a network of "plugged-in" artists throughout the Western world, and compiling, in unedited notebooks, whatever they chose to send back. Lowell Darling, the Southern California-based president of the Fat City School of Finds Art, made frequent visits to the Bay Area to conduct ceremonies at which Masters of Finds Arts certificates and an occasional Doctor of Dada degree were distributed to all comers, conferring upon them full status as faculty members of the "school." Locally, a group known as Dadaland was active in publications and exhibitions involving rubber-stamp works, "mail art," and mechanically reproduced collages and related forms, most of them devoted to parodying the mass media. The militantly anti-style style of such parodistic magazines as *File* and *Vile* (take-offs on *Life*), with their concentration on the bizarre and repulsive, served as a model for many of the publications that grew up around the New Wave scene later in the 1970s.

As conceptualist activities proliferated, Conceptualism, like so many "revolutions" before it, mellowed. It became another of the accepted conventions—even one of the clichés—of Bay Area art. Art Grant displayed an American flag made of colored blocks of dry ice at the 1976 Civic Center Art Festival and was asked back by the Art Commission to do similar pieces in subsequent years. Art schools and university art departments rushed to hire conceptualist and performance art teachers, and students began to submit conceptualist projects for degree requirements. Conceptualism gained an especially strong foothold at the San Francisco Art Institute during the short-lived directorship of Arnold Herstand and his avant-garde dean of students, Roy Ascott. The San Francisco Art Association, in ironic recognition of the conceptualist bias against the materialism of the art object, made its 1975 Annual simply a display, in the Institute's main gallery, of the money traditionally awarded as prizes: $1,000 in cash.

The more militant anti-museum and anti-gallery rhetoric of Conceptualism's idealistic youth began to fade. Chris Burden, the Los Angeles conceptualist specializing in ordeals of physical stress, fell off a high seat after sitting up all day and night at the Hansen-Fuller Gallery—and pictures of the event were later available for purchase. "Alternative spaces" dedicated to exhibiting new, "noncommercial" art forms—80 Langton Street, the La Mamelle Art Center, the SITE—proliferated, and became institutionalized. Most of these centers received financial support from no less an establishment organization than the federal government, through the National Endowment for the Arts—whose federal grants chairman for the visual arts in the last half of the 1970s was a former Bay Area conceptualist, James Melchert.

As conceptualist activity found readier acceptance through other channels, Tom Marioni curtailed the activity of the never hyperactive Museum of Conceptual Art; by the end of 1977, its only regular program was a weekly afternoon "open house" at Breen's saloon downstairs. In 1975, he teamed with Kathan Brown, the editor at the Crown Point Press in Oakland, to publish a slickly packaged triannual dedicated to conceptual art, called *Vision*. Expensively printed in limited editions with numbered copies, the publication sold at collector's prices: $10 an issue, $25 for a year's subscription. Ironically enough, shortly after the first issue of *Vision* appeared, Marioni, once the enfant terrible of Bay Area Conceptualism, was denounced as "elitist" by the participants in Floating Seminar—a self-styled alternative "support" organization dominated by Marxist-oriented "art workers."

Younger performance artists, meanwhile, were turning away from the rigorously antitheatrical actions practiced by artists like Fox and Marioni. Jock Reynolds, a former sculpture student at U.C. Davis whose early installation pieces were built around imagery associated with fishing and farming, collaborated in 1977 with Suzanne Hellmuth to create a full-scale theater piece called *Hospital;* it was produced by the Magic Theatre at Fort Mason, where it ran for several weeks. A group called SOON 3, led by Alan and Bean Finneran, created performance pieces that combined elements of theater and dance within a framework of lighting and stage design rooted in the "total art" concepts of such early modern movements as the Russian Constructivists and the Bauhaus. The freer, improvisatory, and non-narrative character that performance art had largely assumed began to attract people with backgrounds in more tradi-

204

Conceptualism

FIG. 184. Maria
Nordman, part of
Space as Support, a
series of installations
at the University
Art Museum,
University of
California,
Berkeley, 1979.

tional theater. Their performances gravitated away from ritualistic actions in real time toward more briskly paced and theatrical "acts." In the last years of the 1970s, Richard Irwin, a young student at the San Francisco Art Institute, organized a weekly series of performance pieces, many of them by fellow students, in a bar at the funky Hotel Utah, south of Market on the edge of the skid row district. These were frankly theatrical skits, generally involving elements of electronic or punk rock music and reminiscent of Dada cabaret performance. In contrast to the hermetic performances of the early conceptualist purists, they were designed deliberately to entertain. This redirection in performance art was paralleled by a similar shift of emphasis among many people working in video: they moved away from prolonged, sometimes virtually static representations of events (and nonevents) in real time, and adopted more concise and tightly edited approaches, which in many cases seemed to differ little from the conventions of commercial television.

Here and there, an event took place that harked back to the innocence of Conceptualism's earlier underground days. In 1976 a Los Angeles artist, Maria Nordman, slipped quietly into San Francisco and transformed a vacant storefront on Howard Street into an extraordinary meditation chamber by painting half of its interior in gray, the other half in black, and opening between the halves a narrow, floor-to-ceiling slit to the street.

Viewers, admitted only one at a time, observed how light passing through the fissure transfigured the interior space into a palpable, vaporous substance (more precisely, of course, they observed the workings of their own perceptual processes). Though it was given no publicity other than word of mouth, it was one of the most compelling installations ever to appear in the Bay Area. When Nordman returned three years later, it was as part of an ambitious and well-publicized series of installation pieces in which invited artists were given use of the entire interior of the University Art Museum in Berkeley. For a day-long summer solstice piece, Nordman moved everything out of the main exhibition halls and covered the floors and lower walls with white vinyl and sheetboard. Interesting visual effects occurred as the sunlight changed throughout the day. (See Fig. 184.) But the deeply meditative experience that had taken place in the privacy of the earlier storefront installation could not be recreated in the more public setting, amid the chatter and sociability of a gallery opening.

Perhaps the final turn of the screw—and the coup de grâce for Conceptualism as a force carrying overtones of an esthetic "revolution"— occurred in the summer of 1979, when the San Francisco Museum of Modern Art invited the Museum·of Conceptual Art to install an "informational" exhibition. Marioni took over one of the Modern Art's largest galleries to recreate a slice of

Conceptualism

FIG. 185. Tom Marioni, *Museum of Conceptual Art at the San Francisco Museum of Modern Art*, 1979.

his museum, by then all but defunct. For a month or so, a refrigerator full of Anchor Steam Beer, dozens of empty bottles, and a table at which Marioni himself was regularly installed each day, were on formal exhibition at the San Francisco Museum of Modern Art—as thoroughly incorporated as a particle of food engulfed by an amoeba. (See Fig. 185.)

After this, a big retrospective survey of Bay Area conceptualist work called Space/Time/Sound and organized by curator Suzanne Foley, which opened at the Museum of Modern Art in the last days of 1979, came almost as an anticlimax. Indeed, although twenty-one of the area's more prominent conceptualists were represented, the display was hardly a "show" at all; it contained less than a half-dozen actual installations amid a plethora of photographs, videotapes, and other forms of "documentation" of events long past. Despite the assertions of Fox, Marioni, and others that their

work represented an extension of the traditional concerns of sculpture, Space/Time/Sound made clear that conceptualist activity, at least in the Bay Area, had been from the start fundamentally a performing art. Its esthetic life, where it existed at all—in the provocation of new ideas, the spell of ritual, the dramatic impact of novelty, the humor of the irreverent and unexpected—was inseparable from the original event. No matter how "impersonally" trance-like they were, the actions of such artists as Fox, Fried, or Marioni had depended for their effect almost entirely on the artist's personal presence at the center of his work. At the Richmond Art Center in 1970, Fox's *Levitation* (see Fig. 174, p. 194) was powerful and memorable; at the San Francisco Museum of Modern Art in 1980, it was simply a group of not very good black-and-white photographs.

Conceptualism, at least at the beginning, did seem to represent a healthy reaction against the

materialism that had come to dominate the art world in the 1960s—not only the commercialism of the art market, but the lack of intellectual and emotional substance of so much minimalist art (as distinct from the wildly fantastic "content" that was so often superimposed on it by Formalist criticism). At a time when much contemporary art had turned soft, an art that sometimes took the form of self-sacrifice and demanded that its audience stay put for hours at a time seemed, if nothing else, to reaffirm the old-fashioned notion of commitment—indeed, it seemed to make something of a fetish of it.

But there was also in Conceptualism, almost from the start, a tendency to self-destruct. On one hand, because it encouraged the eclipse of visuality by idea, it worked to make much conceptual art a form of intellectual illustration—a mutation of literature or philosophy (although as literature or philosophy it was often quite rudimentary or inadequate). At another extreme, some forms of performance and environmental art seemed all too ready to surrender the crucial distinction between the vision and work of an artist and the more random "energy" of everyday life.

All kinds of problems arose when artists accustomed to working in space began turning their attention to working in time—which was generally "real time" rather than the compressed time, or scale, of traditional theater or dance. Conceptualism's debt to Warhol was often overlooked at the time, perhaps because the jet set chic with which Warhol was so intimately associated seemed the antithesis of the Beuys-like image of tough austerity that most conceptualists sought to project. But the "esthetic of boredom" which Warhol pioneered in his early films, and which was further refined by later structuralist filmmakers, was one of the principal features of much conceptualist activity. It was also Conceptualism's most dramatic departure from its other great father-figure, Marcel Duchamp, who always emphasized surprise.

In general, Conceptualism in the Bay Area began as a reflection of the engagement of the 1960s, and then developed into a manifestation of the withdrawal and privatism of the 1970s. At its most profound—in some of Fox's rituals, in a few of Marioni's and Paul Kos's pieces—it reaffirmed the role of art as a kind of prayer, the monastic kind that remains unheard by the world at large and yet works somehow to bring it grace. At its most shallow and banal, which was most of the time, Conceptualism was the bored, narcissistic yawning and stretching of what commentators in the 1970s began to call the Me Generation.

FIG. 186. Robert Bechtle, *Alameda Gran Torino*, 1974. Oil on canvas, 48" × 69".

The Object Reaffirmed: Photo Realism and the New Abstraction

Even in a locale accustomed to "realism," the paintings that Robert Bechtle and Richard McLean introduced at the Berkeley Gallery in 1968 were sometimes hard to accept. The surpassingly ordinary people and aging residential streets of Bechtle's paintings suggested remote roots in the urban realism of Edward Hopper, but Hopper's somber poetry and subtle geometry were missing. Bechtle's pictures seemed perversely flat, empty, and "dumb." McLean's scrupulously precise replications of horses seemed even more dryly literal—indeed, almost *photographic.* Until now, it had been one of the central tenets of modernism that the development of photography had liberated painters to pursue more ambitiously abstract, imaginative, or expressive ends. Here, however, were paintings that seemed to be blatant imitations of photographs—some of them as indifferently composed, carelessly cropped, and lacking in focus as an amateur's snapshot. Moreover, although they were undeniably a tour de force of technique, it was darkly rumored that their virtuoso effects had been achieved with the help of slides projected directly on the canvases as they were being painted—which made them slavishly beholden to their model, as "mechanical" as a photograph itself.

The work of Bechtle and McLean exemplified the first of two seemingly opposed trends that emerged across the nation in the last years of the 1960s to reassert the integrity of the object, of the artifact itself, against the claim of the more militant conceptualists that the traditional art object was dead. Because the "new realism" of Bechtle and McLean originated in and remained largely confined to painting based on photographic images, it became known as "sharp-focus" realism, or more commonly, Photo Realism. The other trend, which generally used combinations of unusual media and straddled a no-man's land between painting and sculpture, was much harder to label; but since almost all of it was assiduously nonrepresentational, we may conveniently call it the New Abstraction. It shared an emphasis on exposing raw materials—often *very* raw materials, such as sheet rubber, resins, wax, or even axle grease. The highly malleable nature of these materials was well suited to leave clear evidence of the physical process that went into the making of the work. These characteristics generated the epithet "resin and cheesecloth minimalism"—or more charitably, "process-and-materials abstraction."

The development of Photo Realism and the New Abstraction curiously inverted the two major tendencies that had prevailed in the early 1960s. The Photo Realist painters largely preempted the emphasis on slick finish, flat surface, and an all-over gestalt that had preoccupied practitioners of "post-painterly" Formalist abstraction. Experimentation with new "anti-art" materials, and with self-announcing procedures

and forms that made incursions into actual space, passed from the "realists" of the early 1960s into the work of the New Abstractionists.

Neither Photo Realism nor the New Abstraction represented a deliberately singleminded revolt against conceptual art. Both, indeed, shared certain conceptualist attitudes—in particular, a high degree of esthetic self-consciousness. They cultivated the preoccupation with "objectivity"—the striving for a detached and dryly factual if sometimes ironic tone—that was among the dominant characteristics of post-1950s art in general, and were thus correspondingly suspicious of the "subjective."

They did, however, parallel a conservative turn in the world of contemporary art, and in American society generally. This turn was a gradual, sometimes almost subliminal process, lacking the shock, drama, and spectacle that had characterized the rebelliousness of the 1960s, but the changes it brought about were no less decisive and far-reaching. By the end of the 1970s few observers were surprised when Ronald Reagan, whose political philosophy was farther to the Right than any candidate's since Barry Goldwater almost twenty years before, was elected president of the United States.

This new conservatism was, in part, a reaction against the more extreme radicalism of the late 1960s and early 1970s. With the Vietnam war no longer a major issue, some radicals joined in the new struggles for women's rights and "gay rights," but many others retreated from the front, "burned out" after years of efforts that seemed increasingly futile. At the same time, the very gains made by the liberalism of the previous decade sometimes seemed to encourage a complacency that contributed to the conservative mood. By the early years of the 1980s, for example, black mayors held office in big cities such as Chicago, Los Angeles, and Philadelphia, where a black mayor would have been unthinkable twenty years before; but many black leaders were concerned that the energy that had driven the civil rights movement in the 1960s seemed to have dissipated into apathy.

Conservatism in the art world, likewise, was characterized by a mixture of reaction and a consolidation of advances that had been made during the 1960s toward growing professionalization. Esthetically, artists of very different persuasions came to feel that Conceptualism had taken the notions of "revolution" and "progress" in art about as far as they could go without doing away with art altogether. The alternative was to retreat into an all-embracing eclecticism, for which Visionary art had already established a precedent: to assimilate imagery, styles, and ideas from widely separated sources, and thereby draw together the many changes that contemporary art had undergone since the 1950s. This eclectic impulse also gained impetus from the more traditional example and perspective provided by the touring supershows of historic art and antiquities (Tutankhamen, The Splendor of Dresden) which captured such great public attention in the last years of the 1970s.

Socially and politically, the tremendous increase in the number of artists, teachers, and art dealers—as well as the gains made in the campaign to win recognition and privilege for contemporary art—were creating an art world that was increasingly institutionalized. There was a solidification of what came to be known as the "support system": the traditional network of dealers, curators, collectors, teachers, and new satellite functionaries—fund-raisers and proposal drawers, community arts advocates, lawyers for the arts, lobbyists for the arts. By the early 1970s, universities, colleges, and community colleges throughout Northern California had flourishing art departments with fully tenured teachers, and many had full-fledged graduate programs as well. The main purpose of these programs, of course, was not to "train" artists, for whom degrees are irrelevant, but to certify teachers, who could then proceed to train still other prospective teachers. By May of 1975, Phil Linhares, the director of the exhibition program at the San Francisco Art Institute and an active participant in the development of "alternative spaces," estimated that between 500 and 1000 new Master of Fine Arts degrees were being granted each year in the greater Bay Area—a triangle bounded by San Jose, Sacramento, and San Francisco.[1]

This continuing proliferation of new artists was met by new methods of introducing more of them into the system—and a program that was new one year was often an institution by the next. The San Francisco Art Dealers Association, formed in 1974, made its first big project a month of highly publicized, concurrent shows called Introductions in each of nineteen member galleries; they gave exposure to more than forty new artists. The Introductions subsequently became, at least through the 1970s, an annual midsummer event.

In the spring of 1975, David Maclay organized Open Studios, a program in which the public was invited to visit the studios of ten artists in the south-of-Market area in San Francisco. The tour

was repeated, in vastly enlarged form, through most of the 1970s (and was resumed in 1982), but its value became increasingly problematic. The all-inclusive democratic principle on which the idea rested made it difficult for Maclay (and the organizers who succeeded him) to resist pressures to include the studios of commercial craftspersons and dilettante lifestylists. On the other hand, the more polished Open Studios artists were often quickly recruited into the commercial galleries—and gallery affiliation generally prevented them from displaying work in subsequent Open Studios shows.

The "support system" for the arts, with its diversity of motives and points of view, was generally neutral or indifferent toward basic esthetic questions, such as whether art should be involved in *expressing* anything. Its principal purpose was to stimulate more activity: more art, more viewers, more patrons. The question of quality was by no means ignored, but quality was usually conceived as something almost extrinsic to the work of art itself—a matter of professional polish rather than an organic outgrowth of an artist's sometimes painful and awkward struggle to give form to a unique vision.

As the diversity of contemporary art styles continued to multiply, "pluralism"—and the essentially nonjudgmental attitude that it implies—increasingly became the guiding principle in the exhibition and acquisition policies of the three Bay Area museums most active in the display and collection of new work: the San Francisco Museum of Modern Art, the University Art Museum in Berkeley, and the Oakland Museum. Rather than singling out art of exceptional originality and vision, they assumed an increasingly journalistic role, impartially spotlighting new collective "directions" and "explaining" them to the public. The "tastemaker" of the 1950s and 1960s—the museum director or curator with strong commitments and frank partisanships—yielded increasingly to the administrator-broker who pursued a carefully calculated policy of balanced presentation and diplomacy, and whose primary goal was expansion. Henry Hopkins, who became director of the San Francisco Museum of Art in 1973 (it was renamed the San Francisco Museum of Modern Art in 1975), exemplified the new breed. When he first assumed the job, Hopkins suggested that five years might be the limit to the keenness of a museum director's "eye"—an acknowledgment of the controversies (esthetic, social, and political) that had plagued museums nationwide during the 1960s, and had turned museum directorship into a high-risk,

high-turnover profession.[2] But Hopkins's diplomacy and local boosterism were such that he still held the post as director of the Museum of Modern Art in 1984.

The noncritical attitude extended to most of the art publications that appeared, however briefly, as part of the support system. *Art Week,* the longest lived (it was founded in 1969 by Cecile McCann and was still publishing in 1984), in its early years frequently printed museum and gallery press releases more or less verbatim. It gradually enlisted a small staff and a core of regular contributors, but their reviews, though earnest in tone, rarely went beyond description and technical analysis of the work at hand to question an artist's basic motives and premises or the work's relationship to broad cultural values.

Expansion was most conspicuous in the growth of commercial art galleries—in number, in size, and often, in luxuriousness. Paule Anglim established an elegant gallery in the space once occupied by the old Black Cat saloon. John Berggruen—whose father, Heinz, had been an assistant art and music critic for the *San Francisco Chronicle* in the early 1940s, before becoming a successful dealer in New York and Paris—set up his gallery in a luxurious suite on the third floor at 228 Grant Avenue; by 1980 this building also housed the posh Stephen Wirtz and Simon Lowinsky galleries (the latter specializing in photography), as well as the older Hansen Fuller Goldeen Gallery.

A few galleries—and many individual specialists who maintained no showrooms, or had only minimal display areas open to clients by appointment only—began to engage in "art consultancy." Their services attracted wealthy investors, and above all corporations, who were interested in the prestige and the tax breaks afforded by the purchase of contemporary art and the formation of corporate art collections. The successful art consultant was able to steer clients toward work that would present an image of quality and contemporaneity—and also be inoffensive enough to hang in a lobby, a typists' pool, or a vice-president's office, where it would harmonize with the decor. His or her function thus often resembled that of the old-fashioned interior decorator—and the kind of work in which the consultant specialized was often hard to distinguish from simple interior decoration. (See Fig. 187.)

All these changes seemed to fit in with the radical transfiguration that the City itself underwent in the 1970s. The Golden Gateway Center soared skyward to join the Transamerica tower

FIG. 187. Charles
Perry, *Eclipse,* 1973.
Anodized aluminum
tubing, dull gold in
color; 40′ × 35′.

over the blocks where the old produce district, with its inexpensive studio lofts, once stood. (See Figs. 188 and 189.) A host of new office towers followed, concentrating along the Embarcadero and the foot of Market Street. Port activity moved increasingly to the East Bay, leaving deserted many of the wharves along the northern San Francisco waterfront. A motorist driving west across the Bay Bridge in 1980 viewed a city that seemed schizophrenically divided: to the north, the impersonally imposing towers, quasi-rustic shops, and potted shrubbery of a tinselly tourist center and corporate headquarters; to the south, the remaining bone and sinew, the blood

and viscera and bowels of a functioning organic city.

Both Photo Realism and the New Abstraction seemed ready-made to fit the combination of social conservatism and bull-market economic expansionism that prevailed in the art world in the 1970s. Both styles encouraged impersonality to the point of blandness. (Photo Realism, with its roots in photography, had the added advantage of satisfying the traditional fascination with exact replication.) Because both emphasized technique, both were styles that could be learned—and taught—while affording room for marginal differentiation within general limitations. An artist fresh from graduate school could at once be recognized as a Photo Realist, for example, and also as a distinctive painter within the conventions of that genre (by specializing in horses or perhaps airplanes). By and large, Photo Realism and the New Abstraction fulfilled the era's need for an academic contemporary art.

Photo Realism, it might be argued, appeared first not in art but in the "objectivist" novel. One of the most lucid descriptions of the characteristics of Photo Realist painting appears in an introductory essay by Roland Barthes to Alain Robbe-Grillet's 1957 novel, *Jealousy*—eight to ten years before Photo Realist painting began. In the classical conception of painting, Barthes noted, "a *site* is frozen in eternity; the spectator has accorded the painter power of attorney to circulate around the object, to explore with his delegated eyes its shadows and its prospect so that every spectator after the painter himself must look at the picture with the painter's eyes." By contrast, Barthes wrote, the new objectivist esthetic presents "no alibis, no resonance, no depth, keeping to the surface of things, examining without emphasis, favoring no one quality. The function of language is not a raid on the absolute, a violation of the abyss, but a progression of names over a surface. . . . The object has no being beyond phenomenon; it is not ambiguous, not allegorical, not even opaque. . . . [It is] without associations, and without references . . . refusing with all the stubbornness of its thereness to involve the reader in an elsewhere, whether functional or substantial."[3]

Robbe-Grillet himself acknowledged the motion picture as a major influence on his writing; and like Pop art, Photo Realism seemed to reflect the veritable bombardment of almost every aspect of contemporary life with visual information. The camera had served as a visual aid to painters practically since its invention, but with Photo Realism, the photograph was no longer simply a convenient means of "fixing" the subject of the

The Object Reaffirmed

FIG. 188. San Francisco, 1958.

FIG. 189. San Francisco, 1976.

painting, which lay in the real world; the photograph itself became the subject, the content, of the work. The intervention of the photograph between painting and object served to neutralize the original subject of the picture. Its emotional resonance, its physicality, its very existence as material reality, all were called into question. The ironic detachment was heightened by devices borrowed from the "all-over" compositional approach that Formalist abstraction had inherited from Abstract Expressionism. Images were radically cropped in the manner of "badly" composed snapshots, the focus shifting erratically without regard to the relative importance of specific

The Object Reaffirmed

FIG. 190. Robert
Harvey, *Brother
Home on Leave,*
1966. Oil on
canvas, 48″ × 48″.

details. The aloofness was furthered by the impersonal technique—slide projections, frequently—with which the painting was executed.

One of the earliest forerunners of Photo Realism was Robert Harvey, a student of Nathan Oliveira's who began to work in a style inspired by elements of photography as early as 1961. Harvey, however, was interested principally in the almost abstract contrasts of values found in faded and overexposed snapshots. Holding to an almost monochromatic palette of sepias, siennas, and creams, he translated these values into fluid, painterly and essentially impressionistic paintings. (See Fig. 190.) His work had little direct influence in the Bay Area, but the nostalgic mood evoked by his family snapshot images—people in period dress posed in front of vintage cars, old storefronts, and tourist attractions—anticipated a theme that was to reappear in Photo Realism proper, particularly in the work of Robert Bechtle.

Another transitional figure was Charles Gill, an instructor (and former student) at the California College of Arts and Crafts since the early 1960s. Gill's early pantings had a sensuous breadth that reflected the "old" realism of the Bay Area Figurative painters, but the human figures in them

functioned principally as still-life objects in such bland, synthetic environments as the Honolulu Hilton and suburban tract homes. By 1965 Gill had sharpened his focus and honed his style so that a painting such as *Interior with Woman and Carpet* had more in common with the new realism than with the old. Eventually, his paintings grew more abstract and surreal. Figures were reduced to silhouettes that framed voids of delicately sprayed color, against settings that suggested the interiors of vulgarly pretentious cocktail lounges.

Robert Bechtle was the painter whose work most dramatically introduced Photo Realism to the Bay Area, and who remained most strongly identified with it. A student at the California College of Arts and Crafts in the late 1950s, and an instructor there through most of the 1960s, Bechtle at first painted in an expressionistic Bay Area Figurative mode, alternately aggressive and direct or somber and brooding, in a manner that reflected Oliveira's strong presence at the school. His subjects were most often common, middle-class domestic interiors, touched with disquieting overtones: an upright vacuum cleaner left standing in the middle of an empty room; a partially opened french door with a figure reflected in the panels. Many included fragmentary, or shadowy,

The Object Reaffirmed

FIG. 191. Robert Bechtle, *French Doors II,* 1966. Oil on canvas, 72″ × 72″.

FIG. 192. Richard McLean, *Satin Doll,* 1978. Oil on canvas, 54″ × 60″

self-portraits (see Fig. 191). *Pink Toothbrush,* painted in 1966, in which Bechtle's reflected image in a bathroom mirror is treated with the same probing, clinical scrutiny as the toothbrush and the bar of soap, was the most ambitious of these self-portrait interiors—and also the last painting he did from life. "It was not always convenient to have someone sit for me for long sessions. . . . It was, in fact, this very problem plus a desire for a wider range of subject matter which led me to make use of the camera," Bechtle said.[4]

Bechtle's *'60 T-Bird,* painted in 1967–1968, set the pattern for most of his later work. It portrays a man (Bechtle's brother-in-law) posed beside his car in front of a white stucco wall with diminutive

windows and a fragment of tile roofing. These clearly identify the front of one of the typical middle-class homes of 1930s vintage that spread across the lowlands of Berkeley and North Oakland. The lighting is harsh and stark, as in a characteristic snapshot, although the painted surface retains a softly veiled hint of morning overcast that gradually disappeared from Bechtle's later, more sharply focused style. The residential street in the East Bay or the suburbs; frequently, a car; and often one or more casually attired figures of surpassing ordinariness—all became characteristic themes of Bechtle's painting (and of an increasing number of prints and watercolors, the best of which were executed with a transparency

The Object Reaffirmed

FIG. 193. Ralph Goings, *Interior,*
1972. Oil on canvas, 36″ × 52″.

that suggested Winslow Homer). (See Fig. 186, p. 208.) Bechtle once remarked that he could not get involved in a painting unless he was personally acquainted with the people, or things, that it portrayed.[5] And in general, the presence of the artist—a holdover from the Bay Area Figurative tradition—remained more strongly felt in his work than in the painting of other Photo Realists. The conventions of the amateur photographer—banal subject matter, indifferent or careless composition, glaring illumination—seemed to give his paintings a subtle undercurrent of both oblique social commentary and ironic affection. During most of the 1970s, Bechtle was an instructor at San Francisco State College, where, by the middle of the decade, a substantial enclave of Photo Realist painters developed.

The two other most prominent "first-generation" Bay Area Photo Realists were Richard McLean and Ralph Goings. McLean, who grew up in the timber and ranching country of Idaho, enrolled at the California College of Arts and Crafts in the mid-1950s with the aim of becoming a commercial artist, but this goal changed after he saw Diebenkorn's large *Berkeley* paintings. Oliveira, de Kooning, and Francis Bacon were other influences, as were Johns, Rauschenberg, and Pop art in general.

In the mid-1960s, McLean developed a style that played photographic images against an abstract space and gestural brushwork, using a variety of subjects from books, newspapers, and magazines. By the time he showed his paintings at the Berkeley Gallery's new San Francisco site in November of 1968, his style had become fixed as a vivid, super-crisp variant of sharp-focus Photo Realism. He had also staked his claim to a characteristic subject matter: the horse, generally attended by jockeys, cowboys, or society matrons against backdrops redolent of the genteel country ranch, the stable, or the racetrack. (See Fig. 192.) McLean professed no interest in horses or horse fanciers. He saw photography as a reality in itself. "Most of what our culture accepts as Truth is

The Object Reaffirmed

FIG. 194. Jack Mendenhall,
Divorcee's Apartment, 1971. Oil on
canvas, 66" × 81".

drawn from photographic evidence. I'm always intrigued by the superior pictorial quality of the slide over the event. The subjects have a heightened presence and overall relationship of parts within the frame [that is] more exciting . . . than the actual thing. A large reason is the absence of three-dimensional space which, in many ways, is distracting. I'm probably a closet still-life painter. . . . My aim is . . . to 're-authenticate' the documented event through the painting process so that in its final mutation as a painting it will hopefully stand somewhere beyond and experientially superior to both the actual event and the photograph."[6]

Ralph Goings, a classmate of Bechtle's at the California College of Arts and Crafts in the early 1950s, settled in Sacramento and remained there until 1975, when he moved to New York. His specialty, like Bechtle's, was the motor vehicle. In Goings's paintings of the late 1960s, it sometimes resembled one of Wayne Thiebaud's figures: isolated against a flat, unarticulated ground, posed

stiffly alongside its shadows. His paintings gradually acquired settings that reflected the distinctive features of the Sacramento locale: bleakly funky fringe areas that lay on the edges of town in the advance guard of urban sprawl, or landmarks of the mobile subculture of the road—gas stations, fast-food stands, truck stops. (See Fig. 193.) The vehicles in Goings's paintings were generally old pickup trucks or delivery vans. As in Bechtle's earlier Photo Realist paintings, the photographic clarity was balanced by a softness of surface and, often, of light—a late afternoon glow that bound the forms together in a unity of atmosphere and mood.

Bechtle's and McLean's early one-man shows drew only a lukewarm reaction from local critics. But by the end of the 1960s, Photo Realism in general was catching on rapidly among collectors, nationally and internationally, and Bechtle, McLean, and Goings were quickly enlisted into the ranks of its superstars. Most of the Photo Realist painters were handled by the O. K. Harris

gallery in New York; Goings started to exhibit there regularly in 1970, and Bechtle and McLean joined him the following year.

The example of these painters, and the mushrooming market for Photo Realism nationally, stirred up a multitude of followers. One of the first of Bechtle's students to gain prominence was Paul Staiger. His early paintings focused on sun-drenched views of family groups smiling at the camera from in front of the Sacramento Capitol Building and the beach at Santa Cruz. Staiger spent the early 1970s in Los Angeles, and drew most of his images from the rich lode of Southern California visual clichés: movie stars' houses, Malibu Beach, the Griffith Observatory. The paintings, more than those of Bechtle, Goings, or McLean, emphasized light values. His imagery thus took on a generalized, semi-abstract quality that placed it at a certain angle to the "sharp-focus" school of Photo Realists.

Jack Mendenhall's early paintings were somewhat awkward Photo Realist views of the vintage storefronts along Oakland's Piedmont Avenue, the neighborhood shopping center of Bechtleland. But by 1969 Mendenhall had staked out his own iconographic claim: garishly opulent, overembellished interiors out of *House and Garden* magazine at its most extravagant. The synthetic materials, artificial lighting, and general air of unreality were amplified by a style that combined crisp detail with rich, velveteen paint surfaces. (See Fig. 194.)

Photo Realism sometimes shaded by gradual degrees into approaches to realism—or illusionism—that diverged considerably from its basic precepts. Joseph Raffael had begun painting from photographs in the early 1960s while still living on the East Coast, where he studied at Cooper Union and exhibited widely before moving to the Bay Area to join the faculty at Sacramento State College in 1969. His paintings of the late 1960s were large canvases filled with closely cropped, immensely enlarged images gleaned primarily from color reproductions in magazines, generally of an exotic cast: massive profile heads of Indian chiefs, the death mask of King Tutankhamen. They were painted in a kind of intuitive, nonsystematic "pointillism." A bright white gesso underpaint contributed to the glistening brilliance of richly marbled oil surfaces. In the early 1970s, Raffael began to paint from photographs he had taken himself: isolated patches of water, grass, trees, and foliage. These microcosmic views became the starting points for paintings of an

extraordinary opulence that straddled a thin and changing line between abstract color tapestries and images of rippling water, water lilies, and apple blossoms. (See Fig. 195.) The lush hedonism—and increasingly cosmetic seductiveness—of Raffael's style, like his subject matter, was far removed from the cool conventions of Photo Realism. "I don't really paint photographs," he said. "I use [the] image as a structure. I'm usually painting colors and light and forms which flow out of the brush."[7]

In contrast to Photo Realism, the New Abstraction in the Bay Area was largely an import from the East Coast and Southern California. Certain of its features—such as an emphatic materiality of surface, which excluded most other values—had been implicit in the work of late arrivals to Abstract Expressionism like Georges Mathieu and Antonio Tàpies (and, in the Bay Area, Sam Tchakalian). But in general, the New Abstraction was a synthesis of approaches growing out of Formalism, post-Minimalism, and Conceptualism. In the work of East Coast painters such as Robert Ryman, the Formalist emphasis on structure loosened and gave way to a preoccupation with surfaces of an austere but marked sensuality—a kind of post-conceptualist Impressionism. Frank Stella, whose coolly painted shaped canvases of the early 1960s had been the principal pace-setters of Formalist abstraction, adopted brushy, "painterly" surfaces, and as time went on incorporated a variety of materials that built out from his canvases in sculptural relief—a bit like a Red Grooms parody of Stella's original style. In the work of Eva Hesse and Robert Morris, the funky, fragile, often perishable materials favored by conceptualist artists such as Joseph Beuys became absorbed into somewhat more formal and durable sculptural *objects*. Artists such as Sol LeWitt, involved in exploring systems and geometric relations, developed the on-site "installation piece" to give their essentially conceptual themes a concrete, if temporary, form. This impermanence emphasized the character of the work as a projection of a set of instructions—a process that could be duplicated—rather than as a self-contained and unique object, a thing in itself. Meanwhile, in Los Angeles, the "finish fetish" of the 1960s gave way to the raw, unfinished look of Ed Moses's austere abstractions on unstretched canvases, sparsely stained with thin films of acrylic and splotched with globby patches of plastic resin. These were exhibited in San Francisco early in the 1970s, and thereby became an influence closer at hand.

The Object Reaffirmed

FIG. 195. Joseph Raffael, *Lily Painting-Hilo II,* 1975. Oil on canvas, 7' × 11'.

In its more rugged manifestations, the New Abstraction suggested a revival of Abstract Expressionism, but the resemblance was only skin deep. Most New Abstraction carried over, as a scaffolding for its often amorphous surface effects, a loosened version of the rigorous structural devices of Formalist paintings—most often, the grid. Its emphatic surfaces were different in kind from those of Abstract Expressionist painting, which were organic outgrowths of individual volition and expressive gesture, and even from the cake-frosting surfaces that characterized later "decadent A.E.," which were a combination of rhetoric and mannerism in which the artist's personality (if no longer his entire person) remained at the center. The New Abstraction emphasized not only the processes by which surfaces were constructed but also the impersonality of that process, whether based in mechanistic system, ritual, or random chance. The New York artist Lynda Benglis, for example, made sculptural objects by methodically dripping—or permitting to drip—encaustic and resin onto slabs of ma-

sonite; the thick films and encrustations that resulted were not unlike the residue left by melting candles on the necks of Chianti bottles. The New York-turned-Bay Area artist Heléne Aylon made "paintings" in which pockets of oil were encysted behind sheets of paper which they gradually impregnated in various areas according to a combination of predetermined and chance factors.

One of the earliest and most prominent Bay Area painters to adopt the new emphasis on materials and processes was Tom Holland (Fig. 196). Holland's early paintings, inspired by the forms of primitive art, emphasized bold, Abstract Expressionist colors and surfaces, but they already showed indications of erosion by an "anti-form" approach. Canvases were torn, cut, and otherwise manhandled into non-rectangular shapes and sculptural relief. Inspired by the environment of Southern California while teaching at UCLA between 1968 and 1970, Holland flirted briefly with a Pop-Funk style: garish, loosely brushed images of motels and palm trees were painted on

The Object Reaffirmed

FIG. 196. Tom Holland in his
Oakland studio, 1980.

canvases to which real desert water-bags or strips of awning were sometimes attached. At about the same time, he began to work with fiberglass, dripped and gobbed with juicy surfaces of epoxy paints. In the earliest of these pieces, the fiberglass was cut into thin strips which Holland assembled into complex lattice works, or unfurled into long ribbons that clambered across walls and sometimes around corners.

By 1969, Holland had restricted himself to an essentially rectilinear format. Geometric planes or narrower strips of fiberglass—the latter arching out into the physical space in front of the painting—were bolted to large square or rectangular fiberglass sheets. Parts of the fiberglass construction were left exposed, exploiting the delicate translucency of the raw material; others were flooded with runs and spatters of epoxy, built up layer by layer to form opaque, wax-like surfaces with an almost overwhelming opulence of texture and color. (See Fig. 197.) The torrents and cascades of bright, juicy, frequently metallic colors—which changed under variations of lighting—combined the funky Bay Area "look" with the seductiveness of the L.A. "finish." The surfaces called attention to their own physical properties—their density and viscosity—and to the law of gravity that determined their flow. They also heightened a sense of the physical characteristics of the materials they covered, and they created dense, palpable, but illusionistic atmospheres within which the relief forms seemed to have detached themselves from the grounds to hover in the space in front of them. Whether this was enough to make them potently expressive as works of art was another question. In any event, they extended a kind of Abstract Expressionist gesturalism into three-dimensional space.

In the 1970s, Holland moved increasingly toward sculpture—or more accurately, toward freestanding paintings. Pieced together of limp geometric elements in fiberglass or aluminum, these assemblages sometimes approached monumental dimensions, but the emphasis on surfaces, colors,

The Object Reaffirmed

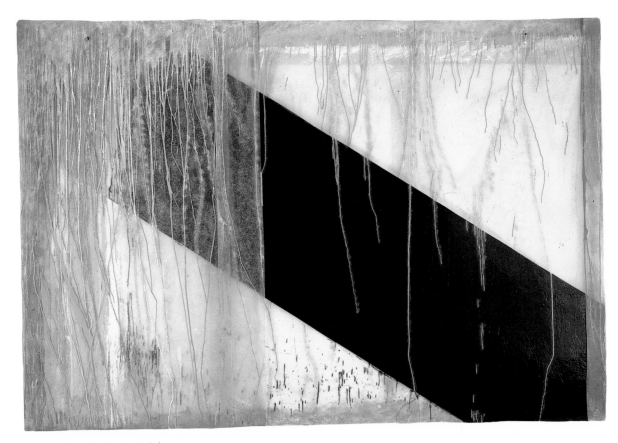

FIG. 197. Tom Holland, *Berkeley Series*, 1969. Epoxy on fiberglass, 89¼" × 133½" × 3½".

and textures remained paramount. With their less than rigorous sculptural forms, they conveyed an impression similar to that of Frank Stella's later work: too much (and in another way, too little) was going on. They were colorful messes.

Among the more prominent younger New Abstractionists were Gregg Renfrow and David Mackenzie. Renfrow's early pieces were hanging constructions formed of long, thin strips of rhoplex and plastic screen, fragmented and arbitrary in shape and assembled in grid structures. Surfaces covered with freely applied rusts and impastos of scabrous paint (sometimes imbedded with thin slivers of wood pulled off the studio floor when the pieces were being put together) alternated with areas veiled with soft colors through which light filtered from behind. Renfrow later moved to large, shaggy, opaque wall reliefs, more intense in color and often bearing the

imprint of floorboards, which provided the otherwise amorphous colors with a grid-like visual structure. The heavily textured surfaces were richly decorative, but it was possible to read into their obdurate materiality intimations not only of process, but of rusting, weathering, and age. (See Fig. 198.)

David Mackenzie's early paintings were raw and bare-boned in the manner of Ed Moses's, playing a sketchy, linear geometry against apparently casual stains and squiggles of soft color. Eventually, he began to make paintings by coating and layering sheets of fiberglass face down on the studio floor, so that the progress of the work remained unseen. These works leaned toward densely textured monochromes of rusts or earth tones. Structure was achieved by folding and creasing. Like the paintings of Renfrow and certain other New Abstractionists, Mackenzie's

The Object Reaffirmed

FIG. 198. Gregg
Renfrow, *Untitled,*
1976. Rhoplex on
fiber mesh, 69″ ×
124″.

pieces conveyed a certain sense of "real time";
they seemed to "record" the tedious, repetitive,
almost mechanical dynamic of construction and
destruction, layering and sanding, that went into
the building of their surfaces.

David Maclay and Cherie Raciti were among
the artists who specialized in on-site works. On
lots south of Market and around China Basin,
where buildings had fallen into disuse or been
destroyed for urban renewal, Maclay rearranged
mesh screens, cement reinforcing rods, old tires,
and other objects that struck his fancy. These
makeshift "installations" generally existed prima-
rily for the sake of being photographed, so that
their physical changes could be documented over a
period of time.

Raciti also worked the blocks south of Market,
primarily the area that had been razed of old hotels
to make way for the Yerba Buena Center. Her

principal elements were modules of fabric, in
simple geometric shapes, laminated with flat
colors and an acrylic coating resin. These were
arranged in regular, rhythmically repetitive struc-
tures that struck a balance between calling atten-
tion to themselves and fading into the landscape of
fragmentary basement walls to which they were
attached. (See Fig. 199.) Mailings, including a
photograph, information, and instructions on
how to find the work, were sent to friends and
other artists; the work itself remained, as Raciti
observed, "anonymous to the countless people
passing by each day . . . simply part of what is
there. I feel that changing the context of where
work is seen changes the manner of how the work
is viewed or experienced. The artist loses much of
the control of how the work is to be seen and by
whom, thus setting up a more arbitrary situation
where the work is on its own."[8] With this idea, art

The Object Reaffirmed

FIG. 199. Cherie Raciti, *Last Yerba Buena Wall*, 1977. Tyvek cloth and rhoplex applied directly to wall at Fourth and Mission streets, San Francisco, 7' × 21'.

seemed to have gone as far as it could from the concept of total responsibility enunciated thirty years before by Clyfford Still.

By the mid-1970s, one of the most popular materials for artists given to exploring new processes and media had become handmade paper, processed from raw paper pulp recycled from old papers or rags. Raw paper pulp could be sculpted, impregnated with pigment, imbedded with found objects, used to cast objects, or embossed by huge hydraulic presses—and it could be worked with almost any combination of these processes. An International Center for Experimental Printmaking, established by Garner Tullis in 1973 in Santa Cruz (it later moved to San Francisco), attracted several of the area's better-known artists to experiment with the medium. Most of them—including Manuel Neri, Harold Paris, and Matt Glavin—extended ideas they had developed previously in other materials, and few among those who were the first to experiment with paper pulp stayed with it very long. The work tended to succumb to the seductiveness of the material's malleability, elegance, and sensuous appeal. By the end of the 1970s, handmade paper had become largely given over to a kind of buttoned-down Formalist abstraction that was hard to distinguish from the chic esthetic of the decorator shops.

At its outer margins, the New Abstraction encompassed work that differed considerably in emphasis, appearance, and expression. Its anti-romantic—even anti-expressive—objectivity and emphasis on materiality were adopted by such sculptors as David Bottini and William Wareham, who worked in more traditional and durable materials, generally in neo-Constructivist styles. The most influential was a British sculptor and former assistant to Barbara Hepworth, Brian Wall, who came to teach, on Peter Voulkos's recommendation, at U.C. Berkeley in 1969. Influenced by the work of Mondrian, Vantongerloo, Moholy-Nagy, Tatlin, and Lissitzky, Wall had begun making steel sculpture in 1958, working in a manner of assemblage that sometimes closely paralleled the sculpture of Anthony Caro. Using industrial production materials—steel plate, tubing, I-beams—which he generally painted a flat black, Wall assembled his pieces in a basically intuitive way, using power tools and an arc welder without guidance of preliminary drawings and maquettes. Generally built low to the floor on a horizontal axis, Wall's sculpture, like its materials, was what it was: simple, direct, and unromantic. (See Fig. 200.)

At the other extreme of the New Abstraction, Kathy Goodell's constructions included such ingredients as blood, hair, bone, and other organic matter, which formed a grittily evocative counterpoint to simple, delicate structural forms—fragile spirals and mazes of wire, glass columns, tubes, and blood specimen slides. (See Fig. 201.) Elin Elisofon's constructions of wax, clay, fabric, and

FIG. 200. Brian Wall, *B1*, 1971. Painted steel, 9½' × 15½' × 7½'.

FIG. 201. Kathy Goodell, *Untitled*, 1981. Brass, salt, glass, and lead weights; 70" × 50" × 20".

FIG. 202. Elin Elisofon, *B. Remnants*, 1977. Mixed media, 11″ × 8″ × 5″.

other perishables sometimes included blood and dead birds. Their forms resembled nests or burial containers, in shades of ashen gray or the chalky white of old bones, and they evoked the feeling of primitive fetishes used in rites celebrating the cycle of death and renewal. (Some did in fact develop out of private rituals that Elisofon carried out at a secluded site in the Southwestern desert.) Many of Elisofon's objects might have passed without notice in the display cases of an anthropology museum devoted to American Indian artifacts. (See Fig. 202.)

In the case of David Ireland, a preoccupation with process and materials shaded into the visionary. Ireland's "gallery art" consisted primarily of wallhangings that emphasized granular textures and were often rent by tears or holes. But these "skins" were conceived as part of a dialogue exchanged with the walls of a vintage Victorian house in the Mission district where Ireland lived and worked. The house itself had been a decrepit, neglected structure when Ireland first moved in. Working painstakingly and ritualistically, he stripped the interior walls down to the plaster, which he sealed with a transparent, high-gloss veneer. In looking at the objects with which he furnished the house, it was often difficult to tell where function ended and abstract sculpture—or Dada—began. (See Fig. 203.) Many

of the furnishings, including odd "historic markers," engraved and attached to otherwise arbitrary sites on the wall or floor, were mementos of the history of the house, including the process of its restoration. Eventually, Ireland opened the house on a sporadic basis to the public, as representing his central work.

Roger Berry achieved a similarly visionary expression using a severe vocabulary grounded in Constructivism. The elemental geometric forms of his monumental outdoor sculptures in Corten steel were distilled from detailed calculations in which the play of light and shadow resulting from their changing relationships to the seasonal and even daily movements of the sun all formed an integral part of the grand design. Like the megaliths at Stonehenge, they seemed to be focal points for mysterious energies, poignant reminders of an age when such monuments were not decorations but essential, functioning elements of culture. (See Fig. 204.)

James Rosen's paintings of the late 1970s—when he joined the art faculty at Santa Rosa Community College—were uniquely luminous abstractions of natural forms that approached the vanishing point of minimalist field painting. He used watercolors to translate the highlights and shadows of stark rock formations into the sparest of gray and beige washes, and oils to reduce them further to greater

FIG. 203. David
Ireland, interior of
500 Capp Street,
San Francisco,
ongoing, 1978 to
present. Traditional
building materials,
50′ × 125′.

or lesser concentrations of light on grounds that were virtually identical in hue and value. These techniques created illusions of forms and shapes that seemed to swim in and out of view as the ambient light changed and the viewer's eyes grew accustomed to their nuances. Eventually—somewhat like the work of Robert Irwin or Maria Nordman—they refocused the observer's attention on his own perceptual processes, through which the illusion on canvas is completed. Rosen later explored other areas of subject matter: on the one hand, abstract forms inspired by ancient Chinese symbols or the architecture of Norman Romanesque cathedrals; on the other, figurative images derived from the painting of the early Renaissance masters. Fragmented, tenuous, and yet persistent, these ghost-like icons projected great poignancy. (See Fig. 205.)

Whether Constructivist or fetishistic, most New Abstraction remained preoccupied with the surface qualities of the materials themselves. Although most of its practitioners claimed to prize "toughness"—an expression of rigor and impersonality conveyed through an austere impoverishment of means—their work had a perverse tendency to assume a blandly decorative elegance. As time went on, many younger artists who had started out in the New Abstraction, as it was taught in art schools, appeared to have forgotten or forsaken the "tough" ideal altogether. They were simply using new and unusual materials—resins, rubber, handmade paper—to make things that looked pretty.

By the early 1980s, the popularity of Photo Realism and its kin had waned in Bay Area painting, and the New Abstraction, in one mani-

The Object Reaffirmed

festation or another, had become one of the more commonplace conventions. There was essentially no great difference between the two. Both emphasized those aspects of art which have to do with the mechanical or "ritualistic" *making* of *things*—that is, with craft: meticulous, almost exhibitionistic slickness and finish in the case of Photo Realism; a studied artful casualness in the case of much of the New Abstraction. Both, with their shared emphasis on method, were principally strategies rather than modes of expression that demanded the full engagement of an artist's (or viewer's) intellectual, emotional, and spiritual resources. Like the Pop art and Formalist painting that preceded them, Photo Realism and the New Abstraction possessed (and frequently exploited) the quality of appealing simultaneously to the viewer's snobbishness—his desire to affect avant-garde tastes—and to his residual philistinism. Photo Realism embraced a contemporary "look," a hip irony, and even, if one wanted to seek it out,

a philosophical rationale of duly impressive subtlety; at the same time it permitted a collector to indulge his taste for horses, seascapes, mountains, airplanes, or even cheesecake. Too often, Photo Realism was removed, through the use of photography and technique, not only from the subject but also largely from the artist (or at least from all but his eye and his fingers); it became basically a form of surface abstraction, a kind of pattern painting in which the patterns simply happened to take the form of images recognizable in the world of "reality." It was decoration done in an illustrational style.

The New Abstraction, although hinting at underlying philosophical, or at least theoretical, concepts, delivered basically an undemanding surface decoration—sometimes a bit raw, but not likely to conflict severely with any color schemes. Far from meeting the challenge posed by Conceptualism, Photo Realism and the New Abstraction thus helped to widen the critical gulf that charac-

FIG. 204. Roger Berry, *Duplex Cone,* at Arrowhead Marsh in Oakland, California, 1982. Corten steel, 11'9" × 22'3" × 15'10".

FIG. 205. James Rosen, *An Homage to Bronzino,* 1975. Oil and wax-oil emulsion on canvas, 53" × 48".

terized most contemporary art in the 1970s—the gulf between ideas without objects, and objects without ideas.

By the beginning of the 1980s, the New Abstraction had turned largely to absorbing and transfiguring elements of earlier historical abstraction, often using more traditional media such as oil or acrylic on canvas. In Frank Stella's late mixed-media creations, the surfaces of "A.E." returned as flat, gratuitous, mechanically applied embellishments, not even supported by a rhetoric of feeling. The mannerisms of Formalist abstraction reappeared in various forms of avowedly decorative pattern painting. Such New York painters as Jennifer Bartlett and Joan Snyder practiced an eclecticism in which Abstract Expressionist, Formalist, and even Funk components were brought together in a kind of neutered pastiche of surface effects: these pastiches never became more than the sum of their parts, and the range of styles they incorporated was in itself their principal content.

By the early 1980s, there was even a flourishing branch of Photo Realist painting that specialized in meticulously airbrushed, trompe l'oeil depictions of the characteristic surface effects of cliché New Abstraction and pattern painting. One of its early forerunners, Wade Hoefer, had captured some attention while still a student at the California College of Arts and Crafts in the early 1970s with a series of big, flatly painted canvases that created an illusion of thickly textured surfaces of paint and sand, criss-crossed by giant X's, Tàpies-style, in what appeared to be high relief. Joe Doyle, a Bay Area Photo Realist who had initially specialized in painting airplanes, attained some nationwide prominence among the many painters who were working in almost interchangeable styles and concentrating on this new area of "subject matter." At last report, their work was being displayed under the banner of Abstract Illusionism.

The Object Reaffirmed

FIG. 206. Joan Brown, *The Bride,*
1970. Oil and enamel on canvas,
96″ × 55″.

Dr. George Gladstone's Wonders of the World Museum occupied a temporary exhibition gallery at the M. H. de Young Memorial Museum in 1975, but normally it resided beside a ditch along the highway on the edge of Port Costa, in the rolling hills on the Contra Costa County side of the Carquinez Strait. Antique hunters and weekend tourists attracted to Port Costa—a sleepy relic of a town that was once a busy center for the shipment of bituminous coal stripmined from the foothills of Mount Diablo—were invited by a homemade sign to stop and view the fossilized eggs and skeletons of creatures from the "Bone Age," including a Cyclops, an Apteryx Destructus, and a Pterodungus. Each "find" was thoroughly documented, with exact site of recovery, dimensions and habits of the creature to which the remains belonged, and other pertinent data. (The Pterodungus was excavated from a suburban septic tank; the Giganticus Erectus Robustus was endowed with a jointed penis that could be bent double, thereby obviating the need for birth control devices.)

These "Bone Age wonders" were exactingly realistic ceramic sculptures, and "Dr. Gladstone" was in fact Clayton Bailey, a formally trained, sophisticated ceramist with a degree from the University of Wisconsin. (See Fig. 207.) After visiting U.C. Davis as a guest artist for two semesters in the early 1960s, he had moved to the Bay Area and made something of a reputation for

comic, gnome-like figures and fancifully bizarre objects (inflatable rubber "grubs," and tacky "nose-pots") that were often inspired by old mechanized toys and other Pop objects that he found on weekends at the Alameda flea market. These still fit comfortably within the framework of Funk art, but early in the 1970s, when he began to concentrate on life-like replicas of imaginary fossils, his work took on a systematic, almost obsessive singlemindedness that was new. Its closest counterpart seemed to be the work of the "outsider" or "nut" artist who devotes his life to constructing an elaborately idiosyncratic environment in his backyard. As Roy De Forest described the impulse: "One day while talking to the poet David Zack, I expressed my belief and interest in the artificer as an eccentric, peculiar individual creating art as a fantasy with the amazing intention of totally building a miniature world into which the nut could retire with all his friends, and animals, and paraphernalia. The little world inside becomes a 'completely fitted out' phantasmagoria."[1]

Bailey—who eventually abandoned archeology to present himself as a mad doctor whose demented anatomical experiments were recorded in mixed media tableaux and enacted in performance pieces—exemplified another development that became increasingly widespread in Bay Area art during the 1970s. Rejecting the impersonal, "objective" attitude that informed the dominant trends of Formalism, Photo Realism, and the New

232

FIG. 207. Clayton Bailey in the
guise of Dr. George Gladstone, at
the Wonders of the World Museum
near his home in Port Costa,
California, c. 1975. Bones are made
of thermally metamorphosed mud.

Abstraction, this strain of expression rejoiced in the intimate, the subjective, the idiosyncratic; personality was its essence. In contrast to Conceptualism, it was still very much involved with the making of objects. Although it was basically a product of the art schools, it grew up—again in contrast to Photo Realism and the New Abstraction—largely on the fringes of the urban centers, on relatively remote college campuses in the Central Valley, and among the growing colony of artist-teachers living in rural communities in the San Geronimo Valley, in Marin County, or along the Carquinez Strait, in Contra Costa and Solano counties. Like the art of the Chicago Imagists that began to surface at about the same time, it expressed a nose-thumbing attitude toward the esthetic and political dominance of the East Coast. More significantly, it was also rooted in several stubbornly persistent regional traditions. The most obvious of these was the Pop-inspired Funk of Robert Arneson and the Neo-Dada Funk of William Wiley, but its lineage also included the

fiercely independent, iconoclastic attitude of Clyfford Still (without the high seriousness and moral fervor); the representational bias of the Bay Area Figurative painters; and the confluence of the two historical veins of Surrealism that occurred in the mid-fifties sculpture of Jeremy Anderson—one mythic, Miróesque, and respectable (Adaline Kent, Robert Howard), and the other spoofing, Duchampian, and underground (the found objects of Clay Spohn).

The chief components of this new approach were autobiography and fantasy, the interpenetrating worlds of the personal surroundings and private dreams. Because it seemed to fall outside existing categories, schools, or movements, this strain of highly subjective personal expression seemed to resist definition. But through its autobiographical nature, it preserved clear and direct links to the outside world—to suburban tract homes in Davis or woodsy havens in Marin County where nostalgic fantasies of Indians lingered, to strong personal ties with other artists

Personal Mythologies

tenured on the same university and college art faculties. And so this individualistic, intuitive personal expression gradually assumed, after all, the character of a distinctive and eventually self-conscious regional style. "Dude Ranch Dada," Hilton Kramer's term for the work of William Wiley, was frequently extended to the work of others who shared Wiley's fondness for ironic allusions to the Western mythology of cowboys and Indians.[2] The more equivocal label "personalism" was also sometimes applied. Writing about some of these artists in *Art and Artists* magazine in 1969, David Zack used the term "California Myth-Making," and we shall make use of it here to suggest what this diverse group of sophisticated, or at least academically trained, "nut artists" seemed to have in common.[3]

The "myths" that attracted Bay Area artists of the late 1960s and the 1970s were of a different order from those that preoccupied the generation of painters who had come of age in the 1940s. Whereas the Abstract Expressionists were drawn to the mythology of the Kabbalah, the Tarot, and ancient Greece, the mythmakers found this kind of symbolism too pretentious. They were more likely to be influenced by the art of children and *naïfs*. They were also more inclined to immerse themselves in the world of commercial kitsch. Irony, parody, and just plain comedy were among their principal interests, and so they frequently picked as subjects myths that had become clichés. Myths or cultural stereotypes *about* Indians, for example, were more likely to figure in their work than the mythology of Indians themselves.

"All real art is self-portraiture," Robert Arneson once said, and the mythmakers tended to project their own personalities through themes and motifs (or found objects) that triggered highly personal associations or were intimately bound up with their daily lives.[4] But equally strong was the inclination to playful, sometimes farcical, fantasy. The mythmaking impulse operated in a gray area between the Surreal or the mystical and Pop. Like science fiction and its counterparts in more traditional mythology and folklore, and related to the cartoon-like dimension of many contemporary novels (Heller's *Catch 22*, Kesey's *One Flew Over the Cuckoo's Nest*), it worked to dilute distinctions between the possible and the actual.

Its most characteristic subject matter was the stuff of myth and legend the world over, but distilled to a personal, private essence: animals (pets), people (friends) and common objects, and their metamorphoses into spirits, talismans, deities, or comic-book heroes. A frequent theme

was travel: through time, either backward into history or forward into prophesy; or through space, as recorded in mythical migration maps or journals of personal pilgrimages. In essence, mythmaking was conceptual, not in the intellectual manner of Joseph Beuys or Hans Haacke, but in the make-believe style of children, which gives form to imagined, intuitively constructed but often highly systematized private worlds. Within these worlds the art objects themselves were like the artifacts of exotic cultures, offering tantalizing clues but rarely telling the whole story straight. It was not uncommon to find a mythmaker developing a body of work that added up to an elaborate pretense—a comprehensive paraphrase of entire branches of human history or prehistory, recast in the image of his or her own imagination. The artist-mythmaker thus became a kind of anthropologist of his own consciousness, giving shape and significance to the impulses that formed his private system of beliefs, using whichever facts and fantasies were most important to his life.

Jeremy Anderson and Fred Martin had anticipated a characteristic tone, as well as a favorite subject, of the mythmakers in the imaginary "maps" each had done independently in the early 1960s. Anderson's had taken form in a series of watercolors, begun in 1963, which he continued to develop for a time in counterpoint to his work in sculpture (discussed in Chapter Seven). They resembled the maps that children (and the deranged) sometimes draw to depict imaginary worlds, and their schematic imagery was accompanied by legends or titles in which outrageous puns mingled with intimations of symbolic journeys into esoteric byways of metaphysics: *Deep Blue Sea, Spaghetti Swamp, Heights of Folly, Passion Pit, The Other Oracle, The Living End.* (See Fig. 208.) Martin completed *A Map of the Isle of Day* in the same year Anderson began his series, and his imaginary explorations continued sporadically through such pieces as *Log of the Sunship* (1969), in tandem with a more encompassing range of allusively mythic imagery.

In the late 1940s Fred Martin had been a student under Erle Loran at U.C. Berkeley, where he painted in an audaciously big Abstract Expressionist style designed "to upstage the academic abstraction" practiced by the campus contingent of Hofmann followers.[5] In the late 1950s he had been loosely associated with the funk artists who showed at The Six. By this time he was doing small watercolors and oil paintings with mere wisps of images, in muted, Morandi-like colors, that concentrated on landscape and

234

FIG. 208. Jeremy Anderson, *Map #3,* 1963. Ink, watercolor, and gouache on paper; 25½″ × 30½″.

decaying Victorian houses in San Francisco's Western Addition.

Martin developed an exceedingly private expression, casual almost to the point of indifference in style and technique. Between 1958 and 1965 he worked principally in collage: pushing around daubs of paint on small sheets of paper until some kind of form emerged; tearing, pasting, and occasionally adding legends and inscriptions with a soft gray pencil. (See Fig. 209.) These collages were generally intended to be displayed in large numbers, as a collective unit. They had in common a prolix vocabulary of symbols and ideograms for a pantheistic sense of universal fertility and regeneration: seeds, genitalia, fountains, cornucopia, ·chalices.

After collaborating with Kathan Brown and her

Crown Point Press in 1966 to produce a volume of etchings called *Beulah Land,* Martin moved for a time into a more conventionally "literary" format, using sketchy but recognizable images—bucolic countrysides with wishing wells and little houses—that followed a more coherent narrative thread. But his work settled into no consistent grooves. Through the 1970s, it ranged between extremes of chaotic abstraction and a broadly, sometimes crudely representational style (often featuring mystically scented images such as Far Eastern temples or Tarot cards) that was almost illustrational, and seemed to combine the crude sexuality of early Funk art with an almost Victorian gentility. There was a curious mixture of nostalgia and sarcasm in Martin's expression. It seemed to reflect an acute awareness of the risks

FIG. 209. Fred Martin, *Little Voyage on the Brenta*, 1965. Collage and mixed media, 18″ × 18″.

involved in the effort to create a personal mythology in an era hostile to the idea of myth in general.

By 1970, the early Funk art of William Wiley and Robert Arneson, together with the expressionistic painting of Joan Brown and Roy De Forest, had evolved into dimensions in which the mythmaking impulses had become paramount. Around 1967 or 1968, Wiley began to expand on the isolated words he had sometimes stenciled into earlier paintings. In his complex construction *Ship's Log,* the verbal component grew into a full-fledged log book (Fig. 210). Its obliquely symbolic narrative elaborated on the mythical theme of the earlier *Columbus Re-Routed* paintings, drawing a parallel between the artist and the explorer—cast adrift on a sea of unknowns and heroically making his way, as much by chance as

by design, to a landfall far distant from his intended destination. At about the same time, Wiley began to provide his watercolors with laconic narratives that sometimes resembled the fragmentary, slice-of-Zen prose of Richard Brautigan—homespun, existential parables on the paradoxes and conundrums of ontology, friendship, and the creative act. These were inscribed beneath scenes of inexplicable chaos and abandon, rendered in a jagged counterpoint of broken pen lines and flagstone-like patches of color. (See Fig. 211.)

Wiley's imaginary world became increasingly "fitted out" in the years that followed. Travel—migration as pilgrimage—remained a persistent metaphor: his mazes or "maps," filled with cryptic diagrams and banal puns, suggested a cross between the hermetic schema of an esoteric

Personal Mythologies

FIG. 210. William T. Wiley, *Ship's Log,* 1969. Canvas, leather, wood, lead, paper, watercolor, cotton webbing, latex rubber, plastic, salt licks, wire, ink, nautical hardware, and assorted hardware; 82″ × 78″ × 54″.

initiation rite and a child's buried treasure map. Another leitmotif was "repair," suggested by the presence of sutures and braces, sawhorses and hatchets—the tools of the painter's studio in an environment that seemed always on the verge of flying apart into a hopeless shambles. They seemed to testify to the impulse of someone never seen—presumably, the artist—to stitch, nail, and bind together the pieces of a shattering world.

As the 1970s wore on, more and more of Wiley's work seemed to play with the myth of the hip-artist-out-West. Lampoon became parody in such constructions as *Modern Sculpture with Weakness* (which later parodied itself in *Modern Sculpture with Freaknest*). Such cartoonish characters as "Mr. Unnatural" and "Sir Rot"—whom Wiley himself had portrayed in occasional performance pieces— spilled over into his paintings; they were the artist

Hung up not far from the Mill

It's so big now that you're always on the edge of it. Playing at laboring under an illusion. All the earmarks of a Revolution are present in the various phases. But like the big saw speed hides some serious points. Through the din I can hear the teeth chatter on the fresh green wood. The sky swallows the sparks. The mill hands work on the mill and the vacuum works on the dust.

Wm T. Wiley
1969

FIG. 211. William T. Wiley, *Hung Up Not Far from the Mill*, 1969. Watercolor and ink on paper, 30" × 22¼".

parodying himself. But in Wiley's best work of the late 1960s and early 1970s, fable and fact became inextricably entangled, and what seemed an "illustrational" style was part of a deception with more complex ends. It suggested a profound symbolism which titles or attendant puns resolutely denied, a world of absurd relationships invested with a sense of absolute clarity—or on closer scrutiny, a world of utter opacity, in which the very idea of clarity is absurd. It was an essentially "literary" expression well conceived to frustrate all attempts to "read" it. Instead, it enticed the eye into a hive of visual-verbal transmutations and contradictions, within which thoughts seemed to swarm like bees; finally, rushing back to the surface for air, the viewer had to settle, somewhat thankfully, for a "Zen-like acceptance" of appearances as sufficient unto themselves.[6]

Personal Mythologies

238

FIG. 212. Joan
Brown, *Dancers in
the City #3,* 1973.
Oil and enamel on
canvas, 96″ × 120″.

Joan Brown, from the beginning of her career, had been inclined to more specific, personal, and idiosyncratic subject matter than other Bay Area Figurative painters, and in 1966, after her year's leave of absence from the art world, she produced a series of self-consciously child-like pictures of wild animals, accompanied by block-letter titles or texts similar to those in the paintings that Wiley was doing at the time. In 1967 and 1968 she returned to the bolder, more aggressive surfaces and colors of her earlier style, which she now applied to massive, greatly simplified, and highly charged images (a wolf, a buffalo) in complex and detailed settings. These paintings combined some of the monumental presence of Rousseau (one of Brown's inspirations) with the high-gloss impastos of van Gogh (another inspiration), which she sometimes enhanced with glitter. Shortly after-

ward, she switched from oil on canvas to enamel on masonite as her principal medium.

Brown's paintings grew more and more intimately linked to her world of personal experience—although in this world there were few clear demarcation lines between fact, fantasy, memory, and the making of art itself. (See Fig. 206, p. 230.) When Brown was married to the painter Gordon Cook in 1968, she painted a lush, pseudo-primitive portrait of the two of them stiffly posed in the formal garden between the San Francisco Museum of Modern Art and the War Memorial Opera House. While living for a brief period in the Sacramento Delta country, she painted fish and introduced lurid Oriental motifs into her work—relics of the large Chinese colony that had flourished in the area when the railroads were built. She did paintings of her young son

FIG. 213. Robert Arneson, 1982.

Noel, and of a black wolf standing menacingly in her studio. A series of paintings from the mid-1970s reflected her involvement in a San Francisco Bay swim club. After her divorce from Cook, a group of paintings and drawings followed a romantic, whirlwind trip to Europe with a new boyfriend.

Brown's fondness for big-band dance music inspired, in the early 1970s, a group of paintings called *Dancers of the Forties*—perhaps her most memorable series of works. Their protagonists were broadly defined self-images that danced with ghosts, skeletons, or male figures whose faces were mere shadows or masks. Some figures were spattered black silhouettes against fields of vivid orange; others were simple outlines scrawled on an anonymous black ground, or against the hallucinatory backdrop of a nocturnal city skyline. (See Fig. 212.) They constituted a kind of "black painting," a dreamlike recreating of the garish beauty and sinister danger associated with romance in the era of hardboiled movie heroes and softly lighted ballrooms.

Brown's paintings of the mid-1970s moved away from the Abstract Expressionist touches (thick impastos, loose spatters) that had sometimes lingered in her painting earlier in the decade. Her strong surface patterns and vividly contrasting colors owed much to Matisse, as well as to

late-1960s Diebenkorn, but they were usually combined with a disarmingly *naïf* directness of drawing and flattened perspectives. In the late 1970s, Brown turned to more exotic themes: Egypt, imagined views of China and Tibet. These caricaturish mementos of travels, or fantasies of imaginary journeys, seemed curiously thin in their substance as well as in their style, which inclined toward a kind of brushy field painting. Brown's better paintings grew out of people, places, and events she had known intimately, and had used to construct a quirky, unsettling aura in which a sense of familiarity vied with strangeness and an underlying intimation of the absurd. Brown became influential in New York all over again in the 1970s, with her representation in the Bad Painting show organized by Marcia Tucker for her New Museum of American Art, and in regular gallery exhibitions. These paralleled the emergence on the East Coast of New Image painting, which Brown's early paintings had clearly anticipated, if not affected directly.

Through most of the 1960s Robert Arneson was occupied with "fitting out" his world with ceramic models of his tract home and comically exaggerated versions of the kinds of furnishings that might be found in it. In the 1970s, like Brown, he turned increasingly from his surroundings to concentrate on a more direct form of

Personal Mythologies

FIG. 214. Robert Arneson, *Smorgi-Bob, The Cook*, 1971. White earthenware with glaze, vinyl tablecloth, and wood, 73″ × 66″ × 53″.

self-portraiture (Fig. 213). In the monumental heads he completed between 1972 and 1974, "self-portraiture" became an embracing concept. They projected different psychological states and ideas with a sometimes dramatic, sometimes hysterically comic impact. They occasionally re-called the grotesque facial distortions of the mad eighteenth-century Austrian self-portrait sculptor, Francis Xavier Messerschmidt. They also alluded, with audacious wit, to the processes of their own construction, and to monumental sculpture of the past. (See Fig. 214.) *Classical Exposure* was a bust in the Roman tradition, mounted on a tall pedestal from the mid-section of which a life-sized penis

dangled. *Corn* was a massive self-portrait head, in raw terra cotta, nested in an immense stone mortar that evoked the artifacts of pre-Hispanic America. *Kiln Man* was Arneson's head con-structed in ceramic bricks to form a large ceramic kiln, with smaller Arneson heads standing just inside its door. In *Kiln Man*, Arneson managed both to carry on and to make fun of a persistent theme in Bay Area art: the creation of art as an analogue for the creation of the artist. (See Fig. 215.)

Later in the 1970s Arneson broadened his explorations of the myth of self and the myth of the artist by doing portrait heads of historically

Personal Mythologies

FIG. 215. Robert
Arneson, *Kiln Man*,
1971. Terra cotta,
36″ high.

famous artists and of his Bay Area artist friends. These incorporated—in details, colors, or surfaces, and frequently on the pedestals supporting them—allusions to the artists' own characteristic motifs and styles. Arneson also began to display large drawings, in swift, bold scrawls and hatchings and smears of conté crayon on paper, which echoed the images of his ceramic portraits, and often nearly equaled them in power.

In 1981 Arneson turned to an area of expression that was dramatically different for him: the highly public mythology of contemporary political life. Asked by the San Francisco Art Commission to do a bust of Mayor Moscone (assassinated by a

former City Supervisor three years earlier) for the new George Moscone Convention Center, Arneson produced a shocker. The grinning ceramic portrait of the late mayor, part photographic likeness and part caricature, was perhaps bound to offend some, but the pedestal was what most clearly violated the canons of "public art": it suggested a New Wave version of Trajan's Column, covered with crudely scrawled graffiti sketching the highlights of Moscone's career and also the events surrounding his murder. (See Fig. 216.) After an intense public controversy, the Art Commission angrily rejected the sculpture. In many ways, however, it was Arneson's most

242

FIG. 216. Robert Arneson, *Portrait of George* (memorial bust of Mayor George Moscone), 1981. Ceramic, 94″ × 29″.

FIG. 217. Roy De Forest at his studio in Port Costa, California, 1980.

significant work. The portrait itself seemed to wear the mask that elected officials so often put on while electioneering, and thus became a caricature of the contemporary politician; the pedestal, with its comic-strip buzzwords and prosaic clichés, was a disconcerting reminder of the way unalterable acts of real-life horror can at any moment rip through the bland, polyester fabric that envelops so much of contemporary life, public and private.

Roy De Forest (Fig. 217) had grown up on a farm in Nebraska and lived in Yakima, Washington, before he enrolled as a student at the California School of Fine Arts in the early 1950s and later at San Francisco State College. His early paintings, in an emphatically textural style that reflected the ebb-tide years of Abstract Expressionism, were accompanied by brightly painted, vaguely fetishistic assemblages. These were probably influenced by the spiky assemblages of a teacher, Seymour Locks, but they also had roots in crude toys that De Forest had made as a youth in the country.

Travel became an important theme of the mythic worlds that De Forest began to construct. His paintings of the early 1960s were primarily abstract, map-like compositions filled with intricately patterned paths of movement, "childishly" painted silhouettes of animal and human figures,

and busy repetitions of vibrant color dots, squeezed directly from the tube, in candy-kiss relief. In this, they resembled the obsessive patterning of "art *naïf*."

Abstraction receded and imagery became more prominent in De Forest's paintings of the late 1960s. Flat, stylized fragments of landscape mingled with cartoon-like images of animals and an occasional human figure, in startling juxtapositions: a cow's belly might contain a window which would frame a brick smokestack or a ship; cartoon balloons issued from the mouths of figures, and contained other figures. (See Fig. 218.) The images that "fitted out" the world of De Forest's paintings—wild, wolf-like dogs and strange old brick buildings—were in part reflections of the surroundings of his home on the edge of Port Costa, where he lived with several dogs (and within a pebble's throw of the sculptor Clayton Bailey). The representational elements loomed larger in De Forest's paintings of the late 1970s, and became more clearly articulated. The bird's-eye perspectives and flat, map-like space of the earlier paintings yielded to a more window-like conception, with a greater illusion of depth. They began to suggest views through the display windows of toy stores, or into the clutter of a children's nursery; that is, they began to look "cute."

Personal Mythologies

FIG. 218. Roy De Forest, *Terrier's World,* 1974. Polymer on canvas, 60″ × 66″.

Many Third World artists, and some women artists, seriously explored the collective myths, or stereotypes, that had traditionally defined their positions in American society; and the intensity of their effort led them to elaborate mythologies that were not only profound but also consistent with the richness and complexity of their heritages. Like the more idiosyncratic, "nut-artist" mythmakers, they contributed to the reaction against the homogeneity of mainstream art, and demonstrated the value of alternative sources of inspiration.

The myths and stereotypes surrounding women in contemporary and historical societies became the central subject of Judy Chicago, who moved from Southern California to Benicia following the exhibition in 1979 of her work *The Dinner Party* at the San Francisco Museum of Modern Art, where it broke all attendance records (Fig. 219). Chicago's projects not only celebrated femininity, but involved collaboration among scores of women, cooperatively organized, who worked together as designers, researchers, artisans, and so on. *The Dinner Party* was an immense "table" arranged with place settings for nearly one hundred famous women, from Cleopatra to Georgia O'Keeffe. Each setting included an elaborate ceramic plate

FIG. 219. Judy Chicago, *The Dinner Party,* 1979. Mixed media, 47' per side.

FIG. 220. Judy Chicago, Georgia O'Keeffe placesetting from *The Dinner Party,* 1979. Ceramic plate on Belgian linen runner, embroidered with Vers au Soie thread.

designed as an abstract "portrait," symbolic of the woman's individual achievements, and a needle-work runner conceived as a representation of the historical and cultural context in which she lived and worked (see Fig. 220). After moving to the Bay Area, Chicago set to work on an equally ambitious *Birth Project,* involving scores of participants in researching, designing, and fabricating textiles that would represent the creation myths of various cultures and the roles performed in them by women.

Personal Mythologies

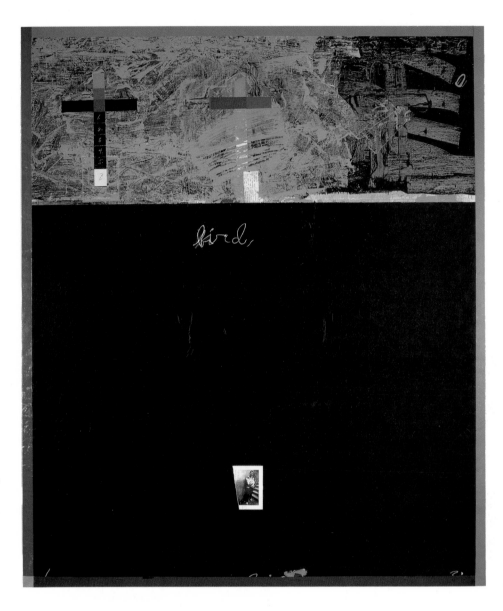

FIG. 221. Raymond Saunders, *Charlie Parker* (formerly *Bird*), 1977. Acrylic, masking tape, newsprint, paper, and ink on canvas, 96⅛" × 82⅜".

Raymond Saunders, who came to the Bay Area from New York, developed a distinctive style in which imagery associated with the Black American ghetto—storefront church windows, Aunt Jemimas—was incorporated into rich, mixed-media pastiches that resembled the early work of Rauschenberg and Johns. (See Fig. 221.) Carlos Villa, an Abstract Expressionist painter as a student at the San Francisco Art Institute in the early 1960s, adorned sheets of unstretched canvas with swirling, vividly painted coil shapes and shags of vibrantly colored feathers, and fashioned them into large capes suggesting the costumes worn by ancient Hawaiian royalty.

Marie Johnson translated vignettes from Black American ghetto life into life-sized, painted wood cut-out figures, adorned with real fabric and hair and sometimes placed in ambitiously scaled tableaux. Robert Colescott made a specialty of anecdotal paintings, sometimes variations on Old Masters, peopled by minstrel-style Step 'n Fetchit figures that satirically enacted farcical parodies of traditional stereotypes about blacks. Larry Fuente covered functional pieces—a toilet, a full-sized racing car—with elaborate mosaics of richly colorful found objects in the spirit of Mexican folk art. Frank La Pena made handsomely crafted objects of wood, bone, pitch, and other organic

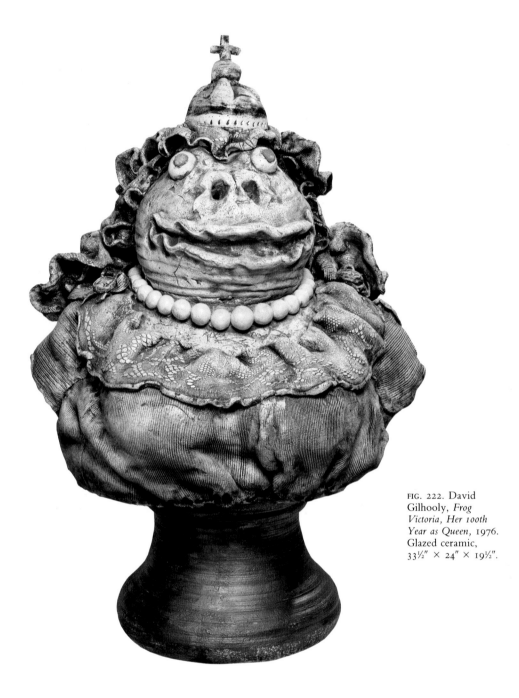

FIG. 222. David Gilhooly, *Frog Victoria, Her 100th Year as Queen*, 1976. Glazed ceramic, 33½″ × 24″ × 19½″.

materials that resembled traditional American Indian artifacts.

Perhaps the most completely "fitted out" mythical universe in Bay Area art was created by David Gilhooly. An anthropology major at the U.C. Davis campus before he happened to enroll in Arneson's first ceramics class there in the early 1960s, Gilhooly embarked on a personal version of Genesis on a relatively modest scale, creating ceramic and papier-mâché replicas of giant ant-eaters, warthogs, and similarly graceless creatures that lent themselves to the globby handling of the funk ceramic style. Frogs gradually assumed a dominant role in Gilhooly's bestiary, becoming increasingly humanoid in behavior and appearance. (See Fig. 222.) By the early 1970s, they began to appear in ancient Egyptian costumes and mummy wraps, and in the guise of Egyptian deities, particularly the fertility god, Osiris. As their tribe increased, the brightly glazed ceramic frogs became deities and earth spirits, whores and horticulturalists, movie stars and street vendors; they had their own Parthenon, their own Mount Rushmore, even a lavish Pornogarden. Their society even advanced into the early stages of written history when Gilhooly published an *Erotic Coloring Book* to accompany a show in 1973, but each of his ceramic tableaux had an elaborate oral

Personal Mythologies

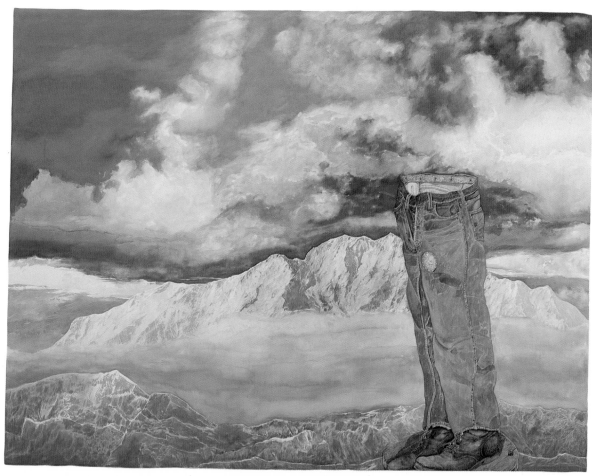

FIG. 223. William Allan, *Shadow Repair for the Western Man*, 1970. Oil on canvas, 90" × 114".

tradition behind it. A frog religion was drawn from elements of ancient Egyptian myth and Christianity, but the main business of the frog civilization remained fertility. Osiris evolved into a Compost God who grew brilliantly glazed ceramic vegetables, which were eventually marketed on a stand operated by a creature called Frog Fred—a thinly disguised alter ego of Gilhooly himself.

By the middle 1970s, mythmakers in the arts were about as plentiful in the Bay Area as Gilhooly's frogs. By its very nature, the mythmaking impulse generated prolixity rather than rigor; eccentricity, idiosyncracy, and diversity multiplied. The paintings of Franklin Williams and Olive Ayhens, like those of De Forest, drew images and design elements from sources in primitive art—and these were given an extra cachet in Williams's work by the addition of spidery tufts of thread. William Snyder brought together anonymous figures in Disneyland cos-

tume with images of his friends and family in big paintings that were often parodies of old masterpieces—Rembrandt's *The Nightwatch* and Courbet's *The Artist in His Studio*. In Barbara Rogers's slickly airbrushed paintings, photographic images of celebrities were incongruously juxtaposed with nude figures and exotic birds in lush tropical foliage. Judy Linhares's drawings and mixed media assemblages cloaked private themes in forms inspired by Mexican folk art.

The concentration of activity spilled over from U.C. Davis (where Wiley, Arneson, and De Forest taught) to Sacramento State College. It gained impetus there when Jim Nutt and Gladys Nilsson, two of the charter members of Chicago's Hairy Who monster artists, sensing a compatible atmosphere, moved to Sacramento in 1968 to spend the next several years teaching at the school. Nutt's specialty was a comically grotesque caricature that exerted a strong influence on such

students as John Buck, who translated Nutt's style to painted cut-out forms in wood. Nilsson's paintings and watercolors were filled with highly patterned, overlapping silhouettes of figures, animals, and less identifiable creatures, and had a remote affinity to De Forest's painting.

For a time, at least, the myth of the frontier in Wiley's "Dude Ranch Dada" had an impact on Wiley's students and artist-peers that was almost comparable to the influence once exerted on Bay Area art by Still, Lobdell, Diebenkorn, or David Park. Robert Hudson, whose sculpture of the early 1960s had been influential in Wiley's own development, in the mid-1970s took to piecing together elaborate constructions of spurs, stuffed animals, and Indian beads. In the big pastiche paintings and small collages on which Hudson concentrated later in the decade, similarly idiosyncratic images were scrambled with geometric motifs that harked back to early Cubism. William Allan, who had made a specialty of funky Cornellian boxes in the late 1960s, moved to painting vast, illusionistic landscapes in which empty pairs of Levi jeans stood on craggy overlooks and fish flew through the sky. (See Fig. 223.) They carried such Wileyesque (or Andersonian) titles as *Traveling in Strange Circles* and *Tentative Assault on Mount Fear*. Jeremy Anderson himself acknowledged the style with an elaborate, hat-tree construction festooned with in-joke fetishes. Jerrold Ballaine essayed the look in watercolor.

Elements of Wiley's style began to appear in the work of younger artists in the Southwest, and even in scattered outposts in Oregon and Washington and along the Atlantic seaboard. In its defiant anti-mainstream posture, Wiley's Dude Ranch Dada in the mid-1970s seemed to present a rallying ground for a new regionalism, not altogether unlike the focus that Thomas Hart Benton had provided for regionalist painting in the 1930s.

The impact of Arneson's ceramics was perhaps even more pervasive. Viola Frey, whose work emerged in the first flush of attention that Arneson had stirred in the late 1960s, developed her own distinctive approach to self-portraiture in life-sized ceramic figures, or in figures of apes, camels, and other creatures which tended to assume human characteristics and gestures. The human figures, particularly, had some of the odd charm and faintly disturbing presence of folk sculpture. (See Fig. 224.) In her early ceramic sculptures, Frey played down color and assigned a relatively larger role to drawing by using hatchings and textured surfaces. Later in the 1970s she began to apply

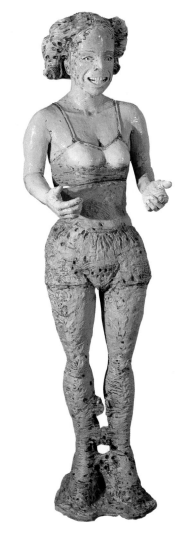

FIG. 224. Viola Frey, *Bricoleuse*, 1976. Whiteware and glaze, 68″ high.

color in large, measle-like daubs that almost overwhelmed her forms, which seemed to be standing in a blizzard of colored confetti.

Arneson's influence was frequently filtered through that of Richard Shaw, who became the most influential of the "second-generation" ceramists. Initially inspired by the work of early Surrealist painters, Shaw's first ceramics were small canvas-textured couches and easy chairs, sometimes placed in miniature interiors. The ceramic objects served as "grounds" for illusionistic paintings of animals and landscape done in a manner reminiscent of Magritte.

Influenced by Ron Nagle as well as by Arneson, Shaw later moved to "functional" objects that made visual puns on the traditional conventions of

FIG. 225. Richard
Shaw, *Walking
Figure Jar #1*, 1978.
Porcelain with decal
overglaze, 18½″ ×
10¾″ × 9″.

function and ceramic decoration. By the mid-1970s, he had refined a trompe l'oeil technique that was almost photographic in its literalism. He used it to replicate playing cards, pencils, sticks, old books, and other common objects, which were pieced together in arbitrary stacks and spindly "stick-man" structures. (See Fig. 225.) These works, like the ceramic sculpture of Marilyn Levine—who specialized in uncannily literal replicas of shoes, suitcases, and other common objects of old leather deeply imprinted with the scars of age and use—were principally virtuoso demonstrations of technique. But they became increasingly influential in the development of the "super object" school—as distinct from the Arneson-inspired "object" school—of late 1970s ceramics.

With the multiplication of individual myth-makers in the later years of the 1970s, a curious entropy settled in. The greater the apparent differences between them, and the more radical and personal their eccentricities, the more predictable and similar their work often seemed to be. The exuberant, adolescent iconoclasm that had fired the mythmaking impulse in its formative years—and which was a principal source of its appeal—had stemmed in large measure from its wild-and-wooly but essentially reactionary stance against mainstream art. This sense of opposition waned as Dude Ranch Dada ("the U.C. Davis Look"), and an anti-Formalist "personalism" in general, came to be seen as *the* established regional style, and as the mainstream itself began to dissipate into innumerable freshets, trickles, puddles, and quagmires. In addition, there was a touch of what Dwight MacDonald called "the birchbark canoe" syndrome (the enthusiasm of avant-garde French filmmakers for Jerry Lewis, bad Hollywood movies, and American gaucherie in general) behind the attraction that East Coast audiences felt for the cultivated eccentricities of the Dude Ranch Dada artists. As their work was increasingly well received in regular shows at New York galleries, it became more difficult for "coonskinners" like Wiley, Hudson, and Arneson to maintain the defiant image of outlaw sharpshooters. The city folk had begun to treat them more like Buffalo Bill and his traveling circus.

Also, much like real folk art, Dude Ranch Dada showed itself incapable of genuine growth. As a pastiche esthetic, it multiplied in terms of iconographic variations and accretion—more in-jokes, more puns, more bric-à-brac—but it failed to develop a formal foundation of its own to build upon and organically extend. Parodies squared and cubed themselves; it became more and more

difficult to figure out whether Hudson was parodying Wiley or himself, or even whether there was any significant difference between them. Its forms remained bound to a backyard hobbyist's esthetic. Deprived of the counterrevolutionary energy that had fired its earliest phases, Dude Ranch Dada was compelled to stand on its own, and very little of the work proved capable of it. It had become just one more ploy, another "alternative" way of "making it" in the ubiquitous art world game.

After his de Young Museum show in 1975, Clayton Bailey relocated his Wonders of the World Museum to the second floor of a large renovated warehouse in Port Costa dedicated to arcades of small shops selling crafts and antiques to tourists. In this setting, his gargoyles and monsters seemed to blend with disconcerting ease into the esthetic of the harmlessly fraudulent roadside attraction—which they had once seemed to parody with such barbed perversity. They passed, almost unnoticed, from "art" into "life." A survey called Diversity in Clay at the San Francisco Museum of Modern Art in the summer of 1979 introduced still a "third generation" of ceramists for whom eccentricity had become simply a style. A small group of assemblagists who used little boxes in the manner of Joseph Cornell to contain hand-fashioned and found bric-à-brac of various sorts perhaps exposed the weaknesses of this esthetic most concisely. Their furnishings were personal, and were often arranged in personal ways, but the "house" belonged to Cornell.

For American art the 1970s, not unlike the 1930s, seemed to be a period of marking time. If the Third World activists, feminists, and other politically militant artists who were vocal in the middle years of the decade were analogous to an earlier generation of Social Realists, the more private (even isolationist) mythmakers and fetishists who proliferated in the late 1970s formed a parallel to the American Scene regionalists. Like much conceptual art, the art of the mythmakers often expressed the narcissistic self-preoccupation of the Me Generation. The sense of mission that had fired the great individualists of the 1940s and 1950s—Still, Rothko, Pollock—had lingered for a while in the more formal and public expression of the 1960s. But in these idiosyncratic creations of the late 1970s, it seemed to have died out; the work seemed as hermetic and stunted as a bonsai garden enclosed by monastery walls.

Perhaps the most significant legacy of the mythmaking of the 1970s was the degree to which it furthered decentralization—stylistic, political, and geographical—in contemporary art as a whole. By 1980, there seemed to be no more vanguard "schools" like those that had challenged the status quo in the 1950s and 1960s. The militant era of modern art—the time of epic battles between abstract and figurative art, rationalism and primitivism, even artist and philistine—seemed to have passed, leaving the battlefield in a state of anarchic disarray. What opponents to ideologies and movements had always sought to achieve had finally happened. A new "pluralism" reigned, and no one knew quite what to do about it.

Epilogue

Harold Rosenberg once observed that given the quantity, quality, and availability of the art left to us by past times and distant cultures, we have no urgent need for new art. Unfortunately, most of the more conspicuous happenings in the art world in the early 1980s seemed to support that dreary proposition. The Search for Alexander and The Vatican Collections: The Papacy and Art were joining the succession of international super-shows of treasures and antiquities which, in the latter years of the 1970s, had included such spectacular crowd-pleasers as Archeological Finds from the People's Republic of China, Treasures of King Tutankhamen, and The Splendor of Dresden—the latter a triumph of packaging that filled the entire California Palace of the Legion of Honor for most of a year.

Revivalism was a major current in much contemporary expression as well. The mussed-up, painterly look—and sometimes even a bit of the ethos—of the Abstract Expressionist painting of the 1940s and 1950s was becoming prominent again, part of a general fifties revival that gained support from an eruption of retrospectives in the late 1970s of the principal artists of the period: Rothko, Still, Pollock, de Kooning, Kline. The renewed interest in Abstract Expressionism seemed to reflect a touching urge to scrape away the veneer of slickness that had spread over so much painting since the Formalist art of the early 1960s, with its emphasis on surface values. But

much of the new painting—like Frank Stella's garish, liquified French curves in mixed media relief—simply replaced one set of surface mannerisms with another, those of the New Abstraction.

The early 1960s became a main source of many of the elements that contributed to the New Wave which surfaced in New York in the last years of the 1970s, and began to appear fitfully in the Bay Area, chiefly among students at the San Francisco Art Institute, as the 1980s began. Influenced strongly by punk rock (with its component of political and social commentary) and by performance art in general, its visual expression drew heavily from Andy Warhol's peculiarly lobotomized Pop art; it emphasized images (generally photographic) that were at once charged and neutralized, both gaudily decorative and exuding an undercurrent of perversity and violence. More positively, the New Wave seemed to reflect a basically healthy urge to expand the visual arts beyond the specialization in which they had become mired in the 1960s, to re-establish connections with "primary experience" as well as with other media of expression. It even included an effort to revive the kind of underground spirit that had nurtured the Beat art of the 1950s—which was touching, or poignant, because by the late 1970s the proliferation of mass media and the ubiquitousness of the "art support system" had made it clear that a genuine underground could no longer exist. Thus almost from its very beginnings, the

New Wave became simply another style, distinguished by an emphasis not on violence itself but on its surface trappings. (Indeed, it sometimes seemed to parody its own inability to cut more deeply.) It quickly became "co-opted"—absorbed into the decadent-chic world of galleries (and alternatives), museums, and collectors.

Color-field painting—perhaps because it had not made a strong showing in the Bay Area when it was new—proved to be another "issue" from the early 1960s that certain artists found worthy of reopening. A number of younger painters—George Lawson and Phil Sims among the stronger of them—produced accomplished if hardly original variations on the motif of the flat canvas flooded with a single color, though their canvases were built up in many layers, or simply and symmetrically divided into rectangles or squares. Their emphasis on surfaces frequently produced painting that amounted more to textural abstraction than to color abstraction. At best, they produced works that could function, depending upon one's point of view, either as handsome decoration for an office-building lobby or as subtly engrossing meditation objects—although one sometimes wondered if such objects might exact more from the viewer than the artist had put into them.

New Image, Narrative Art, Pattern Painting, and even Decoration were among other banners and rallying cries that ambitious museum curators and groups of artists raised aloft in the last years of the 1970s. Perhaps the most interesting thing about artistic pluralism was that the apparent growth in diversity did not seem to encourage a corresponding increase in the number of strongly individual artists. There was, rather, a multiplication of broad general trends and of marginal variations, or idiosyncracies, within them. In practically every medium as the 1980s began, pastiche and eclecticism—the latter no longer considered a pejorative term—were dominant. Among the few younger artists to achieve a measure of national recognition in the 1970s, many made a specialty of a kind of mopping-up operation, rummaging through the debris of shattered movements and styles from the past and assembling the bits and pieces they could use into patchwork creations. The architecturally scaled work of the New York sculptor Alice Aycock, for example—like the post-modernist movement in architecture itself—was built of a deft union of Neoclassicism and Dada. Most of the new painting and sculpture seemed to represent essentially a form of art-school art: the work of artists who have spent too much time looking at surfaces (slides and other reproductions) and immersing themselves in lore *about* art, and too little time in direct communication with art itself, or with the unprocessed experience of the street or the countryside. And most of it seemed intended to allow artists and viewers who shared similar experiences in art history classes and art appreciation slide lectures—a common orthodoxy—to demonstrate their knowledge and connoisseurship. In short, however superficially outrageous, it was an exercise in taste.

Meanwhile, the main fact of life in the world of contemporary art at the turn of the 1980s continued to be proliferation—in the numbers of working artists, schools, galleries, museums, and "alternatives," and in the quantity and variety of financial support. Corporate sponsorship took up much of the slack brought about by such setbacks as a decrease in state spending for the arts following a taxpayers' revolt that culminated in 1978 with the passage of Proposition 13, which sharply reduced state revenue from property taxes. Museums specializing in the exhibition and collection of contemporary art were displaying more and more artists in more and more shows, which were mostly surveys of various trends. But it often seemed that they were showing proportionately less and less work of profound or lasting impact. Artists were finding it easier to exhibit than ever before. But they were finding it harder to keep from getting lost in the shuffle, or to find a context that would not work subtly to transform their art into just another fashion, another commodity, another art-world polemic. "Emerging" artists were everywhere, but few seemed to emerge completely. The question of context—of a genuine alternative to the coalition of galleries, museums, and "alternative spaces" that had become the real Establishment in contemporary art—loomed larger than perhaps all others as the 1980s began. Meanwhile, the vast growth of the contemporary art world seemed to be accompanied by a growing indifference on the part of the art audience. People seemed willing to accept almost any form of expression, but they took less and less contemporary art seriously. It had become a desirable frill—an "amenity," as the developers put it, like swimming pools and tennis courts.

It was sometimes argued, of course, that society has never really *needed* art, and that an utter lack of utilitarian value is what makes art what it is. Such arguments seemed a feeble rationale for excusing the academic and professional sanitization that had come to dominate the contemporary scene. Great works of art throughout history have always

stemmed precisely from need—from cultural need or inner necessity on the part of the artist. And they have always functioned to fulfill real needs that cannot be met by strictly utilitarian means, needs that persist after material requirements have been satisfied.

Here and there—all too often in studios, perhaps the last refuge of an underground—one came across work of genuine originality and vision that clearly needed to be made. Given the proliferation in the 1980s of proficient journeymen and women—painters, sculptors, photographers, printmakers, performers, conceptualists—such exceptions seemed few and far between; yet without an ocean, there could be no waves.

In the late 1960s, Alan Watts celebrated the utopian ideal of eliminating the boundaries between art and everyday life. "The paintings are vanishing into the walls; but they will be marvelous walls. In turn, the walls will vanish into the landscape; but the view will be ecstatic. And after that the viewer will vanish into the view." To a degree, this process is always happening in art. It teaches us to see new things in new ways, and it thereby renders redundant the further production of art of the same kind. Yet, at least so far, new artists have always come along with new visions and new art. In art, as distinct from history, it is always the unique and concrete, rather than the collective and general, that ultimately count. We don't think much about the 1650s; we talk about the Age of Velázquez or the Age of Rembrandt. With contemporary pluralism, perhaps the evolutionary, linear conception of progress, in which one idea always supersedes another and renders it obsolete, has largely yielded to a new vision. In this vision, progress is an ever-enlarging circle, which encompasses a continually expanding area of choice and possibility. From within this area, each individual is free to draw materials for his or her own use, and to work out the only form of evolution that has any real importance in art: the organic development of the artist's own powers of expression.

Asterisk indicates an artist whose work is discussed or illustrated in the text. For an explanation of the purposes of the Appendix, and the principles of selection applied in it, see the Introduction, pp. xv-xvii.

The following abbreviations are used:

CCAC California College of Arts and Crafts
CSFA California School of Fine Arts
SFAI San Francisco Art Institute

Abend, George (1922–1976)

Painter. Born in New York City; attended CSFA (1946–1952), U.C. Berkeley, the Académie de la Grande Chaumière in Paris, and the University of Guadalajara in Mexico. An Abstract Expressionist painter whose early work resembled Clyfford Still's, in the 1950s and 1960s he developed a more gestural, theatrical form of action painting, generally with an underpinning of natural forms. With Jordan Belson and Chris McLain, he was among the first visual artists to work with the environmental light and sound program, Vortex. In the early 1970s he painted large abstract canvases designed to be installed as room-sized environments. He was active on the East Coast between 1962 and 1966, in Los Angeles between 1966 and 1969, and in Big Sur and Santa Cruz from 1969 until his death.

Acton, Arlo (1933–)★

Sculptor. Born in Knoxville, Iowa; attended Washington State University (B.A. 1958) and CSFA (M.F.A. 1959). In the late 1960s Acton turned from wood to metal, primarily titanium, as his principal medium. His work alternated between small spheres with eccentrically funky tubular extensions and more classically geometric pieces, in which large spheres were combined with triangular sections. Both were designed to be moved by the spectator. In the early 1970s he abandoned an increasingly successful career to settle with a rural community of hippies in Northern California.

Adair, Ann (1936–)

Ceramist. Born in Coscosolo, Panama; attended U.C. Berkeley and SFAI. One of the first Bay Area ceramists to develop allegories that used the forms of animals for satiric purposes, in the late 1970s she made miniature vignettes of modeled and glazed porcelain in which alligators appeared in human situations.

Adair, Lee (1934–)

Painter. Born in Norfolk, Va.; attended U.C. Berkeley (B.A. 1956, M.F.A. 1957). Active in the Bay Area through the mid-1970s and associated with the Berkeley Gallery, she painted obese, billowing, cloud-like nude figures in flat white on deep blue grounds.

Adams, Mark (1925–)

Painter. Born in Fort Plain, N.Y.; attended Syracuse University; studied with Hans Hofmann in New York City and Jean Lurçat in France. Known since the 1950s principally as a designer of tapestries and stained glass windows, he turned in the 1970s to watercolors that concentrate on simple images of commonplace objects.

Akawie, Tom (1935–)

Painter. Born in New York City; attended Los Angeles City College (1953–1956) and U.C. Berkeley (B.A. 1959, M.A. 1963). From origins in Abstract

Expressionism, he developed a form of abstraction in which rigidly symmetrical forms, initially inspired by floor plans of historic European cathedrals, were set in etherealized fields that implied vast spaces; meticulously airbrushed, they suggested both precision machine parts and primitively stylized figures, and were frequently exhibited with the work of the Visionaries. Akawie later turned to landscape—Magic Realist deserts and skies, "moonscapes" airbrushed to suggest trompe l'oeil reliefs of ridges and craters—and to figurative works inspired by the symbolism and imagery of the Tarot, astrology, and ancient Egyptian art. In the late 1970s he emphasized more conventional Photo Realist subjects.

Albertson, James (1944–)

Painter. Born in Sturgeon Bay, Wis.; attended the Chicago Art Institute (B.F.A. 1966) and CCAC (M.F.A. 1968). Influenced by the work of Chicago's "Hairy Who," his paintings combined expressionistic paint handling with an irrelevent figurative style derived from cartoons, pulp magazines, and other kitsch sources. They frequently parodied art-historical themes and had strongly sexual overtones.

Albro, Maxine (1895–1966)★

Painter. Born in Iowa; studied at CSFA, in Paris during the 1920s, and later in Mexico with Diego Rivera. She painted a mural at Coit Tower depicting the processes of California agriculture.

Alexander, Robert (1922–)★

Painter and collagist. Born in Chicago; no formal art training. Active in San Francisco, 1957–1960.

Allan, William (1936–)★

Painter and assemblagist. Born in Everett, Wash.; attended CSFA (B.F.A. 1958). Through most of the 1970s he concentrated on small watercolors showing fish in mountain streams in a fluid, semi-abstract style.

Allen, Boyd (1931–)

Painter. Born in Michigan; attended U.C. Berkeley (B.A. 1954, M.A. 1955). Originally an Abstract Expressionist painter, in the 1960s he developed a style distinguished by broadly painted images of mysterious architectures and landscapes. In the early 1970s he turned to visionary views of the Andes, highly simplified and with richly worked surfaces.

Allen, Gary (1936–)

Painter. Born in Altadena, Calif.; attended the University of Oregon, CCAC, SFAI, the Chouinard Art Institute in Los Angeles, and San Francisco State College (B.A., M.A. 1968). In the late 1960s and early 1970s he fashioned works that combined sheets of transparent plexiglass, painted with acrylic or Murano lacquers, with reflecting grounds of aluminum, nickel, or chrome plating; often circular in form, they embraced elements of Visionary art and had something of the pristine, futuristic look then popular in Southern California. In the mid-1970s he turned to lyrical abstract paintings that combined grid structures with free, loosely brushed areas of color.

Allen, Jesse (1936–)

Painter. Born in Masabit, Kenya; attended Oxford University (1958); self-taught as an artist. His commercially popular paintings, inspired by Rousseau and Persian miniatures, were formularized fantasies of jungle life in highly patterned forms and bright, decorative colors.

Almond, John (1939–)

Painter. Born in England; attended San Jose State College (B.A. 1962) and San Francisco State College (M.A. 1968). Trained in the British watercolor tradition by his father, and then in the Abstract Expressionist mode, Almond developed a style of visionary realism inspired by the life of tide pools while living for three years in an isolated beach cottage in Pacifica. After 1968, reflecting the influence of the music, light shows, and drug experiences of the rock subculture, some of his paintings set vastly enlarged images of natural forms— such as rocks and strawberries—in fields divided into intricate, cell-like structures, and others contained nightmarish visions of the nocturnal urban landscape.

Anderson, Alex (1922–)

Painter. Born in Manila, the Philippines; attended U.C. Berkeley. His paintings ranged from a Pre-Raphaelite style of mannered realism to an extravagant, campy expressionism. In the 1940s he painted the murals in the Black Cat saloon in North Beach. He was also active in stage design.

Anderson, David (1946–)

Sculptor. Born in Los Angeles; attended Scripps College in Claremont, Calif. (1963), and SFAI (1968– 1970). His elegant constructions, Oriental in feeling, alternated between linear structures of irregular steel cylinders that resembled slender tree branches, and massive walls assembled from huge steel slabs, broken by one or two discreetly placed apertures. Although Anderson left for New Mexico in the late 1970s, he continued to exhibit regularly in the Bay Area.

Anderson, Jeremy (1921–1982)★

Sculptor and painter. Born in Palo Alto, Calif.; attended CSFA (1946–1950). In the 1970s he concentrated on a series of small figurative sculptures in bronze

depicting the comical adventures of a "Mrs. Allfours," and on large wood figures suggesting the cigar-store Indian vernacular tradition.

Andresen, Steven (1949–)

Painter. Attended CCAC (M.F.A.). His paintings of the mid-1970s were in a cartoon-like, Funk-Pop style. He later turned to plein-air landscape paintings of the North Oakland hills.

Armer, Ruth (1896–1977)

Painter. Born in San Francisco; attended CSFA, the Art Students League of New York, and the New York School of Fine and Applied Arts. Before World War II she had developed a broad, expressionistic, nearly nonrepresentational style distinguished by rock-like images that seemed to draw their inspiration from Surrealism. Her paintings became more abstract and gestural for a brief time in the 1950s. Her work of the 1960s and early 1970s was in a hard-edge style, with small pictographic shapes suspended against amorphous pools of light.

Arnautoff, Victor (1896–1979)★

Painter. Born in Russia; attended CSFA (1925–1929). Studied with Diego Rivera and worked with him on murals in Mexico City, 1929–1931. He was one of San Francisco's most influential mural painters in the 1930s, working in a heroicizing, Rivera-inspired style with a strong expression of social protest. He taught at Stanford from 1948 to 1963. In 1963, following the death of his wife, he returned to Russia and was repatriated as a citizen of the Soviet Union, where he continued his career as a painter. His murals may be seen at Coit Tower, George Washington High School, and the Presidio in San Francisco, and in post offices in Richmond, South San Francisco, and Pacific Grove.

Arneson, Robert (1930–)★

Sculptor and painter. Born in Benicia, Calif.; attended CCAC (B.A. 1954) and Mills College (M.F.A. 1958).

Asawa, Ruth (1926–)★

Sculptor. Born in Norwalk, Calif.; attended Black Mountain College, N.C. (1946–1949). Her frieze-encircled fountain at the Hyatt Union Square hotel is a San Francisco landmark.

Ayhens, Olive (1943–)

Painter. Born in Oakland; attended SFAI (B.F.A. 1968, M.F.A. 1969). Her paintings, primarily watercolors, combined primitive design elements with schematic images of figures, animals, birds, and landscape, and were allied with the work of the "mythmakers."

Aylon, Heléne (1935–)★

Painter and conceptual artist. Attended Brooklyn College, N.Y. (B.A. 1960), the Art Students League of New York (M.F.A. 1961), the Brooklyn Museum Art School (1962), and Antioch College, San Francisco (M.A. 1980). In addition to the works she made with oil stains on paper, she presented occasional performance pieces and temporary installations, usually on environmentalist themes.

Baden, Mowry (1936–)

Sculptor. Born in Los Angeles; attended Pomona College (B.A. 1958) and Stanford University (M.F.A. 1965). After beginning as a painter influenced by the expressionism of Rico Lebrun, he turned to mixed media sculpture, creating forms that suggested internal organs or headless, dismembered torsos. In the late 1960s he began to use fibered polyester, and the distended organic forms of his sculpture sometimes expanded to environmental dimensions. He taught at the University of the Pacific in Stockton before leaving the Bay Area in the early 1970s.

Badger, Jennifer (1941–)

Painter. Attended Pomona College and Columbia University (M.F.A.). Associated with the Visionary painters of the late 1960s and 1970s, she concentrated on intricate, maze-like abstractions in which mandalas were interwoven with fluid ribbons of transparent color.

Baer, Martin (1894–1961)

Painter. Born in Chicago; attended the School of the Art Institute of Chicago; studied in Munich, and lived and worked in Paris, where he knew Picasso, Matisse, and Isadora Duncan. He was active in Carmel between 1941 and 1947, and then moved to San Francisco, where his studios—from 1946 to 1953 in the "ghost house" at 1350 Franklin Street, and after 1956 in the historic Goodman Building—became gathering places for artists and poets associated with the bohemian community in North Beach. His paintings of the 1930s and early 1940s were strange Arcadian fantasies inhabited by Giorgionesque nudes and flying putti. In the mid-1950s he developed a more abstract style, concentrating on fragmented, angularly stylized forms of landscape and faces, both enmeshed in richly textured paint surfaces. In his last paintings, Baer moved toward total abstraction, using a folded sheet of cloth and translating its shapes into vigorous, gestural forms in which direct-from-the-tube colors were combined with more carefully blended color mixtures.

Bailey, Clayton (1939–)★

Sculptor. Born in Antigo, Wis.; attended the University of Wisconsin (B.A. 1961, M.A. 1962) and U.C.

Davis (1960). A teacher at California State University, Hayward, since settling in the Bay Area in the late 1960s.

Ballaine, Jerrold (1934–)★

Painter and sculptor. Born in Seattle; attended the University of Washington, the Art Center School in Los Angeles, and SFAI (B.F.A. 1960, M.F.A. 1961). A teacher at U.C. Berkeley since 1966, Ballaine concentrated on photography through much of the late 1970s.

Barletta, Joel (1924–)

Painter. Born in New Jersey; attended the Newark School of Fine and Industrial Arts, the Art Students League of New York, and CSFA. His paintings of the mid-1950s were big, craggy abstractions in which dramatic sweeps of pigment contrasted with the movement of energetic black-and-white lines. Around 1957 his paintings assumed somewhat more recognizable landscape forms, built in flowing, horizontal layers that suggested mountains, canyons, and buttes. In the early 1960s these strata became more fluid and atmospheric, and by the late 1960s his canvases had become monochromatic fields, divided diagonally into two or three broad geometric planes that differed only in subtle (sometimes almost subliminal) nuances of value and intensity. Barletta was one of the earliest exhibitors at the Dilexi Gallery in the late 1950s.

Barnes, Carroll (1906–)

Sculptor. Born in Des Moines, Iowa; attended the Corcoran School of Art in Washington, D.C., and the Cranbrook Academy of Arts in Bloomfield Hills, Mich. Living and working in Sonoma County, he has made most of his sculpture of wood, cut and laminated in rhythmically undulating forms and assembled into abstract structures that resemble walls or vertical monuments. His constructions, which occasionally include contrasting accents of colored or transparent plastic, are sometimes designed so that elements can be moved and rearranged.

Barnes, Matthew (1880–1951)★

Painter. Born in Kilmarnock, Scotland. Trained as an ornamental plasterer, Barnes came to San Francisco in 1906. He became known in the 1930s as a painter of romantic, moonlit scenes in which solitary figures appeared against backdrops of ghostly, deserted buildings.

Barnhart, Raymond (1903–)

Assemblagist. Born in West Virginia; attended Marshall University, W.Va. (B.A. 1932), Ohio State University (M.F.A. 1936), the Chicago Art Institute (where he studied with Moholy-Nagy in 1939), and Black Mountain College, N.C. (where he studied with Joseph Albers in 1944). Moved to the Bay Area in 1955,

and settled in Sonoma County in the late 1960s. His assemblages, made primarily from weathered debris picked up in ghost towns in the Mojave Desert, display a firm geometric structure grounded in the constructivist esthetic.

Battenberg, John (1931–)★

Sculptor. Born in Wisconsin; attended the University of Wisconsin (1949), the State College in Saint Cloud, Minn. (B.S. 1954), the Ruskin School of Fine Art and Drawing at the Ashmolean Museum at Oxford (1955), Michigan State University (1960), and CCAC (1963–1964). A professor at San Jose State University since 1966, he has been influential as an instructor of bronze casting techniques.

Baxter, John (1912–1966)★

Sculptor. Born in San Francisco; attended UCLA (B.A. 1933); no formal training in art. Curator of education, San Francisco Museum of Art (1956–1959).

Beasley, Bruce (1939–)★

Sculptor. Born in Los Angeles; attended Dartmouth College (1957–1959) and U.C. Berkeley (B.A. 1962). While still a student he won purchase awards from the Museum of Modern Art in New York and the Musée d'Art Moderne in Paris for his organic abstractions made in metal; he has returned to aluminum and steel, together with wood, for his more geometrically inclined abstractions of recent years.

Beattie, Paul (1924–)

Painter. Born in Michigan; attended the Society of Arts and Crafts in Detroit (1945–1947), Sonoma State University (B.A. 1973), and U.C. Berkeley (M.A. 1976). He worked in a Pollock-inspired Abstract Expressionist style and later in a broadly figurative vein while in New York. After moving to San Francisco in 1955, he showed at The Six Gallery but soon turned to photography, film, and mixed media, and also became active as a jazz saxophonist. In 1963 he built a house near Healdsburg, where Arthur Richer lived briefly, as did George Herms, with whom Beattie collaborated in films and Dadaesque combinations of poetry and graphics, printed on a cheap hand-press. In the late 1960s, inspired by studies in astronomy, he returned to painting, drawing, and collage. The new work contained complex abstract fields, sometimes worked in an obsessively ritualistic manner, in which variations in shading and density suggest constellations, nebulae, and other cosmic phenomena.

Beaumont, Mona (1927–)

Painter. Born in Paris; attended U.C. Berkeley (B.A., M.A.), and studied at the Fogg Museum at

Harvard, at the Hans Hofmann School in New York, and in France. Her paintings of the late 1960s were abstractions distinguished by interlocking, crisp-edged organic shapes, often framed in separate compartments. Her forms later became more spare and architectural.

Bechtle, Robert (1932–)★

Painter. Born in San Francisco; attended CCAC (B.A. 1954, M.F.A. 1958) and U.C. Berkeley (1960–1961).

Beery, Gene (1937–)

Painter. Born in Racine, Wis.; attended the Layton School of Art in Milwaukee and the Art Students League of New York. While working as a guard at the Museum of Modern Art in New York in the early 1960s, he began a series of paintings that consisted entirely of words, brushed and dripped in the crudely painted manner of hastily made picket signs, which made satirical comments on the exhibiton and marketing of contemporary art. Previously a figurative painter, he concentrated exclusively on these "logoscapes" after moving to the Bay Area in the mid-1960s. In the 1970s he gathered inexpensively printed variations on the idea into artist's books.

Bell, Scott (1945–)

Painter. Attended University of Nevada, Las Vegas (B.A. 1970), and U.C. Berkeley (M.A. 1974, M.F.A. 1976). His works of the late 1970s were austere constructions of wood and canvas that combined elements of painting and sculpture and were related to the New Abstraction, emphasizing process and materials. He later turned to straight painting, in a neo-Abstract Expressionist style.

Bellow, Cleveland (1946–)

Painter and printmaker. Born in San Francisco; attended CCAC (B.F.A. 1969, M.A. 1971). Active in the late 1960s and early 1970s, he drew his imagery from the street subculture of the urban black ghetto, working in a bold, Pop-related style.

Belson, Jordan (1926–)

Filmmaker and painter. Attended U.C. Berkeley (B.A. 1946). Initially an Abstract Expressionist painter, he began to make abstract films in 1947, at first from drawings that he had made on cards. His early films were conceived primarily as abstractions of form and dance, although the mystical mandala was the subject of a 1952–1953 film that used animated scrolls, inked and dyed and illuminated from behind. After collaborating with Henry Jacobs on the Vortex multimedia program from 1957 to 1959, he turned increasingly to films that used abstract optical effects and were conceived as documentaries of mystical experiences. He has been one of the Bay Area's most respected and influential makers of personal film.

Benton, Fletcher (1931–)★

Sculptor. Born in Ohio; attended Miami University of Ohio (B.A. 1956) and San Francisco City College (1959–1960). A professor at San Jose State University since 1967.

Benvenuto, Elio (1914–)

Sculptor. Born in Pietrasanta, Italy; studied at the Academy of Fine Art in Genoa (1931–1934) and the San Marco Liceum in Florence (B.F.A. 1937); came to the United States in 1948. His sculpture of the late 1950s was primarily in stone, carved into abstract figures in a Cubist-inspired style. In the 1960s he experimented with a variety of materials and forms, largely geometric and abstract. In the 1970s he returned to the figure, working in a direct, simplified style with roots in folk sculpture. Benvenuto was influential as the principal director of the annual San Francisco Art Festival between the late 1950s and the end of the 1970s, and as the active head of other San Francisco Art Commission programs involved in commissioning and purchasing work from local artists.

Berger, Richard (1944–)

Sculptor. Born in Los Angeles; attended Sacramento State University (B.A. 1968, M.A. 1970). His work of the early 1970s effected transformations of the natural environment, primarily by means of large mirrors that were placed where they reflected the movement of ocean waves, in the water or along the beach. In the mid-1970s he turned to indoor installations, constructing images with countless pieces of steel shot attached to suspended nylon fishing lines, so that from a distance the tiny metal balls coalesce to form the three-dimensional outlines of bicycles, chairs, and other common objects.

Berk, Henrietta (1919–)

Painter. Attended CCAC (1955–1959). Her specialty has been landscape, painted in a vigorous style influenced by Abstract Expressionism and emphasizing a sense of deep space.

Berman, Wallace (1926–1976)★

Assemblagist and collagist. Born on Staten Island, N.Y.; attended the Jepson Art Institute in Los Angeles (1944). Active in San Francisco between 1957 and 1961.

Berry, Roger (1950–)★

Sculptor. Born in Chico, Calif.; attended the University of the Pacific (B.A. 1972).

Best, David (1945–)

Sculptor. Born in San Francisco; attended the College of Marin and SFAI (B.F.A. 1974, M.F.A. 1975). Has

created plaster figures, three or four feet high, covered with cast porcelain and found objects, which suggest Indian shamans buried beneath a carapace of talismans and fetishes.

Bing, Bernice Lee (1936–)

Painter. Born in San Francisco; attended CCAC and SFAI (B.F.A. 1959, M.F.A. 1961). Her paintings have held to a lyrical Abstract Expressionist style, anchored to broadly conceived landscape forms and spaces.

Bischoff, Elmer (1916–)★

Painter. Born in Berkeley; attended U.C. Berkeley (B.A. 1938, M.A. 1939).

Bitney, Sue (1942–)

Sculptor. Born in Seattle; attended U.C. Berkeley in the mid-1960s. Her abstract sculptures, of brightly painted wood and stuffed canvas, are cheerfully bizarre organic abstractions that resemble the playthings of a child's nursery. They were among the more characteristic works displayed at the Funk Show at the University Art Gallery in Berkeley in 1967, and were frequently reproduced.

Blackburn, Ed (1947–)

Ceramic sculptor. Born in New York City; attended Humboldt State University (B.F.A.) and SFAI (M.F.A.). His constructions in cast porcelain mix abstract and natural forms, and their surfaces are stippled, sprayed, or painted in a way that combines the detailed design of Art Deco with a funky expressionism.

Bladen, Ronald (1918–)

Painter and sculptor. Born in Vancouver, B.C.; attended the Vancouver School of Art and CSFA. He was a painter working in a densely piled variant of Abstract Expressionism before he left the Bay Area in 1957 for New York, where he became known in the 1960s as one of the pioneers of minimalist sculpture.

Blell, Dianne (1943–)

Conceptualist. Born in Los Angeles; attended SFAI (B.F.A. 1973, M.F.A. 1974). Her conceptualist works and performances of the mid-1970s frequently dealt with the theme of women depicted as sexual objects.

Blunk, J. B. (1926–)

Sculptor. Born in Kansas; attended UCLA (B.A. 1949); traveled in the West Indies and Japan, 1949–1954; settled in the Bay Area in 1955. Living and working in Inverness, in Marin County, he makes sculpture from natural wood—stumps and logs—that is sparingly worked to accentuate the forms, textures, and colors inherent in the material itself.

Boers, Marianne (1945–)

Painter. Born in Modesto, Calif.; attended San Francisco State University (B.A. 1971). A student of Robert Bechtle's, she was one of the first Bay Area Photo Realists to specialize in watercolor, using as her subject the rows of packaged goods on supermarket shelves, seen in series or singly and close-up.

Boise, Ron (1932–1966)

Sculptor. Born in Colorado. His sculpture, assembled from cut and welded parts of junked automobiles found in Death Valley, interpreted the human figure with a heroic, if battered, monumentality. His most celebrated work was a series of small pieces that portrayed, largely in terms of abstract rhythms and movement, various sexual positions illustrated in the Kama Sutra; exhibited in 1964 at the Vorpal Gallery, then located in an alleyway behind the Vesuvio cafe in North Beach, they became a cause célèbre when the show was closed by police, and Muldoon Elder, the gallery's proprietor, was arrested for obscenity (he was acquitted after a jury trial).

Bolomey, Roger (1918–)

Sculptor. Born in Torrington, Conn.; attended CCAC (1948–1950), the Academy of Art in Florence (1947–1948), and the University of Lausanne, Switzerland (1947); lived in New York, 1954–1972. His early sculptures were large polyurethane reliefs. In the early 1970s he turned primarily to metal—bronze and stainless steel—and frequently combined it with granite or painted wood, in simple constructivist structures that emphasized contrasting textures and a dynamic symmetry. Since 1975 he has taught at California State University, Fresno.

Bolton, James (1938–)

Painter. Born in Corpus Christi, Tex.; attended Colorado State University (1956–1957), the Colorado School of Mines (1957–1958), the University of New Mexico (1958–1961, B.A. 1964, B.F.A. 1966, M.A. 1967), and Florida State University (1968). Working in a precise, realistic style, he moved in the early 1970s from surrealist imagery to subjects associated with Photo Realism (sunbathers, figures in automobiles), and thence to crisply literal representations of waste paper, discarded box lunches, and similar trash arranged in basically abstract compositions. In the late 1970s he turned to still life of a more conventional kind, although it frequently included incongruous objects and juxtapositions.

Bond, Peter (1880–197?)

Painter. Born in Australia; studied design and sign-painting at Sydney Technological College; came to San Francisco in 1905. Self-taught as a painter, he painted scenes of Golden Gate Park and other San Francisco

landmarks in a primitive manner and a style that combined the conventions of realism with Victorian allegory. In the early 1950s he began to construct a "peace garden," filled with hortatory signs of an anarchist political and religious persuasion, around his home at 1039 Clayton Street. The garden was part of a broader self-constructed philosophical system within which Bond went by the name of Pemabo.

Borge, Martha (1928–)

Painter. Born in Harrisburg, Ill.; attended CCAC and U.C. Berkeley. Her paintings are primarily illusionistic landscapes of the Marin County hills, with a strong sense of atmosphere.

Borge, Ralph (1922–)★

Painter. Born in Oakland; attended CCAC (1946–1951, B.F.A. and M.F.A.). His meticulously realistic interiors and landscapes of the 1950s were infused with an enigmatic sense of déjà vu that recalled the painting of Andrew Wyeth. Recent paintings have been more literal. He was an influential teacher at CCAC from the early 1950s through the early 1970s.

Bothwell, Dorr (1902–)

Painter. Born in San Francisco; attended CSFA (1921–1923), the University of Oregon (1922), and the Rudolph Schaeffer School of Design in San Francisco (1924). Her paintings combined stylized images, frequently of birds and other natural forms, with more abstract, linear elements. Since 1961 she has been active with the art community in Mendocino.

Bottini, David (1945–)

Sculptor. Born in San Jose; attended San Jose State University (B.A. 1969, M.A. 1970). A student and apprentice of John Battenberg (1968) and Fletcher Benton (1973), he did his early work in a cool, classical, but tongue-in-cheek constructivist style, combining simple geometric planes in flat whites and primary colors. In the mid-1970s he developed a more open style, emphasizing cubic elements that were welded into askew, slender, generally vertical structures inspired by the abstract forms of New Hebrides sculpture and other "primitive" styles. His expression became increasingly eccentric in the late 1970s. Large asymmetrical architectural forms were played against much smaller geometric elements, which were arbitrarily attached to or balanced against them, and raw metal surfaces were set in contrast to surfaces painted in rich lacquers.

Bowden, Harry (1907–1965)

Painter and photographer. Born in Los Angeles; a student in Los Angeles and New York and a commercial artist in Hollywood motion-picture studios before coming to the Bay Area in 1931, he studied with Hans Hofmann at U.C. Berkeley. He followed Hofmann to New York in 1932, and worked there as his assistant until 1941, when he returned and settled in Sausalito. He then turned from abstractions that had closely paralleled Hofmann's to more conservative, Cézannesque landscapes in dark, earthen colors; he also devoted increasing time to photography, concentrating on nude figures posed in landscape and on portraits of local painters, writers, and jazz musicians.

Bowen, Michael (1937–)

Painter and assemblagist. Born in Los Angeles; attended the Chouinard Art Institute in Los Angeles. Associated with Edward Kienholz and Wallace Berman in Los Angeles in the mid-fifties. He came to San Francisco in the late 1950s and was part of the Beat scene in North Beach. His early work alternated between funky assemblages and paintings that moved from an Abstract Expressionist style to a loose, painterly figurative manner with overtones of mysticism. In the mid-1960s he became involved with the hippie movement; influenced by experiments with psychedelics, meditation, and travels in Mexico, Nepal, and Southeast Asia, he turned to an overtly visionary expression, emphasizing facile draftsmanship and motifs drawn from sources in Tibetan religious art and other exotic traditions.

Bowers, Cheryl (1938–)

Painter. Born in Berkeley; attended the Santa Rosa School of Nursing (R.N. psychiatry, 1959), U.C. Berkeley (1972–1973), and SFAI (M.F.A. 1973). Her paintings of the mid-1970s were unstretched canvases dominated by thinly painted areas of tawny browns broken by puddles of blue, which suggested rustic personal "maps" of deserts and watering holes. Her work later became more gestural, painterly, and "window-like" in vantage point, opening on vistas that incorporated loosely brushed skies, trees, fragments of classical architecture, and other images.

Bowman, Richard (1918–)

Painter. Born in Illinois; attended the School of the Art Institute of Chicago (B.F.A. 1942) and the State University of Iowa (M.F.A. 1949). Visiting Mexico on a traveling fellowship in the early 1940s, he met Gordon Onslow-Ford, with whom he renewed a friendship after moving to San Mateo County in the early 1950s. His paintings, although gestural and abstract, were closer in spirit to those of the Dynaton artists than to the mainstream of Abstract Expressionism. They constituted an intensely lyrical and metaphorical abstract Impressionism inspired by Bonnard and an intimacy with the natural environment. Bowman was also influenced by jazz improvisation and the jazz poetry of Kenneth Patchen, a close friend. After 1950 he worked principally in fluorescent colors, at first using lacquer, later turning to fluorescent oil (1956) and then to acrylic (1965).

Appendix: Bay Area Artists

Boyle, Keith (1930–)

Painter. Born in Defiance, Ohio; attended the Ringling School of Art in Florida and the University of Iowa (B.F.A.). Moved to the Bay Area in 1960. Inspired by Matisse's late cut-outs, his paintings of the mid-1960s were in a hard-edged, abstract style, limited to a few broad, geometric forms that suggested highly rhythmic movement through their diagonal or curving shapes, and a restrained use of eye-stimulating, Op art color contrasts. Reminiscent of the painting of Stuart Davis, Boyle's paintings frequently carried jazz-related titles that underlined their sense of rhythm and tension. In the 1970s he introduced Miróesque, free-form, acrobatically gestural lines into the brightly decorative geometric fields of his paintings, enhancing their sense of graceful, fluid movement. He is a professor at Stanford University.

Boynton, Ray (1883–1951)

Painter. Born in Whitten, Iowa; attended the Chicago Academy of Fine Arts (1903–1906). Came to San Francisco in 1915 and taught at CSFA between 1921 and 1923 and at U.C. Berkeley between 1923 and 1948. Associated with the "progressive" faction of San Francisco artists in the 1920s, he concentrated on boldly stylized landscapes in a soft, grayed palette. He was among the muralists of Coit Tower.

Bradley, Michael (1944–)

Painter, sculptor, photographer. Born in New York City; attended U.C. Berkeley (B.A. 1971, M.A. 1973, M.F.A. 1974). His work of the mid-1970s consisted of both painting and sculpture, the latter in an expressionistic style and frequently inspired by the votive objects and fetishes of the religious art of Mexico, which was also the subject of a book of color photographs he published. His paintings, upon which he concentrated increasingly, were generally soft, amorphous abstractions of skies.

Brady, Robert (1946–)

Ceramic sculptor. Born in Reno, Nev.; attended CCAC (B.F.A. 1968) and U.C. Davis (M.F.A. 1975). His early ceramic sculptures were vessels distinguished by boldly stylized surface patterns and immense size. He later turned to larger-than-life figures inspired by the forms of primitive art, and to objects associated with ritual.

Branaman, Robert (1933–)

Painter, sculptor, filmmaker. Born in Wichita, Kan.; moved to San Francisco in 1959, to Big Sur in 1962, and to Los Angeles in the late 1960s. His paintings of the early 1960s were big, tangled, energetic abstractions; he also worked on an environmental scale, painting the walls and ceilings of entire rooms. He worked with Bruce Conner on Conner's films in the late 1950s, and later turned increasingly to his own personal filmmaking, recording his surroundings and friends in a style that emphasized multiple images, abstract light, and rapid cutting.

Brandon, Henry (1934–)

Painter. Born in Cuenca, Ecuador; attended CCAC (B.F.A. 1959, M.F.A. 1961). His landscape and figure paintings are in a broad, Bay Area Figurative style strongly influenced by Richard Diebenkorn.

Brawley, Robert (1937–)

Painter. Born in Washington State; attended Central Washington College, the University of Washington, and SFAI (B.F.A. 1963, M.F.A. 1965). Loosely associated with the Photo Realists in the early 1970s, he concentrated on painting obese, middle-aged women in a relentlessly crisp, sharp-focus style; his subjects were posed against carpeting and knotty-pine walls rendered with a precision that approached trompe l'oeil.

Brayman, Frederick (1943–)

Painter. Born in Seattle; attended SFAI. One of the Visionaries active at the turn of the 1970s, he painted colorful, highly stylized images that generally derived from the symbolism of astrology.

Breger, Helen (1926–)

Painter. Born in Vienna; attended the Textil Hochschule, the Kunstgewerbe Schule, and the Frauen Akademie in Vienna, and the Art Students League of New York. Her paintings were in a broad figurative style with roots in Abstract Expressionism.

Breger, Leonard (1920–)

Painter. Born in New York City; attended City College of New York (B.S. 1941); came to California in 1951. His expressionist figure paintings of the 1960s moved away from a rectangular format, at first taking the form of images painted on canvases filled with stuffing and later of painted cut-outs in plywood.

Breschi, Karen (1941–)

Ceramic sculptor. Born in Oakland; attended CCAC (B.F.A. 1963), Sacramento State University, and SFAI (M.F.A. 1965). Her specialty has been grotesque images of human figures and humanoid animals, generally with sources of pop culture or fairy tales and with strongly Freudian undertones.

Bridenthal, Tad (1942–)★

Sculptor. Born in the Cherokee Nation, Muskogee, Oklahoma; attended Oklahoma State University, Stillwater (B.S. 1964), and California State University, San Jose (M.A. 1971), where he studied under Roger Ferragallo.

Briggs, Ernest (1923–)★

Painter. Born in San Diego; attended the Rudolph Schaeffer School of Design in San Francisco (1946–1947) and CSFA (1947–1951). Moved to New York in 1953.

Britton, John (n.d.)

Painter. Attended the San Francisco Academy of Art and SFAI. Associated with the Blackman's Gallery, he painted in a realistic, figurative style with an emphasis on richly worked surfaces.

Britton, John (n.d.)

Sculptor. Attended CCAC (1962–1965, B.F.A.) and taught there in the late 1960s and early 1970s. His principal works were small Surrealist landscapes in cast bronze, and monumental heads in cast bronze and resin.

Brody, Blanche (n.d.)

Painter. Born in New York City; attended Hunter College, CCAC, and SFAI. Her paintings, in a broad, Bay Area Figurative style, concentrated on domestic interiors and figures in landscape.

Brooks, Alan (1931–)

Painter. Born in Burbank, Calif.; attended SFAI and San Jose State College (M.A. 1960). His paintings of the late 1960s were based on nostalgic photographs from family albums, emphasizing contrasting areas of light and dark in a manner similar to that used in the paintings of Robert Harvey. His imagery, frequently based on the forms of rumpled bed sheets, gradually grew more abstract.

Brooks, Joseph (1929–)

Painter. Born in Oakland; attended SFAI (1947–1950) and U.C. Berkeley (1953–1956). Working in a Bay Area Figurative vein, he concentrated on sparsely furnished interiors, in a painterly style that approached total abstraction.

Brotherton, Joe (1918–)

Painter. Born in Montana; attended the University of Washington (1936–1940), the U.C. Extension (1949–1951), and the San Francisco Conservatory of Music (1949–1952). His big ink and tempera works on paper grew out of his studies of Chinese art and Asian philosophy, and were also influenced by Abstract Expressionism.

Brown, Christopher (1951–)

Painter. Born in Camp Lejeune, N.C.; attended the University of Illinois (B.F.A. 1973) and U.C. Davis (M.F.A. 1976). His paintings are skillful adaptations of the Bay Area Figurative style of the 1950s—including its penchant for art-historical allusion—to the sensibility of the late 1970s and 1980s; they incorporate spare, broadly brushed images into a predominant concern with richly seductive, painterly surfaces in unusual harmonies of browns, greens, and blues.

Brown, Joan (1938–)★

Painter. Born in San Francisco; attended CSFA (B.F.A. 1959, M.F.A. 1960). She has been a teacher at U.C. Berkeley since the mid-1970s.

Brown, William Henry (1931–1980)

Painter. Born in Oakland; attended San Francisco State College, the American Art School in New York, and CSFA. He worked in a Bay Area Figurative style and his paintings of the late 1950s—when he was married to the painter Joan Brown—were reminiscent of Edward Hopper. In the 1960s he moved toward a more precise and hard-edge style. He left for Europe in the mid-1960s, and was living in Bristol, England, when he died.

Brown, William Theo (1919–)

Painter. Born in Illinois; attended Yale University (B.A. 1941) and U.C. Berkeley (M.A. 1952). After his discharge from the army in the late 1940s, he studied in Paris with Ozenfant and Léger. In the 1950s, he developed a series of paintings based on photographs from sports magazines; he translated the images of figures in motion into boldly outlined, vigorously entangled abstract shapes that constituted a kind of gestural Cubism. With Paul Wonner, he spent most of the 1960s and 1970s in Santa Barbara (and briefly in New England) and returned to the Bay Area in the mid-1970s. His later paintings have been related in style to Matisse; they contain allegorical figures, highly simplified and thinly painted, frozen in strange interiors or engaged in dance-like motion and set in generalized landscapes suffused with muted colors.

Buck, John (1946–)

Painter and sculptor. Born in Montana; attended the Kansas City Art Institute and School of Design (B.F.A. 1968), U.C. Davis (M.F.A. 1972), and the Skowhegan School of Painting and Sculpture in Maine (summer 1971). In the mid-1970s he produced open-work sculptures of wood, cut into zany humanoid or animal shapes, sometimes carved in low relief, and brightly painted on one side; they formed a parallel, in three dimensions, to the cartoonish painting of Jim Nutt. In the later 1970s he turned to combinations of painting—generally big fields of color with crude, child-like images of landscape or architecture—and three-dimensional, schematic figures, in wire or brick, that commented obliquely on the relationship between man and the environment.

Appendix: Bay Area Artists

Bufano, Beniamino (1898–1970)★

Sculptor. Born in San Fale, Italy; attended the Art Students League of New York (1913–1915). First visited the Bay Area in 1915; traveled to Europe and China (1916–1921) and then settled in San Francisco in 1921.

Bustos, José María (1950–)

Conceptualist. Born in New York City. In the late 1970s he produced installation pieces that were in most cases highly formal, emphasizing repeated geometric forms in relief.

Butterfield, Deborah (1949–)

Sculptor. Born in San Diego; attended San Diego State University (1966–1968), U.C. San Diego (1969), U.C. Davis (B.A. 1972, M.F.A. 1975), and the Skowhegan School of Painting and Sculpture in Maine (1972). Her ceramic sculpture of the mid-1970s was based on the forms of saddles and was glazed in traditional Chinese styles. She later turned to life-sized figures of horses, naturalistic in form but with abstract painted surfaces. The horse has remained the central image of her more recent sculpture, but her media range from scrap metal to chickenwire and old wood slats, and the forms and attitudes have grown more abstract and expressionistic.

Calcagno, Lawrence (1916–)★

Painter. Born in San Francisco; attended CSFA (1947–1952). Reared on a remote homestead in the Santa Lucia mountains near Big Sur, he has continued to draw heavily on natural forms in abstract paintings that have become increasingly refined since the late 1940s. He has lived in New York since the 1950s.

Camacho, Cristiano (1946–)

Sculptor. Born in Fall River, Mass.; attended Rhode Island Junior College (1964–1966) and SFAI (B.F.A., M.F.A. 1971). His generally rugged raw materials—timbers, slabs of marble, cement—are sparingly worked, and the individual elements are assembled into structures, groupings, and occasionally installations of environmental dimensions, generally with expressionistic and mythic overtones. Since the late 1970s he has lived alternately in Taiwan and San Francisco.

Campbell, Don (1942–)★

Painter and sculptor. Born in Kokomo, Ind.; attended the John Herron Art Institute, Indianapolis (B.F.A. 1965), and the University of Arizona (M.F.A. 1968). Following the laser sculpture he made in collaboration with Matt Glavin in 1969, in 1971 he created a room-sized laser environment at the San Francisco Museum of Art, in which rays of light created continually shifting patterns as they bounced from motorized rotating mirrors.

Carrillo, Ed (1937–)

Painter. Born in Santa Monica, Calif.; attended Los Angeles City College (1955–1956) and UCLA (B.A. 1962, M.A. 1964). A teacher at Sacramento State University since 1970. His bluntly realistic paintings concentrated on interiors and old houses typical of the Sacramento area.

Carlin, Jerome (1927–)

Painter. Born in Chicago; attended Harvard University, the University of Chicago, the Yale Law School, and the Art Institute of Chicago. His paintings, in a Bay Area Figurative style, concentrate on views of the Berkeley hills.

Carnwath, Squeak (1947–)

Painter and ceramist. Born in Abington, Pa.; attended Goddard College in Plainfield, Vt. (1969–1970) and CCAC (1970–1971, M.F.A. 1977). Her paintings, on unstretched canvas in a flat, boldly patterned, quasi-primitive style, center on schematic images of figures and familiar objects, suggesting pictographic, shorthand accounts of dreams. They are frequently accompanied by words that seek to confer on the essentially private visions a more universal, mythic significance.

Carraway, Arthur (1927–)

Painter. Born in Fort Worth, Tex.; attended the San Francisco Academy of Art (1947–1950), SFAI (1950–1953), the University of Ghana (1971–1972), and U.C. Extension (1973–1974). His paintings of the mid-1950s were Abstract Expressionist in style, containing organic shapes that verged on figurative images. In the 1960s, he turned to a more intimate scale, and to shorthand, symbolic motifs, often drawn from sources in African religious art, in a style that suggested Paul Klee.

Carrigg, Jack (1925–)

Painter. Born in San Francisco; self-taught. Associated with the Beat artists in North Beach in the 1950s, he initially worked in a turgid Abstract Expressionist style. By the early 1970s, when he abandoned painting altogether, he had developed a form of vibrantly coloristic geometric abstraction. His strongest paintings were done during the transition between these styles; they consisted of canvases filled with broad horizontal and diagonal bands of intense color, applied with heavily loaded brushes so that the paint dripped and ran and colors fused, creating a sense of raw, elemental grandeur.

Carson, Lew (1938–)

Painter, collagist, photographer. Born in Philadelphia; attended Alfred University in New York (B.A. 1960) and U.C. Berkeley (M.A. 1963). His collages of the early 1970s drew on sources in vintage commercial

art—advertisements, picture postcards—and emphasized incongruous juxtapositions and dislocations of scale. In the late 1970s he turned to combinations of painting and photography, the photographs being radically cropped pictures of debris around his garage and house, in which surreal and abstract formal elements were equally emphatic.

Castellón, Rolando (1937–)

Painter and sculptor. Born in Managua, Nicaragua; no formal schooling in art; came to California in 1956. His early paintings on paper contained ghost-like images of pyramids, suns, and moons, and were built in transparent, overlapping pastel colors to suggest the layered surfaces of old walls. In the 1970s he began to crease, fold, and otherwise shape these works, first into reliefs and eventually into sculptural forms that frequently suggested primitive talismans and fetishes. In the 1980s his works in paper—impregnated with dark-toned oils and smeared with dirt—have come to resemble the detritus squashed into the pavement of back alleys and deteriorating streets. Castellón was a curator at the San Francisco Museum of Modern Art from 1972 through the end of the decade, and has since been active in directing various alternative spaces.

Cavalli, Guy John (1942–)

Painter. Born in San Francisco; attended SFAI (B.F.A 1966) and Mills College (M.F.A. 1971). Initially a painter of surrealist landscapes, he moved to a form of geometric abstraction in the late 1960s. In the early 1970s he developed an extraordinary series of shaped canvases in geometric formats based on models made by folding squares of paper according to certain prescribed limitations. The formats played against the shapes that were painted on the canvas surface: thin bands of closely graded pastels. At certain points these bands blended into expansive color planes that seemed to open on vast spaces, and at others, where the colors of the bands and the planes strongly contrasted, they appeared to unfold, or open outward, toward the viewer. In the late 1970s he turned from these "folded diamonds" to a variety of experimental formats in which the painted shapes became simpler and the architectural forms of the canvases grew correspondingly more important.

Cervantes, Luis (1923–)

Painter. Born in Santa Barbara, Calif. He was associated with the Visionary artists of the late 1960s and was one of the earliest (c. 1965) to concentrate on the mandala form; in his work, the mandala occupied fields that emphasized repeated geometric patterns in intense Op art colors. Between 1962 and 1964 he directed and owned the New Mission Gallery in San Francisco which displayed work by Ron Davis, William Geis, Carlos Villa, and other emerging artists associated with the SFAI and the North Beach undergound.

Chamberlin, Wesley (1932–)

Painter. Born in Huntington Park, Calif.; attended Reed College, Portland, Ore. (B.A. 1958), and UCLA (M.A. 1961). Influential as an art historian and teacher at San Francisco State University since the early 1960s. His paintings of the early 1970s, loosely related to Photo Realism, used immensely enlarged images of cocktail glasses as scaffoldings for fluid abstractions of color. He later moved toward subjects of a more enigmatic, visionary kind.

Chase, Ronald (1934–)

Painter, assemblagist, filmmaker. Born in Seminole, Okla.; attended Bard College, Annandale-on-Hudson, N.Y. (B.A. 1956). His assemblages of the middle and late 1960s combined weathered whitewashed boards, windows, mirrors, old photographs, dolls, and other bric-à-brac in compartmentalized reliefs or shrine-like structures that suggested funky Victorian reliquaries and exuded nostalgia and decay. In the early 1970s he turned to painting over tattered scraps and pieces of canvas and attaching them to larger canvases to create abstractions that suggested old walls or desert landscapes. In the late 1970s he concentrated on designing sets for theater and opera and on filmmaking. In 1980 he returned to a combination of painting and collage similar to his work of the early 1970s, but with more vivid color and a Mediterranean sense of atmosphere and light.

Chesse, Ralph (1900–)

Painter and sculptor. Born in New Orleans; came to San Francisco in the early 1930s. A professional puppeteer and theater set designer, Chesse painted a mural in fresco of a children's playground on the second story of Coit Tower.

Chicago, Judy (1939–)★

Sculptor. Born in Chicago; attended UCLA (B.A. 1962, M.A. 1964).

Chipman, Jack (1943–)

Sculptor. Born in Los Angeles; attended the Chouinard Art Institute in Los Angeles (B.F.A. 1966) and SFAI (1968). His mixed media works of the early 1970s used strips of painted canvas hung from frames that were attached to the wall, or wrapped tightly around long sticks; they were related both to fetish sculpture and to process-and-materials abstraction. Later, he made collages from sections of cardboard shipping cartons, arranged in geometric structures.

Clapp, William (1879–1954)★

Painter. Born in Montreal; studied in Montreal with William Brymner (1900–1904) and in Paris at the Académie Julian, the Académie Colarossi, and the Académie de la Grande Chaumière. He came to Oakland in 1917. His style, more conservative than that of most other members of The Society of Six, remained grounded in a pointillist variation of Impressionism.

Clark, Joe (1929–1975)

Sculptor. Born in Washington, D.C.; attended St. Johns College (Annapolis, Md.), the University of Maryland, the Pratt Institute (N.Y.), and the New School of Social Research (N.Y.). Active in the Bay Area from the early 1960s until his death, he worked in welded steel, frequently using pieces from junked automobiles, to make expressionistic figures with sources in classical mythology.

Cohen-Stuart, Victor (1946–)

Sculptor and painter. Born in Athens, Greece, and came to California in 1956; attended U.C. Berkeley (B.A. 1970, M.A. 1971, M.F.A. 1972). His kite or tent-like structures of the 1970s, fashioned of canvases painted in dusky shades of black and trussed to armatures of slender wood slats, suggest tautly stretched membranes or bruised skins, body parts that had been bandaged, dressed, and splinted. They were frequently exhibited with the work of the process-and-materials abstractionists. He later turned to neo-expressionist figure paintings.

Colescott, Robert (1925–)★

Painter. Born in Oakland; attended U.C. Berkeley (B.A. 1949, M.A. 1952) and studied at Atelier Fernand Léger in Paris (1949–1950). Returned to California in 1970 after sojourns in the Pacific Northwest (1952–1964), Egypt (1964–1967), and France (1967–1969).

Collier, Will (1929–)

Painter. Born in New York City; attended Antioch College, Ohio (B.A. 1952), and U.C. Berkeley (M.A. 1956). His paintings of the late 1960s and the 1970s were impressionistic views of landscapes and interiors with an emphasis on abstract architectural form and light.

Collins, Jess (1923–)★

Painter and collagist. Born in Long Beach, Calif.; attended California Institute of Technology, Pasadena (B.S. 1948) and CSFA (1949–1951).

Colwell, Guy (1945–)

Painter. Born in Oakland; attended CCAC. His paintings, in a tight, linear style of illustrative surrealism, focused on themes of urban violence and social protest.

Comings, Robert (1941–)★

Painter and assemblagist. Born in the San Joaquin Valley of California; attended the University of Kansas (1960–1961) and San Francisco State College (B.A. 1966, M.A.). Formally trained as a student in Kansas in the classical disciplines of sculpture—carving, model-

ing, and casting—he nonetheless considered his first significant art work to have dated from 1961, in Washington, D.C., when he and a friend spent the day organizing and arranging the debris they found on a two-acre supply and dumping yard—gravel piles, used firehoses, tires, and other salvage—into a sculptural environment that included reflecting pools of rainwater and the silhouette of the Capitol building in the background. His graduate project at San Francisco State consisted of a series of rituals; the hostility with which it was met by some members of the academic committee confirmed his sense of his work as an essentially religious expression, rather than a strictly artistic one. After dropping out of the San Francisco art world in 1971, he settled in Mendocino County, where he became an administrator at Mendocino Community College and eventually a city councilman and mayor at Willits—activities that he regarded as an extension of his art.

Concha, Gerald (1935–)

Painter. Born in Sacramento; attended SFAI (B.F.A.). His paintings of the late 1960s were hard-edge abstractions dominated by cool, pastel colors. In the 1970s he developed a more loosely structured, atmospheric field painting irradiated with warm colors and light.

Conner, Bruce (1933–)★

Painter, assemblagist, filmmaker. Born in Kansas; attended the University of Nebraska (B.A. 1956), the Brooklyn Museum Art School (1957), and the University of Colorado (graduate school). He is married to Jean Conner.

Conner, Jean (1933–)

Painter. Born in Brookline, Mass.; attended the University of Nebraska (B.A. 1955) and the University of Colorado (M.F.A. 1957). Her paintings deal with floral and other still-life subjects in a broad style related to Bay Area Figurative painting. She is married to Bruce Conner.

Cook, Gordon (1927–)

Painter. Born in Chicago; attended Illinois Wesleyan University (B.F.A. 1950) and the State University of Iowa in Iowa City (1951). Known primarily as a traditionalist printmaker after he came to the Bay Area in the early 1950s, Cook became active as a painter during his marriage to Joan Brown in the early 1970s. His early paintings were generally small, muted still lifes of commonplace objects—a bottle, a box, a wheel of cheese—located ambiguously in space, and combining the painterly clarity of Thiebaud with the solemnity of Morandi. In the late 1970s he turned increasingly to landscape, particularly solitary buildings in the Sacramento River delta country in a veiled light and with a remotely dream-like quality resembling de Chirico.

Cook, John (1904–1963)

Painter. Born in Yreka, Calif.; attended U.C. Berkeley (graduated 1926), the Art Students League of New York, and the New York School of Fine and Applied Arts. Active as an illustrator in San Francisco after 1935. His watercolors were spare, soft abstractions that evoked the sense of flying, hovering, or falling forms, and suggested sources in Japanese sumi painting. During his later years, he painted part time while working as a hotel clerk. He died of a heart attack less than a week after his first one-man show opened at the San Francisco Museum of Art.

Cooper, Michael (1943–)

Sculptor. Born in Richmond, Calif.; attended San Jose State College (B.A. 1966, M.A. 1968) and U.C. Berkeley (M.F.A. 1970). His comical constructions of steel, leather, and other materials were inspired by the forms of machines: strange, winged contraptions or fantastic motorcycles, which usually included electrically powered moving parts.

Coppola, Eleanor Neil (n.d.)

Conceptualist. Born in Long Beach, Calif.; attended UCLA (B.A. 1959, graduate study in 1962). Her conceptualist works of the mid-1970s were rigorously formal and tended to mirror themselves and their environments.

Corbett, Edward (1919–1971)★

Painter. Born in Illinois; attended CSFA (1937–1941). He taught at CSFA from 1947 until 1951. After leaving the Bay Area in 1951—first for New Mexico and later for the East Coast—he developed a style of hard-edge abstraction in which landscape forms were distilled to spare, organic shapes in flat, unmodulated colors.

Costanzo, Tony (1948–)

Ceramist. Born in Schenectady, N.Y.; attended SFAI (B.F.A. 1971) and Mills College (M.F.A. 1973). His ceramic wall reliefs combined elements of Dada—doughnut forms, painted surface images—with fragmentary serial structures derived from minimalist abstraction.

Costello, Kevin (1948–)

Conceptualist. Born in St. Peter Port, Guernsey (the Channel Islands); attended Chelsea School of Art and Goldsmith's College, the University of London (1971). Active in San Francisco in the mid-1970s, he made austere installation pieces that emphasized raw materials and process.

Cotton, Paul (1939–)★

Conceptualist. Born in Fitchburg, Mass.; attended the University of Rochester, N.Y. (B.A. 1961, M.A. 1965), and U.C. Berkeley (M.F.A. 1967). His performance pieces of the early 1970s generally featured his appearance in the nude, or in a bunny costume that left genitalia exposed.

Crehan, Hubert (1918–)★

Painter and critic. Attended UCLA (1945–1948), Stanford University (1948), CSFA (1948–1950), and the University of Guadalajara, Mexico (1951–1952). A practitioner of a soft-spoken gestural abstraction during the late 1940s, in the late 1960s and 1970s he worked primarily on paper in a spare calligraphy influenced by Japanese art. He was managing editor of *Arts* magazine, 1952–1956, and an associate editor of *Art News* from 1957 to 1960.

Cremean, Robert (1932–)★

Sculptor. Born in Ohio; attended Alfred University, N.Y. (1950–1952), and Cranbrook Academy of Arts, Bloomfield Hills, Mich. (1954, M.F.A. 1956); studied in Italy (1954).

Cross, Chris (1946–)

Painter. Attended San Jose State University (B.A., M.A. 1971). Active in the mid-1970s, he worked in a Photo Realist style, concentrating on urban themes—automobiles, store windows and their reflections—and emphasizing soft-textured, spray-painted surfaces that alleviated the crisp literalism of his drawing.

Crowley, Paul (1936–)

Multimedia artist. Attended San Francisco State College. His best-known piece was a well-publicized "concert" presented from the summit of Twin Peaks on August 20, 1969, with Margaret Fabrizio performing (on synthesizer) an electronic composition by Robert Moran, while 39 automobiles honked and flashed their headlights on and off and homes and office buildings in the city below answered according to a complex prearranged "score" published in that morning's *San Francisco Chronicle*.

Crumb, Robert (1944–)★

Cartoonist. Reared in Philadelphia, Crumb left home at age nineteen for Cleveland, where he worked for the American Greeting Card Company, doing color separations and later designing cards. His first comic strip, Fritz the Cat, was published in a 1965 issue of *Cavalier* magazine. Two years later, in San Francisco, he published the first issue of *Zap,* and shortly thereafter collaborated with Rick Griffin, Victor Moscoso, and S. Clay Wilson to publish *Zap 2,* the first of the hardcore

"underground comix." His vigorous cartoon style was a unique amalgam of sources drawn from across the historical spectrum of American cartooning: Popeye, Little Orphan Annie, Krazy Kat, Snuffy Smith, Jules Feiffer, and *Mad Magazine*.

Crumpler, Dewey (1949–)

Painter and muralist. Born in San Francisco; self-taught in high school; studied in Mexico with Pablo O'Higgins and other muralists. His expressionistic figurative works depicted the histories of Third World peoples.

Cucaro, Pascal (1915–)

Painter. Born in Youngstown, Ohio; attended CSFA in the late 1940s and also studied in Paris. The first artist to exhibit work at the popular basement bistro, the hungry i, he quickly attracted patrons from the show business and movie worlds with his facile paintings of clowns, circuses, and crowds. By the mid-1960s he had become one of San Francisco's most successful schlock artists, selling collectors entire walls of his work and, in one notable instance, painting a series of vignettes on a long board that was cut and sold by the foot.

Cuneo, Rinaldo (1882–1939)

Painter. Born in San Francisco; studied at the Mark Hopkins Institute of Art with Gottardo Piazzoni. Associated in the 1920s and 1930s with the bohemian artists of San Francisco's North Beach, he was known for paintings of hills and orchards and scenes of San Francisco.

Cunningham, Benjamin (1904–1975)

Painter. Born in Cripple Creek, Colo.; attended the University of Nevada and SFAI. Supervisor of the mural program for the Northern California Art Project, 1936–1938. He was attracted to color theory at an early stage in his career, and by the late 1940s he had developed an original form of geometric abstraction emphasizing pulsating, Op art color juxtapositions on shaped canvases that frequently took the form of "corner paintings." He left San Francisco for New York in the early 1960s.

Cyrsky, Frank (1948–)

Painter. Attended the School of Visual Arts in New York (1966–1969) and SFAI (B.F.A. 1971). Active in the Bay Area in the early 1970s, he painted in a style similar to that of Joseph Raffael, using realistic images that were vastly enlarged to emphasize abstract surfaces produced by pointillistic technique.

D'Agostino, Peter (1945–)

Conceptualist. Born in New York City; attended the Art Students League of New York (1963–1964), the

School of Visual Arts in New York (1964, 1966–1968, B.F.A.), the Acadèmia di Belle Arti in Naples (1965–1966), SFAI (1968), and San Francisco State University (M.A. 1975). Working primarily with the media of photography and video, he explored structuralist ideas that involved the theme of passage—means of transportation, comings and goings—and emphasized the self-reflexive qualities of photography.

Dahl, Ron (1938–)

Painter. Born in Oakland; attended CCAC (B.F.A. 1960) and SFAI (M.F.A. 1962). The quirky, broadly expressionistic style of his paintings of the 1960s gradually yielded to a more visionary imagery.

Dahl, Taffy (n.d.)

Ceramic sculptor. Born in San Francisco; attended U.C. Berkeley. Her ceramic pieces of the early 1970s generally depicted images of inanimate objects metamorphosing into living things.

Dannenfelser, Susan (1949–)

Sculptor. Born in San Mateo, Calif.; attended U.C. Berkeley (B.A. 1971, M.A. 1978, M.F.A. 1979). Her first sculptures were metal castings that commented critically on environmental issues. In the mid-1970s she turned to ceramic fantasies of cats and other animals. Later she returned to metal, fashioning fragile plant forms in thin pieces of steel covered with enamel paints.

Davies, Harold C. (1891–1976)

Painter. Born in Seattle; attended the Corcoran School of Art in Washington, D.C., and CSFA (in the early 1920s). Davies spent most of his life as a successful businessman, and his first one-man show was held in San Francisco a year before his death. He painted in a style that developed from early Fauve-inspired watercolors of California's Central Valley (1916–1917) through landscapes grounded more firmly in the structure of Cézanne. In the early 1940s, while heading his own chemical company in Huntsville, Alabama, he painted his first abstractions. These works were blunt, deliberately "ugly" paintings with thickly piled surfaces and somber color areas claustrophobically compressed within grid structures freely brushed in heavy black lines, which suggested parallels to the early Abstract Expressionist paintings of de Kooning. In the late 1950s, after moving to East Hampton, N.Y. (where he knew de Kooning, Gottlieb, and Kline), he turned to a more colorful, open, and freely gestural style grounded in a sense of natural space and atmosphere. He continued this style of abstract Impressionism after settling in Inverness, in Marin County, in 1969, producing a large number of uneven but, at best, zestful and fresh works.

Davis, Jerrold (1926–)

Painter. Born in Chico, Calif.; attended U.C. Berkeley (B.A. 1952, M.A. 1953). His landscape paintings of

the early 1950s were related to Abstract Expressionism in freedom and scale; varied paint textures and strong colors contrasted with large areas of white that conveyed a sense of vast spaces. In the late 1960s his paintings took on mythic overtones, incorporating generalized human figures painted in creamy whites and mounted astride the forms of shadowy black horses. His small "Paintings of the Coast" of the 1970s were landscapes in a spare, gentle style with sources in Oriental painting.

Davis, Kenn (1932–)

Painter. Born in Salinas, Calif.; attended San Francisco City College and CSFA. Associated with the North Beach scene in the 1950s, he has continued to work in a crisply realistic style that focuses on Surrealistic subject matter, frequently in a satirical vein.

Davis, Ron (1937–)★

Painter. Born in Santa Monica, Calif.; attended the University of Wyoming (1955–1956), Yale University, the Norfolk School of Music and Art (1962), and SFAI (1960–1964). The paintings he did before leaving San Francisco in the mid-1960s were in a dense Abstract Expressionist style. After settling in Los Angeles, he became known for works in which loose, gestural paint surfaces were distributed across large sheets of plastic in geometric formats that suggested foreshortened boxes and frames.

Davis, Stephen (1945–)

Painter and sculptor. Born in Fort Worth, Tex.; attended the University of Madrid (1966), the University of Texas (1967–1968), and the Claremont Graduate School (M.F.A. 1971). Active in San Francisco, 1970–1975. His early paintings were large, unstretched canvases flooded with motes of color applied in a mechanical and apparently random way, emphasizing the painting as object. He later turned to smaller stretched canvases painted in solid colors and displayed as complementary or contrasting pairs. By the mid-1970s, he was concentrating on combinations of flat and three-dimensional painted forms—generally squares or rectangles of canvas or sheetrock that were attached to the wall, and painted mattresses that were placed horizontally in front of them and supported by flower pots.

Dawkins, Charles (1922–1973)

Sculptor. A student at CSFA in the 1940s, he was associated with the Beat scene in North Beach in the 1950s and 1960s. A merchant seaman, he brought back ebony and other exotic hardwoods that he carved into the figures of cats and other animals; their severe stylizations reflected the influence of African sculpture.

De Feo, Jay (1929–)★

Painter. Born in New Hampshire; attended U.C. Berkeley (B.A. 1950, M.A. 1951). In the late 1970s she turned to more realistic, if elusive, drawings of still-life objects, such as camera tripods and glasses. A subsequent series of small "works on paper" concentrated on abstract discs and circles, inspired by the forms of nuclear reactors, and combined with erasures, smudges, and smears of paint that suggested indeterminacy and flux. In the 1980s she turned again to large paintings—generally of heavy, angular abstract forms that suggested mangled industrial objects suspended in ambiguous spaces—and for the first time introduced strong color into her work.

De Forest, Roy (1930–)★

Painter. Born in North Platte, Nebr.; attended CSFA (1950–1952) and San Fransisco State College (B.A. 1953, M.A. 1958).

DeLap, Tony, Jr. (1927–)★

Painter and sculptor. Born in Oakland; attended CCAC (1946–1947), the San Francisco Academy of Art (1948), and Scripps College in Claremont, Calif. (graduate school, 1949–1950). In the late 1950s his abstract collages of torn paper touched with gouache were characterized by emphatic contrasts between blacks and whites, and by loosely ordered structures that were related to those of Diebenkorn's paintings. These developed into reliefs that incorporated slats of wood and other materials. By the time he moved to Southern California in 1965, he was making exactingly crafted, freestanding works in metal and wood. These were two-sided reliefs of concentric and terraced geometric forms, painted in dark, saturated colors.

Delos, Kate (1945–)

Painter. Born in Stockton, Calif.; attended U.C. Davis (1963–1966), U.C. Berkeley (B.A. 1970), and San Francisco State University (M.A. 1971). In her paintings, simple architectural—and later, floral—images were reduced to basic shapes, and suspended or imbedded in highly worked surfaces that suggested both ambiguous fields of space and opaque walls.

De Rockere, Herbert (1941–)

Painter. Born in Vienna; attended the Academy of Art and Music in Vienna, SFAI (B.F.A. 1967), and Stanford University (M.A. 1969). In the early 1970s he became identified with large wall structures composed of small flaps of canvas cut into repeated regular shapes, each painted in a single solid color.

De Staebler, Stephen (1933–)★

Sculptor. Born in Saint Louis; attended Princeton University (degree in religion, 1954), Black Mountain College, N.C. (summer 1953, studied with Ben Shahn and Robert Motherwell), and U.C. Berkeley (M.A. 1961). He has been a teacher at San Francisco State University since the 1960s. In the late 1970s, he began to translate his sculptural ideas into cast and painted bronze

and to experiment with a broadly figurative style of painting on canvas.

deViveiros, Don (1935–)

Painter. Born in Oakland; attended CCAC (1948, 1954, 1959–1965, M.F.A. 1969), Laney Junior College, Oakland (1956–1957), and San Francisco Academy of Art (1958). His emphatically textured realistic paintings revolved around environmental concerns: landscapes seen through wire fences, close-up views of tree stumps.

Dickinson, Eleanor (1931–)

Painter and conceptualist. Born in Knoxville, Tenn.; attended the University of Tennesse (B.A. 1952) and SFAI (1961–1963); came to California in 1953. Early drawings concentrated on sleekly outlined images of nude models posing in the studio; in the late 1960s, she turned to dream images freighted with Freudian symbolism, in a mixture of media and a freer style. In the 1970s she developed a body of diverse work around her experiences with the world of fundamentalist religion. It included found objects and documentation as well as original drawings, and paintings on velvet in the tradition of revivalist folk art.

Diebenkorn, Richard (1922–)★

Painter. Born in Portland, Ore.; attended Stanford University (1940–1943, B.A. 1949), U.C. Berkeley (1943), CSFA (1946), and the University of New Mexico (1950–1951). Lived in the Bay Area between 1953 and 1966 and then moved to Santa Monica.

Diehl, Guy (1949–)

Painter. Born in Pittsburg, Calif.; attended Diablo Valley College (1968–1970), California State University, Hayward (B.A. 1973), and San Francisco State University (M.A. 1976). His paintings, in a slick Photo Realist style, focused on suburban swimming pools and their accoutrements.

Dietrich, Henry (1918–)

Painter. Born in Berlin; attended the Kunstschule Reimann and the Kunstschule des Westens in Berlin (1934–1938). Lived in Shanghai, 1939–1947; came to San Francisco in 1948. Influenced by children's art, as well as by Picasso and Klee, his paintings were whimsical, brightly decorative abstractions that joined the style of synthetic Cubism to the spirit of the cartoon.

di Gesu, Peter (1943–)

Painter. Born in Los Angeles. A student of Norman Stiegelmeyer's at SFAI in the mid-1960s, he produced paintings and drawings of visionary landscapes in a crisply outlined, highly finished style governed by strict symmetry. He was inspired by studies in alchemy and magic and by Zen meditations.

di Suvero, Mark (1933–)★

Sculptor. Born in Shanghai, came to San Francisco in 1941; attended San Francisco City College (1953–1954), U.C. Santa Barbara (1954–1955), and U.C. Berkeley (B.A. 1956). Left for New York in 1957. In the mid-1970s, he began to divide his time between New York and a Bay Area home and studio in Petaluma.

Dixon, James Budd (1900–1967)★

Painter. Born in San Francisco; attended U.C. Berkeley, the Mark Hopkins Institute of Art in San Francisco, and CSFA (1945–1947).

Dixon, Maynard (1875–1946)

Painter. Primarily self-taught (he was encouraged by Frederic Remington after he sent Remington a sketchbook at the age of sixteen). He was active in the Bay Area and the Southwest from 1893, at first as an illustrator as well as painter. In the 1920s he began painting desert scenes in a stark, highly rhythmic style influenced by the formal simplifications of Cubism. In the late 1930s he turned to Social Realist themes, notably monumental groupings of workers engaged in dynamic action.

Dixon, Willard (1942–)

Painter. Born in Kansas City, Mo.; attended the Art Students League of New York, the Brooklyn Museum School of Art, Cornell University, and SFAI (M.F.A. 1969). His paintings of the early 1970s were prosaic landscapes with grayed atmospheres, punctuated by such incongruous touches as the tiny image of a Mondrian painting isolated in a meadow. In the late 1970s he took a more straightforward approach to landscape, generally choosing spectacular views from high in the hills of Marin County or the East Bay. These paintings combined a photographic literalness with the illusionistic space of an old-fashioned panorama, emphasizing the sense of atmosphere and distance between viewer and images.

Doyle, Joe (1941–)★

Painter. Born in New York; attended San Francisco State University (B.A. 1969, M.F.A. 1971). His early paintings were in a Pop-Surrealist style, painted in the flat manner of signboards. By 1972 he had taken up the airbrush, specializing in paintings of airplanes that frequently emphasized differences in "focus" and increasingly abstract effects. In the mid-1970s he shifted his imagery to the squiggles, globs, and graffiti characteristic of New Wave abstract painting, which he painted in a trompe l'oeil style of "abstract illusionism."

Draegert, Joe (1945–)

Painter. Born in Iowa; attended the Yale School of Art (1967), Kansas City Art Institute (B.F.A. 1968), and U.C. Davis (M.F.A. 1970). His paintings of the mid-1970s focused on the heavy equipment of manual laborers (vises, hammers, railroad locomotives); later, his subject became the tools of the painter himself. Using black-and-white photographs as a starting point, he preserved the original light values but greatly enlarged the images and translated them into intense colors and richly worked surfaces that resembled those of Wayne Thiebaud (one of his teachers at U.C. Davis) and Joseph Raffael.

Dubin, William (1937–)

Sculptor. Born in Los Angeles; attended San Francisco State College and SFAI. Working in wood, he carved visceral and glandular forms which he assembled into constructions that resembled the Surrealist abstractions of Yves Tanguy. The wood was sometimes embellished with imbedded jewels and exotic carved designs.

Dubovsky, Anthony (1945–)

Painter. Born in San Diego; attended Reed College (B.A. 1967) and U.C. Berkeley (M.A. 1970). His formal abstractions of the early 1970s contained modular grids and close-valued colors. He later made "construction paintings" inspired by the techniques of photo montage and by his interest in phenomenology.

Du Casse, Ralph (1916–)

Painter. Born in Kentucky; attended the University of Cincinnati (B.A. 1940) and U.C. Berkeley (M.A. 1948); studied with Hans Hofmann in New York and attended CCAC (M.F.A. 1950). His early paintings ranged from a loose, gestural abstraction to a predominantly linear style rooted in Cubism and resembling the early work of Diebenkorn. His paintings of the 1960s and 1970s were dominated by simpler, thinly stained abstract forms with sources in Oriental philosophy, although some bordered on figuration. He taught at U.C. Berkeley, CCAC, and CSFA, and through the 1970s was chairman of the art department at Mills College in Oakland.

Duena, Victor (1888–1966)

Painter. Born in the Philippine Islands. A dishwasher who painted in his spare time in a cheap North Beach hotel, he was "discovered" by Henri Lenoir; his primitive fantasies, based on memories of early life in the jungle, were displayed in Lenoir's bar, the Vesuvio, during the heydey of the Beat era in the late 1950s.

Duff, John (1943–)

Sculptor. Born in Lafayette, Ind.; attended SFAI (B.F.A. 1967). His spare, linear wall pieces, their armatures wrapped in black electrical tape, suggested primitive or organic forms—boomerangs or pelvic girdles. After leaving for New York in the 1970s, he turned to more austere, geometric constructions of black steel rods.

Dugmore, Edward (1915–)★

Painter. Born in Connecticut; attended the Hartford Art School (1934–1938), CSFA (1948–1950), and the University of Guadalajara, Mexico (1951–1952). His abstractions of the late 1940s generally consisted of heavily applied patches of color in the manner of Nicolas de Staël, sometimes interspersed with thinly brushed areas that seemed to reflect the influence of Rothko. He lived in New York after 1952.

Duncan, Charles Stafford (1892–)

Painter. Born in Hutchinson, Kan. One of the "progressive artists" of San Francisco in the late 1920s, he worked in a style influenced by Cubism and Matisse. In the mid-1930s, he moved toward the massive, stylized forms of Diego Rivera.

Dunham, A. Ward, IV (1941–)

Calligrapher. Born in Denver, Colo.; attended St. John's Military Academy in Delafield, Wis. After becoming interested in calligraphy while stationed in Vietnam in 1964, he continued to instruct himself in the art through the mid-1970s in association with Byron J. Macdonald in New Orleans and Donald Jackson in New York. He moved to San Francisco in the mid-1970s, and has supported himself as a bartender and occasional bodyguard. Eventually concentrating on the Gothic style, and immersing himself in lore of the Gothic period, he has devised elaborate variations on Gothic script, frequently on an extremely large scale and in tandem with dramatic ink drawings of eagles.

Eckart, Charles (1935–)

Painter. Born in Oakland; attended the University of the Pacific (B.A. 1957) and the Art Center School in Los Angeles (B.F.A. 1961). His paintings of the late 1960s were heavily textured mixed media abstractions that looked like slices of street pavement and resembled the early paintings of Howard Hack. In the 1970s he turned to the human figure, painted in dense, linear scrawls and with grotesque distortions that suggested both Francis Bacon and Hans Bellmer.

Ekks, Redd (1937–)

Ceramic sculptor. Born in Oslo, Norway; came to the United States at the age of ten; attended SFAI

(B.F.A. 1959) and CCAC (M.F.A. 1970). His sculpture drew on symbolic motifs from a variety of cultural contexts; these were translated into outrageously comical, garishly colored, and often erotic forms, and were assembled into structures that joined Funk Art and Surrealism.

Elder, Muldoon (1935–)

Painter. Born in California. His early figurative works were pastels that dealt with dancers and other figures in motion. In the mid-1960s he turned to abstract landscapes, working in a rich, densely textured, tapestry-like style related to Abstract Expressionism. He was the founder of the Vorpal Galleries.

Elisofon, Elin (1952–)★

Sculptor. Born in New York City; attended the Haystack Mountain School of Crafts, Deer Isle, Maine (1969), the Skowhegan School of Painting and Sculpture in Maine (1970), and SFAI (B.F.A. 1974).

Ellison, Robert (1946–)

Sculptor. Born in Detroit; attended Michigan State University (B.F.A. 1969, M.F.A. 1971). Active in San Francisco in the late 1970s. His monumental painted steel sculpture translated forms that suggested machinery into whimsical, "soft," seemingly collapsing structures.

Evans, Jan (1927–)

Sculptor. Born in Oakland; attended U.C. Berkeley (1945–1946) and the University of Washington (1946–1948). Initially a painter associated with Mark Tobey in Seattle, she exhibited widely in the Bay Area as a sculptor in the late 1960s and early 1970s. Her spare, geometric abstractions consisted of free-standing, transparent plexiglass cases that contained simple, modular forms of anodized aluminum—generally a U-shape with a notch cut into its center. Arranged at varying intervals, their rhythms suggested a transparent calligraphy.

Fabert, Jacques (1925–)

Painter. Born in Paris; attended the Ecole Nationale Supérieure des Beaux Arts, Paris. His paintings of the late 1960s and early 1970s, when he taught at CCAC, combined hard-edge abstraction with a kind of Pre-Raphaelite Surrealism. Their subjects were usually figures wearing bizarre, Brittany-style headdresses and occupying elegantly patterned landscapes.

Falkenstein, Claire (1908–)★

Sculptor. Born in Coos Bay, Ore.; attended U.C. Berkeley and CSFA (1939). During the 1940s she was a teacher at Mills College and CCAC. In 1950 she left for Paris, where she spent the next nine years, her home and studio serving as the center for other Bay Area artists

who visited and studied there in the early 1950s. After returning to the United States, she settled in Los Angeles. Her sculptures often took the form of networks of slender metal tubes or rods, gathered into intricately crisscrossing open-work thickets or clusters suggesting concentrations of magnetic forces.

Faralla, Richard (1916–)

Sculptor. Born in Brooklyn; came to California in 1934; attended CSFA (B.F.A. 1955) and San Francisco State College (1956). Previously a painter, he turned in 1959 to sculptures and reliefs assembled from small scraps of wood, which he generally painted white; like the wood sculptures of Louise Nevelson, they were built around an essentially Cubist formal vocabulary, animated by a Byzantine intricacy of surface pattern and richness of texture. His earliest works were mosaics made of geometric bits of wood gathered from construction sites. In the early 1960s he began to use driftwood and his constructions became more organic. In the 1970s he concentrated on two-dimensional reliefs, their forms generally inspired by the human figure in motion.

Farley, William (1942–)

Conceptualist. Born in Quincy, Mass.; attended the Vesper George School of Art in Boston (1961–1964), the Skowhegan School of Painting and Sculpture in Maine, the Maryland Institute College of Art in Baltimore (B.F.A.), and CCAC (M.F.A. 1971). Although he received his degree in sculpture, Farley devoted most of his time to filmmaking. He achieved brief notoriety in the early 1970s when he was arrested for a conceptualist stunt in which he had printed (and used successfully to mail letters) several blocks of mock U.S. postage stamps that featured an image of the back of his head.

Farnsworth, Don (1952–)

Painter, printmaker, papermaker. Born in Palo Alto, Calif.; attended SFAI (B.F.A.) and studied at the Chouinard Art Institute in Los Angeles (1972). In 1974 he opened a paper mill in Oakland. It became a center for artists experimenting in handmade paper pulp and related processes.

Farr, Charles Griffin (1908–)

Painter. Born in Alabama; studied at the Art Students League of New York, in Paris, and at SFAI (1967). His realistic landscape and cityscape paintings were characterized by a meticulous technique and subtle simplifications of form, assuming a quiet intensity that approached the expressive qualities of Magic Realism.

Feldman, Bella Tabak (1930–)

Sculptor. Born in New York; attended Queens College in Flushing, N.Y., and CCAC. In the mid-

1970s, she made menacing Surrealist tableaux acrawl with rats made from bronze and aluminum. Her range of animal imagery broadened as she turned to cast paper sculpture. In 1980 her environmentalist themes took more abstract forms, combining luminous fiberglass with thorned rose branches.

Felter, June (1919–)

Painter. Born in Oakland; attended SFAI and CCAC. Her paintings, in a broad Bay Area Figurative style, were generally of landscapes and figures in interiors.

Ferlinghetti, Lawrence (1919–)★

Poet, painter, critic. Born in Yonkers, N.Y.; attended the University of North Carolina (B.A.) and Columbia University (M.A.); came to San Francisco in 1952. His paintings of the 1950s were primarily monochromatic abstractions influenced by Franz Kline. He returned to painting in the late 1970s, working in a crude figurative style that combined elements of expressionism, fantasy, and urban realism.

Fernie, John (1945–)

Sculptor. Born in Kansas; attended the Kansas City Art Institute (B.F.A. 1968) and U.C. Davis (M.F.A. 1970). His installations of the late 1960s and early 1970s were generally built around photographic images of commonplace objects (or sometimes actual objects) in combination with frames, racks, shelves, and other simple constructions of raw wood. These structures were rigidly symmetrical, creating formal environments that encouraged meditation and conferred upon the simple images or objects within them a Zen-like sense of being simultaneously ordinary and extraordinary.

Ferragallo, Roger (1923–)★

Painter, photographer, filmmaker. Attended the Art Institute of Chicago (B.A. and M.A. in art education, 1950 and 1953). An industrial designer in Chicago between 1953 and 1957, he was active in designing for the stage between 1957 and 1961, and taught at Laney College in Oakland after moving to the Bay Area in the mid-1960s. Among his technological inventions was the Ferragallo Console, a multiple projector console designed to control as many as eight different slide projectors.

Finnegan, Jim (1944–)

Sculptor and painter. Born in Janesville, Wis.; attended the University of Wisconsin (B.A. 1968, M.F.A. 1970). Working in wood, generally painted and sometimes combined with other media, he made comical structures, sometimes of environmental dimensions, that frequently parodied the kitsch furniture of Western style restaurants and motels, or the chic excesses of New Wave fashion.

Finneran, Alan (1944–)★

Performance artist. Born in Massachusetts; attended Massachusetts College of Art (B.F.A. 1966) and the University of Michigan (M.F.A. 1968). After experimenting with motorized, movable objects that combined sculpture and painting while still a student, he gravitated increasingly toward multimedia performance art of environmental dimensions. In 1972 he founded and became artistic director of SOON 3, which presented its first performance that year in the rotunda of the San Francisco Museum of Art. Combining elements of theater and dance within a framework of avant-garde lighting and stage design, it was rooted in the "total art" concepts of early modern movements such as the Russian Constructivists and the Bauhaus. The group's productions became increasingly theatrical in character and elaborate in their use of visual effects throughout the 1970s, and won wide acclaim on the East Coast and in Europe.

Finneran, Bean (1947–)★

Performance artist. Born in Ohio; attended Goucher College (1965–1966), the University of Michigan (1967–1968), and the Massachusetts College of Art (1968–1970). A principal performer and designer for SOON 3 since the unit's inception in 1972, in 1982 she also became its associate director.

Fiscus, Richard (1926–)

Painter. Born in Stockton, Calif.; attended U.C. Berkeley (B.A., M.A.). A teacher of humanities at CSFA since 1955, he began to display paintings in the late 1960s. Their subjects were the picturesque towns and landscapes of the East and North Bay, translated into flat areas of color enclosed by heavy black lines.

Fleming, Dean (1933–)

Painter. Born in Santa Monica, Calif.; attended California Polytechnic State University in San Luis Obispo (1951–1952), Santa Monica City College (1955), Mexico City College (1955–1956), and CSFA (B.A. 1958, M.F.A. 1959). Painting in an Abstract Expressionist style, he was active among the North Beach artists, exhibiting at The Six (1957), Spatsa (1959), and Batman (1961) galleries before leaving California in 1962.

Foolery, Tom (n.d.)

Name used by a Bay Area artist, active since the late 1970s, whose specialty is boxes that contain found objects arranged in whimsical, Surrealist tableaux.

Foosaner, Judith (1940–)

Painter. Born in Sacramento; attended U.C. Berkeley (B.A. 1964, M.A. 1968). Her paintings of the early 1970s were abstractions of freeway overpasses, painted in a crisp, hard-edge style and in varying tones of white

or gray. After briefly experimenting with a nostalgic Photo Realist style, she turned to paintings based on the forms of skeletal buildings, and thence to a more abstract style emphasizing loosely shifting geometric planes and variations of light. In the early 1980s she moved to a more gestural, calligraphic abstraction.

Forakis, Peter (1927–)

Sculptor. Born in Hanna, Wyo.; attended CSFA (B.F.A. 1957). A painter in the late 1950s, he worked in an abstract style with symbolic motifs drawn from sources in American Indian art. After moving to New York in 1960, he began making sculpture in a monumental, geometrically abstract style.

Forbes, Deanna (1940–)

Painter. Born in San Rafael, Calif.; attended SFAI (B.F.A. 1962). Her paintings of familiar domestic objects—kitchen utensils, her pet dogs—were done in a realistic style touched with a quirky eccentricity. This quality became more pronounced in the late 1970s, and her imagery gradually grew more fantastic, abstract, and imbued with a sense of latent violence.

Ford, John (1950–)

Painter. Born in Washington, D.C.; moved to California in 1970; self-taught. His abstract paintings of the mid-1970s were filled with broad daubs of pigment in a manner of oversized pointillism. In the late 1970s his style became more monumental, his composition built on Kline-like skeletal architectures dominated by massive diagonals that suggested gigantic spars of timber, painted in flat, bright reds and blacks. He left for New York early in 1980.

Foreman, Doyle (1933–)

Sculptor. Born in Ardmore, Okla.; attended Arizona State University and CCAC (B.F.A. 1960). His cast-bronze sculpture combined three-dimensional forms with ruggedly textured relief and realistic images with symbolic motifs, the latter generally drawn from sources in traditional African art.

Forney, Darrell (1933–)

Painter and collagist. Born in Oregon; attended Sacramento State College (B.A. 1962) and CCAC (M.F.A. 1965). Based in Sacramento, he specialized in collages that emphasized unexpected juxtapositions of realistic imagery, often drawn from old engravings, in the Dada-Surreal manner of Max Ernst. His paintings and drawings used similarly montaged images.

Forrester, Patricia Tobacco (1940–)

Painter. Born in Northampton, Mass.; attended Smith College (B.A. 1962) and Yale University (B.F.A. 1963, M.F.A. 1965); came to the Bay Area in 1967. Her large watercolors concentrated on the lush foliage of trees, with bright, light-saturated colors.

Foster, Barbara (1947–)

Painter. Born in Glendale, Calif.; attended the University of Guadalajara, Mexico (1967), U.C. Berkeley (1968), U.C. Santa Barbara (B.A. 1969), San Francisco State University (M.A. 1971), and Laney College (1976). In the late 1970s her gouache and watercolor paintings on paper pictured interiors of rooms in a way that emphasized highly patterned wallpapers and fabrics and made whimsical juxtapositions of flatness and illusions of space.

Fox, Terry (1943–)★

Sculptor and performance artist. Born in Seattle; self-taught, but studied in Rome in 1962. Came to San Francisco in 1967; also lived in Paris in 1967. Active in San Francisco from 1969 through the mid-1970s, when he moved to New York.

Francis, Sam (1923–)★

Painter. Born in San Mateo, Calif.; attended U.C. Berkeley (1941–1943 and 1949–1950); studied privately with David Park while a patient at Letterman Hospital in San Francisco (1945–1946). After leaving the Bay Area in 1950, he lived in Europe and the Orient before settling in Santa Monica in 1962.

Freeman, John (1938–)

Painter. Born in Richmond, Va.; attended the Richmond Polytechnic Institute, Georgia State College in Atlanta, and SFAI. From an Abstract Expressionist style influenced by Jack Jefferson and Frank Lobdell, he moved in the late 1960s and early 1970s to still life and to interior and figure studies in a high-keyed, painterly manner that had roots in Fauvism and Matisse. Later in the 1970s he concentrated on landscape, in a tremulous, expressionistic style that resembled Kokoschka's, and eventually on scenes that were dominated by mythological themes.

Frey, Viola (1933–)★

Ceramic sculptor. Born in Lodi, Calif.; attended CCAC (B.F.A.) and Tulane University (M.F.A.) She has been an influential teacher at CCAC since 1970.

Fried, Gail (1946–)

Painter. Born in Brooklyn; attended the Brooklyn Museum School (1963), Pratt Institute (1963), the Art Students League of New York (1963–1964), the Tyler School of Fine Arts at Temple University (1963–1966), and SFAI (B.F.A. 1968). In her watercolors of the late 1960s and early 1970s, which were frequently exhibited with the work of the Visionary painters, fluid images of flowers or birds floated against fields of color that suggested skies.

Fried, Howard (1946–)★

Conceptualist. Born in Cleveland; attended Syracuse University (1964–1967), SFAI (B.F.A. 1968), and U.C. Davis (M.F.A. 1970).

Fried, Robert (1937–1974)

Painter, postermaker, sculptor. Born in Brooklyn; attended New York Community College (A.A.) and the Cooper Union, studied in Spain (1963–1965) and at SFAI (M.F.A. 1968). In New York, Fried exhibited at the Brata Gallery with Nicholas Krushenick and Al Held, and became involved with Timothy Leary and LSD. While studying at the SFAI in 1966, he began to make rock dance posters for the Avalon Ballroom. He also made ambitiously scaled paintings that combined organic abstraction with Pop-inspired forms, emphasizing flat, vibrant colors and heavy black outlines in a manner related to Krushenick's painting. In the early 1970s he turned to projects of a more conceptualist kind: printing blocks of "postage stamps," for example, with images that made pointed social criticism. Also in the early 1970s he joined a group of Visionary artists (including Gerald Gooch, Bill Martin, Gage Taylor, and Robert Moon) on an extended trip—sponsored by the San Francisco Museum of Art's Society for the Encouragement of Contemporary Art—to the desert of Baja California. On his return, he began to experiment with bizarre wood constructions—variations on the theme of "walking sticks"—that suggested Dada fetishes. He died in 1974 of a brain hemorrhage.

Friedman, Ken (1949–)★

Sculptor and conceptualist. Born in New London, Conn.; attended San Francisco State University (M.A. 1971). In addition to his prolific activity as a "correspondence artist" and director of Fluxus West, he exhibited a variety of work: it ranged from caricaturish drawings and small abstract paintings to combinations of found objects, generally commonplace and ephemeral ones (sardine tins were a favorite motif), and was characterized by a gentle wit and feeling of reverence for the trivial and particular. He spent most of the 1970s traveling between the Bay Area, San Diego, and New York City, where he settled at the end of the decade.

Fritzius, Harry (1933–)

Painter and assemblagist. Born in Arkansas; attended the Memphis Academy of Art. Associated with the Abstract Expressionist painters in New York in the 1950s, he abandoned art in the 1960s to head his own public relations agency in Mississippi, but left the business world to resume painting when he came to San Francisco in the early 1970s. His extraordinary mixed media paintings and assemblages, founded on a belief that by "destroying" art in its conventional sense he might release its fundamental spiritual energy, were allied in spirit to the funky expressionism of the Beat era. His works combined fractured abstract forms, crudely realistic images, and childishly scrawled religious symbols with tawdry trinkets and found objects to create artlessly vulnerable memorials to personal experiences and records, or scenarios, of hermetic rituals. Sometimes reduced in scale and gathered into book format, his work has a Byzantine richness and an unsettlingly intense, iconic power, suggesting votive objects used in cryptic rites of private worship.

Frost, Nemi (n.d.)

Painter. Active in North Beach in the late 1950s, she painted portraits of many of the local poets in a crisp, Pre-Raphaelite style, against imaginative backdrops that suggested inspiration in Henri Rousseau.

Fuapopo, Sekio (1947–)

Painter. Born in Samoa; came to California in 1954; attended SFAI (B.F.A. 1972) and Sacramento State University (M.A. 1975). His boldly stylized abstract patterns, painted on unstretched canvas cut in shapes resembling shields, evoke the traditional forms and designs of South Sea Islands art.

Fuente, Larry (1947–)★

Assemblagist. Born in Chicago; attended the Kansas City Art Institute (1966–1967). His work of the late 1960s and early 1970s consisted of functional objects—notably a racing car and a toilet—covered with elaborate mosaics of richly colorful found objects in the spirit of Mexican folk artifacts.

Fuhrman, Charles (1939–)

Painter. Born in New York City; attended the Pratt Institute (B.F.A. 1961); came to California in 1976. His abstract paintings emphasize harmonic rhythms arising from the interplay of repeated zig-zag patterns, geometric shapes, and bands of vibrant color.

Garcia, Rupert (1941–)★

Painter. Born in French Camp, Calif.; attended Stockton Junior College (A.A. 1962), San Francisco State University (B.A. 1968, M.A. 1970), and U.C. Berkeley. He was one of the founders of the Galeria de la Raza in San Francisco in 1970. In the mid-1970s he translated the style he had developed in his posters to large works on paper in pastel, and he turned increasingly to portraiture of subjects—Orozco, Frida Kahlo, and the Julius Rosenbergs—who had become heroes of political radicals.

Garfinkel, Ada (n.d.)

Collagist. Attended San Francisco State College (B.A. 1959), SFAI, and the College of Marin. Her collages of the late 1970s combined sheets of rumpled and stained paper with fragmented images and abstract calligraphy to suggest relics of great age.

Gaw, William (1891–1973)

Painter. Born in San Francisco; attended the Mark Hopkins Institute of Art. Associated in the 1920s with The Society of Six, he was an influential teacher from 1938 to 1955 at CSFA (where he was acting director between 1942 and 1945); from 1946 to 1957 he was chairman of the art department at Mills College. His still life and landscape painting, noteworthy for its strong formal stylization and vivid colors, was influenced by Cubism and the paintings of Matisse.

Gay, August (1891–1949)★

Painter. Born in France; attended CSFA (1918–1919). Active in Oakland until 1919 as a member of The Society of Six, he then settled in Monterey, where he shared a studio (the former home of Robert Louis Stevenson) with Clayton S. Price. Influenced by Cubism as interpreted by The Blue Four, his landscapes became increasingly geometric in form.

Gechtoff, Sonia (1926–)★

Painter. Born in Pennsylvania; attended Philadelphia Museum School of Art (1946–1950) and CSFA (1951–1952). Moved to New York in 1958.

Gee, Yun (1906–1963)

Painter. Born in China; came to California in 1921. Associated with Kenneth Rexroth, Jehanne Biétry-Salinger, and other Bay Area avant-garde literary figures of the early 1920s, he studied with Piazzoni and Oldfield at CSFA and developed a style he called "diamondism." This style, influenced by the painting of André Lhote, involved the fragmentation of forms and figures into small, angular facets of color and resembled Orphism in its emphasis on vivid color contrasts. In 1926 Gee established a Chinese Revolutionary Artists Club to teach modern art to young Chinese and Chinese-Americans, and, with Oldfield, opened the short-lived Modern Gallery on the edge of Chinatown. After he left for Paris in late 1926, his style grew more conservative. He alternated residence between Paris and New York until a nervous breakdown ended his career in 1945.

Geis, William (1940–)★

Sculptor. Born in Kansas; attended SFAI (1959–1963, B.F.A. and M.F.A.). In the late 1960s Geis moved from plaster to fiberglass and frequently combined his characteristic organic forms with geometric shapes, in painted metal or transparent plexiglass. In the early 1970s he turned away from large-scale works to concentrate on miniatures made of gnarls and chunks of congealed Fix-All, a cheap, commercial plaster-like substance. These were fitted with various kinds of objects—constructions of wire or wood, broken planes of glass, holograms—and resembled the disheveled wastelands frequently depicted in William T. Wiley's watercolors.

Genn, Nancy Thompson (1929–)

Painter. Born in San Francisco; attended CSFA and U.C. Berkeley (1947–1949). Her abstractions of the late 1950s emphasized calligraphic elements, and suggested sources in images associated with the sea. In the late 1970s she worked in handmade paper, in a style of geometric abstraction. She also did decorative works in enamel on tile, based on natural forms.

Geran, Joseph, Jr. (1945–)

Painter and sculptor. Born in San Francisco; attended San Francisco City College (1966), San Fransisco State College (B.A. 1970), and CCAC (M.F.A. 1972). His paintings and sculptures were strongly influenced by sources in African art.

Giambruni, Tio (1925–1971)★

Sculptor. Born in San Francisco; attended U.C. Berkeley (M.A. 1951). In the early 1960s he began to use cast and formed cement, creating works that resembled the Surrealist sculpture of Miró. After joining the faculty at U.C. Davis, he built a foundry there where he constructed monumental pieces of cast aluminum, sometimes with the addition of bronze fittings. These immense, dramatic sculptures—some as long as thirty feet, and eleven feet or more in height—combined a Baroque exuberance and complexity with the severity of contemporary industrial forms. Some consisted of huge, ringed pipes assembled in structures that Alfred Frankenstein likened to maddened conduits of the kind that run beneath city skyscrapers. Others emphasized rectilinear forms, pierced by organic cut-out shapes or embellished with flat, rounded appendages that resembled the stylized cloud shapes of Chinese painting.

Gibney, Luke (1894–1960)

Painter. Born in Dublin, Ireland; came to San Francisco in 1932. He painted portraits and romantic, nocturnal seascapes while supporting himself as a bartender in North Beach.

Gile, Selden Connor (1877–1947)★

Painter. Born in Maine; attended Shaw's Business School in Portland, Maine. Active in Oakland after 1903, and in Marin County, where he occupied a houseboat-studio in Belvedere after 1927.

Gilhooly, David (1943–)★

Ceramic sculptor. Born in Auburn, Calif.; attended U.C. Davis (B.A. 1965, M.A. 1967). Moved to Canada in 1969, but continued to exhibit regularly in the Bay Area and remained identified with it.

Gill, Charles (1933–)★

Painter. Born in Idaho; attended CCAC (B.F.A. 1955) and Mills College (M.F.A. 1961). A teacher at CSFA between 1959 and 1963, and from 1967 to the present.

Ginnever, Charles (1931–)

Sculptor. Born in San Mateo, Calif.; attended the College of San Mateo (A.A. 1951); the Alliance Française, the Académie de la Grande Chaumière in Paris, and Atelier 17 in Paris (1955); the Italian University in Perugia, Italy; CSFA (B.F.A. 1957); and Cornell University (M.F.A. 1959). His frequently monumental steel sculpture of the 1970s, although geometric and constructivist in style, often suggested sources in the skeletal structures of living organisms. He has lived and worked primarily on the East Coast since the late 1950s.

Gintner, Anton (1941–)

Painter. Born in Berlin; attended Ohio State University (1960–1962) and SFAI (B.F.A 1964, M.F.A. 1965). His paintings, somewhat broader and more illusionistic than Photo Realism in style, centered on buildings in odd corners of San Francisco—Fort Mason warehouses, residential streets in the Sunset district—bathed in rich, warm, twilight colors.

Glassman, Joel (1946–)

Conceptualist. Attended the University of New Mexico (B.F.A. 1967). His sculpture, which he displayed at the Gallery Reese Palley in the late 1960s, generally consisted of enigmatic objects, wrapped in black electrician's tape, that were related to his performance pieces.

Glavin, Matt (1926–)★

Painter and sculptor. Born in Portland, Ore.; attended CCAC (B.A. 1956) and Mills College (M.F.A. 1960). Originally a painter in an Abstract Expressionist style, he turned to sculpture in the early 1960s while sharing studio space with Peter Voulkos; he worked in a large scale and in clean, geometric forms. In the late 1960s, while nearly blinded from a retinal disorder, he teamed with Don Campbell to create sculpture with the only material he could see—laser light. After regaining his sight, he turned primarily to collages (in the early 1970s) and mixed media constructions (in the late 1970s). These works, often inspired by the writings of James Joyce, incorporated a densely layered abstract symbolism of triangles and circles.

Goings, Ralph (1928–)★

Painter. Born in Corning, Calif.; attended CCAC (B.F.A. 1953) and Sacramento State College (M.A. 1966). Moved to New York in the late 1970s.

Goldin, Leon (1923–)

Painter. Born in Chicago; attended the Chicago Art Institute and Iowa State University (M.F.A. 1950). An influential teacher at CCAC between 1950 and 1954, he painted landscapes abstracted to broad masses of color and flat surface patterns.

Goldyne, Joseph (1942–)

Painter and printmaker. Born in Chicago; studied at U.C. Berkeley (B.A. 1964), U.C. San Francisco (M.D. 1968), and Harvard University (M.A. 1970). A medical doctor who had also studied extensively in art history, he turned in the late 1960s to monotypes (and in the 1970s, to paintings) that combined familiar elements from the works of old and modern masters in pastiches that dealt humorously with the myths of art history, particularly the myth of the "fine print."

Gonzales, Robert (1939–1981)

Painter. Born in Phoenix, Ariz.; attended the Chouinard Art Institute in Los Angeles (1958), Arizona State University (1962), and UCLA (1962). Active in San Francisco in the 1970s, he developed a luminous color-field painting, related in feeling to that of Mark Rothko, from origins in an improvisatory, gestural abstraction which he continued to emphasize in works on paper that paralleled his more polished canvases. A year or two before his death from cancer, he moved toward a schematic figurative imagery—sometimes solemn and expressionistic in a manner that resembled Nathan Oliveira, sometimes quirky and humorous in the spirit of children's art and the Bay Area "mythmakers."

Gooch, Gerald (1933–)★

Painter, sculptor, graphic artist. Born in Mannington, W.Va.; attended CCAC (B.F.A. 1965) and San Jose State College (M.A.

Goodell, Kathy (1947–)★

Sculptor. Born in San Francisco; attended SFAI (B.F.A. 1970, M.F.A. 1972).

Gordin, Sidney (1918–)★

Sculptor. Born in Cheliabinsk, Russia; came to the United States in 1922; attended the Brooklyn Museum Art School (1935–1936) and the Cooper Union (1937–1941). Moved to the Bay Area in 1958 to teach at U.C. Berkeley. His principal works have been in a style of constructivist abstraction, frequently spiced with Dada humor. The humor has been especially prominent in small sculptures and wall reliefs of painted wood: tableaux that suggest miniature Art Deco interiors, and black "shadow-boxes" that contain solid geometric forms painted in bright colors. Parallel to his geometric abstraction, Gordin has also done smaller bronze sculptures in organic forms that emphasize an acrobatic sense of movement.

Gordon, Russell T. (1936–)

Painter. Born in Philadelphia; attended Temple University (B.F.A. 1962) and the University of Wisconsin (M.F.A. 1967). Active in the Bay Area (where he taught at Mills College) through most of the 1970s, he painted crisp, highly patterned canvases that centered first on odd permutations of images of fried eggs, and later of light bulbs, in interiors or landscape settings. In the late 1970s he turned his realistic style to more abstract subjects, concentrating on shapes and patterns that suggested those of torn and peeled wallpapers.

Gould, Mary (1923–)

Sculptor. Born in Seattle; attended SFAI and U.C. Davis. She made life-sized and larger-than-life figures in stuffed fabrics, fancifully distorted and frequently combined in dramatic tableaux.

Gover, Roy (1927–)

Painter. Born in London; attended Willesden College of Art, London (1941–1944). Came to San Francisco in 1958. His small, whimsical abstractions, strongly influenced by Paul Klee, combined organic and geometric forms and schematic symbols, and suggested fantastic landscapes.

Goya-Lukich, Jorge (1924–)★

Painter. Born in Ohio; attended Western Reserve University (early 1940s) and CSFA (1947–1950).

Grace, Cynthia (1941–)

Painter. Born in San Francisco. Her paintings, associated with the Visionary school, contained shimmering fields of color on which were superimposed intricate linear "drawings"; sometimes the "drawing" depicted the transparent images of figures, waterfalls, and mountain ranges, and sometimes it made repetitive abstract patterns of flowing movement.

Grachis, Dimitri (1932–)

Painter. Attended CSFA (1954–1957). An Abstract Expressionist painter during his student years, he developed a more formal, geometric approach to abstraction, buttressed by an elaborate philosophical and mathematical theory.

Grafton, Frederick (1952–)

Painter. Born in Middletown, Conn.; attended CCAC (B.F.A. 1976). His paintings of the late 1970s are large watercolors that focus on images of transparent plates of glass, sometimes slightly cracked or chipped along the edges and placed in neutral interior settings. They are painted in a bland, impersonal style so that trompe l'oeil "realism" becomes virtually identical with the formal abstraction of their geometric shapes, the areas of light that they refract, and the shadows that they cast.

Graham, Robert (1938–)★

Sculptor. Born in Mexico City; attended San Jose State College (1961–1963) and SFAI (1963–1964). Before leaving for Los Angeles in 1964, he had begun to develop the tiny, cast bronze nude figurines—"bronze Barbie dolls," as a classmate at SFAI described them—for which he later became well known.

Grant, Art (1927–)★

Sculptor and conceptualist. Born in San Francisco; attended San Francisco City College (1945–1948), San Francisco State College (1954–1955 and 1956–1958), CSFA (1955–1956), and the College of Marin (1958–1962). A junk sculptor in the late 1950s who specialized in assembling chunks of partially burned wood, he turned in the early 1970s to festive and highly public installation and performance pieces, which first involved using blocks of colored dry ice, and later made use of foodstuffs of various kinds—bananas, pizzas, jelly beans.

Grant, James (1924–)

Painter and sculptor. Born in Los Angeles; attended USC (B.E. 1945, M.F.A. 1950) and the Jepson Art Institute in Los Angeles (1947–1949). After developing a complex form of collage-painting in which he saturated layers of canvas, fabric, and paper in bright, transparent colors, he came to the Bay Area, where he became known in the late 1960s for simple, polychrome target patterns cast in discs of polyester resin.

Grant, Josie (1949–)

Painter. Born in Los Angeles; attended SFAI (B.F.A. 1970, M.F.A. 1972). Her Visionary paintings gathered profusions of precisely detailed images into structures that were dominated by abstract massings of light and shadow and by intimations of symbolic geometries.

Greeley, Charles (1941–)

Painter. Born in New Jersey; attended the New York School of Visual Arts (1963) and came to San Francisco in 1967. Associated with the Visionaries, his paintings used a pointillist technique to create dense abstract fields that suggested interstellar tide pools. He was associated with John Almond in founding the San Francisco Art Commission's Capricorn Asunder Gallery.

Greer, Charles (1945–)

Painter. Born in Dallas, Tex.; attended SFAI (B.F.A. 1967, M.F.A. 1969). His works on paper, primarily in

pencil with accents of paint, portrayed inanimate objects—generally old clothes and clothes hangers—against backgrounds of old walls, in an intensely realistic style that bordered on Surrealism.

Griffin, Rick (1944–)★

Postermaker and cartoonist. Born in Los Angeles; briefly attended the Chouinard Institute of Los Angeles, but essentially self-taught. His rock posters, which he began to produce in 1967, emphasized hip symbols of fertility and nature—Indians, marijuana plants—executed in a meticulous, boldly stylized, and emblematic style that recalled the traditions of nineteenth-century advertising art and packaging design.

Grillo, John (1917–)★

Painter. Born in Massachusetts; attended the Hartford Art School (1935–1938) and CSFA (1946–1948). Grillo was described by Douglas MacAgy as one of the earliest "action painters" at CSFA. He moved to New York in the early 1950s.

Gronborg, Erik (1931–)

Sculptor. Born in Copenhagen; attended U.C. Berkeley (B.A. 1962, M.A. 1963). Living and working on the Northern California coast in the 1970s, he assembled elegant constructions of wood, sometimes with additions in steel and ceramic, that combined geometric and organic shapes and had overtones of Surrealist ritual objects.

Growden, James (1944–)

Sculptor. Born in Muskegon, Mich.; attended Western Michigan University (B.F.A. 1969) and SFAI (M.F.A. 1972). His wall pieces and free-standing sculptures, assembled largely from cast-off industrial objects found along the waterfront, were spindly but taut linear structures, generally symmetrical, that suggested strange talismans and totems.

Gutierrez, Louis (1933–)

Painter. Born in Oakland; attended Diablo Valley College (A.A. 1954), San Jose State College (B.A. 1957), and the Instituto San Miguel Allende, Mexico (M.F.A. 1958). His collages of the mid-1960s emphasized highly textured surfaces on a structure of overlapping geometric planes. In the late 1960s he moved first to more flowing abstract paintings in vibrant, densely layered colors, and then to broadly figurative works in which the image serves as a scaffolding for rich surface and color effects.

Gutierrez-Solana, Carlos (1947–)

Painter and performance artist. Born in Havana; attended Kansas City Art Institute (B.F.A. 1970) and U.C. Berkeley (M.A. 1972). He moved from figurative painting to abstraction and then to nonrepresentational work in which painterly gestures were anchored to a rigorous grid structure. In the mid-1970s he began to incorporate elements of performance into his work, placing cast latex figures in environmental settings that became grounds for participatory "action drawing."

Gutkin, Peter (1944–)★

Sculptor. Born in Brooklyn; attended the Tyler School of Art, Temple University (B.F.A. 1966) and SFAI (M.F.A. 1968).

Hablig, Beatrice (1945–)

Painter. Born in Oakland; attended Laney College and U.C. Berkeley. From paintings in a realistic style of underwater fantasies involving sharks and Egyptian ruins, she moved in the mid-1970s to works that concentrated on the increasingly abstract forms of human skeletons painted on supports pieced together from heavy brown paper and resembling fragments of old walls. In the late 1970s she developed this approach into a unique form in which painting approached the physical presence of sculpture; her method was to tear, rearrange, destroy, and reconstruct the paper supports so that the format itself could change and grow, in tandem with the forms painted on it, like the tissues of a living organism. Her immense abstractions, in irregular organic shapes, projected a grandeur of pure form and scale while retaining a charge of symbolic associations from the images or ideas that had initially inspired them—a cross, Athena's saffron veil, shapes that suggested the slumbering peril of intercontinental ballistic missiles.

Hack, Howard (1932–)

Painter. Born in Wyoming; attended Mills College (1949), CCAC (1956–1957), and the University of San Francisco (B.S. 1962); studied privately with Martin Baer. His paintings of the early 1960s incorporated the simple shapes of street markings and manhole lids into the richly textured paint surfaces of Abstract Expressionism, underlining their similarity to the "real" textures of asphalt pavement. He then turned to windows, at first emphasizing gestural, "dust"-streaked surfaces, and later concentrating more on the views seen through them: usually interiors of old offices and storefronts, furnished with vintage desks and safe boxes, in the picturesque area of San Francisco where he had his studio—on Mission Street, just off the Embarcadero. Later in the 1960s he began to focus on increasingly bizarre images of a quasi-Oriental cast, and made "blueprint drawings" based on signs of the zodiac. In

282

the 1970s he concentrated on silver-point drawings, which alternated between renderings of exotic images and of commonplace objects that sometimes assumed an unreal intensity. Hack's first "store windows," with their "grime" and "spatters" and "fingerprints"—gestural markings largely made over into the neutralized subjects of a more illustrative representation—formed one of the early links between Bay Area Figurative painting and the Photo Realism that developed from it in the late 1960s.

Haley, John (1905–)★

Painter. Born in Minnesota; studied in Minneapolis (with Cameron Booth), Paris, Munich (with Hans Hofmann), Capri, and Ravenna, and came to teach at U.C. Berkeley in 1930. His paintings of the 1960s and 1970s emphasized central forms composed of simple, gestural swatches and arabesques of color in the manner of Guston's abstract paintings, their margins worked into plain white or light-colored grounds.

Hall, Susan (1943–)

Painter. Born in Kentfield, Calif.; attended CCAC (B.F.A. 1965) and U.C. Berkeley (M.A. 1967). Her paintings of the late 1960s were abstractions in which forms were boldly defined in heavy black lines and entered into dynamic rhythms that seemed to move in and out of space. After leaving for New York in the 1970s, she adopted an arch, schematically figurative style.

Halpert-Ryden, Jean (1919–)

Painter. Born in New York; attended Brooklyn College; came to California in 1949. Her highly stylized figurative and architectural abstractions were derived from synthetic cubism, with an emphasis on heavy black lines that recalled the paintings of Max Beckmann.

Hamilton, Frank (1923–)

Ceramist and painter. Born in Tennessee; studied at Colorado College and Stanford University (B.A. 1948). An instructor in ceramics at SFAI in 1958–1959, he taught himself to paint in 1960. His early paintings were abstractions animated by fluid, sometimes pictographic shapes that suggested the markings of medieval maps. In later paintings, he played areas of small forms in rapid movement against the geometry of vertical stripes.

Hamlin, Edith (1902–)

Painter. Studied at CSFA. She is best known for her murals, which include the "hunting scenes" at Coit Tower and frescoes and mosaics in many places in California, Arizona, Wyoming, Utah, and Illinois. They range in style from figurative realism to geometric abstraction, and varying combinations of the two.

Hamm, Bill (1932–)★

Painter and light-show artist. Born in Greenville, Miss.; attended the University of Houston (B.F.A. 1954).

Handelman, Edward (n.d.)

Painter. Attended the University of Omaha (1955–1956), SFAI (1956), and the University of Florence (1957–1959). His paintings of the late 1960s were in an expressionist figurative style related to that of Nathan Oliveira, and incorporated fragments of posters and other collage elements. In the 1970s he turned to more fanciful themes in a loose, shifting, out-of-focus style.

Hannah, David (1937–)

Painter. Born in Sherman, Tex.; attended the University of Oklahoma, Rice Institute, and SFAI (M.F.A.). His paintings of the mid-1970s were immense abstractions in which ponderous, labyrinthine shapes moved through heavily worked fields of rich color in a manner reminiscent of Julius Hatofsky. In the late 1970s his colors became more restrained, and he explored images of simple, straightbacked chairs that were turned at various odd angles and appeared to float through ambiguous spaces.

Hansen, Armin (1886–1957)★

Painter. Born in San Francisco; studied at the Royal Academy in Stuttgart, Germany, and in Munich and Antwerp. After returning to California in 1913, he settled in Monterey, where he was active as a teacher. Influenced by Manet and Monet, he was known principally for seascapes and harbor scenes, done in a broad, painterly style that sometimes approached the vigor of George Bellows.

Hanson, Jo (n.d.)

Conceptualist sculptor. Born in Carbondale, Ill.; attended the University of Illinois and San Francisco State University (M.A. 1973). Her first major work, installed at the San Francisco Museum of Modern Art in 1975, was a replica of a country cemetery in southern Illinois where generations of her family were buried; it included life-sized reconstructions of tombstones, transparent filmstrips of the surrounding woods, and tape-recorded sounds. In 1980 she displayed folios filled with litter, collected from the street in front of her Pacific Heights home and catalogued as anthropological documentation, in the lobby of the San Francisco City Hall.

Hanson, Mel (1938–1962)

Painter and assemblagist. Born in Stockton, Calif.; attended the College of the Pacific (B.A. 1960, philosophy). In the late 1950s and early 1960s he was associated with a group of bohemian painters, including William

Appendix: Bay Area Artists

Snyder, Jack Farloux, and Terry St. John, who lived and worked in an old Stockton firehouse and exhibited together at the Green Gallery in San Francisco in 1960 as the Firehaus Group. Hanson, like the others, worked in a broad, Bay Area Figurative style touched with elements of funky art. Shortly before his death, however, influenced by Snyder's interest in the fantastic qualities found in the icons of contemporary pop culture, he completed a large painting, *The Temptation of St. Walt Disney,* in which his interest in German Expressionism took on overtones of Pop art.

Hanson, Suzanne (1942–)

Painter. Born in Huron, S.D.; attended the University of South Dakota (B.A. 1964), the University of Michigan (M.A. 1965), and Mills College (M.F.A. 1977). Her paintings of the late 1970s were made by exposing sheets of oatmeal paper to the elements and then cutting, tearing, adding touches of Prismacolor or fragments of photographs, and reassembling the components into loosely geometric structures.

Harris, Paul (1925–)★

Sculptor. Born in Orlando, Fla.; attended the University of New Mexico and the Hans Hofmann School in Provincetown, Mass. In addition to producing sculptures in stuffed fabric, Harris worked in bronze, generally fashioning forms based on the imagery of traditional still-life objects (bottles, ink wells, vases of flowers) but with unexpected dislocations of perspective and scale and frequent allusions to sources in well-known sculpture or paintings of the past.

Hartman, Robert (1926–)

Painter. Born in Sharon, Pa.; attended the University of Arizona (B.F.A. 1951, M.F.A. 1952), the Colorado Springs Fine Arts Center, and the Brooklyn Museum Art School. Since the 1960s he has been a teacher at U.C. Berkeley. An aviator in his spare time, he made paintings in the 1960s in which loosely brushed and stained atmospheres and "clouds" were often combined with inset renderings of vintage aircraft. These gradually receded from his work, which in the early 1970s was dominated by amorphous abstract masses resembling clouds; later, more ordered planes of thinly stained colors suggested aerial views of fields and the rolling foothills around Mount Diablo in Contra Costa County. He also took up aerial photography.

Harvey, Robert (1924–)★

Painter. Born in Lexington, N.C.; attended the Ringling School of Art in Sarasota, Fla., the Art Students League of New York, and SFAI. Since the early 1970s Harvey has lived primarily in Spain. His recent work has emphasized flat, highly patterned silhouettes and decorative motifs suggesting those of wallpaper.

Hasegawa, Sabro (1906–1957)

Painter. Born in Japan; attended the Imperial University in Tokyo. A visiting instructor at CCAC in the early 1950s, he also taught calligraphy at the American Academy of Asian Studies organized by Alan Watts. He was highly influential in the awakening of interest among Bay Area artists in Japanese calligraphy, and in its relationship to Abstract Expressionism as well as to Zen Buddhism. His esthetic philosophy was the subject of a book, *Hasegawa, Master of the Controlled Accident,* published by the Oakland Art Museum. In his own work, he sought to translate the qualities of French Impressionism and the School of Paris into the traditional Japanese idiom.

Hatofsky, Julius (1922–)

Painter. Born in Ellenville, N.Y.; attended the Art Students League of New York (1946–1950), the Académie de la Grande Chaumière in Paris (1950–1951), and the Hans Hofmann School of Fine Arts in New York (1951–1952). When he came to San Francisco to teach at SFAI in 1961, at the invitation of Frank Lobdell, Hatofsky had already received attention in New York for Abstract Expressionist paintings that emphasized darkly glowing colors, heavily varnished surfaces, and ponderous, labyrinthine forms that sometimes suggested convulsive, churning movement. These works were strongly influenced by his admiration for the visionary paintings of Albert Ryder and William Blake. In his paintings of the 1970s he frequently introduced images of tiny, ambiguous figures that seemed to hurtle through vast spaces, dwarfed by the elements.

Hayward, James (1943–)

Painter. Born in San Francisco; attended San Diego State University (B.A. 1966), UCLA (1966–1969), and the University of Washington (M.F.A. 1972). His paintings of the late 1970s were divided into equal rectangles or squares of starkly contrasting, densely layered black and white. By 1980 he had simplified his conception still further, producing squares that were all white or all black, painted by a mechanical process from which all traces of incident or personality were removed.

Hazard, Ben (1940–)

Painter and sculptor. Born in Newport, R.I.; attended Vallejo Junior College (1963–1965), CCAC (B.F.A. 1968), and U.C. Berkeley (M.F.A. 1969). His paintings and prints of the late 1960s used a cool, emblematic style for expressionist themes that were frequently edged with social comment. Since 1970 he has been curator of special exhibitions and education at The Oakland Museum.

Hedrick, Wally (1928–)★

Painter and assemblagist. Born in Pasadena, Calif.; attended the Otis Art Institute in Los Angeles, CCAC, CSFA (B.F.A. 1955), and San Francisco State College (M.F.A.). A co-founder and director of The Six Gallery.

Heineman, Carol (1945–)

Painter. Born in Milwaukee; attended Carnegie-Mellon University in Pittsburgh (B.A.), the University of Wisconsin (M.A.), SFAI, and the Art Students League of New York. Active in California from 1965 to 1975. Associated with the Visionary artists, Heineman generally worked on paper, combining dense linear thickets drawn in graphite with transparent stains of color to create the outlines of heads or figures that resembled those of Salvador Dali or Hans Bellmer.

Heizer, Michael (1944–)★

Sculptor. Born in Berkeley; attended SFAI (1963–1964). Heizer, whose father, Robert Heizer, was a distinguished archeologist on the faculty at U.C. Berkeley, became known for the massive "earthwork" sculpture he began to pursue in 1967, after he had left the Bay Area for the East Coast.

Hellyer, Sally (1919–)

Sculptor. Born in Portland, Ore.; attended CSFA. Her sculpture of the late 1960s, primarily of painted plaster, was abstract, organic, and frequently erotic in its associations.

Henderson, Mel (1922–)★

Sculptor and conceptualist. Born in Colfax, Calif.; attended CCAC (B.A. 1955) and Mills College (M.F.A. 1961). In the mid-1960s he worked in a Funk style in plaster and aluminum. He later made kinetic contraptions in wood that suggested crude machines. In the 1980s he turned to environmental works that involved a sometimes almost unnoticeable modification of natural forms in their own settings.

Henderson, Mike (1943–)

Painter. Born in Marshall, Mo.; attended SFAI (B.F.A., M.F.A. 1970). His collage-paintings were gestural abstractions that often comprised fragments of earlier painted canvases that had been torn, burned, and otherwise mutilated.

Henderson, Robbin (1942–)

Painter and sculptor. Attended SFAI (1969–1970). Her constructions emphasized simple, repetitive structures that served as scaffoldings for material with richly varied surfaces and textures.

Henry, Robert (1944–)

Painter and sculptor. Born in Chicago; self-taught. Came to San Francisco in 1968. Associated with the Blackman's Gallery in the late 1960s and early 1970s, he painted the violent side of life in the urban black ghetto in a blunt, expressionistic style.

Herman, Richard (1945–)

Painter. Born in the Canal Zone, Panama; attended CCAC (B.F.A. 1971, M.F.A. 1975). His mixed media paintings were in a broad, figurative style, and emphasized idiosyncratic juxtapositions of images.

Herman, Roger (1947–)

Painter. Born in Saarbrücken, West Germany; attended the Universität des Saarlandes (1969–1971); Hochschule für Zeichnung, Darmstadt (1971–1972); Staatliche Akademie der Bildenden Künste, Karlsruhe (1972–1976). Came to the Bay Area in 1977. His heroically scaled canvases focused on broad, simple images that became arenas in which dense, aggressively slashed brushloads of paint were alternately built up and destroyed in an equivocal dialogue between gesture and form, and between the emotionalism or rhetoric of action painting and the calculation and reserve of Formalist abstraction. As the first exponent of German neo-Expressionism to take up residence in the Bay Area, Herman exerted a strong influence on many younger painters before he left for Los Angeles in 1982.

Herms, George (1935–)★

Assemblagist. Born in Woodland, Calif.; studied engineering at U.C. Berkeley (1955–1956).

Hernandez, Robert (1943–)

Painter. Attended San Francisco State University (B.A.) and Mills College (M.F.A. 1974). In the mid-1970s he made wall constructions in a variety of materials—cardboard, lead, aluminum. They combined a linear geometry with ragged-edged fragments in structures that suggested a spare, gestural calligraphy. In the late 1970s he turned first to large drawings and then to paintings, which generally consisted of loose scrawls of white through a black ground.

Hernandez, Sam (1948–)

Sculptor. Born in Hayward, Calif.; attended California State University, Hayward (B.A. 1970), and the University of Wisconsin (M.F.A. 1974). His carved and often painted wood sculpture combined Surrealist fantasy with forms and motifs that had sources in the art of Southwestern Indians.

Hero, Michi (1943–)

Sculptor. Born in Tokyo; attended Tokyo Sumindo Technical School of Architecture (graduated 1961) and

SFAI (M.F.A. 1970). Active in the Bay Area in the early 1970s, he made sculpture of simple, structural forms that emphasized the juxtaposition of surfaces and textures of different materials.

Hershman, Lynn (1941–)*

Conceptualist sculptor. Born in Cleveland; attended Ohio State University, the Cleveland Institute of Art, Case Western Reserve University (B.S. 1963), UCLA, the Otis Art Institute, CCAC, and San Francisco State University (M.A. 1972). In the late 1970s she founded and directed The Floating Museum, a flexible support organization which sponsored a variety of conceptualist activities that ranged from performance pieces to the painting of a mural on an outdoor wall at San Quentin prison; the mural was completed in collaboration with inmates, who also chose the subject—a view of the countryside directly beyond.

Hibi, Hisako (1907–)

Painter. Born in Fukuiken, Japan; attended CSFA (1926–1929), the school of the Museum of Modern Art in New York (1952–1954), and U.C. Extension (1966–1968). Her paintings were gentle, lyrical abstractions in which small, squiggly shapes moved through light-saturated, atmospheric fields to evoke sensations of natural forms and seasonal changes.

Hiersoux, Arne (1938–1983)

Painter. Born in West Virginia; attended U.C. Berkeley (M.A. 1968). His works of the early 1960s were big abstractions that combined collage with elegantly flung paint. In the mid-1960s he developed a hard-edge style in which symbolic and organic shapes became the dramatis personae of abstractions whose geometric planes suggested the walls of anonymous interiors. In the early 1980s, after an absence of several years from the art world, he joined Donald Farnsworth to found the Magnolia Papermill Press, a printmaking facility in Oakland.

Higgins, Ed (1934–)

Painter. Born in San Bernardino, Calif.; attended Santa Rosa Junior College (A.A. 1959), Chico State College (A.B. 1960), San Francisco State College, and U.C. Davis (M.A. 1965). His paintings of the late 1960s and 1970s were Surrealist fantasies that drew on imagery of the countryside around the Carquinez Strait. In his later paintings, images became increasingly subordinate to intricate abstract patterns.

Hilger, Charles (1938–)

Sculptor. Born in Garden City, Kan.; attended Kansas State University, Wichita (B.A. 1962), and U.C. Santa Cruz (M.F.A. 1976). One of the earliest Bay Area artists to specialize in handmade paper pulp as a medium, Hilger worked with Garner Tullis in the mid-1970s at Tullis's Center for Experimental Printmaking in Santa Cruz. He fashioned simple, abstract, frequently layered forms, preserving the natural white of the raw material. These generally functioned as wall hangings.

Hoare, Tyler James (1940–)

Sculptor and printmaker. Born in Joplin, Mo.; attended the University of Colorado, the Sculpture Center in New York, the University of Kansas (B.F.A. 1963), and CCAC. He assembled figures in often humorous combinations of found and tooled objects, primarily of wood, coupling a basically Cubist style with overtones of Surrealism. Some of Hoare's pieces occupied the anonymous, grassroots sculpture garden that began to flourish in the mid-1960s on the mudflats in Emeryville. In the 1970s he was one of the earliest Bay Area artists to experiment with color xerox as a medium for printmaking.

Hobbs, Fredric (1931–)*

Painter, sculptor, filmmaker, conceptualist. Born in Philadelphia; attended Cornell University (B.A.) and the Academia de San Fernando de Bellas Artes in Madrid. Served as chairman of the Department of Fine Arts, Lincoln University, San Francisco, 1963–1965. In addition to his activities as an artist, Hobbs organized the San Francisco Art Center, a complex of exhibition and studio space on 14th Street in the Mission district, and directed it through most of the 1960s.

Hocking, Philip (1940–)

Painter. Born in Palo Alto, Calif.; attended CCAC (B.F.A. 1962, M.F.A.). Associated with the Visionaries in the late 1960s and early 1970s, he was influenced by Sufi poetry and the writings of Meher Baba. His oils and small, delicate watercolors alternated between relatively straightforward landscapes—mountain ridges, deserts—and images of shells or gauzy draperies that were startlingly displaced from their normal contexts. His emphasis in both was on light and atmosphere, his forms frequently dissolving in shimmers that suggested waves of heat.

Hoefer, Wade (1948–)*

Painter. Born in Long Beach, Calif.; attended CCAC (B.F.A. 1970, M.F.A. 1972). In the 1970s, Hoefer turned to paintings, still highly textured, that concentrated on the interaction of one or two simple, pictographic abstract shapes against wall-like grounds.

Hofmann, Hans (1880–1966)*

Painter. Born in Weissenberg, Bavaria, Germany; attended the Gymnasium Munich and the Académie de la Grande Chaumière in Paris (1904). He opened his first art school in Munich in 1915, and came to the United States in 1930 to teach at U.C. Berkeley. He opened an

art school in New York in 1933 and a summer school in Provincetown, Mass., in 1934 (where he taught until 1958).

Holdeman, Robert (1912–)

Painter. Born in Nebraska; came to California in 1919; attended Los Angeles City College and Chouinard Art Institute. Came to San Francisco in 1954 to teach at CCAC. Primarily a watercolorist, he painted in a variety of styles that ranged from realism to abstraction.

Holdsworth, Anthony (1945–)

Painter. Born in Bournemouth, England; attended the Bournemouth College of Art (1968–1970) and SFAI (1971–1973). His paintings, in a broad figurative style, alternated between a proletarian realism and more exotic subjects, with overtones of both van Gogh and Gauguin.

Holland, Tom (1936–)★

Painter and sculptor. Born in Seattle; attended Willamette University, Salem, Oregon (1954–1956), U.C. Santa Barbara (1957), and U.C. Berkeley (1957–1959).

Holman, Arthur (1926–)

Painter. Born in Oklahoma; attended the University of New Mexico (B.F.A. 1951), the Hans Hofmann School of Fine Arts in New York (1951), and CSFA (1953). Holman's abstract paintings of the 1950s used regular, abbreviated brush strokes—almost a kind of pointillism—to build subtly modulated surfaces of extremely close-valued colors. They paralleled in some ways the highly formal, non-objective paintings that Robert Irwin was simultaneously developing in Los Angeles, although Holman's abstractions remained grounded in impressions of nature: natural light, natural spaces. In the 1960s and 1970s he turned to more clearly defined, visionary landscapes bathed in radiant colors and reminiscent of the paintings of Bonnard.

Holmes, Douglas (1940–)

Sculptor. Born in Lafayette, Ind.; attended CCAC (B.F.A. 1968, M.F.A. 1970). Combining organic and geometric forms, often in material that ranged from cast metal to vacuum-formed plastic, his sculpture was generally based on ideas that involved ecological issues.

Horton, M. M. (n.d.)

Painter. Attended the Portland (Ore.) Art Museum School, the Corcoran Art Museum School in Washington, D.C., and SFAI (M.F.A. 1967). Her paintings of the late 1960s, in a crude, expressionistic style, ranged from psychedelic abstraction to whimsical versions of Pop-related themes, such as interior views of Woolworth stores.

Howard, Blanche Phillips (1908–1979)

Sculptor. Born in Mt. Union, Pa.; attended the Cooper Union, the Art Students League, and the Steinhof Institute of Design in New York; also studied at CSFA, and with Ossip Zadkine. Lived in the Bay Area between 1942 and 1950, and again in the 1970s. Associated with Louise Nevelson and other members of the "New Sculpture Group" in New York in the 1950s, she made expressionistic abstractions, primarily in brass, which she exhibited at the Stable Gallery. After returning to the Bay Area in the 1970s, she turned to fragmentary figures, generally in relief, modeled after classical sources.

Howard, Charles (1899–1978)★

Painter. Born in Montclair, N.J.; attended U.C. Berkeley (graduated in 1921). Between 1922 and 1940, Howard lived in New York and England, where he associated with the European Surrealists. His painting of the late 1930s and early 1940s had sources in Miró and Synthetic Cubism. It influenced several Bay Area artists while Howard lived in San Francisco between 1940 and 1946 (teaching at CSFA in 1945). At the end of the Second World War, he returned to England.

Howard, John Langley (1902–)

Painter. Born in Montclair, N.J.; came to California in 1902; attended the Art Students League in New York (with Kenneth Hayes Miller), U.C. Berkeley, and CCAC. A brother of Robert and Charles Howard, John Langley remained little affected by modernist styles throughout a long career in which he concentrated on landscape and related subjects, working in a meticulous style that bordered on Magic Realism. He was one of the muralists of Coit Tower, and an illustrator for many years for *Scientific American* magazine. He was married to the sculptor Blanche Phillips Howard.

Howard, Robert (1896–1983)★

Sculptor. Born in New York City; attended CCAC, U.C. Berkeley (1915–1916), and the Art Students League in New York (1916–1917). One of the influential Bay Area sculptors of the 1940s and 1950s, Howard was one of the four sons of John Galen Howard, the architect of the principal buildings on the U.C. Berkeley campus; three of the sons were artists, as were their wives, and the fourth was an architect. Influenced by Miró in the 1940s, Robert Howard turned away from his Art Deco stylizations of the 1930s (although they surfaced again in large-scale fiberglass figures that he did in the 1970s) to more fanciful, quasi-primitive forms. These frequently suggested bones, prehistoric birds, or dinosaurs. Howard experimented with fiberglass as early as 1950 (in *Nightwatch*) and was a Bay Area pioneer of kinetic sculpture. Most often, his sculpture contained elements ingeniously balanced on ball-and-

socket joints so they could be set in motion by the viewer. Howard's wife was the sculptor Adaline Kent.

Howell, Raymond (1927–)

Painter. Born in Oakland; self-taught. His paintings combined urban realism with fantasy in a baroque style strongly influenced by that of Reginald Marsh.

Hudson, Robert (1938–)★

Sculptor. Born in Salt Lake City; grew up in Richland, Wash.; attended SFAI (B.F.A. 1962, M.F.A. 1963). In the 1970s Hudson turned to rustic constructions similar to those of William T. Wiley, although they often contained a more Baroque profusion of objects—beer cans, a fishing basket, a stuffed and painted deer—and their surfaces were more brightly colored. He also returned frequently to painting, generally combining gestural abstraction, geometric shapes, and fragmentary images to establish contradictions between illusionistic spaces and the flat surface.

Huette, Julia (1948–)

Painter. Born in Saint Louis; attended Bradford Junior College, Bradford, Mass. (1968), the University of Michigan (B.F.A. 1970), and U.C. Berkeley (M.A. 1972, M.F.A. 1973). Her paintings, primarily watercolors, focused on interiors of genteel apartments, viewed from radical angles that emphasized the abstract qualities of their appointments and furnishings.

Hughes, Joseph (1941–)

Painter. Born in West Virginia; attended Marshall University, W.Va. (B.A. 1964, M.A. 1967), the University of London, the University of Cincinnati, and the Art Academy of Cincinnati. He was among a "second generation" of color-field painters active in the late 1970s, most of them associated with the Shirley Cerf Gallery and later the Bluxome Gallery, who explored large areas of color, sometimes subdivided into simple, symmetrical geometric planes, built up in multiple layers of paint.

Hultberg, John (1922–)★

Painter. Born in Berkeley; attended Fresno State College (B.A. 1943), CSFA (1947–1949), the Art Students League of New York (1949–1951). Hultberg's paintings of the late 1960s (when he alternated residence between San Francisco and Honolulu) continued to suggest distant views of gigantic megalopolises, seen from overhead, although their broad, expressionistic style bordered on abstraction.

Humble, Patrick (1932–)

Painter. Born in London; self-taught; came to the Bay Area in 1959. Humble's Abstract Expressionist

paintings played amorphous nimbuses of softly stained acrylics against intimations of geometric structures that suggested windows opening through space to still deeper spaces. Calligraphic elements of a vaguely Oriental cast became more prominent in his work in the late 1970s.

Hyde, Nick (1943–)

Painter. Born in San Francisco; attended the San Francisco Academy of Art (B.A. 1967), SFAI (M.F.A. 1971). Associated with the Visionary group, Hyde painted in an apocalyptic style resembling the later work of George Grosz. His profusions of figurative images were engulfed in swirling color masses that resembled the abstract forms of liquid light projections.

Ideal, Phillis (1942–)

Painter. Born in Roswell, N.M.; attended the University of New Mexico (B.F.A. 1964), New York University (M.A. 1966), and U.C. Berkeley (M.F.A. 1976). Her paintings of the late 1970s focused on simple, generally symmetrical shapes that suggested sources in architectural elements, brushed into grounds built up in many layers of paint so that the forms resembled images worn into the structures of old walls.

Ireland, David (1930–)★

Sculptor. Born in Bellingham, Wash.; attended CCAC (B.A. 1953) and SFAI (M.F.A. 1974). Ireland worked as an industrial designer, and then, after having lived for a period in West Africa, as a safari guide with his own North Beach retail store that sold big-game skins, before he resumed his studies of art in the early 1970s. In 1983, he completed a second structure, a few blocks away from his original house, which was its esthetic opposite, or complement: sheathed in corrugated metal, its interior fastidiously finished with sheetrock, it was as severely constructivist and minimalist in style as the older building was funky Gothic with a touch of the Dadaesque. The two buildings shared an emphasis, however, on directing and altering combinations of natural and artificial light to give each interior its distinctive ambiance. The second house was purchased in 1983 by a nonprofit organization that operated it as the Capp Street Project, bringing artists-in-residence to occupy the building for three-month periods while they used it to create site-specific installation pieces and performance works.

Izu, David (1951–)

Painter. Born in Palo Alto, Calif.; attended U.C. Santa Cruz (B.A. 1975) and Stanford University (M.F.A. 1979). His paintings of the late 1970s were abstractions in which organic forms seemed to float through indeterminate fields of soft, fused colors, in a manner that suggested an underwater Arthur Dove. In

the 1980s he moved to a sparer style, dividing canvases with vertical bands of light that resembled the "zips" of Barnett Newman, although their outlines were softer and they diffused into richly textured grounds.

Jackson, Oliver (1935–)

Painter. Born in Saint Louis; attended Wesleyan University, Bloomington, Ill. (B.F.A. 1958), and the University of Iowa (M.F.A. 1963). A teacher at U.C. Davis since the late 1960s, Jackson began at about that time to develop a synthesis of abstract and figurative painting. By the late 1970s he was painting immense canvases in which stick-like "paint figures" were interwoven among hatchings and thatchworks of gestural, softly stroked colors that suggested lush tapestries or jungles. Other schematic images and symbols—such as hats and rings—together with letters and scrambled words, were also often incorporated into compositions that were characterized by tumultuous movement over a generally circular substructure.

Jacobsen, Rodger (1939–)

Sculptor and painter. Born in Seattle; attended the College of Marin (1958–1960) and SFAI (1960–1964). Associated with the "polychrome movement" at SFAI in the early 1960s, Jacobsen worked primarily in cut and welded heavy-gauge sheet steel. His sculpture was generally vertical, spare, open, and linear, suggesting bulbs, sprouts, and plant growth; surfaces were sometimes painted, but in a more subdued manner than those of Robert Hudson or William Geis. His relatively rugged handling of material gradually yielded to sleek chrome plating and enamel surfaces in the late 1960s; in the 1970s he turned primarily to painting landscapes in dense films of enamel on metal panels.

Jampol, Glenn (1950–)

Sculptor and painter. Born in Los Angeles; attended U.C. Berkeley (1968–1975, B.A., M.A., and M.F.A.). His installation and performance art of the mid-1970s explored the perspective relations that developed by juxtaposing identical or similar objects of radically different scales. In the late 1970s he turned to painting in a manner that combined the foreshortened, box-like geometric forms associated with Ron Davis and the gestural manner of neo-Expressionism.

Jefferson, Jack (1921–)★

Painter. Born in Lead, S.D.; attended the University of Iowa (1940–1942) and CSFA (1946–1950).

Jepson, Warner (1930–)★

Composer. Born in Sioux City, Iowa; attended Oberlin Conservatory of Music (B.M. 1953) and the San Francisco Conservatory of Music. He worked with Ann Halprin and her dancers in the 1960s and composed scores for many experimental films, including James Broughton's *The Bed*.

Johnson, Bruce (1947–)

Sculptor. Born in Portland, Ore.; attended U.C. Davis (B.A. 1969, teaching credential 1972). He carved and assembled redwood timbers into heroic abstractions of architectural and organic forms, generally with strongly symbolic implications. He displayed his sculpture primarily in the place where it was made, a clearing in the wooded coastal mountains overlooking the ocean north of Fort Ross in Sonoma County.

Johnson, Bruce James (1944–)

Painter. Born in Riverside, Calif.; attended the University of Hawaii (B.F.A. 1966) and CCAC (M.F.A. 1970). His abstract paintings, generally small in size, combined amorphous, densely textured surfaces with a geometric substructure achieved by applying layers of acrylic color on sheets of paper which were repeatedly folded and smoothed flat again, so that the process was thereby built into the structure.

Johnson, James (1936–)

Painter. Born in Minneapolis; attended Olympic College in Bremerton, Wash., SFAI (B.F.A. 1964), and Stanford University (M.A. 1966). His paintings of the late 1960s and early 1970s were hard-edge abstractions, emphasizing vibrant colors and optical illusions. In the mid-1970s he moved to more architectural forms and muted colors, and then to landscapes, conceived as large masses of earth or sea, peopled by solitary figures.

Johnson, Jerome (1933–)

Sculptor. Born in Elkhart, Ind.; attended Notre Dame University (1952–1953), the University of Michigan (B.S. 1960), and U.C. Berkeley (M.A. 1962). His big constructions of I-beams, pipe, welded aluminum, and other materials suggest obscure parables of industrial machinery. Some (such as *Soft Sidewalk*) were designed for the spectator to walk on; others had parts he was supposed to move (such as a piece including little flat cars that rolled over rails to disappear in a tunnel-like enclosure).

Johnson, Marie (1920–)★

Painter and assemblagist. Born in Baltimore, Md.; attended Morgan State College in Baltimore (B.A. 1952), San Jose State University (M.A. 1968), Stanford University (1969), and San Francisco State University (Ph.D. equivalency 1977). Johnson translated vignettes from Black American ghetto life into life-sized painted cut-out wood figures adorned with real fabrics and hair, which were set in tableaux that sometimes reached an environmental scale.

Johnson, Ralph (1925–)

Painter and sculptor. Born in Vancouver, Wash.; attended U.C. Berkeley (B.A. 1951, M.A. 1952). A

teacher at U.C. Davis since 1957. His paintings of the early 1960s were Abstract Expressionist, combining color areas and dynamic calligraphy in the manner of Hassel Smith. The image of a chair began to enter his painting in the mid-1960s, and by the early 1970s the chair, undergoing countless variations, had become the central theme of his paintings, and also of a growing body of sculpture. By the mid-1970s, he was concentrating on sculpture, although his interests in furniture had broadened to encompass variations on tables, shelves, and other forms, in a punning, Dada-inspired style.

Johnson, Robert Emory (1932–)

Painter and photographer. Born in Boone, Iowa; attended the American Academy of Art in Chicago (1949), the Art Center School in Los Angeles (1950–1953), UCLA (1954), and San Francisco State College (B.A. 1962). His paintings of the late 1960s, sometimes executed on reflecting mirrors left partly exposed, were crisp-edged organic abstractions influenced by his photographs of dancers, and also by his earlier studies in Los Angeles with Lorser Feitelson. In the 1970s he turned to small-scale works on paper, using automatist methods to arrive at "accidental" forms that he then developed, sometimes into abstract landscapes, sometimes into expressionistic abstract "portraiture" with roots in primitive art. Johnson was also active as an organizer of exhibitions, most notably The Rolling Renaissance, a survey of underground art in San Francisco, from bohemian North Beach to the hippie period in the Haight-Ashbury, presented cooperatively by several San Francisco galleries in 1968.

Johnson, Sargent (1887–1967)★

Sculptor. Born in Boston; attended CSFA (in 1919–1923, studying with Ralph Stackpole and Beniamino Bufano, and again in 1940–1942). Among Johnson's best-known works are the reliefs on the Maritime Museum at Aquatic Park in San Francisco (done under the W.P.A.) and the organ screen at the California School for the Blind on Derby Street in Berkeley.

Johnston, Ynez (1920–)

Painter. Born in Berkeley; attended U.C. Berkeley (B.F.A. 1941, M.F.A. 1946). Her paintings, often in miniature scale, contained fanciful pictographic shapes in compositions that suggested Toltec codices and medieval maps as well as the abstractions of Paul Klee. After moving to Los Angeles in 1956, she concentrated increasingly on printmaking.

Jones, David (1948–)

Painter and sculptor. Born in Columbus, Ohio; attended the Kansas City Art Institute (B.F.A. 1970) and U.C. Berkeley (M.A. 1971, M.F.A. 1973). Associated with the abstract artists of the 1970s whose work emphasized process and materials, Jones first worked with large, rectangular panels of sheet rubber in which forms were cast in relief; they suggested inspiration in the work of Antonio Tàpies. Later he turned to large sheets of lead cast from the internal structures of walls, with studs and joists exposed. Constructions in wood, fiberglass, and heavily lacquered steel followed; they emphasized highly patterned geometric shapes, with mesh-like or Ben Day textures, and were related to the Art Deco-inspired reliefs of Roy Lichtenstein.

Jordan, Larry (1934–)

Assemblagist and filmmaker. Born in Colorado; attended Harvard University and studied privately with Joseph Cornell. Influenced by a fellow Denver high school student, Stan Brakhage, he began to make personal films in the early 1950s. In San Francisco in the late 1950s he was introduced by Jess to the collage novels of Max Ernst, which inspired him to make his own Surrealist combinations of Victorian engravings of animals, butterflies, and mechanical objects. He began to translate these into animated films in 1960. He worked with Cornell in New York in 1965, and in the 1970s he developed a series of Cornell-like box assemblages in conjunction with his continuing work in film.

Joyce, Donald (1944–)

Sculptor. Born in Keene, N.H.; attended the Rhode Island School of Design (B.F.A.) and CCAC (M.F.A. 1968). The work he exhibited in the late 1960s emphasized the use of electric lights, incorporated into sculptural structures that included cords, tubes, plugs, and outlets. He left the Bay Area for Oregon in 1969.

Kaltenbach, Steven (1940–)

Sculptor and painter. Born in Battle Creek, Mich.; attended U.C. Davis (B.A. 1966, M.A. 1967). A maker of small ceramic cups and large minimalist sculptures in fiberglass during his student years, he gained an early reputation after moving to New York in 1976 for "word pieces"—unsigned advertisements in *Artforum* and bronze plaques that said "Build a Reputation," "Become a Legend," "Flesh," "Skin," and "Bone." After returning to the Bay Area in 1970 he created installation pieces in which large minimalist cubes, pyramids, and wedges, covered with carpeting, left just enough room for the viewer to circulate; and he built room-sized environments around such concepts as invitation (a darkened room whose walls gradually filled with fluorescent dots of light, like stars) and repulsion (one opened the door to an emission of blinding glare, blistering heat, and choking chalk dust). In the late 1970s he developed a technique in which several identical color photographs, usually of landscape, were cut into intricate patterns and then "rewoven" to recreate the original image, on which the

patterns were superimposed in low relief. He later translated this idea to paintings in which countless small, arabesque modules coalesced at a distance to form an almost photographic image.

Kano, Betty Nobue (1944–)

Painter. Born in Sendai, Japan; attended U.C. Berkeley (M.A., M.F.A.). Her paintings of the mid-1970s were distinguished by graffiti and handwriting submerged beneath layers of radiant, transparent color. In the late 1970s she began to explore the interaction of more solid color shapes.

Kasten, Karl (1916–)

Painter. Born in San Francisco; attended U.C. Berkeley (B.A. 1938, M.S. 1939), the University of Iowa, and the Hans Hofmann School in Provincetown, Mass. Kasten's early painting combined the gestural brushwork and thick textures of Abstract Expressionism with a more firmly geometric substructure. The formal elements became more pronounced in his paintings of the mid-1960s, and eventually came to dominate a hard-edged but softly textured architectural abstraction. An influential teacher at U.C. Berkeley from the 1950s through the early 1980s, Kasten was also active in intaglio printmaking. His prints often included images of medallions, found objects, and pieces of flora.

Katano, Marc (1952–)

Painter. Born in Tokyo; attended CCAC (B.F.A. 1975). His big abstract paintings of the late 1970s consisted of sweeping black calligraphic abstractions on contrasting grounds of roughly brushed color.

Kauffman, Craig (1932–)

Painter. Born in Los Angeles; attended the USC School of Architecture (1950–1952) and UCLA (M.A. 1956). Active in the Bay Area in 1959–1960, he worked in an improvising, Abstract Expressionist style that was beginning to crystallize into the shrill, organic, erotically charged forms of Funk art, somewhat parallel to the development of John Altoon.

Keane, Walter (1917–)★

Painter. Born in Nebraska; studied in Paris. Originally in the real estate business in Berkeley, by the end of the 1950s he had become one of the best-known schlock artists in the United States on the basis of paintings of waif-like children with saucer-shaped eyes, supposedly based on memories of privations in postwar Europe. These were first exhibited and sold at the hungry i nightclub in North Beach, where they quickly attracted the patronage of Hollywood celebrities. In the late 1950s, with his wife Margaret and their two daughters, he opened a gallery on Broadway devoted to the work of "the painting Keanes." The paintings attributed to Margaret were similar in style to those identified as Walter's (which fetched higher prices), but her figures were distinguished by almond-shaped eyes and a more mannered, Modigliani-like draftsmanship. It was frequently rumored that Keane himself painted only the eyes of the paintings that carried his name, and after the couple's divorce in 1965 Margaret claimed that she had painted everything; she said Walter had merely marketed the work, and had never learned to paint at all. She challenged Walter to a "paint-in" in Union Square, at which he failed to appear, and she proceeded to turn out a patented Walter Keane–style painting. However, some people who knew the couple assert that Walter did, in fact, paint at least some of his own paintings, and the matter remains to be resolved in court.

Kees, Weldon (1914, disappeared in 1955)

Poet, painter, filmmaker, and critic. Born in Beatrice, Neb. His paintings and collages of the mid-1940s frequently incorporated numerals or letters of the alphabet as scaffoldings for thickly built-up surfaces and generally somber, reticent harmonies of blacks, browns, and grays; and in many ways they anticipated the funky expression of the following decade. His car was found abandoned in a parking lot at the north end of the Golden Gate Bridge on July 21, 1955, and he never reappeared.

Kelly (1940–)★

Postermaker. Born in Houlton, Me.; attended the Philadelphia Museum College of Art and the Art Students League of New York. Came to San Francisco in 1959. A frequent collaborator with Stanley Mouse in posters advertising rock productions by the Family Dog, he specialized in montages of images that called to mind both the Surrealism of Magritte and the Victorian spirit of Maxfield Parrish.

Kelly, James (1915–)★

Painter. Born in Pennsylvania; attended the Pennsylvania Academy of Fine Arts (1938), the Barnes Foundation (1941), and CSFA (1951–1954). He left California for New York in 1958.

Kennedy, Michael (1941–)

Painter. Born in Des Moines, Iowa; attended SFAI (B.F.A. 1963, M.A. 1965). His abstract paintings of the 1970s, most often on large sheets of paper, combined broad color areas—and an occasional "window" resembling the loose geometric structures of Diebenkorn—with softly stroked, gestural surfaces that recalled the lyrical early abstraction of Philip Guston.

Kent, Adaline (1900–1957)

Sculptor. Born in Kentfield, Calif.; attended Vassar College and CSFA (1923–1924) and studied with the sculptor Antoine Bourdelle in Paris (1924). In her work

of the 1940s, which was generally small and carved in magnesite and other stone, Kent developed an abstract style rooted in Surrealism. Her forms sometimes suggested fragments of skeletons or totems, sometimes a fossilized calligraphy. Kent's husband was the sculptor Robert Howard. An annual award to a contemporary local artist is presented in her name by SFAI.

King, David (1937–)

Sculptor. Born in Sacramento; attended Sacramento State College (B.A. 1964) and U.C. Davis (M.A. 1966). His constructions in wood and steel of the 1970s were variations on the forms of hand tools, infused with Dadaesque visual-verbal puns, meticulously crafted and generally housed in elegant wood containers.

King, Hayward (1928–)★

Painter and sculptor. Born in Little Rock, Ark.; came to California in 1928; attended Pasadena City College, UCLA, CSFA (B.A. 1955), and the Sorbonne in Paris (1955–1957). His paintings and graphic works of the mid-1950s were abstractions with richly textured surfaces and a foundation of strongly architectural design. He was one of the founding members of The Six Gallery. In the late 1960s he was director of the John Bolles Gallery and was later director of the Richmond Art Center.

Kingman, Dong (1911–)★

Painter. Born in Oakland; attended schools in Hong Kong and returned to California in 1926. Known primarily as an illustrator, he specialized in picturesque watercolor views of San Francisco.

Kinmont, Robert (1937–)

Conceptualist sculptor and photographer. Born in Los Angeles; attended SFAI (B.F.A. 1970) and U.C. Davis (M.F.A. 1971). His early small sculpture was in wood or plastic, sometimes with neon tubes. His later work showed a common preoccupation with the natural environment and man's relationship to it. A series of photographs depicted eighteen "Favorite Dirt Roads" and another showed the artist doing handstands in the High Sierra. Another work, a complex construction of wooden bars, was held together by water fed through tubes from copper containers which caused its joints to swell. By the early years of the 1980s Kinmont had turned to rather conventional watercolors.

Kirchmeier, Jen-Ann (1937–)

Painter. Born in Tomahawk, Wis.; attended U.C. Irvine (B.F.A. 1971) and SFAI (M.F.A. 1973). In *The Rooted Men* (1981), thirteen big oil paintings designed to hang together as a circular mural, she used the forms of old gnarled trees as metaphors for the cycle of growth and decay, in a style that combined a rich abstract Impressionism with a dramatic action painting. The images, intense and self-contained, together tended to blur into a whirl that seemed to draw the viewer directly into a cyclical vortex of movement—an idea Kirchmeier continued to explore in a monumental single painting, *Carousel,* and in a series of paintings in which moving images on city streets were abstracted to blurs and shimmers on the very threshold of perception. These were painted in acrylic, in a light-saturated style in which photographic imagery burst into a loose, gestural calligraphy. Kirchmeier was also practically alone among Bay Area artists in bringing credibility to the genre of portraiture.

Kishi, Masatoyo (1924–)

Painter and sculptor. Born in Sakai, Japan; attended Tokyo University of Science, Physics, and Chemistry (graduated 1945); came to the Bay Area in 1960. His paintings of the early 1960s were in a spare, elegant, gestural vein of Abstract Expressionism. In the late 1960s he translated these gestural forms into sculpture, fashioning shaggy, delicate structures in translucent white fiberglass.

Klayman, Toby Judith (1935–)

Painter and printmaker. Born in Providence, R.I.; attended Brandeis University (B.A. 1956); came to the Bay Area in 1966. Her whimsical figure paintings were done in a bold, poster-like style—with flat patches of color and heavy dark outlines—related to that of Peter Max.

Klein, Pat (1951–)

Painter. Born in New York City; attended U.C. Berkeley (B.A. 1974, M.A. 1975, M.F.A. 1977). Her paintings, in vibrant, expressionistic colors and thick impastos, portrayed anonymous figures in generalized landscape settings, with an unsettling anxiety and the distortions of form and scale found in dreams.

Koblick, Freda (1921–)★

Sculptor. Born in San Francisco; attended the City College of San Francisco, San Francisco State College (1938–1941), and the Plastic Industries Technical College in Los Angeles (1941–1943). A pioneer among California artists in the casting of acrylic plastic, Koblick attended the only school that offered instruction in plastics technology at the time. Despairing of supporting herself as an artist, she set up a small company that specialized in decorative accessories—lucite door knobs, pulls, chandeliers—which she designed in conjunction with architects. She gradually moved into large-scale architectural commissions and, in the 1960s, to self-contained works of sculpture—sleek, transparent, rhythmic abstractions that took their principal inspirations from such natural forms as waves, icicles, half moons, and mandalas. Working in a studio on Francisco Street, Koblick also spent several months

each year in London, where casting equipment was less expensive, and where she gave occasional master classes and workshops at the Royal College of Art.

Koci, Frank (1904–1983)

Painter. Born in Pilsen, Czechoslovakia. After arriving in Texas in 1923 he worked as a cowboy and a farmhand, then drifted to Hollywood, where he taught himself to paint with supplies he found in a movie studio while working there as a guard (and occasional movie extra). He continued to paint while shipping out as a merchant seaman and occasionally working as an actor in the theater. He moved to San Francisco in 1952 and settled into a cheap hotel. In the late 1950s Henri Lenoir discovered his paintings and began to sell them in his North Beach bar, the Vesuvio. Koci developed a unique synthesis from sources in European Expressionism: Beckmann, Rouault, Kirchner, Nolde, Soutine, Grosz. His subjects ranged from frumpish nudes in barrooms to Old World cityscapes, but he concentrated primarily on authority figures—uniformed military men, Roman Catholic nuns—which he treated with a combination of satire and hallucinatory intensity. He was extremely prolific and uneven, but his strongest work represented a remarkable union of naïveté and canny sophistication.

Kohlmeyer, Ida (1912–)

Painter. Born in New Orleans; attended Tulane University (B.A. 1933, M.F.A. 1956). Her paintings are characterized by a recurring vocabulary of pictographic shapes and personal symbols, generally framed within loose compartments that bleed into grounds of softly brushed colors.

Komisar, Milton (1935–)

Painter and sculptor. Born in Nashville, Tenn.; attended Vanderbilt University (B.A. 1958), SFAI (1960), and U.C. Berkeley (M.A. 1964). Initially a painter in the Bay Area Figurative style of James Weeks, with whom he studied, he began adding three-dimensional objects to his canvases. In the late 1960s, he abandoned painting entirely and began translating themes rooted in the Bay Area Figurative esthetic—parking lots, junkyards filled with hulls of old cars—into full-scale environments. In the 1970s he turned to making sculptural constructions of transparent plastic tubing. In some cases geometric and symmetrical, in others free-form and organic, they served as conduits for the movement of light, which circulated through the structures according to complex electronically controlled programs.

Kondos, Gregory (1923–)

Painter. Born in Lynn, Mass.; attended Sacramento State College (B.A., M.A.). His landscape paintings of the Greek Islands and sites in Northern California are similar to Wayne Thiebaud's in the vividness of their color and "glare," but are less dense in texture and more conservative in style.

Kos, Paul (1942–)★

Conceptualist sculptor. Born in Rock Springs, Wyo.; attended Georgetown University (1962) and SFAI (B.F.A. 1965, M.F.A. 1967).

Kuhlman, Walter (1918–)★

Painter. Born in Minnesota; attended the Saint Paul School of Art (1936–1939), the University of Minnesota (B.A. 1941), CSFA (1947–1950), and the Académie de la Grande Chaumière in Paris (1950–1951). Kuhlman's early Abstract Expressionist paintings paralleled Rothko's in their emphasis on peachy blonde, orange-yellow colors and a use of soft-edged, floating shapes, although his forms were less inclined to geometry. Landscape images eventually began to appear in the murkily romantic atmospheres of his paintings, which ultimately presented shadowy figurative images that suggested mythological themes.

Labaudt, Lucien (1880–1943)★

Painter. Born in Paris; studied in London (1901–1904) and settled in San Francisco in 1911. Essentially self-taught, Labaudt was an early disciple of Cubist abstraction; later, in the 1930s, he alternated between and sometimes combined a neo-classicizing Surrealism and a Rivera-inspired Social Realism. He was founder and director of the California School of Design, and also operated, with his wife Marcelle, an atelier on Gough Street where he taught dress and costume design. His best-known murals (in San Francisco) are at Coit Tower and the Beach Chalet on the Great Highway. Labaudt died in a plane crash in India while on assignment to do war sketches for *Life* magazine.

Lamanet, Shari (1949–)

Painter. Born in San Francisco; attended SFAI (B.F.A. 1972, M.F.A. 1979). Her paintings draw together figurative, architectural, and abstract imagery in complex compositions that evoke a variety of associations.

Langton, Ben (1935–)

Painter. Born in Oakland; attended CCAC. His paintings of the 1960s were ambiguous landscapes done in an impressionistic style that emphasized sun-dappled atmospheric space. In the 1970s he turned to more mythical themes, incorporating schematic nude figures and symbolic images—hearts, flowers, sun discs—into landscapes painted in a broader style allied to Funk and Abstract Expressionism.

La Pena, Frank (1937–)★

Assemblagist. Born in San Francisco; attended Chico State College (B.A. 1965) and San Francisco State College.

Lapp, Maurice (1925–)

Painter. Born in Illinois; attended the Chicago Art Institute (M.F.A.). In the 1950s Lapp developed an Abstract Expressionist style in which vaguely defined but tightly structured images of city streets and buildings were viewed as if from overhead, and painted principally in white and gray monochrome. In the 1970s he turned to a more rural imagery—landscape and rustic villages. He has been an instructor at Santa Rosa Junior College since the 1950s.

Lark, Sylvia (1947–)

Painter. Born in Buffalo, N.Y.; attended the State University of New York at Buffalo (B.A. 1969), Mills College (1969), and the University of Wisconsin (M.A. 1970, M.F.A. 1972). Her paintings are in a lyrical vein of gestural Abstract Expressionism.

Laub, Stephen (1945–)

Conceptualist. Born in Oakland; attended U.C. Berkeley (architecture, 1962–1964), the Ecole de Louvre at the Sorbonne in Paris (1964–1966), and U.C. Berkeley (1966–1970, B.A. and M.A.). Active in the early 1970s, he presented performances that generally made use of his own body as the principal prop for works that focused on physical functions.

LaVigne, Robert (1928–)

Painter and assemblagist. Born in Idaho; attended CSFA (1953) and San Francisco State College (1954). Active among the circle of Beat artists and poets living at the Hotel Wentley on Polk Street in the 1950s, LaVigne worked in a bold figurative style that sometimes branched into portraiture. His simplified forms, his emphatic, rhythmic contours, and his interweaving of figure with ground suggested sources in the late paintings of Matisse. In the late 1950s he turned to collages in which a spare repertoire of objects and images was used to explore the ambiguous relationship between the thing itself and its pictorial representation. He left for New York in 1964 and was later active in Los Angeles. Returning to San Francisco briefly in the late 1970s, he showed small drawings that treated mystical themes in a crumbled, diffuse abstract style that had a remote relationship to the drawings of Bruce Conner.

Lawson, George (1951–)★

Painter. Born in Miami, Fla.; studied in Paris at the Atelier Louis Calevaert. His paintings of the mid-1970s were abstract compositions of labyrinthine organic forms that resembled the early abstractions of de Kooning. In the late 1970s he turned to a more minimalist style, dividing his canvases in simple geometric forms and emphasizing layers of color.

LeBlanc, Peter (n.d.)

Painter and printmaker. Active in North Beach from the late 1950s to the late 1970s, when he moved to New York. A former New York advertising artist, LeBlanc was a student of Oriental philosophy, particularly Taoism, and he gradually acquired proficiency both in sumi ink drawing and in the painstaking craft of color woodcut. He used both techniques to create posters for North Beach jazz and poetry performances in the late 1950s, anticipating the revival of poster art in the 1960s. His principal work in the 1970s was a series of portraits of San Francisco poets.

Lemmy (1940–)

Painter. Born in Ipoh, Malaysia; attended the University of Oregon (1956–1960) and San Francisco State College (1962–1964). His paintings of the early 1960s were abstractions in which indeterminate organic forms coalesced from thinly stained nimbuses and delicate motes and spatterings of transparent acrylic color, on grounds of fine silk. In 1967, inspired by microscopic slide specimens in a chemistry laboratory, he turned from conventional painting to a technique that involved chemically bonding layers of polyester resin to transparent sheets of acrylic. The organic forms were combined with a new richness of surface and textural effects that were peculiar to the new medium: intricate fractures, cracklings, shatter formations, and cellular units that multiplied to form faceted, crystalline structures. Since the mid-1970s he has alternated residence between the Bay Area and Europe.

Leon, Dennis (1933–)

Sculptor and painter. Born in London; came to the United States in 1951; attended the Tyler School of Fine Arts at Temple University in Philadelphia (B.F.A., B.S., M.F.A.). His work of the early 1970s, when he came to the Bay Area to become chairman of the sculpture department at CCAC, consisted of enigmatic constructions of found objects related to the "magic boxes" of Marcel Duchamp. In the later 1970s he turned to site-specific works in more or less remote locations in the Oakland hills; inspired by the ancient ruins found in rural England, and composed of fieldstones, rope, bamboo, and similar materials, they were intended to disappear into the landscape, and were documented by drawings and slides. Eventually, he moved to paintings of the landscape itself, in a broad, brushy manner related to the Bay Area Figurative style as well as to the British watercolor tradition.

294

LePell, Corban (1933–)

Painter. Born in Birmingham, Ala.; attended the University of Nebraska and Wichita State University in Kansas (B.F.A. 1957, M.F.A. 1959). His small works, which combined painting and drawing on smooth gesso surfaces, presented images of vegetables together with more abstract shapes—spheres, pyramids, cones—in a precise, Magic Realist style and enlarged to immense scale.

Leptich, Elisa Maria (1936–)

Painter. Born in Copenhagen; came to California in 1951; attended San Francisco State University (B.A. 1971, M.A. 1973). Her landscapes and scenes of San Francisco were painted in an idiosyncratic style that drew a balance between realistic imagery and crisp, rhythmic abstract patterns.

Levine, Marilyn (1935–)

Ceramic sculptor. Born in Alberta, Canada; attended the University of Alberta, Edmonton (B.Sc. 1957, M.Sc. 1959), and U.C. Berkeley (M.A. 1970, M.F.A. 1971). Her specialty has been ceramic replicas of old objects characteristically made of leather—shoes, jackets, suitcases—in a trompe l'oeil style that recorded the wear and scars of long use.

Light, Alvin (1931–1980)*

Sculptor. Born in New Hampshire; attended Stockton College and CSFA (1951–1953, 1956–1961; B.F.A. 1959, M.F.A. 1961). Light taught at CSFA from 1961 until his death.

Linhares, Judith (1940–)

Painter and assemblagist. Born in Pasadena, Calif.; attended CCAC (B.F.A. 1964, M.F.A. 1970). Her works on paper and mixed-media assemblages of the late 1960s and early 1970s combined images that suggested autobiographical sources through symbolic motifs associated with loss, violence, and death, and were inspired by Mexican folk art. In the late 1970s she began creating primitivistic scenes in which broadly painted, schematic figures inhabited fantastic landscapes and enacted narratives that suggested myth or dreams. She left for New York in the late 1970s.

Linhares, Phil (1939–)

Sculptor and painter. Born in Visalia, Calif.; attended Modesto Junior College (1958) and CCAC (B.F.A. 1964, M.F.A. 1966). In the late 1960s he made sculptural constructions in a Dada manner inspired by the work of William T. Wiley. In the 1970s he turned to small, enigmatic, and brightly painted reliefs suggesting obscure origins in functional objects, and to paintings in black-and-white checkerboardings that resembled table-cloths. He was director of the gallery at SFAI from 1967 through the mid-1970s, when he became director of the Mills College Art Gallery.

Lipofsky, Marvin (1938–)

Glass sculptor. Born in Barrington, Ill.; attended the University of Illinois (B.F.A. in industrial design, 1961) and the University of Wisconsin (M.S. and M.F.A. in sculpture, 1964). A specialist in the medium of hand-blown glass, he has been an influential teacher at CCAC since the 1960s. His own work is characteristically abstract and organic in form, frequently with overtones of eroticism.

Lloyd, George (1945–)

Painter. Attended the Rhode Island School of Design (B.F.A. 1967) and Yale University (M.F.A. 1969). Active in the Bay Area in the 1970s. His small paintings combined the gesturalism of Abstract Expressionism and elements of Funk with structures derived from sources in Cubism, Futurism, and Constructivism. They seemed at once homage to and parodies of the heroic early years of European modernism.

Loarca, Carlos (1937–)

Painter. Born in Quezaltenango, Guatemala; attended the John Adams Adult School at San Francisco Community College (1964–1965); the J. Mast-Bownd Adult School in Philadelphia (1964–1966), and Brigham Young University (1966–1967). He draws on the symbolic imagery and mythologies of Central America in big, expressionistic, but softly sensuous paintings distinguished by rich color and highly saturated light.

Lobdell, Frank (1921–)*

Painter. Born in Missouri; attended the Saint Paul (Minn.) School of Fine Arts (1938–1939), CSFA (1947–1950), and the Académie de la Grande Chaumière in Paris (1950). Between 1957 and 1965 he was one of the most influential teachers at CSFA (after 1960, SFAI). Since 1965 he has taught at Stanford University.

Loberg, Robert (1927–)

Painter. Born in Chicago; attended U.C. Berkeley (B.A. 1952, M.A. 1954) and studied with Hans Hofmann in Provincetown, Mass. (1956). His abstractions of the 1950s combined painting with collage in compositions of interlocking and overlapping fragmentary shapes. In the late 1960s and 1970s he turned to more figurative motifs, frequently using Indians and Indian mythology as the subject of dramatic expressionistic paintings.

Locks, Seymour (1919–)

Sculptor. Born in Illinois; attended San Jose State College (B.A.) and Stanford University (M.A. 1946). His best-known sculptures were funky totems made of

wood into which were driven hundreds of nails, their heads overlapping to form bristling, armor-plated surfaces. In the 1970s he made mixed-media tableaux of a mystically Surrealist cast. Locks began teaching at San Francisco State College in 1947.

Logan, Maurice (1886–1977)

Painter. Born in San Francisco; attended the Partington Art School and the Mark Hopkins Institute of Art in San Francisco (1907–1914), the School of the Art Institute of Chicago, and CCAC (then in Berkeley). A member of The Society of Six, Logan later painted many of the diorama murals for the natural history displays at the California Academy of Sciences in Golden Gate Park, San Francisco.

Lomahaftewa, Linda (1947–)

Painter. Born in Arizona; attended the Institute of American Indian Arts in Santa Fe, N.M., and SFAI (B.F.A. 1970, M.F.A. 1971). Her hard-edge abstractions, which featured stylized birds and other motifs, were based on traditional Southwestern Indian forms.

Longfish, George Chester (1942–)

Assemblagist. Born in Ontario, Canada; attended the School of the Art Institute of Chicago (B.F.A. 1970, M.F.A. 1972). Active in the Bay Area in the mid-1970s, he fashioned masks and costumes with sources in traditional Native American artifacts.

Loran, Erle (1905–)★

Painter. Born in Minnesota; attended the Minneapolis School of Art (with Cameron Booth) and the University of Minnesota. A teacher at U.C. Berkeley from 1936 through the late 1970s. In 1927 Loran lived in Cézanne's studio in Aix-en-Provence and photographed the landscapes that Cézanne had painted; these, and his diagrammed analyses of the paintings, were published by the University of California Press in 1943 as *Cézanne's Composition*. These studies of Cézanne influenced Loran's paintings of the 1930s and 1940s. In the 1950s he turned to an abstract style related to that of Hans Hofmann. In the late 1960s he painted in a classicizing figurative style with overtones of Surrealism, setting statuesque human forms in abstract architecture and landscape; he also experimented briefly with effects borrowed from solarized color photography and psychedelic light shows. In the late 1970s he concentrated on watercolor abstractions of the landscape in intense, high-keyed colors. Loran was one of the Bay Area's earliest collectors of African art, and he has amassed a significant collection of it.

Lord, Charles ("Chip") (1944–)

Conceptualist. Born in Cleveland; attended Tulane University (B.A. 1968). A former architecture student, he was a co-leader of Ant Farm, a group of conceptualists and former architects from Texas who came to San Francisco in the late 1960s and were active there through most of the 1970s. The group's earliest involvement was with concepts for inflatable and portable environments that could house city-sized crowds of people who gathered for events such as rock concerts, and with Clockwork Orange-like ideas for programming images and entire "environments" electronically into people's brains. They later turned to performances of strong, sometimes flamboyant social comment, often using the electronic media—primarily TV—to examine their own role in society. Their most noteworthy work involved the partial burial of several old Cadillacs in a stretch of desert on the ranch of an art collector in Texas.

Louie, Harry (1947–)

Painter. Born in San Francisco; attended SFAI (B.F.A. 1973) and Mills College (M.F.A. 1975). In the late 1960s and early 1970s his paintings emphasized simple, boldly scaled geometric forms woven into broadly brushed, neutralized grounds. He later turned to softly brushed abstractions in vivid colors that suggested sources in nature and a kind of abstract Impressionism.

Lubell, Bernard (1947–)

Sculptor. Born in Baltimore, Md.; attended Columbia University (B.A. 1968), the University of Wisconsin (M.A. in social psychology, 1970), and SFAI. His sculpture of the mid-1970s emphasized Funk-inspired organic abstract forms, generally in wood. Later he turned to more structural elements—meticulously cut and joined blocks, slats and gracefully bowed arcs of wood—assembled into rambling, sometimes movable constructions strung with cords and pulleys. An appealing combination of constructivist sobriety and Dada comedy, these constructions suggested utilitarian mechanical devices while remaining utterly devoid of purpose or use, bringing to mind an abstract interpretation of Rube Goldberg's cartoons.

Lynch, Vincent (n.d.)

Painter. Attended SFAI (B.F.A. 1971). Inspired by an interest in primitive cultures, his "paintings" of the late 1970s were made of yoghurt, ketchup, and similarly perishable ingredients and represented an extreme form of process-and-materials abstraction.

Mackenzie, David (1942–)★

Painter. Born in Los Angeles; attended Orange Coast College (Costa Mesa, Calif.) and SFAI (B.F.A. 1968, M.F.A. 1970). In the late 1970s Mackenzie turned to a style closely related to constructivism, retaining the rich, laboriously processed surfaces of his previous

work but using them as grounds for spare arrangements of geometric forms. He was also active in a curatorial role, organizing a large show of new Bay Area artists—largely of the New Abstraction persuasion—for the Los Angeles Institute for Contemporary Art (1976) and the University Art Museum in Berkeley (1977).

Maclay, David (1946–)★

Sculptor and photographer. Born in Boston; attended the School of the Museum of Fine Arts in Boston (1964–1967) and SFAI (B.F.A. 1968).

Majdrakoff, Ivan (1927–)

Assemblagist. Born in New York City; attended the Cranbrook Academy of Art in Michigan; came to California in 1955. His emblematic, densely encrusted assemblages, composed of found objects deriving from the visual environment of the street and the five-and-ten cent store (signs, toys), were distinguished by complex textures and strong colors, and suggested Pop art versions of Byzantine icons.

Makanna, Philip (1940–)

Sculptor, filmmaker, photographer. Born in New York City; attended Brown University (B.A. 1962), and U.C. Berkeley (M.A. 1963). His sculpture of the late 1960s, in painted plastic with metal fittings, took the form of sleek, horizontal floor pieces that suggested a hybrid between abstract landscape and machinery. After his first one-man show at the Dilexi Gallery in 1967, he abandoned sculpture to direct a movie, filmed in Death Valley and sponsored by the Dilexi Foundation, and to race motorcycles. When he returned to the art world in the late 1970s, it was as a still photographer, with a series of color prints recording "The Confederate Air Force," an organization of World War II Air Force veterans based in Texas who salvage, rehabilitate, and fly vintage bombers and fighter planes.

Maradiaga, Ralph (1934–)

Painter and printmaker. Born in San Francisco; attended San Francisco State College (B.A., M.A.) and Stanford University (M.A. in filmmaking). His paintings and silkscreen prints centered on images of Mission district street life, in a style influenced by the photographic approach and impersonal techniques of the mass media. He was a founder of the Galeria de la Raza and remains its co-director.

Marcus, Irving (1929–)

Painter. Born in Minnesota; attended the University of Minnesota (B.A. 1950) and the University of Iowa (M.F.A. 1952). Based on newspaper photographs of the suburban environment, his paintings translate images into broad silhouettes and are energized by vibrantly hatched colors that contribute to an expressionistic feeling with disturbing undertones of violence. He has been a teacher at Sacramento State University since the 1960s.

Marie-Rose, Henri (1922–)★

Sculptor and painter. Born in Martinique; attended the Ecole Nationale Supérieure des Beaux Arts, Paris (1945–1952); arrived in San Francisco in 1953. He fabricated figurative sculpture in welded steel, and painted boldly stylized portraits in a primitivistic style.

Marin, Sutter (1926–)

Painter and poet. Born in San Francisco; attended San Francisco State College (B.A.) and SFAI. His small paintings were in a fantastic figurative style, influenced by Surrealism and masterpieces of the Renaissance.

Marioni, Tom (1937–)★

Conceptualist sculptor and performance artist. Born in Cincinnati; attended the Cincinnati Conservatory of Music (1954–1955) and the Cincinnati Art Academy (1955–1959); came to San Francisco in 1959. Founder and director of the Museum of Conceptual Art, which opened in 1973.

Martin, Bill (1943–)★

Painter. Born in South San Francisco; attended SFAI (B.F.A. 1968, M.F.A. 1970). The Visionary landscapes for which Martin became known in the late 1960s first appeared as "portholes" in cloud shapes that dominated his early Surrealist abstractions. In the late 1970s Martin sometimes returned to more overtly Surrealist imagery, but in the immaculately "realist" style of the landscape paintings.

Martin, Fred (1927–)★

Painter. Born in San Francisco; attended CSFA (1949–1950) and U.C. Berkeley (B.A. 1949, M.A. 1954). Martin was the director of SFAI between the mid-1960s and the mid-1970s, and he resumed that post in 1983.

Martinez, Xavier (1869–1943)★

Painter. Born in Guadalajara, Mexico; attended the California School of Design (1893–1897), the Ecole des Beaux Arts, Atelier Gérôme, in Paris (1897–1899), and the Académie Eugène Carrière in Paris (1900–1901). Martinez was one of the principal Bay Area exponents of a tonalist style influenced by Whistler. He was active in the Bay Area between 1893 and 1897 and again from 1901 to 1942, when he moved to Carmel.

Mason, Philip Lindsay (1939–)

Painter and sculptor. Born in Saint Louis; attended CCAC (B.F.A. 1969, M.F.A.) and U.C. Berkeley

(Ph.D.). His primitively stylized paintings portrayed flat figures that represented various types of Black Americans and illustrated mythic themes of birth and regeneration.

Mathews, Arthur (1860–1945)

Painter. Born in Markesan, Wis.; came to Oakland in 1867; studied with Henry Bruen (1875–1880) and at the Académie Julian in Paris (1885–1886). With his wife, Lucia, Mathews was the best-known practitioner of the California Decorative style, a form of muted tonalist painting founded on sources in Art Nouveau and in the work of Puvis de Chavannes. Besides painting pictures on canvases, they painted furniture and other household accessories, including the frames for their pictures, in line with the Art Nouveau ideal of bridging the division between art and everyday life.

Mathews, Lucia (1870–1955)

Painter. Born in San Francisco; attended Mills College (1892–1893), the Mark Hopkins Institute of Art in San Francisco (1893–1894), and the Académie Carmen in Paris (1899). She lived in San Francisco until 1951, when she moved to Los Angeles.

Matsumoto, Masashi (1942–)

Painter. Born in San Bruno, Calif.; attended SFAI (B.F.A. 1972, M.F.A. 1975). Preoccupied with the ambiguities and paradoxes of the relationship of inside and outside, Matsumoto first built small models of houses and rooms in which interior walls were painted with exterior views, or vice versa. He later turned to life-sized images of doors, distilled to mere outlines or ideographic shapes (keyholes, doorknobs) on monochromatic grounds painted on big canvases that were offhandedly wrapped in plastic and leaned against the wall. By the early 1980s, Matsumoto was moving away from painting altogether, retaining the image of the door but translating it into other media, such as neon tubing and etched glass. He also engaged in performance art.

Mattox, Charles (1910–)

Sculptor. Born in Bronson, Kan.; attended McPherson College in Kansas and the Kansas City Art Institute (1930–1931); studied with Arshile Gorky in New York City (1933–1934). His kinetic sculpture of the 1960s and 1970s was related to Alexander Calder's early motorized sculptures of the 1930s in their machine esthetic—balls, tubes, belts, and pulleys—and playful spirit, but their motion was frequently more suggestive of organic life, occurring in spasmodic and sudden lurches, tics, and twitches. His pieces took many different forms, generally geometric, and were often designed to be activated by the spectator.

Mayeri, Beverly (1944–)

Ceramic sculptor. Born in New York. Her ceramic tableaux are in a style of naturalistic surrealism, suggesting sources in intimate personal experience and dreams.

McChesney, Mary Fuller (1922–)

Sculptor and writer. Born in Wichita, Kan.; came to California in 1924; studied philosophy at U.C. Berkeley; apprenticed in ceramics at the California Faience Company, Berkeley; largely self-taught in art. Her sculpture in carved stone was generally based on animal or gnomic human forms, strongly stylized according to the conventions of Art Moderne and often reflecting the influences of pre-Columbian, Egyptian, Assyrian, and other non-Western sculptural traditions.

McChesney, Robert (1913–)

Painter. Born in Marshall, Mo.; attended Washington University in Saint Louis (1933–1934), and the Otis Art Institute in Los Angeles (1936); came to San Francisco in 1938. A teacher of serigraphy at CSFA beginning in 1950—and a merchant seaman who continued to ship out—McChesney was inspired primarily by the forms and colors of nature in abstractions that also emphasized the swirling linear arabesques characteristic of the graphic style of Stanley William Hayter (a guest instructor at CSFA in the late 1940s). McChesney's later abstractions played erosive black shapes against arid reds, suggesting dramatic interpretations of the desert landscape; in the late 1960s and early 1970s he often heightened this effect by attaching bones—sometimes painted in fluorescent colors—to his surfaces. In the late 1970s he began to introduce small, crisply painted symbols, reminiscent of scarabs and other traditional motifs, into his paintings.

McClintock, Byron (1930–)

Painter. Studied at CSFA. His paintings of the 1950s were luminous abstractions emphasizing soft, diffuse light and Turneresque atmospheric effects.

McCracken, John (1934–)

Sculptor. Born in Berkeley; attended CCAC (B.F.A. 1962, graduate study 1962–1965); moved to Venice, Calif., in 1965 and to New York in 1968. McCracken became well known internationally in the late 1960s for plank-like structures made of wood and covered with polyester resins in solid, luscious, decorator colors. These were essentially paintings that were converted into "sculpture" by leaning them against the wall rather than hanging them on it when the works were exhibited.

McCray, James (1912–)

Painter. Born in Niles, Calif.; attended U.C. Berkeley (B.A. 1934, M.A. 1935) and the Barnes Foundation

in Pennsylvania (1937–1939). By the mid-1940s, McCray had developed a distinctive style of geometric abstraction related to graphs, maps, and other kinds of diagrams. It was based on linear grids, irregular in size and interval, that were played against small squares and rectangles of bright color and an occasional larger color plane intersected by diagonal lines in the manner of a mechanical drawing projection. McCray continued to explore this style with great consistency while he pursued a long career as a teacher at CSFA, Washington State University (Pullman), and U.C. Berkeley.

McGaw, Bruce (1935–)

Painter. Born in Berkeley; attended CCAC (B.F.A. 1957). One of the artists to exhibit in the contemporary Bay Area Figurative Painting show at the Oakland Art Museum in 1957, he worked in an expressionistic style with angular forms, bold outlines, and dissonant color combinations that recalled Max Beckmann. His style became somewhat less graphic and more painterly, and also more inclined to eccentricity, in the 1960s and 1970s, when he was an influential teacher at SFAI.

McGinley, Louise (1922–)

Sculptor. Born in Ohio; attended U.C. Berkeley (B.A. 1945). Her dramatic tableaux, primarily in raw clay, were satirical Gothic fantasies in which castles, monasteries, and other medieval settings were peopled by dog-like creatures who engaged in humanoid follies and were observed by menacing reptilian monsters.

McKee, Charles (1929–)

Ceramist. Born in San Francisco; attended San Jose State College (B.A. 1956) and Mills College (M.F.A. 1961). A relatively traditional craftsman, McKee began in the 1960s to venture cautiously in more unorthodox directions, combining traditional notions of craftsmanly finish with generally swelling, bulbous forms that had sources in fantasy and incorporated deftly imaginative details. Since the early 1960s he has been extremely influential as a teacher at San Francisco State University.

McLean, Richard (1934–)★

Painter. Born in Hoquiam, Wash.; attended CCAC (B.F.A. 1958) and Mills College (M.F.A. 1962).

Melchert, James (1930–)★

Sculptor. Born in New Bremen, Ohio; attended Princeton University (B.A. 1952), the University of Chicago (M.F.A. 1957), Montana State University in Missoula (1958–1959), and U.C. Berkeley (M.A. 1961).

Mendenhall, Jack (1937–)★

Painter. Born in Ventura, Calif.; attended CCAC (B.F.A. 1968, M.F.A. 1970). He designed and directed the execution of the rainbows over the Waldo Tunnel on the Marin County side of the Golden Gate Bridge.

Mendenhall, Kim (1949–)

Painter; attended CCAC (B.F.A. 1970) and Mills College (M.F.A. 1976). Her Photo Realist paintings concentrated on table arrangements of dishes and food painted in a lush, overripe style.

Middlebrook, David (1944–)

Ceramic sculptor. Born in Jackson, Mich.; attended Albion College, Mich. (B.A. 1966), and the University of Iowa (M.A. 1969, M.F.A. 1970). His sculptures combined grossly oversized trompe l'oeil ceramic replicas of ordinary objects—sponges, rolling pins, cactus leaves—in idiosyncratic, cantilevered structures of a cartoon-like exuberance.

Miller, Aaron (1928–1972)★

Painter and muralist. Born in San Francisco. Miller claimed that he first learned painting when he was ordered to paint insignia on trucks while stationed in Guam with the Air Force, and that shortly afterward he reproduced Leonardo da Vinci's *Last Supper* from memory in a mural for the company's mess room. He was committed to a federal mental hospital in 1955 after holding up a bank, and was later in frequent trouble with the law for outbreaks of violence when he was associated with the Beat scene in North Beach. He was one of the three artists (the others were Mike Nathan and John Reed) to paint murals on the interior of the Co-Existence Bagel Shop. He spent his last years in destitution, living in cheap hotel rooms.

Miyasaki, George (1935–)

Painter. Born in Hawaii; attended CCAC (B.F.A., M.F.A. 1958). After a brief flirtation with Pop art in the mid-1960s, he moved to large abstract canvases in which elliptical linear bands seemed to float on fields of closely graded pinks and purples. In the mid-1970s, he turned to a freer and elegant painterly style into which certain Pop images, largely having to do with the process of art-making itself—color charts, pencils— discreetly reappeared. He then moved to richly textured abstractions that were related compositionally to Diebenkorn's *Ocean Park* paintings and were loosely based on the forms of mountain peaks and ridges, although their crackled and creased surfaces more nearly suggested those of folded paper run through a photocopying machine.

Modecke, Charles (1923–)

Painter. Born in San Francisco; attended U.C. Berkeley (B.A., B.S., M.A.). His paintings of the 1950s and 1960s were in a shimmering style of abstract Impressionism, suggesting flowers, gardens, and other natural forms.

Molitor, Gary (1940–)

Sculptor. Born in Modesto, Calif.; attended San Francisco City College (A.A. 1961) and San Francisco State College (B.A. 1964, M.A. 1965). His Funk sculpture of the late 1960s combined elements of landscape—usually geometric blocks of plastic cooly painted with baby-blue skies and fleecy white clouds—with organic abstraction, generally connected by pieces of plastic tubing that extended along floor, walls, and sometimes ceiling to end in a swelling, visceral protuberance painted a bright, bloody red. His work was represented in several important exhibitions, including Funk Art and Plastics: West Coast, but by the early 1970s he had withdrawn from the art world and was working as a salesman.

Moment, Joan (1938–)

Painter. Born in Pennsylvania; attended the University of Connecticut (B.S. 1960) and the University of Colorado (M.F.A. 1970). Her paintings of the early 1970s were lush, tropical landscapes, painted in acrylic on rubberized latex canvas, and in a highly patterned, primitivistic style that suggested sources in Australian aboriginal bark painting. She later turned to more abstract forms painted on canvas and related to the "pattern painting" movement, although they retained roots in the design motifs of primitive cultures. She has taught since 1970 at Sacramento State University.

Monroe, Arthur (1935–)★

Painter. Born in New York City; attended New York City College, the Brooklyn Museum Art School, U.C. Berkeley, and the Pratt Institute. Came to the Bay Area in 1957. In the late 1970s Monroe served as curator of exhibitions for the African-American Historical and Cultural Society in San Francisco.

Montano, Linda (1942–)

Performance artist. Born in Saugerties, N.Y.; attended the College of New Rochelle in New York (B.A. 1965), the Villa Schifanoia in Florence (M.A. 1966), and the University of Wisconsin (M.F.A. 1969). Active in the Bay Area through the 1970s, she presented ritualistic performances that explored the concept of femininity by drawing on childhood memories and her experiences with Roman Catholic nuns.

Monte, James (1934–)

Painter. Born in San Francisco; attended CCAC, the Académie de la Grande Chaumière in Paris, the College of Marin, and SFAI. Initially an Abstract Expressionist, he turned in the mid-1960s to muted, soft-edged, circle-and-target abstractions in the manner of Kenneth Noland. Director of the gallery at SFAI (and San Francisco correspondent for *Artforum*), he left in 1967 to become curator of contemporary art at the Los Angeles County Museum of Art, and later moved to New York to take a curatorial post at the Whitney Museum. By this time his painting had become a loose, luminous, and broadly but thinly painted variant of "lyrical abstraction."

Montez, Richard (1948–)★

Muralist. Born in Oakland. No formal art training; gained experience by working with muralist Michael Rios.

Moon, Robert (1941–)

Painter and printmaker. Born in Oregon City, Ore.; attended SFAI (B.F.A. 1966, M.F.A. 1969). Associated with the Visionary artists, Moon worked in a hyperrealistic style, generally portraying figures in unusual relationships with landscapes—such as floating above the waters of San Francisco Bay in a yoga position.

Moquin, Richard (1934–)

Ceramic sculptor. Attended San Francisco City College (B.A. 1958) and San Francisco State College (M.A. 1964). His characteristic sculptures in the 1970s were mound-like shapes bisected by gaping cuts through which passed "freeways" whose painted images appeared on the sculpture's pedestals.

Morehouse, William (1929–)★

Painter. Born in San Francisco; attended CSFA (1947–1950, B.F.A. 1954) and San Francisco State College (M.A. 1956). His paintings have generally been broadly representational, concentrating on images of mountains or ocean, greatly simplified and with undertones of mysticism. In the late 1960s and early 1970s he worked for a time with urethane foam, poured to create gnarled, convulsive relief forms to which he added violent color. In the late 1970s he turned to painting in a diptych format, painting related or contrasting images, symbols, or abstract forms. They were sometimes painted in contrasting (though basically bold and painterly) styles as well.

Morris, Robert (1931–)★

Sculptor. Born in Kansas City, Mo.; attended Kansas City Art Institute (1948–1950), CSFA (1950–1951), and Reed College (1953–1955). Active in the Bay Area from 1955 to 1961, when he moved to New York.

Morton, Geer (1935–)

Painter. Born in Maine; attended SFAI (B.F.A. 1962) and San Francisco State College (M.A. 1964). His paintings of the early 1970s were primarily portraits with intense brushwork and vigorous colors that recalled the portrait paintings of Soutine.

Moscoso, Victor (1936–)★

Painter and postermaker. Born in La Coruña, Spain; attended Cooper Union College in New York City (1957), Yale University (B.A. 1959, studied with Joseph Albers), and SFAI (M.A. 1961).

Mossholder, Donna (1946–)

Painter. Born in Pasadena, Calif.; attended CCAC (B.F.A. 1967, M.F.A. 1969). Her paintings of the late 1970s, primarily watercolors, were tapestries of overlapping images related to the illustrated fantasies of children's storybooks. They combined illusions of deep perspective with trompe l'oeil effects that resembled decals.

Motherwell, Robert (1915–)★

Painter. Born in Aberdeen, Wash., and moved to California in 1926; attended Stanford University (B.A. 1937) and Harvard University (1937–1938).

Mouse, Stanley (n.d.)★

Postermaker. A producer of some of the earliest "monster" T-shirts in Los Angeles before he came to San Francisco in the mid-1960s, he made posters that frequently combined elements of the hysterical pop style characteristic of drawings in *Mad Magazine* with the expressionism of early, pre-abstract Paul Klee. He worked with Alton Kelly in Mouse Studios. His real name is Stanley Miller.

Mullican, Lee (1919–)★

Painter. Born in Oklahoma; attended Abilene Christian College in Texas (1937), the University of Oklahoma (1939–1941), and the Kansas City Art Institute (1942). Moved to San Francisco in 1947, and to Southern California in 1951. Mullican continued to exhibit regularly in San Francisco through the mid-1970s, primarily at the Rose Rabow Gallery on Russian Hill.

Mundt, Ernest (1905–)

Sculptor. Born in Germany; attended the Technische Hochschule in Berlin (graduated 1936) and came to the United States in 1939. His sculpture of the 1950s generally took the form of openwork "drawing in space," using wire or tubing and abstracting from the structures of plants and flowers. His book *Art, Form and Civilization* was published in 1953 by the University of California Press.

Myers, Martin (1951–)

Painter and sculptor. Born in Syracuse, N.Y.; attended Virginia Commonwealth University (B.F.A. 1973) and CCAC (M.F.A. 1974). His works of the

mid-1970s were tall, free-standing vertical shafts, their surfaces honeycombed with grids and window-like painted rectangles to resemble high-rise office towers. He later became more interested in the abstract play of different effects of light across these surfaces, and began to assemble his columns into more complex and eccentric structures.

Nadalini, Louis (1927–)

Painter. Born in San Francisco; attended the Art Students League in New York (studied with George Grosz), and studied with Martin Baer in San Francisco (1955–1957). In the late 1960s he developed a form of painted relief, painting hard-edge forms on vertical louvres arranged so that different compositions were seen when observed from the right or the left side of the picture.

Nagle, Ron (1939–)★

Ceramic sculptor. Born in San Francisco; attended SFAI (summer student, late 1950s) and San Francisco State College (B.A.).

Nathan, Michael (c. 1938–)

Painter. Attended CSFA (c. 1957). Active in North Beach in the late 1950s, he painted flat, primitively stylized portraits of authority figures—doctors, a Jehovah's Witness sidewalk preacher—centered on intense color grounds and projecting an obsessive presence. The earliest of three muralists to paint the interior of the Co-Existence Bagel Shop (the others were John Reed and Aaron Miller), he also had the first one-man show to open the Coffee Gallery in 1957; he had just turned twenty, and was too young to be admitted. He painted for only two or three years before falling victim to a series of nervous breakdowns.

Nauman, Bruce (1941–)★

Conceptualist sculptor and performance artist. Born in Fort Wayne, Ind.; attended the University of Wisconsin (B.S. 1964), and U.C. Davis (M.F.A. 1966); moved to Pasadena in 1969.

Nelson, Arthur (1942–)

Ceramic sculptor. Born in Everett, Colo.; attended the University of Colorado (B.A. 1964) and CCAC (M.F.A. 1969). He has been a teacher at CCAC since the late 1960s. The characteristic imagery of his ceramics of the 1970s was drawn from the world of racing cars and hot rods.

Nepote, Alexander (1913–)

Painter and collagist. Born in Valley Home, Calif.; attended CCAC, U.C. Berkeley, and Mills College. He developed an abstract style in the late 1940s and early

1950s, based on natural forms and emphasizing simple, decorative shapes that suggested rocks or the structures of cliff faces. In the 1960s and 1970s, his paintings often included paper cut into loosely geometric forms that underlined their architectonic structures. He has been an influential teacher at San Francisco State since the 1950s.

Neri, Manuel (1930–)*

Sculptor. Born in Sanger, Calif.; attended San Francisco City College (1950–1951), U.C. Berkeley (1951–1952), CCAC (1952–1953, 1955–1957), the Archie Bray Foundation in Helena, Montana (1953), and CSFA (1957–1959).

Neubert, George (1942–)

Sculptor and collagist. Born in Minneapolis; attended Hardin-Simmons University in Abilene, Texas (B.S. 1965), SFAI, and Mills College (M.F.A. 1969). A minimalist sculptor in the late 1960s, Neubert drew on his background as a college football player to fashion spare, linear, painted gray structures inspired by the forms of football-field goal posts. In the 1970s he turned to delicate collages of an Oriental cast. He was chief curator of the art division at the Oakland Museum after Paul Mills left to become director of the Santa Barbara Museum of Art in the late 1960s; in 1980 he was appointed associate director in charge of exhibitions at the San Francisco Museum of Modern Art. In 1983 he left the Bay Area to direct the art gallery at the University of Nebraska.

Neuhaus, Eugen (1879–1963)*

Painter and art historian. Born in Barmen, Germany; studied at the Realgymnasium in Elberfeld and the Royal Art School in Kassel (graduated 1899); came to the United States in 1904. He became an assistant professor of decorative design at the School of Design, San Francisco Institute of Art (1907–1911), and was a professor of decorative design at U.C. Berkeley (1908–1949). He was associated primarily with landscapes painted in a mural-like style, characterized by bold design and broad, flat areas of color.

Ng, David (1942–)

Painter and sculptor. Born in Macao and came to the United States in 1958; attended SFAI (B.F.A. 1970). His soft-spoken wall reliefs of the mid-1970s combined elements of painting and sculpture, emphasizing process and the modular geometries and muted tones of unusual materials such as sanitary napkins.

Ng, Win (1935–)

Painter and sculptor. Born in San Francisco; attended San Francisco City College and CSFA (B.F.A. 1959). His work has ranged from sculptural playground figures to murals painted in the Orinda BART station.

Most characteristic of his work of the late 1960s and early 1970s was ceramic sculpture, generally white or earthen in color, roughly geometric in form, and with hollows and crevasses opening to hidden interior spaces.

Nilsson, Gladys (1940–)

Painter. Born in Chicago; attended the School of the Art Institute of Chicago (1958–1962); moved to Sacramento in 1968 to teach at Sacramento State University. Her paintings, primarily watercolors, consisted of fanciful figures and bizarre creatures painted in transparent colors and tightly interlocked, as in a jigsaw puzzle.

Nong (1931–)

Painter. Born Robert Han, in Seoul, Korea. Trained as a lawyer at the University of Korea, he did graduate work at the University of Michigan and worked as a teacher at the U.S. Language Institute in Monterey before turning full time to painting in the early 1960s, when he established his own gallery on Union Street in San Francisco. He specialized in decorative abstractions of simple, symmetrical forms—generally, the silhouettes of vases—adorned with abstract calligraphy and painted in polyester-based colors built up to evoke a patina of great antiquity.

Nordman, Maria (1943–)*

Conceptualist. Born in Goerlitz, Silesia, Germany; came to California in 1961; attended UCLA, 1961–1967 (B.F.A., M.F.A.).

Norman, Irving (1910–)

Painter. Born in Poland; came to the United States as a child and settled in the Bay Area in 1940; attended CSFA. His paintings, generally of immense size, portray nightmarish visions filled with countless images of cadaverous androids and mechanized robots engaged in scenes of avarice and victimization amid cell-like geometric architectures that suggest the high-rises and technological environment of the modern city. He has supported himself through most of his career in the Bay Area by working as a barber.

Nutt, James (1938–)*

Painter. Born in Pittsfield, Mass.; attended the School of the Art Institute of Chicago (1960–1965); moved to Sacramento in 1968 to teach at Sacramento State University. His paintings emphasized rubbery, cartoon-like figures engaged in enigmatic actions and often arranged in tableaux that suggested theater stages.

Oback, N. Eric (1920–)

Painter. Born in Sweden; attended CCAC (1949–1953, M.F.A. 1953). His landscape compositions, primarily in watercolor, pivoted around contrasts between broad, organic areas painted in dry, earth colors and

302

stark geometric planes that often consisted of unpainted "white space." Since 1967 he has been a teacher at San Jose State University.

Oda, Joe (1931–)

Painter. Born in New York City. Attended the Institute of Design at the Illinois Institute of Technology in Chicago and SFAI. His paintings, in a Bay Area Figurative style akin to that of James Weeks, concentrated on interiors containing discreetly misplaced objects and enveloped in soft, nocturnal shadows.

Odza, Theodore (1915–)

Sculptor. Born in New York City; attended U.C. Berkeley (B.A. 1959, M.A. in painting 1961, in sculpture 1963). His sculpture of the 1960s and 1970s consisted of gnarled, expressionistic slags of welded steel or bronze, frequently suggesting mythological themes. These organic forms were sometimes combined with geometric ones, generally large circles, in translucent polyester resins.

Ogden, Jack (1933–)

Painter. Born in French Camp, Calif.; attended Sacramento State College (B.A. 1961, M.A. 1962). Ogden worked in a bluntly direct, painterly style that he applied to a wide range of imagery; he often portrayed historic artists of the past—Cézanne, van Gogh, Rembrandt—and alluded to their respective styles. His idiosyncratic manner of recasting art-historical themes (and more general ones as well) in his own image was related to the painting of Joan Brown.

O'Hanlon, Richard (1906–)★

Sculptor. Born in Long Beach, Calif.; attended CCAC (1926–1927) and CSFA (1930–1933). His abstract sculpture, generally carved in granite or travertine, combined organic and geometric shapes in a classic modern style based on Cubism and designed to give form to symbolic themes (*Nest of the Oracle, Kabuki*). He had the distinction of being one of the very few Bay Area sculptors to carry a sophisticated knowledge of stone-carving techniques into the 1960s and 1970s.

Okamura, Arthur (1932–)

Painter. Born in Long Beach, Calif.; attended the School of the Art Institute of Chicago (1950–1954), the University of Chicago (1951, 1953, 1957), and Yale University (summer art seminar, 1954). Inspired chiefly by natural forms—landscape, seascape, flowers—his paintings have ranged in style from a broad, loosely painted Impressionism to flatly patterned abstraction based on the spatial conventions of Chinese and Japanese painting. He has been a teacher at CCAC since the late 1950s.

Okubo, Miné (1912–)

Painter. Born in Riverside, Calif.; attended Riverside Junior College (1933–1934) and U.C. Berkeley (1935–1936, B.A. and M.A.). In the late 1930s she did figure paintings in the monumental style of Diego Rivera and landscapes influenced by Dufy. In 1944, after being interned for two years in Japanese-American relocation camps, she moved to New York where she illustrated for *Fortune* and other magazines. She returned to U.C. Berkeley as a lecturer in art between 1950 and 1952. Her paintings of the 1950s were in a style influenced by Matisse, Fauvism, Japanese folk art, and children's art.

Oldfield, Otis (1890–1969)★

Painter. Born in Sacramento; returning to San Francisco in 1924, after studying for fifteen years in Paris, he became one of the most influential teachers of the 1920s and 1930s at CSFA. An enthusiast of André Lhote's painting and color theories, he transmitted to his students a similar fondness for heavily geometricized, cubistic forms modeled on Cézanne, and livelier color ideas that ran parallel to those of Orphism. In 1926 he and Yun Gee founded the short-lived Modern Gallery on Montgomery Street near Chinatown.

Oliveira, Nathan (1928–)★

Painter. Born in Oakland; attended CCAC (M.F.A. 1953) and Mills College (summer 1950, studied under Max Beckmann).

O'Neal, Mary Lovelace (1942–)

Painter. Born in Jackson, Miss.; attended Howard University (B.F.A. 1964) and Columbia University (M.F.A. 1969). Her paintings of the late 1970s were gestural abstractions dominated by spare, thin linear scrawls in pastel against black charcoal grounds on stretcherless raw canvas.

O'Neill, Dan (1942–)

Cartoonist. Born in Virginia; attended the University of San Francisco. His popular comic strip, "Odd Bodkins," which ran in the *San Francisco Chronicle* through most of the 1960s, drew on the graphic tradition of Krazy Kat and combined social satire with metaphysical fantasy in a way that anticipated the underground comics of the late 1960s. In the 1970s he moved to parodies of Walt Disney creations and later to more political themes.

Onslow-Ford, Gordon (1912–)★

Painter. Born in England; attended the Dragon School in Oxford, the Royal Naval College at Dartmouth, and the Royal Naval College at Greenwich. Associated with the Surrealist group in Paris, London,

and New York, 1938–1943; came to San Francisco in 1947. His paintings were increasingly governed by his theory that art revolved principally around the use of the circle, the line, and the dot (a reduction to their surfaces of the proverbial "cylinder, sphere, and cone" described by Cézanne), which he combined in a freely improvisatory way, sometimes to highly kinetic effect. He was also a significant collector of modern art.

Oppenheim, Dennis (1938–)★

Conceptualist sculptor. Born in Mason City, Wash.; attended CCAC (B.F.A. 1965); Stanford University (M.A. 1966). He was caught up in the Funk esthetic while a student at CCAC in the early 1960s, and was prominently represented in the Abstract Expressionist Ceramics show organized by John Coplans for the art gallery at U.C. Irvine in 1966.

Ortman, George (1926–)

Painter. Born in Oakland; attended CCAC (1947–1948), Atelier 17 in New York (1949), Atelier André Lhote in Paris (1949–1950), and the Hans Hofmann School of Fine Arts in New York (1950–1951). His early student paintings were influenced by Surrealism. After leaving the Bay Area, he became known for painted reliefs in which a constructivist geometry was used to express a personal symbolism.

Overhoff, Jacques (1933–)★

Sculptor. Born in the Netherlands; attended the Graphics School of Design at the School of Fine Arts in Amsterdam, the Brussels Academy, and the University of Oregon. In San Francisco since the late 1950s, he has made civic sculpture in a variety of styles, ranging from symbolic figures to structural abstractions and entire sculptural plazas, generally working in cement.

Overstreet, Joe (1934–)

Painter. Born in Conehatta, Miss.; attended CCAC and U.C. Berkeley (B.F.A.). Associated with the Beat scene in North Beach in the late 1950s, he took informal sculpture lessons from Sargent Johnson and worked in a similar, African-inspired style. In 1959 he left for New York, where he was active among black artists' groups in Harlem, but he frequently visited the Bay Area in the late 1960s and early 1970s, when he was a guest instructor at California State University, Hayward. In the late 1960s he developed a form of painted construction in which shaped canvases, stained with richly decorative geometric patterns based on African design motifs, were arranged in taut, sculptural configurations by means of cords that guyed them to the ceiling, wall, and floor.

Paalen, Wolfgang (1905–1959)★

Painter. Born in Vienna; studied in Italy, Paris, and Munich, 1921–1927. Settled in Mexico in 1939. Active in the Bay Area, 1950–1954.

Packard, Emmy Lou (1914–)★

Painter and sculptor. Born in Imperial Valley, Calif.; studied with Diego Rivera (1928), and at U.C. Berkeley (1936) and SFAI (1939, 1970). From her initial Social Realist style her work developed in the 1960s and 1970s into a more fanciful form of abstraction, based on natural forms but translated into boldly stylized surface patterns. Her sculpture commissions have included a carved concrete wall at Kaiser Center in Oakland and an 85-foot concrete frieze on the student union building at U.C. Berkeley.

Palmer, Jon (1942–)

Sculptor. Born in San Francisco; attended Chico State College (B.A. 1965, M.A. 1967) and San Jose State College (M.A. 1970). His work of the late 1960s and early 1970s consisted of positive and negative castings of torsos in plaster and fiberglass, sliced into strips and rearranged in geometric blocks. In the mid-1970s he cast fragments of figures—arms, torsos, faces—in soft latex, which was hung from the wall and suggested flayed skins.

Paris, Harold (1925–1979)★

Sculptor. Born in Edgemere, Long Island, N.Y.; attended Atelier 17 (1949) and the Creative Lithographic Workshop in New York City (1951–1952) and the Akademie der Bildenden Künste in Munich (1955–1956). Moved to Berkeley in 1960.

Park, David (1911–1960)★

Painter. Born in Boston; attended the Otis Art Institute in Los Angeles (1928–1929). Lived in San Francisco, 1929–1936, Boston, 1936–1941, and in the Bay Area after 1941.

Parkinson, Ariel (n.d.)

Painter. Attended Scripps College and U.C. Berkeley (M.A. in English literature); studied art in Paris, Rome, and at SFAI. Her paintings, and the stage sets and costumes that she has also been active in designing, have concentrated on fantasies of mythological creatures—griffins, fauns, and satyrs—in dramatic, Wagnerian settings of flame and mist.

Patchen, Kenneth (1911–1972)

Poet and painter. Born in Niles, Ohio; attended Commonwealth College, Mena, Ark. (1930). One of

the earliest American poets to become interested in trying to incorporate elements of jazz rhythms and phrasings into his writing, he frequently handpainted the covers of his published volumes of poetry, sometimes adding collage elements to the pictorial ingredients. He also did independent paintings and drawings, integrating words and signs with fanciful pictorial images in a casual, innocent, almost childlike style.

Pearson, John (1931–)

Sculptor. Born in Kansas City, Mo.; attended the University of Wichita (B.A. 1955) and SFAI (M.F.A. 1960). His bronze sculptures combined castings made from found objects—most often, women's shoes in various stages of derangement—with relief images that suggested ritual or fetish objects. He was the founder, in the mid-1960s, of the Berkeley Art Foundry in Berkeley.

Pecoraro, Salvatore (1936–)

Painter. Born in Chicago; attended CCAC (B.A. 1957) and San Francisco State College (M.A. 1966). His paintings of the mid-1970s were "skyscapes"—areas of clouds or blue sky under various conditions of light and atmosphere—painted in a meticulous Photo Realist style after color photographs. His most ambitious work, *Sky,* consisted of 365 one-foot-square panels of acrylic spray-painted on vacuum-formed styrene, arranged chronologically in a composition seven feet high and fifty-two feet long; it constituted a "diary" of the appearance of the sky each day over a year-long period.

Penker, Ferdinand (1950–)

Painter and printmaker. Born in Klagenfurt, Austria; attended the University of Graz, Austria (1968–1972). His paintings, in egg tempera on canvas, are abstractions in which repeated, capsule-like oblongs in varying tones of a single color—pink, rose, or gray—move diagonally across transparent color fields like sheets of rain, in counterpoint to thin white lines that slice in the opposing direction with the pinpointed force of a beam of laser light. They combine a meditative calm with a sense of latent kinetic energy.

Perez, Vincent (1938–)

Painter. Born in Jersey City, N.J.; attended the Pratt Institute in Brookyn (B.F.A.), The University of the Americas in Mexico City, and CCAC (M.F.A.). His paintings of the 1960s and early 1970s focused on anonymous, depersonalized figures imprisoned in revolving doors, ticket booths, and similar enclosures, and were related in theme and mood to the painting of George B. Tooker. His figures were executed, however, in a highly graphic style rooted in German Expressionism, and the mottled and marbled surfaces of the paintings were scrubbed and polished to a glossy hardness that resembled the texture of floor tiles. A

teacher at CCAC, he lapsed into inactivity as a painter in the mid-1970s.

Pernish, Paul (1936–)

Painter. Born in Michigan; attended Michigan State University (B.A. 1958) and SFAI (1960). His paintings in the early 1960s were in a direct, improvisatory figurative style reminiscent of the East Coast painter Lester Johnson. In the late 1960s he turned to a Pop-inspired portraiture that resembled color-solarized photography in its emphasis on vibrant color contrasts and liquified forms. In the 1970s he concentrated on photography.

Perrizo, James (1938–)

Sculptor. Born in Los Angeles; attended U.C. Berkeley (B.A. 1967, M.A. 1969, M.F.A. 1974). His monumental steel structures of the early and mid-1970s, influenced by the bronze sculpture of Peter Voulkos, took the simple forms of pyramids or plinths, their planes broken by bulging convex hemispheres in dramatic relief.

Perry, Charles (1929–)

Sculptor. Born in Helena, Mont.; attended Columbia University, U.C. Berkeley, and Yale University (B.A. in architecture, 1958). His symmetrical metal sculptures of the early 1960s were fluid but carefully worked-out extensions of geometric formulas. His work from later in the decade seemed to fuse abstract geometry with intimations of natural forms. It was often made of clustered wires and rods in a manner that recalled the work of Naum Gabo, and it frequently incorporated concentric outlines of its own forms. Perry began to spend increasing periods of time in Italy following a two-year residence there in the mid-1960s. His sculpture entitled *Eclipse* dominates the lobby of the San Francisco Hyatt Regency hotel.

Petersen, Roland (1926–)

Painter. Born in Denmark; attended U.C. Berkeley (A.B. 1949, M.A. 1950), SFAI, CCAC, Atelier 17 in Paris, and the Islington Studio in London. A teacher at U.C. Davis since the early 1960s. Petersen's best-known paintings used images of picnic tables and picnickers as the elements of rigorously geometric structures that became scaffoldings for heavy impastos of brilliant pure colors set off by dazzling whites, in a style that seemed to combine Diebenkorn with Thiebaud.

Peterson, Margaret (1902–)★

Painter. Born in Seattle; attended U.C. Berkeley (B.A. 1926), the Rudolph Schaeffer School of Modern Design in San Francisco (1927), and again U.C. Berkeley (studied with Hans Hofmann, M.A. 1931). A

teacher at U.C. Berkeley between 1928 and 1950, she was influential in stimulating the interest of students in a range of modernist ideas and enthusiasms, from Picasso to El Greco and Byzantine icons. Her own painting was influenced largely by Picasso until the late 1940s, when she turned to sources in Northwest Indian art.

Piazzoni, Gottardo (1872–1945)*

Painter. Born in Intragna, Switzerland; came to California in 1886; attended the California School of Design in San Francisco (1891–1893), the Académie Julian in Paris (1895), and the Ecole des Beaux Arts in Paris (1895–1898). Settled in San Francisco in 1898.

Pinkerton, Clayton (1931–)

Painter. Born in San Francisco; attended CCAC (B.F.A. 1952, M.F.A. 1953). Initially working in Bay Area Figurative style, he turned in the mid-1960s to themes of social comment and a more clean-cut, boldly stylized manner, with a wryly ironic humor related to Pop art. In the 1970s his style loosened again, and he frequently painted landscape in a cool, emotionally neutral style.

Ploeger, John (1943–)

Painter. Attended CCAC (B.F.A. 1970, M.F.A. 1972). His Photo Realist paintings of the late 1970s focused on gaudy Hawaiian print shirts isolated against overripe landscape backgrounds in a way that suggested Surrealist portraiture. He later turned to more conventional scenes of nocturnal streets and old houses around Santa Cruz.

Polos, Theodore (1902–1976)

Painter. Born in Greece; came to the United States in 1916; studied at the Mark Hopkins Institute (with Constance Macky) and at CCAC (with Xavier Martinez). He painted under the Federal Arts Project, 1937–1940, and taught at CCAC between 1946 and 1959. Initially a landscape painter, in the 1950s he simplified his forms to chunky planes of color laid on in thick slabs with the palette knife.

Pomeroy, James (1945–)

Sculptor. Born in Pennsylvania; attended the University of Texas (B.F.A. 1968) and U.C. Berkeley (M.A. 1970, M.F.A. 1972). His sculpture of the early 1970s—most often temporary installation pieces—took the form of skeletal structures constructed of common building materials; one enclosure, of metal beams, was fitted with the innards of a dozen or more music boxes programmed to play the same tune at different speeds, in a musical round that enveloped the viewer. In the later 1970s he moved to works that emphasized the use of rubber stamp marks gathered in complex grids and

intricate moiré patterns from which elusive images emerged. His most ambitious work of this kind was a monumental version of the four presidential heads carved on Mount Rushmore. It was part of a larger project that included a collection of souvenirs and relics associated with the site, and an essay on its historical, sociological, and personal implications.

Pompili, Lucian Octavius (1942–)

Ceramic sculptor. Born in Washington, D.C.; attended Montana State University in Bozeman, and U.C. Davis (M.F.A. 1971). His ceramic sculpture of the mid-1970s generally made references to ruins and classical architecture.

Poor, Henry Varnum (1888–1970)

Painter and ceramist. Born in Chapman, Kan.; attended Stanford University (1910), the Slade School in London, and the Académie Julian in Paris. An instructor in the Stanford University art department from 1917 to 1921, he was known for landscape painting in a mildly simplified, cautiously modern style.

Posey, Ernest (1937–)

Painter. Born in New Orleans; attended Louisiana State University (B.A. 1959). His paintings of the early 1970s were neutral fields divided into grids that contained pinpoints surrounded by small auras of color, suggesting crystallized light. His paintings of the late 1970s were looser in style, and contrasted soft, iridescent surfaces with apparently random dots, squiggles, and geometric shapes painted in brilliant colors.

Post, George (1906–)

Painter. Born in Oakland; attended CSFA. A specialist in picturesque land and harbor scenes painted in a conservative watercolor style, he was a teacher at CCAC from 1947 to 1972.

Potts, Don (1936–)*

Sculptor. Born in San Francisco; attended San Jose State College (B.A. 1963, M.A. 1965). Potts began as a student of painting but soon began working pieces of wood into his paintings and then started shaping the canvas itself into a disc format. He turned to wood sculpture as a graduate student in 1964–1965.

Pratchenko, Paul (1944–)

Painter. Born in Virginia; attended San Jose State University (B.A. 1969, M.A. 1971). Inspired by the work of M. C. Escher, his paintings of the late 1960s and early 1970s explored the metamorphosis of figures into architectural backgrounds. In the mid-1970s he turned to a more illustrative vein of Surrealism, which

had parallels in the work of Magritte and also in magazine illustration styles of the 1930s and 1940s.

Prestini, James (1908–)★

Sculptor. Born in Connecticut; attended Yale University (B.S. in engineering, 1930). He was an instructor at the Institute of Design at the Illinois Institute of Technology, 1939–1946; studied sculpture in Italy, 1953–1956; and joined the faculty of the design department in the School of Architecture at U.C. Berkeley in 1956. In the late 1930s he became known for elegant bowls of birch, cherry, mahogany, and poplar, shaped on a lathe to an extraordinary thinness and achieving the maximum height and diameter from a given piece of wood.

Price, Clayton S. (1874–1950)

Painter. Born in Iowa; attended the Saint Louis School of Fine Art (1905–1906). Living in Monterey between 1918 and 1929, he was closely associated with The Society of Six (August Gay shared a studio with him in the historic Robert Louis Stevenson house there). Through the mid-1920s he painted farms and farm animals in a style that alternately emphasized simple, Cézannesque volumes and the decorative silhouettes of Gauguin's painting. Around 1925 he began to carve miniature sculptures—animals, farm workers—in cork or wood; arranged together with paint rags and other still-life objects, these figurines became relatively literal models for quite unliteral paintings: tightly interlocking, nearly abstract compositions in dour, earth colors and built up in thick, Soutine-like impastos. Price moved to Oregon in 1929.

Prieto, Anthony (1913–1967)

Ceramist. Born in Valdepeñas, Spain; came to San Francisco in the early 1940s; attended CSFA and Alfred University in New York. His utilitarian vessels, although conceived largely within the conventions of the functional and decorative ceramic tradition, were influenced by Picasso and Miró in the fanciful linear drawing of their surfaces, and were also distinguished by superb craftsmanship. As a teacher (at CCAC, 1946–1950, and Mills College, 1950–1967), he was an important force behind the growth, if not the direction, of the Bay Area ceramics movement, two of whose most influential figures, Robert Arneson and Charles McKee, studied under him.

Provenzano, Sam (1923–)

Painter. Born in Pennsylvania; attended Syracuse University (B.F.A. 1949), studied at the Colorado Springs Fine Art Center, the Academy of Fine Arts in Florence, the Academy of Fine Arts in Mexico City, and the Hans Hofmann school in New York. In the 1950s, when he arrived in San Francisco, he practiced a vigorous, gestural variety of Abstract Expressionism. In the 1960s and 1970s he experimented with a more

formal style, based on wedge shapes and other simple forms. He has directed his own studio school for painters since the 1960s.

Provisor, Janis (1946–)

Painter. Born in Brooklyn; attended the University of Michigan (1964–1966) and SFAI (B.F.A. 1969, M.F.A. 1971). Her work of the mid-1970s consisted of grids and related constructions of canvas strips, coated with fiberglass, metallic flakes, formica, and glitter. In the late 1970s she turned to painting schematic figures and simple signs on impastoed grounds as thick as cake frosting. They suggested a cryptic personal symbolism and were related to the work of the Bay Area "mythmakers."

Pruner, Gary (1940–)

Painter. Born in Kearney, Neb.; attended CCAC, U.C. Davis, and Sacramento State College (B.A., M.A.). In his Photo Realist paintings of the early 1970s he approached abstraction by enlarging mundane still-life subjects to immense scale, cropping out most of their surroundings, and recreating sharp differences in "focus" between foreground and background, highlights and reflections.

Quagliata, Narcissus (1942–)

Stained-glass artist. Born in Rome; a U.S. citizen; attended SFAI (B.F.A. 1966, M.F.A. 1968). His stained-glass work of the late 1970s achieved a sculptural dimension, generally taking organic forms, most often those of human hands in expressive gestures.

Quandt, Elizabeth (1922–)

Painter and printmaker. Born in Oxfordshire, England; came to California in 1944; attended SFAI (B.F.A. and M.F.A., 1964–1969). Her paintings of the late 1950s were abstractions of the forms of birds in flight. She later concentrated primarily on etchings of the interiors and exteriors of old frame houses.

Raciti, Cherie (1942–)★

Painter. Born in Chicago; attended the University of Illinois (1960–1961), Memphis Academy of Art (1963–1965), San Francisco State College (B.A. 1968), and Mills College (M.F.A. 1979).

Raffael, Joseph (1933–)★

Painter. Born in Brooklyn; attended Cooper Union in New York City (1951–1954) and the Yale School of Fine Arts (B.F.A. 1956); moved to the Bay Area in 1969.

Ramos, Mel (1935–)★

Painter. Born in Sacramento; attended Sacramento City College (1954–1955), San Jose State College

(1955–1956), and Sacramento State College (1956–1958, B.A., M.A.). His early student paintings were in a symbolic vein of Surrealism, influenced by Dali. By 1960 Ramos had executed his first Pop painting, *Chiquita*. In the 1970s he turned to caricaturing the compositions of old masters—Ingres, Manet—in his own Pop-influenced style, and he later painted a series of variations on de Kooning's *Woman* paintings in a style of "abstract illusionism." In the 1980s he turned to landscape subjects in a steely, almost trompe l'oeil realistic style.

Randell, Richard (1929–)

Sculptor. Born in Minneapolis; attended the University of Minnesota (B.A. 1953). His sculpture of the late 1960s and early 1970s—big, zig-zagging, angular pieces called *Clackers,* and pieces with undulating ribbons of brightly colored fiberglass (or sometimes marble)—were installed horizontally on the floor or ground, forming rhythmic sequences of rising and falling peaks and valleys. He taught at Sacramento State University in the late 1960s and later at Stanford.

Rapoport, Sonya (1923–)

Painter. Born in Roxbury, Mass.; attended New York University (B.A.) and U.C. Berkeley (M.A.). Her paintings of the early 1970s generally played abstract organic shapes against fine, linear grids, initially derived from those found in old geological survey maps.

Rauh, Fritz (1920–)

Painter. Born in Wuppertal, Germany; attended Brunswick Art School (1939) and the Academy of Brunswick (1950) in Germany; came to the United States in 1954. His acrylic paintings of the late 1960s and the 1970s were rhythmic abstractions filled with squiggles of color through which flowed meandering paths of radiant light, suggesting microscopic views of nature. He was associated with Richard Bowman, Lee Mullican, Fred Reichman, and other painters who drew on sources both in nature and in Oriental art, and who were affiliated in the late 1960s with the Rose Rabow Gallery.

Rees, Joseph (1946–)

Sculptor and video artist. Born in Hayward, Calif.; attended CCAC (B.F.A. 1971, M.F.A. 1973). In the 1970s he worked in concrete, steel, rubber, and neon, and frequently introduced overtones of violence—as in *Fire Ladder,* which incorporated jets of burning natural gas. In the late 1970s he established Target Video, a cooperative of video artists active in documenting the punk rock scene.

Refregier, Anton (1905–1979)

Painter. Born in Russia; arrived in the United States in 1920; was in California between 1945 and 1948.

Studied at the Rhode Island School of Design, and in Munich and Paris. Known for murals of social protest and for his cover illustrations for *Fortune* magazine, his best-known works remaining in San Francisco are the murals depicting California history on the walls of the Rincon Annex Post Office.

Reichman, Fred (1925–)

Painter. Born in Bellingham, Wash.; came to California in 1934; attended U.C. Berkeley (B.A. 1950, M.A. 1952) and SFAI. Reichman developed a unique variant of Impressionism with strong affinities to Japanese painting. His painting was characterized by images of everyday life—a cat, a bird, a tree branch, a kitchen table, a transistor radio—which were reduced to spare, soft-edged outlines or silhouettes and floated in a space without gravity; films and veils of paint built up shimmering atmospheres through which the forms and colors of the images seemed to diffuse and pulsate. In the late 1950s he concentrated on landscape images in a shadowy, nocturnal palette. In the 1960s he turned to interior still-life objects into which light and color streamed with a vibrancy that suggested the Intimism of Bonnard, filtered through a sensibility colored by the painting of Mark Rothko and Milton Avery and by Oriental art. Reichman continued to develop his singular expression through the 1970s, while teaching in various contexts, primarily adult .education classes. Through most of the 1960s and 1970s he exhibited at the Rose Rabow Gallery, which also handled such painters as Gordon Onslow-Ford, ,Lee Mullican, and Richard Bowman, each of whom shared a preoccupation with light as a means of maintaining a tense and tenuous balance between natural and abstract forms.

Reid, Dorothy (1944–)

Sculptor. Born in Washington, D.C.; attended SFAI (B.F.A. 1971, M.F.A. 1973). Her work of the mid-1970s consisted primarily of temporary, on-site structures made of poles and strips of muslin or other fabric, arranged in a systematic fashion and incorporating changes of light among their principal effects. She later emphasized more primitivistic structures—spiral constructions of cloth, wood, and reed, or towering columns of wood carved with zigzag shapes—that suggested a hermetic personal symbolism.

Reineking, James (1937–)★

Sculptor. Born in Minot, N.D.; attended Eastern Montana State College at Billings, Montana State University at Bozeman, and SFAI (M.F.A. 1967). After moving to New York, he took up a more minimalist style, fashioning wall pieces in single large sheets of metal that were generally folded and then flattened into an extremely shallow relief.

Reinhardt, Ad (1913–1967)★

Painter. Born in Buffalo, N.Y.; attended Columbia University (1935) and the Institute of Fine Arts at New

York University (1946–1950). At the time he taught in San Francisco—at CSFA in the summer of 1950—his work was undergoing a dramatic change; the linear calligraphy that had dominated his earlier abstractions was giving way to broadly brushed swatches, often of a single color, on a plain white ground.

Remington, Deborah (1930–)★

Painter. Born in Haddonfield, N.J.; attended CSFA (1949–1952, 1953–1955, B.F.A.); traveled in the Far East, 1955–1958. By 1964 Remington's work had evolved from a heavy-textured, clangorously coloristic action painting to the hard-edge, air-brushed abstraction for which she became recognized after moving to New York in 1965. These later paintings counterposed jagged and cursive forms, intense colors and muted atmospheric ones, and suggested distant and ethereal-ized landscapes viewed through shattered windows.

Remsing, Gary (1946–)

Sculptor. Born in Spokane, Wash.; attended San Jose State College (B.A. 1968, M.A. 1969). His work of the late 1960s and early 1970s consisted of sheets of transparent plastic fit together like sandwiches, between which liquid mercury formed changing patterns.

Renfrow, Gregg (1948–)★

Painter. Born in San Francisco; attended San Francisco State College (1966–1969), SFAI (B.F.A. 1972), and the Skowhegan School of Painting and Sculpture in Maine (1972).

Reynolds, Jock (1947–)★

Sculptor, photographer, conceptualist. Born in New Brunswick, N.J.; attended U.C. Santa Cruz (B.A. 1969) and U.C. Davis (M.F.A. 1972). His sculpture of the early 1970s consisted of installation pieces which used imagery associated with fishing and farming, and frequently included organic material such as dried corn husks or live minnows. Later in the 1970s he collaborated with Suzanne Hellmuth on photographic projects mounted in elaborate installations.

Riccio, Joseph (1939–)★

Light artist. Born in New York City; active in San Francisco in the late 1960s.

Rich, Don (1941–)

Sculptor. Born in Oklahoma; attended CCAC (M.F.A. 1966). Rich's sculptures were generally miniature tableaux, in bronze combined with titanium and other alloys, honed to a jewel-like finish and furnished with symbolic forms—architectural elements, urns— that reflected his interest in alchemy. In the late 1960s he established the Oakland Art Foundry, which served as a center for much of the bronze casting done by Bay Area sculptors in the 1970s.

Richardson, Sam (1934–)★

Sculptor and painter. Born in Oakland; attended CCAC (B.F.A. 1956, M.F.A. 1960). In addition to his landscape sculpture, he did paintings in the 1970s that gave bird's-eye views of snowcapped mountain peaks. Since the mid-1960s he has been a teacher at San Jose State University.

Richer, Arthur (1928–1965)

Painter. Born in New York; moved to California about 1950; attended Finch-Warshaw College in Los Angeles. Associated with the artists who showed at the Ferus Gallery in Los Angeles, he moved to San Francisco in the late 1950s, where he lived with his family in a cottage on the Potrero Hill property of the North Beach doctor and art collector Reidar Wennesland, and was involved in the Beat scene. Initially influenced by the expressionistic figure painting of Rico Lebrun, he turned to big abstractions in which shadowy suggestions of images were immersed in surging rhythms and richly worked surface textures. He was also active as a jazz saxophonist. In the early 1960s he and his family moved to Healdsburg, where he committed suicide in 1965.

Rios, Michael (1947–)

Painter and mosaicist. Born in Oakland; attended the Academy of Art College in San Francisco and SFAI. His paintings and murals were done in a strong abstract style, dominated by dynamic, heavily outlined forms that suggested industrial and building materials in a manner related to Léger.

Rippon, Tom (1954–)

Ceramist. Born in Sacramento; self-taught (studied with Robert Arneson, 1971–1975). His ceramic sculptures of the late 1970s were life-sized tableaux and oversized portrait heads that resembled three-dimensional cartoons.

Rivera, Gustavo (1940–)★

Painter. Born in Ciudad Acuña, Coahuila, Mexico; self-taught as a painter. His early paintings, done while living in Mexico City, were in an Impressionist manner related to Pissaro. After moving to San Francisco in 1969, he turned to abstractions that incorporated ragged collage elements and contrasted dark fields of color with glowing traceries of light.

Roddy, Michael (1948–)

Painter. Born in Marietta, Ga.; attended the University of Georgia (B.F.A. 1970) and CCAC (M.F.A. 1972). His paintings of the early 1970s were Photo Realist reproductions, in black-and-white monochrome, of the corny photographs published in hunting and fishing magazines. Later he turned to a variety of abstraction that emphasized process and materials, and

to installation pieces in which the creation of the piece was often also its principal subject.

Rodriguez, Peter (1926–)★

Painter. Born in Stockton, Calif.; self-taught. His abstract paintings contained allusive fragments of motifs drawn from pre-Hispanic Mexican art, immersed in impressionistic veils of paint that suggested natural atmosphere and light. He was founder and director of the Mexican Museum in San Francisco.

Roeber, Philip (1913–)★

Painter. Born in Colorado; attended CSFA (1948–1952); moved to New York in 1960.

Rogers, Barbara (1937–)★

Painter. Born in Newcomerstown, Ohio; attended Ohio State University (B.S. 1959) and U.C. Berkeley (M.A. 1963).

Rollins, Henry (1937–)

Sculptor. Born in Kansas City; attended the University of Washington (B.A. 1962), the Rhode Island School of Design (M.F.A. 1964), and the American Academy in Rome (1966). His sculptures of the late 1960s and early 1970s were most often highly ornamental heads, in a variety of media and inspired by the forms of African sculpture. He also made abstract works, such as his monumental untitled sculpture across from the Oak Street entrance to the Oakland Museum, in which the rhythms and formal structure of African figure carvings have been reduced to spare, skeletal forms.

Roloff, John (1947–)

Sculptor. Born in Portland, Ore.; attended U.C. Davis (B.A. 1970) and Humboldt State University (M.A. 1973). His sculpture of the mid-1970s used mixtures of clay, cement, glass, volcanic ash, and other materials to evoke romantic underwater worlds of gnarled caves and the coral-encrusted hulls of long-sunken boats. In the late 1970s he turned to making huge "kilns" of ceramic fiber blankets, reinforced with steel rods and fashioned in the shapes of starfish, submarines, or ocean waves. These were fired with propane gas at remote sites on the desert or prairie, and photographically documented as an explosive form of performance sculpture.

Romano, Joseph (1911–)

Painter and sculptor. Born in New Orleans; attended CCAC and CSFA. His paintings of the late 1960s, which generally included crumpled paper and other collage elements, were thick sludges inscribed with crudely scrawled images and graffiti-like symbols in the manner of the Art Brut of Dubuffet. In the 1970s he moved to sculpture with ragged surfaces fashioned of handmade paper. Related to the thin, linear figures of Giacometti, and more strongly to the "primitive" forms of South Sea Islands sculpture, these pieces emphasized silhouette, posture, gesture, and movement with a sense of comedy and pathos.

Romero, Elias (1925–)★

Painter and poet. Born in Denver, Colo.; attended Los Angeles City College. In the 1970s he painted spare, lyrical Abstract Expressionist canvases that suggested meteorological phenomena.

Rose, Mary Anne (1949–)

Painter. Born in San Francisco; attended U.C. Santa Cruz (B.A. 1970) and U.C. Berkeley (M.A. 1972, M.F.A. 1973). Her abstractions consisted of regular strokes of color, applied according to prearranged systems but in a free, gestural manner, accumulating to form dense fields dominated by obsessive movements and patterns. They looked like ordinary pattern paintings, but they were frequently interpreted as having emanated from a kind of trance-like state that produced a conceptualist awareness of the body—not as a subject that acts, but as a constellation of virtually mechanical biorhythms.

Rosen, James (1933–)★

Painter. Born in Detroit; attended Cooper Union, New York City (1955–1956), Wayne State University (B.S. 1957), and the Cranbrook Academy of Art in Michigan (M.F.A. 1958).

Rosenbaum, John (1934–)★

Sculptor. Born in Atlantic City, N.J.; attended Cornell University (1952–1957, B.A. in engineering and physics). He began to explore polarized light in 1965.

Ross, Elliot (1946–)

Painter and photographer. Born in Illinois; attended SFAI (B.F.A., M.F.A. 1971). His work of the early 1970s brought together scores of snapshot-sized photographs, sometimes modified with scratches or touches of color, in compositions that emphasized abstract rhythms and light values.

Rothko, Mark (1903–1970)★

Painter. Born in Dvinsk, Russia; emigrated to Portland, Ore., in 1913; attended Yale University (1921–1923). Having briefly met Clyfford Still at a mutual friend's in Berkeley when Still was living there in the early 1940s, Rothko became a close friend of Still's when the two met again in New York in 1945, and was responsible for first getting Peggy Guggenheim to see Still's work. Still, in turn, was instrumental in Rothko's being invited to CSFA to teach in the summers of 1947 and 1949. (During the 1949 session, Rothko borrowed two of Still's recent paintings to hang in the Francisco

Street studio he rented from Robert Howard.) Some CSFA students, including Elmer Bischoff and Richard Diebenkorn, had already been influenced by Rothko's earlier Surrealist style when his painting was exhibited at the San Francisco Museum of Art in 1946. Rothko returned to the Bay Area in 1967 at the invitation of Peter Selz to teach a summer session at U.C. Berkeley.

Royer, Victor (1936–)★

Sculptor. Born in Fountain Spring, Pa.; attended the University of Florida (B.A. 1958) and U.C. Berkeley (M.A. 1965).

Rubenstein, Avrum (1918–)★

Painter. Born in Oregon; attended U.C. Berkeley (B.A. in mathematics); no formal training in art.

Ruvolo, Felix (1912–)

Painter. Born in New York City; studied in Italy and at the Art Institute of Chicago; a teacher at U.C. Berkeley since 1950. His early paintings were large, ominous, and expressionistic, containing dark symbolic figures inspired by traditional Sicilian rituals. Later he adopted a volcanic Abstract Expressionist style. In the late 1960s, this yielded to a flat, fluid, sinuous style of hard-edge painting, as well as some brief experiments with a Pop art manner related to Richard Lindner. In the 1970s he returned to a more painterly but less explosive Abstract Expressionism dominated by fragmentary organic shapes and related to Elmer Bischoff's abstract paintings of the same period.

Ryder, Worth (1884–1960)★

Painter. Born in Kirkwood, Ill.; attended U.C. Berkeley (left in 1906), the Art Students League of New York (1906–1908), and the Royal Bavarian Academy in Munich. An influential teacher at U.C. Berkeley through the 1950s, he was an early adherent of modernist ideas and was also strongly influenced by the revival of interest in early Florentine and Sienese painters. According to Elmer Bischoff, Ryder had little interest in any premodern painters after Giotto, but he drew upon the early Renaissance masters for coherent and teachable principles that set the primary stylistic direction for the U.C. art department throughout the 1930s.

Saccaro, John (1913–1982)

Painter. Born in San Francisco; attended CSFA (1951–1954). Under the WPA in the 1930s he worked in a Regionalist style, contributing to the murals at the Treasure Island World's Fair. In the early 1950s, under the influence of Abstract Expressionism, he developed a rich abstract style he called "sensorism." Gestural flurries of paint were massed in densely overlapping thickets and patchworks of kaleidoscopically shifting colors. The paintings, he stressed, were not conceived expressionistically, but purely as surfaces that would provoke sensory excitement. In the 1960s and 1970s, Saccaro's paintings became smaller and their forms became simpler, more closely related to forms in nature and also to the abstract style of Conrad Marca-Relli. In the mid-1950s Saccaro's studio at 1458 Broadway was shared by such painters as James Weeks, James Monte, Victor Moscoso, and Masatoyo Kishi.

Safford, Charles (1900–1963)

Painter. Born in Indiana. After running away from home at the age of fourteen, he spent his teenage years as a hobo, meanwhile learning to draw and paint in part through a brief attendance at the Pratt Institute in New York City. He moved West during the Depression to work in a trading post in the Coachella Valley, and later in San Francisco he worked as an illustrator on the WPA Writers' Project. After World War II (when he sustained an injury in Okinawa that would later cause his death), he went to the Hans Hofmann School in New York on the G.I. Bill. The abstract paintings he did after he returned to San Francisco—inspired by frequent visits to the Southwestern desert—were big, gestural oils filled with a slashing, linear energy that reflected Hofmann's influence, but which also had a raw intensity and bluntness as well as persistent roots in the forms and spaces of the natural landscape.

St. Amand, Joseph (1925–)

Painter. Born in New York City; attended Loyola University in Los Angeles, U.C. Berkeley, CCAC, and CSFA. He is known primarily for portraits painted in a bright, boldly patterned, primitively stylized manner.

St. John, Terry (1934–)★

Painter. Born in Sacramento; attended U.C. Berkeley (B.A. 1958), CSFA (1960), and CCAC (M.F.A. 1966). Associated in the early 1960s with the Firehaus group in Stockton, he painted in a Bay Area Figurative style influenced by his studies with James Weeks and Richard Diebenkorn. His paintings of the late 1960s and early 1970s became more somber, centering on interiors and still-life arrangements bathed in veiled shadows and dappled light in a manner related to Elmer Bischoff, and painted in areas of strongly contrasting values that produced these spatial relationships. In the mid-1970s, inspired by an exhibition of The Society of Six that he organized for the Oakland Museum, where he has been a curator in the art division since the late 1960s, he turned to painting high-keyed, plein-air landscapes in a bold, gestural style.

Salz, Helen Arnstein (1883–1978)

Painter. Born in San Francisco; studied with Gottardo Piazzoni, Robert Henri, and Rockwell Kent. Her pastels and watercolors included floral still lifes, landscapes, portraits, and genre subjects, painted in a bright, Fauve-inspired style.

Sanzenbach, Keith (1930–1964)★

Painter. Born in Minneapolis; attended Syracuse University (B.A. in art) and the University of New Mexico. Came to San Francisco in 1957.

Sapien, Darryl (1950–)

Performance artist. Born in Los Angeles; attended Los Angeles Valley College (1967), Fullerton Junior College (1969–1971), and SFAI (B.F.A. 1972, M.F.A. 1976). His performances were generally rituals that involved situations of unusual physical or social stress and suggested biological metaphors. They were sometimes plotted with the help of elaborate storyboards, which were occasionally exhibited as works of art in themselves.

Sätty, Wilfried (1939–1982)★

Collagist and postermaker. Born in Bremen, Germany; real name, Wilfried Podriech.

Saul, Peter (1934–)★

Painter. Born in San Francisco; attended CSFA, Stanford University (1950–1952), and Washington University in Saint Louis (B.F.A. 1956). Lived in Europe, 1956–1964.

Saunders, Raymond (1934–)★

Painter. Born in Pittsburgh, Pa.; attended the Pennsylvania Academy of Fine Arts in Philadelphia, the University of Pennsylvania, the Carnegie Institute in Pittsburgh (B.F.A. 1960), and CCAC (M.F.A. 1961). Besides being a painter, Saunders has been a prolific graphic artist. His drawings, often in a pastiche style akin to that of Larry Rivers or the early David Hockney, deftly balance nostalgia and irony. Since 1969 Saunders has taught at California State University, Hayward.

Savo, Joan (1918–)

Painter. Born in Portland, Ore.; self-taught. Active in North Beach in the 1950s, and later in the Monterey area, she worked in a broadly brushed figurative style. In the 1970s, she practiced geometric abstraction.

Scarritt, Alan (1945–)

Painter and sculptor. Born in Oak Park, Ill.; attended Brown University (B.A. 1967) and CCAC (M.F.A. 1972). His paintings of the early 1970s, though related to Photo Realism, used photographic negatives as sources for big canvases filled with simple, highly enlarged images painted in fluid, thinly stained acrylic restrained to a range of blacks, whites, and silvers. He turned later to severely minimal installation pieces in which seemingly casual arrangements of fragmentary structural elements—baseboards, moldings—were designed as abstruse metaphors for the parables of Jorge Luis Borges and other writers. In the later 1970s he founded and operated SITE, an alternative space on lower Mission Street specializing in installation and performance art.

Schlotzhauer, Harold (1941–)

Painter and sculptor. Born in Schenectady, N.Y.; attended CCAC (B.F.A. 1965, M.F.A. 1968). Assembled primarily from brightly painted rods and blocks of wood, his constructions of the late 1960s and early 1970s resembled the skeletal architectures and machinery that children make with tinker toys.

Schmaltz, Roy (1937–)

Painter. Born in Belfield, N.D.; attended the University of Washington (1956–1957, 1960–1961), the Otis Art Institute in Los Angeles (1959–1960), and SFAI (B.F.A. 1964, M.F.A. 1965). In the mid-1970s he concentrated on small-scale paintings and watercolors that were primitivistic in theme and style, emphasizing a prickly linear drawing and highly patterned design.

Schneider, Ursula (1943–)

Painter. Born in Zurich; attended the Ceramic School in Bern (1961–1964, B.F.A.) and SFAI (1968–1972, M.F.A.). Her sculpturally shaped paintings of the mid-1970s combined geometric structures—pyramids, grids—with rough, primitivistic textures in unusual materials such as dripped plastic and woven hair.

Schnier, Jacques (1898–)

Sculptor. Born in Constantsa, Romania; came to California in 1905; attended Stanford University (B.A.), CCAC, U.C. Berkeley (M.A.), and CSFA. His early sculpture, in bronze and wood, often resembled the Art Deco stylizations of Ralph Stackpole, who was among Schnier's teachers. Lipchitz, David Hare, and Duchamp-Villon were other influences as Schnier moved from figuration toward more expressionistic, symbolic, and sometimes abstract forms—often vertically stacked cubes that were sometimes given "windows" to create a sense of Gothic fantasy. Before the Second World War, when he had a studio on the edge of San Francisco's Chinatown, he had admired the carvings in rock crystal displayed in Grant Avenue shop windows. Hoping to duplicate their brilliance and transparency, he tried carving pieces of rock crystal he gathered on trips to the desert. The mineral proved too hard for conventional cutting equipment, but Schnier finally found the qualities he had sought in nature in the acrylic plastics that were developed in the 1960s. In contrast to Bruce Beasley's cast acrylic sculpture, Schnier's equally crystalline acrylic sculptures were carved, sanded, and polished; frequently, they were made of two or more pieces, almost seamlessly joined. His forms remained essentially Cubist, but their content

tended to be light itself, gathered in vertiginous whirlpools on the surfaces of the sculptures and collected in hemispheres that were hollowed into them. In the late 1970s Schnier turned to steel, fabricating cubes of sometimes monumental size that were usually balanced delicately on their corners, as though en pointe. Schnier was an influential teacher of sculpture at U.C. Berkeley from 1936 to 1966.

Schoener, Jason (1919–)

Painter. Born in Ohio; attended the Cleveland Institute of Art (1937–1941), Western Reserve University (1940–1943, B.S.), the Art Students League of New York (1946–1947), and Columbia University (M.A. 1949). A professor at CCAC since the 1950s, he has been associated primarily with mildly geometricized landscape paintings.

Schueler, Jon (1916–)★

Painter. Born in Wisconsin; attended the University of Wisconsin (M.A.) and CSFA (1948–1951). Schueler's early abstractions suggested gentle atmospheres and vast spaces, perhaps reflecting his wartime experiences as a flyer. He moved to New York in the early 1950s, and in 1957 moved to the northwest coast of Scotland, where he painted luminous seascapes reduced to simple, rectangular forms related to the abstractions of Mark Rothko.

Schuler, Melvin (1924–)

Sculptor. Born in San Francisco; attended Yuba College (1942–1947), CCAC (B.A., M.F.A.), and the Danish Royal Academy of Fine Arts in Copenhagen (1955–1956). While working as a teacher at Humboldt State College in Eureka (1957–1965), he developed a form of sculpture characterized by tall, irregular, solemnly monumental columns in elegantly carved and finished black walnut; they were sometimes clustered and partly enclosed in "racks," and suggested archaic runes and totems. In the 1970s he turned to carving rhythmically organic columns in redwood, which were then covered with overlapping plates of copper that formed scaly, armor-like carapaces, and given a rich green patina that suggested great antiquity.

Schulz, Cornelia (1936–)

Painter. Born in Pasadena, Calif.; attended Pasadena City College (A.A. 1956); the Los Angeles County Art Institute (1956–1958), and SFAI (B.F.A. 1960, M.F.A. 1962). In the early 1970s she painted abstractions in latex and acrylic over tattered sheets of stretched cheesecloth that were frequently adorned with feathers. In the mid-1970s she turned to more conventional painting methods to produce abstractions in which lightly penciled grid structures, veiled in thin films of white and off-white, were contrasted with flame-like gestural ripplings and marblings of vibrant color, which in turn

were anchored by rectangles or vertical bars of silver or frosted gray-blues.

Scott, Jack (1953–)

Painter. Born in San Francisco; attended the College of Marin (1971–1974), San Francisco State University (B.A. 1976), and SFAI (M.F.A. 1978). His abstractions of the late 1970s were large unstretched canvases covered with countless arcs applied in charcoal. They gathered in densely concentrated thickets that suggested dark storm clouds, broken by auras of light.

Seidemann, Robert (1941–)

Postermaker and photographer. Born in New York City. No formal art training. He was art director for the Grateful Dead in the early 1970s, in addition to creating numerous record covers, concert and movie posters, and other related film work.

Sells, Raymond (1931–)

Sculptor. Born in San Francisco; attended U.C. Santa Barbara and San Francisco State College (B.A. 1959, M.A. 1968). His handsomely finished abstract forms, principally in laminated wood, had their sources in the organic geometry of flower blooms and sea shells.

Senger, Martha (1925–)

Painter, conceptualist, filmmaker. Born in Tampa, Fla.; attended the University of Illinois, Monterey Peninsula College, Sacred Heart College in Los Angeles, and San Francisco City College. She was one of the artists who lived in the historic Goodman Building on Geary Street near Van Ness Avenue; after 1973, when these residents were first threatened with eviction, she began a ten-year political battle to preserve the building for use as artists' live-in studios. When this failed, she campaigned to keep the Goodman community together as "a progressive/symbolic stance-for-value in its situation vis-à-vis the larger community."

Serra, Richard (1939–)★

Sculptor. Born in San Francisco; attended U.C. Berkeley (1959), U.C. Santa Barbara (B.A. 1961), and Yale University (M.F.A. 1964). Associated with the Funk artists at U.C. Davis while he was in San Francisco in the mid-1960s, he attained an international reputation for his austere minimalist sculpture after settling in New York in the late 1960s.

Serra, Rudy (1948–)★

Sculptor. Born in San Francisco; attended San Francisco City College (A.A. 1968), San Francisco State University (B.A. 1971), and U.C. Berkeley (1973–1974). His work of the late 1960s and early 1970s was of two types: skeletal geometric structures in raw milled wood; and post-minimalist constructions in cement,

wood, and other materials that sometimes carried conceptualist or mythic dimensions. (A work of the conceptualist type, installed on a vacant lot south of Market Street, consisted of hills of dirt and gravel in the shape of burial mounds.) These early works were generally installation pieces, designed to be dismantled when an exhibition had run its course, but by the end of the 1970s Serra had converted his "mound" sculpture into a form of gallery art: the gravel was imbedded in and covered with black asphalt that bound it in more durable forms.

Shannonhouse, Sandra (1947–)

Sculptor. Born in Petaluma, Calif.; attended U.C. Davis (M.F.A. 1973). Her early works were small porcelain wall reliefs that generally took the form of shelves filled with wittily flattened and dislocated cups and glasses. In the late 1970s she turned to stringing together combinations of funky ceramic bladders, hearts, and viscera which were suspended from the ceiling; these developed into dangling skeletal constructions of organs and vertebrae that were accompanied by ceramic women's hats and shoes. In the 1980s she turned to more fully fleshed-out, albeit elongated and frequently bladder-shaped, figures that were related to Picasso's sculpture of the 1930s. Cast in bronze, they emphasized dance-like movement and gesture.

Shapiro, Daniel (1920–1982)

Painter. Born in New York City; attended Cooper Union (graduated in 1941) and Columbia University (1944–1946). A teacher at U.C. Davis from 1959 until his death. In his earliest years in the Bay Area, he produced parodistic figurative paintings in a bravura, gestural style out of Abstract Expressionism and funky combinations of paintings and assemblage. In the mid-1960s he developed a style of abstraction that combined a swift, linear calligraphy related to that of Gorky and de Kooning, with crisp, swelling, and frequently erotically suggestive organic shapes in flat areas of color that were related to the late cut-outs of Matisse. In his last years, afflicted with diabetes and heart ailments, he concentrated on small collage drawings that distilled the richly evocative imagery of his earlier assemblages of found objects—"fossils of our culture," as he described them—into a spare and intensified form of visual poetry.

Shaw, Richard (1941–)*

Ceramic sculptor. Born in Hollywood; attended Orange Coast College in Costa Mesa (1961–1963), SFAI (B.F.A. 1965), the State University of New York at Alfred (1965), and U.C. Davis (M.A. 1968).

Sherk, Bonnie (1945–)*

Conceptualist. Born in Massachusetts; attended Rutgers University (B.A. 1967) and San Francisco State University (M.A. 1970).

Shoemaker, Peter (1920–)

Painter. Born in Newport, R.I.; attended CSFA (1940, 1947–1950) and U.C. Berkeley (B.A. 1951). His early painting combined large color areas with a dynamic, automatist calligraphy, reflecting the influence of Stanley William Hayter (a guest instructor at CSFA in the late 1940s). His later abstraction developed toward combinations of organic shapes, often rooted in recognizable landscape images, and geometric forms.

Siegriest, Louis (1899–)*

Painter. Born in Oakland; attended CCAC in Berkeley (1914–1916) and CSFA (1916–1918). Following his youthful association with The Society of Six, and after driving across the country in the early 1930s, he turned to the desert as his principal subject, emphasizing the blacks and earth tones that The Six had banished from their painting. In the mid-1940s, he painted abandoned buildings in the ghost town of Virginia City, where his grandparents had operated a boarding house in the Comstock gold and silver boom. He turned to abstract landscape in the 1950s.

Siegriest, Lundy (1925–)*

Painter. Born in Oakland; attended CCAC. Originally working in a thick-textured, Abstract Expressionist style (which influenced the mature painting of his father, Louis Siegriest), he moved in the late 1950s to grotesque figurative images inspired by the mummies of Guanajuato, Mexico. In the 1970s he turned to landscape in a broad, painterly style that was related to the Bay Area Figurative tradition and the earlier plein-air painting of The Society of Six, and was also allied to the work of Terry St. John, with whom he sometimes painted in the countryside around Mt. Diablo.

Silverberg, Leonard (1939–)

Painter. Born in Brooklyn; studied at the New York Museum of Modern Art (1958–1959), attended the Brooklyn Museum Art School (1959–1962), Brooklyn College (B.F.A. 1962), the University of Mexico (1965), and U.C. Extension (1967). His paintings of the late 1960s and early 1970s were abstractions of exploding organic shapes and skeins of color loosely related to the work of the Visionary artists. In the mid-1970s he turned to expressionistic versions of skull-like, Baconesque heads and scenes of figures massed in anonymous interiors in attitudes suggesting acts of violence.

Simonds, C. G. (1939–)

Sculptor. Born in San Jose, Calif.; attended San Jose State College (B.A. 1964) and U.C. Berkeley (M.A. 1967). His streamlined linear structures of sleekly formed plastic and elegantly milled wood treated familiar schematic images and signs—a question mark, a lightning bolt—in a way that mingled Surrealist allu-

siveness with the ironic detachment of Pop art, and was related in sensibility to the work of the Chicago sculptor H. C. Westermann. His conception of sculpture as quirkily personal, handsomely crafted objects was influential among students at CCAC, where he taught in the late 1960s and early 1970s. In the late 1970s he moved to Humboldt State University and his sculpture grew more rustic and closer in spirit to Indian fetishes.

Simpson, David (1928–)★

Painter. Born in Pasadena, Calif.; attended Pasadena City College (1942–1943), CSFA (1949–1951; 1955–1956, B.F.A.), and San Francisco State College (M.F.A. 1958).

Sims, Phillip (1940–)★

Painter. Born in Richmond, Calif.; attended San Francisco City College, San Francisco State College (1961–1962), and SFAI (1965–1966).

Sinton, Nell (1910–)

Painter and collagist. Born in San Francisco; attended CSFA (1926–1928) and studied with Maurice Sterne (1938–1939). Her work has included painting in an Abstract Expressionist style and assemblage influenced by funk and Dada. Most persistent has been an approach rooted in the Bay Area Figurative style, while a preoccupation with interpreting her intimate personal world—as an artist and a society figure—has allied her distantly with the "mythmakers." Sinton has also been a noteworthy Bay Area collector of contemporary art.

Sloan, Diane (1940–)

Painter. Born in Minneapolis; attended the College of St. Catherine, Saint Paul, Minn. (B.A. 1962), and San Francisco State University (M.A. 1970). Her *Carapace* series of the early 1970s consisted of meticulously realistic paintings of brides, unsettlingly lifeless beneath elaborate attire built up in sensuous layerings of color. Later in the 1970s she concentrated on painting old-fashioned pistols and other weaponry.

Slusky, Joe (1942–)

Sculptor. Born in Philadelphia; attended U.C. Berkeley (B.A. 1966, M.A. 1968). His early sculptures were large, sometimes monumental constructions; in their emphasis on comic-strip forms occupying a borderland between organic abstraction and Surrealist imagery, they were related to the early work of Robert Hudson, but they were also cool and sleek, fashioned in iridescently painted plastic. In the late 1970s his constructions, in welded steel combined with found objects, became smaller, more rugged, and funky. They were generally covered with drips and spatters of color that parodied the effects of gestural painting.

Smagula, Howard (1942–)

Painter. Born in Passaic, N.J.; attended Yale University (B.F.A. 1963, M.F.A. 1965). His work of the late 1970s combined unstretched canvases covered with thin films of paint and fine horizontal lines to resemble large video screens, with small photographs of fragmentary images and words attached to the canvases in regular grid patterns. They generally suggested self-reflexive systems in which the medium became identical with the message.

Smith, Harry (1923–)★

Filmmaker and painter. Born in Portland, Ore. Self-taught, he grew up in a deserted boomtown on Puget Sound, where his father, an occultist, turned over to him an abandoned blacksmith shop when Smith was twelve years old and instructed him in alchemy. Active in Berkeley and San Francisco in the 1940s, he associated with such innovative filmmakers as John and James Whitney, Frank Stauffacher, James Broughton, and Jordan Belson, and made his own first abstract films by painting, drawing, and batiking directly on the film. He also painted murals at Jimbo's Bop City, an after-hours jazz club on Fillmore Street. Smith left for New York around 1950, where he began to concentrate on animated collages that translated the dream language of Max Ernst to film with extraordinary magic and beauty. His early abstract films were influential in the 1950s among such Bay Area filmmakers as Jordan Belson, Jane Conger Belson, and Patricia Marx.

Smith, Hassel (1915–)★

Painter. Born in Sturgis, Mich.; attended Northwestern University (B.S. 1936) and CSFA (1936–1938). Left the Bay Area in the mid-1960s to teach for a year at UCLA and then moved to Great Britain in 1966, where he has taught at the West of England College of Art in Bristol. Since 1973 he has returned frequently to the Bay Area, and has taught at U.C. Davis, U.C. Berkeley, and SFAI.

Snelgrove, Walter (1924–)

Painter. Born in Seattle; attended the University of Washington and U.C. Berkeley (B.A., M.A.). Among the painters exhibited in the Contemporary Bay Area Figurative Painting show at the Oakland Museum in 1957, he worked in a densely painted but strongly architectural style influenced by the reductive abstraction of Mondrian and Nicolas de Staël. He later came to specialize in landscape views of the Pacific Coast and nearby hill country, with heavily loaded, tracked, and spattered surfaces on an armature of solid geometry, which emphasized the dramatic division between land and sky or sea.

Snowden, Mary (1940–)

Painter. Born in Pennsylvania; attended Brown University (B.A. 1962) and U.C. Berkeley (M.A. 1964); a teacher at CCAC since the late 1960s. Her paintings of the late 1960s were hard-edge abstractions based on the industrial forms of oil refinery hardware. In the 1970s she turned to cool, softly modulated, illusionistic paintings of farm animals, generally in such unexpected settings as kitchens and living rooms. She gradually developed a more conventional, flatly patterned Photo Realism.

Snyder, Dan (1948–)

Sculptor. Born in Philadelphia; attended Pennsylvania State University (B.F.A. 1970) and U.C. Davis (M.F.A. 1972). His early sculptures were expressionistic figures in plaster and mixtures of other materials inspired by the work of Manuel Neri. After a residence in Italy as a Prix de Rome winner in the mid-1970s, he turned to ceramic, and to slicker, more caricaturish life-sized figures frozen in dynamic, cartoon-like gestures that seemed to parody the traditional attitudes of classical sculpture.

Snyder, William (1926–)★

Painter. Born in San Francisco; attended Chouinard Art Institute, Los Angeles (1942–1943), San Francisco State College (B.A. 1954, M.A. 1957), and Stanford University (1961–1963). He was associated with the Firehaus group in Stockton in the late 1950s, when he painted in a variant of the Bay Area Figurative style, meanwhile using the camera to explore icons of the everyday environment that he saw as symbolic of American Pop culture—Mickey Mouse, images from advertising. His paintings of the late 1960s dealt with figures associated with World War I and the 1920s, based on old magazine photographs and frequently painted on unusual materials such as naugahyde. In the 1970s he concentrated on images drawn from Disneyland and kitsch Hollywood movies, such as those by the Three Stooges.

Sotomayor, Antonio (1902–)

Painter, muralist, cartoonist, sculptor. Born in Chulumani, Bolivia; attended the Escuela de Bellas Artes in La Paz, Bolivia. Came to San Francisco in 1923, where he attended the School of Arts and Crafts in Berkeley and the Mark Hopkins Institute of Art in San Francisco. His work has ranged from figurative paintings that portray South American Indian life, in a manner influenced by Diego Rivera, to abstract works in terra cotta and mosaic. He is perhaps best known for his gentle caricatures of San Francisco celebrities.

Spohn, Clay (1898–1977)★

Painter and assemblagist. Born in San Francisco; attended U.C. Berkeley (1918–1921), CSFA (1926–1927), the Art Students League in New York (1922–1925), and the Académie Moderne in Paris (1926–1927). Active in the Bay Area from 1927 to 1952, when he moved to Taos, N.M.; he later moved to New York.

Spratt, Fred (1927–)

Painter. Born in Iowa; attended Iowa Wesleyan College, Iowa State University, and San Jose State College. A teacher at San Jose State since the mid-1960s, he was an early experimenter in plastics, painting spare, minimalist landscape images on plastic grounds molded into the shapes of stelae. In the 1970s he painted large vertical and rectangular panels in flat, uniform industrial colors.

Spring, Barbara (1917–)★

Sculptor. Born in England; attended the Central School of Art in London (1943–1945) and the Gravesend School of Art in Kent; came to San Francisco in 1952. She spent most of the 1960s and 1970s living and working in Big Sur.

Stackpole, Ralph (1885–1973)★

Sculptor and painter. Born in Williams, Ore.; attended the Mark Hopkins Institute of Art in San Francisco (1901–1902) and the Ecole des Beaux Arts in Paris (1906–1908), and studied with Robert Henri in New York (1911). Settled in San Francisco in 1914. Stackpole was one of the muralists of Coit Tower. He left the Bay Area in 1949 to live in France, where his style in both sculpture and painting became increasingly abstract.

Staiger, Paul (1941–)

Painter. Born in Portland, Ore.; attended Northwestern University (B.A. 1962, M.F.A.). His early Photo Realist paintings of the late 1960s were sun-drenched views of figures and family groups posed in front of Northern California tourist attractions, their slightly askew compositions suggesting snapshots that were not quite on target. In the early 1970s he turned to painting the homes of movie stars in Beverly Hills, in the bland, objective manner of the color photographs found in realtors' windows. He also painted such Southern California landmarks as the Griffith Observatory and Malibu Beach, with broad white borders that emphasized their photographic quality, and with titles (*Where James Dean Had Shown Them the Way*) that called attention to their roles in the mythology of popular culture. Through most of the 1970s Staiger taught at San Jose State University.

315

Appendix: Bay Area Artists

Stanley, M. Louise (1942–)

Painter. Born in Charleston, W.Va.; attended La-Verne College, Calif. (B.A.), and CCAC (B.F.A. 1967, M.F.A. 1969). Her paintings and watercolors, done in a rubbery style of comic-book realism, generally centered on feminist themes and were charged with violence.

Staprans, Raimonds (1926–)

Painter. Born in Riga, Latvia; attended the School of Art in Esslingen, Germany, the University of Washington (B.A. 1952), and U.C. Berkeley (M.A. 1954). His paintings, popular in the 1950s and 1960s, were primarily picturesque landscapes and harbor scenes translated into highly stylized, thickly painted abstractions.

Stephan, Gary (1942–)

Painter. Born in Brooklyn; attended the Parsons School of Design (1960–1961), the Art Students League of New York (1961), the Pratt Institute (1961–1964), and SFAI (1964–1966, M.F.A.). His paintings of the late 1960s, which emphasized color and texture, investigated the relationships of minimalist images to those of the canvases on which they were painted.

Sterne, Maurice (1878–1957)★

Painter. Born in Libau, Russia; came to the United States in 1890; studied in New York at the National Academy of Design and the Art Students League, and also in Paris and Rome. He was a visiting instructor of composition and figure drawing at CSFA, 1935–1936.

Stiegelmeyer, Norman (1937–)★

Painter. Born in Denver, Colo.; attended Pasadena City College (1959–1961), SFAI (B.F.A. 1963, M.F.A. 1964), and the Academy of Art in Nuremburg, West Germany (1964–1965).

Stiles, Knute (1923–)★

Painter and critic. Born in St. Croix County, Wis.; attended the Saint Paul Gallery School of Art (1942–1943), Black Mountain College, N.C. (1946–1947, 1948), the New School for Social Research in New York (1948–1949), and CSFA (1950–1952). His art ranged over a variety of styles, from book illustration to paintings that combined Formalism with an ironic approach rooted in Dada.

Still, Clyfford (1904–1980)★

Painter. Born in Grandin, N.D.; attended Spokane University (B.A. 1933) and Washington State College, Pullman (M.A. 1935).

Stillman, George (1921–)

Painter. Born in Laramie, Wyo.; attended U.C. Berkeley, New York University, CSFA (1945–1949), and Arizona State University (B.F.A., M.F.A. 1970). His paintings of the late 1940s (when he shared a studio in Sausalito with Frank Lobdell) were related to Gottlieb's early abstractions; they were divided into rectangular panels, each of which contained an independent motif that resembled sometimes a pictograph, sometimes the calligraphic fantasies of Rothko's mid-1940s abstractions. In 1949 Stillman visited Mexico on a Bender Foundation grant to study pre-Hispanic art, and he later moved to Washington State, where he was a teacher through the 1970s at Eastern Washington State University.

Stoddart, Edna (1897–1966)

Painter. Born in Oakland; attended Mills College, CSFA, CCAC, and U.C. Berkeley. Her heavily textured paintings focused on images of fanciful, primitivistic figures and animals influenced by pre-Hispanic Mexican art.

Storer, Inez (1933–)

Painter and collagist. Born in Santa Monica, Calif.; attended San Francisco College for Women (A.A. 1953), U.C. Berkeley (1953–1954), the Los Angeles Art Center (1954), SFAI (1955), Dominican College in San Rafael (B.A. 1970), and San Francisco State University (M.A. 1972). Her collages and assemblages combined everyday objects with drawings of images done in a realistic style and arranged in a collage manner.

Strini, Robert (1942–)

Sculptor. Born in Hayward, Calif.; attended San Jose State College (A.A. 1965, B.A. and M.A. 1968) and U.C. Berkeley (M.F.A. 1970). One of the earliest ceramic sculptors to explore trompe l'oeil effects, his assemblage-like structures of the late 1960s emphasized rounded, swelling, suggestively erotic forms—doughnuts, bladder-like shapes resembling punching bags. Their variety of textures was sometimes enhanced by the use of non-ceramic materials such as leather. In the early 1970s he used laminated wood to produce the fifteen-foot-long *Hot Fudge Sunday*, which reproduced a giant pencil undergoing various stages of metamorphosis. He was an instructor in the late 1970s at U.C. Santa Cruz.

Strong, Charles (1938–)

Painter. Born in Colorado; studied at SFAI in the early 1960s. Influenced by Clyfford Still (with whom he studied while Still was a guest instructor at the University of Colorado in 1961) and by Frank Lobdell, he developed a variety of approaches to the central problem of balancing the tense organic shapes, richly

worked textures, and strong colors of Abstract Expressionism with the bold, emblematic forms and rigorous, frequently symmetrical geometric structures of contemporary Formalism. His best paintings of the 1970s combined the compositional strength and presence of Formalism with the improvisational daring of Abstract Expressionism, and often evoked mythic themes associated with episodes in the history of the American Indians.

Sultan, Henry (1938–)

Painter. Born in San Francisco; attended San Francisco State College (B.A. 1966, M.A. 1968). Associated with the Visionary painters of the late 1960s and early 1970s, he painted abstract mandalas that combined a strong geometry with intricate surface patterns.

Surendorf, Charles (1906–1979)

Painter and graphic artist. Born in Richmond, Ind.; attended the Art Institute of Chicago (1924–1926), the Art Students League of New York, Ohio State University, and Mills College. Associated with the North Beach bohemian scene in the late 1930s and the 1940s—and director of the first San Francisco Art Festival in 1946—he moved in 1946 to the town of Columbia, in the Sierra foothills, where he operated a short-lived Mother Lode Art School and his own art gallery. His paintings and prints depicted the rough-and-tumble life of the old mining country in an expressionistic Regionalist style related to that of Thomas Hart Benton.

Suzuki, James (1933–)

Painter. Born in Yokohama, Japan; came to the United States in 1952; attended the school of Fine Arts in Portland, Me., and the Corcoran School of Art in Washington, D.C. In the late 1960s he worked in a hard-edge style, edging simple, twisting forms with parallel bands of color that made them appear to vibrate. In the 1970s he turned to an apocalyptic style of Surrealism in which multitudes of figures intertwined and mingled with gestural, abstract slashes of color.

Tavenner, Patricia (1941–)

Collagist and conceptualist. Born in Doster, Mich.; attended Michigan State University (B.A.) and CCAC (M.F.A.). Her work of the 1970s consisted primarily of photo-silkscreen prints, montage, and collage in a Dada-Surrealist style, but she also practiced sculpture, experimented with xerox printing, and engaged in mail-order art.

Taverner, Irene (n.d.)

Painter. Born in Wales; active in North Beach in the late 1950s. Her abstract watercolors were related to the paintings of Franz Kline, with whom she had been associated in New York. Their jagged, angular black lines, which suggested the movement of music and dance, were combined with rich, transparent colors.

Taylor, Gage (1942–)★

Painter. Born in Fort Worth, Tex.; attended the University of Texas (B.F.A. 1965) and Michigan State University (M.F.A. 1967). Came to California in 1969.

Tchakalian, Sam (1929–)★

Painter. Born in Shanghai; came to San Francisco in 1947; attended San Francisco State College (B.A. 1952, M.A. 1958). Tchakalian has been an influential teacher since the early 1960s at SFAI.

Tepper, Irvin (1947–)

Conceptualist photographer, sculptor. Born in Saint Louis; attended the Kansas City Art Institute (B.F.A. 1969) and the University of Washington (M.F.A. 1971). Initially a photographer, in the late 1970s he turned increasingly to sculpture, primarily in ceramic or plaster. His principal theme in both media was the ordinary coffee cup, viewed as a kind of portrait subject. In his photographs, it was covered or surrounded by handwritten diaristic notations; in his sculpture, it was eccentrically distorted and rent with gashes and holes.

Thiebaud, Wayne (1920–)★

Painter. Born in Mesa, Ariz.; came to California in 1939; attended San Jose State College (1949) and Sacramento State College (B.A. 1951, M.A. 1952).

Thollander, Earl (1922–)

Painter and illustrator. Born in Kingsburg, Calif.; attended CSFA, San Francisco City College (1939), and U.C. Berkeley (B.A. 1944). An illustrator for the *San Francisco Examiner* for many years, he began to concentrate on painting landscapes in the late 1950s in a style influenced by Abstract Expressionism and loosely related to the calligraphic abstraction of Bradley Walker Tomlin.

Thomas, Lew (1932–)★

Conceptualist. Born in San Francisco. In addition to his work as a photographer, he has also been active as a curator of exhibitions and a publisher of books in which conceptualist and linguistic components are of primary consideration.

Thomas, Margaret Haggerty (1938–)

Painter. Born in Pittsburgh, Pa.; attended Mercyhurst College in Erie, Pa. (B.A.), and the University of Maryland (M.A.). A student of George Stillman's at

Washington State University in Pullman before coming to the Bay Area in 1975, she painted in an Abstract Expressionist style rooted in the early work of Jackson Pollock.

Thornton, Reese (1929–)

Sculptor. Born in Baltimore, Md.; attended Brown University (B.A.). Associated with the Los Angeles art scene in the early 1960s, he moved in the late 1960s to the Bay Area, where he first exhibited assemblages of junk and found objects, often of a satirical cast. Later he took a more abstract approach to assemblage, combining found and tooled objects in elaborate, Baroque, and strongly organic structures.

Tidd, Patrick (1929–)

Painter. Born in Maryland; attended San Diego State College (B.A. 1959) and U.C. Berkeley (M.A. 1961). His paintings of the late 1960s and the 1970s were enigmatic landscapes, done in a bland pastel palette, that combined elements of science-fiction Pop imagery, Surrealist architecture, and abstract natural forms. He has taught at Contra Costa College.

Titus, Rod (1941–)

Painter. Born in Coronado, Calif.; attended SFAI (B.A. 1964, M.F.A. 1966). In the 1970s he painted landscapes and still lifes in a broad, Bay Area Figurative style that alternated between a densely textural Impressionism and a more gestural, Fauve-like approach.

Tomidy, Paul (1944–)

Painter. Born in Utica, N.Y.; studied at the Pratt Institute in Brooklyn (B.F.A. 1966) and Mills College (M.F.A. 1973). His paintings of the late 1970s played opaque, hard-edged forms against gestural patches of color and large areas of white gessoed surfaces.

Tondre, Calvin (1940–)★

Assemblagist. Born in Albany, Calif.; attended CCAC (B.F.A., M.F.A.).

Torlakson, James (1951–)

Painter. Attended CCAC (B.F.A. 1973) and San Francisco State University (M.A. 1974). A student of Robert Bechtle's, he specialized in the mid-1970s in Photo Realist watercolors depicting moving vans and semi-trailer trucks parked at filling stations and other roadside points, generally edged with a red aura suggesting the glow of late afternoon sun. In the late 1970s he began painting a greater variety of urban icons—facades of deserted amusement parks, abandoned storefronts and Quonset huts, and other old buildings—in a more literal style.

Trave, Horst (1918–)

Painter. Born in Germany; attended CCAC (B.A., M.F.A.). A member of the Metart Galleries in the late 1940s, he worked initially in an Abstract Expressionist style that was more structural than gestural and was related to the painting of Franz Kline in its emphasis on a ragged linearity. In the 1960s and 1970s he moved to small geometric abstractions that sometimes recalled Feininger in their fragmentation of forms, radiant light, and soft atmospheric colors.

Truesdell, Edith (1888–)

Painter. Born in Connecticut; studied at the Boston Museum of Fine Art (1906–1912). The aunt of David Park and his earliest teacher, she moved to Mill Valley in 1953, and settled in Carmel Valley in 1964. Having painted little in her middle years, she returned to painting seriously in the 1970s. Her work consisted primarily of landscapes of the Carmel countryside and remembered views of the Southwestern desert, translated into broad, almost abstract shapes recalling the painting of both Park and Marsden Hartley in their weight, immediacy, and structural solidity.

Tullis, Garner (1939–)★

Painter and sculptor. Born in Ohio; attended the University of Pennsylvania (B.A. 1963, B.F.A. 1964) and Stanford University (M.A. 1967). In 1973 he founded the International Center for Experimental Printmaking in Santa Cruz. In the early 1970s he experimented with a process in which thin films of titanium and quartz were bonded in a vacuum chamber to plates of glass, producing mists of rainbow color spectra over mirror-like reflecting surfaces. In the mid-1970s, using the resources of his printmaking center, he produced a series of reliefs using handmade paper (often recycled from discarded canvases) to "cast" sculptural heads that he had previously made in bronze. In the late 1970s he did still-life paintings in acrylic on paper that emphasized the materials and props of the artist's studio, abstracted to crisp silhouettes.

Tuttle, Lyle (1931–)

Tattoo artist. Born in Millerton, Iowa; reared in Mendocino County, Calif., he dropped out of high school in Ukiah, and received his first tattoo in 1947 on a trip to San Francisco. By the early 1950s—with the tutelage of such old-time tattooers as Ralph "Duke" Kaufman, C. J. "Pop" Eddy, and Bert Grimm—he had set up his own tattoo parlor on Market Street, near the Greyhound Bus depot. Since the late 1960s he has campaigned for the recognition of tattooing as a legitimate art form, and in 1974 he established the first Tattoo Art Museum in his parlor on Seventh Street.

Unterseher, Chris (1943–)

Ceramist. Born in Portland, Ore.; attended San Francisco State College (B.A. 1965) and U.C. Davis (M.A. 1967). His ceramic objects of the late 1960s and the 1970s made the conventional dime-store and curio-shop ceramic artifact itself their principal subject by way of variations on the kinds of imagery commonly found in the context of kitsch: covered bridges, ceramic translations of tourist attractions shown on picture postcards, and an homage to the "greats" of the steel guitar.

Vaea (1929–)

Ceramic sculptor. Born in Tahiti; studied in Paris (1954–1960) and Japan (1963–1964, with Kawai Kanjiro); moved to Berkeley in 1966, to work and study with Peter Voulkos. His richly glazed ceramic sculpture of the 1960s generally combined smooth, spherical shapes with gnarled slags that were cracked, furrowed, and rent with ragged crevices and cavernous holes. In the early 1970s his forms became more streamlined and elegant. They were often modeled on the forms of saddles (between 1950 and 1952 Vaea had worked as a cowboy in Australia), with frankly phallic saddlehorns, invested with Dada puns, and conceived in various styles—T'ang Dynasty, Victorian, Pop art. Later his sculpture took on the character of archeological finds—wedge shapes and other forms that suggested fragments of partially disintegrated ancient monuments; or conversely, the forms of geology growing into those of geometry and objects of ritual. Vaea was among the earliest Bay Area artists to display what were essentially installation pieces in which many diverse components were brought together to convey an experience that was designed to be more than that of the sum of the individual parts.

Valledor, Leo (1936–)

Painter. Born in San Francisco; attended CSFA (1953–1955). His early paintings, which were exhibited at the Six and Dilexi galleries (1955–1959 and 1959 respectively), were gestural abstractions in which calligraphy was a paramount element. In 1962 Valledor went to New York, where he associated with the Park Place group (which included Mark di Suvero and Peter Forakis) and began to work in a hard-edge style of geometric abstraction that emphasized pulsating or eye-blurring juxtapositions of complementary or close-valued colors. After returning to San Francisco in 1968, he adopted a circular format (somewhat later, he turned to the trapezoid); the surfaces of these works were reduced to brushy monochrome fields that were narrowly rimmed with contrasting, heavily painted borders which emphasized the shape and scale of the

canvas. These paintings were frequently displayed as pairs. Vestiges of "painterly incident" gradually disappeared from Valledor's work in the mid-1970s. His recent works have been structures composed of two or three separate canvas panels, each of a different geometric shape and generally painted a different, uniform color in a flat acrylic.

Vandenberge, Peter (1935–)

Ceramic sculptor. Born in the Netherlands; attended Sacramento State College (1954) and U.C. Davis (M.A. 1963). His ceramic sculptures of the late 1960s were mostly low-fire, large-scale replicas of garden vegetables. In the 1970s he turned to figurative images—larger-than-life busts and full figures—that incorporated primitivistic elements, sometimes recalling the folkloric style of Elie Nadelman, sometimes the more alien traditions of New Hebrides sculpture.

Van Hoesen, Beth (1926–)

Watercolorist and graphic artist. Born in Idaho; attended Stanford University (B.A.), SFAI, and San Francisco State College. Her portraits and renderings of simple still-life objects—vegetables, plants—follow the conventions of academic realism but are endowed with an undertone of quirky idiosyncrasy that grows largely out of a lively, spidery line.

Van Sloun, Frank (1879–1938)

Painter. Born in Saint Paul, Minn.; attended the Saint Paul Art Academy, the William Merritt Chase School in New York, and the Art Students League of New York (where he studied with Robert Henri). Soon after coming to San Francisco in 1918 to teach at CSFA, he set up a studio school of his own, in which Louis Siegriest and Bernard von Eichman were students. Working in a style influenced by Chase, he painted several murals in the Bay Area before his death in San Francisco in 1938; among these were twelve panels in the State Library and Court building in Sacramento, lunettes in the mayor's office of the Oakland City Hall (since lost), and murals at the Bohemian Club and Elks Club and in the Canterbury and Mark Hopkins hotels.

Varda, Jean (1893–1971)*

Painter and collagist. Born in Smyrna, Turkey; studied in Athens, Munich, and Paris before coming to the United States in 1939.

Vasica, Joseph (1921–)

Painter. Born in Vienna; came to the United States in 1960. His abstractions of the 1960s and 1970s contained flowing, angular shapes whose soft edges and fused

colors suggested enigmatic objects refracted through water.

Villa, Carlos (1936–)★

Painter. Born in San Francisco; attended SFAI (B.F.A. 1961) and Mills College (M.F.A. 1963). An Abstract Expressionist in the late 1950s and early 1960s, he began in the late 1960s to paint swirling arcs and coils of color in acrylic on unstretched canvases, adding to them such materials as feathers and broken glass. Following the feathered, cape-like works for which he became known in the early 1970s, he turned to imprinting canvases directly with images of his face, hands, and other parts of his body, during quasi-primitive dances and other ritualistic actions that he performed.

Villamor, Manuel (1928–)

Painter. Born in Belize, British Honduras; attended St. John's College in Belize (B.A. 1949) and Cooper Union in New York (1959). In the late 1960s he painted landscapes and interiors in a moodily realistic style reminiscent of Edward Hopper. In the 1970s he turned to motifs inspired by pre-Hispanic—generally Mayan—art, frequently fragmented, more or less randomly arranged, and immersed in abstract matrices and veils of richly worked paint.

von Eichman, Bernard (1899–1970)★

Painter. Born in San Francisco. After moving to New York in the early 1930s, he turned from the experiments with Fauvism and Cubism that he had conducted during his participation in The Society of Six to a more conservative style related to the painting of the Ash Can School. He returned to the Bay Area in 1942.

Voulkos, Peter (1924–)★

Sculptor. Born in Bozeman, Mont.; attended Montana State University (1946–1951, B.S.) and CCAC (1951–1952, M.F.A.).

Vredaparis, Frieda (1928–)

Painter and sculptor. Attended Brooklyn College, the Academia de San Fernando in Madrid, the Akademie der Bildenden Künste in Munich, the Harold Paris School of Graphic Art in New York, and Lone Mountain College in San Francisco (M.F.A. 1976). Her paintings of the late 1960s and early 1970s were fantasies of a semi-figurative Surrealist style. Her sculpture, which was related to that of Harold Paris (her husband), consisted of bubbles of transparent acrylic plastic shaped into sensuous, organic forms that contained rats' nests of tinsel, reflecting discs, and other objects.

Walburg, Gerald (1936–)

Sculptor. Born in Berkeley; attended CCAC (1954–1956), San Francisco State College (B.A. 1965), and U.C. Davis (M.F.A. 1967). His first works, as a student of Robert Arneson at U.C. Davis, were in ceramic; inspired by Claes Oldenburg's translations of "hard" objects into soft materials and forms (and vice versa), they explored organic, erotic shapes. Late in 1965, inspired by his first view of David Smith's *Cubi* sculpture, Walberg made his first large-scale sculpture in metal: *Opposing Soft Loops,* a pair of Corten steel arches that seemed to have "relaxed" to a point at which their tops cantilevered along a horizontal axis parallel to the ground. He made similar large-scale works that explored the ambiguities of soft and hard forms through the late 1960s, and also more slick geometric relief constructions in steel plated with high-reflecting chrome. Following a trip to Japan in 1970—when he was one of five U.S. representatives at the Osaka World's Fair (the others were Sam Francis, Isamu Noguchi, Kenneth Noland, and David Smith)—Walburg began to work with arch-shaped forms in copper. They combined pillow and heart shapes, cylinders, and soft loops, and were distinctly Oriental in their stylizations of form. He also translated these forms into watercolor renderings that were exhibited independently from the sculptures.

Wall, Brian (1931–)★

Sculptor. Born in London; left school at the age of fourteen to work as a glassblower while taking classes part time at local art schools. Came to teach at U.C. Berkeley in 1969.

Wareham, William (1941–)

Sculptor. Born in Cleveland; attended the Philadelphia School of Art (B.F.A. 1965) and U.C. Berkeley (M.A. 1969, M.F.A. 1971). Associated with Peter Voulkos and Brian Wall at Berkeley, he made relatively simple, basically horizontal constructions of large sheets of steel, the generally raw surfaces of which were folded and broken by ragged "tears" similar to those in the torn-and-folded-paper sculpture upon which he concentrated for a time in the mid-1970s (and similar as well to elements in the work of David Smith).

Warner, Mary (1948–)

Painter. Born in Sacramento; attended Sacramento State University (B.A. 1971, M.A. 1974). Her highly patterned watercolors, related to the work of the "mythmakers," focused on close-up views of desert sand and cactus, which suggested microcosms of primitivistic, private worlds.

Washburn, Stan (1943–)

Painter and printmaker. Born in New York; came to California in 1957 and attended CCAC (B.F.A., M.F.A.). His graphic work, upon which he concentrated in the 1970s, consisted of highly detailed drawings and prints of landscape and figures in a style that

often resembled that of Albrecht Dürer. In the late 1970s he moved to painting bucolic landscape views that included ironic quotations from and paraphrases of familiar paintings of the nineteenth century.

Washington, Horace (1945–)

Sculptor. Born in Atlantic City, N.J.; attended Columbus College of Art and Design in Ohio, SFAI (B.F.A. 1970), and Sacramento State University (M.A. 1973). The forms of African, pre-Columbian, Egyptian, and other non-European art traditions inspired a series entitled *Masks,* in materials ranging from carved stone to cast cement, that Washington sustained into the 1980s.

Wasserman, Herbert (1925–)

Painter. Born in New York City; attended the Art Students League of New York (1947–1949) and the Académie de la Grande Chaumière in Paris (1950). His paintings of the late 1950s, which he showed at the old Triangle Gallery in North Beach, were abstractions that frequently suggested impressionistic views of the countryside as seen from the air. In the 1960s he turned to a painterly style of urban realism, emphasizing dark, somber views of the industrial areas around the lower slopes of Potrero Hill and the Embarcadero.

Wasserstein, Julius (1924–)★

Painter. Born in Providence, R.I.; attended CSFA (1950–1953) and San Francisco State College (1955–1958). His paintings of the 1960s and 1970s became more spare, concentrating on small, irregular areas or expansive ribbons of vivid, marbled colors against grounds of flat, darker colors.

Weeks, James (1922–)★

Painter. Born in Oakland; attended CSFA (1940–1942, 1946–1948), the Hartwell School of Design in San Francisco (1946–1947), and the Escuela de Pintura y Escultura in Mexico City (1951). He left the Bay Area to teach at UCLA in 1967, and in 1970 moved to Massachusetts to teach at Boston University.

Weinbaum, Jean (1926–)

Painter and collagist. Born in Zurich, Switzerland; attended the Zurich School of Fine Arts (1942–1946); studied with Paul Colin and André Lhote, and at the Académie de la Grande Chaumière in Paris (1947–1948); came to San Francisco in 1968. His watercolors and collages used simple, highly stylized shapes abstracted from natural forms—rainbows, flower petals, watermelon slices—as armatures for areas of intense, radiant colors that dramatically collided or bled and fused softly together at their edges.

Wells, Mason (1906–1984)

Painter. Born in Southbridge, Mass.; attended Harvard (B.A.), Yale (B.F.A.), and SFAI. His paintings of the late 1960s and early 1970s contained soft-edged, generally vertical rectangles of color that "bled" into atmospheric fields.

Wessels, Glenn (1895–1982)★

Painter. Born in Capetown, South Africa; studied with André Lhote in Paris, at the Hans Hofmann School in Munich, at CCAC (B.F.A.), and at U.C. Berkeley (B.A., M.A.). An assistant to Hofmann during his lectures at U.C. Berkeley in 1931, he remained a teacher there for many years. His paintings of the 1950s were influenced by Abstract Expressionism, although their swift, gestural brushwork and rough surfaces remained anchored to landscape subjects generally suggesting tumultuous seas and stormy skies. He painted murals at the Laguna Honda Hospital in San Francisco.

Wetterstein, Ansel (1949–)

Sculptor. Born in Kotka, Finland; attended SFAI (B.F.A. 1972, M.F.A. 1973). He combined found objects with enigmatic, meticulously handcrafted objects of wood in tidy, fanciful box constructions that resembled those of Joseph Cornell.

Weygandt, Don (1926–)

Painter. Born in Illinois; attended Washington University in Saint Louis (B.F.A.) and the University of Illinois, Urbana (M.F.A.). Active in the Bay Area in the late 1960s and early 1970s, he painted in a broad, heavily textured variant of the Bay Area Figurative style.

Wiley, William T. (1937–)★

Painter and sculptor. Born in Bedford, Ind.; attended SFAI (B.F.A. 1960, M.F.A. 1962).

Wilkins, Deborah (1952–)

Painter. Born in Berkeley. Associated with Blackman's Gallery in the mid-1970s, she concentrated on intricate ink drawings in which the figurative forms of traditional African art were combined with obsessive, "psychedelic" design patterns.

Williams, Don (1941–)

Painter. Born in Louisiana; attended the Brooklyn Museum Art School (1961–1962), the University of Nebraska (B.F.A. 1964), and Newcomb Art School, Tulane University (M.F.A. 1966). His paintings of the early 1970s were in a dry, somewhat broadly patterned Photo Realist style, emphasizing landscape themes.

Williams, Franklin (1940–)

Painter and sculptor. Born in Utah; attended CCAC (B.F.A. 1964, M.F.A. 1966). In the early 1970s he fashioned three-dimensional creatures that suggested fanciful versions of starfish and other forms of marine life out of stuffed canvas decorated with brightly painted surface patterns and tufts of thread. He also made paintings of tropical landscapes combined with obsessively repeated design motifs that suggested the forms of cells and other microscopic organisms and were related in feeling to the work of the contemporary Visionary artists. In the mid-1970s he introduced boldly silhouetted life-sized human figures into compositions that grew increasingly complex in their prolixity of surface patterns and mixtures of media. His later paintings, some of which grew into three-dimensional painted constructions, were simpler in structure but retained their surface activity, combining sharply silhouetted abstractions of organic images with flat, irregular color areas filled with surface patterns like those found in aboriginal art: prickly dots, squiggles, scales, wavy lines, and suggestions of egg cells and spermatozoa.

Williams, Neil (1934–)

Painter. Born in Utah; attended CSFA (B.F.A. 1959). He painted in a gestural style based in Abstract Expressionism.

Wilmarth, Christopher (1943–)

Sculptor. Born in Sonoma, Calif.; attended the Cooper Union in New York City (1960–1965). Although he has lived and worked in New York since the age of seventeen, his sculpture was exhibited frequently in the Bay Area in the 1970s. It combined plates of glass that were frosted with translucent, grayish films, with plates of steel that were cut and folded into various geometric shapes and visible behind the glass as subtle gradations of light and dark.

Wilson, Bryan (1927–)

Painter. Born in Stockton, Calif.; attended Stanford University. His big paintings featured wild animals brushed in a swift, facile, quasi-Oriental style.

Wilson, Richard (1944–)

Painter. Born in Kansas; attended San Jose State College (B.A. 1967, M.A. 1968). His abstract paintings of the late 1960s were six-sided canvases in which elegantly curving shapes were played against angular geometric planes in variations of subdued, close-valued colors. In the 1970s his paintings became more conventional in format. Their compositions were based on regular geometric forms symmetrically arranged and suggesting sources in architecture. Their colors were even more closely keyed, so that shapes frequently seemed to emerge from and disappear into their grounds in the manner of the painting of Ad Reinhardt.

Wilson, S. Clay (1941–)★

Cartoonist. Born in Lincoln, Neb.; attended the University of Nebraska. His drawings for the underground comic books focused on themes of unbridled violence and orgiastic fantasy involving motorcycle gangs and pirates, lesbians and urban hustlers, and the scum of the Old West.

Wilson, Wes (1937–)★

Postermaker. Born in Sacramento; attended Sacramento State and San Francisco State Colleges, and SFAI. Influenced by the Art Nouveau styles of Aubrey Beardsley and Gustav Klimt, his posters were characterized by medusa-haired figures, sometimes barely decipherable lettering in a sinuous line, and pulsating colors.

Wolff, William (1922–)

Painter and printmaker. Born in San Francisco; attended CSFA, U.C. Berkeley (B.A., M.A.), and SFAI. He worked in an expressionistic style, often using mythological themes in a way reminiscent of William Blake.

Wonner, Paul (1920–)★

Painter. Born in Arizona; attended CCAC (1942), the Art Students League of New York (1947), and U.C. Berkeley (1952–1955). He lived in Southern California from 1963 to the early 1970s, when he returned to the Bay Area.

Woo, Gary (1928–)

Painter. Born in Canton, China; came to the Bay Area at the age of ten. Studied at the Art League of California and CSFA. His paintings of the 1960s were soft-spoken abstractions influenced by the traditions of Chinese painting, and rooted in a feeling for the natural world.

Woodall, John (1940–)

Conceptualist. Born in Lakeland, Fla.; attended SFAI (B.F.A. 1968, M.F.A. 1969). His environments and performances, and the independent sculptural objects that occasionally grew out of them, expressed a preoccupation with "noumenal static states"; his work was an investigation of phenomena related to the ability to perceive, choose, act, and invent. His recurrent themes—dilemma, handicap, breakage, and repair—were related to those of William T. Wiley and Bruce Nauman.

Woods, Gurdon (1915–)★

Sculptor. Born in Georgia; studied at the Copley Society in Boston (1933–1935), the Art Students League of New York (1935–1939), and the Brooklyn Museum (1945–1946). In the late 1960s he worked primarily in concrete, making fragmented architectural structures with mangled and twisted reinforcing rods that suggested contemporary ruins in the aftermath of inexplicable catastrophe.

Worthington, Nancy (1947–)

Sculptor. Born in Norfolk, Va.; attended Madison College (B.A. 1969) and Pennsylvania State University (M.F.A. 1972). Her assemblages of the late 1970s, constructed primarily of found objects, resembled game machines and were frequently designed to be manipulated by the viewer, although they generally dealt with themes of a socially critical nature.

Yanez, Rene (1942–)★

Painter, graphic artist, assemblagist. Born in Mexico; came to California in 1954; attended SFAI (1970) and Golden Gate College (arts administration). As an artist, Yanez has been best known for his "taco art," a form of Mexican-American Pop assemblage in which makeshift, altarlike constructions are covered with Mexican breads, chilis, religious pictures, and commercial objects of various kinds in the spirit of traditional Day of the Dead offerings. He was a founder of the Galeria de la Raza and has remained its co-director.

Yokoi, Rita (1938–)

Ceramic sculptor. Born in New York City. Attended Alfred University, New York (1956–1959), SFAI (B.F.A. 1961), Tokyo University of Art (1962–1963), and U.C. Berkeley (M.A. 1970). Her ceramic sculpture of the late 1960s and early 1970s took simple geometric, organic, and symbolic forms and were glazed with vivid colors. In the late 1970s she began to combine several individual pieces into installation works that had literary and surreal overtones.

Zack, Maija (1942–)

Painter. Born in Riga, Latvia; attended U.C. Davis (B.A. 1964, M.A. 1965). Her paintings featured fanciful images of animals and still-life objects, with decorative borders, in a free and highly patterned style with sources in folk art. In 1967 she and her husband, the poet David Zack, bought an old Victorian house at 908 Steiner Street in San Francisco and spent the next year or two covering it inside and out with psychedelic design motifs in five colors, with countless handpainted images of animals, including one ten-foot-long papier-mâché crocodile that crawled up an outside wall.

Zakheim, Bernard (1898–)★

Painter and sculptor. Born in Warsaw, Poland; attended the Warsaw School of Applied Arts, the Polish Academy of Fine Arts, the School of Fine Arts in Munich, and the Politechnicum in Danzig; came to the United States in 1920 and to San Francisco in 1932. Active as a muralist in the 1930s (Coit Tower, the San Francisco Public Library's Periodical Room, the Alemany Health Center, the U.C. Medical School and Hospital), he worked in a Social Realist manner that had undertones of expressionism and was frequently heavy with social comment. In later years he concentrated on easel paintings and ruggedly carved sculptures in wood, frequently revolving around Jewish themes and in a style strongly influenced by German Expressionism.

Zogbaum, Wilfrid (1915–1965)

Sculptor. Born in Rhode Island; attended the Yale School of Fine Arts (1933–1934) and the Hans Hofmann School in New York (1935–1937). Came to the Bay Area as a visiting teacher at U.C. Berkeley in 1957 and remained there until 1964. His mature sculpture used industrial metals—generally painted black or in a flat, industrial orange and sometimes combined with one or two smoothly rounded natural stones—to fashion sleek, linear "drawings in space," in a style that combined Cubist abstraction with elements of organic surrealism.

Notes

1. Before the Storm: The Modernist
 Foundation

1. Thomas Albright, "A Conversation with Clyf-
 ford Still," *Art News,* Mar. 1976, p. 33.
2. Irving Sandler, *The Triumph of American Painting:
 A History of Abstract Expressionism* (New York:
 Praeger, 1970), p. 158.
3. Clay Spohn, letter to the author, Mar. 17, 1976.
4. Quoted in Terry St. John, *Society of Six* exhibi-
 tion catalogue (Oakland: The Oakland Museum,
 1972), p. 12.
5. Ibid., p. 15.
6. Ibid., p. 13.
7. Robert Howard, quoted in Frank Herbert, "Ad-
 ventures in Movement," *San Francisco Sunday
 Examiner and Chronicle,* Aug. 1, 1968, *California
 Living* section.
8. Spohn, letter to the author, Mar. 26, 1976.
9. Jean Lipman, *Calder's Universe* (New York: Vik-
 ing Press, in cooperation with The Whitney
 Museum of American Art, 1976), p. 233.
10. *San Francisco Chronicle,* June 8, 1930.
11. Dean Wallace, "A Few More Words on Hans
 Hofmann," *San Francisco Chronicle,* July 26, 1961.
12. Thomas Albright, "Elmer Bischoff: Bay Area
 Figurative," *Currant,* Dec. 1975–Jan. 1976, p. 36.
13. Sargent Johnson, quoted in *San Francisco Chroni-
 cle,* Oct. 6, 1935.
14. Interview with Hassel Smith, Oct. 1975.
15. Ibid.
16. Spohn, letter to the author, Mar. 27, 1976.
17. Conversations with Clyfford Still, Oct. 1978.
18. Alfred Frankenstein, "The Annual Exhibition of

Drawings and Prints," *San Francisco Chronicle,*
Mar. 14, 1943, *This World* section.

2. Clyfford Still and the Explosion of
 Abstract Expressionism

1. Mary Fuller McChesney, *A Period of Exploration:
 San Francisco, 1945–1950* (Oakland: The Oakland
 Museum, 1973), p. 4.
2. Conversations with Clyfford Still, Oct. 1978.
3. Interview with Hassel Smith, Oct. 1975.
4. McChesney, *A Period of Exploration,* p. 12.
5. Ibid., p. 13.
6. Ibid., p. 9.
7. Thomas Albright, "Elmer Bischoff: Bay Area
 Figurative," *Currant,* Dec. 1975–Jan. 1976, pp.
 38–39.
8. Ibid., p. 36.
9. Clay Spohn, letter to the author, Apr. 2, 1976.
10. McChesney, *A Period of Exploration,* p. 5.
11. Thomas Albright, "The Painted Flame," *Hori-
 zon,* Nov. 1979, p. 26.
12. Ibid., p. 26.
13. Ibid., p. 32.
14. Ibid.
15. Ibid.
16. Ibid.
17. *Clyfford Still* (San Francisco: San Francisco Mu-
 seum of Modern Art, 1976).
18. Albright, "The Painted Flame," p. 32.

19. McChesney, *A Period of Exploration,* pp. 40–41.
20. Ibid., p. 11.
21. Albright, "Elmer Bischoff: Bay Area Figurative," pp. 38–39.
22. Quotations are from Hubert Crehan, "Art Schools Smell Alike," *San Francisco Sunday Examiner and Chronicle,* Oct. 4, 1970, *This World* section; and Spohn, letter to the author, Apr. 14, 1976.
23. Conversations with Clyfford Still, Oct. 1978.
24. Quotations are from Spohn, letter to the author, June 16–24, 1976; and Crehan, "Art Schools Smell Alike."
25. Schueler, quoted in McChesney, *A Period of Exploration,* p. 46; and Crehan, "Art Schools Smell Alike."
26. Crehan, "Art Schools Smell Alike."
27. Kenneth Rexroth, "Americans Seen Abroad," *Art News,* Summer 1959, p. 54.
28. Kenneth Sawyer, "U.S. Painters Today, No. 1: Clyfford Still," *Portfolio and Art News Annual,* no. 2, (1960).
29. McChesney, *A Period of Exploration,* p. 43.
30. Ibid., p. 33.
31. Ibid.
32. Albright, "Elmer Bischoff: Bay Area Figurative," p. 38.
33. Spohn, letter to the author, June 16–24, 1976.
34. Ibid.
35. Clyfford Still, quoted in McChesney, *A Period of Exploration,* p. 43.
36. Spohn, letter to the author, Apr. 24, 1976.
37. McChesney, *A Period of Exploration,* p. 43.
38. Schueler and Briggs are quoted in McChesney, pp. 47 and 52; Diebenkorn and Bischoff (on straight edges) are quoted in Maurice Tuchman, "Diebenkorn's Early Years," in *Richard Diebenkorn: Paintings and Drawings, 1943–1976,* catalogue of exhibition organized by the Albright-Knox Art Gallery (Buffalo: The Buffalo Fine Arts Academy, 1976), p. 12.
39. Conversations with Clyfford Still, Oct. 1978.
40. McChesney, *A Period of Exploration,* quotes Schueler on p. 46 and Corbett on p. 37.
41. Conversations with Clyfford Still, Oct. 1978.
42. Correspondence with Betty Parsons, Betty Parsons papers, Archives of American Art, Smithsonian Institution, Washington, D.C.
43. Spohn, letter to the author, Apr. 25, 1976.
44. McChesney, *A Period of Exploration,* quotes Schueler on p. 47 and Briggs on p. 42.
45. Albright, "The Painted Flame," p. 33.
46. Edith Dugmore, letter to the author, Apr. 29, 1977.
47. Press release, Metart Galleries, Apr. 1949.
48. Conversations with Clyfford Still, Oct. 1978.
49. McChesney, *A Period of Exploration,* p. 38.
50. Crehan, "Art Schools Smell Alike."
51. Alfred Frankenstein, *A Century of California Painting, 1870–1970,* catalogue of exhibition sponsored by Crocker-Citizens National Bank (San Francisco, 1970).
52. Irving Sandler, *The New York School: The Painters and Sculptors of the Fifties* (New York: Harper and Row, 1978), p. 16.
53. Hubert Crehan, "Is There a California School?" *Art News,* Jan. 1956, p. 65.
54. McChesney, *A Period of Exploration,* p. 50.

3. The Golden Years of Abstract Expressionism

1. Interview with Hassel Smith, October 1975.
2. Mark Schorer, "Elmer Bischoff," announcement for exhibition of recent paintings at the Staempfli Gallery, New York, Jan. 5–23, 1960.
3. Conversations with Clyfford Still, Oct. 1978.
4. Mary Fuller McChesney, *A Period of Exploration: San Francisco, 1945–1950* (Oakland: The Oakland Museum, 1973), p. 57.
5. Ibid., p. 53.
6. Interview with Erle Loran, 1977.
7. Ibid.
8. Wolfgang Paalen, "The New Image," Robert Motherwell, trans., *DYN,* no. 1 (April–May 1942), p. 9; quoted in Irving Sandler, *The Triumph of American Painting: A History of Abstract Expressionism* (New York: Praeger, 1970), p. 37.
9. Wolfgang Paalen, in *Dynaton,* catalogue of exhibition (San Francisco: San Francisco Museum of Art, 1951).
10. Jacqueline Johnson, "Taking a Sight," in *Dynaton,* catalogue of exhibition (San Francisco: San Francisco Museum of Art, 1951).
11. McChesney, *A Period of Exploration,* p. 60.
12. Ibid., p. 61.
13. Erle Loran, "San Francisco Art News," *Art News,* Apr. 1950, p. 50.
14. Maurice Tuchman, "Diebenkorn's Early Years," in *Richard Diebenkorn: Paintings and Drawings, 1943–1976,* catalogue of exhibition organized by the Albright-Knox Art Gallery (Buffalo: The Buffalo Fine Arts Academy, 1976), p. 12.
15. McChesney, *A Period of Exploration,* pp. 83–84.
16. Ibid., p. 84.
17. Ibid., pp. 51–64.
18. Ibid., p. 77.
19. Ibid., p. 76.
20. Alfred Frankenstein, "The Depth and Radiance of Lobdell," *San Francisco Chronicle,* Sunday, May 8, 1966, *This World* section.
21. Herschel B. Chipp, "This Summer in San Francisco," *Art News,* Summer 1958, p. 48.
22. Hilton Kramer, "Dude Ranch Dada," *The New York Times,* May 16, 1971.
23. Interview with Hassel Smith, Oct. 1975.
24. Ibid.
25. McChesney, *A Period of Exploration,* pp. 43, 44.
26. *Jack Jefferson,* catalogue of exhibition at M. H. de

Young Memorial Museum, Winter 1962–1963 (San Francisco: de Young Museum, 1962).

27. Interview with Erle Loran, 1977.

4. "Back to Nature": The Bay Area Figurative School

1. Betty Turnbull, "David Park: Unyielding Humanist," in *David Park*, catalogue of exhibition organized by the Newport Harbor Art Museum, Sept. 16–Nov. 13, 1977 (Newport Beach, Calif., 1977), p. 2.

2. Paul Mills, *Contemporary Bay Area Figurative Painting: An Introduction to New Work by a Number of Bay Area Painters, Presented in Connection with the Exhibition Held September 1957* (Oakland: The Oakland Art Museum, 1957), pp. 5, 8.

3. Louis Finkelstein, quoted in Irving Sandler, *The New York School: The Painters and Sculptors of the Fifties* (New York: Harper and Row, 1978), p. 49.

4. Paul Mills, *Contemporary Bay Area Figurative Painting*, p. 14.

5. Bonny B. Saulnier, *James Weeks*, catalogue of retrospective exhibition (Waltham, Mass.: Rose Art Museum, Brandeis University, 1978), p. 9.

6. Brenda Richardson, *Joan Brown*, catalogue of retrospective exhibition organized by the University Art Museum, University of California (Berkeley, 1974), p. 4.

7. Mills, *Contemporary Bay Area Figurative Painting*, pp. 6–7.

8. Maurice Tuchman, "Diebenkorn's Early Years," in *Richard Diebenkorn: Paintings and Drawings, 1943–1976*, catalogue of exhibition organized by the Albright-Knox Art Gallery (Buffalo: The Buffalo Fine Arts Academy, 1976), p. 10.

9. Ibid., p. 9.

10. Mills, *Contemporary Bay Area Figurative Painting*, p. 7.

11. Richard Diebenkorn, quoted in Terry St. John, "David Park: A Retrospective Exhibition," checklist published by The Oakland Museum to accompany catalogue of the retrospective exhibition organized by the Newport Harbor Art Museum for its showing in Oakland, Nov. 29, 1977–Jan. 15, 1978 (Oakland, 1978).

12. Paul Mills, "Excerpts from 'The Figure Reappears: The Life and Art of David Park," in *David Park*, catalogue of exhibition organized by the Newport Harbor Art Museum, Sept. 16–Nov. 13, 1977.

13. Ibid.

14. Ibid.

15. Ibid.

16. Thomas Albright, "Elmer Bischoff: Bay Area Figurative," *Currant*, Dec. 1975–Jan. 1976, p. 40.

17. Ibid.

18. James Benet, "Award Winning Artist to Work On in Tiny Studio," *San Francisco Chronicle*, Feb. 17, 1959.

19. Albright, "Elmer Bischoff: Bay Area Figurative," p. 40.

20. Tuchman, "Diebenkorn's Early Years," p. 6.

21. Ibid., p. 26.

22. Mills, *Contemporary Bay Area Figurative Painting*, p. 12.

23. Ibid., p. 11.

24. Saulnier, *James Weeks*, p. 22.

25. Mills, *Contemporary Bay Area Figurative Painting*, p. 15.

26. "Edging Away from Abstraction," *Time*, Mar. 17, 1958.

27. Herschel B. Chipp, "Diebenkorn Paints a Picture," *Art News*, May 1957, pp. 44–47, 54–55.

28. Thomas Albright, "Manuel Neri: A Kind of Time Warp," *Currant*, Apr.–May 1975, p. 11.

29. Ibid., p. 13.

30. Dean Wallace, "Action Sculpture by Manuel Neri," *San Francisco Chronicle*, July 8, 1960.

31. Albright, "Manuel Neri: A Kind of Time Warp," p. 14.

32. Ibid.

33. Lecture, San Francisco Museum of Art, Oct. 9, 1974.

34. Joan Brown, "In Conversation with Jan Butterfield," *Visual Dialog* (Los Altos, Calif.) 1 (Dec. 1975 and Jan.–Feb. 1976): 15.

35. Richardson, *Joan Brown*, p. 20.

36. Brown, "In Conversation with Jan Butterfield," p. 16.

37. Ibid.

38. Dore Ashton, *The New York Times*, Jan. 8, 1960.

39. Hilton Kramer, "Month in Review," *Arts*, Jan. 1960, p. 45.

40. Hilton Kramer, "Pure and Impure Diebenkorn," *Arts Magazine*, Dec. 1963, pp. 47–48.

5. The Beat Era: Bay Area "funk"

1. Conversations with Bruce Conner, 1968.

2. Harold Paris, "Sweet Land of Funk," *Art in America*, Mar.–Apr. 1967, p. 97.

3. Norman Mailer, "The White Negro," published in *Dissent*, Summer 1957.

4. Jack Spicer, "After Lorca," in *The Collected Books of Jack Spicer*, edited and with a commentary by Robin Blaser (Los Angeles: Black Sparrow Press, 1975), pp. 33–34.

5. Thomas Albright, "Manuel Neri: A Kind of Time Warp," *Currant*, Apr.–May 1975, p. 13.

6. Ibid.

7. Tim Holt, "North Beach," *San Francisco Magazine*, Dec. 1972, p. 27.

8. Robert Duncan, *A Book of Resemblances* (New Haven, 1966) pp. 10, 9.

9. Alfred Frankenstein, "The Visual Quotations by Jess," *San Francisco Sunday Examiner and Chronicle*, June 12, 1977, *This World* section.

10. Alfred Frankenstein, "Sculpture's New, Happy Marriage," *San Francisco Chronicle*, Feb. 12, 1961, *This World* section.

11. Duncan, *A Book of Resemblances*, p. 10.

12. Alfred Frankenstein, "Art Exhibits—Large and Small," *San Francisco Chronicle*, June 7, 1953, *This World* section.

13. Fred Martin, in *Wally Hedrick, Sam Tchakalian*, catalogue of exhibition at the Balboa Pavilion Gallery, May 3–June 11, 1967 (Balboa, Calif., 1967).

14. Ibid.

15. Ibid.

16. Merril Greene, "Jay De Feo," in *Art as a Muscular Principle: 10 Artists and San Francisco, 1950–1965—Roots and New Directions*, catalogue of exhibition at the John and Norah Warbeke Gallery, Mount Holyoke College, Feb. 28–Mar. 20, 1975 (South Hadley, Mass., 1975), pp. 44, 47.

17. Ibid.

18. Ibid.

19. Robert Duncan, "Wallace Berman: The Fashioning Spirit," in *Wallace Berman*, catalogue of retrospective exhibition organized by the Fellows of Contemporary Art in cooperation with the Otis Art Institute Gallery, Oct. 24–Nov. 26, 1978, with Foreword by Hal Glicksman, curator; interview with Walter Hopps; and essays by Robert Duncan and David Meltzer (Los Angeles, 1978), pp. 19, 20.

20. John Coplans, *Assemblage in California*, catalogue of exhibition organized by the art gallery of the University of California, Irvine (Irvine, Calif., 1968).

21. Joan C. Siegfried, *Bruce Conner*, catalogue of exhibition organized by the Institute of Contemporary Art, University of Pennsylvania, Nov. 29–Dec. 31, 1967 (Philadelphia, 1967).

22. Conversations with Bruce Conner, 1968.

23. Philip Leider, "Bruce Conner: A New Sensibility," *Artforum*, Nov. 1962, pp. 30–31.

24. Conversations with Bruce Conner, 1968.

25. Thomas Albright, "Art: Bruce Conner, Film-Maker," *Rolling Stone*, Mar. 9, 1968, p. 18.

26. Thomas H. Garver, "Bruce Conner Makes a Sandwich," *Artforum*, Sept. 1957, pp. 51–55.

27. Robert Rauschenberg, quoted in Aldo Pellegrini, *New Tendencies in Art* (New York: Crown, 1966), p. 216.

28. Fred Martin, in *Wally Hedrick, Sam Tchakalian*, catalogue of exhibition at the Balboa Pavilion Gallery, May 3–June 11, 1967 (Balboa, Calif., 1967).

6. The Watershed: Funk, Pop, and Formalism

1. Clement Greenberg, "American Type Painting," in Clement Greenberg, *Art and Culture: Critical Essays* (Boston: Beacon, 1961), p. 221.

2. Quoted by Samuel A. Green in *Andy Warhol*, catalogue of exhibition organized by the Institute of Contemporary Art, University of Pennsylvania (Philadelphia, 1965).

3. Interview with Erle Loran, 1977.

4. Lesley Wenger, "William T. Wiley: Fall Fashions," *Currant*, Oct.–Nov. 1975, p. 54.

5. Unpublished interview with William T. Wiley, 1971.

6. John Coplans, "West Coast Art: Three Images," *Artforum*, June 1963, p. 25.

7. Philip Leider, "California Art After The Figure," *Art in America*, Oct. 1963, p. 77.

8. Interview with William T. Wiley, 1971.

9. Ibid.

10. Wenger, "William T. Wiley: Fall Fashions," p. 17.

11. Interview with William T. Wiley, 1971.

12. Wenger, "William T. Wiley: Fall Fashions," p. 55.

13. Hilton Kramer, "Dude Ranch Dada," *New York Times*, May 16, 1971.

14. Robert Arneson lecture, San Francisco Museum of Art, Dec. 4, 1974.

15. Stephen Prokopoff, "Robert Arneson I," in *Robert Arneson*, catalogue of exhibition organized by the Museum of Contemporary Art, Chicago, in collaboration with the San Francisco Museum of Art, 1974.

16. Garth Clark and Margie Hughto, *A Century of Ceramics in the United States, 1878–1978* (New York: E. P. Dutton, in association with The Everson Museum of Art, 1979), p. 162. The Frankenstein quote comes from "Of Bricks, Pop Bottles, and Better Mousetraps," in the *San Francisco Sunday Examiner and Chronicle*, Oct. 6, 1974, *This World* section. The term "mastadon droppings" in reference to Voulkos's work, according to Clark and Hughto, was coined by Elena Natherby; see *A Century of Ceramics*, p. 271.

17. Thomas Albright, "Wayne Thiebaud: Scrambling Around with Ordinary Problems," *Art News*, Feb. 1978, p. 82.

18. Ibid., p. 84.

19. Ibid.

20. John Coplans, Introduction to *Wayne Thiebaud* (Pasadena: Pasadena Art Museum, 1968), p. 8.

21. Albright, "Wayne Thiebaud: Scrambling Around with Ordinary Problems," p. 84.

22. Ibid., p. 85.

23. Ibid., p. 82.

24. All information on the Slant Step is from Phil Weidman, *Slant Step Book* (Sacramento: The Art Co., 1969).

25. David Simpson, "An Illogical Positivist Manifesto" (1976), quoted in Harvey L. Jones, *David Simpson*, catalogue of exhibition organized by The Oakland Museum, Art Special Gallery, Oct. 17–Dec. 3, 1976 (Oakland, 1976), p. 9.

26. Harold Paris, "Sweet Land of Funk," *Art in America,* Mar.–Apr. 1967, p. 98.
27. Conversations with Gerald Gooch, 1973–1974.
28. Ibid.

7. Sculpture of the Sixties

1. Quoted in Gerald Nordland, *Peter Voulkos, Bronze Sculpture,* catalogue of exhibition organized by the San Francisco Museum of Art, Oct. 14, 1972–Jan. 14, 1973 (San Francisco, 1973).
2. Thomas Albright, "Manuel Neri: A Kind of Time Warp," *Currant,* Apr.–May 1975, p. 11.
3. Quoted in Jane Livingston, *Bruce Nauman* (Los Angeles: Los Angeles County Museum of Art, 1972), p. 11. Livingston's source is Robert Pincus-Witten, "New York," *Artforum,* Apr. 1968, p. 63.
4. Quoted in Sylvia Brown, *Ron Nagle,* catalogue of 1978 Adaline Kent Award Exhibition organized by the San Francisco Art Institute, Sept. 30–Oct. 19, 1978 (San Francisco, 1978).
5. Conversation with Peter Selz, December 1981.
6. Conversation with Stephen De Staebler, Summer 1982.
7. Alfred Frankenstein, "A Roof Garden of Sculpture," *San Francisco Chronicle,* Aug. 25, 1963, *This World* section.
8. Gerald Nordland, *Jeremy Anderson,* catalogue of exhibition organized by the San Francisco Museum of Art, Nov. 30–Dec. 31, 1966 (San Francisco, 1966), p. 5.
9. "Saul on Saul," in *Peter Saul,* catalogue of exhibition organized by Northern Illinois University, Nov. 3–Nov. 30, 1980 (De Kalb, Ill., 1980), pp. 12–13.
10. Fidel Danieli, "Robert Hudson, Space and Camouflage," *Artforum,* Nov. 1967, pp. 32ff.
11. Thomas Garver, *Don Potts: My First Car,* catalogue of exhibition organized by the Newport Harbor Art Museum (Newport Beach, Calif., 1972).
12. "A Human: Spontaneous Conversation by Fletcher Benton and William Minschew," in *Fletcher Benton,* catalogue of exhibition organized by the University Art Gallery of the Phebe Conley Building, California State University, Fresno, Mar. 13–Apr. 10, 1977 (Fresno, 1977).
13. Quoted in Gerald Nordland, *James Prestini: Sculpture from Structural Steel Elements,* catalogue of exhibition organized by the San Francisco Museum of Art, Nov. 6–Dec. 7, 1969 (San Francisco, 1969), p. 5.

8. The Utopian Vision

1. Norman Stiegelmeyer was the first to use the term Visionary art, in the title of a group show he organized for the San Francisco Art Festival in 1968. See Stiegelmeyer, *Visionary Art,* catalogue of exhibition organized by the Walnut Creek Civic Arts Gallery, Sept. 10–Nov. 1, 1981 (Walnut Creek, Calif., 1981), p. 2.
2. Thomas Albright, "The Poet Who Became a Movie Maker," *San Francisco Chronicle,* Dec. 15, 1967.
3. Interview with Victor Moscoso, 1969.
4. Roger Ferragallo, *A Manifesto Directed to the New Aesthetics of Stereo Space in the Visual Arts and the Art of Painting,* Nov. 12, 1972 (unpublished); partly reprinted in Ferragallo, "On Stereoscopic Painting," in *Leonardo* (Oxford: Pergamon Press, 1974), vol. 7, pp. 97–104.
5. Thomas Albright, "Zap, Snatch, and Crumb," *Rolling Stone,* Mar. 1, 1969, p. 25.
6. Donald Brewer, *Other Landscapes and Shadow Land (Visionary Paintings by Ten Bay Area Artists),* catalogue of exhibition organized by the University of Southern California Art Galleries, Nov. 10–Dec. 3, 1971 (Los Angeles, 1971).
7. Thomas Albright, "Visionary Art," *Rolling Stone,* Aug. 20, 1971.
8. Quotations from Taylor and Martin all from Thomas Albright, "Visuals" (second in a series), *Rolling Stone,* Sept. 2, 1971, pp. 48–50.
9. Thomas Albright, "Introduction to Sätty," *The Cosmic Bicyle* (San Francisco: Straight Arrow Books, 1971).
10. Conversations with Sätty.
11. William Moore, "Sacramento Scene: Good-By, Day-Glo Bus," *San Francisco Chronicle,* Oct. 23, 1976.

9. Conceptualism

1. "Dilexi to Be a Non-Gallery," *San Francisco Chronicle,* Dec. 6, 1968.
2. "Sam's Cafe: Art World Decays," unidentified newspaper article signed "Mankin," reproduced in *Especially Galleries* (David Y. Allen, ed.), San Francisco, Nov. 1971, p. 13.
3. Willoughby Sharp, "Terry Fox: I wanted to have my mood affect their looks," *Avalanche,* Winter 1971, pp. 70–71.
4. Brenda Richardson, *Terry Fox* (Berkeley: University Art Museum, 1973).
5. Tom Marioni, *The Sound of Flight,* brochure accompanying exhibitions at the M. H. de Young Memorial Museum, Fine Arts Museums of San Francisco, Apr. 23–June 26, 1977, and the Gallery Paule Anglim, San Francisco, May 3–May 28, 1977; reprinted from an interview with Carl Loeffler, *La Mamelle,* Spring 1976.
6. Ibid.
7. Ibid.
8. Lynn Hershman, in *Data,* no. 27 (1977), p. 4.

10. The Object Reaffirmed: Photo Realism
and the New Abstraction

1. Thomas Albright, "The Expanding Alterna-
tives," *San Francisco Chronicle,* May 1, 1975.

2. Thomas Albright, "New Museum Director: A
Stress On Local Artists," *San Francisco Chronicle,*
Sept. 14, 1973.

3. Roland Barthes, "Objective Literature: Alain
Robbe-Grillet," *Evergreen Review,* no. 5 (Summer
1958), pp. 113–126; translated by Richard Ho-
ward from "Littérature objectif: Alain Robbe-
Grillet," in *Critique,* nos. 86–87 (1954).

4. Ann C. Van Devanter and Alfred Frankenstein,
with the assistance of Shirley S. Simpson, *Por-
traits—Self-Portraits,* catalogue of exhibition orga-
nized by the International Exhibitions Foundation
(Washington, D.C., 1974), p. 206.

5. Lecture at the San Francisco Museum of Art,
Nov. 20, 1974.

6. "Richard McLean," interview by John Marlowe,
in *Currant,* Aug.–Sept.–Oct. 1976, p. 51.

7. Mary Fuller, "The Water Becomes the Lily: An
Interview with Joseph Raffael," in ibid., p. 20.

8. Cherie Raciti, *Five Women Artists in Las Vegas,*
catalogue of exhibition at the University of
Nevada, Las Vegas, Gallery, Mar. 3–14, 1975
(Las Vegas, 1975).

11. Personal Mythologies

1. *Nut Art,* catalogue of exhibition organized by the
Art Gallery of California State University, Hay-
ward (Hayward, Calif., 1972).

2. Hilton Kramer, "Dude Ranch Dada," *The New
York Times,* May 16, 1971.

3. David Zack, "California Myth-Making," *Art and
Artists,* July 1969, pp. 27–30.

4. Lecture at the San Francisco Museum of Art, Dec.
4, 1974.

5. Conversation with Fred Martin, 1974.

6. Brenda Richardson, "I Am My Own Enigma,"
in *William T. Wiley,* catalogue of exhibition
organized by the University Art Museum, Uni-
versity of California (Berkeley, 1971), p. 14.

photographed c. 1947. Photo by Ellen Bransten. Courtesy of the San Francisco Art Institute. 17

17. Elmer Bischoff and Hassel Smith in the courtyard of the California School of Fine Arts in 1947. Photo by William Heick. 19

18. Mark and Mell Rothko with Clyfford Still in San Francisco, 1946. Photo by Consuelo Kanaga. Courtesy of Christopher Rothko, Kate Rothko Prizel, and the Solomon R. Guggenheim Museum, New York. 20

19. Clyfford Still, *Self Portrait*, 1940. Oil on canvas, 41½" × 38". 21

20. Clyfford Still, *Row of Elevators*, c. 1928–1929. Oil on canvas, 34¼" × 44½". National Museum of American Art (formerly National Collection of Fine Arts), Smithsonian Institution. Gift of IBM Corporation. 23

21. Clyfford Still, *Brown Study*, c. 1935. Oil on canvas, 29¹⁵⁄₁₆" × 20¼". Munson-Williams-Proctor Institute, Utica, N.Y. Photo by Edward Michael. 23

22. Clyfford Still, *1941-R*, 1941. Oil on denim, 58⅛" × 25⅛" (Ph-169). San Francisco Museum of Modern Art. Gift of the artist. Photo by Rudi Bender. 24

23. Clyfford Still, *Untitled*, 1946. Oil on canvas, 61¾" × 44½". The Metropolitan Museum of Art. Museum purchase, Arthur Hoppock Hearn and George A. Hearn Funds, 1977. 25

24. Clyfford Still, *Untitled*, 1948. Oil on canvas, 80¾" × 68¾". Private collection. 27

25. Mark Rothko in a classroom at the California School of Fine Arts in the late forties. Photo by William Heick. 28

26. Mark Rothko, *Number 15*, 1948. Oil on canvas, 52⅜" × 29⅜". © The Mark Rothko Foundation, Inc., New York. 1981. Photo by Quesada/Burke. 29

27. Clyfford Still, *Untitled*, 1949. Oil on canvas, 68" × 58¼". The Museum of Fine Arts, Houston. Museum purchase with funds from the Brown Foundation. 33

28. Clyfford Still, *1950-B*, 1950. Oil on canvas, 83½" × 67⅜". The Phillips Collection, Washington, D.C. 34

29. Frank Lobdell, *Black Edges III*, 1962. Oil on canvas, 83½" × 70". Collection of Sally Lilienthal. Photo by M. Lee Fatherree. 36

30. Hassel Smith, *Homage to Bob Scobey*, 1963. Oil on canvas, 48" × 48". Collection of Byron Meyer. Photo by M. Lee Fatherree. 36

31. Classroom at the California School of Fine Arts, 1947. Photo by William Heick. 38

32. Edward Corbett, *Untitled*, 1949. Oil on panel, 23" × 17¼". Collection of Elizabeth and Allan Temko. Photo by M. Lee Fatherree. 39

33. Richard Diebenkorn in David Park's studio, 1949. In the background is Hassel Smith. Photo by George Stillman. 39

34. Richard Diebenkorn, *Untitled*, 1949. Oil on canvas, 45" × 36". The Oakland Museum. Gift of the Women's Board. Photo by M. Lee Fatherree. 40

35. Wolfgang Paalen, *Planetary Face*, 1947. Oil on canvas, 59" × 55¼". San Francisco Museum of Modern Art purchase. Photo by Don Myer. 41

36. *The Museum of Unknown and Little Known Objects*, exhibited at the California School of Fine Arts in 1949. Photo by F. W. Quandt. 43

37. Explanatory sketch made by Clay Spohn for the *Museum of Unknown and Little Known Objects*. Photo by M. Lee Fatherree. 43

38. Frank Lobdell, 1974. Photo by Mimi Jacobs. 45

39. Frank Lobdell, *April 1957*, 1957. Oil on canvas, 70" × 60". Collection of the artist. Photo by Blair Paltridge. 45

40. Frank Lobdell, *Summer 1967*

(in memory of James Budd Dixon), 1967. Oil on canvas, 91" × 180". Courtesy of the Oscarsson Hood Gallery, New York. 46

41. Frank Lobdell, *Dance VIII*, 1971. Oil on canvas, 62" × 88". Collection of the artist. Courtesy of the Smith-Andersen Gallery, Palo Alto, Calif. 47

42. Hassel Smith, *Self Portrait*, 1948. Oil on canvasboard, 16" × 12". The Oakland Museum. Gift of the Art Guild of the Oakland Museum Association. 48

43. Hassel Smith, *Alone with the Killer*, 1948. Oil on canvas, 20" × 22". The Oakland Museum. Gift of Mrs. Lydia Park Moore. Photo by M. Lee Fatherree. 49

44. Jack Jefferson, *Mission #20*, 1957. Oil on canvas, 76" × 50". Photo by M. Lee Fatherree. Courtesy of Gallery Paule Anglim, San Francisco. 50

45. Alvin Light, *November 1964*, 1964. Wood and pigmented epoxy, 98⅜" × 59" × 61⅛". San Francisco Museum of Modern Art. Gift of the Women's Board. Photo by Phillip Galgiani. 51

46. James Kelly, *Last Days of Dylan Thomas*, 1953. Oil on canvas, 64½" × 87". Collection of the artist. Photo by James Kelly. 52

47. James Budd Dixon, 1948. Photo by William Heick. 54

48. James Budd Dixon, *Study in Red and Green #13*, 1958. Oil on canvas, 48" × 48". The Oakland Museum. Gift of the Estate of Peggy Nelson Dixon. Photo by M. Lee Fatherree. 54

49. Louis Siegriest, *Dark Canyon*, 1962. Oil on canvas, 36" × 48". The Oakland Museum. Gift of Louis Siegriest. Photo by M. Lee Fatherree. 55

50. David Park, *Kids on Bikes*, 1950. Oil on canvas, 48" × 42". Collection of Mr. and Mrs. David Lloyd Kreeger. Photo by Joel Breger. 56

51. David Park, 1956. Photo by

1964. Mixed media on mason-
ite; three pieces: 44⅛″ × 31¼″,
47¾″ × 49¼″, 44¼″ × 31″. On
extended loan at the Univer-
sity Art Museum, University
of California, Berkeley. Col-
lection of the Janss Founda-
tion, Thousand Oaks, Calif.
Photo by Ben Blackwell.
100–101

86. Bruce Conner, *Untitled Draw-
ing 1966-D-9,* 1966. Felt-tip
pen on paper, 25½″ × 25½″.
Collection of Mr. and Mrs.
C. David Robinson. Photo
by M. Lee Fatherree. 102

87. George Herms, Larkspur,
California, 1961. Photo by
Patricia M. Jordan. 103

88. George Herms, *The Librar-
ian,* 1960. Stool, wood box,
papers, brass bell, and books,
57″ × 63″ × 21″. Norton
Simon Museum of Art at
Pasadena. Gift of Molly
Barnes. 103

89. George Herms, *Temple of the
Sun,* 1964. Mixed media as-
semblage, 58″ × 27¾″ ×
21½″. Private collection.
Photo by Ben Blackwell.
104

90. Keith Sanzenbach, *Mandala,*
1960. Oil and lacquer on bur-
lap, 86″ × 69″. The Oakland
Museum. Gift of Reidar
Wennesland. Photo by M.
Lee Fatherree. 106

91. Aaron Miller, *Jesus is Laid in
the Tomb,* 1950. Housepaint
on plasterboard, 168″ × 108″.
One of the two murals saved
when the Emanuel Church of
God in Christ at 1540 Post
Street in San Francisco was
demolished in 1974. This and
the other surviving mural
are in the possession of the
San Francisco Redevelopment
Agency. Courtesy of the
San Francisco Museum of
Modern Art Conservation
Laboratory. 107

92a. Fredric Hobbs, *The Trojan
Horse,* 1966–1967. Fiberglass
and acrylic on Chrysler sedan
chassis. Collection of the Los
Angeles dump. 108

92b. Fredric Hobbs driving *The
Trojan Horse.* Photo by Gor-
don Mueller. 108

93. Robert Arneson, *Alice House
Wall,* 1967. Polychromed
earthenware, 60″ × 95″ × 13″.
Permanent collection of the
American Craft Museum.
Gift of the Johnson Wax Co.,
from OBJECTS: USA. Photo
by David F. Penney,
Inc. 110

94. The Oakland Museum,
opened in 1969 on a 7.7-acre
site in downtown Oakland.
Kevin Roche and John Dinke-
loo Associates, Architects.
115

95. Interior of the University Art
Museum, Berkeley. Opened
in November 1970. Mario J.
Ciampi and Associates, Ar-
chitects. Courtesy of the
University Art Museum,
University of California,
Berkeley. 115

96. William T. Wiley in his Wood-
acre studio, 1975. Photo by
Blair Paltridge. 117

97. William T. Wiley, *Whats It All
Mean,* 1967. Acrylic on ply-
wood and mixed media. Col-
lection of the artist. Courtesy
of Wanda Hansen. 118

98. William T. Wiley, *One Ab-
stract Expressionist Painting
Rolled and Taped,* 1966. Can-
vas, tape, and wire, 34″ × 5″.
Courtesy of Wanda Hansen.
Photo by J. Fulton. 118

99. William T. Wiley, *Thank You
Hide,* 1970–1971. Construc-
tion with wood, leather,
pick, found objects, and ink
and charcoal on cowhide, 70″
× 64″. Des Moines Art
Center. Coffin Fine Arts
Trust Fund purchase. Photo
by David Penney. 120

100. Robert Arneson, *No Deposit,
No Return,* 1961. Stoneware,
10¾″ × 5″. Collection of Mr.
and Mrs. Paul C. Mills,
Santa Barbara, Calif. Cour-
tesy of the artist. 121

101. Robert Arneson, *Funk John,*
1963. Stoneware, 36″ × 20″.
Destroyed c. 1978. Courtesy
of the artist. 122

102. Wayne Thiebaud in his stu-
dio, c. 1980. Courtesy of the
Allan Stone Gallery, New
York. 123

103. Wayne Thiebaud, *Desserts,*

1961. Oil on canvas, 24″ ×
30″. Private collection. Cour-
tesy of the John Berggruen
Gallery, San Francisco. 124

104. Wayne Thiebaud, *Reflected
Landscape,* 1966–1968. Oil on
canvas, 40″ × 40″. Private
collection. Courtesy of the
John Berggruen Gallery, San
Francisco. 125

105. *The Slant Step,* date un-
known. Wood, linoleum,
rubber, and nails, 18¹³⁄₁₆″ ×
15″ × 12¼″. Collection of the
New York Society for the
Preservation of the Slant
Step. Arthur G. Schade,
Franklin C. Owen, and
Wayne E. Campbell, Trus-
tees. Photo by Pam
Maddock. 127

106. William T. Wiley, *Slant Step
Becomes Rhino/Rhino Becomes
Slant Step,* 1966. Plaster,
acrylic, paint, and chain, 22″
× 12″ × 12″. Collection of
Ron Wagner. Photo by Pam
Maddock. 127

107. Ron Peetz and Phil Weid-
man, *Hairy Slant Step,* 1968.
Original burned in 1973 and
documented by Phil Weid-
man in *Burning Slant Step,* an
8mm color film. Wood, hu-
man hair, size unknown.
Courtesy of Phil and Pat
Weidman and the Richard L.
Nelson Gallery and Fine Arts
Collection, Department of
Art, University of California,
Davis. 127

108. David Simpson, *Storm, Stars,
and Stripes,* 1960. Oil on can-
vas, 64″ × 45″. Collection of
the City and County of San
Francisco, San Francisco In-
ternational Airport. Pur-
chased through the Joint
Committee of the San Fran-
cisco Arts Commission and
the San Francisco Airport
Commission. 129

109. Sam Tchakalian in his Du-
boce Street studio, San Fran-
cisco, 1975. Photo by Blair
Paltridge. 130

110. Sam Tchakalian, *Orange Juice,*
1966. Oil on canvas, 76¼″ ×
97⅛″. San Francisco Museum
of Modern Art. Beatrice Judd
Ryan Bequest Fund purchase.

List of Illustrations

List of Illustrations

Wall, 1977. Tyvek cloth and rhoplex applied directly to wall at Fourth and Mission streets, San Francisco, 7' × 21'. Photo by Cherie Raciti. 224

200. Brian Wall, *B1,* 1971. Painted steel, 9½' × 15½' × 7½'. The Oakland Museum. Gift of Brian Wall. Photo by M. Lee Fatherree. 225

201. Kathy Goodell, *Untitled,* 1981. Brass, salt, glass, and lead weights, 70" × 50" × 20". Courtesy of Gallery Paule Anglim, San Francisco. 225

202. Elin Elisofon, *B. Remnants,* 1977. Mixed media, 11" × 8" × 5". Courtesy of the Braunstein Gallery, San Francisco. 226

203. David Ireland, interior of 500 Capp Street, San Francisco, ongoing, 1978 to present. Traditional building materials, 50' × 125'. Collection of the artist. Photo by M. Lee Fatherree. 227

204. Roger Berry, *Duplex Cone,* at Arrowhead Marsh in Oakland, California, 1982. Corten steel, 11'9" × 22'3" × 15'10". East Bay Regional Parks, Oakland. Photo by Roger Gass. Courtesy of the Bluxome Gallery, San Francisco. 228

205. James Rosen, *An Homage to Bronzino,* 1975. Oil and wax-oil emulsion on canvas, 53" × 48". Collection of Professor Carl Djerassi. Photo by Roger Gass. Courtesy of the Bluxome Gallery, San Francisco. 229

206. Joan Brown, *The Bride,* 1970. Oil and enamel on canvas, 96" × 55". Collection of David Peugh. Photo by M. Lee Fatherree. 230

207. Clayton Bailey in the guise of Dr. George Gladstone, at the Wonders of the World Museum near his home in Port Costa, California, c. 1975. Bones are made of thermally metamorphosed mud. Collection of the artist. 232

208. Jeremy Anderson, *Map #3,* 1963. Ink, watercolor, and gouache on paper, 25½" ×

30½". Collection of Ninfa Valvo. Photo by M. Lee Fatherree. 234

209. Fred Martin, *Little Voyage on the Brenta,* 1965. Collage and mixed media, 18" × 18". Collection of the artist. Photo by M. Lee Fatherree. Courtesy of The Quay Gallery, San Francisco. 235

210. William T. Wiley, *Ship's Log,* 1969. Canvas, leather, wood, lead, paper, watercolor, cotton webbing, latex rubber, plastic, salt licks, wire, ink, nautical hardware, and assorted hardware, 82" × 78" × 54". San Francisco Museum of Modern Art. William L. Gerstle Fund purchase. Photo by Ben Blackwell. 236

211. William T. Wiley, *Hung Up Not Far from the Mill,* 1969. Watercolor and ink on paper, 30" × 22¼". Collection of Alice Adam. Courtesy of Fuller Goldeen Gallery, San Francisco. 237

212. Joan Brown, *Dancers in the City #3,* 1973. Oil and enamel on canvas, 96" × 120". Collection of Dorothy A. Goldeen, San Francisco. Courtesy of Fuller Goldeen Gallery, San Francisco. 238

213. Robert Arneson, 1982. © Ira Nowinski, 1982. 239

214. Robert Arneson, *Smorgi-Bob, The Cook,* 1971. White earthenware with glaze, vinyl tablecloth, and wood, 73" × 66" × 53". San Francisco Museum of Modern Art purchase. 240

215. Robert Arneson, *Kiln Man,* 1971. Terra cotta, 36" high. Collection of Gerald Hoepfner. Photo by Amanda Merullo. 241

216. Robert Arneson, *Portrait of George* (memorial bust of Mayor George Moscone), 1981. Ceramic, 94" × 29". Collection of Foster Goldstrom. Photo by M. Lee Fatherree. 242

217. Roy De Forest at his studio in Port Costa, California, 1980. © Kurt E. Fishback, 1980. 243

218. Roy De Forest, *Terrier's World,* 1974. Polymer on can-

vas, 60" × 66". Collection of Louis A. Hermes. Photo by M. Lee Fatherree. 244

219. Judy Chicago, *The Dinner Party,* 1979. Mixed media, 47' per side. © Judy Chicago, 1979. Photo by Michael Alexander. 245

220. Judy Chicago, Georgia O'Keeffe placesetting from *The Dinner Party,* 1979. Ceramic plate on Belgian linen runner, embroidered with Vers au Soie thread. © Judy Chicago, 1979. Photo by Michele Maier. 245

221. Raymond Saunders, *Charlie Parker* (formerly *Bird*), 1977. Acrylic, masking tape, newsprint, paper, and ink on canvas, 96⅛" × 82⅜". San Francisco Museum of Modern Art. Gift of Mr. and Mrs. Robert Krasnow. 246

222. David Gilhooly, *Frog Victoria, Her 100th Year as Queen,* 1976. Glazed ceramic, 33½" × 24" × 19½". Vancouver Art Gallery. Photo by Jim Jardine. 247

223. William Allan, *Shadow Repair for the Western Man,* 1970. Oil on canvas, 90" × 114". University Art Museum, University of California, Berkeley. Purchased with the aid of the National Endowment for the Arts. Photo by Ben Blackwell. 248

224. Viola Frey, *Bricoleuse,* 1976. Whiteware and glaze, 68" high. Collection of the artist. Photo by M. Lee Fatherree. 249

225. Richard Shaw, *Walking Figure Jar #1,* 1978. Porcelain with decal overglaze, 18½" × 10¼" × 9". Collection of Byron Meyer. Photo by Schopplein Studio. Courtesy of the Braunstein Gallery. 250

Note: Measurements for two-dimensional works are expressed as height by width; those for three-dimensional works, as height by width by depth.

Index

Italic page numbers indicate Appendix entries.

Designer: Steve Renick
Compositor: Huron Valley Graphics, Inc.
Text: Mergenthaler Linotron 202 Bembo
Printer: Toppan Printing Co., Ltd.
Binder: Toppan Printing Co., Ltd.
Editorial Coordinator: Marilyn Schwartz
Production Coordinator: Ellen Herman